BEGINNINGS OF INTERIOR ENVIRONMENTS

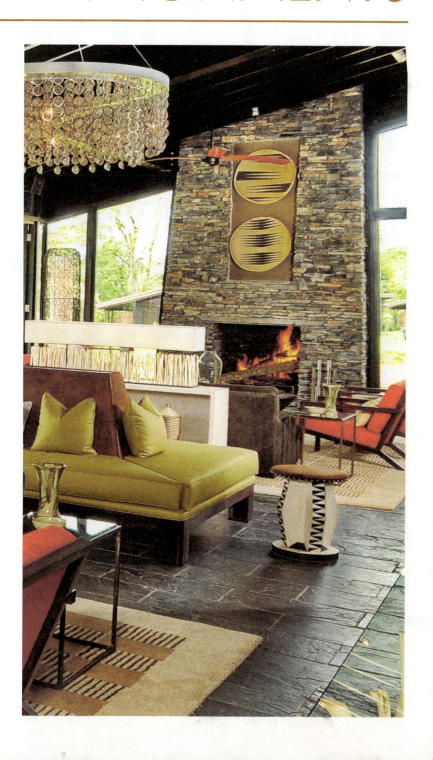

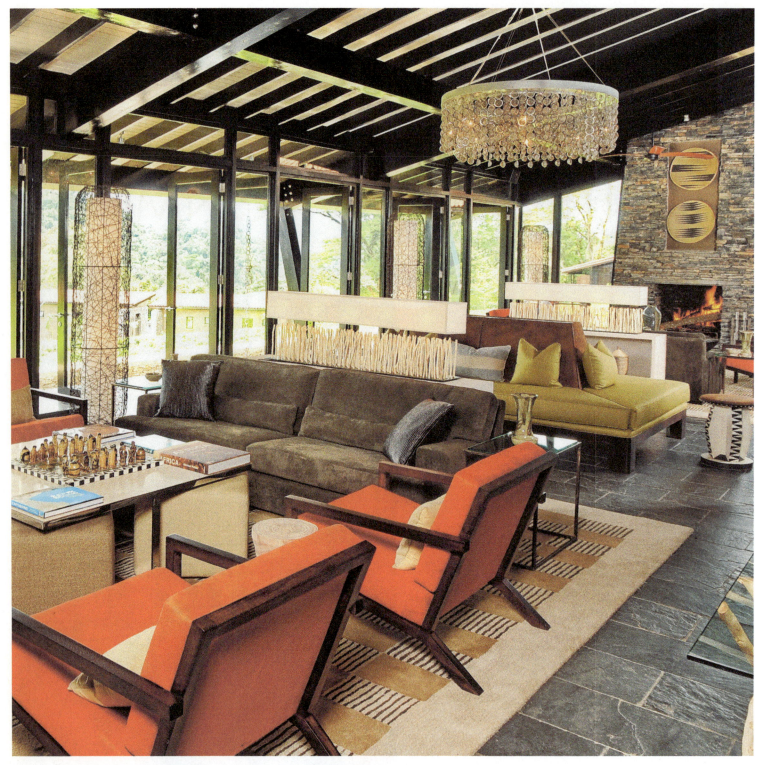

The Nyungwe Forest Lodge was selected for the cover because it exemplifies the philosophies expounded within the text. The Nyungwe Forest Lodge captures its *sense of place*. Bordering on the edge of the Nyungwe National Park—a rainforest teeming with birds, monkeys, and rare gorillas—the lodge was designed to reflect the spirit and character of the surrounding native culture and the environment. Native artisans completed much of the interior artwork including the "tea ball" chandelier; the space featured on the cover is called the Tea Lounge. More information can be found in Chapter 2, Sense of Place, and at www.nyungweforestlodge.com

(Designer: Keith Interior Design. Architect: MK2 Architecture. Client: Dubai World Africa. Photograph by Ryan Plakonouris/IYAMILA.COM)

BEGINNINGS OF INTERIOR ENVIRONMENTS

ELEVENTH EDITION

LYNN M. JONES ASID, IDEC, LEED^{AP}

Brenau University

PEARSON

Boston Columbus Indianapolis New York San Francisco Upper Saddle River
Amsterdam Cape Town Dubai London Madrid Milan Munich Paris Montréal Toronto
Delhi Mexico City São Paulo Sydney Hong Kong Seoul Singapore Taipei Tokyo

Editorial Director: Vernon R. Anthony
Editor, Digital Projects: Nichole Caldwell
Assistant Editor: Laura Weaver
Editorial Assistant: Doug Greive
Director of Marketing: David Gesell
Executive Marketing Manager: Harper Coles
Senior Marketing Manager: Alicia Wozniak
Marketing Assistant: Crystal Gonzalez
Associate Managing Editor: Alexandrina Benedicto Wolf
Production Project Manager: Alicia Ritchey
Operations Specialist: Deidra Skahill
Image Director: Mike Lackey
Coordinator of Professional Images and
 Permissions: Philip A. Jones

Art Director: Diane Ernsberger
Cover Designer: Wanda España
COVER IMAGE:
 Interior Designer: Keith Interior Design
 Architect: MK2 Architecture
 Client: Dubai World Africa
 Photographer: Ryan Plakonouris/IYAMILA.COM
Full-Service Project Management: Linda Zuk, WordCraft LLC
Composition: S4Carlisle Publishing Services
Printer/Binder: LSC Communications
Cover Printer: LSC Communications
Text Font: Garamond 3 LT Std

Credits and acknowledgments borrowed from other sources and reproduced, with permission, in this textbook appear on the appropriate page within text.

Library of Congress Cataloging-in-Publication Data
Jones, Lynn M.
 Beginnings of interior environments / Lynn M. Jones, ASID, IDEC, LEED[AP] Brenau University. — Eleventh Edition.
 pages cm
 ISBN 0-13-278600-1 (978-0-13-278600-3) 1. Interior decoration—Handbooks, manuals, etc. I. Title.
 NK2115.A59 2014
 729—dc23 2012018101

ISBN 10: 0-13-278600-1
ISBN 13: 978-0-13-278600-3

To all beginning interior designers

who desire to enrich the quality of life

through the respectful use of our earth's resources:

May each of you come to appreciate the earth's gifts

and use them wisely in your future interiors.

Brief Contents

Contents

Preface

The field of interior design encompasses a unique blend of art and science. I have always told my students that successful designers construct a balance between their left and right brains. The designer's goal in any interior is to analyze the needs and desires of the client, and through the synthesis of this information, create a healthful, safe, and sustainable environment that enhances the client's quality of life. The mission of this text is to assist beginning designers in achieving this goal.

Significant Changes in the Eleventh Edition

The eleventh edition of *Beginnings of Interior Environments* discusses foundation information that helps the reader understand the nature of interior design and the interior design profession. The text continues the tradition of earlier editions as an introductory and practical approach to understanding interior design. When I became sole author with the 8th edition, I intentionally addressed interior design holistically, stressing the importance of commercial and residential environments equally. Considerable attention was given in the 8th and 9th editions to the design process, conceptual development, sustainable design, Internet resources, multiculturalism, and design for special populations. **Design Scenarios** were added to exhibit project work that illustrates concepts explained in preceding chapters. **Sustainable Design** sidebars include specific information on green design. These are updated as needed with each new edition.

The most significant changes in content in the 11th edition include a section on Evidence-Based Design (EBD) in Chapter 2. New information reviews EBD's history and application in the health, safety, and welfare of the inhabitants as well as its ability to advance the profession. EBD is also viewed with respect to the traditional design process. Additionally, the Sustainable Design section has been enhanced in Chapter 2. As most now recognize, sustainable design is part of every design project. Sidebars on sustainable design continue to emphasize this throughout the text.

Discussions on design theory and processes have been expanded and include a section on Design Think!. The space planning chapters have advanced information on commercial building analysis, and additional information on systems furniture has been provided.

Significant chapter reorganization occurred based on feedback from the reviewers. The Lighting sections were reorganized within Chapter 6, moving the more technical information to the latter part of the chapter. Information on doors, windows, and fireplaces from later chapters is now grouped with construction components in Part III, Building Systems. Part V has been reorganized to start with the interior background materials for floors, then walls and ceilings. The later chapters

embrace furniture and textiles and end with window treatments, accessories, and art.

Much care has been taken to update images and ensure that illustrations and figures clearly enhance the text discussion. One of the greatest challenges of updating texts is, as Don Schlitz wrote, "knowing what to throw away and knowing what to keep." With 150 new images as well as updated and new illustrations, the text continues to be stimulating, intriguing, and current.

Text Overview

The following synopsis is repeated in the Introduction to ensure that students understand the broad knowledge base required of interior designers.

Part I, Introduction to Interior Environments, discusses the history of the design profession and reviews in detail the process by which interior designers complete an interior space. Drawings and plans demonstrate the use of visual communications. Chapter 2 looks at the Human Factors in interior design including Evidence-Based Design, Universal Design, and health, safety, and welfare issues. Additionally, Chapter 2 expands on the interior environment's influence on humans and the earth—from the personal space needs and desires of the inhabitants to the global impact on the natural world. A pictorial essay on the history of style familiarizes students with significant eras of design that influence today's interiors and form the basis of where we have come from, and thus where we are headed.

Part II, Design Fundamentals, establishes the basics for the study of design in all creative fields. Part II emphasizes the design thinking process, visual literacy, and the principles and elements of design that guide designers in technical and decorative design decisions. Color is given special attention because of its complexity.

Part III, Building Systems, emphasizes the architectural, building components, lighting, electrical, and mechanical aspects of design. This section assists future designers in understanding the visual communications needed to collaborate with electrical, mechanical, and structural engineers; the client; and the rest of the design team.

Part IV, Space, addresses both the technical requirements and the creative dimensions of planning the layout of furniture and rooms. Designers learn to read floor plans by thinking and visualizing in three dimensions (3-D). These chapters encourage designers to recognize space as *volume* and to design from the *inside out.*

Part V, Materials, Furnishings, and Fabrics, provides a foundation for understanding the multitude of selections available to designers. It is

organized to first review the options of background surfaces, floors, ceilings, and walls; it then moves to furniture and textiles; and it ends with decorative elements.

Finally, **Part VI, The Profession of Interior Design,** discusses the steps required to become a professional member of the interior design industry. It reviews basic business practices, ethics, and the future of the profession. The final chapter brings the interior design topics full circle. Text and images illustrate the variety of design opportunities available to students. Faculty may wish to merge this section with Chapter 1 depending on the scope of the course.

I appreciate comments on the text—what is working, what is not, or new ideas. Please send them to lmjones@brenau.edu with *Beginnings of Interior Environments* in the subject line.

Download Instructor Resources from the Instructor Resource Center

The Instructor will have access to Pearson Education's Instructor Resource Center (IRC), which provides an Instructor's Manual and PowerPoint slide presentation to accompany this content. The online Instructor's Manual develops standard test questions and practical studio design problems.

A series of electronic visual presentations has also been developed for this edition. These visuals provide a basis for instructor lectures and/or presentations. These presentation materials also allow the online links, embedded in the chapters, to become live.

To access supplementary materials online, instructors need to request an instructor access code. Go to www.pearsonhighered.com/irc to register for an instructor access code. Within 48 hours of registering, you will receive a confirming e-mail including an instructor access code. Once you have received your code, locate your text in the online catalog and click on the Instructor Resources button on the left side of the catalog product page. Select a supplement, and a login page will appear. Once you have logged in, you can access instructor material for all Prentice Hall textbooks. If you have any difficulties accessing the site or downloading a supplement, please contact Customer Service at http://247pearsoned.com.

Acknowledgments

Special appreciation is extended to the photographers, designers, architects, and manufacturers who contributed images and information for this text. Truly one of the most rewarding experiences of working on this text was searching for and securing the images created by many talented professionals. The design community has been very helpful in sharing pertinent information and materials.

I am particularly grateful to photographers Gabriel Benzur, Chris Little, Jeffrey Jacobs, and Robert Thien, and to the photographers of Hedrich Blessing for their extensive photo contributions. Jenny Fidler and Creel McCormack at TVS; Kim Scarbourgh at Design Directions, Inc.; Barbara Shadomy at Stonehurst Place; Barbara Brennan at Lifetime Television; and Amy Tessier at Wilson Associates were invaluable in answering project questions and securing images. Cynthia Pararo at Pineapple House Interior Design and Shelly Hughes at Hughes|Litton|Godwin were instrumental in the sharing of resources, images, and projects throughout much of this edition. Their attention to detail is greatly appreciated.

Many individuals have assisted in verifying information. Several practicing designers and educators reviewed chapters for accuracy and readability. I appreciate their candid and constructive comments and have altered much of the text based on these reviews.

Many thanks to the following individuals who reviewed the manuscript: Robin Carroll, Mississippi State University; Zane D. Curry, Texas Tech University; Deirdre J. Hardy, Florida Atlantic University; Sharon Hodson, Florida Atlantic University; Catherine Kendall, University of Tennessee at Chattanooga; Evelyn Everett Knowles, Park University; Jason Meneely, University of Florida; Sister Denise M. Mollica, IHM, Immaculate University; Janet P. Pazdemik, American River College; Marilyn A. Read, Oregon State University; and Nancy Wolford, Canada College. I do wish you could see your reviews amassed. It is amazing how we all decide to teach in different orders and stress different subject matter. What each of us values in the text also varies greatly. It is the diversity that makes this profession great. That being said, where a majority suggested changes, those changes did occur.

The following individuals deserve special recognition for their assistance in previous editions with their respective areas of expertise: Chris Strawbridge (UPS design scenario), Felicia Arfaoui and Deirdre O'Sullivan (Suntory), Tom Szumlic (concept), Andrea Birch (concept), Janet Morley (textiles), and Carol Platt (modern design history).

The accomplished freehand renderings of the space planning process, visual literacy, furniture types, and three-dimensional volume development are from the creative hand of Carol Platt. Paul Petrie, Steve Clem, Marcia Davis, Charles Gandy, and Roger Godwin served as a constant source of encouragement, vision, and stability throughout my design career. I still value their insights.

Linda Zuk at WordCraft was patient throughout the many changes occurring in this text and worked as a great liaison to S4Carlisle. I am grateful for her insights and attention to detail. A sincere thank-you is extended to copyeditor Marianne L'Abbate and indexer Karen Winget. Their willingness to pose questions and review details accurately are highly valued! Laura Weaver and Alicia Ritchey of Pearson/Prentice Hall were supportive throughout the process and open to the necessary changes relating to images and text and, in particular, the paper selection. To all the staff at Prentice Hall/Pearson who worked to upgrade the design, your efforts are appreciated. Joanne Casulli with the Bill Smith Group was helful in securing the last round of image permissions and supplying sites for appropriate substitutions.

To my colleagues in ASID, IDEC, and at Brenau University, as well as to my students, I express my wholehearted appreciation for your support, motivation, and understanding. To my dearest friends and family in Georgia, Indiana, and in the North Fork, I appreciate the space (both physical and psychological) you allowed for my husband and me to complete the text. To my parents, Verle and Nona Fiegle, I express deep-felt gratitude for the tenacity and dedication that you instilled in me. These characteristics have helped immensely. And, Mom, we miss you dearly, but I feel your gentle spirit guiding my thoughts.

Finally, to my husband Philip, I cannot adequately express my sincere appreciation for the hundreds of hours (taken from our personal time) that you spent, once again, wordsmithing, typing, calling, and generally assisting with the organization of this text, its first edit, and the art and photo manuscript. For your spirit and sustained encouragement, I am forever indebted.

History of This Text

Phyllis Sloan Allen began the first edition of *Beginnings of Interior Environments* in 1968. She updated and enhanced the textbook five times, until requesting that her protégé, Miriam F. Stimpson, assist with the 6th edition. The text was considerably rewritten by Miriam and included new information on history, furniture, CAD, and residential space planning. For the 7th edition, Miriam added a lighting chapter, expanded information on accessories, and introduced commercial design. More than half the photos were also updated at this time. Lynn M. Jones took over the text with the 8th edition and it has evolved as indicated above.

About the Author

Lynn M. Jones, ASID, IDEC, LEED[AP], knew she wanted to pursue interior architecture at an early age. In grade school she developed house plans on graph paper and raked leaves or shoveled snow into floor plan patterns; furniture in her room was always on the move. Lynn graduated from Purdue University magna cum laude with a Bachelor of Science in Environmental Design, and at age 23 became NCIDQ certified. She earned her Masters in Historic Preservation from the University of Georgia summa cum laude. Her thesis, *The Design of National Park Visitor Centers: The Relationships between Buildings and Their Sites*, took Lynn and her husband to more than 100 National Park locations. She has since earned an MBA in Leadership.

Lynn worked full time as a designer in Atlanta for several years, focusing on hospitality and commercial office design. She has been an educator since 1984 and opened her own business, *Jones* Interiors, in 1989 to coincide with her educational endeavors. Her work has received awards from ASID, AIA, and IDEC. She was named outstanding faculty member at Brenau University, where she served as Interior Design Program Director from 1988–2000, Chair of Art & Design from 1997–2005, Graduate Coordinator/Chair of Interior Design from 2006–2011, and currently serves as Associate Dean of the Undergraduate College.

Lynn and her husband spend their summers at a remote homestead in northwest Montana, where she finds inspiration and respite in the beauty and simplicity of nature.

Part I

Introduction to Interior Environments

Interior design unites the seemingly opposite disciplines of art and science by relying on the tools of science to craft the functional elements of three-dimensional space as well as the aesthetic ones.

—International Interior Design Association

CHAPTER 1
Understanding Interior Design

CHAPTER 2
The Value of Interior Design: Health, Safety, and Welfare

PICTORIAL ESSAY
History of Style

FIGURE I.1A In the true blend of art and science, the CIDA office emulates the importance of interior design. The open office areas, collaborative spaces, and enclosed work areas meet the diverse needs of the client. Warm colors and bamboo flooring (a good sustainable product selection) provide a warm entry for visitors and employees. As seen on the floor plan on the next page, a strong angled axis leads the visitor into the workspace.
(Designer: Progressive AE. Photograph by Kevin Beswick, People Places & Things)

1

Throughout history humans have organized and enhanced their surroundings to meet their physical and psychological needs. Tools and products were developed and refined to perform specific tasks. Furniture, fabrics, and finishes changed to meet people's needs. The physical arrangements of rooms, furnishings, and mechanical and electrical systems have been relocated based on aesthetics and function. Today, the interior design profession incorporates a broad scope of services offered to a wide variety of clients (Figure I.1A and B).

DEFINITION OF INTERIOR DESIGN AND RESPONSIBILITIES OF AN INTERIOR DESIGNER

The following definition, developed by the National Council for Interior Design Qualification (NCIDQ), demonstrates the scope of the interior design profession:

Interior design is a multifaceted profession in which creative and technical solutions are applied within a structure to achieve a built interior environment. These solutions are functional, enhance the quality of life and culture of the occupants, and are aesthetically attractive. Designs are created in response to and coordinated with the building shell, and acknowledge the physical location and social context of the project. Designs must adhere to code and regulatory requirements, and encourage the principles of environmental sustainability. The interior design process follows a systematic and coordinated methodology, including research, analysis, and integration of knowledge into the creative process, whereby the needs and resources of the client are satisfied to produce an interior space that fulfills the project goals.

Interior design includes a scope of services performed by a professional design practitioner, qualified by means of education, experience, and examination, to protect and enhance the life, health, safety, and welfare of the public. These services may include any or all of the following tasks:

- Research and analysis of the client's goals and requirements; and development of documents, drawings, and diagrams that outline those needs;
- Formulation of preliminary space plans and two- and three-dimensional design concept studies and sketches that integrate the client's program needs and are based on knowledge of the principles of interior design and theories of human behavior;
- Confirmation that preliminary space plans and design concepts are safe, functional, aesthetically appropriate, and meet all public health, safety, and welfare requirements, including code, accessibility, environmental, and sustainability guidelines;
- Selection of colors, materials, and finishes to appropriately convey the design concept, and to meet socio-psychological, functional, maintenance, life-cycle performance, environmental, and safety requirements;
- Selection and specification of furniture, fixtures, equipment, and millwork, including layout drawings and detailed product description; and provision of contract documentation to facilitate pricing, procurement, and installation of furniture;
- Provision of project management services, including preparation of project budgets and schedules;
- Preparation of construction documents, consisting of plans, elevations, details, and specifications, to illustrate nonstructural and/or nonseismic partition layouts; power and communications locations; reflected

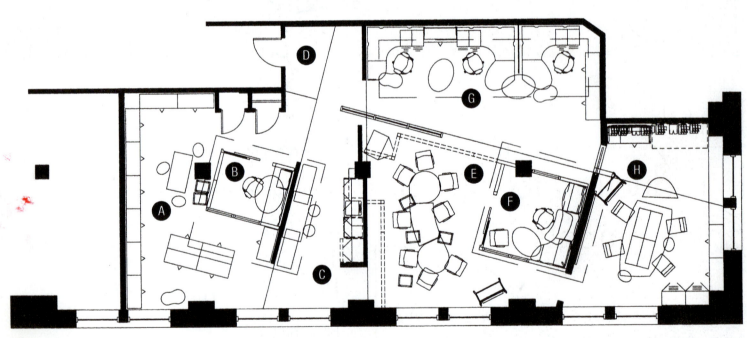

Floor Plan

A. Resource alley
B. Private enclave
C. Kitchen/café
D. Entry
E. Collaborative space
F. Private office
G. Individual work space
H. Project workroom

FIGURE I.1B The floor plan of the CIDA office illustrates the emphasis of interior design on concept, function, and aesthetics. The angled axis, as seen in the image on page 1 and in the computer-aided design plan above, draws the visitor into the space. Interior designers develop the ability to visualize interior environments by reading two-dimensional floor plans. These plans define the interior partitions, furniture locations, and traffic flow.
(Designer: Progressive AE)

ceiling plans and lighting designs; materials and finishes; and furniture layouts;

- Preparation of construction documents to adhere to regional building and fire codes, municipal codes, and any other jurisdictional statutes, regulations, and guidelines applicable to the interior space;
- Coordination and collaboration with other allied design professionals who may be retained to provide consulting services, including but not limited to architects; structural, mechanical, and electrical engineers; and various specialty consultants;
- Confirmation that construction documents for nonstructural and/or nonseismic construction are signed and sealed by the responsible interior designer, as applicable to jurisdictional requirements for filing with code enforcement officials;
- Administration of contract documents, bids, and negotiations as the client's agent;

- Observation and reporting on the implementation of projects while in progress and upon completion, as a representative of and on behalf of the client; and conducting postoccupancy evaluation reports.

Source: http://ncidq.org/AboutUs/AboutInteriorDesign/DefinitionofInteriorDesign.aspx

Design for Multicultural Environments

Designers coordinate interiors that are welcoming to a multicultural community. Different cultures view color and space in a variety of ways. As global travel and the Internet bring design communities closer together, designers commonly complete projects overseas. Sensitivity to individuals' tastes and cultural preferences permits designers to suggest the appropriate design solutions for these clients (Figure I.2).

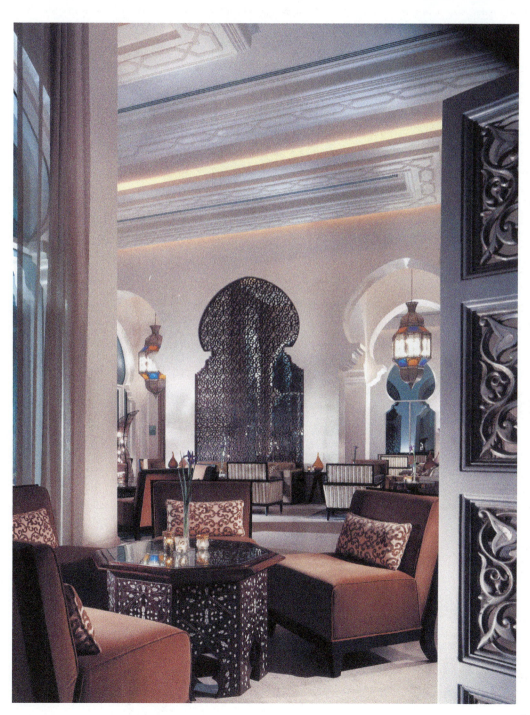

FIGURE I.2 Interior design for clients of diverse cultural backgrounds is an expanding market. This seating area, located in the Park Hyatt Dubai, was designed based on the client's request for "a simplistic form of Arabic architecture combined with the crispness of simple Greek architectural building elements." Custom shapes, intricate patterns, delicate moldings, and indigenous materials reflect the country's native culture. Strong architectural forms reflect the classical Greek design.
(Interior Architectural Design by Wilson Associates. Photography by Michael Wilson)

Design for Sustainable Environments

Interior designers also are responsible for protecting the environment by employing sustainable resources whenever possible. Designers develop design solutions that promote environmental considerations and use and specify products that are recycled and can be recycled. The use of sustainable products and the development of environmentally sensitive interiors is called **sustainable** or **green design** (Figure I.3).

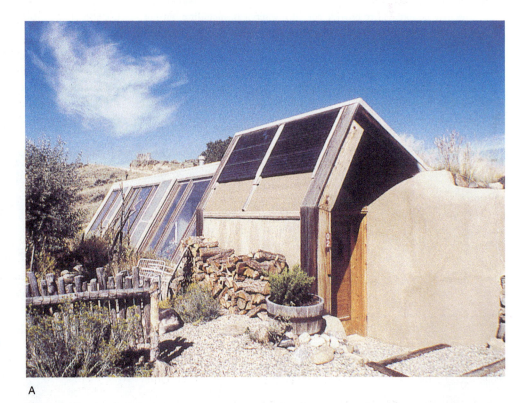

FIGURE I.3 This house, called the Suncatcher, is constructed from used tires packed with dirt and stacked to form the walls. The walls are covered with stucco to create a Southwest adobe interior. The windows face south to aid in the solar design. (A) Exterior; (B) entry hallway, looking back toward the front door; (C) living area.

(Jones Interiors Photography by Philip A. Jones)

A

B

C

More info online @

www.asid.org/designknowledge/sustain American Society of Interior Designers
Sustainable Design Knowledge Center; links to many other resources
www.aiasdrg.org American Institute of Architects Sustainable Design Resource
Guide; links to other resources

Design for Special Population Environments

Interior designers are responsible for developing interior environments for people of all ages and abilities, including the elderly, children, and those who are temporarily or permanently disabled. According to Anita Rui Olds in *Child Care Design Guide*, one out of every three children under the age of five is enrolled in a part-time or full-time day care program. Conversely, by 2030, approximately 26 percent of the population will be over the age of sixty-five; many of these individuals will prefer to age at home, called *aging in place*. Designers understand the complexities related to the diverse needs of these clients.

The concept of **universal design** focuses on creating spaces and furnishings to meet the needs of individuals regardless of age and ability. Interior designers integrate the needs of a wide variety of individuals into a particular space.

More info online @

www.design.ncsu.edu/cud The Center for Universal Design
www.universaldesign.org Universal Design Alliance

Interior Designer/Architect and Decorator: The Taxonomy

The terms interior *designer/interior architect* and *interior decorator* have different meanings. Interior design is the profession that embodies the previous definition and responsibilities as defined by NCIDQ. In some countries, the practice of interior design is referred to as interior architecture. Some universities in the United States also use the title interior architecture for their interiors program's name.

The International Federation of Interior Architects/Designers (IFI) is a nonprofit organization formed in 1963 that serves as the singular international voice that "acts as a global forum for the exchange and development of knowledge and experience, in worldwide education, research and *practice.*" Note the use of the organization's title—Interior Architects/Designers. IFI "exists to expand, internationally and across all levels of society, the contribution of the Interior Architecture/ Design profession through the exchange and development of knowledge and experience, in education, practice and fellowship." Their definition of a professional interior architect/designer parallels NCIDQ's definitions; IFI's definition states the following:

Qualified by education, experience and applied skills, the professional Interior Architect/Designer accepts the following responsibilities:

- Identify, research and creatively solve problems pertaining to the function and quality of the interior environment
- Perform services relating to interior spaces including programming, design analysis, space planning, aesthetics and inspection of work on site, using specialized knowledge of interior construction, building systems and components, building regulations, equipment, materials and furnishings

- Prepare schematics, drawings and documents relating to the design of interior space, in order to enhance the quality of life and protect the health, safety, welfare and environment of the public

Source: http://ifiworld.org/#Definition_of_an_IA/D

In the United States, however, professionals who use the title "interior architect" are challenged by the architectural community for the use of the term *architect*. Currently that title is limited to those who have earned an architectural degree from an accredited institution, gained practical experience, passed the national architectural exam, and become registered by the state. Graduates of bachelor-level interior design (and interior architecture) programs in the United States are positioned to combine their academic and professional experiences to sit for NCIDQ.

Many states have legislation concerning the practice of interior design through practice and/or title acts. These are regulated through a state board, frequently in conjunction with the regulation of architecture. These states may require the completion of a bachelor's degree accredited by the Council for Interior Design Accreditation, CIDA (see below), and passage of the NCIDQ exam as the basis for licensing, registration, or the use of the title "registered interior designer" or similar. However, in states without these acts, individuals can practice as interior designers without education, experience, and/or examination. Much effort is extended nationwide by the interior design professional community to ensure that practice and title acts are enacted in all states to protect the profession and the public. Legislation is constantly changing; therefore students pursuing a career in interior design are encouraged to confer with their state boards. (See Chapter 14 for more information.)

Interior decorating, or the embellishment of interiors through the use of finishes and the selection and arrangement of fabrics and furnishings, is a subset of interior design. A decorator is not required to complete a bachelor's degree and typically works only in residential design.

It is important to emphasize that, although the interior designer may be responsible for the application of design solutions for load-bearing walls, the practice of interior design does not include the structural design of buildings. Designers collaborate with a team of allied professionals, especially when working with mechanical and electrical systems and construction components.

As defined earlier by NCIDQ, the interior designer is "qualified by education, experience, and examination, to protect and enhance the life, the health, safety, and welfare of the public." The Council for Interior Design Accreditation (CIDA) is a self-governing organization that reviews and accredits educational programs in interior design (as well as college programs entitled interior architecture). The standards developed by CIDA, with input from practitioners and educators, form a common body of knowledge required of all interior designers, regardless of their specific career direction. University programs certified by CIDA ensure that aspiring designers receive the appropriate content knowledge to practice as entry-level interior designers.

More info online @

www.accredit-id.org Council for Interior Design Accreditation
http://ifiworld.org/#About _IFI International Federation of Interior Architects/ Designers
www.ncidq.org National Council for Interior Design Qualification

RELATIONSHIP WITH ALLIED PROFESSIONS

While developing a new or renovated interior for a client, a designer works as a member of the design team. Interior designers may work with architects; builders; decorators; landscape architects; mechanical, electrical, and structural engineers; and product and graphic designers. Designers are also likely to work with other professionals including lighting and sound specialists, historic preservationists, and a wide variety of other specialized contractors in interior finishes, fabrics, furniture, and products. The success of a job depends on communication and collaboration among these design professionals.

TRAITS AND KNOWLEDGE REQUIRED BY INTERIOR DESIGNERS

Successful interior designers develop strong communication and business skills to perform competently and effectively with clients and allied professionals. Interpersonal communication skills are a key attribute of a professional interior designer, as both a listener and a communicator. Designers work with a variety of trades that require concise interactions to ensure accuracy in project specification and timeliness. Visual as well as written communication skills enable the designer to describe design solutions clearly. Designers are also clever managers and business entrepreneurs. Designers work with budgets, schedules, contracts, and other legal documentations necessary in the built environment. Designers must be able to sell their ideas, manage their time, and work collaboratively in team situations.

Designers develop a knowledge base that provides a background for their design decisions and project solutions. A broad-based curriculum combining a strong liberal arts foundation with a professional interior design component prepares emerging design professionals for successful careers.

This text prepares aspiring interior designers for the study of the interior environment.

TEXTBOOK ORGANIZATION

Part I, Introduction to Interior Environments, discusses the history of the design profession and reviews in detail the process by which interior designers complete an interior space. Drawings and drafted plans demonstrate the use of **visual communications** required of all design professions. Students using this text as a part of an introductory design course may be required to start drafting or to work with **computer-aided design (CAD)** software (Figure I.4). This section also expands on the interior environment's influence on and value to humans and the earth—from personal space needs and desires of inhabitants, regardless of nationality or ability, to the global impact of design on the natural world. Also in Part I, a pictorial essay traces the history of style, illustrating the importance of past eras and their influence on contemporary interiors.

Part II, Design Fundamentals, establishes the basics for the study of design in all creative fields, including the importance of the design thinking process, **visual literacy**, and the development of the **concept**. Part II emphasizes the principles and elements of design that guide designers in technical and decorative design decisions. Color is given special attention because of its complexity.

Part III, Building Systems, emphasizes the architectural, electrical, and mechanical aspects of design. Lighting solutions are particularly important in interior spaces. This section assists future designers in understanding the visual communications needed to collaborate with electrical, mechanical, and structural engineers, the client, and the rest of the design team.

Part IV, Space, addresses both the technical requirements and the creative dimensions of planning the layout of furniture and rooms. Designers learn to read floor plans by thinking and visualizing in three dimensions (3-D). These chapters encourage designers to recognize space as **volume** and to design space from the *inside out*.

Part V, Materials, Furnishings, and Fabrics, provides a foundation for understanding the multitude of selections available to designers. For example, designers need to know the advantages and disadvantages of selecting cut-pile carpet over level-loop carpet, or flat latex paint over semi-gloss alkyd.

Finally, Part VI, The Profession of Interior Design, discusses the steps required to become a professional member of the interior design industry and reviews basic business principles and ethics. The text concludes with an outlook for the profession.

More info online @

www.careersininteriordesign.com/what.html Career website sponsored by professional design organizations

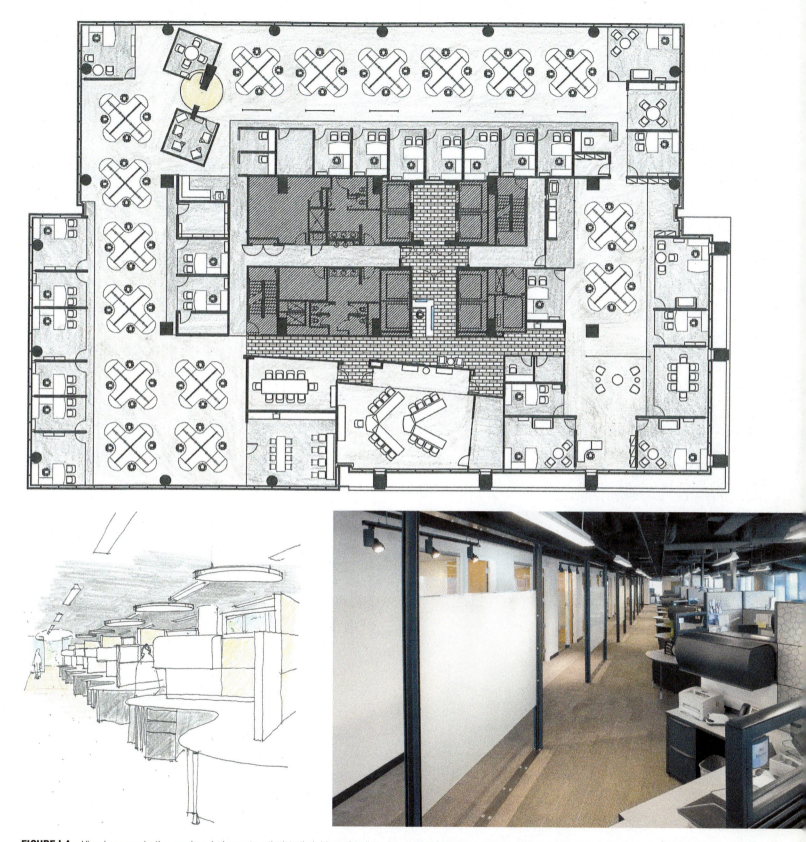

FIGURE I.4 Visual communication requires designers to articulate their ideas visually to the client before completing the project. In this project, the designer developed the presentation floor plan using CAD software. The perspective was created by first using a wire frame drawing in CAD. A freehand sketch then personalized the wire frame form. The photograph indicates the same perspective view upon completion of the interior space.

(Architect/Designer: Hughes|Litton|Godwin. Photograph by John Haigwood)

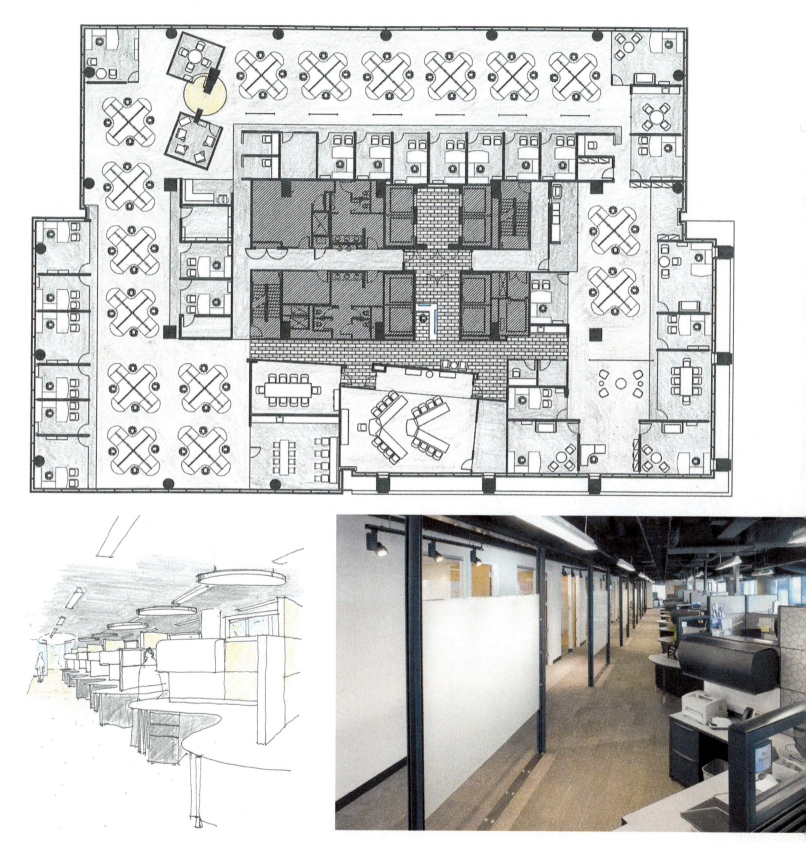

FIGURE I.4 Visual communication requires designers to articulate their ideas visually to the client before completing the project. In this project, the designer developed the presentation floor plan using CAD software. The perspective was created by first using a wire frame drawing in CAD. A freehand sketch then personalized the wire frame form. The photograph indicates the same perspective view upon completion of the interior space.

(Architect/Designer: Hughes|Litton|Godwin. Photograph by John Haigwood)

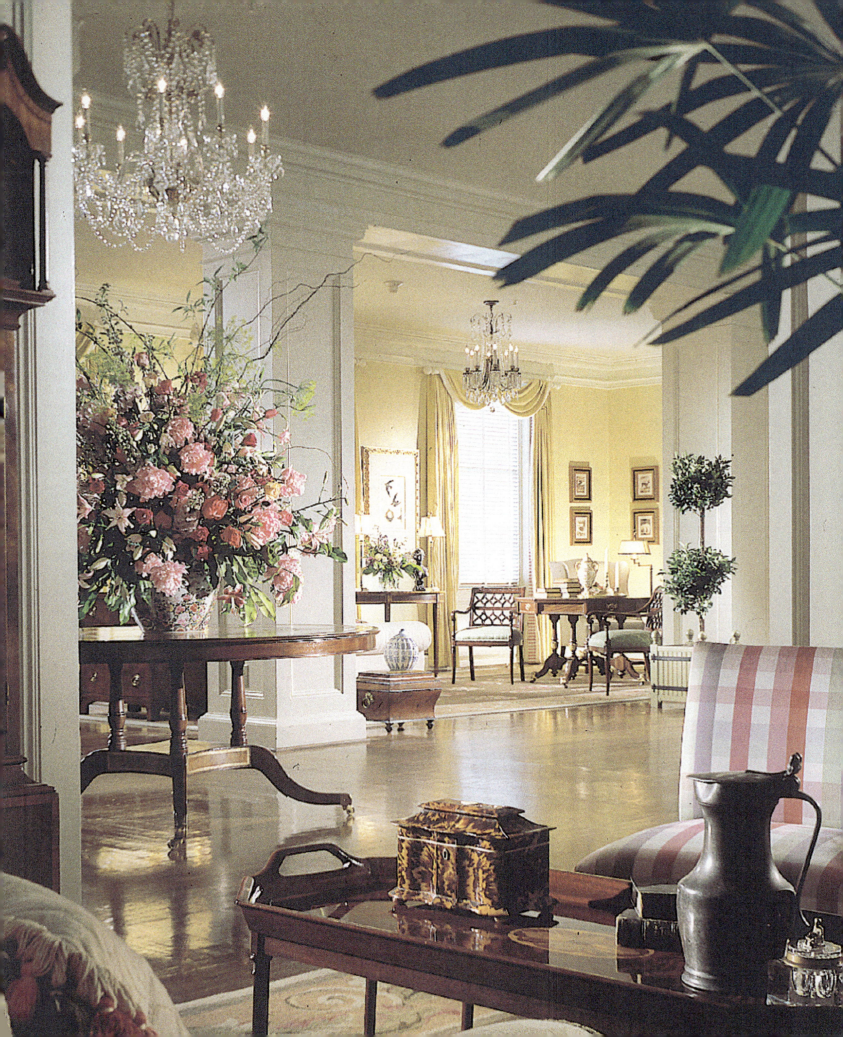

1 Understanding Interior Design

FIGURE 1.1 This warm and inviting space welcomes guests into the Carolina Inn lobby and makes them feel pampered. Hospitality design requires designers to create interiors not only for their clients—the hotel owners—but also the clients' clients—the hotel guests.
(Architect/Designer: The Glave Firm. Photograph by Robert Miller)

Interior design is as old as the Cro-Magnon culture, where walls were decorated to bring a *sense of place* to the interior environment. Ancient designs from the Egyptians, Greeks, and Romans form the basis of interior design. Middle Age and Renaissance designs are applied in many interiors, particularly in Europe. Dr. Henry Hildebrandt of the University of Cincinnati notes that during the 1700s the English designer Robert Adam and his family formed a business creating interior spaces by combining furniture design, interior architecture, and decoration—thus, integrating the entire interior environment. (See the History of Style—English Styles following Chapter 2.) Adam and others like him, such as John Nash and John Soane, coordinated with cabinetmakers, painters, upholsterers, plasterers, and related artisans.

The *profession*, however, of interior design is relatively new. It evolved during the latter half of the nineteenth century and the early twentieth century, and then fully emerged following World War II. As with Robert Adam, interiors designed before the establishment of the profession as it is known today were executed primarily by furniture designers, cabinetmakers, architects, and others active in the decorative arts.

■ DEVELOPMENT OF THE INTERIOR DESIGN PROFESSION

In the 1850s, authors became deeply interested in how human comfort was affected by sound principles of design. At the time, the Industrial Revolution (particularly in Europe) was producing a variety of poor-quality household goods. Many individuals condemned the use of the machine to create inferior products and designs.

William Morris and the Arts and Crafts movement in 1860s England advocated "good design for everyone." English author and moralist Charles Eastlake wrote *Hints on Household Taste* in 1868, one of the first books on interior decoration. In the United States, American Arts and Crafts movement leader Gustav Stickley published *The Craftsman* at the turn of the century, featuring numerous articles on home design. In the late nineteenth century, various publications such as *Godey's Lady's Book, Harper's New Monthly, Harper's Bazaar*, and *Ladies' Home Journal* advocated more tasteful interiors. As early as 1890, Candace Wheeler published an article entitled "Interior Decoration as a Profession for Women." Later that decade, Edith Wharton and Ogden Codman wrote *The Decoration of Houses*, which was intended to explain that the purpose of interior decoration was to accentuate the proportions of a well-designed room. W. C. Gannet wrote a privately printed series of essays called "The House Beautiful," from which in 1896 a magazine of the same title derived its impetus and was first published. Soon, other home decorating periodicals appeared on the market.

Candace Wheeler and Elsie de Wolfe

Candace Wheeler, a textile designer, is considered by many to have been the first interior decorator. In the late 1870s, Wheeler established the Society of Decorative Arts. Louis Comfort Tiffany hired Wheeler to manage the textiles side of his design firm. Wheeler's luxurious textiles with patterns reflective of nature adorned the walls of the homes of Cornelius Vanderbilt II and actress Lily Langtry. Wheeler also decorated Mark Twain's homes, his main residence in Hartford and his summer home in Onteora, New York (Susan Dominus, *New York Times Magazine*, Fall 2001).

One of the most famous individuals to offer interior decorating services to the public was New York actress Elsie de Wolfe, who had expert knowledge of French furniture and antiques. Her decorating expertise could transform a room with a somber, cluttered, Victorian feeling into one with a light, airy, eclectic French design (Figure 1.2).

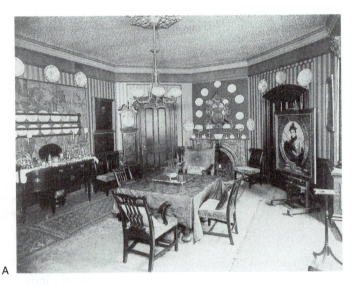

FIGURE 1.2 A dining room designed by Elsie de Wolfe early in her career is shown in (A). The lighter, refreshing redesign (B) of the same room exemplifies de Wolfe's later design character.

(Photographs from the Byron Collection, The Museum of the City of New York)

In 1901, Elsie de Wolfe began her business as "America's first professional interior decorator." Through her efforts, along with the work of others during this period, including Candace Wheeler, Nancy McClelland, English decorator Syrie Maugham (known for her "white" interiors), Dorothy Draper (who wrote a decorating advice column and was a pioneer in hospitality design), Rose Cummings, and later Billy Baldwin (who was known as the "Dean of Decorators"), the profession of interior decorating was established.

Frank Lloyd Wright

Whereas Elsie de Wolfe focused on the embellishment of surface decoration and the placement of furniture and accessories, Frank Lloyd Wright, an architect working in the early 1900s, brought to the profession an integration of structure and design. Wright was concerned with the planning of space, its function, and its relationship to the structure. He defined spaces based on furniture arrangements rather than enclosures. His integration of furnishings, light, construction materials, ornamental detail, and structural materials formed what he called **organic design.**

In the Robie House (Figure 1.3), as in all his prairie-style homes, Wright emphasized the fireplace. Materials used on the exterior of the home were brought inside to become part of the hearth. The hearth became the heart or core of his homes, symbolizing the strength of the American household.

Other progressive designers and architects, in both America and Europe, saw the need to integrate the exterior of a structure with the interior spaces and furnishings. Designers also began to integrate acoustical and lighting solutions into their designs during this era.

Following World War II, the explosive growth of commercial and residential development created a greater demand for interior design services. Americans wanted more efficient and aesthetically pleasing private and public environments—and were willing to support a new profession that would implement that desire.

More info online @

www.greatbuildings.com/architects/Robert_Adam.html Information on Robert Adam
http://ocp.hul.harvard.edu/ww/wheeler.html and www.metmuseum.org/special/Candace_Wheeler/Wheeler_more.htm Information on Candace Wheeler
www.architecturaldigest.com/architects/legends/archive/dewolfe_article_012000 Information on Elsie de Wolfe
www.franklloydwright.org Frank Lloyd Wright Foundation

◼ PROFESSIONAL DESIGN ORGANIZATIONS

The establishment of professional interior design societies began in the 1930s with the development of the American Institute of Interior Decorators (AIID), which gave credibility to the new profession. In order to be a member of the organization, individuals were required to have a combination of education and experience. The society emphasized continuing education programs, a code of ethics, outreach to the community and students, and collaboration with related professions. These same values are still intrinsic in the American Society of Interior Designers (see Chapter 14, page 438).

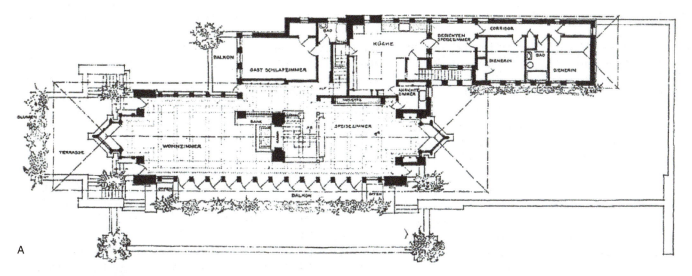

FIGURE 1.3 In the plan of the 1909 Robie House (A), Frank Lloyd Wright's emphasis on the fireplace as the heart of the home is evidenced by its central location. (B) shows an interior view of the home from the dining room looking into the living room. The bank of windows to the left pulls the outdoors into the home.
(© 2012 Frank Lloyd Wright Foundation, Scottsdale, AZ / Artists Rights Society (ARS), NY)

form IIDA, the International Interior Design Association, with approximately 13,000 members. Both ASID and IIDA require the passage of the National Council for Interior Design Qualification (NCIDQ) exam as one requirement for professional membership. In 2002, ASID and IIDA again joined forces to pursue merging into one interior design professional organization. Unfortunately, an agreement on critical issues was not met. The Unified Voice movement was reopened in 2011 with strong encouragement from the Interior Design Educators Council (IDEC). Both professional organizations do, however, continue to collaborate, particularly at the local level. Canadian interior designers can join Interior Designers of Canada (IDC), a professional organization started in 1980. IDC works closely with ASID and IIDA and collaborates with NCIDQ. More information about these organizations is presented in Part VI, The Profession of Interior Design.

More info online @

www.asid.org American Society of Interior Designers
www.interiordesigncanada.org Interior Designers of Canada
www.iida.org International Interior Design Association
www.ncidq.org National Council for Interior Design Qualification

After World War II, the nonresidential or contract market developed. Decorators were designing hotels, offices, and retail establishments. Space planning became a focus of the decorating community. For many, the term *decorator* no longer fit, and in 1957 the National Society of Interior Designers (NSID) was formed, the second professional design organization in the United States. In 1975, the two organizations merged to form the American Society of Interior Designers (ASID). Currently ASID has 18,000 practicing members, 7,500 industry affiliates, and 10,500 student members.

Various other professional organizations developed throughout the 1970s and 1980s. In the 1980s and 1990s, a movement called the Unified Voice was created to bring all competing professional interior design organizations under one umbrella. In 1994, three organizations (the Institute of Business Designers, the Council of Federal Interior Designers, and the International Society of Interior Designers) merged to

■ GOALS OF INTERIOR DESIGN

Designers are aware of the impact of the physical interior environment on the occupants' lives. The need for adequate shelter is only the beginning. The environment also must promote the comfort and convenience of the end users, both physically and psychologically, while taking into account economic realities. Meeting human needs in specific environments, whether residential or commercial, requires a balance of technical knowledge and an appreciation of quality aesthetics.

The designer's ultimate goal when planning a residence or commercial structure should be the integration of the basic requirements for an efficient and aesthetically pleasing space. If the interior space satisfies the *function* requested by the client, meets the *aesthetic* criteria of the design, and is completed within the client's *economic* directives, the project is a success (Figure 1.1).

Function and the Human Factor

To be livable, an interior first should fulfill its intended function of satisfying the needs of the people for whom it is designed. Careful consideration of functional space begins in the programming phase. Specific design requirements may be necessary for the special needs of users such as children, the elderly, or the physically challenged. The human factor is a primary concern when determining the function of the space (Figure 1.4). This is obvious when one considers the needs of a day care or elementary school in contrast to a care center for the elderly or a university classroom building.

From a psychological viewpoint, humans must feel comfortable in relation to the scale and proportion of the interior architecture. The three-dimensional aspects of ceiling height, wall length, and cubic feet should be considered because, if the space is too vast or too small, the occupants may feel uncomfortable or out of place. Satisfying human psychology entails many other design criteria as well, including selection and arrangement of line, color, form, lighting, and texture to create a sense of balance and harmony.

Interior spaces and fixtures need to be scaled to meet the proportions of the users, while also meeting their physical needs. Furniture should be suitably scaled and arranged for purpose and efficiency. For example, a chair for relaxing should be comfortable and should fit the size of the occupant, with a table at the appropriate height close by to accommodate a lamp that produces adequate lighting with no glare.

The designer should create an environment that not only meets the client's needs, but also is a safe environment in which to live. Life safety and building codes must be followed. No matter how wonderful an interior space looks, if the users cannot efficiently complete the activities and functions required in the space, the design has failed. Chapter 2 expands on this goal of design.

Aesthetics

The second goal of an interior space should be to create a pleasant and appealing environment. It is essential that students of design develop awareness and sensitivity to the aesthetics of all interior environments, including private dwellings, financial or educational institutions, offices, retail and hospitality spaces, health care centers, and other non-residential interiors.

Anyone can express personal preferences, but developing good aesthetic judgment requires a high level of *discernment* that is acquired through years of experience and observation. Good design has no absolute formula; however, the successful use of aesthetic principles—scale and proportion, rhythm, balance, emphasis, and harmony—aids in decision making and enhances the designer's results. Integrity and simplicity are important ingredients in good design, along with consideration for the design's function and its relationship to the environment and to people.

The following guidelines can help the beginning designer develop a discriminating eye for quality design:

- The elements and principles of design (discussed in Chapter 3) must be understood and applied.
- Objects in nature should be carefully observed. Their play of light and shadow, and their shape, texture, pattern, and color are fine examples of design (Figure 1.5).
- Historical and contemporary eras of design serve as a foundation for current design solutions (see Pictorial Essay).
- Professional design periodicals provide valuable ideas. (A listing of selected periodicals appears at the end of the reference list.)
- Fashion is not a criterion of good design. Like fashion in clothes, fashion in home furnishings often becomes outdated. National

FIGURE 1.4 The needs of individuals' spaces vary greatly based on their physical and psychological abilities. A significant goal of the interior environment is accommodate those needs. Potential impediments are eliminated by the interior designer.

(© Yuri Arcurs / Fotolia; © Picture-Factory / Fotolia; © pressmaster / Fotolia; © Darrin Henry / Fotolia)

Radial balance Asymmetrical balance Symmetrical balance

FIGURE 1.5 Objects in nature demonstrate the various types of balance. A spider's web indicates radial balance. This tree exhibits asymmetrical balance, whereas a butterfly is an example of symmetrical balance.

trends, events, and celebrities can influence individual taste, but do not necessarily relate to good design.

- *Simplicity* is key to quality design. The famous architect Ludwig Mies van der Rohe coined the phrase, "Less is more."
- All design decisions and selections should possess *integrity*. Furnishings with integrity exhibit their true identity. For example, a plastic laminate surface should look like plastic, not like cheap wood grain.
- Quality design is not "cute."
- Quality design is timeless.

Elsie de Wolfe expressed the interior design aesthetics through the terms "simplicity, suitability and proportion." Knowledge of what constitutes good design enables designers to guide their clients toward wise design decisions. This may mean educating the client. Good design is a long-term investment, and although at times expensive, it is worth the cost.

Economics and Ecology

The third goal of interior design is to work within the proposed budget. Designers work to satisfy the client's needs and desires within a reasonable budget to which both parties agree. If during the planning stages it becomes apparent to the designer that the project is exceeding the cost of the original projection, the designer has an ethical obligation to inform the client. Changes in the project scope or budget need to be addressed immediately.

Economic value becomes an important factor when designing and selecting interior components. Long-term upkeep and **life cycle costing** (the total manufacturing and operating cost for the life of the product) are important factors when considering which items to recommend to a client. For instance, a desk chair for a client's office may be available at a local office supply store for around $125; however, if the casters easily fall off or the chair is not ergonomically designed to fit the client, the value of the chair is low. Conversely, a more expensive office chair with a five-star base and adjustable arms, back, and seat would prove to be the better long-term investment and therefore is a better value to the client.

Economic considerations also relate to ecological and environmental concerns, or sustainable design. Designers must not compromise their client's health by specifying potentially harmful materials to save on costs. For example, some inexpensive carpet padding may serve its intended purpose, but the gasses released from the padding could harm the building's inhabitants.

Similarly, designers should consider long-term environmental costs before specifying the use of any product that may be rare or endangered or that through its production may harm the environment. For instance, rare woods may look appealing, yet by specifying them the designer may be encouraging the harvesting of threatened forests. Effective environmental design decisions produce interiors that utilize materials and products that ensure environmental sustainability for future generations (Figure 1.6). Sustainable design considerations are discussed in Chapter 2 and are highlighted throughout the text in relationship to each chapter's subject matter.

■ THE DESIGN PROCESS/SCOPE OF SERVICES

Knowing where to begin with a client, what information to obtain, and then how to proceed through the installation and evaluation of the completed space is a comprehensive task. Designers follow the **design process** to ensure creative and comprehensive design solutions that satisfy clients' needs and desires while meeting the goals of interior design (Table 1.1).

Designers may use a variety of terminologies to describe the design process or the methods of completing a project. All terminologies or methods center on the analysis and synthesis of the design solution.

Analysis focuses on discovery. Analyzing a design project requires gathering information, understanding goals and objectives, researching related codes and other technical data, comprehending the design problem, and defining the design criteria. Once this information has been assimilated, designers begin to synthesize the solution.

Like the analysis phase, the *synthesis* phase also requires an immense amount of contemplative thought. Designers stretch their imaginations and develop alternative solutions to the design problem. Only then does the designer return to the analysis phase to select the best

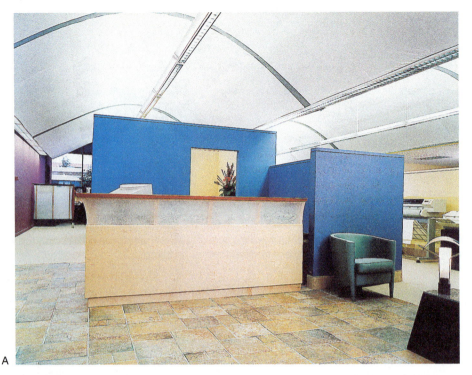

FIGURE 1.6 This industrial and mechanical engineering firm's office is designed to bring the feeling of natural light into the building. Because only one side of the building opens to natural sunlight, a canopy made of Tyvek (a product normally used in overnight express mail packages) was suspended from the ceiling. This translucent canopy allows light to filter into the room much like sunlight. *(Architect/Designer: Lippert & Lippert Design, Palo Alto, CA. Photograph by Don Roper Photography)*

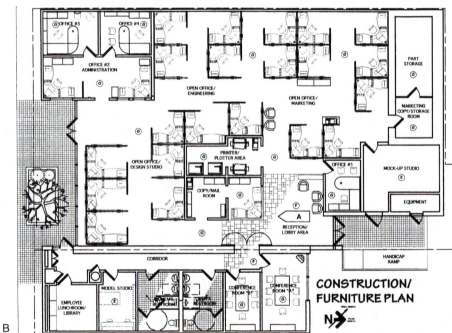

solution and refine it to meet the client's needs. The designer creates, selects, and produces design presentations by way of visual communications for the client's review. Based on the client's feedback, the designer will return to the analysis phase to rethink or retool the solution.

The design process is dynamic and cyclical, allowing the designer to create interiors that are responsive to particular situations. The analysis and synthesis of the design problem form the basis for all creative design solutions.

In some projects, phases of design may be combined or condensed, and in other projects (particularly residential) the phases may occur simultaneously. The following discussion utilizes the terms frequently employed by the practicing professional.

Initial Client Contact

The initial client contact is an integral part of the design process. It is through the initial meeting(s) that designers and clients evaluate their compatibility. Designers evaluate whether the project fits their firm, time frame, and staff load. Clients evaluate previous projects related

TABLE 1.1 The Design Process

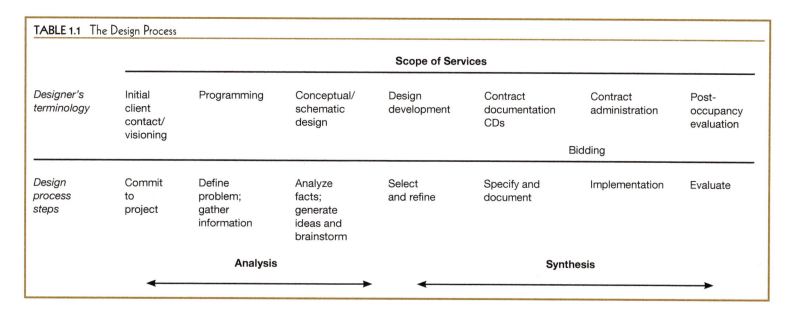

Designer's terminology	Initial client contact/ visioning	Programming	Conceptual/ schematic design	Design development	Contract documentation CDs	Contract administration	Post-occupancy evaluation
						Bidding	
Design process steps	Commit to project	Define problem; gather information	Analyze facts; generate ideas and brainstorm	Select and refine	Specify and document	Implementation	Evaluate
	← Analysis →			← Synthesis →			

Scope of Services

to their needs completed by the firm. Both the client and the designer should interview each other to look for a cooperative blend.

Shelly Hughes, owner and founder of Hughes|Litton|Godwin, refers to this work with the client as *visioning*. "The collaborative session may include a discussion of the client's desired image and aesthetics, financial drivers, operations, hiring goals, and cultural aspects." It is essential that designers understand the *corporate culture* of the commercial client.

Some projects may incorporate **evidence-based design (EBD)**. Historically, it was practiced in the health care industry but is also applicable in all areas of design. When EBD is applied, the goals and objectives are discussed in this preliminary client contact phase. Chapter 2 reviews EBD in more detail.

At the end of the initial client contact, the designer defines the **scope of services,** establishes an estmated timeline and budget, and secures a contract with the client.

Programming

The **programming** phase is the information-gathering phase. Designers identify and analyze the needs and desires of the client, usually through personal interviews. In a residential project, the designer should meet with everyone in the household. A typical residential programming questionnaire or client profile can be found in Appendix A. In a commercial project, the president or facilities planner may serve as the client contact, or this person may appoint a committee or team to work with the designer. Typical questions for both types of clients relate to design preferences, space needs, and the interrelationships of spaces and/or departments. Information gathered in programming assists the designer in developing a concept for the project that is carried throughout the design process. Concept development is discussed in greater detail in Part II.

Designers also review existing conditions or items (furniture, artwork, etc.) that are to remain. Furniture and other artwork may be inventoried and photographed to help the designer assimilate all the information. An example of a furniture inventory sheet can be found

in Appendix B. If the interior space already exists, the designer also develops a floor plan of the space. Sometimes clients have a floor plan (a measured drawing produced by the original designer, architect, or builder of the home or office), but frequently the designer will measure and draw a new plan of the interior space. The floor plan is the first step in developing visual communications for the client.

During this programming phase, the designer researches life safety codes (fire codes) and universal design requirements and begins coordinating with other specialists, if necessary. As in all phases of the design process, the designer will be reviewing the budget and schedule and making recommendations for changes. If EBD is incorporated, designers also research and interpret literature and establish baseline measurements and statistics with respect to the project's scope to inform future design decisions.

By the end of the programming phase, the designer should fully understand the scope of the project and be able to produce a *design concept statement* outlining the broad-based requirements of the project. Depending on the scope of the design project, the programming phase may take one afternoon (if the client only needs a small bathroom remodeled, for example), or it could take months (for a commercial client with several hundred employees). In general, 5 to 15 percent of the time in a design project is spent in programming. As with all other design phases, the designer reviews the final programming information with the client and incorporates his or her feedback before proceeding to the next phase of design.

Conceptual or Schematic Design

During the **conceptual** or **schematic design** phase, designers formulate preliminary broad-based concepts. Design decisions regarding the character, function, and aesthetics of a project are presented to the client for approval.

When working with a client who is remodeling a home, the designer may show the client a preliminary floor plan indicating where new and existing furniture would be located. The designer would also present the client with a few fabric and paint samples indicating the

conceptual direction of the color palette and design scheme. The client can respond to the plan and selections before the designer spends hours selecting the specific new sofa and exact fabric.

In a commercial project, or a residential project requiring an entire custom home design, the designer may begin by developing a **matrix** (sometimes called a *compatibility matrix*) indicating the relationship of particular individuals, departments, or spaces (Figure 1.7A). Another tool is the **bubble diagram**, which helps the designer and the client visualize the requirements of the space (Figure 1.7B). The bubble diagrams can lead to the **blocking diagram** that helps to establish the

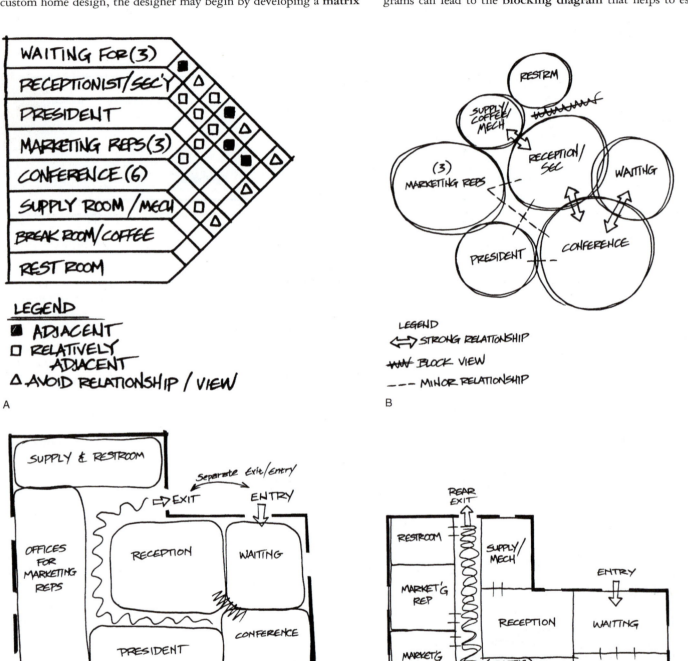

FIGURE 1.7 In this series of illustrations, a small commercial real estate office floor plan is developed through conceptual design: (A) matrix; (B) bubble diagram; (C) blocking diagram—step 1; (D) blocking diagram—step 2.

flow and arrangement of rooms and the outline for the perimeter of the building (Figure 1.7C and 1.7D). A designer who is working with a multistory house or high-use office complex may develop a **stacking diagram** (see Design Scenario) to help evaluate what departments or rooms are located on each level. As with the smaller residential project, the designer ultimately puts all this information on a floor plan to illustrate the layout of the space. This process is called **space planning.**

Also during conceptual design, the designer selects sample color chips for reference to the color palette, fabrics, and/or furniture for the design scheme. The designer may also prepare a preliminary three-dimensional drawing or a perspective to help the client visualize the proposed new space. As with the floor plan and preliminary furniture plan, all of these diagrams, drawings, and sketches add to the process of visual communication (Figure 1.8).

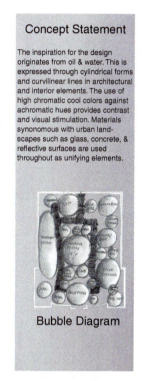

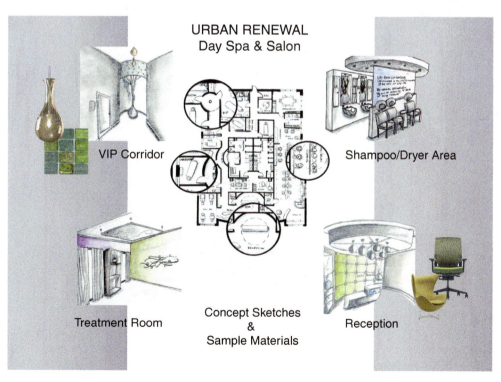

FIGURE 1.8 Schematic design presentations can include concept statements, relationship diagrams, loose furniture plans, and quick sketch perspectives. The goal is to relay the feel of the space to the client and confirm agreement on the project's design. The sketches remain rough to allow the client the opportunity to comment and perhaps redirect the project. Schematic presentations that are too formal may restrict the client's belief that they can alter the direction and/or change the scope. A more team-oriented approach allows for active participation by the client and therefore ownership by the client of the project's final solution.

(Designer: Jonalisa M. Kelley. Photograph by Tom Askew)

If the designer is working with an EBD project, a hypothesis of the projected outcomes would be developed. Research regarding prior design solutions is incorporated into the design concepts.

The designer prepares all of this conceptual design documentation while considering the life safety and building codes, universal accessibility codes, sustainable design options, and budget (all of which are discussed in later chapters). Only after presenting these designs to the client *and* receiving client approval will the designer move on to the next phase of the design process. The conceptual design phase consumes from 15 to 20 percent of the time in the total design process.

Design Development

The **design development** phase is also a creative phase. During this phase, all the furniture, fabrics, finishes, hardware, and lighting fixtures are selected for the client's review. Space planning of rooms and furniture arrangements is refined based on feedback from the client's review of the conceptual design. Designers may develop art, accessory, graphic, or signage programs. Walls, windows, doors, fireplaces, stairs, and ceiling designs are defined and detailed where necessary. This entire array of information is shown to the client via a presentation.

A small residential project presentation may include photographs of selected pieces of furniture and actual samples of fabrics, floor coverings, and wall treatments along with a presentation floor plan. More likely, however, the client will be taken to a showroom or a decorative arts center to view specific selections.

A more complex residential project or a commercial project usually requires a series of presentation boards (physical or electronic) that illustrate the interior space (Figure 1.9). Visual communications may

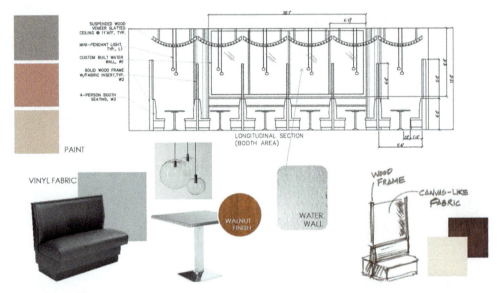

A. FF & E selections, dining room

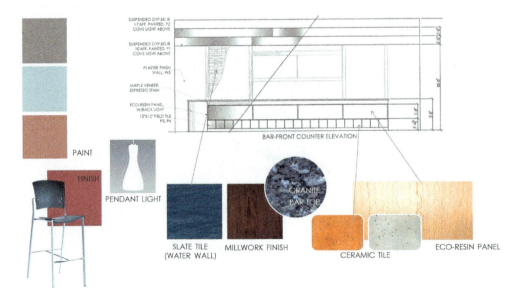

B. FF & E selections, bar area

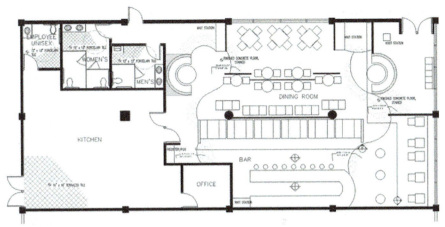

C. Floor plan

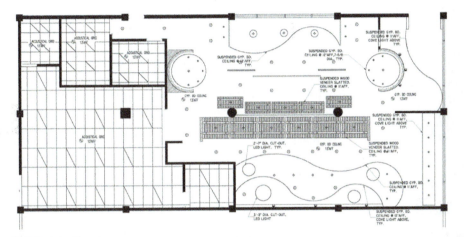

D. Reflected ceiling plan

REFLECTED CEILING PLAN SYMBOL LEGEND		
MARK	DESCRIPTION	REMARKS
	2 X 2 FLUORESCENT LIGHT FIXTURE	DESCR: MIR RECESSED
	RECESSED 6" DIA LIGHT FIXTURE	LAMP TYPE: PAR 20
	RECESSED 3-1/4" DIA LIGHT FIXTURE, ADJ.	LAMP TYPE: T6
	PENDANT LIGHT	INSTALLED @ 10'AFF LAMP TYPE: E17
	RECESSED WALL WASHER	LAMP TYPE: T6
	FINISHED DRYWALL CEILING	
	2' X 2' ACOUSTICAL SUSPENDED CLG. ASSEMBLY	
	2' X 4' ACOUTICAL CLG ASSEMBLY	

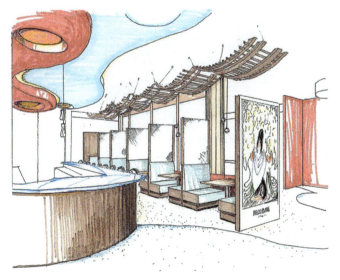

E. Perspective, bar/booth area

FIGURE 1.9 For the design development phase of this project, the designer prepared an electronic presentation. The client wishes to open a Mexican restaurant and requested a design based on Mexican cityscape. C illustrates the proposed floor plan; D illustrates the reflected ceiling plan, which includes lighting locations, fixture types, and variations in ceiling heights and shapes. An elevation of the booth area and selected finishes and fabrics is shown in A. B illustrates the design of the bar and its adjacent finishes. The final figure (E) reemphasizes the main booth area and bar in a perspective.
(Designer: Kristen McKey)

include black and white or colored floor plans, **elevations** (drawings of walls), and perspectives. The presentation boards include samples of fabrics and finishes, and photographs of furniture, art, and accessories. Models are sometimes built to show unusual or dynamic spaces such as lobbies and entry halls or soaring ceiling designs (Figure 1.10). CAD technology allows designers and clients to view the virtual interior (Figure 1.11).

As in the previous design phases, the designer is always aware of and designing within the budget, life safety, and universal design requirements. None of the design recommendations are acted upon until the client has approved the design. This phase of design occupies 25 to 30 percent of the overall time in the design project.

Contract Documentation

The next phase of design, called **contract documentation**, allows the designer to document the design decisions made in the previous design phases. Interior designers prepare **construction** or **working drawings** (detailed plans, elevations, and sections). Designers collaborate with allied professionals such as architects and engineers who determine mechanical, electrical, and structural requirements.

For a small residential project, the contract document (CD) phase may include only writing purchase orders for furniture, fabrics, and other items to be purchased for the client and installed by the vendors. For a large residential project or commercial project, the designer not only will be involved with the development of the working drawings but also may write **specifications**. The specification (or spec) book is a documentation of all the furniture and other items that are not attached to the building. The spec book or **furniture, fixtures, and equipment package (FF&E)** is sent to several vendors for bidding. Specifications are also written that identify building materials and construction procedures, practices, and acceptable tolerances. These specifications, called the construction manual, are organized per the industry standard MasterFormat divisions developed by the Construction Specifications Institute (CSI).

The working drawings are sent out to bid to qualified contractors. Once bids have been collected, reviewed, and awarded, the contract documents phase is complete. This tedious yet exacting phase of design may take 30 to 35 percent of the total design process time. If the budget preparation by the designer has proven effective, the bids meet the planned budget. Otherwise, the designer may need to select less expensive items or finishes, or alternative design solutions. Sometimes, however, the client may like the design enough to increase the budget to meet the higher cost. Appendix C illustrates a small set of construction documents.

A

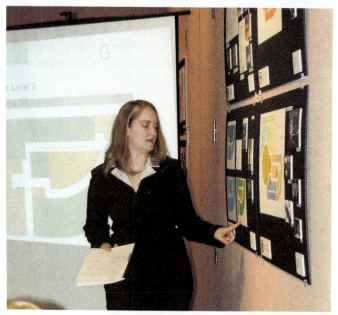

B

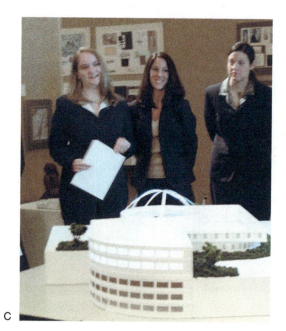

C

FIGURE 1.10 In this design development presentation, the designers worked as a team to present their findings for a multistoried building. Multimedia presentation techniques allowed the client to view presentation boards, a model, and a PowerPoint slideshow. Clients were also given presentation binders that included prior programming and conceptual development decisions, updated site plans, floor plans, and estimated costs. Note that the lighting is not directed on the presenters, but rather on the project, to focus the client's attention.
(Designer: GTTO. Photographs by Mark A. Taylor)

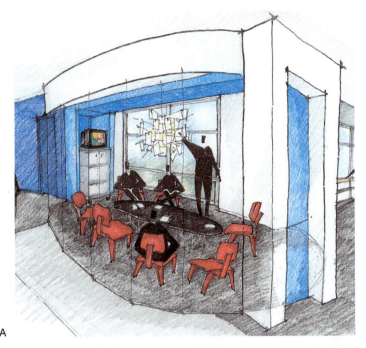

A

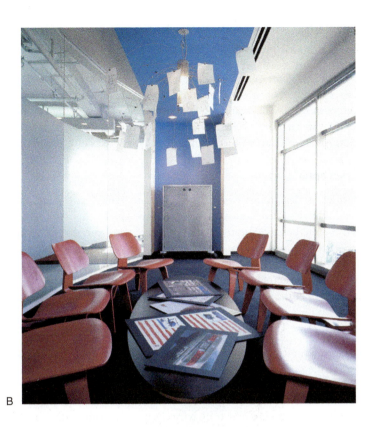

B

FIGURE 1.11 A computer-generated view of the corporate office lobby is shown in (A). (B) is a photo of the completed interior.
(Architect: Thompson, Ventulett, Stainback & Associates, Inc. Designer: TVS Interiors. Photograph by Brian Gassel)

Contract Administration

Contract administration is usually the most rewarding phase of the project. All of the design decisions become real as the walls are built; mechanical, lighting, and electrical systems are installed; finishes are applied; and the FF&E is placed according to the designer's plans. As the title implies, the designer is administering the contracts completed in contract documentation.

For a smaller residential project, the designer places orders and continually monitors the status of the shipments and the installation of the items. For larger projects, the designer regularly visits the job site to verify that the working drawings are followed and the job is progressing as planned. The designer oversees the installation of the FF&E. At the end of this phase, which takes 5 to 15 percent of the design process time, the designer prepares a **punch list** indicating all the items not yet finished in the project. Final payments to vendors and contractors are withheld until the items are completed.

Evaluation

In this final phase of design, sometimes called **postoccupancy evaluation (POE)**, the designer and client evaluate the effectiveness of the design decisions. The designer may interview selected individuals in the firm to determine their level of satisfaction with the new interior space. The designer may also photograph the space and visually analyze the design solutions.

In EBD projects, measurements of the EBD concept and goals are taken. These measurements are evaluated against the hypothesis and baseline measurements. The results are then analyzed and shared with the client. The results should also be published so others may learn from the process.

According to NCIDQ's *Definition of Interior Design:* "The interior design process follows a systematic and coordinated methodology. Research, analysis, and integration of information into the creative process result in an appropriate interior environment." Utilizing these phases of the design process helps ensure that designers' solutions will not only satisfy their clients' needs but also result in successful interior spaces.

The design process is a continuous flow of information through all phases. Certainly for billing and for educational purposes it is simpler to establish separate categories, although in practice the phases tend to merge. For example, in residential design a client may accompany a designer on a buying trip. On the trip, the selection, specification, and purchasing of goods (which correspond to the design development, contract documentation, and contract administration phases) may occur simultaneously. It is important to note in this situation that the designer completed the programming and conceptual phases (which correspond to the analysis and initial synthesis) before escorting the client on the buying trip. The Design Scenario at the end of this chapter illustrates a successful commercial design project.

More info online @

www.iida.org/i4a/pages/index.cfm?pageid=379 Further explanation of the design process

www.csinet.org/Functional-Menu-Category/About-CSI.aspx Info on the Construction Specifications Institute

■ CAREER SPECIALIZATIONS IN INTERIOR DESIGN

As the demand for quality housing, products, and commercial facilities rises, interior designers are finding more opportunities for creative design positions. When searching for a career path, a designer may choose from a variety of possibilities including residential design, contract or commercial design, product design, or other related design industries.

Residential Design

Residential design involves designing private living quarters or homes, including detached homes, condominiums, apartments, townhouses, and mobile homes (Figure 1.12). Designers may specialize in kitchen and bath design, residential lighting, designs for the elderly or disabled, children's rooms, vacation homes, remodeling, or additions. Residential designers usually work very closely with their clients, the **end users** of the space, to develop specific personalized solutions.

Contract or Commercial Design

The opportunities in commercial design are broad. Table 1.2 lists several of the options along with a brief explanation of each area. Commercial or contract designers work with a variety of clients who may or may not be the end user (Figure 1.13). For example, a designer working on a restaurant design may meet with the owner, the developer, and the chef to determine the desires of each for the new facility. Ultimately, however, the designer is designing for the client's client, the patrons who will be eating at the restaurant. Commercial as well as residential designers must follow strict fire and life safety codes and must also meet universal design criteria. Surface materials, fabrics, and finishes must not endanger the health, safety, or welfare of the public.

More info online @

www.careersininteriordesign.com/interior_disciplines.html Specializations in interior design

Related Design Professions

Designers may also choose to concentrate their efforts in one specific area or phase of design. Design specialty areas include communication (audio/video) design; exhibit design; model home design; solar design; and storage, cabinet, and closet design. Some designers may choose to specialize in selecting drapery and window treatments, or other finishes such as flooring or wallcovering. Other designers may find that they have particularly strong selling skills and therefore may work as sales representatives.

Although many times overlooked, product design is an expansive field that requires creative minds. Product designers are responsible for the design of the furnishings, finishes, and fabrics in the interior environment. Textiles, wall and floor coverings, furniture, lighting, and hardware (to name but a few) are items that product designers create to be placed in the interior space.

Other challenging specialty opportunities are available in industry, manufacturing, transportation, communications, recreation, and in

FIGURE 1.12 A custom-designed door with onyx insets adds character to this interior space. The designer created an environment that accentuates the client's collection of paintings and decorative arts.
(Designer: BRITO Design Studio. Photograph by Brian Gassel. As seen in Atlanta Homes & Lifestyles*)*

state and federal governments, where the diverse skills of design professionals are considered essential to long-range planning and product development. Table 1.3 lists additional design specialties.

Designers with strong business skills will find job opportunities in the retail and sales areas—the *industry foundation*. The industry foundation includes sales representatives, vendors, suppliers, showroom managers, and manufacturers. These industry members, referred to respectfully as *partners* or *affiliates*, are valuable associates to the interior designer. Product knowledge—including its appropriate application, accurate ordering, prompt delivery, careful installation, and

TABLE 1.2 Opportunities in Contract (Commercial) Design

Major Specialty Areas	
■ Commercial office design	Involves extensive space planning and design of small to large corporate office environments.
■ Health care design	Involves designs for hospitals, clinics, nursing homes, disabled and elderly care facilities, and doctors' offices (Figure 1.13). The current trend in elderly care facilities blends this specialty with hospitality design.
■ Hospitality design	Involves the design of hotels, motels, restaurants, casinos, resorts, clubs, and inns. Blends many aspects of residential design with contract design (as seen in Figures 1.1 and 1.9).
■ Institutional design	Involves the design of government buildings, such as courthouses, city halls, libraries, and museums as well as educational facilities such as public and private universities, colleges, and schools.
■ Retail design	Involves the design of shopping malls, stores, boutiques, strip malls, and showrooms. Designers must be sensitive to the products to be displayed in the various areas.
Minor Specialty Areas	
■ Entertainment design	Involves the design of theaters, concert halls, auditoriums, and convention centers.
■ Financial institutions	Involves the design of banks, stock and commodity exchanges, and credit unions.
■ Industrial design	Involves the design of warehouses, factories, laboratories, workshops, and manufacturing plants.
■ Recreational design	Involves the design of health and spa centers, swimming pools, bowling alleys, and other sports facilities.
■ Transportation design	Involves the design of airports, train stations, terminals, motor homes, boats and ships, aircraft interiors, and other transportation vehicles and facilities.

FIGURE 1.13 Sensitivity to the quality of life is put to the greatest test in the design of health care environments. Patients heal faster in environments that are responsive to their physical and psychological needs. In the Dubai Mall Medical Center, hospitality elements such as marble flooring, sheer draperies, and coved ceilings with LED lighting bring tranquility and comfort to the entry of this 60,000-square-foot facility. *(Architect/Designer: NBBJ. Photograph by Tim Griffith)*

maintenance procedures—plays an important role in the success of an interior. It is accurately stated that "designers are only as good as their sources."

Allied Professions

Interior designers must develop strong working relationships with other professionals in the construction and design industries. Allied professionals work closely with designers to form design teams and partnerships. This collaboration and networking enhances the communication skills required of interior designers.

Architects

The architect generally designs the exterior of the building. In small remodeling projects, an architect may be contracted to advise on structural or mechanical systems. On larger residential and commercial facilities, the architect works directly with the client, designing the exterior as well as the structural components of the building. Architects and designers frequently collaborate on the building's interior construction of non-load-bearing walls. The architect may also oversee the construction of the space.

More info online @
www.aia.org American Society of Architects

Engineers

Engineers work with architects and designers to produce the mechanical, electrical, plumbing, and structural drawings for a building. Proper

TABLE 1.3 Related Opportunities in the Design Industry

■ Adaptive use designer	Works on the restoration or remodeling of historic buildings for a new function.
■ Buyer	Purchases merchandise for furniture or department stores and studios.
■ Color consultant	Aids clients in both residential and commercial design, with regard to color.
■ Design journalist	Completes work for newspapers, magazines, or publishers on a variety of timely aspects of interior design.
■ Drafter or CAD operator	Prepares precise mechanical drawings, often on the computer, for architects, designers, builders, and furnishing manufacturers.
■ Educator	After seeking advanced degrees, the educator instructs at a college or university.
■ Facilities manager	Works with companies to determine the best use of their space and equipment.
■ Fine art or accessory designer	Selects and purchases personal and corporate art and accessories.
■ Historic preservation designer	Restores and preserves a historic structure as it was in the past.
■ Lighting specialist	Designs lighting plans essential in the design process.
■ Purchasing agent	Orders, coordinates, and installs FF&E per designer's specifications.
■ Renderer	Prepares realistic three-dimensional drawings and illustrations of a designer's concept for an interior.
■ Set designer or stylist	Works on television, theater, and movie productions or creates complete room displays for department stores, furniture companies, and manufacturers for advertising.
■ Sustainable design consultant	Aids in the design and product selection of materials that ensure environmental sustainability.
■ Universal designer	Specializes in the design of spaces to meet universal design concepts.

communication is particularly critical when working with engineers to ensure that the design concept complies with engineering limitations. Designers also examine drawings produced by engineers to ensure that placement of engineering components does not interfere with the design intent.

General Contractor

The general contractor, or GC, administers the actual construction process. Generally, the GC oversees the process and subcontracts the work to others.

More info online @

www.agc.org/ Associated General Contractors of America
www.nawic.org National Association of Women in Construction

Graphic Designers

In commercial design, the graphic designer may assist in the development of appropriate signage for a building, brochure design, menu design, or a corporate identification and marketing package.

More info online @

www.aiga.org American Institute of Graphic Arts
www.icograda.org/ International Council of Graphic Design Associations

Landscape Architect

The landscape architect (LA) should be involved in the design process from the initial site selection. The LA can share crucial information with the architect and designer that may affect the shape and form of buildings. During contract documentation, for instance, the LA provides important grading plans to prevent erosion and future water problems, and provides planting and vegetation plans allowing the building to relate to its site.

More info online @

http://asla.org American Society of Landscape Architects

SUMMARY

From its beginnings in the nineteenth and twentieth centuries, the profession of interior design has become a multibillion-dollar industry. The profession has grown to encompass a broad scope of responsibilities, procedures, relationships, and opportunities, which NCIDQ synthesized into an established definition of the field of interior design. Professional design societies such as ASID and IIDA support NCIDQ by acknowledging the passage of the NCIDQ exam as one of their requirements for acceptance as a professional member.

Creating interiors based on the goals of function and the human factor, aesthetics, and economics and ecology allows the designer to address all aspects of a successful interior environment. In order to better analyze the abundance of information required in a design project and then synthesize that information into a cohesive design solution, the design process and scope of services were developed. Each phase of the process interlocks, ensuring creative design solutions that address the client's needs. These phases allow for the unique contributions of universal and sustainable design solutions. Finally, allied design professionals collaborate to create the accurate communications necessary for successful interior environments.

design SCENARIO

Fortune 500 Consumer Products Company

PROJECT DESCRIPTION

Hughes|Litton|Godwin has been retained by a fortune 500 company to complete a workplace study to meet several project goals including the following:

- Create workplace to appeal to Generation "Y"
- Improve departmental adjacencies and synergies
- Promote open collaborative work environment
- Allow for growth through adjusted square footage per occupancy
- Eliminate duplicate support space
- Obtain feedback from employees with flexible work plans
- Identify hoteling and desk sharing candidates
- Reduce real-estate costs through the elimination/consolidation of offsite locations
- Develop a plan to reduce production costs due to construction and relocation

Hughes|Litton|Godwin's interactive approach included the use of focus groups to obtain key information and build consensus. The intent was to engage the staff, thereby creating champions of the initiatives.

PROGRAMMING

Figures DS1.1 through DS1.3 illustrate the overall findings from the focus group sessions. Hughes|Litton|Godwin developed a series of work tiles, each defining a type of work completed by the end users. These tiles were discussed as part of the focus group session and were used to develop a baseline of needs for the employees. Figure DS1.1 and the chart below indicate the top ten tile issues that needed to be applied in the design.

Top Ten Work Tiles for the Company by Name & Number		
1	Head Down Working	18
2	Group Communication Face to Face	12
3	Group Collaboration Virtual	15
4	Flexible Work Arrangement	6
5	Personalization of Workplace	14
6	Creating Innovating	10
7	Private Communication	7
8	Emotional Satisfaction	9
9	Connection to Culture & Social Interaction	8
10	Variety of Workspaces	13

FIGURE DS1.1 Programming—Results of the focus groups session reveal the top-ten work tiles for all departments. Work tiles analysis is a method developed by Hughes|Litton|Godwin to define the employees' needs. These diagrams were presented to the client.
(Architect/Designer: Hughes|Litton|Godwin)

Figure DS1.2 defines the tiles using a Cartesian graph for the Customer Service Division. Figure DS1.2 also shows the frequency of each specific work tile with respect to its duration. Figure DS1.3 summarizes the square footage needs for the entire facility.

FIGURE DS1.2 Programming—Each department's needs were analyzed based on the work tiles. These were then fitted into a Cartesian graph in this example for the Customer Service Division. The graph illustrates the frequency of the task first in relation to its duration. Other graphs were also developed to illustrate the relationship of the work tiles with respect to the company's mission.
(Architect/Designer: Hughes|Litton|Godwin)

FIGURE DS1.3 Programming—Summary of estimated square footage requirements for the second floor.
(Architect/Designer: Hughes|Litton|Godwin)

Fortune 500 Consumer Product Company, 2nd Floor Bldg. 100

Space Planning Program — 50% circulation factor

Description	Current office	ws	other	Growth office	ws	other	Work space	Square Ft.	Total Square Ft.	Comments/Requirements	
A) Staff											
Executive											
President	1						11'-6" × 12'	138	138		
Vice President	1						11'-6" × 12'	138	138	Adjacent to President's office	
Admin. Assistant		1					11'-6" × 12'	138	138	Supports President & Vice President	
Subtotal	2	1	0	0	0	0			414		
Circulation									207		
Total	2	1	0	0	0	0			621		
Staff											
Director	8						11'-6" × 12'	138	1,104		
Staff		66			4		6' × 8'	48	3,360		
HR	1						11'-6" × 12'	138	138	Located in Main Lobby	
Subtotal	9	66	0	0	4	0			4,602		
Circulation									2,301		
Total	9	66	0	0	4	0			6,903		
Total Staff	11	67	0	0	4	0			5,016		
Circulation									2,508		
Total Area A:	**11**	**67**	**0**	**0**	**4**	**0**			**7,524**		
B) Support Spaces											
Lobby/Security	1						30' × 30'		900	900	Includes (1) Security Desk, (1) Security Photo Room & (4) Guest Lounge Chairs
HR Waiting Room	1						10'-6 × 6'	2 people	63	63	Located adjacent to HR office
Conference Room	1						15' × 40'	16 people	600	600	Projector, Projection Screen, Whiteboard & AV Closet
Existing Conference Room	1						19'-6" × 29'-6"	16 people	575	575	Update finishes only
Conference Room	2						10' × 14'	6 people	128	256	Locate in Lobby
Huddle	6						11'-6" × 12'	4 people	138	828	Wall mounted TV
Huddle	1						11'-6" × 18'	8 people	207	207	Wall mounted TV
Library	1						11'-6" × 12'	4 people	138	138	Tablet Arm Seating
Phone Rooms	7						5' × 6'	1 person	30	210	Sound attenuation
Executive Coffee	1						6' × 11'		66	66	Locate near Executive Admin. Assistant
Breakroom	1						11' × 28'		308	308	Locate adjacent to Collaborative. Area. Include (2) Ref, (1) Icemaker, (1) Coffee, (2) Microwave & (1) Double Sink. Interchangeable product display
Collaborative Area	1						25' × 30'	10-12 people	750	750	Include variety of seating options, wall mounted TV & conferencing.
Touchdown Area	1						10' × 15'-6"	4 people	155	155	Locate adjacent to Collaborative Area.
Mail/Copy	2						10' × 18'		180	360	Design as a pass through
Existing AV Closet	1						10'-6" +/- × 24'-6"		189	189	Existing finishes to remain
AV Closet	1						5' × 12'		60	60	Located in 16 person conference room.
Supply	1						10' × 17'-6"		175	175	Secure storage, recorrds
Subtotal B									4,877		
Circulation									2,439		
Total Area B:									**7,316**		
Total Space Requirements									**14,840**	**USF** Available SF - 18, 980 USF	
Total workspaces	82	(including growth)					Total usf/person =		181		

CONCEPTUAL/SCHEMATIC DESIGN

After the programming information was shared with the client, and based on the success of this workplace study, the company hired Hughes|Litton|Godwin to continue the work in the remodeling of the facility to meet the client's needs and objectives. Figure DS1.4 illustrates a hand-drawn schematic floor plan indicating a conceptual layout for the third and fourth floors. Figure DS1.5 indicates a proposed design for the open office areas. Preliminary FF&E selections were also shared with the client.

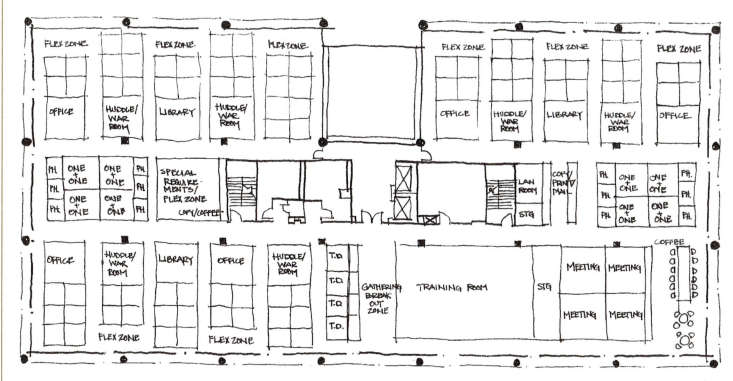

FIGURE DS1.4 Schematic floor plan for the third and fourth floors.
(Architect/Designer: Hughes|Litton|Godwin)

FIGURE DS1.5 Schematic perspective of the open office workstations.
(Architect/Designer: Hughes|Litton|Godwin)

DESIGN DEVELOPMENT

Based on the client's feedback and approval of the conceptual design, Hughes|Litton|Godwin continued to refine the design solution and select actual finishes and furnishings while defining custom details and elevations.

The design development presentation had several components, including a CAD floor plan color coded to illustrate major work spaces (Figure DS1.6) and computer-generated perspective renderings (Figures DS1.7 and DS1.8).

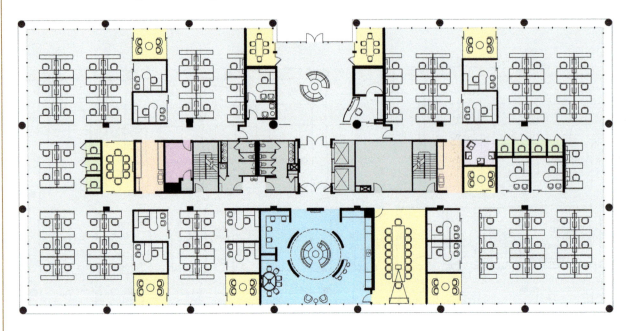

UNIVERSAL PLAN WORK SPACES

MEETING SPACE	PHONE ROOM	SHARED STORAGE
COMMUNITY ZONE	LIBRARY	MAIL/COPY/PRINT

FIGURE DS1.6 Design development—Computer-generated floor plan of universal work spaces.
(Architect/Designer: Hughes|Litton|Godwin)

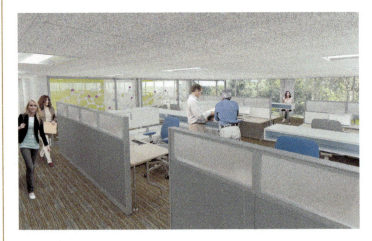

FIGURE DS1.7 Design development—Presentation perspective of the open office area.
(Architect/Designer: Hughes|Litton|Godwin)

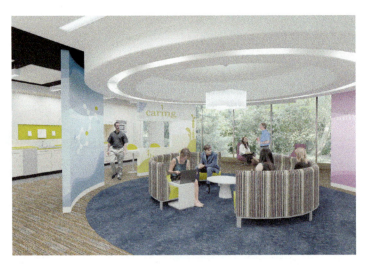

FIGURE DS1.8 Design development—Presentation perspective of the break-out area.
(Architect/Designer: Hughes|Litton|Godwin)

CONTRACT DOCUMENTS

During the CD phase, Hughes|Litton|Godwin produced an extensive set of construction drawings and construction and furnishings specifications.

Select examples are seen in the second floor power and communication plan (Figure DS1.9), enlarged dimension and reflected ceiling plans of the elevator lobby and break-out area (Figure DS1.10), and reception desk details

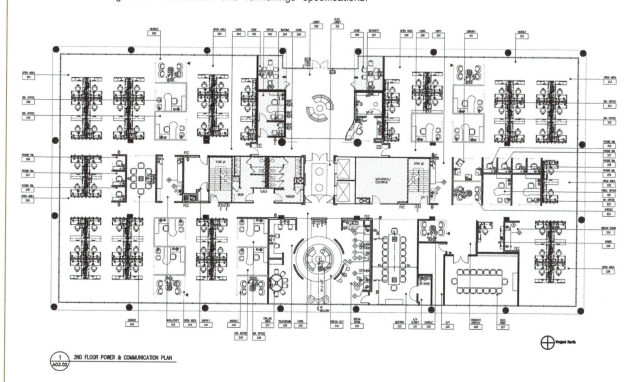

FIGURE DS1.9 Construction drawing— Second floor power and communication plan.
(Architect/Designer: Hughes|Litton|Godwin)

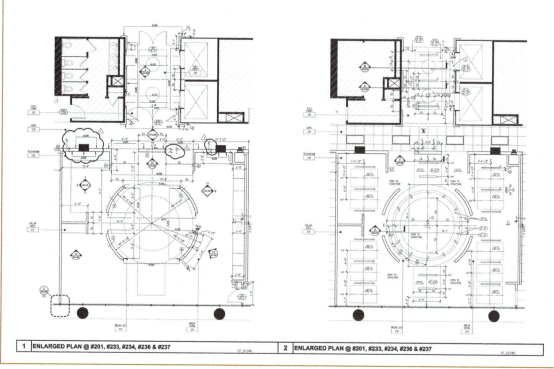

FIGURE DS1.10 Construction drawing—Two enlarged plans of the elevator lobby and break-out area. The left illustrates the dimension partition plan; the right illustrates the reflected ceiling plan.
(Architect/Designer: Hughes|Litton|Godwin)

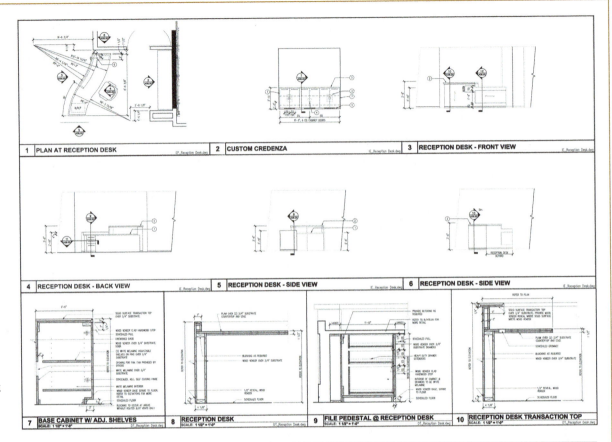

FIGURE DS1.11 Partial page including reception desk details, and sections.
(Architect/Designer: Hughes|Litton|Godwin)

(Figure DS1.11). Figures DS1.12 through DS1.14 show completed spaces. These include the break-out area, a portion of the open office, and the waiting area.

COMPLETED SPACE

Figures DS1.12 through DS1.14 show completed spaces. These include the break-out area, a portion of the open office, and the waiting area. Note how the design development presentation drawings, Figures DS1.8 and DS1.9, clearly reflect the final space.

FIGURE DS1.12 Completed space— Open office.
(Architect/Designer: Hughes|Litton|Godwin. Photograph by Gabriel Benzur)

FIGURE DS1.13 Completed space— Break-out area.
(Architect/Designer: Hughes|Litton|Godwin. Photograph by Gabriel Benzur)

FIGURE DS1.14 Completed space—Waiting area.
(Architect/Designer: Hughes|Litton|Godwin. Photograph by Gabriel Benzur)

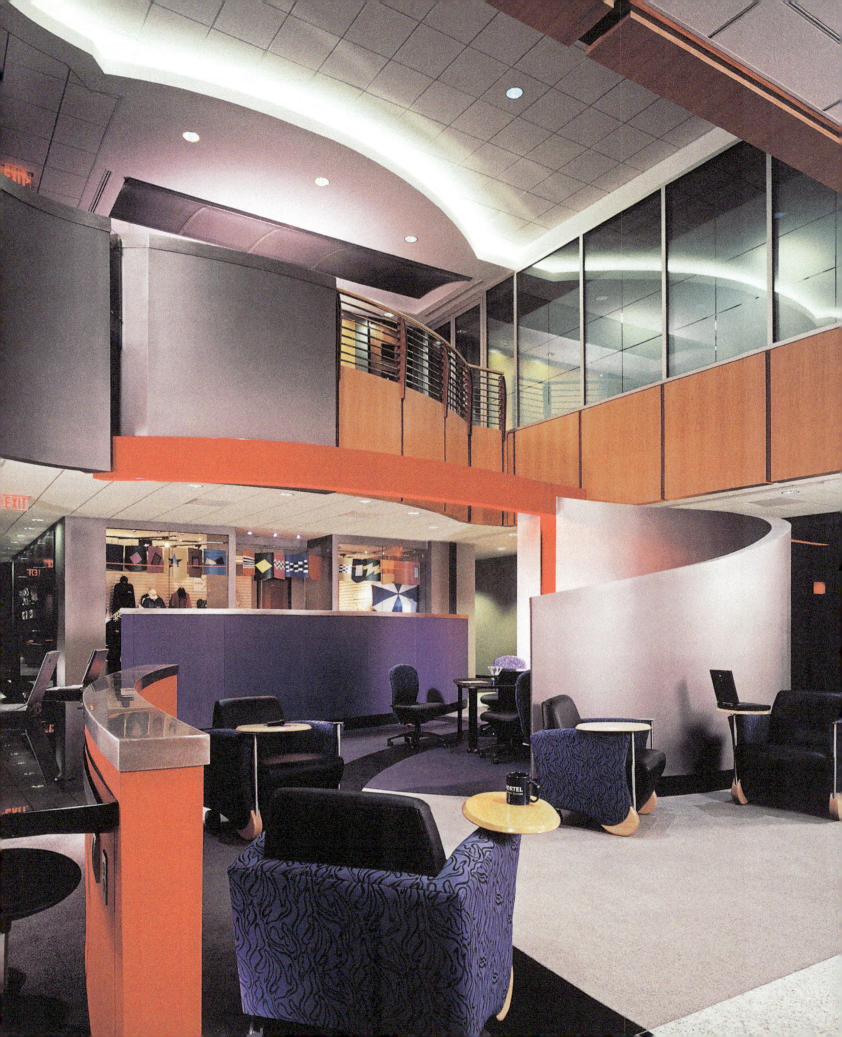

The Value of Interior Design:
2 Health, Safety, and Welfare

The three overarching goals of interior design, as discussed in Chapter 1, are function and the human factor, aesthetics, and economics and ecology. This chapter takes a closer look at the intrinsic *value* of interior design on the health, safety, and welfare of the occupants—the human factor—and interior design's value on environmental sustainability—ecology. Although aesthetics play a crucial role in interior design, if the needs and welfare of the inhabitants are not met, the most attractive interior is a charade. Similarly, if the products and design solutions negatively affect the environment, or produce health and safety concerns for its occupants, the interior lacks integrity.

■ HEALTH, SAFETY, AND WELFARE

Because interior design affects the health, safety, and welfare of the public, the profession in many states is regulated, and interior designers are licensed professionals. The health and safety of a client are affected by many factors of interior design including, but not limited to, the specification of materials that affect indoor air quality (IAQ); adequate lighting that does not produce glare; appropriate clearances for safe passageways; material surface selections that meet codes and help to prevent falls; and the accurate applications of life safety and fire codes. *Welfare*, commonly defined as health, happiness, and general well-being, describes the physical *and* psychological well-being of the client (Figure 2.1). It is not enough for an interior to meet the functional needs of a client; an interior must also meet the needs of comfort and security as well as create a *sense of place*.

Sense of Place

The Nyungwe Forest Lodge photo, selected for the cover, captures the lodge's *sense of place*. Bordering on the edge of the Nyungwe National Park—a rainforest teaming with birds, monkeys, and rare gorillas—the

FIGURE 2.1 In corporate business, the competition for quality employees is fierce. Companies endeavor to recruit and retain their workforce—their most valuable asset. According to the designer of this space, "employee happiness was paramount" to the client. Comfortable chairs and counters include laptop connections, while lighting is directed upward to prevent glare on the screens. Brilliant colors and dynamic forms enliven the interior. Notice also the clearly delineated exit signs as required in all buildings to safeguard the occupants. *(Architect/Designer: Jova/Daniels/Busby. Photography by David Schilling)*

lodge was designed to reflect the spirit and character of the surrounding native culture and the environment.

The facility is located on the adjacent Gisakura Tea Plantation. The main facility is built solid and low to the ground, reflecting its connection to the earth. The guest suites, on the other hand, sit near the rainforest's edge and are elevated on stilts. These lighter-scale buildings allow the guests literally to look into and be surrounded by the forest.

Sustainable building techniques were applied wherever possible. Local materials, patterns, and color are seen in the furnishings and design elements. Native artisans completed much of the interior artwork including the "tea ball" chandelier, designed by Keith Mehner and manufactured by Ikhaya Design.

The designers were sensitive to the true native culture of Rwanda, and careful not to reflect a colonial direction; instead, they developed a contemporary design based on the traditions and customs of the Rwandan people. Keith Mehner and Mark Treon, designer and architect for this project, recognized the need to create this sense of place as Rwanda works to promote its true culture and bury its tarnished past. The image on the cover is in the main facility and is called the Tea Lounge.

More info online @

www.nyungweforestlodge.com Website for the Nyungwe Forest Lodge; includes more photos and information on the lodge and its surroundings

■ INTERIOR ENVIRONMENT THEORY: WHY WE NEED THE BUILT ENVIRONMENT

Shelter is a primary human need. Tom Brown, Jr., an authority and author on wilderness survival, explains the four primary human needs as shelter, water, fire, and food, in that order. Although we can live without water for a few days, and without food for many more, the lack of adequate shelter can, under severe conditions, be lethal to us within a matter of hours.

Maslow's Human Needs

The need for shelter is innate. Psychologist Abraham Maslow developed a hierarchy of human needs (Figure 2.2). According to his theory, only when our most basic needs are satisfied do we advance to the next level of needs. On Maslow's levels of human needs, shelter is at the foundation of the pyramid as a component of physiological need. Shelter is repeated on the second level through the need for security and protection. The third level addresses the need for companionship, and the fourth level addresses the need for self-esteem. Both companionship and self-esteem are enhanced by one's surroundings; at level five, self-actualization, we experience fulfillment. This is frequently reached through participation in and the application of the arts.

Communities to Personal Space: Home and Comfort

Early humans found or created shelter to meet the most basic of these physiological needs; later, simple structures for homes were developed. Once these basic needs were met, social structure dictated the building of political and religious buildings, many of which provided a safe haven and necessary social order. This parallels the next level of human needs: safety and security. These religious and social structures were followed by commercial buildings; villages and towns emerged as places of social acceptance, fulfilling the need to belong (Maslow's third level). These structures also provided a means for the rulers, owners, and architects to achieve status, thereby satisfying the esteem needs of level four. Maslow's hierarchy is reflected in the evolution of the built environment, as seen in Figure 2.3.

The desire to define one's own space is best seen in children's efforts to control their environment—to find spaces of safe haven that they can

FIGURE 2.2 Abraham Maslow's hierarchy of human needs is represented in the triangular form. Maslow's theory states that the lower-level needs, the foundation needs, must be met before an individual can progress upward to the next level of needs.

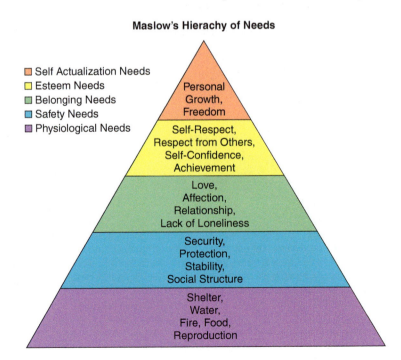

Maslow's Hierachy of Needs

- ■ Self Actualization Needs
- ■ Esteem Needs
- ■ Belonging Needs
- ■ Safety Needs
- ■ Physiological Needs

Personal Growth, Freedom

Self-Respect, Respect from Others, Self-Confidence, Achievement

Love, Affection, Relationship, Lack of Loneliness

Security, Protection, Stability, Social Structure

Shelter, Water, Fire, Food, Reproduction

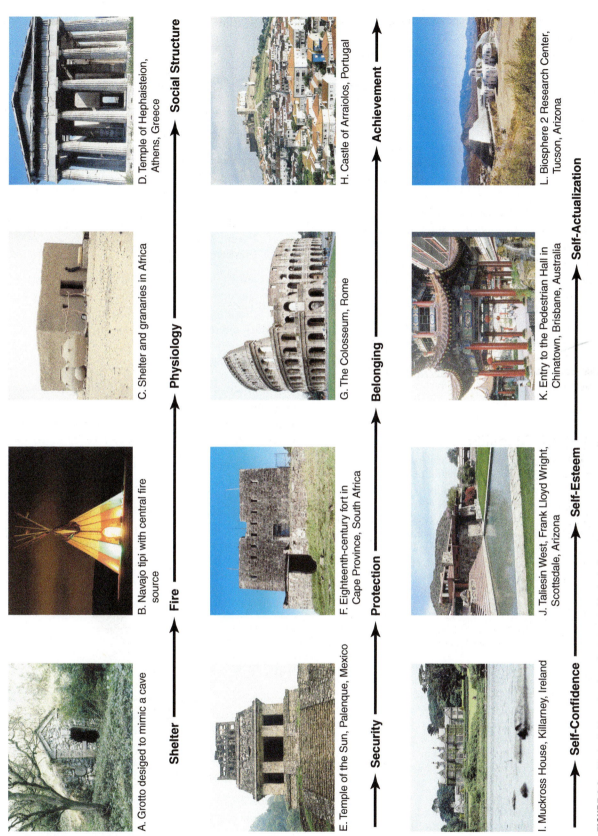

Shelter → **Fire** → **Physiology** → **Social Structure**

A. Grotto desiged to mimic a cave

B. Navajo tipi with central fire source

C. Shelter and granaries in Africa

D. Temple of Hephaisteion, Athens, Greece

Security → **Protection** → **Belonging** → **Achievement**

E. Temple of the Sun, Palenque, Mexico

F. Eighteenth-century fort in Cape Province, South Africa

G. The Colosseum, Rome

H. Castle of Arraiolos, Portugal

Self-Confidence → **Self-Esteem** → **Self-Actualization**

I. Muckross House, Killarney, Ireland

J. Taliesin West, Frank Lloyd Wright, Scottsdale, Arizona

K. Entry to the Pedestrian Hall in Chinatown, Brisbane, Australia

L. Biosphere 2 Research Center, Tucson, Arizona

FIGURE 2.3 Maslow's hierarchy of needs represented in the built environment.

(A: Geoff Dann © Dorling Kindersley; B: Demetrio Carrasco © Dorling Kindersley; C: Christopher and Sally Gable © Dorling Kindersley; D: Demetrio Carrasco © Dorling Kindersley; E: Demetrio Carrasco © Dorling Kindersley; F: Shaen Adey © Dorling Kindersley; G: Mike Dunning © Dorling Kindersley; H: Paul Harris © Dorling Kindersley; I: Joe Cornish © Dorling Kindersley; J and L: Alan Keohane © Dorling Kindersley; K: Rob Reichenfeld © Dorling Kindersley)

call their own. This desire continues through our adult lives as we seek to create our own versions of comfort and home. Witold Rybczynski, in *Home: A Short History of an Idea*, spoke to the idea of comfort. Although comfort evolved through the years fueled by Greek, Roman, Dutch, and French influences, Rybczynski credited the flourishing of comfort to Georgian England: "Here, thanks to a happy confluence of economic and social conditions and national character, it flowered" (pg. 104). He further revealed that the meaning of home solidified in Georgian England as well. The regard of the English for the countryside, and their independent nature, led to their pride in rural properties and their desire for privacy. The English were said to "have *houses* in London . . . but their *homes* are in the country" (p. 105).

The development of the arts and of personal fulfillment can be found in much of the great literature of the Romantic Movement, which coincided with Georgian England. The movement reflected a return to nature and the need for personal expression. It allowed for the freedom of mind and spirit—level five: self-actualization.

The need and desire for a personal space, a space to call home (in any language), belongs to all cultures. The following quotes on the personal meaning of home were taken from two individuals. One is American; the other is Japanese. Although the Japanese-to-English translation obviously identifies which statement belongs to which individual, the overlap in meaning is equally obvious:

Individual #1

I still believe the home is warm and comfortable space which feels like mother's arm. . . . Before, I just have simple idea that home is place we can relax. But I never think deeply why people can relax or feel comfortable at home. People will have different reasons to feel comfortable. People feel comfortable because of private, family, or secure. Most of us have our own private room to have our own time. Every *home* has living room to gathering up with family to have fun time. And we believe *home* is secure place.

I can relax at home because I know *home* is secure. Because I believe and trust my family and they give me calm feeling to feel comfortable at home. Therefore, I can relax, sleep, and feel comfortable without worrying anything. . . . Because of all reasons to feel comfort at home make me to return home. I believe *home* is place that we can *return* and feel comfort.

Individual #2

My home is so many things to me. It is my idea of a place that is all about tradition and family. It is my refuge at the end of the day and the place that sends me off each day with a smile. It is the place where I relax, have privacy, and really belong. It holds memories for me of being newlyweds, of my children's first steps and falls, of family Thanksgiving gatherings, and it is the place where we always rush back to after a vacation. Home to me embraces all of the senses. I love hearing my daughter's laugh, playing the piano, and especially loading the dishwasher. It is also the smell of a meal and the taste when we enjoy it as a family. Visually it is the place where I can be creative and display the furniture and art we enjoy. The touch of a goose down comforter before I go to bed is also part of what I think about when I think of home.

At different times in my life, home has been different places. From growing up with my parents, to leaving home after graduation, and finally to marrying, home has always been special. Although the location has changed, the comfort concept is something that has moved along with me. I hope that the tradition of home and family will also mean my husband and me sitting in rockers, enjoying our future grandchildren, and being a part of their idea of home, tradition, and family. I can't think of any place better than home.

Society's Collective Values

In *The Built Environment*, Wendy McClure and Tom Bartuska discusses human value-driven needs based on Lawrence Kohlberg's six stages of moral development. Kohlberg's study states that ethical behavior is based on moral reasoning. He divides moral reasoning into three levels with six stages, as follows:

Level 1: Preconventional Morality

Stage 1. Obedience and punishment orientation. Behavior is based on the power of an authority figure and the desire to not be punished.

Stage 2. Individualized or self-interest orientation. Behavior is based on personal interests or the gain of a personal reward.

Level II: Conventional Morality

Stage 3. Interpersonal relationships. Behavior is based on the need to gain approval from others.

Stage 4. Abiding by the law or social order. Behavior is based on one's duty and the desire to avoid guilt.

Level III: Postconventional Morality

Stage 5. Individual rights and social contract. Behavior is based on the awareness of others and a genuine desire to help others.

Stage 6. Universal ethical principles. Behavior is guided by conscience.

It is at the fifth stage of moral development that one's ethical behavior is motivated by social equality—universal design. At the highest stage of universal ethical principles, behavior addresses environmental consciousness. Society's collective values are revealed by our emerging awareness of and appreciation for the needs of special populations and the importance of our cultural and global environment.

More info online @

http://faculty.plts.edu/gpence/html/kohlberg.htm W. C. Crain. (1985). *Theories of Development*. Prentice Hall. pp. 118–136

■ HISTORIC PRESERVATION

The application of historic preservation serves as an excellent example of society's collective level of human values. Historic preservation recognizes the importance of sustaining a community's cultural heritage to enrich the quality of life and community diversity. According to the Advisory Council on Historic Preservation, the reasons for the support of preservation are varied.

■ Some desire a tangible sense of permanence and community, whereas others wish to know about and embrace America's heritage in a direct and personally meaningful way.

■ Recognition that historic preservation often is associated with economic successes is an important reason, as is the fact that many see the preservation of historic districts, sites, buildings,

structures, and objects as enhancing their quality of life, adding variety and texture to the cultural landscape in which they live and work (Figure 2.4).

Primarily because of such highly personal responses, public support for historic preservation has blossomed from the bottom up, making it in the truest sense a grassroots movement, not just another government program.

Grassroots Development

The need to preserve America's cultural heritage began as a grassroots movement in the 1800s and continues to have its most effective results at the community level. One of the first architectural buildings to be

A

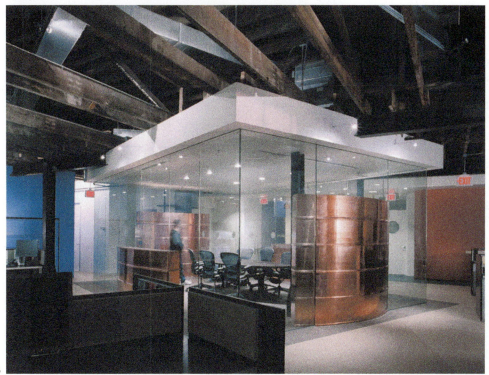

B

preserved was George Washington's home, Mount Vernon. The Mount Vernon Ladies Association was formed and raised the funds to purchase and restore the home in the 1880s. The Mount Vernon Ladies Association is still responsible for the home and the tours.

Before the turn of the twentieth century, America recognized the need to preserve its national treasures. Large areas of land were set aside as national parks (a concept developed in America), national monuments, and historic sites. In 1914 the National Park Service was formed to manage these and future acquisitions. Throughout the early 1900s many homes and buildings were preserved and restored to be used as museums to define America's heritage. Williamsburg, a reconstructed village, illustrates how an early American community lived and worked. The Historic American Buildings Survey, or HABS, was begun by the Park Service in 1933. The initial record produced 24,000 measured drawings of historic structures.

The National Trust for Historic Preservation in Washington, D.C., founded in 1949, is the largest organization in the country devoted to the preservation of historic buildings, districts, and neighborhoods. Its mission is to "provide leadership, education, advocacy, and resources to save America's diverse historic places and revitalize our communities." A nonprofit membership organization, the National Trust maintains the National Historic Register. The National Trust also administers historic buildings as museums; disseminates information about preservation to property owners and to the public at large; and assists in a variety of preservation, restoration, and rehabilitation efforts around the country. However, it is important to note that the National Historic Register designation does not ensure a building's sustained preservation. The National Historic Register is a recognition status that requires only government-owned buildings to be subject to environmental review before

FIGURE 2.4 Sensitivity to historic structures and their adaptive use brings together an appreciation of our cultural heritage and sustainable design. In this commercial office setting, in order to preserve the visual character of the original timber frame structure and provide an acoustically sound conference room, the ceiling was dropped under the timbers and the conference room was encased in glass. Copper end panels provide some visual privacy and contrast in material usage. Massive Victorian doors are placed on pivots to allow for fluid traffic flow between the library and pantry, or they can be closed, if necessary. (© Richard Greenhouse Photography. Architect/Designer: Gensler. Client: Gordon and Betty Moore)

a proposed demolition. Any community that is determined to maintain its local historic character must invoke local ordinances and regulations to preserve its structures.

From the 1950s through the 1970s, many national treasures were destroyed in the name of progress. Of the structures surveyed by HABS in the 1930s, over half had been destroyed. Recognizing the need to reaffirm America's historical heritage, the grassroots movement lobbied Congress, and the national Historic Preservation Act was greatly enhanced in 1980. Tax relief and grants-in-aid (among other important legislative actions) were established to promote preservation. Downtown communities were granted funding through the Mainstreet Program to save their historic downtown character. Businesses that renovated historic homes, public buildings, and even factories helped to create the design specialty of adaptive use.

Publications and Standards

The U.S. Secretary of the Interior through the National Park Service has published standards for preserving, rehabilitating, restoring, and reconstructing historic buildings and archeological sites. Following these guidelines can help communities use best practices for preservation and also open opportunities for economic gains through tax incentives. *Preservation Briefs*, also published by the National Park Service, contain critical technical data relating to the restoration of historic building materials.

Through the grassroots efforts of many individuals and organizations, America's cultural heritage before and after European occupancy can be observed through buildings, historic sites, and communities, as well as in the open spaces of national parks and monuments (Figure 2.5). Americans have recognized the need to preserve a *sense of place*. They also recognize that natural resources, elaborate architecture, and unique details are costly to replace once destroyed. In fact, many are irreplaceable.

Interior design recognizes and honors the study of historical architecture and interiors in university curriculums and in the professional process of research for a design problem. Designers use historic precedent to inform design solutions. CIDA Standard 8 History states, "Entry-level interior designers apply knowledge of interiors, architecture, art, and the decorative arts within a historical and cultural context" (CIDA Professional Standard 2011, II-18).

The recognition and preservation of historical interiors or their sensitive adaptive use provide cultural and economic value to communities. The Pictorial Essay at the end of Part I provides a brief overview of the historical design eras.

More info online @

www.achp.gov/overview.html Advisory Council on Historic Preservation
www.cr.nps.gov/hps/tps/briefs/presbhom.htm National Park Service site for *Preservation Briefs*
www.preservationnation.org National Trust for Historic Preservation
www.cr.nps.gov/standards.htm The *Secretary of the Interior's Standards and Guidelines for Archeology and Historic Preservation*

■ MULTICULTURAL ENVIRONMENTS

An appreciation for and awareness of the needs of multicultural interiors is also reflective of our collective societal values. The business of design is global, with several leading design firms securing branch offices in overseas locations. China, Dubai, England, and Hong Kong, among other countries, include Canadian and American design firms. The ability to communicate fluently in a second or even third language, and a willingness to travel, will help to secure one's place in a design firm.

Awareness of other cultures, however, extends beyond language and physical location. Multicultural understanding also requires a sensitivity to ethnic customs, regional philosophies, indigenous characteristics, religious

A

B

FIGURE 2.5 Old Faithful Inn (1901) in Yellowstone National Park, designed by Robert Reamer, is listed on the National Register of Historic Places. Reamer created the rustic lodge to serve as a safe refuge from the wild. Wilson Associates, an architectural and design firm, designed Fort Wilderness Lodge at Disney World to reflect the historic character of Old Faithful Inn: See www.wilsonassoc.com and click on See Our Work, then Disney Fort Wilderness Lodge.
(Photography by Lynn M. Jones)

and/or spiritual traditions, and societal values. When working with clients from other cultures, designers immerse themselves in the study of these clients' cultures as part of the programming phase of the design process.

Ellen Lupton, Director of the MFA program in graphic design at Maryland Institute College of Art (MICA) Baltimore and Curator of Contemporary Design at Cooper-Hewitt National Design Museum notes,

> Design is an international phenomenon. Every culture in the world uses design, both to communicate within local communities as well as to speak to the larger world. We learn about other cultures in order to learn about people and practices that are different from our own. We also learn about other cultures in order to discover what draws us together, what we have in common, what makes us neighbors on the same planet. Other people are different from us, but they are also in many ways the same as we are. Design is a powerful force in bringing people together through shared visual languages as well as through the personal and cultural particularities.

> *(Retrieved from www.aiga.org/content.cfm/encouraging-us-graphic-design-students-to-learn-about-other-cultures)*

A designer should have a strong background in design, art, and cultural history as well as the humanities such as literature, philosophy, religion, and the social sciences of psychology and sociology. College-level courses in the liberal arts are crucial in an interior designer's education. CIDA requires that all accredited programs include a minimum of 30 semester hours of "diverse college level liberal arts and sciences" and that the program "culminates in a minimum of a bachelor's degree" (CIDA Professional Standard 2011, pg. II-3).

Clients' backgrounds and experiences influence their preferences. Chapter 4, for example, discusses color and its meanings in various cultures. Cultural upbringing affects perception. A good designer is able to perceive the environment through the perspective of the client. Interior design provides awareness of cross-cultural values through the physical expression of the interior environment (Figure 2.6).

More info online @

http://johnnyholland.org/2010/01/11/my-days-are-filled-with-questions-the-bridge-between-cultures-and-design Blog on Culture and Design

www.informedesign.org InformeDesign has an extensive list of articles. Search for cross-cultural

FIGURE 2.6 This hotel lounge in Bali, Indonesia, opens to the exterior environment. Architectural lines reflect Indonisian characteristics.
(© LOOK Die Bildagentur der Fotografen GmbH / Alamy)

■ THE SCIENCE OF SPATIAL BEHAVIOR

Cultural, social, behavioral, and societal values influence the design of the built environment; however, these influences must collaborate with the physical requirements of a space. This relationship is symbiotic. Completing a physical task requires a functional space and appropriate components. Sufficient design solutions elicit a positive response from the user; insufficient solutions elicit a negative response. For instance, a hotel that is designed for wheelchair accessibility may boast additional space in bathrooms to allow for a 5-foot wheelchair turnaround. However, if this space were taken away from the bedroom area, resulting in the wheelchair not having room to fit between the wall and bed, the value of accessibility is lost on the end user.

The study of space needs in the built environment overlaps with the sciences of sociology and psychology. Two notable discourses on the subject are Edward T. Hall's pioneering book, *The Hidden Dimension*, and Robert Sommer's work on social design, *Social Design: Creating Buildings with People in Mind.*

Proxemics and Social Design

Proxemics is the study of the use of space by human beings in a particular culture. Everyone has an invisible comfort zone or area of surrounding space called a "space bubble." In his book, Hall illustrates the bubble expanding into four zones (Figure 2.7). Discomfort may result when a person with a smaller space bubble gets too close to a person with a larger space bubble. Our individual comfort zones vary in relation to our culture and background experiences. The designer can use this information to create environments with furniture that will meet particular needs for comfort and space, especially in a nonresidential setting.

In all environments, most people want a space that belongs to them—such as a bedroom, or a certain chair in the family room or

breakroom. Children who share a bedroom often reveal this need for private space; for example, they may define what side of the room is theirs, or what part of the closet is for their belongings only. This need for a personal space usually carries over into adult life, and a sensitive designer plans furnishings accordingly.

Robert Sommer has written extensively on personal space, the built environment, and the overlap of design research and the social sciences. In his text, *Social Design: Creating Buildings with People in Mind*, he expanded on this relationship, coining the term *social design*: "Social design is working with people rather than for them; involving people in the planning and management of the spaces around them; educating them to use the environment wisely and creatively to achieve a harmonious balance between the social, physical, and natural environment."

Proxemics and social design merge cultural, physical, and psychological components to create adequate space in interior environments. The more scientific study of physical space needs, referred to as human factor engineering, occurs in the disciplines of anthropometrics and ergonomics.

Anthropometrics

The physical and psychological comfort of the occupants is an important aspect of the space planning process. People should be comfortable in relation to the scale and proportion of the architecture. The three-dimensional aspects of a space must be considered because if the space is too vast or too small, people may feel out of place.

Furniture should be suitably scaled for comfort and arranged for purpose and efficiency. It should also be easy to use and operate. For example, a desk and desk chair should be the appropriate height, and a storage cabinet should have shelves the user can reach. *User-friendly* furniture is also easy to move or rearrange and clean.

Anthropometrics studies the size and proportions of the human body including variations in cultural populations. Research in this area

FIGURE 2.7 Edward T. Hall, in his book *The Hidden Dimension,* discusses four distance zones: the intimate, the personal, the social, and the public.

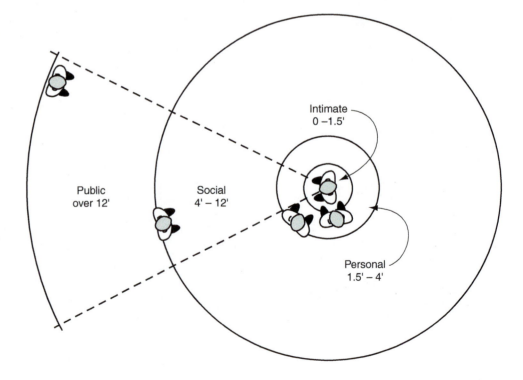

Intimate
0 – 1.5'

Public
over 12'

Social
4' – 12'

Personal
1.5' – 4'

identifies typical human heights, widths, and sizes in various postures. This information can be used to determine optimum space needs and the level of mobility and physical strength required of the end user.

Human dimension data are divided into categories for various cultures, males, females, and children and recorded in both the metric and U.S. customary systems of measurement. These data define information in ranges between the 95th and 5th percentiles; for example, as shown in Figure 2.8, 90 percent of women's eye heights would fall between 56.3 inches and 64.1 inches. The application of this information is the science of ergonomics. For instance, in the preceding example, the eye height dimensions may guide a designer in the height of a security peephole. An accessible room would require a second peephole at a lower height to coincide with the needs of someone in a wheelchair.

Ergonomics

Ergonomics is the study of human beings and their responses to various working conditions and environments. Ergonomic data provide designers with information on such subjects as comfortable seating as well as visual and acoustical issues. For example, a computer chair that provides maximum back, arm, and leg support may be said to be ergonomically designed (Figure 2.9).

The study of anthropometrics and ergonomics is extremely valuable in the development of the Americans with Disabilities Act and universal design guidelines. Interior design adds value to environments by creating spaces that adapt to clients' physical and psychological cultures.

More info online @

www.hf.faa.gov/Webtraining/HFModel/Variance/anthropometrics1.htm Government site on anthropometrics
www.ergonomics.org Professional site on Ergonomics

Adult Physical Body Dimensions								
	Men				Women			
Measurements	5%		95%		5%		95%	
	in	cm	in	cm	in	cm	in	cm
Standing Dimensions								
A Crouch height	30.8	78.2	36.2	91.9	26.8	68.1	32.0	81.3
B Elbow height	41.3	104.9	47.3	120.1	38.6	98.0	43.6	110.7
C Eye height	60.8	154.4	68.6	174.3	56.3	143.0	64.1	162.8
D Shoulder breath	17.4	44.2	20.7	52.6	14.9	37.8	17.0	43.2
Sitting Dimensions								
E Mid-shoulder height sitting	23.7	60.2	27.3	69.3	21.2	53.8	24.6	62.5
F Buttock-toe length	32.0	81.3	37.0	94.0	27.0	68.6	37.0	94.0
G Eye Height sitting	30.0	76.2	33.9	86.1	28.1	71.4	31.7	80.5

FIGURE 2.8 Example of an anthropometric study.
Adapted from Human Dimensions and Interior Space by Julius Panevo & Martin Zelnik.

FIGURE 2.9 Ergonomic furniture is designed to be flexible and to adjust to various users. Back and foot support as well as elbow support level with the keyboard assist the end user.
© Maluson/Shutterstock

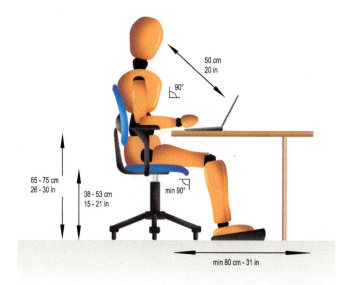

■ UNIVERSAL DESIGN

Universal design is the design of products and environments to be usable by all people, to the greatest extent possible, without adaptation or specialized design. The principles of universal design are listed in Table 2.1. The authors of this list, which included architects, product designers, engineers, and environmental design researchers, compiled these seven principles to guide the design process and educate both designers and consumers about the characteristics of more usable products and environments.

The Center for Universal Design brings us full circle—reemphasizing the symbiotic relationship of the built environment between physical functionality *and* cultural, social, behavioral, and societal values—in the following notation:

The Principles of Universal Design address only universally usable design, while the practice of design involves more than consideration for usability. Designers must also incorporate other considerations such as economic, engineering, cultural, gender, and environmental concerns in their design processes. These Principles offer designers guidance to better integrate features that meet the needs of as many users as possible.

TABLE 2.1 Principles of Universal Design

Principle	Description	Guidelines
EQUITABLE USE **Principle One:**	The design is useful and marketable to people with diverse abilities.	1a. Provide the same means of use for all users: identical whenever possible; equivalent when not. 1b. Avoid segregating or stigmatizing any users. 1c. Provisions for privacy, security, and safety should be equally available to all users. 1d. Make the design appealing to all users.
FLEXIBILITY IN USE **Principle Two:**	The design accommodates a wide range of individual preferences and abilities.	2a. Provide choice in methods of use. 2b. Accommodate right- or left-handed access and use. 2c. Facilitate the user's accuracy and precision. 2d. Provide adaptability to the user's pace.
SIMPLE AND INTUITIVE USE **Principle Three:**	Use of the design is easy to understand, regardless of the user's experience, knowledge, language skills, or current concentration level.	3a. Eliminate unnecessary complexity. 3b. Be consistent with user expectations and intuition. 3c. Accommodate a wide range of literacy and language skills. 3d. Arrange information consistent with its importance. 3e. Provide effective prompting and feedback during and after task completion.
PERCEPTIBLE INFORMATION **Principle Four:**	The design communicates necessary information effectively to the user, regardless of ambient conditions or the user's sensory abilities.	4a. Use different modes (pictorial, verbal, tactile) for redundant presentation of essential information. 4b. Provide adequate contrast between essential information and its surroundings. 4c. Maximize "legibility" of essential information. 4d. Differentiate elements in ways that can be described (i.e., make it easy to give instructions or directions). 4e. Provide compatibility with a variety of techniques or devices used by people with sensory limitations.
TOLERANCE FOR ERROR **Principle Five:**	The design minimizes hazards and the adverse consequences of accidental or unintended actions.	5a. Arrange elements to minimize hazards and errors: most-used elements, most accessible; hazardous elements eliminated, isolated, or shielded. 5b. Provide warnings of hazards and errors. 5c. Provide failsafe features. 5d. Discourage unconscious action in tasks that require vigilance.
LOW PHYSICAL EFFORT **Principle Six:**	The design can be used efficiently and comfortably and with a minimum of fatigue.	6a. Allow user to maintain a neutral body position. 6b. Use reasonable operating forces. 6c. Minimize repetitive actions. 6d. Minimize sustained physical effort.
SIZE AND SPACE FOR APPROACH AND USE **Principle Seven:**	Appropriate size and space is provided for approach, reach, manipulation, and use regardless of user's body size, posture, or mobility.	7a. Provide a clear line of sight to important elements for any seated or standing user. 7b. Make reach to all components comfortable for any seated or standing user. 7c. Accommodate variations in hand and grip size. 7d. Provide adequate space for the use of assistive devices or personal assistance.

Source: Compiled by advocates of universal design, listed in alphabetical order: Bettye Rose Connell, Mike Jones, Ron Mace, Jim Mueller, Abir Mullick, Elaine Ostroff, Jon Sanford, Ed Steinfeld, Molly Story, and Gregg Vanderheiden. Major funding provided by: The National Institute on Disability and Rehabilitation Research, U.S. Department of Education. Copyright © 1997 North Carolina State University, The Center for Universal Design.

Interior designers who follow the guidelines of universal design create spaces that accommodate a wide-range of individuals regardless of ability. The application of these principles brings value to the end user through a safer, more adaptive interior, minimizing adverse interior environment conditions.

The Universal Design Alliance was one of the first in the nation to apply the principles of universal design to a show house setting. According to Sandra G. McGowen, FASID and co-founder of the Alliance, "Ours [show house] was unique in that we treated it just like a show house and used professional designers. We wanted to show that universal design can be beautiful and functional, not institutional. We wanted to take away the "handicapped" stigma. It's just good design, for everyone." Figure 2.10 illustrates some of their solutions.

More info online @

www.design.ncsu.edu/cud The Center for Universal Design
www.asid.org/designknowledge/aa/universal ASID's Knowledge Center on Universal Design
www.asid.org/designknowledge/aa/accessible ASID's Knowledge Center on Accessible Design

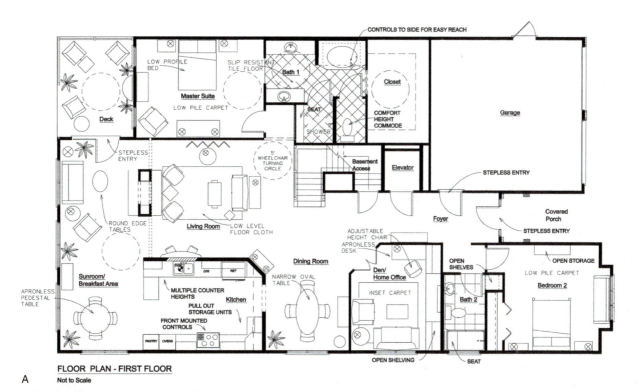

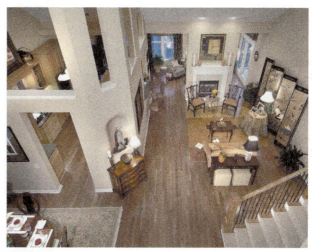

FIGURE 2.10 The Universal Design Alliance, located in Atlanta, Georgia, sponsored a showhouse reflecting the principles of universal design. The floor plan (A) was adapted to include an elevator, stepless entry, accessible bathrooms, and kitchen facilities (B), and many additional universal principles in the furnishings and finishes (C).
(Designers: Dining Room - Rita Goldstein, ASID, Interiors by Rita; Living Room - Anna Marie Hendry, Allied Member ASID, Classic Interiors by Anna Marie; Sunroom and CADD Drawing - Maria Nutt, Allied Member ASID, McLaurin Interiors; Kitchen - Pamela Goldstein Sanchez, CMKBD, Allied Member ASID, Pamela Sanchez Designs and Fusion Design Group, LLC. Photograph by Fred Gerlich Photography)

■ DESIGN FOR SPECIAL POPULATIONS

As mentioned in the Introduction to Interior Environments, Part I, interior designers have a responsibility for developing interior environments that meet the needs of all people, regardless of age and ability. Special considerations are given to environments designed for children, the elderly, and special user groups. The commercial design market is directed by federal regulations (such as the Americans with Disabilities Act, or ADA) to allow for accessible environments. The housing market, however, is not as closely monitored by the federal government, and rightfully so. Residential clients have the right to create individualized interiors not controlled by ADA guidelines. To that end, however, designers have a responsibility to share with clients design opportunities that will allow for quality-of-life environments that can adapt to anyone. Furthermore, the housing market has a significant need and the greatest potential for adaptability, not only for families with children, but also for those wishing to continue to reside in their homes as they age in place. Universal design concepts support these design ideals.

Americans with Disabilities Act (ADA)

The ADA, a civil rights act, was passed in 1990 and has greatly affected building design. Among other things, the ADA requires government buildings, contract design facilities (including all the specialty areas discussed in Chapter 1, Table 1.2), public accommodations (residential or otherwise), and public transportation systems to provide equal accessibility to all people regardless of disability. Many of the ADA's physical regulations are based on the 1986 American National Standards Institute (ANSI) codes (which have since been updated). Designers frequently reference the ADA. (A complete copy of the "Accessibility Guidelines for Buildings and Facilities" is available from the U.S. Architectural and Transportation Barriers Compliance Board at

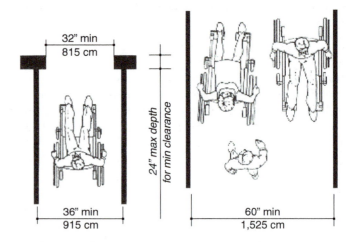

FIGURE 2.11 Minimum clear width for wheelchairs, from the ADA guidelines. www.access-board.gov/bfdg.html

1-800-USA-ABLE or at http://www.access-board.gov/adaag/ADAAG.pdf.) A sample of these regulations is shown in Figure 2.11. It is important to emphasize that these regulations are laws, not codes or standards. The monitoring of these laws varies from state to state; nevertheless, quality interior solutions integrate these design regulations.

Children

Designing for children requires many not-so-subtle accommodations relating to size, physical ability, safety, and human scale. Size and scale are the most difficult of these accommodations because of the differences in size and scale between, say, a toddler and an elementary school child. Designing for children is also complicated by their ever-changing psychological development and their uninhibited perceptions of their environments (Figure 2.12).

FIGURE 2.12 Children require spaces that meet their ergonomic and anthropometric needs. Furnishings and finishes should be durable and cleanable, as well as safe. Heavy objects should remain low, and toys should be kept at a level to accommodate a child's reach. This play area is part of a children's cancer center and includes plenty of storage, resilient materials, and sound attenuating walls.
(Architect/Designer: Perkins+Will. Photography by Chris Little Photography)

When accommodating children, designers should keep the following in mind:

- Anthropometric and ergonomic statistics must be considered for children at various age/grade levels. Designs have to meet the physical size of the client.
- Children's spaces must meet their physical abilities. For instance, young children cannot read; therefore, graphics help them to understand the spaces they are entering and assist them in way finding. Symbolism is their visual communication.
- Safety is critical in the design of children's spaces. Because children are naturally inquisitive and active, places need to be designed to accommodate their activities—safely. For instance, duplex outlets at standard height have no place in the child's play area of a waiting room. Bookshelves displaying toys must be within children's reach or children will *invent* a way to reach them. Plants must be nontoxic.
- Children's areas must also be durable and easily cleaned. For instance, children will climb onto furniture. Their shoes may have come into previous contact with grass, dirt, used bubblegum, and so on.
- Design intended for the user must meet the scale of the user. For instance, what one views at a 3'-0" eye height is remarkably different from what one views at a 5'-6" eye height. Crawling is an excellent mental (and for that matter, physical) exercise for adult designers attempting to view the world from a child's perspective.

From the floor a designer can look at all the opportunities to play with objects: Light switches become toggle toys; electrical outlets are places to hide little things; drapery cords are for wrapping around; and end tables and chairs are for climbing (Figure 2.13). The designer is now thinking like a child and has entered the elusive arena of child development.

Randy White, CEO of White Hutchinson Leisure & Learning Group, a leading firm specializing in children's design, notes in his article "Adults Are From Earth; Children Are From the Moon" that children are more interested in the *process* of using the environment; adults are more interested in *achieving a result*. "Adults view the environment in terms of form, shapes, and structures and as background. So if something like a couch is in a public place, adults will interpret it only for its socially acceptable use, for sitting upon. Children, on the other hand, interpret the environment holistically and evaluate it for all the ways they can interact with it" (paragraph 4).

How the child uses the environment is related to the child's psychological development and how much the child has been influenced by the societal behavioral norms. Most of us can remember secretive opportune moments that included the amusement of jumping on the bed and climbing over the sofa (when adults were not looking). This is not bad behavior, just behavior that is not accepted by current society. White continues:

> Most of young children's play centers around their incredible imaginations. The environment needs to promote and support imaginative role-play with props and loose parts. However, the environment needs to be open-ended so children can use their imaginations to develop their own play scripts. Highly scripted, structured, and overly themed environments stifle children's creativity, short-circuit extended play, and can quickly lead to boredom (paragraph 22).

Designing for children is further complicated by children's continuing development. Children's areas must be adaptable, particularly in residential design. Children's furniture needs to grow with the child. For instance, a bed designed as a ship or flying saucer may serve the child for one or two years, but the theme and scale will quickly be outgrown. What was amusing today will become passé tomorrow. If the client requirements dictate a themed child's room, the design should include solutions that are decorative in nature. Paint and linens can provide the theme, allowing for relatively inexpensive and environmentally responsible changes in the near future.

Source and more info online @
www.whitehutchinson.com/children/articles/earthmoon.shtml White Hutchinson Leisure & Learning Group, a firm specializing in children's designs

FIGURE 2.13 Children view objects as items to be played with and manipulated. Locating electrical outlets within their reach can lead to serious injury.
(Eddie Lawrence © Dorling Kindersley)

Elderly and Special User Groups

The guidelines that designers follow to create children's environments are also applicable when designing spaces for the elderly and others with special needs. We experience our environment through our mental processes and through our physical processes such as mobility and senses. When one of these is impaired, our interpretation of the environment changes. When designing for the elderly, or any special user group, designers need to adapt the environment to accommodate special needs (Figure 2.14).

Users with Mental Challenges

Alzheimer's and dementia patients require interiors that offer a safe and secure environment, while providing assistance with mental clarity. For instance, to assist patients in way finding, designers can use color to distinguish areas; individual rooms may have memory boxes outside as visual cues to help patients recognize their spaces. Because

FIGURE 2.14 Designing for the elderly requires sensitivity to special needs. This continuing care retirement facility, located in Sun City Kanagawa, Japan, also required special research into multicultural awareness.
(Architect/Designer: Hellmuth, Obata & Kassabaum, Tokyo and San Francisco. Photographs by Jaime Ardiles-Arce)

most Alzheimer's patients are active and mobile, dead-end corridors can create frustration; circular pathways provide a flow and encourage interaction in a meaningful environment. Bold patterns and frequent floor surface changes may hinder mobility and cause confusion. The design of interior environments for people with Alzheimer's requires extensive study, but with over 4 million individuals affected by the disease, the need for quality design is essential.

People with autism also require special considerations in design. Soothing colors and uncomplicated spaces void of excessive patterns can calm the mind. Psychotic patients require safe, secure spaces. Most important, the design of an environment for mentally challenged patients should be holistic, encompassing the environment, the caregivers, and the family, while considering the needs and security of patients.

Physical Immobility

The ADA's primary focus is on creating environments that are physically accessible to all. A goal of such an environment is to be barrier-free. **Barrier-free designs** present no physical obstacles or barriers, allowing free movement for individuals with disabilities. Designers need to be aware of the extensive ADA regulations and implement design solutions that conform to them. At a minimum, accessible planning should include the following:

- Parking spaces for individuals with disabilities must be conveniently placed, adequate in number, clearly marked, and not on a slope.
- The environment, both interior and exterior, should be free of architectural barriers so those who may be using a wheelchair, crutches, or a walker can easily circulate throughout various areas. In a commercial environment, doors must be a minimum of 36" wide and must have lever handles. The pull side of the door should be free of any obstructions for a minimum of 18" (preferably 24"). Though not required by law, this approach also works best in residential environments for people who are physically challenged (Figure 2.15).

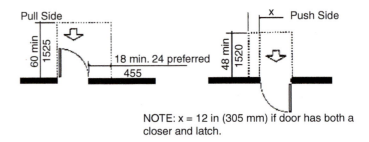

NOTE: x = 12 in (305 mm) if door has both a closer and latch.

FIGURE 2.15 The minimum clear requirements for an accessible swinging door.
(Federal Register, Vol. 56, No. 144, Figure 25, Maneuvering Clearances at Doors, July 26, 1991)

- Traffic lanes or corridors must be kept free of clutter and be wide enough for easy movement in a wheelchair or walker (as seen in Figure 2.11).
- Floor coverings that are hard, smooth, and slip-resistant work most efficiently for safe and easy movement. If carpet is used, a dense, short pile is best. Generally, area and throw rugs should be avoided. Thresholds should be flat, or not more than 1/2" high.
- In the kitchen, where people are especially susceptible to accidents, heights, clearances, and other measurements should be planned for convenience and safety. Working surfaces that pull out and storage areas with open and revolving shelves are an asset. A front-loading dishwasher and washer/dryer, an upright refrigerator, and an oven with front controls are convenient. For those using wheelchairs, oven and dishwasher doors hinged at the side are better; however, controls on the front of appliances may not be the best solution for households with young children.
- Bathrooms and fixtures must be conveniently and safely located with ample room for manipulating a wheelchair. A 5'-0" clear area is required. Grab bars conveniently positioned by the tub and toilet provide added safety (Figure 2.16).

- Signage, water fountains, sconces, telephones, and emergency alarms must also be easily used by people who have physical impairments.

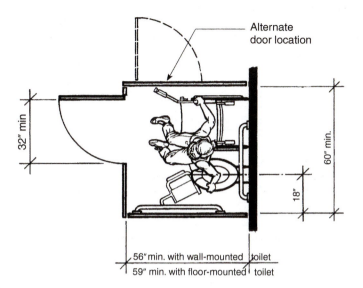

Alternate door location

32" min

60" min.

18"

56" min. with wall-mounted toilet
59" min. with floor-mounted toilet

FIGURE 2.16 A typical layout for an accessible commercial toilet area. *(From U.S. Department of Housing and Urban Development)*

Hearing Impairments

Although less than 0.05 percent of the American public is functionally deaf (according to the Hearing Loss Association of America), 28 million Americans have some form of hearing loss. Designers need to note that sounds used as notifications may not be perceived by much of the public; those with hearing impairments rely on visual cues. For instance, fire alarms need to be tied to bright blinking lights, telephones require blinking lights to indicate incoming calls, and clear communications systems are required on transportation vehicles.

Properly designed interiors help to enhance the acoustics. Reverberation, or the reflection or echoing of sound, negatively affects auditory understanding. Noise from sources outside the interior space also will interfere with the listener. Chapter 5 discusses acoustical options to enhance sound attenuation for all users.

Visual Impairments

All humans experience some level of vision loss as part of the aging process. Loss may be due to glaucoma, cataracts, macular degeneration, or complications from diabetes or other diseases. Older eyes also interpret color differently, creating a yellowish cast. When designing for the elderly, designers will find it useful to wear a pair of yellow-tinted sunglasses to replicate this change when selecting a color palette.

Depending on the cause of diminished vision, altering the interior can help improve eyesight and prevent falls. Options are numerous, but should include the following as a minimum:

- Light levels may need to be raised (or lowered depending on the disease).
- Lighting should be located to avoid glare and shadows.
- Dramatic changes in light levels should be avoided.

- Signage should include raised letters (Braille) and sufficient type size for ease of reading.
- Changes in elevations, such as steps, should be avoided. If required, they should be clearly demarcated.
- Edges of tables and other surfaces, such as counters, should be clearly delineated by a change in surface texture and/or color.
- Auditory and tactile design qualities should be enhanced, as these senses are more acute in people with visual challenges.

Just as actors conduct research on their characters, interior designers must research the needs of their clients. The best way for a designer to understand a client is to mentally place him- or herself in that client's shoes. How high can you reach when you are in a wheelchair? How do you transfer to a toilet? Get in a wheelchair and try. If you were blind, how would you know which elevator button to push? If you were deaf, how would you know if there were a fire in your building or perhaps a tornado drill? What if you were on crutches? How would you carry your books and laptop? Interior design provides value to the public through creative and innovative designs that make spaces accessible to all through universal design solutions.

More info online @
www.asid.org/designknowledge/aa/inplace ASID's Knowledge Center on Aging in Place
www.alz.org Alzheimer's Association
www.alzfdn.org Alzheimer's Foundation of America
www.afb.org/default.asp American Foundation for the Blind
www.humanics-es.com/index.html Website on human factors; contains articles and info on special populations

■ EVIDENCE-BASED DESIGN

The Center for Health Design defines evidence-based design (EBD) as "the process of basing decisions about the built environment on credible research to achieve the best possible outcomes" (www.healthdesign .org/chd). Additionally, EBD documents the results of the design solutions and publishes those findings promoting the sharing of research. It is a practice that has its roots in the medical profession, but is expanding into all facets of the construction industry.

History

The Center for Health Design started as a grassroots organization in 1993. Its primary focus initially was to use design "to improve patient outcomes in healthcare environments." The Center has since grown to provide extensive resources, research, conferences, and programs and has launched a searchable database called Ripple.

The Pebble Project, initiated in 2000, is a research component of the Center. Their website notes that the "purpose of the work is to create change in the healthcare industry by providing researched and documented examples of healthcare facilities whose design has made a difference in improving patient and staff outcomes, as well as operating efficiency." The Center also oversees the Evidence-Based Design Accreditation and Certification program (EDAC).

Dr. Jim Whitlock, past President and Chief Executive Officer (CEO) of Bradley Medical Center in Cleveland, Tennessee, discussed the role of interior design in the healthcare industry. He spearheaded the Patient Satisfaction Revolution for Bradley Medical Center in the 1990s and early twenty-first century, published in *The Healthcare Customer Service Revolution* by David Zimmerman. He provides the following historical analysis of the healthcare industry, relating to the value of interior design and evidence-based design.

In 1946, Congress passed the Hill-Burton act and provided funding for hundreds, and ultimately thousands, of new hospitals to be built throughout the United States, primarily in rural America. Not unlike most Government buildings of that day, the new facilities were brick boxes, built of concrete and cinder block—interior walls painted with a thick green covering. The plaster ceilings, fluorescent lighting, and tile floors suggested the need to keep things clean and sterile. This was the image of the facilities. Decisions regarding the design, both outside and in, were typically controlled by local physicians with an emphasis on emerging technologies.

In 1965, Congress passed the first healthcare reform issues in a century and billions of dollars were made available to physicians and providers to care for the poor and elderly; the Investor-owned Healthcare Industry was born. This new industry moved quickly into rural America, bringing new doctors, new technology, and modern architecture. Interior design was now an issue for the newly constructed and competing hospitals; healthcare architecture and interior design industries emerged as specialties in their professional fields.

Ironically, the benefits were not exclusively economical in nature; research has demonstrated that patients' recovery is directly influenced by their environment. The buzz word of the 70s and 80s was Holistic Medicine, treating the whole patient, not just the physical ailment. In today's highly competitive healthcare markets, patients make decisions based on "quality of care." The definition of quality is in the eyes of the beholder, so to speak. Consequently, patients begin to form an opinion of quality as they visualize the building, pull into the parking lot, enter the building, and are greeted, both physically and mentally, by their surroundings. The interior design of these spaces creates in the minds of patients a perception of quality. They begin to feel good about the experience and optimistic that those who care for them are equally as impressive as the surroundings. Whether or not this proves to be the case, the potential for dissatisfaction is reduced.

These environments inspire not only the patient, but also the employee; again, research suggests that environments do influence the culture of an organization and that culture inspires the employee to deliver "quality care" to the patient, confirming my personal philosophy that caring cannot be legislated, it must be a natural transition between the patient and the caregiver. I believe that interior design plays a huge role in that transition.

Design professionals have embraced the EBD process in the healthcare industry for documentation of results to improve patient outcomes; currently, professionals are also applying it in the corporate sector to document improvements in employee performance and satisfaction and to improve business productivity.

Relationship to the Design Process

Portions of the evidence-based design (EBD) process have been employed in design practice for many years in the form of postoccupancy evaluations. Designers visit the job site several months after a client has established occupancy and evaluate the effectiveness of their designs through interviews with end-users and through personal observations. Using this process, designers learn which design practices were effective and which were not. Unfortunately, without an initial baseline

TABLE 2.2 The EBD Process Incorporated into the Design Process	
Traditional Phases of the Design Process	**EBD Activities Related to These Phases**
Preliminary Phase – Initial Client Contact	Define EBD goals and objectives Define key research questions
Programming	Research relevant sources Interpret relative evidence Define and collect baseline data
Schematic of Conceptual Design	Develop a hypothesis
Design Development	Incorporate EBD concepts in design where applicable
Contract Documentation	Prepare the contract documents incorporating the research
Contract Administration	Monitor the construction
Postoccupancy Evaluation	Measure the results Publish performance research

to compare to the final outcomes, results were subjective. EBD, however, eliminates this subjectivity through the implementation of the scientific method. Table 2.2 illustrates how the EBD process parallels the design process discussed in Chapter 1.

Advancement of the Profession

Deborah R. Dunlap, a graduate interior design student at the University of Nebraska in Lincoln, researched the value of EBD in college design curriculums. In her research, Dunlap defines EBD as

research or evidence that supports designing the built environment used to measure successes and failures, share knowledge, and gain credibility. The interior designer benefits by using this information to provide the best possible design solution to the client. The satisfied client benefits from these solutions and considers the interior designer as a credible resource for future projects. EBD brings value to the interior design profession and the clients it serves by creating a win-win scenario through the quality of the final design, documented improved results as well as the confidence instilled in the designer-client relationship.

This win-win situation creates value for the end users, the owner, and the designer. Documented results using the EBD method fosters the advancement of the interior design profession.

More info online @
www.healthdesign.org Website for the Center for Health Design

http://cadreresearch.org/pages/research/files/presentations/24-COAA%202008
.pdf Panel Discussion PowerPoint on EBD

■ ENVIRONMENT: SUSTAINABLE DESIGN

As noted in the Introduction to Interior Environments, Part I, designing for sustainable environments is a critical component in interior design. It is also one of the most talked about, written about,

and researched subjects in interior design in the past ten years. ASID, IIDA, and IDEC include dedicated sections on their websites for sustainability. CIDA updated its standards in 2006 and in 2009 to reflect the current needs in environmental education. *Interiors & Sources* publishes a "Green Guide" and the *EnviroDesign Journal*. Sustainable literature and electronic resources have flooded the building industry. Most manufacturers include green products in their inventory, and third-party verification is common practice. Energy codes define limits of energy consumption in commercial structures. Sustainable design is no longer a niche business, but instead serves to guide the very form of a building and its interior environment.

Environment, Economics, and Equity

The terms *green design, ecological design, ecodesign, environmental design*, etc. differ subtly in their meanings; however, all focus on one overarching mission of sustainability: *"Development that meets the needs of the present without compromising the ability of future generations to meet their own needs."* (Retrieved from www.un-documents.net/ocf-02.htm, para. 1)

This statement is from *Our Common Future*, commonly referred to as the Brundtland Commission report from the World Commission on Environment and Development in 1987. The report also contains the following conclusions that help to further define the breadth of sustainability:

In its broadest sense, the strategy for sustainable development aims to promote harmony among human beings [sic] and between humanity and nature. . . . [T]he pursuit of sustainable development requires:

- a political system that secures effective citizen participation in decision making
- an economic system that is able to generate surpluses and technical knowledge on a self-reliant and sustained basis
- a social system that provides for solutions for the tensions arising from disharmonious development
- a production system that respects the obligation to preserve the ecological base for development
- a technological system that can search continuously for new solutions
- an international system that fosters sustainable patterns of trade and finance, and
- an administrative system that is flexible and has the capacity for self-correction. *(para. 81)*

William McDonough and Michael Braungart, in *Cradle to Cradle*, an influential book on sustainable design, call for the "transformation of human industry through ecologically intelligent design" (www.mcdonough.com/cradle_to_cradle.htm). The book focuses on the philosophies and strategies that allow for cradle-to-cradle manufacturing. In other words, items and their interior components are repeatedly used, or business practices are self-sustaining.

Sustainable development is also discussed in three conceptual components sometimes referred to as environmental ethic-environmental sustainability, economic sustainability, and social sustainability, or equity and engagement. Therefore, a truly sustainable design extends beyond environmentally responsible building materials to include equity in societal values and economic vitality and stability (Figure 2.17).

This holistic approach to sustainable design challenges the designer to consider not only wise green design solutions but also the social implications of design solutions, thus overlapping with the mission of universal design to create socially enriched interiors. Furthermore, the financial vitality of a business or residence aligns with the economic goal of interior design. Nevertheless, the selection of green materials and sustainable building methods remains a primary issue in interior design and deserves further study.

FIGURE 2.17 The three divisions of sustainable development.

Reduce, Reuse, Recycle

The three original Rs of green design—reduce, reuse, and recycle—still form the foundation of all sustainable environmental design criteria. Life cycle assessment (LCA) reviews all facets of a product's journey from initial development through its ability to be reused or regenerated into other products. Green design has become marketable, and the market is flooded with green products. The difficulty for designers is determining which environmental products are truly sustainable.

The International Standards Organization, with more than 160 international members, is the world's leading developer of standards of all kinds. Standards in the 1400 family relate to environmental management and, specifically, eco-labeling. The Federal Electronics Challenge states, "Eco-labeling is a voluntary approach to environmental performance certification that is practiced around the world. An eco-label identifies a product that meets specified performance criteria or standards. In contrast to green symbols or claim statements made by manufacturers and service providers, an eco-label is awarded by a third-party organization for products or services that are determined to meet specific environmental criteria." (See www.federalelectronicschallenge.net/resources/docs/ecolabel.pdf.) According to *Interiors & Sources* "Green Guide," ISO has developed three levels of eco-labels to assist designers. Table 2.3 defines these levels. Table 2.4 lists several third-party resources and their area of specialty.

TABLE 2.3 Eco-Labels by the International Standards Organization

Type	Features
Type I Classical Eco-Label	Features multiple environmental impacts Does not require life cycle assessment (LCA) Provides third-party verification
Type II Declaration by Manufacturer	Does not provide third-party verification Can encompass single or multiple impacts Might include a product LCA
Type III Next Generation Eco-Labels and Environmental Product Declarations	Requires use of LCA to measure environmental impacts Can include other product performance data (e.g. safety, human health, etc) Requires third-party certification of all product information provided

Fields of Study Related to Sustainable Design

Sustainable design encompasses many fields of study including solar design—both passive and active—earth-sheltered buildings, energy-efficient designs such as the Smart House, Earth Craft, and ASID's RE-GREEN Residential Remodeling Guidelines (in conjunction with the United States Green Building Council [USGBC]), the ANSI/BIFMA e3-2010 Furniture Sustainability Standard, straw bale homes, Earthships, historic preservation, and adaptive use as mentioned earlier in this chapter. Another field of study is LEED (Leadership in Energy and Environmental Design), an internationally recognized system for rating energy-efficient buildings.

The USGBC developed the LEED program. This program addresses all phases of the design of a building and is divided into several commercial and residential categories. LEED rating systems areas include New Construction, Core and Shell, Schools, Healthcare, Retails, Commercial Interiors, Existing Buildings-Operations and Maintenance, and Homes and Neighborhood Development. Other systems areas are under consideration.

TABLE 2.4 Third-Party Resources

Cradle-to-Cradle Certification (C2C)	Cradle to Cradle® Certification is a multiattribute eco-label that assesses a product's safety to humans and the environment and design for future life cycles. More info online @ http://mbdc.com/detail.aspx?linkid=2&sublink=8
Energy Star	ENERGY STAR is a government-backed program helping businesses and individuals protect the environment through superior energy efficiency. More info online @ www.energystar.gov
EPP Certification (EPP)	The EPP Program certifies composite panel products that are 100 percent recycled and low emitting. More info online@ www.pbmdf.com/index.asp?bid=1050
FSC Certified (Forest Stewardship Council)	Forest Stewardship Council (FSC) is a nonprofit organization devoted to encouraging the responsible management of the world's forests. FSC sets high standards that ensure forestry is practiced in an environmentally responsible, socially beneficial, and economically viable way. More info online@ http://fscus.org
GREENGUARD Indoor Air Quality Certification	The GREENGUARD Indoor Air Quality Certification Program gives assurance that products designed for use in office environments and other indoor spaces meet strict chemical emissions limits, which contribute to the creation of healthier interiors. More info online @ www.greenguard.org/en/CertificationPrograms/CertificationPrograms_indoorAirQuality.aspx
Green Label Plus (Carpet & Rug Institute)	The CRI Green Label Plus logo certifies that the product has been tested by an independent laboratory and has met stringent criteria for low emissions and high standards for IAQ. (Also see Chapter 11 Sustainable Design sidebar on Flooring Materials.) More info online @ www.carpet-rug.org/commercial-customers/green-building-and-the-environment/green-label-plus
Green Seal	Develops life-cycle-based sustainability standards for products, services, and companies and offers third-party certification for those that meet the criteria in the standard. More info online @ www.greenseal.org/AboutGreenSeal.aspx
Scientific Certification Systems (SCS) Material Content Certification FloorScore Indoor Advantage and Indoor Advantage Gold Sustainable Choice	Scientific Certification Systems offers a wide range of green product certifications. SCS offers Material Content Certification and assessment services to manufacturers of carpet, textiles, ceramic tile, building products, wood products, insulation, flooring, cleaning agents, and jewelry. FloorScore® was developed by the Resilient Floor Covering Institute (RFCI) together with Scientific Certification Systems (SCS) to test and certify flooring products for compliance with indoor air quality emission requirements adopted in California. Indoor air quality certification programs are part of SCS's ongoing efforts to improve the environmental performance of building products. SCS Sustainable Choice is a multiattribute certification label for products that have met environmental, social, and quality standards for furniture, carpet, and other building products. More info online @ www.scscertified.com/gbc/index.php
SMART Sustainable Product Standard (MTS)	Provides substantial global benefits for building products, fabric, apparel, textiles, and flooring, covering over 80% of the world's products with environmental, social, and economic criteria. More info online @ http://mts.sustainableproducts.com/SMaRT_product_standard.html
SFI Certified (Sustainable Forestry Initiative)	The Sustainable Forestry Initiative® (SFI®) label is a sign you are buying wood and paper products from a certified source, backed by a rigorous, third-party certification audit. More info online @ www.sfiprogram.org

According to their website, "LEED promotes a whole-building approach to sustainability by recognizing performance in five key areas of human and environmental health." These five areas are sustainable sites, water efficiency, energy and atmosphere, materials and resources, and indoor environmental quality. The newest version of LEED has added two additional areas—innovation in design and regional priority. Buildings earn LEED points for adherence to guidelines in each of the key areas or categories. LEED buildings may be certified at four levels (see Tables 2.5 and 2.6).

Designers can also become LEED-accredited professionals. All LEED professionals must first complete the Green Associates credentialing. Then, via practice, design professionals can earn LEED specialty designations in the areas of Building Design + Construction, Interior Design + Construction, LEED for Homes, Building Operations + Maintenance, and LEED for Neighborhood Development. The USGBC also sponsors Greenbuild—the world's largest conference and expo dedicated to green building.

Sustainable building systems, techniques, and products are discussed throughout this text in the Sustainable Design sections. Each section also includes links to websites for further study on this lively and highly relevant subject. Topics include the following:

Colorants in Chapter 4
Low-E Glass in Chapter 5
Solar Energy in Chapter 5
Indoor Air Quality—Sick Building Syndrome in Chapter 5
Energy Codes and Lighting in LEED in Chapter 6
Economy of Space Planning in Chapter 8
Flooring Materials in Chapter 9
Moveable Wall Systems in Chapter 10
Furniture in Chapter 11
LEED CI and e3-2010 in Chapter 11
Fibers and Textiles in Chapter 12
Energy Efficient Window Treatments in Chapter 13
Solar Architecture and Earthships in Chapter 14

The use of sustainable design practices adds value to the interior environment. Occupants are provided with healthier interiors, such as improved indoor air quality; owners save money through energy-efficient design solutions; communities benefit from new economies. (See Design Scenario, Willson Hospice Home, at the end of this chapter.) Sustainability not only preserves the earth's resources, but it also positively affects the quality of life for the present generation and generations to come.

More info online @
www.iso.org/iso/en/iso9000-14000/understand/inbrief.html ISO's Environmental Standards
www.greenerchoices.org/eco-labels/eco-home.cfm?redirect=1 Consumers Union Guide to Environmental Labels
www.usgbc.org/DisplayPage.aspx?CategoryID=19 LEED website through the USGBC
www.asid.org/designknowledge/sustain ASID's Knowledge Center on Sustainable Design
www.idec.org/greendesign/home.html IDEC's Green Design Education Initiative

TABLE 2.5 LEED Rating System Based on LEED for New Construction

LEED Category	Possible Points
Sustainable Sites - SS	21
Water Efficiency - WE	11
Energy and Atmosphere - EA	37
Materials and Resources - MA	14
Indoor Environmental Quality - IAQ	17
Innovation in Design - ID	6
Regional Priority - RP	4

TABLE 2.6 LEED Building Certification Levels

Certification Level	Points Required
Platinum	80+
Gold	60–79
Silver	50–59
Certified	40–49

SUMMARY

Interior design affects the health, safety, and welfare of the public. Interior designers have a responsibility to create spaces that support socially responsible design solutions, embrace sustainable design philosophies, and provide for advancements in the quality of life.

Functionally, we need shelter to survive and a secure place to feel safe. Our community buildings and homes partially satisfy our need to belong. The design of these spaces helps to establish our reputation in society and defines our achievements, thereby helping to meet our self-esteem needs. It is, however, the elusive element of personal space, whether through the home or office, that helps us achieve personal growth and self-actualization (Figure 2.18).

Interior design reflects the values of society. Awareness of society's needs is seen in our appreciation of our cultural and global environments. This is directly reflected in the studies of historic preservation, multiculturalism, and sustainable design. Awareness of functional and social needs is also reflected in the study of universal design, ADA requirements, proxemics, and the sciences of anthropometrics and ergonomics. Designers' sensitivity to the needs of special user groups, such as children and the elderly, results in interiors that are universally accepted and used by all people, regardless of age and abilities.

Through the Evidence-Based Design (EBD) process, interior designers use research to form hypotheses that guide design concepts and applications. Results from EBD projects quantitatively define the value of interior design through improvements in areas such as patient healing, business efficacy, and employee satisfaction.

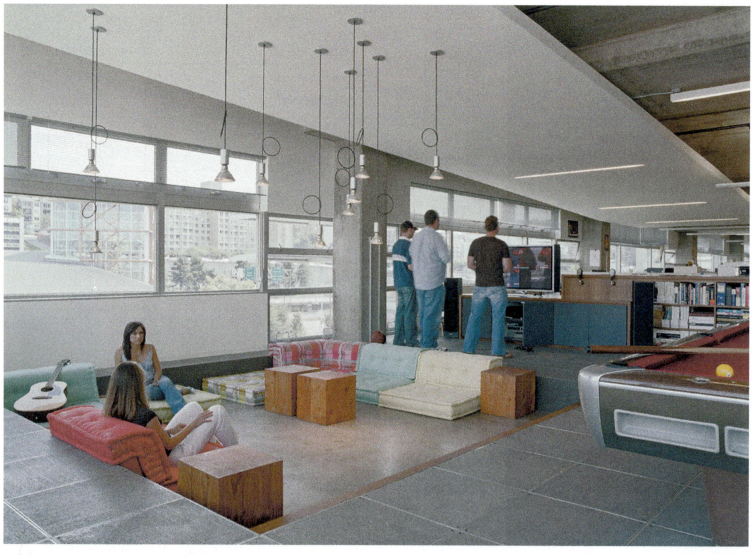

FIGURE 2.18 The design of the interior needs to reflect the corporate philosophy, as well as the needs of the employees. In this commercial space, employees require creative, flexible space to share ideas and brainstorm. The relaxed atmosphere in this informal environment is created through casual seating, playful lighting, the use of daylight, and a change in ceiling and floor planes.
(Architect/Designer: Gensler. Photography by Sherman Takata)

Interior design extends beyond the basics of function and aesthetics to include the well-being of the public. Interior designers pay attention to the human factor to bring about an awareness of and sensitivity to human needs and desires. In addition to adding *value* to the human experience, interior design accomplishes the following:

- Enriches users' quality of life
- Helps users make sense of their physical world
- Affirms the role of users' personalities and identities
- Identifies the character of communities
- Facilitates the preservation of culture

- Evokes sensitivity to diverse cultures and unique user groups
- Improves and quickens physical healing
- Advances employee productivity and contentment
- Touches the human heart
- Engages the emotion and spirit of the end user
- Honors the earth's resources through wise use
- Promotes economic sustainability

The following Design Scenario, Willson Hospice House, serves as an outstanding example of many of the values of interior design.

designSCENARIO

Willson Hospice House

A hospice center must take into account the physical needs of many special populations and be designed to meet the psychological needs of the patients as well as those of their family members and friends. Perkins+Will incorporated these characteristics into their design of the Willson Hospice House (Figure DS2.1).

The client requested a southern version of Frank Lloyd Wright buildings and a space that felt livable while ensuring that family members could be close and spend the night. The hospice serves an eleven-county area and received the support of the community. Over half of the construction budget was raised from community donations.

The 14-acre landscape plan (Figure DS2.2) includes walking areas linking a memorial garden, chapel garden, and healing garden. Administrative parking and visitor parking are removed from the view of the patient rooms. Local civic organizations and medical groups as well as the Boy Scouts use the sites and facilities.

The campus plan (Figure DS2.3) includes an administrative wing and three patient wings. The administrative wing houses fifty home care workers that assist in the eleven surrounding counties. Public meeting spaces, a library, and team work rooms round out the administrative wing. The three additional pods, or cottages, each contain areas for six patients in individual rooms, with a shared family room area appropriate for reading, dining, or visiting (Figure DS2.4). The wings also include a family kitchenette, chapel, playroom, and quiet space.

FIGURE DS2.2 Landscape plan. Fourteen acres nestled in a 200-acre site.
(Architect/Designer: Perkins+Will)

FIGURE DS2.1 Willson Hospice House Exterior, main entry into administrative wing. The building used structural steel, glu-lam timbers, and low-e glass.
(Architect/Designer: Perkins+Will. Photograph by Jim Roof Creative Photography)

Each patient room (Figure DS2.5) opens into a tranquility garden and includes a built-in window bed, providing views into the garden space and a place for family members to sleep over. Double doors to the courtyard allow patient beds to be moved outdoors. A wood millwork panel behind and over the bed conceals medical equipment and overhead exam lighting.

The building received LEED Silver status and design awards from the Environments for Aging and the Audubon Society. Willson Hospice House exemplifies the importance of health, safety, and welfare in the interior design profession. The marriage of the human experience and environmental sensitivity expressed by the design exemplifies the values of the design profession.

FIGURE DS2.3 Campus plan. Includes an administrative wing and three pods referred to as cottages by the designers.
(Architect/Designer: Perkins+Will)

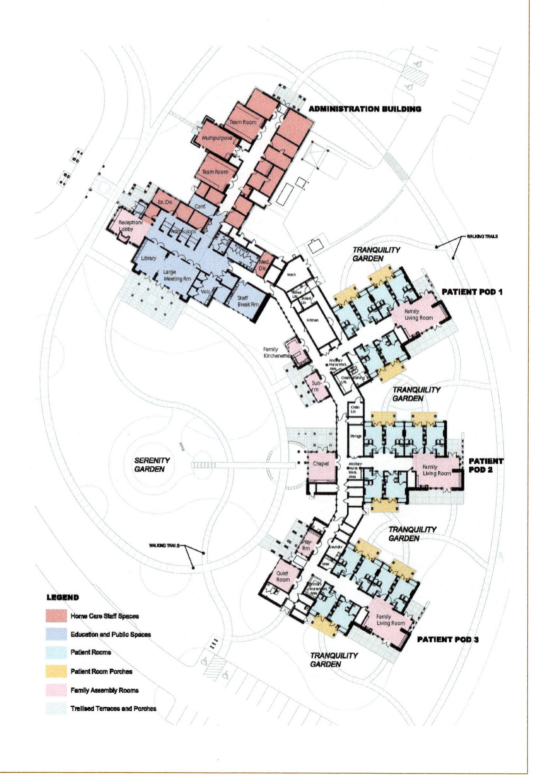

LEGEND
- Home Care Staff Spaces
- Education and Public Spaces
- Patient Rooms
- Patient Room Porches
- Family Assembly Rooms
- Trellised Terraces and Porches

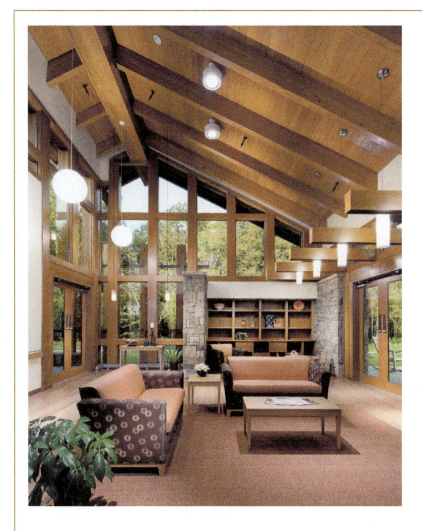

FIGURE DS2.4 Family space in one of the cottages. Eco-friendly materials included bamboo flooring, wool carpeting, and antibacterial linoleum. Native Southern Pine and water-conserving features added to the LEED certification.
(Architect/Designer: Perkins+Will. Photograph by Jim Roof Creative Photography)

FIGURE DS2.5 Patient room. Warm colors, such as butterscotch and caramel, were selected for the interiors to complement the cool green and blues of the exterior. Medical equipment is concealed behind the stained birch panel located behind and above the bed.
(Architect/Designer: Perkins+Will. Photograph by Jim Roof Creative Photography)

PICTORIAL ESSAY

History of STYLE

Throughout history, the diversity of cultures has found expression in many directions, including the way people have designed and furnished their built environment. Design is shaped by many factors, including environmental, religious, and political circumstances. As these factors change, design reflects these changes while building on previous design theories and philosophies. Styles of design, therefore, reflect these social surroundings and their foundations.

The term *style* generally refers to a segment of design history that is typical of an individual, a period, or a philosophy of design. Style may also refer to a particular culture or region. Style categories are developed by historians in an attempt to organize history. In reality, however, styles do not necessarily have sharp starting and stopping points. History is fluid. Designs from one region may influence others, and therefore styles intermingle.

Having a working knowledge of these styles is essential. Such understanding deepens the interior designer's aesthetic appreciation of design and serves as a basis to foster creative energies.

Designers study styles of the past and present to enrich current interior environments. This pictorial essay briefly outlines the major styles that have had an impact on architecture and interior design. The first section, Historical Styles and Their Evolution, reviews classical design styles and how these styles have been adapted through history. The pages on the Ancient, Middle Ages, Renaissance, and Baroque eras define universal design styles based on time period classifications; the French, Chinese, Hispanic, African, Japanese, English, and American pages define styles that are more typically associated with their respective regions. The second section, Evolution of Modern Design, looks at the development of modern design and how these styles and philosophies have been applied.

Built in 1631, the Taj Mahal is a memorial to Mumtaz Mahal, wife of Emperor Shah Jaham. The dome is of white marble, and intricate tile patterns are used throughout the structure. Taj Mahal translates to "Crown Palace."
(Shutterstock)

More info online @
www.greatbuildings.com General website of world buildings
www.washington.edu/ark2 University of Washington database of over 5,000 buildings worldwide
www.greatbuildings.com Website of images of historical significant buildings

Historical Styles and THEIR EVOLUTION

Interior design and decoration dates back to the Upper Paleolithic era (30,000–10,000 B.C.). Drawings found in caves in Spain and France show evidence of wall decorations using grouping and spacing concepts as well as a limited understanding of perspective. Sculpted figures of stone, ivory, and clay depicted the human form and often included enlarged reproductive organs, perhaps to influence fertility and thus the continuation of the species. These drawings and artifacts represent the following important concepts:

1. Creative expression is instinctive.
2. The art of interior design dates from early humankind and serves as an integral part of the human psyche.

Design evolved rapidly through the last several millenia. The Egyptians (circa 3000 B.C.), with their sophisticated art and architecture, made a lasting contribution to the interior design field.

Egyptian (4500–330 B.C.) • ANCIENT

- Known for their pyramids built as tombs for kings and pharaohs.
- Developed **trabeated construction**, in which vertical posts support a horizontal lintel.
- Used **hieroglyphics** (a system of writing using pictorial symbols) inscribed on walls.
- Columns, perhaps originally made from papyrus reeds lashed together, created vertical lines, which led to **fluting** on columns in later designs.
- Utilized the mortise-and-tenon joint in their furniture.
- Used straw for flooring; therefore, furniture was raised on small blocks so animal-shape legs could be seen.
- Motifs included the lotus bud, reeds, papyrus, and lilies.

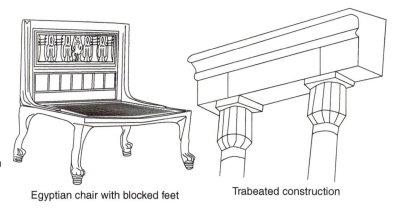

Egyptian chair with blocked feet

Trabeated construction

Greek (3000 B.C.–A.D. 150) • ANCIENT

The Parthenon is located on the Acropolis in Athens, Greece. Completed in 438 B.C., the building was dedicated to the goddess Athena. Doric columns form a portico around the building.
(Adam Crowley)

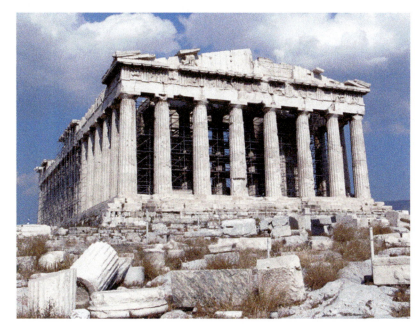

- Known for their order, proportion, and refinement of design.
- Built temples to honor their gods, surrounded by open porticos (porches) and columns.
- Developed the **truss system**, a triangulated load-bearing construction that allows for sloped roofs. The triangle formed by the truss is called a **pediment**.
- Developed a system of naming the design and details of columns. These classical orders of architecture, still used today, include the Doric (plain square capital on top of column), Ionic (capital with spiral design called a volute), and Corinthian (capital with two rows of acanthus leaves).
- Mastered the art of carving marble into a human form. When used for support, the female human form is called a **caryatid**.
- Developed the klismos chair.

Pediment

Fret

Klismos chair

Acanthus leaf

Doric

Ionic

Corinthian

ANCIENT • Roman (750 B.C.–A.D. 400)

- Known for their engineering expertise, particularly the development of roads and aqueducts.
- Adapted Greek designs.
- Vitruvius, a Roman architect, developed standard sizes and dimensions for the architectural orders (columns).
- Added two classical orders, the Tuscan (similar to Doric, but without column fluting) and Composite (capital combines acanthus leaves and volutes).
- Developed the concrete arch, barrel vault, and dome.
- Developed **pilasters** (columns partially embedded in the walls).
- Motifs included dolphins, eagles, ribbons, swans, and **grotesques** (fanciful human/animal forms).

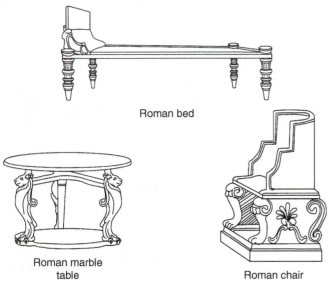

Roman bed

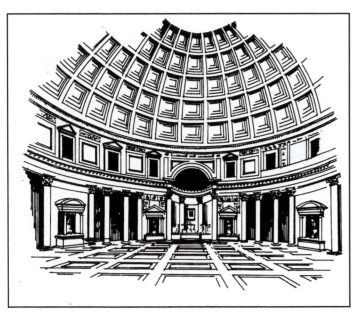

Roman marble table

Roman chair

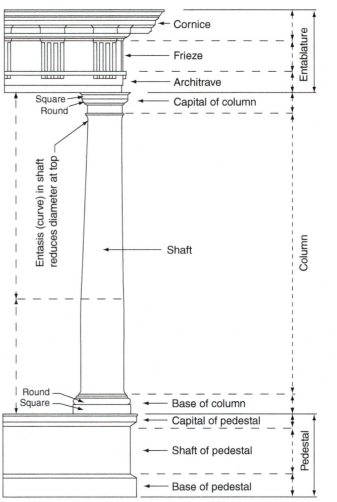

The parts of the Tuscan order as defined by Vitruvius.

Tuscan Composite

Interior of the Pantheon, Rome

(325–1500) • MIDDLE AGES

- Designs dominated by religion, particularly Christianity.
- Four general divisions:
 1. Early Christian era (325–800): characterized by the development of the basilica church plan, rectangular, with side aisles, and with **clerestory** windows lighting the central space.
 2. Byzantine era (330–1450): church still the dominant building, with domed structures and elaborate mosaic designs.
 3. Romanesque era (Norman in the British Isles) (800–1150): massive stone structures, including churches, monasteries, and castles, with round arches and heavy columns.
 4. Gothic era (1150–1500): architectural features commonly associated with ecclesiastical design include the pointed arch and vault, tracery, slender columns in clusters, and buttresses or flying buttresses.

Early rose window

Linenfold motif

Gothic church plan

The cathedral in Chartres, France, with its large stained-glass windows and soaring interior space, is considered an outstanding example of Gothic architecture.
(Photograph by Martial Colomb from PhotoDisc)

(1400–1660) • RENAISSANCE

- Means "rebirth."
- Major influence came from Italy (1400–1580), although it spread throughout Europe.
- Rejected Middle Ages design and returned to classic design motifs.
- Included work by Andrea Palladio, Michelangelo, and Leonardo da Vinci.

Plan, Villa Rotonda

Cassone

Cassapanca

Savonarola chair

The Villa Rotonda (1550) was designed by Andrea Palladio, who helped promote the rebirth of classic style.
(Alinari/Art Resource)

BAROQUE • (1600–1715)

- Means "misshapen pearl."
- Major influence came from Italy and France.
- Ornate, asymmetrical designs.
- Flamboyant and heavy proportions.

Baroque chair

St. Peter's in Rome was designed and built under the direction of a series of architects, including Donato Bramante and Michelangelo. The original design reflects the Italian Renaissance. In the interior, seen above, the immense altar canopy, designed by Gianlorenzo Bernini, incorporates Baroque characteristics. *(Alinari/Art Resource)*

Built during the reign of Louis XIV, Versailles became an immense complex of buildings housing 10,000 people. The designers included the painter Charles LeBrun and the architects Louis LeVau and, later, Jules Hardouin-Mansart. Bernini was also consulted. André LeNôtre's design for the surrounding landscape became a prototype for future town planning. *(Photodisc)*

Rococo—Louis XV (1715–1774) • FRENCH STYLES

- Coincides with the reign of Louis XV.
- Means "rock and shells."
- Related to interiors more than to architecture.
- Flowing, feminine design with delicate decorative details and free-form curves.
- Pastel colors.
- Gilded, painted, or **chinoiserie** lacquered surfaces on furniture (see Chinese styles).
- Chinese influence introduced by Madame de Pompadour.
- Motifs included fret designs, and Chinese influences such as exotic flowers, birds, pagodas, monkeys, and mandarins (officials at the royal court).

Fauteuil

Console
and mirror

Alcove bed

Tête-à-tête

Cabriole legs

Commode

Neoclassic—Louis XVI (1760–1789) • FRENCH STYLES

- Coincides with the reign of Louis XVI and Marie Antoinette.
- Similar to Rococo, but focused on straight lines, rectangular forms, and symmetrical balance.
- Motifs and designs influenced by the discovery of Pompeii, an ancient Greco-Roman resort city in southern Italy, which had been buried by the eruption of Mt. Vesuvius in A.D. 79.

Reeded legs

Bouillotte

Fauteuil

Bergère

Chaise longue

Ormolu

FRENCH STYLES • Empire (1804–1815)

- Coincides with the reign of Napoleon.
- Characterized by the return of classic Greek, Roman, and Egyptian designs.
- Massive, asymmetrical designs.

Console with
Egyptian heads

Table support

Psyche mirror

Fauteuil

French Empire bed

Lion's paw
foot

Bergère

X-stool

FRENCH STYLES • Provincial (18th century–present)

- Designs for lesser nobility and merchants.
- Copied or adapted Rococo and Neoclassic designs in simpler, unadorned styles.

Stool

Hutch

Salamander back

Open armchair

Wing chair

Long, narrow table

CHINESE STYLES

- Upswung roof is the distinguishing architectural feature.
- Greatly influenced French Rococo and Neoclassical styles.
- Furniture characterized by chinoiserie surfaces.
- Motifs of monkeys, pagodas, and mandarins (officials at the royal court).

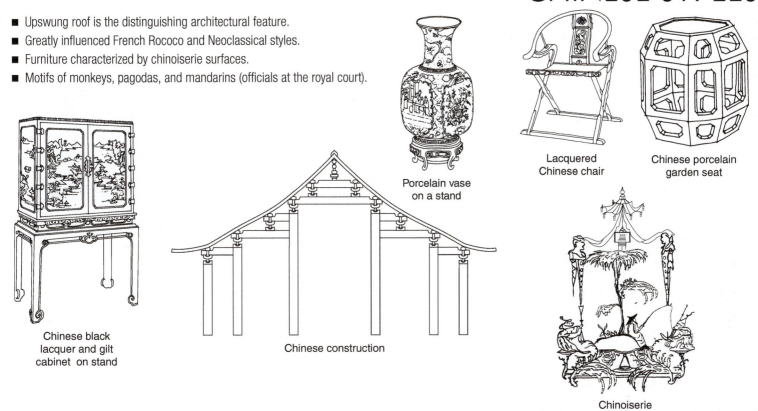

Porcelain vase
on a stand

Lacquered
Chinese chair

Chinese porcelain
garden seat

Chinese black
lacquer and gilt
cabinet on stand

Chinese construction

Chinoiserie
motif

1200–Present • # HISPANIC STYLES

- Similar to Italian Renaissance but also included Moorish influence (1200–1600).
- Moorish interiors were highly decorated and used the horseshoe arch.
- Colored marbles, geometric patterns, tiled walls, and **wrought iron** (worked iron).
- Carved wood doors, window shutters, and ceilings called **artesonado**.
- Influence in America called Colonial/Mission style.

Vargueno

Spanish foot

Paneled door

Moorish arch

Ladderback

Shepherd's
chair

Trestle table

AFRICAN STYLES • 1000–Present

- Architecture and design influenced by religion.
- Art used to resolve conflicts, to educate, and to symbolize worship.
- Rich in visual literacy. Patterns contain cultural meanings.
- The chair or stool is a very personal item—historically carried with the individual and not shared with others.
- Extensive use of geometric patterns and inlays of ebony and ivory.

Zaire round home

Great Mosque, Djenne (built 1906–1909)

Dinka people's stool, Sudan

Zaire wood stool attributed to the Kusu tribe. (Courtesy of the Noel Collection at the Tubman African American Museum, Macon, Georgia.)

(Courtesy of the Noel Collection at the Tubman African American Museum, Macon, Georgia)

JAPANESE STYLES • Ancient to Present

- Emphasized simplicity, horizontal line, and nonformal balance.
- Rooms arranged around **tatami mats** measuring 3' × 6'.
- **Fusuma screens** made of translucent materials used to separate rooms.
- **Shoji** doors or screens of translucent materials used at windows and sometimes as room dividers.
- **Tokonoma** is an alcove containing a special item on display.
- Architecture thought of as an art form, which influenced Wright, Mackintosh, the Greene brothers, and Godwin, among others in Modern Design.

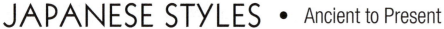

Wood armchair

Rattan armchair

Coromandel screen

Chest with brass fret hardware and "monkey paw" leg

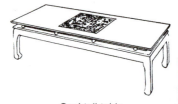

Cocktail table "monkey paw" leg

Black lacquered fret design couch

Japanese house

"Elephant leg" low table

Tudor, Elizabethan, and Jacobean (circa 1440–1700s) • ENGLISH STYLES

- Dominated by heavy, masculine designs.
- Architecture characterized by **half-timber construction** (timbers are visible on the outside of the building) and oriel windows (projecting bay windows).
- Interiors characterized by plain, plastered walls or ornately carved panels.
- Furniture frequently made of oak.
- Elizabethan furniture had bulbous (melonlike) legs.
- Jacobean furniture had turned legs.

Jacobean daybed

Jacobean wainscot chair

Tudor arch

Linenfold motif

Paneled hall

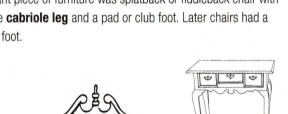

Tudor half-timber

1612 1656
Chair legs

Early Georgian with Queen Anne Furniture (1700–1745) • ENGLISH STYLES

- Prominent architects included Inigo Jones and Sir Christopher Wren.
- Symmetrical designs exhibited dignity and formality, reflecting classic Greek and Roman architecture.
- Queen Anne furniture based on cyma (S) curve.
- Most significant piece of furniture was splatback or fiddleback chair with an animal-like **cabriole leg** and a pad or club foot. Later chairs had a ball and claw foot.

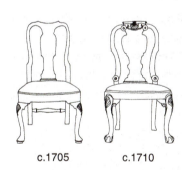

Highboy

c.1705 c.1710

Tall case clock

Finial

Lowboy

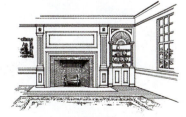

Cupola on roof

Shell cupboard

Wren Georgian

ENGLISH STYLES • Middle Georgian - Chippendale Furniture (1745–1770)

Gothic influence

Ladderback

Gothic back

Chinese
Chippendale

Ribband back

Marlborough
(left)

Claw and ball
cabriole leg

Goddard
foot

Camelback sofa

- Architecture still influenced by Wren.
- Golden Age of great cabinetmakers, including Thomas Chippendale.
- Chippendale wrote *The Gentleman and Cabinet-Makers Director* (1754).
- Chippendale chairs distinguished by yokebacks with Chinese, Queen Anne, Gothic, French, and Neoclassic influences.

Pie-crust
table

Breakfront

An American adaptation of Georgian design is seen in the Port Royal Parlor at the Winterthur Museum. Georgian features included Chippendale furniture with a few Queen Anne pieces, typical wood floors with Oriental rugs, dadoes, cornices with dentil trim, and a chimneypiece with the broken pediment design. *(Courtesy, Winterthur Museum)*

- Architecture influenced by Roman Palladian style; even more formal.
- Coincided with French Neoclassic style and the discovery of Pompeii.
- Robert Adam and his four sons designed classical interiors. Known for their sideboard designs. Utilized **paterae** (oval-shape decorations).
- George Hepplewhite designed furniture with straight, square, tapered legs usually terminating with a spade foot. Known for his shield and heart-shape chair backs.
- Thomas Sheraton designed furniture with straight lines and classical motifs such as urns, festoons, and scrolls.

Longfellow House (1750), Cambridge, Massachusetts. Its classical detail with the triangular-topped pavilion reveals Gibbs's Palladianism.
(Courtesy of National Park Service, Longfellow House – Washington's Headquarters National Historic Site)

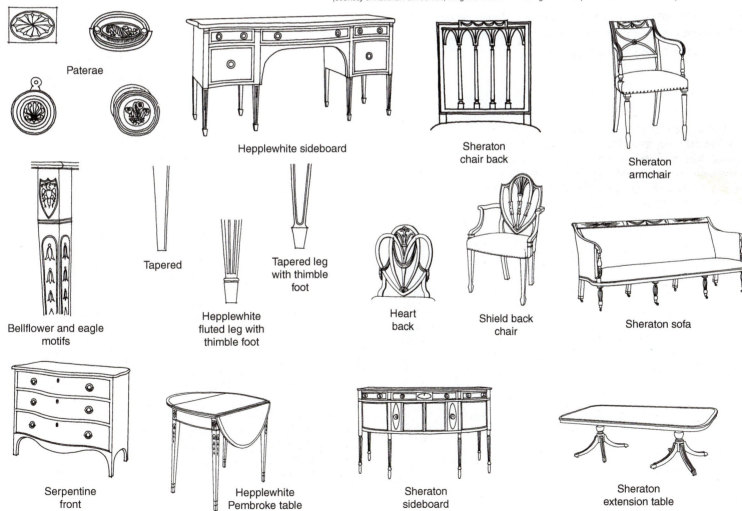

Paterae

Hepplewhite sideboard

Sheraton chair back

Sheraton armchair

Bellflower and eagle motifs

Tapered

Hepplewhite fluted leg with thimble foot

Tapered leg with thimble foot

Heart back

Shield back chair

Sheraton sofa

Serpentine front

Hepplewhite Pembroke table

Sheraton sideboard

Sheraton extension table

AMERICAN STYLES • Colonial American (1600–1700)

- Influenced by Dutch, German, Swedish, English, French, and Hispanic styles.
- Most common architectural styles true to American designs included the following:
 1. Saltbox: front rooms with a lean-to on the back.
 2. Garrison (jetty): second floor extends over the first floor, creating a **jetty**.
 3. Gambrel: a house with a double-pitched roof creating more headroom in the attic.
 4. Cape Cod: a house covered in wood with a sloped roof, central chimney, small paned windows, and plank door. Later features included dormers, Georgian details, and double-hung (sash) windows.

Saltbox

Garrison or jetty

Dormer

Gambrel

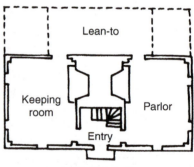

Cape Cod

Half-house—1650

Two-room or double house—1675

Lean-to

Keeping room

Parlor

Entry

Lean-to or saltbox

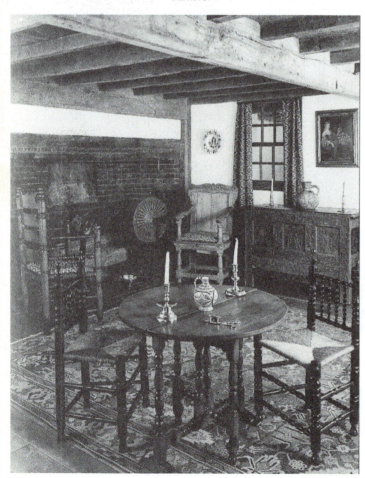

The Oyster Bay Room at the Winterthur Museum reflects a typical seventeenth-century interior: wood plank floors with an Oriental rug, plaster walls, a low-beamed ceiling, a large fireplace, and simple wood furniture.
(Courtesy, Winterthur Museum)

Colonial American (1600–1700) •

- Most common Early American interiors included Tudor, Elizabethan, Jacobean, and Spanish Mission/Colonial style influences.
- In southwest America, furniture designs were called the Santa Fe style and incorporated bold colors and geometric forms.

Adobe house

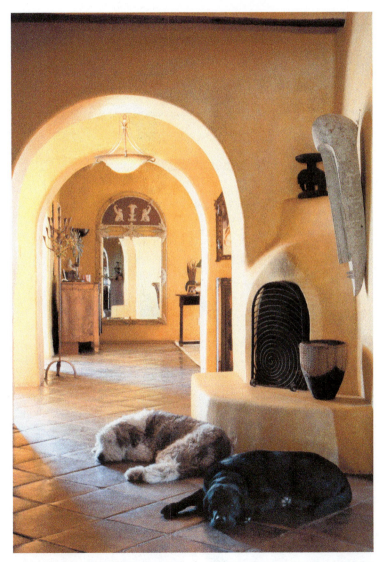

A contemporary adaptation reflecting the Santa Fe style features a corner adobe (or kiva) fireplace, white textured walls, and cool tiled floors.
(© BUILT Images / Alamy)

Bannister back

Carver

Brewster

Equipale leather and wood chair

Windsor

Hitchcock

Lodge pole pine chair

Corbel bracket

Zapata (double corbel bracket)

Indian pottery

Indian basket and wool rug

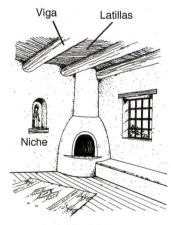

Viga Latillas

Niche

Adobe interior

AMERICAN STYLES • Colonial Georgian (1700–1790)

- Greatly influenced by English Georgian styles with variations in wood usage, specific ornamentation, and proportions.

Wingback armchair

Desk

Martha Washington chair

Mirror

Grandfather clock

AMERICAN STYLES • Neoclassic (1790–1845)

- Several distinctive designs including Federal, Greek Revival, Duncan Phyfe furniture, and Empire furniture.
- Federal design emphasized Greek and Roman design, rejecting English influence. Thomas Jefferson was an advocate.
- Greek Revival architecture was particularly prominent in the South for plantation homes. Greatly influenced by early Greek designs.
- Duncan Phyfe furniture was characterized by fine proportions and simple lines.
- Empire furniture was bold and monumental.
- Industrial Revolution (circa 1830s–1900) brought about machine-made, mass-produced furnishings and a decline in the fine art of furniture making.

Duncan Phyfe sofa with cornucopia legs

Greek Revival carved sofa

Greek Revival gondola chair

American Empire pier table

Curule form chair

Girandole mirror (Bull's eye)

Monticello, home of Thomas Jefferson, was completed in 1809 in Charlottesville, Virginia. The Early Classic revival style was promoted as a "national" style by Jefferson. It reflects the Federal-Roman influence.
(Photodisc / Izzy Schwartz)

This parlor reflects the designs from the Greek Revival and Empire periods.
(Courtesy, Winterthur Museum)

A contemporary Greek Revival interior designed by Robert Metzger is reminiscent of this early nineteenth-century style, including the use of gold and blue, a patterned rug, torchères, and asymmetrical couches with the distinctive lion's paw foot.
(Antique architectural Aubusson courtesy of F. J. Hakimian, Inc., N.Y., and Robert Metzger Interiors. Photograph by Phillip Ennis)

Farmers Hall, completed in 1826, in Pendleton, South Carolina, is an excellent example of Greek Revival architecture.
(Courtesy of Lynn M. Jones.)

Historical Styles Summary

In the study of the history of design, a significant break in design occurs with the Industrial Revolution. The fine art of furniture making is overshadowed by the ease of mass-producing machine-made furniture. For this reason, the historical/classic eras end in the 1830s, completing another era of cyclical design.

The cyclical nature of design is seen in the shift from the clarity of the Egyptian and early Greek designs to the eventual heavy embellishment of the more ornate Roman designs. The cycle was repeated in the early simple English Queen Anne style that led to the Georgian and Federal styles, which eventually led to the heavy, ornate furniture of the Empire era. It is the nature of design to start with the purest and cleanest forms and then to embellish those forms again and again until the next generation must once more break free (or "rebirth") to new classics. The following section begins with yet another heavily decorated era, that of the Victorian period. From this ornately decorated style, designers once again rebelled against elaborate motifs and designs, and architecture and interior design evolved into the Modern era.

Evolution of Modern Design

The roots of modernism are primarily traced to the Industrial Revolution, a period that continued from the early 1800s until the early twentieth century. This era introduced machines for manufacturing furniture and other modern conveniences, changing the way people lived. Advancements in technology and the development of new materials led to extraordinary architectural innovations. For example, iron grid construction allowed the architect to enclose vast spaces for railroad stations, exhibition halls, libraries, stock exchanges, theaters, and other public buildings.

The first World's Fair and Exhibition, in London in 1851, is a fundamental starting point for modern designs. The Fair's Crystal Palace, designed by Joseph Paxton, was over 1,600 feet long and resulted from technical advances in the use of glass and iron. The Exhibition served as a transition between historic and modern design, for although the structure and modern machines housed within spoke to the twentieth century, the furnishings and architectural details produced by the machines were rooted in the past.

(circa 1840–1920) • VICTORIAN ERA

Queen Anne

- Coincided with the reign of Queen Victoria.
- Nostalgia for past styles prevailed with machinery producing intricate designs, details, and carvings referred to as gingerbread.
- Four major architectural styles in America included the following:
 1. Gothic Revival: Andrew Jackson Downing was the primary proponent.
 2. Italianate: modified Italian villa.
 3. Mansard or Second Empire: style delineated by sloping mansard roof defining the top floor.
 4. Queen Anne: most whimsical of all Victorian-era eclectic styles (not related to Queen Anne furniture styles previously discussed).
- Other Victorian styles included Exotic Revivals, Octagonal, Stick, Shingle, and Romanesque.
- Interiors were profusely decorated with patterned wallpaper, fabrics, and rugs.
- Elaborate furnishings were adapted from the French Rococo, Neoclassic, Gothic, Renaissance, Oriental, and Elizabethan/Jacobean eras.
- Prominent designers included John Belter (who developed a wood-laminating technique that allowed for ornate rosewood carvings) and Charles Eastlake.

Mansard Victorian

Italianate Victorian

Tete-a-tete

Carpenter Gothic

Belter carved
rosewood sofa

Eastlake
chair

A contemporary Victorian interior, designed by Michael R. LaRocca, demonstrates the eclectic look. Tudor, Moorish, French, and Greek Revival are the principal styles employed. The patterned rug and numerous accessories further convey the Victorian feeling.
(Antique French needlepoint courtesy of F. J. Hakimian, Inc., N.Y., and Michael R. LaRocca, Ltd. Photograph by Phillip Ennis)

Pictorial Essay ■ 73

TRADITIONAL REVIVALS • (circa 1880–1920)

- Revival of Old World styles.
- World-famous design school L'École des Beaux Arts in Paris promoted these styles.
- Opulent designs by Richard Morris Hunt and McKim, Mead & White (architectural firm).
- Included Beaux Arts, Châteauesque, Georgian Revival, Spanish Colonial, Neoclassical, Tudor, Colonial Revival, French Eclectic, and Italian Renaissance.

This Beaux Arts–style residence in Atlanta, Georgia, was designed by Neil Reed and built in 1911. The residence is in the historic Druid Hills district designed by the great landscape architect Frederick Law Olmstead.
(Photo by Lynn M. Jones)

Biltmore House (1888–1895), the Châteauesque mansion built by architect Richard Morris Hunt for George W. Vanderbilt and patterned after a French Renaissance château.
(Photo by Lynn M. Jones)

Construction of this United States Post Office in Fernandina Beach, Florida, was completed in 1912. It is in the Italian Renaissance Revival style.
(Photo by Lynn M. Jones)

EARLY MODERNISM

- Coincided with the Victorian era and Traditional Revivals.
- Pioneering designers rebelled against historical eclecticism.
- Utilized technological advances in iron frame construction, laminated wood, and plate glass windows.
- Bridged art and technology.
- Earliest designs came from the Shakers, a religious order that believed beauty resides in utility and simplicity.
- Austrian designer Michael Thonet (1830–1870s) developed a process for bending wood into gentle curves.
- Thonet's designs are still used today, including the famous bentwood rocker and café chair.

Bentwood rocker
Michael Thonet

Vienna café chair
Michael Thonet

Arts and Crafts Movement (1860s–1920s) • EARLY MODERNISM

The Gamble House designed by the Greene Brothers in Pasadena, California, remains the finest example of their craftsman approach to architecture.
(Courtesy of the Gamble House. Photograph by Alexander Vertikoff)

- Revolted against machine-made products.
- Advocated handcrafted furnishings.
- Prominent English architects and designers included William Morris, Charles Eastlake, Edward W. Godwin, Philip Webb, Ernest Gimson, and Charles F. A. Voysey.
- Prominent American architects and designers included Gustav Stickley, Frank Lloyd Wright, Henry Hobson Richardson, and Charles and Henry Greene.
- Greene brothers developed the bungalow.

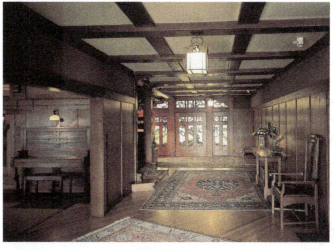

This interior view of the Gamble House reveals exquisitely handcrafted wooden architectural members and handcrafted furnishings.
(Photograph by Tim Street-Porter)

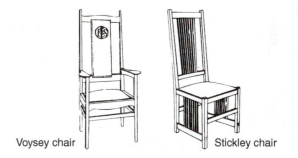

Voysey chair Stickley chair

Skyscrapers (1880s–1920s) • EARLY MODERNISM

- Although the first metal frame buildings were in New York, the skyscraper is credited to Chicago architects.
- Louis Sullivan, father of the skyscraper, is credited with coining the phrase "Form follows function."
- Many skyscrapers reflect the three parts of a column: the base, the shaft, and the capital.

The Home Insurance Company Building (1883–1885), Chicago, by William LeBaron Jenney, was the first fully steel-frame building. Jenney studied in Paris at L'École Centrale des Arts et Manufactures. Unfortunately, the building was demolished in 1931.
(Chicago History Museum)

EARLY MODERNISM • Art Nouveau (circa 1890–1910)

- Style based on nature, employing organic flowing forms.
- Prominent proponents included Victor Horta, Henri van de Velde, Hector Guimard, and Antonio Gaudi.
- Called *Jugendstil* in Austria and Germany.
- Charles Rennie Mackintosh combined aspects of Art Nouveau with strong geometric forms.
- Louis Comfort Tiffany is best known for Art Nouveau stained-glass designs.

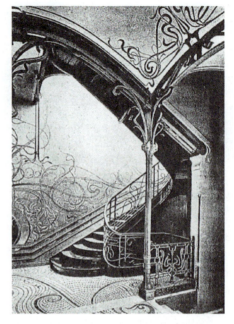

Art Nouveau chair
Hector Guimard

Art Nouveau chair
Antonio Gaudi

Argyle chair
C.R. Mackintosh

The Tassel House (1892–1893) in Brussels, Belgium, is one of Victor Horta's best-known townhouses and one of the earliest private residences designed in the Art Nouveau style. Swirling organic forms decorate the entry. The graceful stair railings and supports are fashioned in iron.
(Art Resource/The Museum of Modern Art)

MODERN STYLES • Organic Architecture (circa 1894–Present)

- Characterized by a building that appears to "grow out of the land."
- Greatest proponent was Frank Lloyd Wright.
- Wright developed the *prairie-style* house (as seen in Figure 1.3).

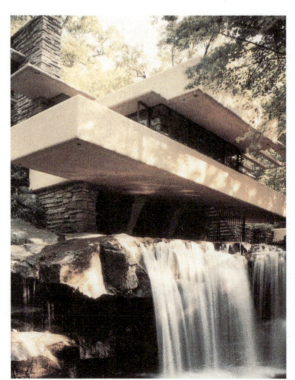

Frank Lloyd Wright's modern residential design, Fallingwater (1936), in Mill Run, Pennsylvania, was built over a waterfall. It demonstrates the architect's philosophy: "A house should grow out of the land."
(Courtesy of Western Pennsylvania Conservancy)

- Style based on functionalism and purity of line.
- Term coined by American architect Philip Johnson.
- Common materials included reinforced concrete, stucco, steel, and glass.
- Stark white finishes.
- Open floor plan and large expanses of glass.
- International design movements leading to the fully developed style included the following:

 1. The Secession—an artistic movement in Austria led by Otto Wagner, Adolf Loos, and Josef Hoffmann. Hoffmann also led the Wiener Werkstätte (studio), a more geometric offshoot.

 2. De Stijl—a movement in Holland that reduced design to its basic elements, including the use of only red, blue, yellow, black, gray, and white. Most famous proponent was Gerrit Reitveld.

 3. Bauhaus—an experimental design school in Germany formed to simplify design to its purest state, incorporating machine-age manufacturing. The school was closed by the Nazis in 1933, and designers fled to America. Most famous proponents included Walter Gropius, Marcel Breuer, and Ludwig Mies van der Rohe. Mies coined the phrase "Less is more."

 4. Le Corbusier (Charles-Edouard Jeanneret-Gris)—a giant of modern architecture; studio was in Paris. Designed the Villa Savoye, the chapel at Ronchamp, and classic furniture pieces.

Prague chair
Josef Hoffmann

Fiedermaus chair
Josef Hoffmann

Haus Koller chair
Josef Hoffmann

Secession stool
Otto Wagner

One of the finest examples of furniture from De Stijl is the Red/Blue chair (1918), designed in Holland by Gerrit Reitveld. It is constructed of wood in an abstract arrangement and painted red, blue, yellow, and black.
(Courtesy of Cassina USA Inc.)

Zig-Zag chair
Gerrit Reitveld

Barcelona chair
Mies van der Rohe

Grand Confort chair
Le Corbusier

Classic Bauhaus furniture designed by master architect and furniture designer Marcel Breuer. From left to right, the Cesca chairs, Laccio table, and Wassily lounge, designed by Breuer while he taught at the Bauhaus. The Isokon lounge, far right, was designed in 1935 in England.
(Courtesy of Knoll)

MODERN STYLES •

The Villa Savoye, designed by Le Corbusier, comprises three floors. The main living level is on the second floor, which opens to a terrace and the third-floor roof garden. Le Corbusier wrote, "The house is a machine to live in."
(© Bildarchiv Monheim GmbH / Alamy)

Architect Philip Johnson's "Glass House" in New Canaan, Connecticut (1949), with glass walls and Barcelona furniture by Ludwig Mies van der Rohe. Johnson was an early follower of Mies van der Rohe.
(Source: AP WideWorld Photos)

Art Deco (circa 1909–1940) • MODERN STYLES

- Decorative style advocating strong geometric forms including the pyramid, ziggurat (stepped pyramid), zigzag, and sunburst.
- Inspired by the glamour of movies and stage, jazz music, African art, and new technology.
- Prominent designers included Paul Frankl and Donald Deskey.
- Eliel Saarinen, a Finnish-born designer, started the prestigious Cranbrook Academy in Michigan.

Paul Frankl helped promote modern American furniture during the 1920s and 1930s and was inspired in his own approach to furniture design by the uniquely American skyscraper—an Art Deco theme he employed for numerous pieces.

Eliel Saarinen designed the Blue Chair in 1929, at the Cranbrook Academy of Art. The Art Deco piece has a blue lacquered frame accented with gold leaf.
(Courtesy of ICF)

Post–World War II (1950s–1970s) • MODERN STYLES

- New architectural directions emerge.
- New technologies included air-conditioning, suspended ceilings, synthetic fibers, and plastics.
- Scandinavian designers included Alvar Aalto, Eero Aarnio, and Hans Wegner.
- Italian designers in particular exploited the use of plastics; designers included Joe Columbo and Vico Magistretti.
- American designers included the following:
 1. Charles and Ray Eames—pioneered chairs constructed of molded plywood and fiberglass.
 2. Eero Saarinen—came to the United States with his father Eliel; known for his womb and tulip chairs.
 3. Buckminster Fuller—known for his geodesic domes.
- Brutalism develops as a reaction to the International style. Massive sculptural structures of raw concrete were designed by noted architects such as Paul Rudolph and Louis Kahn.

"The Chair"
Hans Wegner
Scandinavia

Peacock chair
Hans Wegner
Scandinavia

Palmio (Scroll) chair
Alvar Aalto

Finnish designer Alvar Aalto designed the cantilevered Pension chair in 1946 using laminated birch with a seat and back of webbing. The birch table is also by Aalto. They are excellent examples of Scandinavian modern furniture design.
(Artek Oy Ab)

MODERN STYLES • Post–World War II (1950s–1970s) (continued)

Eames lounge
Charles Eames, U.S.A.

Tulip/pedestal chair
Eero Saarinen
U.S.A.

The spherelike U.S. Pavilion at the Montreal World's Fair Expo '67, designed by Buckminster Fuller, is a good example of the architect's patented method of construction known as the geodesic dome.
(© M&N / Alamy)

MODERN STYLES • Postmodernism (1960s–Present)

- The style borrows from the past but in extremely contemporary terms.
- Major proponents include Michael Graves, Robert Venturi, Robert Stern, and Philip Johnson.
- Furniture styles include the Craft Revival, Art Furniture, Ergonomic Furniture, and most recently furniture to meet the needs of a mobile workforce.
- Other design trends during the Postmodern era are generally divided into four categories:
 1. High-Tech Style—utilizes exposed industrial and construction elements; started by the Eameses.
 2. Memphis Style—advocates freedom of expression in style, color, and form.
 3. Classic Modernism—advocates classical, simplified elegance; influenced by ancient Greek designs.
 4. Deconstructivism—an extreme reaction to the negative aspects of current society; leading proponent is Frank O. Gehry.

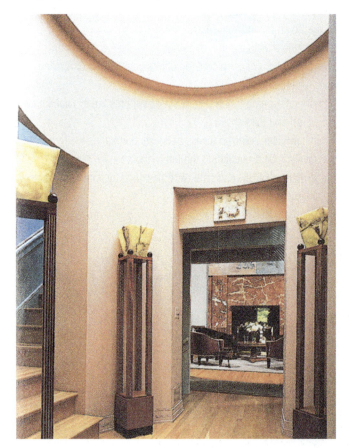

Michael Graves designed this Postmodern residence in New Jersey in 1986. In the entry, tall lighting fixtures are capped with Egyptian-like capitals. In the living room beyond, the fireplace wall dominates the space. See Figure 5.37.
(Photograph by William Taylor)

Dakota Jackson has designed many detailed functional pieces of furniture, including his Calliope Chaise (1995). (Also see Figure 11.22.)
(Courtesy of and design by Dakota Jackson)

Horses bench
Judy K. Mckie
Craft Revival

Graves chair
Postmodern

Venturi chair
Postmodern

Grande Flute
Angelo Donghia
Classic Modern

Queen Anne, Queen Anne
Terence & Laura Main
Art Furniture

Louis Ghost chair
Philippe Stark
More info at www.starck.com
(Courtesy of S+ARCK NETWORK)

Seconda chair
Marlo Botta
Italy

This Memphis style sofa upholstered in bright-colored fabrics was created by Austrian-born Italian designer Ettore Sottsass. The style advocates freedom of expression, especially when combining color and form.
(© Elizabeth Whiting & Associates / Alamy)

Completed in late 1997, the Guggenheim Bilbao in Spain was designed by Frank Gehry. The fragmented volumes and curved forms are covered with titanium. A central axis and curved interior forms reflect the influence of the Guggenheim Museum in New York by Frank Lloyd Wright.
(© Eric Vandeville)

MODERN DESIGN SUMMARY

Historians find it difficult to define what will be considered classic 100 years from now. Current design trends may be remembered only as passing fads, or they may start a definitive movement in history. Note that once again design seems to have reached the end of a cycle. Whereas design was formerly clean, crisp, and uncomplicated (as promoted by organic architecture and the Bauhaus purism), the current images of the avant-garde Memphis-style expression, the reinventing of the classic Queen Anne chair in style and color, and the radical nature of Deconstructivism suggest that the next movement may be to a new cycle of simplicity.

STYLE SELECTION

After studying these design styles, you should consider how these historical styles could be adapted and applied in current interiors. When selecting a style for a client, it is important to understand the overall feeling that the client desires. Generally, five basic style categories are used to help guide the client. These are formal traditional, formal modern, informal provincial, informal modern, and eclectic.

Formal Traditional

The term *formal traditional* refers to interior furnishings, finishes, and backgrounds from historical styles that are of the more refined or court types. Many of the traditional designs come from the eighteenth and early nineteenth centuries, an age of great prosperity during which the arts flourished in the Western world. French and English furniture styles of this period exemplify

this warmth, grace, and elegance. Some of these styles have been adapted and scaled to meet present-day requirements without losing their character (as seen in Figure 1.1). Styles appropriate for a formal traditional look include English designs (Queen Anne, Chippendale, Adam, Hepplewhite, and Sheraton), Court French (Louis XV, Louis XVI, Empire), and America's Federal.

Formal Modern

A formal modern environment can be created by employing modern furnishings, finishes, and backgrounds that are elegant and sophisticated. Art Nouveau, Art Deco, Classic Modern, and Postmodern furniture are particularly well suited for a formal setting (see Figure VI.2). Italian, Secession, Wiener Werkstätte, De Stijl, Bauhaus, and International Style furniture may be very formal and sophisticated, depending on supportive elements. Modern Oriental is often used in a formal manner.

Informal Provincial

Historically, provincial furniture was produced in rural areas. Provincial furniture used native woods and techniques that imitated finer, more expensive furnishings. The provincial interior is generally handcrafted, simple, and casual, appearing unpretentious. The look is cloistered, comfortable, and rustic; it may incorporate furniture from a number of countries as long as designs are rooted in the past and have an aura of charm and informality (see Figure 14.7). Styles most commonly employed that provide this feeling are Colonial American, Medieval English (as well as simplified Georgian), French Provincial, and Spanish. Also appropriate are Dutch, Swedish, and German furnishings.

Informal Modern

Numerous types and styles of modern furniture are available on the market, drawing principally from European, Asian, and American designers. When an informal modern setting is preferred, generally casual fabrics with a matte finish, simple materials, and unpretentious accessories are used (see Figure 7.1). Informal modern can also use fun, "funky" designs. Plastics and disposable furniture work in this style. Informal modern furniture styles particularly suitable for this direction include Scandinavian and modern furniture inspired by Japanese prototypes and the Craft Revival. Other modern styles, including Secession, De Stijl, Bauhaus and International Style, Postmodern, and Italian, can generally be designed in either an informal or formal manner, depending on the supportive treatment.

Eclectic

The **eclectic** look—which is a mixing rather than a matching one—is common; however, *eclectic* does not mean hodgepodge. Furnishings should be related in scale and chosen with a goal in mind. There should be a common theme—some element that ties the pieces together. For example, to achieve the provincial look, informality may be the key, and all country furniture, regardless of the source, is generally compatible. For a formal traditional look, dignity may be the key, and refined pieces of almost any style can be combined with pleasant results. The eclectic look often allows for more daring and imaginative interiors (see Figure 14.4).

Whatever the general theme of a room, it should not dominate and thereby create a feeling of monotony. Interest is aroused by the unexpected. For example, a pair of Victorian chairs placed in a modern setting brings something special to a room. A modern sofa gives a period room a fresh, updated look. The clean sweep of contemporary decor may serve as the most effective background for a highly prized antique. As Dorothy Draper put it, "I'll always put in one controversial item. It makes people talk."

These chairs are lit from the inside using LED lights. Designed for outdoor use, the chair merges classic design style with state-of-the-art electronics.
(Designers: Matthew Quinn and Rick Parrish. Photograph by Mali Azima)

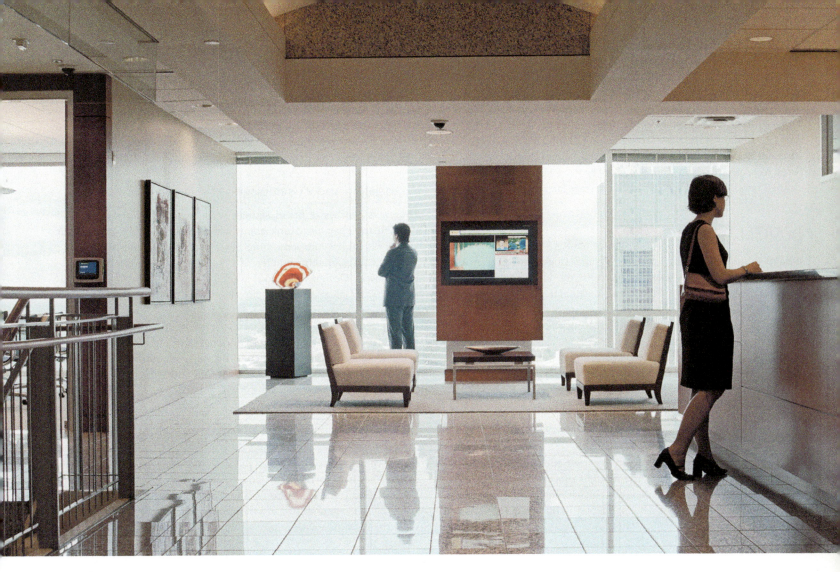

Part II

Design Fundamentals

*The desire for symmetry, for balance,
for rhythm is one of the most
inveterate of human instincts.*

—Edith Wharton and Ogden Codman, Jr,
The Decoration of Houses

CHAPTER 3
Elements and Principles of Design

CHAPTER 4
Color

FIGURE II.1 In commercial office design, a welcoming reception area is a significant factor in meeting the human expectations of clients as well as employees. In this interior, the dropped ceiling identifies the reception area and visually cues clients to stop before proceeding to the inviting waiting area beyond. *(Architect/Designer: Gensler. Photography by Sherman Takata)*

As discussed in Chapter 1, the design process is complex; however, it is the complexity that fuels designers with opportunities despite design and budget restraints. Design involves discovering the possibilities given a list of limitations. Consider the Egyptian tombs, Greek temples, Gothic cathedrals, and modern skyscrapers. Resources for these structures were limited, and designs were based on available engineering and labor of the time; yet these structures transcended their limitations to become timeless design, still studied hundreds and even thousands of years later.

DESIGN THINK!

Designers think differently; they form connections between seemingly diverse ideas. Designers mentally perceive the idea, research related concepts and theories, synthesize and document these concepts, and maintain the discipline to produce the desired result. Designers assemble the pieces of a puzzle while creating the image those pieces form—in three dimensions.

Design is a broad-based method of thinking that includes investigation and interpretation, association and assemblage, resolution and review . . . repeated. Design Think! parallels the design process with a healthy dose of creativity.

Investigation and Interpretation

The thinking process begins with an extensive education in the liberal arts forming the foundation of the thought process. Designers understand global perspectives, business and finance, and human behavior in addition to the multitude of details inherent in building materials and construction methods.

Designers know how to research—to investigate that which they do not know. They are sponges for information, seeking out innovation as well as historical facts.

Designers listen. Clients may not know what they want, or may know only what they don't want, or perhaps know what they want to be able to do with the resources they have. Designers' broad knowledge base interprets the needs of a particular problem searching for a solution.

Association and Assemblage

Designers synthesize broad sources of information. They search out parallelism. They also think about associations, forming groups that can be assembled into something new, both literally and figuratively. As Kevin McCullagh, founder of Plan (a strategic consulting company) notes, "Designers are good at 'making it real'"(www.core77.com/reactor/07.07_flux.asp). They sketch, they conceptualize, they write, and they produce.

As part of the assemblage, they experiment with a variety of potential solutions (Figure II.2). These options lead to other ideas, generating new thoughts and processes leading to diverse resolutions. Designers walk on the edge of chaos, and then find order in it.

Resolution and Review

Designers follow through. They are accustomed to meeting deadlines and completing the project, and they understand budgets. Designers review their results—the good and the bad—and seek to learn from them. They add to the knowledge base of the profession by sharing their results. Their ability to Design Think! is fueled by their level of awareness and their ability to interpret their suroundings and visually share their insights with others.

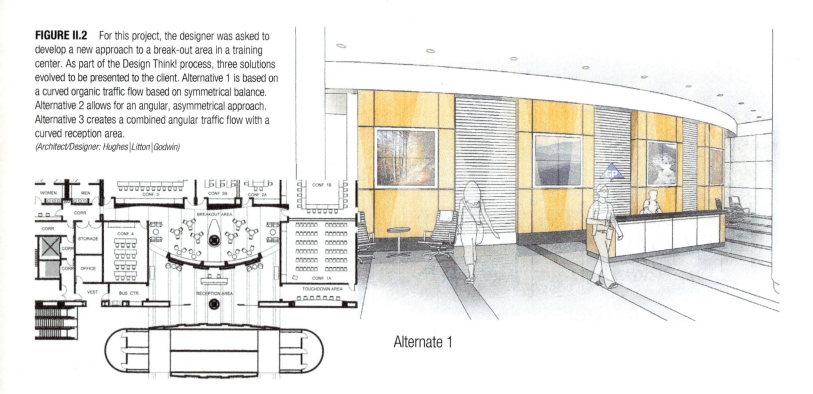

FIGURE II.2 For this project, the designer was asked to develop a new approach to a break-out area in a training center. As part of the Design Think! process, three solutions evolved to be presented to the client. Alternative 1 is based on a curved organic traffic flow based on symmetrical balance. Alternative 2 allows for an angular, asymmetrical approach. Alternative 3 creates a combined angular traffic flow with a curved reception area.
(Architect/Designer: Hughes|Litton|Godwin)

Alternate 1

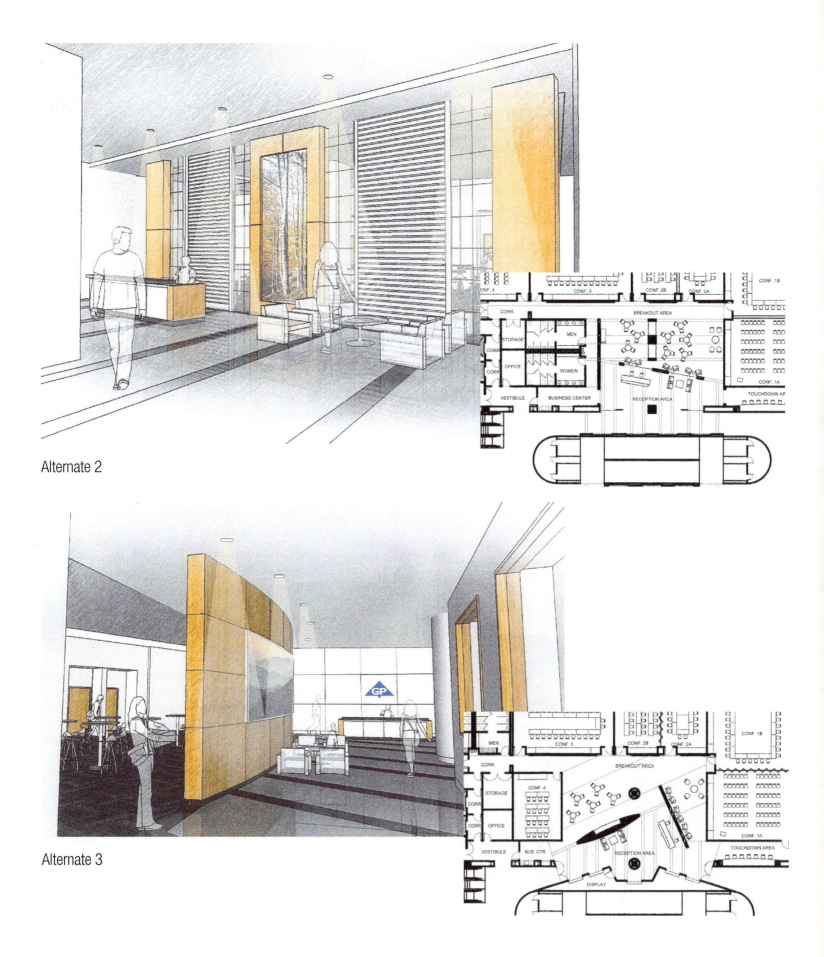

Alternate 2

Alternate 3

VISUAL LITERACY

Designers use many tools in the thinking process. The ability to read and write—or literacy—is learned within each culture. Children are taught the alphabet, spelling, appropriate grammar, and syntax throughout their formative years. Mastery of language is critical to the success of the individual. Once mastery is achieved, each phrase, essay, report, or book takes on the individual's creativity and becomes a unique work.

A similar progression occurs in the field of music. Musicians employ twelve distinct pitches (represented by seven white keys and five black keys on a piano) in endless combinations, progressions, and rhythms to create a variety of songs and styles. Likewise, the ability to effectively create an advertisement, lay out a web page, develop a floor plan, or design an entire interior environment uses **visual literacy**.

Visual literacy requires the effective application of design elements and principles coupled with an understanding of pattern, ordering, and visual perception (Figure II.1). Visual literacy embodies the way designers think.

There exists a natural tendency for individuals to organize and group information. The eye is automatically drawn to dominant elements; natural progressions lead the eye; the eye seeks to find closure in missing information, just as the ear seeks to resolve the final note of a song. The eye attempts to find meaning in whatever it views. The classic example of this phenomenon is the vase and profiles image (Figure II.3). In this example, the eye perceives either the vase (the white portion) or the profiles of faces (the black portion). Eyes work to find images or order in cloud formations or perhaps in cracks in a wall, ceiling, or pavement. The eye shifts from its focused vision to a broader wide-angled vision to perceive these changes.

Designers create environments that assist the occupants in these perceptual tendencies (Figure II.4). Conflicting design components, such as misplaced furniture or poorly planned room layouts, create visual and physical ambiguity for the occupant.

More info online @

www.ivla.org International Visual Literacy Association

FIGURE II.4A Organization of elements through the use of proximity.

FIGURE II.4B Organization of elements through the use of proximity applied to an interior floor plan.

Gestalt and Perceptual Theories

One theory of how humans perceive what they see is called Gestalt psychology. In the early 1900s, German psychologists studied how the brain tends to organize and group elements into simpler patterns and closes a space with an approximate outline. Designers use these tendencies of the brain and frequently group items by their proximity, their similarity, or through their perceived movement or continuance. Additionally, designers may define a space using closure and alignment.

For example, note Figure II.4A. Although there are eleven distinct elements, the eye naturally organizes them into three groups due to their **proximity**. The same could be said of Figure II.4B. Thirteen pieces of furniture are represented, but the designer has grouped them by proximity into three conversation areas.

The eye also has a tendency to group elements by **similarity**. In Figure II.5, the eye wants to order the triangles and circles into diagonal rows. This type of organizing may be applicable to designers as they arrange a client's accessory collection or select a multitude of chairs for a

FIGURE II.3 In this example, the eye attempts to find meaning in the shapes. The image can be read as profiles of faces looking at each other, or as a vase.

FIGURE II.5 Visual pattern perception using grouping tendencies of similarity and continuance.

FIGURE II.6 Visual perception through the use of closure.

hotel banquet room. Figure II.5 also illustrates how the arrangement of objects can draw the eye in a desired direction, in this case, a diagonal plane. **Continuance** occurs as the eye continues to follow the diagonal.

Another common tendency is for the eye to complete an image that is represented; this is referred to as **closure**. In Figure II.6, the eye recognizes a box and a circle instead of a series of lines. This technique is used in the development of universally understood symbols. Although there are over 3,000 languages, symbols transcend language differences as a form of visual literacy (Figure II.7). The eye completes the drawing of the male and female figures and understands the messages conveyed by the no smoking and handicap symbols.

Closure is frequently applied in space planning as designers create spaces that do not require four walls, a floor, and a ceiling. Note how the area rug in Philip Johnson's Glass House (see page 78) delineates the conversation area. The eye perceives the designated space through changes in ceiling heights, textures, surfaces, or even color.

Another perceptual theory that is applied in many areas of design involves the use of **alignment**. In the book *Architecture: Form, Space, and Order*, Francis Ching discusses five forms of alignment or organization: gridded, linear, clustered, radial, and centralized. Many designs and buildings are based on linear or grid organization. It is important to note that linear and grid organizations do not need to be rigid. Organic forms may even read as a contour map or as a flowing river or group of pebbles (Figure II.8). Open office planning, seen in the Suntory Water Group project (see Figures II.10–II.14) is based on linear and grid organization. Plan organization is further discussed in Chapter 8.

The theories of visual perception and Gestalt psychology help designers define social and cultural solutions that are aesthetically pleasing while meeting the functional and economic requirements of the project. Visual literacy, the construction of components in an ordered and perceptive manner, is applied throughout the design process including the conceptual development of interior environments.

More info online @

www.usask.ca/education/coursework/skaalid/theory/gestalt/similar.htm
Information on Gestalt
http://daphne.palomar.edu/design/gestalt.html and www.leonardo.info/isast/
articles/behrens.html Art, design, and Gestalt theory

FIGURE II.7 Universal visual literacy used in symbols. Note how the symbols for men and women use proximity to create a form. Closure is used in the no smoking and handicap symbols, as the eye fills in the gaps and details to create the whole.

FIGURE II.8 Alignment grids created in organic forms.

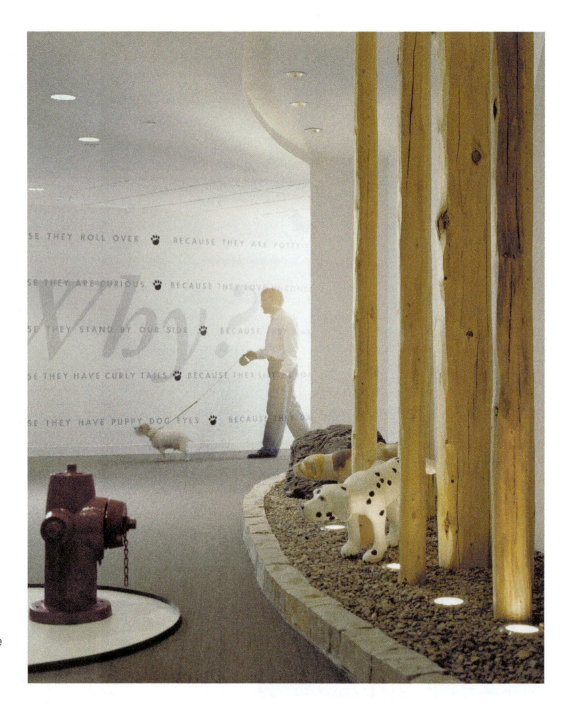

FIGURE II.9 In this whimsical development of concept, the designer created a delightful entry for Doane Pet Care. The reception area includes a dog-walk portraying dogs doing what they do. Reasons "Why" we care for pets are shared in the quotes on the wall graphics.
(Architect/Designer: VOA. Photograph by Nick Merrick © Hedrich Blessing)

CONCEPT

An important fundamental aspect of a design project is the *concept*. Concept refers to the underlying thought or motivator that defines the solution to the design problem. The concept may include the design and historical styles, but extends these concrete elements to include abstract characteristics. Tom Szumlic, a design instructor in Tampa, Florida, notes that "a concrete thought is a chair 20″ high by 30″ wide made of wood. An abstract thought is a place to sit, a place to read, talk to a friend" or look out the window.

Concepts give a project integrity and character. They are used as a point of reference to help define design decisions. Concepts may be found in a company's business philosophy, professional image, or product (Figure II.9). A concept may be found in a client's prized possession, or a favorite song, painting, or poem; it may originate in a thumbnail sketch conceived by the designer or from an abstract drawing or parti. The **parti** is a sketch usually encompassing geometric shapes or other series of lines and forms. The floor plan and other elements of the design are developed from the parti. Students using this text may be required to design a room based on a particular fruit, vegetable, breed of dog, or car. The physical as well as the abstract traits associated with the selection should be brought forward in the design characteristics of the space.

The Suntory Water Group project (Figures II.10–II.14) illustrates the design process with added emphasis on concept. A commercial design

firm, idea|span, was retained by Suntory to design a new call center that reflects the products it promotes and that encourages customer service representatives to familiarize themselves with these products. The majority of Suntory's call center customers are residential and small businesses. The call center representatives answer regional calls that focus on water products. The new one-story call center included approximately 20,000 square feet. Review the following images and note the emphasis on the concept and how it led to the formation of the design solution.

Part II, Design Fundamentals, continues with Chapter 3 and a review of the two basic design directions, structural and decorative design, followed by a detailed discussion of the elements and principles of design. Note how these elements and principles augment visual literacy and the theories of perception and concept, as well as assist designers in their thinking processes. Chapter 4 is dedicated to the study of color. The Design Scenario at the end of Part II discusses another project focused on concept.

SUNTORY PROGRAMMING REQUIREMENTS

PRIVATE SPACES

Area and Description	Head Count	Square Footage	Extended Square Footage
Private Office	5	120	600
Supervisor	9	80	720
Customer Service Representative	135	36	4,860
Administrative	7	80	560
Subtotal	156		6,740
Circulation Factor (.50)			3,370
Total for Personnel	156		10,110

PUBLIC SPACES

Area and Description	Number of Rooms	Square Footage	Extended Square Footage
SERVICE FUNCTION REQUIREMENTS			
Privacy Rooms	5	100	500
Team Room (Seat 16)	1	400	400
Computer Training Room (Seat 24)	1	800	800
Conference Room (Seat 12)	1	400	400
Interview Room	1	64	64
Screening Room (Seat 2 – 3)	1	100	100
H. R. File Area	1	120	120
Receiving/Mail/Equipment	1	300	300
Equipment Areas	2	100	200
Central Break Room (Seat 50)	1	1,200	1,200
Reception Area (Seat 4 – 6)	1	500	500
Quiet Room	1	225	225
Sick Room	1	100	100
Coats	4	20	80
Storage	3	80	240
Subtotal			5,229
Circulation Factor (.45)			2,353
Total for Service Function Requirements			7,582
COMPUTER FUNCTION REQUIREMENTS			
MDF/UPS Room	1	800	800
Central Electrical Room	1	150	150
Wiring closets for tele/data	1	100	100
Restrooms	2	450	900
Janitor Closet	1	60	60
Subtotal			2,010
Circulation Factor (.45)			905
Total for Computer Function Requirements			2,915

SUMMARY	Head Count		Square Footage
Personnel			10,110
Service Function Requirements			7,852
Computer Function Requirements			2,915
TOTAL	156		20,607

FIGURE II.10 As part of the programming, idea\span created the following analysis of the two major areas of the Suntory Water Group: Private and Public Spaces.
(Designer: idea\span)

A

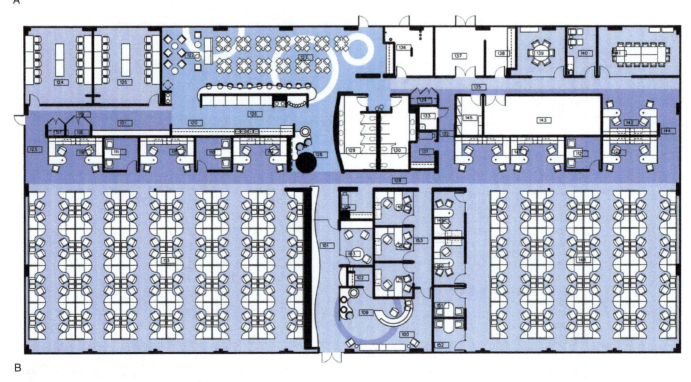

B

FIGURE II.11 In the conceptual or schematic design phase, idea\span developed a space plan and a finishes and furniture palette based on three design concepts. Concept one (customer oriented) was to design a space that encourages customer service representatives to visualize the customer and to be familiar with all the products (water) in different regions. Concept two (product and branding) was to design a space that reflects the products the customer service representatives are promoting by using the environment as well as the products themselves. Concept three was to promote employees' and potential customers' health. Note the rough schematic sketch (A) in the development of the plan.

(Designer: idea|span)

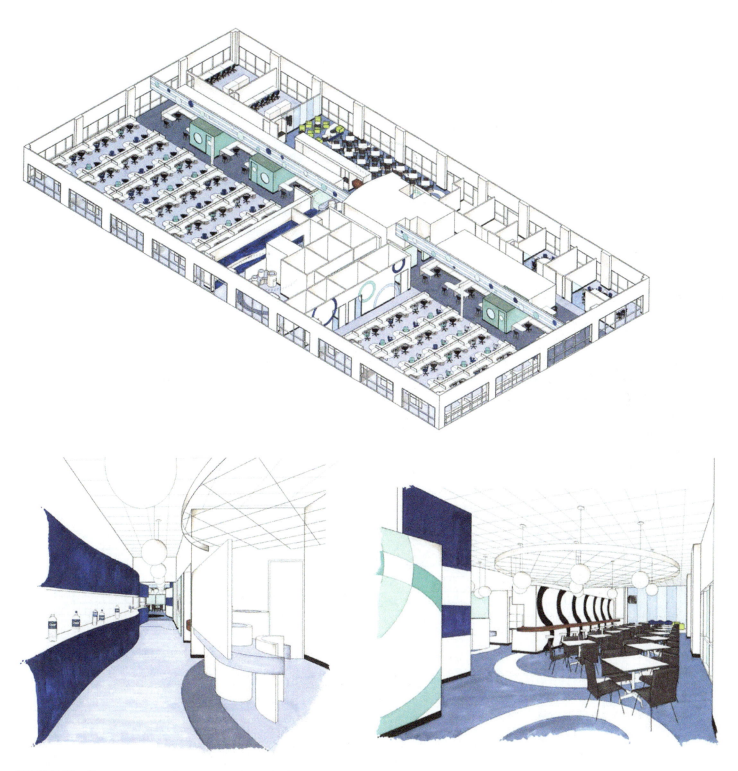

FIGURE II.12 After client approval of the conceptual design, idea\span continued to develop and refine design solutions in the design development phase. Concept one was achieved by incorporating the products on a display wall facing occupants as they enter the space. Concept two also utilizes the display wall for monthly specials to educate the customer service representatives about new products. Laminates with digital images of water are used throughout the space. Waves are incorporated in the carpet design and interior architecture. The breakroom is an "area of retreat" where employees can gather for a more social interaction at lunch. Ergonomics also played an important role in workstation configuration and task seating selections. These areas promote a healthy environment.

(Designer: idea|span)

FIGURE II.13 During the construction documents phase, idea\span produced a set of furniture specifications and construction drawings that also included mechanical and electrical drawings produced by a mechanical, electrical, and plumbing (MEP) consultant. Examples from the set of drawings include a dimensioned partition plan (A), the reflected ceiling plan (B).

(Designer: idea\span)

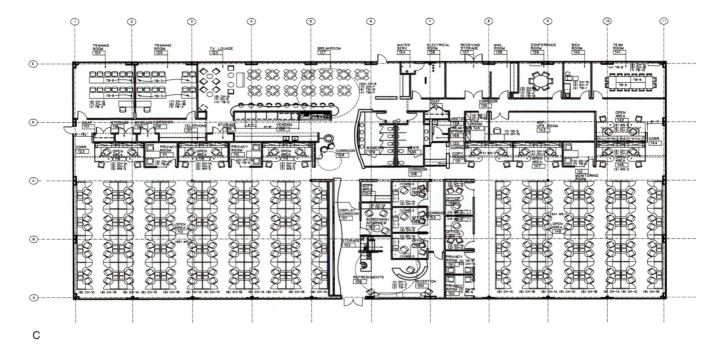

C

FIGURE II.13 *continued* the keyed furniture plan (C), and an elevation of the reception area (D).

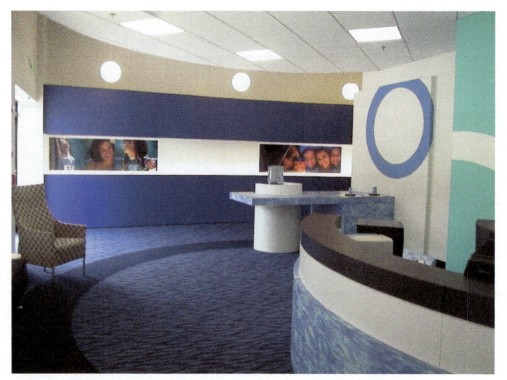

A

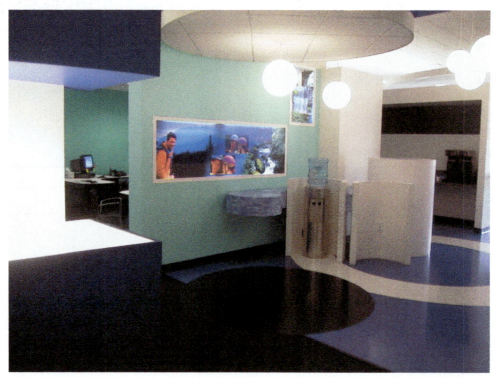

B

FIGURE II.14 In the completed reception area (A), notice how the design concepts are illustrated in the forms, finishes, and space planning of the interior. After entering the reception area (labeled space 100 and 109 on the plans), occupants proceed through the display corridor (space 101) and arrive in a central congregating area (space 128, Figure II.14B). For this congregating area just outside the breakroom, the designer focused attention on the product distributed by the company (water) as well as on the client who consumes the product (the end user). Ceiling height changes and color help the eye perceive the various spaces. Circles and wavelike forms emphasize the water concept. Beyond the congregating area is the employee breakroom (space 127, Figure II.14C).
(Designer: idea|span)

C

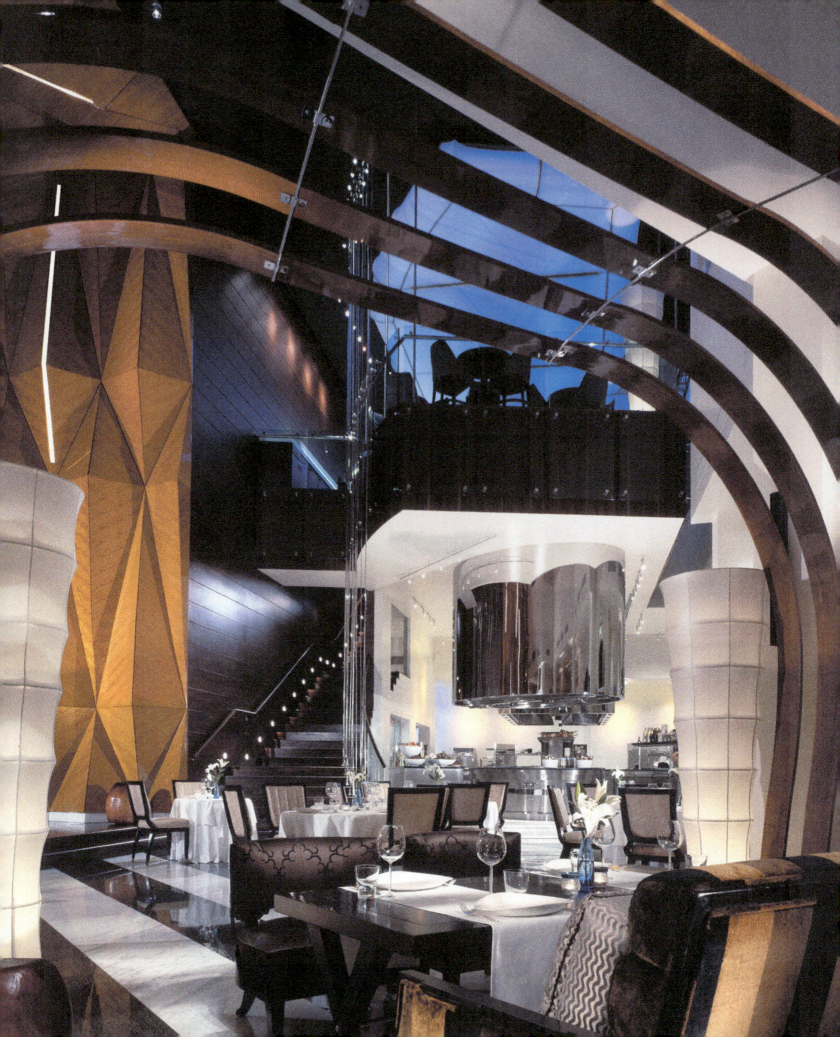

3 Elements and Principles of Design

Design is the planned arrangement of basic elements and principles that work together to create an image, object, or environment (Figure 3.1). The creator of a well-planned and well-executed design—whether for a brass candlestick, a bedroom, or an entire office building—has carefully analyzed the use of space, line, shape and mass, texture, light, color, and pattern. The creator synthesizes these elements to ensure that the unity and variety of the design encompasse appropriate scale and proportion, balance, rhythm, and emphasis.

■ TWO BASIC TYPES OF DESIGN

Becoming familiar with the two basic types of design, *structural* and *decorative*, is a helpful introduction to the principles and elements of design (Figure 3.2).

Structural Design

Structural design relates to the size and shape of an object reflected in the materials. In other words, the design is an integral part of the structure itself. For example, the ancient pyramids of Egypt are structural designs because they expose the stone blocks from which they were made.

FIGURE 3.1 In this multifaceted interior space, the designer created a fascinating array of interior elements that delight the senses. Suspended curved slabs define the human scale beneath. Glowing tubular frames covered in fabric create warmth and general lighting. One of six restaurants located in the hotel Park Hyatt Dubai, the space "brings drama to dining." An image of the lobby is seen in Figure I.2 and a detail of the wall in Figure 10.31.
(Interior Architectural Design by Wilson Associates. Photography by Michael Wilson)

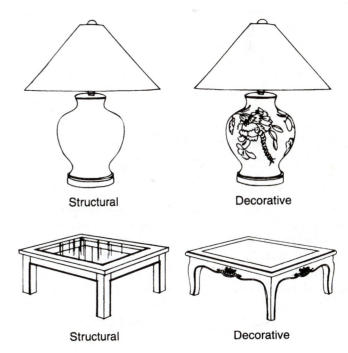

Structural Decorative

Structural Decorative

FIGURE 3.2 Structural design and applied ornamentation or decorative design.

FIGURE 3.3 In this dining room the basic type of design is structural. The simplicity of the design belies the attention to detail. The geometric forms are highlighted by a cove lighting detail, recessed down lights, and accent lighting. The long horizontal windows are backlit to bring the exterior inside.

(Designer: Bruce Benning, ASID/CID, Benning Design Associates. Photograph by David Duncan Livingston)

FIGURE 3.4 In this dining room, the basic type of design is decorative. Trims are added to the patterned drapery. Curved details accentuate the valance. Brass tacks are added to the pattern upholstery on the chairs. The frame surrounding the art is gilded. The highly polished wood grain adds yet another dimension to the applied ornamentation.

(Designer: Jerry Pair. Photography by Chris Little Photography)

Contemporary architecture, both inside and out, reveals the materials that make up the basic structure, such as wood or metal beams, brick, stone, and concrete (Figure 3.3). In modern furniture, the form itself (such as the metal frame of the Barcelona chair shown in Figure 3.16) is an integral part of the design statement. Successful structural design depends upon *simplicity* and *appropriateness of materials used*.

Simplicity

A structure, whether serving as the finished product itself or as the supporting element of a design, should be kept simple. For example, a room with too many or poorly placed openings, arches, and niches is seldom pleasing.

Appropriateness of Materials

Various objects use different materials and require different methods of construction. Glass is blown and can be intricately decorated by skilled craftspeople; molded plastic chairs may be turned out on an assembly line. Interchanging procedures and materials when producing an object may not be feasible or may not achieve the desired result. Materials selected for a structural design should be appropriate for the intended purpose.

Applied Ornamentation or Decorative Design

Decorative design relates to the ornamentation of the basic structure with color, line, texture, and pattern. For example, the exterior surfaces of East Indian temples are completely covered with embellishment in color, line, and texture. Victorian-style houses often couple fanciful decoration and bright color schemes with unique structural elements. Furniture may be handsomely carved to add charm and dignity. Fabrics, wallpapers, rugs, accessories, and other furnishings can be attractively enhanced with decorative design (Figure 3.4).

Four classifications (as seen in Figure 3.5) apply to applied ornamentation or decorative design: *naturalistic, stylized, abstract*, and *geometric*.

1. Naturalistic, realistic, or photographic design reproduces a motif from nature in its natural form. In naturalistic design, flowers look like flowers as they are seen in the garden or growing wild.

2. Stylized design creates a motif taken from nature but adapted to suit the shape or purpose of the object to be decorated. In this case, flowers are recognizable but are modified or slightly changed. This type of design is often used for interior furnishings.

3. Abstract design departs from nature. The elements, which may or may not be recognizable, are transformed into nonrepresentational design.

4. Geometric design is made up of geometric motifs such as stripes, plaids, chevron patterns, and zigzags.

Successful decorative design depends on *suitability and placement* and *appropriateness*.

Naturalistic

Stylized

Abstract

Geometric

FIGURE 3.5 Types of applied ornamentation.

Suitability and Placement

An item's purpose should be immediately recognizable. Additionally, the embellishment on any item should not interfere with the item's comfort or functionality. **Bas-relief** on a wall plaque is attractive and suitable, although such carving on the seat of a chair would be very uncomfortable to the occupant.

Appropriateness

Appropriate decoration should accent the shape and beauty of the object. For example, vertical fluting on a supporting column makes it seem higher, but crossbars appear to reduce its height and detract from its dignity. Classic figures on a Wedgwood vase emphasize its rounded contour, whereas harsh lines would destroy its beauty. Figure 3.6 illustrates contrasting examples of structure and decorative design.

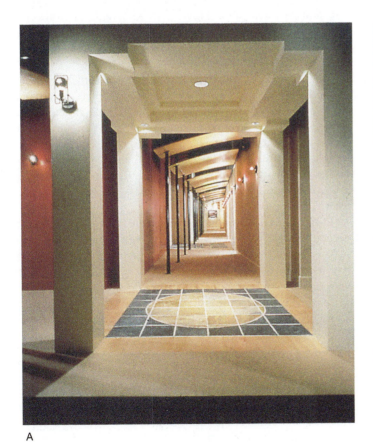
A

B

FIGURE 3.6 These successful corridor designs illustrate structural and decorative design solutions. Structural design is stressed in (A). Vertical and horizontal lines emphasize the angles of the building. Applied design is limited.
(Resurgens Orthopedics, Atlanta, Georgia. Design Firm: Farrington Design Group. Hiro Isogai, Design Director. Photograph by Hedrich-Blessing)

(B) emphasizes decorative design. Applied ornamentation results in colorful walls and decorative carpet treatments.
(MTV Network, Atlanta, Georgia. Design Firm: studio epic 5, Hiro Isogai, Principal. Photograph by Rion Rizzo)

A

B

FIGURE 3.7 In these two studies, the artists illustrate the use of negative and positive space. Drawing (A) is more naturalistic and decorative; (B) is more geometric and structural.
(Artists: Drawing A—Kimberly Dorsey; Drawing B—Antonina Grib)

■ ELEMENTS OF DESIGN

The **elements of design** are space, line, shape and mass, texture, light, color, and pattern. These elements aid the designer when creating a visual environment and are often referred to as *tools*. The organization and arrangement of these elements or tools are closely allied to the principles of design, which are explained later in this chapter.

FIGURE 3.8 Soaring verticals and intersecting diagonals silhouetted against the sky carry the eyes, and spirit, upward in the Thorncrown Wayfarer's chapel in Arkansas, designed by E. Fay Jones.
(Courtesy of E. Fay Jones, FAIA, Maurice J. Jennings, AIA, and David W. McKee, AIA)

Space

Space is best explained as the area found within an enclosure. As discussed in relationship to closure, space may be real or perceived. This may include one's personal space, the walls and ceilings of a room, a fence around a yard, or even the boundaries that define nations. Space is the area in which people live. Line, shape or mass, texture, and so on, are elements working together in space to form dynamic negative–positive interactions (Figure 3.7). In design, walkways or **traffic lanes** define some of the negative space; furnishings define the positive. Well-planned and well-organized space produces a functional and comfortable interior.

The challenge of many residential interiors is that they may simply lack the adequate space required to complete necessary tasks. Many individuals have acquired more "stuff" than is needed; in some situations, in order to provide enough space, the designer must gently persuade the client to remove some of his or her "precious cargo." In design, less is more. On the other hand, an accumulation of memorabilia may be important for the elderly; Robert Venturi was quoted as saying, "Less is a bore." As always, designers must be sensitive to their clients' needs.

In commercial environments, the quantity of space is equally as important, especially when clients are leasing the interior and paying for it based on the quantity of square feet. A designer who understands how to utilize the premium commodity of space cleverly and efficiently will be rehired on future projects. Part IV, Space, reviews layout and space requirements for furniture arranging as well as space planning for a variety of rooms.

Line

Line forms the direction or feeling of a design and is particularly dominant in contemporary art and interiors. The composition of a room is established by the lines that give it motion or repose. Skillful use of line is therefore of utmost importance (Figure 3.8).

Line can seemingly alter the proportion of an object or an entire room. For example, in Figure 3.9, two identical rectangles are divided, one vertically and the other horizontally. As the eye travels upward along the vertical line, the rectangle seems higher. Along the horizontally divided area, the eye is directed across, making the rectangle appear wider. Each kind of line has a particular psychological effect on

When two identical rectangles are divided differently—one horizontally and one vertically—the proportion seems to change.

Vertical lines add height and dignity.

Vertical lines emphasize and enhance the basic structure.

Zigzag lines detract from the basic structure.

Horizontal lines give a feeling of repose.

The curved line was used by Eero Saarinen to create the classic pedestal chair.

Diagonal lines are lines of movement.

FIGURE 3.9 The use of line.

a room. To achieve the desired result, the interior designer should keep in mind the distinct effects of each line.

Vertical lines tend to provide a feeling of height, strength, and dignity. These lines are particularly evident on the exterior of a building where columns are used, in the interior where upright architectural members are conspicuous, in tall pieces of furniture, and in the long, straight lines of vertical louvers or folds of drapery.

Horizontal lines create a feeling of repose and solidity and, like vertical lines, also provide strength. These lines are often seen in **cornices**, **dadoes**, bookshelves, and long, low pieces of straight-lined furniture.

Fallingwater, a famous Frank Lloyd Wright house, is an excellent example of horizontal architecture (see page 76).

Diagonal lines give a room a feeling of action and movement. They are evident in slanting ceilings, staircases, Gothic arches, and sloping furniture. Too many diagonals in a room, however, may create a feeling of unrest.

Curved lines have a graceful and delicate effect on a room. They are found in arches and other curved architectural treatments, drapery **swags**, rounded and curved furniture, and rounded accessories. Curved features may also be employed in interior architectural elements, such as counters and fixtures (Figure 3.10).

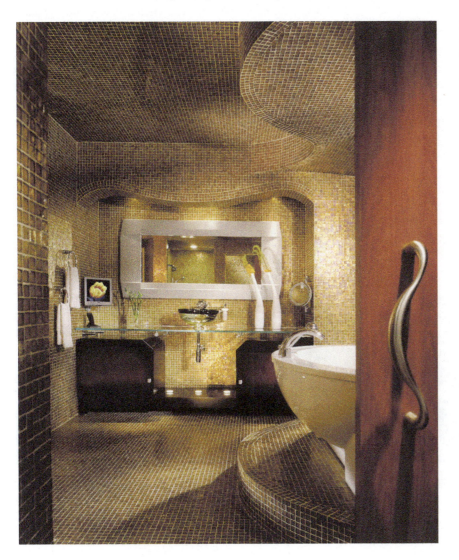

FIGURE 3.10 In this custom-designed bathroom, emphasis has been placed on the curved line. Intricate tile patterns, a floating glass countertop, and amorphously styled hardware enhance the fine details. *(Designer: Charles Greenwood, IIDA, of Greenwood Design Group, Inc. Photograph © Robert Thien)*

Curved lines fall into the following four general categories:

1. Large convex (upward) curves tend to provide an uplifting feeling, such as a curved staircase opening from a foyer.

2. Large concave (downward) curves often give a feeling of solidity, and in art, even sadness. (Artists have used this line to evoke a feeling of mourning or unhappiness.) Downward curves such as a domed ceiling or series of arches may also be very dramatic.

3. Long, flowing horizontal curves (like those seen on a shoreline or gently curving mountain road) can imply restfulness.

4. Small curves such as those commonly found in patterned carpets, rugs, and fabrics often express lightness and merriment. They add life and character to a space.

Too much line movement in a room may evoke a feeling of instability. A careful balance of line is essential to the feeling of comfort and harmony in a room. A designer can use line to create a mood or feeling, give direction to a room, create an optical illusion, achieve a feeling of balance and rhythm, support a room's focal point by directing the eye toward that feature, and give variety and unity to a room through the skillful blending of the various line types.

Shape and Mass

The terms *form, shape,* and *mass* are frequently used interchangeably in the profession. Technically, however, *form* defines the essential nature of the design that distinguishes it; a grand piano looks like a grand piano because of its form. The contour of an object is represented by its *shape,* which is made up of lines. When a two-dimensional shape takes on a third dimension, it becomes a *mass* made up of a volume outlined by the shape. In the planning of interiors, mass can be perceived as objects (e.g., furniture) that require space and may be moved to various locations. The arrangement of mass within a room—furniture arrangement—is discussed in Chapter 7. Basic masses (or forms as used below) or shapes fall into the following three categories:

1. Rectangles and squares are the most dominant shapes used in architecture and interior design. They provide a sense of unity and stability, are easy to work with, and may be arranged to conserve space. Too many rectangular and square forms may produce monotony; however, introducing circular and angular forms into the space alters this effect.

2. Diagonal forms frequently begin with triangle shapes. The diamond shape results when triangles are arranged base to base. A variety of other shapes using the diagonal line may be created. These forms are often seen in sloping ceilings and motifs applied to fabrics and wallpapers. Triangular, diamond, and other diagonal shapes may be used for flooring materials, furniture, and accessories, providing a dynamic effect.

3. Curved forms include spheres, circles, cones, and cylinders. Curved forms are found everywhere in nature. (The shape of the human body is curved.)

Curved forms are constant, unifying, and pleasing. When used in the interior environment, curved forms may be dramatic, like a sweeping

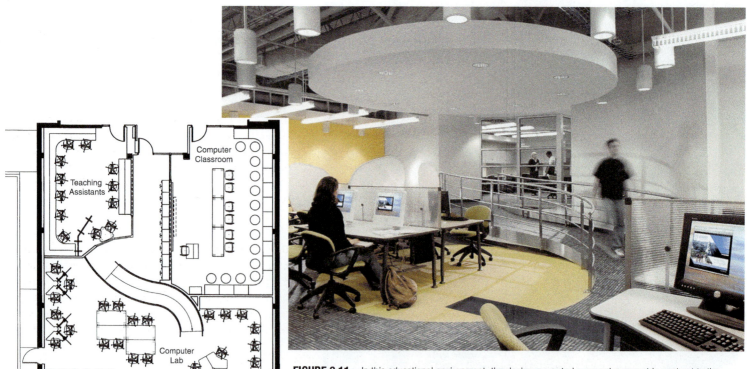

FIGURE 3.11 In this educational environment, the designer created a curved ramp set in contrast to the rectangular walls. The circular dropped ceiling and yellow carpet inset define a specific set of computer terminals. The furniture plan (B) illustrates how the curved accent adds interest to all rooms in the computer work area. The ramp also meets ADA requirements for level changes.
(Architect/Designer: Jova/Daniels/Busby. Photography by Robert Thien, Inc.)

staircase or domed ceiling; curved forms are also used for accessories such as pieces of pottery, plates, lamps, round tables, or sculptures. Curves may give relief and variety to a room with a predominance of angular and rectilinear forms.

Very few interiors employ only one shape or form. The environment is most often enhanced by skillfully combining the three basic forms for architecture and furnishings. However, too much variety of form and shape may produce a room with a feeling of confusion. The visual transition from one object to another should be easy and pleasurable. The emphasis created when a curved form is placed against a rectangular panel may provide unexpected and agreeable relief from a room's otherwise severe lines. For example, a curved floor plan, when used with rectangular rooms, as seen in Figure 3.11, creates such an effect. The sophisticated combination of forms is evident today in both modern and traditional styles.

Texture

Texture refers to the surface quality of objects—the quality that can be not only touched but also sensed in memory. In art and design fundamentals, texture is frequently discussed as an element paired with pattern. In interior design, these two are more distinctive due to the sense of touch inherent in interior design. The roughness of sandstone, the softness of a deep-pile rug, the smoothness of glass, and the shininess of growing leaves all produce a particular sensation because of previous associations with these textures.

Textures fall into the following categories: soft or hard, smooth or rough, and shiny or dull. Throughout history, smooth, highly polished surfaces, lustrous metals, and fabrics of satin, silk, and fine linen have been symbolic of wealth and high status, whereas rough, hand-hewn textures and homespun fabrics have characterized lower economic classes. This is no longer the case. Many wealthy individuals prefer a handcrafted look, which may cost as much as the most refined look.

Additionally, smooth and shiny surfaces are typically reserved for formal interiors, whereas dull and rough textures are associated with informal treatments. Regardless of style, a knowledgeable use of texture is a means to bring character to a room. Textures in the interior environment often combine several characteristics. For example, a wool carpet can have a soft and dull texture. Properties and considerations regarding texture are discussed next.

Visual Interest, Beauty, and Character

Texture adds much visual interest in the environment. The early Greeks delighted in the smoothness and beauty of marble floors. The people of Iran take pride in the fine texture of their hand-knotted rugs, and the Japanese enjoy the woven texture and look of grass mats called *tatami*. Modern interiors depend on the physical impression of texture to create variety and interest. The texture of a surface reflects a particular character and unique beauty that makes a lasting physical or psychological impression (Figure 3.12).

Light Reflection

Each texture has a surface quality that affects light reflection. Smooth, shiny surfaces such as glass, mirrors, satin, porcelain, and highly polished wood reflect more light than do rough and dull textures such as brick, concrete, stone, and coarse wood. Shiny surfaces will reflect light, brightening the room, but the reflections may also cause glare.

FIGURE 3.12 The entry to this mountain escape embraces the use of texture. Rough, stacked stone walls contrast with a polished stone ledge. Custom iron door hardware accentuates the heavy wood-grained door, while glistening steel forms the header. Flagstone, both jagged and smooth, defines the walkway. The antique polished brass vase provides the appropriate level of sheen, without overpowering the rustic appeal. *(Designer: Gandy/Peace, William B. Peace, ASID. Photograph by Chris Little Photography)*

Maintenance

The choice of a particular texture determines the amount of maintenance a surface requires. Smooth textures may show fingerprints. Shiny textures may scratch easily. Rough textures, while more durable, may collect dirt in crevices. A shiny, glossy paint will hold up longer but will highlight imperfections in the wall. A matte finish paint may not wash as well, but it hides imperfections in the wall.

Acoustics

Textures can absorb or reflect sound. Smooth and hard surfaces tend to magnify sound, whereas soft and rough textures have a tendency to absorb sound. Walking through an unfurnished room with a hard floor produces a high level of sound. When the same room is furnished with rugs, fabrics, draperies, and furniture, the sound is greatly muffled. Designers can control the acoustics of a particular space with wise textural combinations.

A Combination of Textures

Formal textures such as satin and polished marble and informal textures such as burlap and stone generally are not mixed in the same environment unless a specific effect is desired. The dominant texture of a room is often established by the architectural background. For example,

FIGURE 3.13 Shape, form, line, and color have been manipulated in this entry lobby to affect the scale and proportion of the interior. The space embraces the occupants as they climb the stairs to the main reception area. The interior is a treat to the senses.
(Photo by Brian Gassel/tvsdesign)

a room paneled in fine-grained and polished wood or papered in a traditional formal wallcovering generally requires furniture woods and fabrics with a smoother and shinier texture than that required of a room paneled with natural coarse-grained wood or constructed of masonry. Contemporary use of texture may break these traditional rules, providing an element of surprise. A combination of textures, whether employed for an avant-garde or conservative environment, enhances the total visual experience.

Light

The element of *light* combines the creativity of the arts and the technology of science. Light affects the physical as well as the emotional comfort of the user. A room must have sufficient light; however, too much light or the inappropriate use of light can cause headaches and inhibit productivity.

The mood and appearance of a room can be greatly altered through the use of light. Uniform light (light lacking in contrast) can lead to boredom and a lack of energy. The quantity as well as the quality of light is critical in a well-designed room. Light variations create interest in a room, but can also affect the perceived color of the interior. Without light, no visual elements can be experienced. Light, its effect on the user, and its proper placement and selection are discussed briefly in Chapter 4 and in detail in Chapter 6.

Color

Color is dependent on light. Color can alter the perceived shape, size, and location of an object. It can create the illusion of texture, stimulate interest, or calm a busy environment (Figure 3.13). Color has a strong psychological effect on the user. Because of its central role in design, color is discussed in greater detail in Chapter 4.

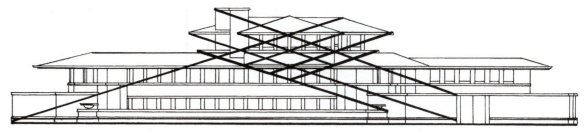

FIGURE 3.14 In the elevation of the Robie House by Frank Lloyd Wright, a pattern of diagonal lines is created. Wright repeated this pattern in a much smaller scale in the design for the windows, adapted from *The Old Way of Seeing* by Jonathan Hale.

Pattern

Pattern as an element of design interacts and combines with other elements, including space, line, texture, and light. Color can also be incorporated into the patterned arrangement, adding character and focus. The ordering of elements creates pattern. Patterns are created and applied in the horizontal space plan and the vertical elevation, as well as in the volume of space. For example, in Figure II.11B, note how the open office layouts form a pattern, or visual literacy. Jonathan Hale in *The Old Way of Seeing* illustrates the pattern development of the façade reflected in the design of the windows in Frank Lloyd Wright's Robie House (Figure 3.14). The proportions of these patterns are frequently based on the golden section discussed later in this chapter. The eye perceives the pattern and finds order in the arrangement.

Pattern is also used as a decorative design element. Japanese designs are known for their embellishment of pattern in the smallest detail. From a distance, the material or finish appears to be solid. It is only on closer observation that the playful pattern is revealed.

Pattern can be effectively employed to create interest, although too much pattern can make a room too "busy" and uncomfortable. In contrast, a room devoid of pattern may be stark and uninviting. The total arrangement of the components of a room creates an overall pattern, but more obvious patterns are seen in fabric and wallpaper. The application of pattern and pattern combinations is more thoroughly covered in Chapter 12, Textiles.

■ PRINCIPLES OF DESIGN

Through the centuries, **principles of design** have evolved through careful observation of both nature and art. When these principles of design (scale and proportion, balance, rhythm, emphasis, and harmony) are thoughtfully considered and sensitively applied, they contribute to achieving the goals of design. The elements of design discussed in the first part of this chapter (space, line, shape and mass, texture, light, color, and pattern) can be manipulated to achieve the desired principles of design (as seen in Figure 3.13).

While there are no absolute rules when creating a design project, most interiors are enhanced by adhering to these basic guidelines. Although some successful designs violate these time-tested principles, understanding them is central to the interior designer's creativity and is essential to the beginning designer.

Scale and Proportion

The elements of *scale* and *proportion* are both dependent on size and the relationships between objects. Scale compares an item or space to *something of a known size*. For instance, to understand the meaning of a small-scale (or -size) living room, one must know the standard scale or size of a living room. Children's rooms or furniture in elementary schools are *scaled down*, or reduced in scale, to fit the needs of the occupants.

In interior design, human scale is the most common reference. Interior design deals with size relationships geared to human scale (Figures 3.15 and 3.16). The dimensions used in the classic styles of the Ancient, Middle Age, and Renaissance eras are based on the human scale. The foot measurement was based on the size of a human foot and contained 12 inches. Each inch is approximately equal to the length of the thumb from the tip to the first joint. It is important to note, as

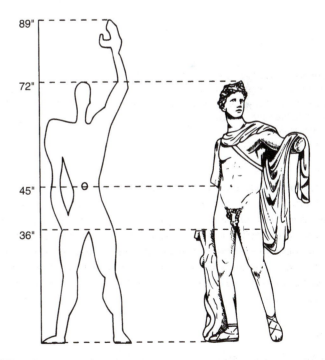

FIGURE 3.15 Le Corbusier planned his architectural projects to be consistent with the proportions of this human Modular (left). The same ideal proportions can be applied to the famous statue of the Apollo Belvedere (right), probably a first-century B.C. Roman copy in marble of a fourth-century B.C. Greek original.

FIGURE 3.16 The beautiful lines and scale of the highly acclaimed Barcelona chair, designed by Ludwig Mies van der Rohe in 1929 for the Barcelona Exhibition, have made it a timeless classic.
(Courtesy of Knoll, Inc.)

Poor Better

FIGURE 3.18 These plan views indicate inappropriately scaled and appropriately scaled furniture to fit the room.

Jonathan Hale does, that the measurement of 1 foot is equal to 1/360,000 of 1/360 (one degree) of the circumference of the Earth, accurate to 99 percent. In preindustrialized Japan, the version of the foot was called the *shaku*. It measured 11.93 inches. The Egyptian version measured 12.25 inches.

Additionally, the length from the elbow to the tip of the middle finger is 18 inches, or a cubit. The midpoint of a 6-foot person (usually at the top of the leg) is 3 feet, or 1 yard. The Japanese frequently use the tatami mat for measurement. It is 3 feet by 6 feet. The importance of human scale is cross-cultural and apparent in all successful design solutions.

Scale is also based on perception. Objects appear to change size based on other objects around them. Note in Figure 3.17 the perceived differences in the sizes of the middle circles. Similarly, furniture should be sized to fit the scale of the room or area that surrounds it.

A B

FIGURE 3.17 Perception: The center circles in each of the diagrams are identical. The apparent change in size is due to the difference in size of the surrounding circles.

Furniture that is too large crowds a small room and makes it appear even smaller, whereas furniture that is too small seems even smaller in an oversized room. Large, overstuffed furniture should not be placed in a small living room (Figure 3.18). When surrounded by small-scale furniture, a large piece of furniture appears larger than when surrounded by large-scale pieces. A small table with spindly legs placed at the end of a heavy sofa or chair looks out of place, and a large-scale table placed near a dainty chair is not enhanced.

Accessories such as mirrors, pictures, and lamps need to be scaled for the items with which they are to be used. A lamp generally must not overpower a table, nor should it be so small that it looks minuscule.

Scale is a relative issue, dependent on the known size of another object. *Proportion* is also a relative issue, but it does not depend on a known size. Proportion encompasses both the relationship of one part of an object to

its other parts or to the whole, as well as the relationship of one object to another. So in the case of the lamp above, both the lampshade and base must be suitably scaled in relationship to each other.

Proportion has been a major concern of creative minds through the ages. Although no absolute formula for good proportion works in all design projects, the Greeks discovered some secrets of good proportion over 2,000 years ago and set down rules that have been incorporated into compositions for centuries. For instance, a square room has been considered the most difficult room to design and is also the least pleasing to the eye. Recognizing this, the Greeks developed the **golden rectangle**, which is a rectangle whose proportion of width to length is 2:3. This proportion is considered the most pleasing. A common use of the golden rectangle is in the residential conversion of a 24′ × 24′ garage. Designers must artfully place furniture and interior components to give the square room the illusion of a rectangular space (Figure 3.19).

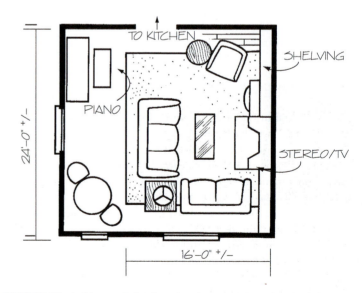

FIGURE 3.19 In this presentation floor plan of a garage conversion, the designer arranged the furniture and floor coverings to allow the seating arrangement to more closely reflect the proportions of the golden rectangle.

A = 2 B = 3

C = 5

2 is to 3 as
3 is to 5

FIGURE 3.20 In the golden section, the ratio of A to B is the same as the ratio of B to C. In other words, 2/3 is approximately equal to 3/5. The precise ratio is 1:1.618.

The **golden section**, also developed by the Greeks, involves the division of a line or form in such a way that the ratio of the smaller portion to the larger is the same as that of the larger portion to the whole (Figure 3.20). The progression 2, 3, 5, 8, 13, 21, 34, and so on, in which each number is the sum of the two preceding numbers, provides a close approximation to this relationship. For example, 2:3 is roughly the same as 3:5, and 5:8 is roughly the same as 8:13, and so forth. Another pleasing ratio is 4:7. These ratios can help designers decide room sizes and shapes, as well as the most pleasing proportions for windows and fireplace moldings and openings.

Perhaps the most important application of these proportions in planning and furnishing lies in the relationship of sizes or areas. For example, if the length of a room measures 25 feet, a desirable width would be 15 feet. This measurement is determined by the following process. Because the length of the living room (25 feet) is divisible by 5, the 3:5 ratio may be used.

$$\frac{3}{5} = \frac{x}{25}$$

To solve for x, cross multiply 3 × 25 to get 75. Now divide 75 by 5 to get 15.

In another example, a piece of furniture 4 feet long would be a good size to place against a 7-foot wall space. These dimensions have the desirable ratios of 4:7. Even the human body contains the golden section. The ratio from the feet to the navel in comparison to the entire body height is approximately 1:1.618, the precise ratio for the golden section.

Another Greek discovery was that the division of a line somewhere between one-half and one-third its length is the most desirable. This division, called the **golden mean**, can be applied when planning any wall composition, such as determining the height for a mantel, tying back drapery, or hanging pictures, mirrors, or wall sconces (Figure 3.21).

The Greeks also observed that odd numbers are preferable to even ones. A group of three objects is more pleasing than two or four. These guidelines might be applied, for example, when selecting the quantity of pillows for a sofa or when arranging pictures on a wall.

In addition to form, the elements of color, texture, and pattern are also important in the consideration of scale and proportion. Whatever attracts the eye seems larger. Coarse textures, large patterns, and bold colors cause the object on which they are used to appear larger than an object with smooth textures, small patterns, and soft, light colors. Through the skillful use of these principles, the apparent size and proportion of rooms and objects create a pleasing environment in relatively small or large spaces (Figure 3.22).

More info online @

www.vashti.net/mceinc/golden.htm Website on the golden mean
http://www.youtube.com/watch?v=AzfHbETDbN8 "Fibonacci and the Golden Mean" Educational YouTube video on Fibonacci and the Golden Mean, posted 8/14/2009; produced by Beau Jenzen, Palladian Group and Florida Tech

The Parthenon at Athens—based on a mathematical ratio of 1:1.6—fits almost precisely into a golden rectangle. Because of the frequency with which it occurs in the arts, the golden rectangle has fascinated experts for centuries.

FIGURE 3.21 The use of Greek proportions.

4:7 is a pleasing proportion.

The golden mean. The division of a line somewhere between one-half and one-third is the most pleasing.

FIGURE 3.22 Ecclesiastical design blossoms under the principles of scale and proportion. In this cathedral, the entablature is approximately 2/3 the height of the structure. The capitals on the columns are approximately 2/3 the height of the arches. The eye and body relax in the ideal proportions created in this sanctuary.
(© Jeffrey Jacobs)

Balance

Balance is that quality in a room that establishes a sense of equilibrium and repose. It is a sense of weight as the eye perceives it. Generally, humans have a need for balance in many aspects of their lives (review Figure 1.5). In the interior environment, balance is necessary to achieve a comfortable atmosphere.

Balance is based substantially on visual perception. Donis Dondis in *A Primer of Visual Literacy* noted the importance of balance on movement. In Figure 3.23, the first circle appears balanced or stable; the second circle appears to be rolling to the right.

Balance brings a sense of order. For instance, in Figure 3.24, box A appears to be balanced; the dot is centered. The dot in box B, although not centered, has been placed on a diagonal axis that allows for more visual comfort. In box C, however, the dot is placed in such a location as to cause visual unrest or ambiguity.

The architectural background of rooms including doors, windows, paneling, and fireplaces, along with accompanying furnishings, can be

effectively arranged to provide a feeling of equilibrium. Some considerations include the following:

- Opposite walls and interior spaces and objects should have a comfortable feeling of balance through the distribution of high and low, as well as large and small objects.

- When furnishings are positioned above eye level, they appear heavier than items positioned below.

- Bright colors, heavy textures, unusual shapes, bold patterns, and strong lighting readily attract attention and can be manipulated to achieve balance within a space.

- Large furnishings in a space can be complemented by placing them next to groups of small items, and vice versa, creating a refreshing contrast.

The three types of balance used to provide this equilibrium are symmetrical, asymmetrical, and radial (Figure 3.25).

FIGURE 3.23 Note how the vertical line appears to balance the circle; however, in the second circle, the diagonal line adds movement to the circle.

FIGURE 3.24 In boxes (A) and (B), the dot is located on an imaginary vertical or diagonal axis. This brings a perceived visual order to the image. In box (C), however, the dot is haphazardly located, causing unrest to the viewer.

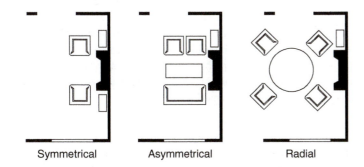

Symmetrical Asymmetrical Radial

FIGURE 3.25 Three types of balance.

Symmetrical, or Formal, Balance

In **symmetrical balance** identical objects are arranged equally on each side of an imaginary line. This type of balance is often employed in traditional and formal environments and adds a feeling of dignity to the

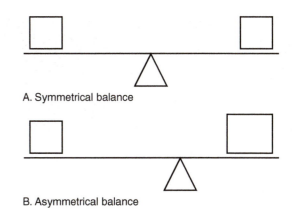

A. Symmetrical balance

B. Asymmetrical balance

FIGURE 3.26 In asymmetrical balance, the triangular balance point must be moved to the right in order to keep the seesaw level.

interior (as seen in Figure 3.22). Formal balance usually conveys a restful and peaceful sensation, because this type of balance is easily perceived and appreciated; however, too much symmetry can create monotony.

Asymmetrical Balance

Asymmetrical balance is more subtle than symmetrical balance. It requires more thought and imagination, but once achieved, remains interesting for a longer time. In this type of balance, objects of different sizes, shapes, and colors may be used in an infinite number of ways. Two small objects may balance one large item, a small shiny object may balance a larger dull one, a spot of bright color may balance a large area of neutral color, and a large object moved closer to a central point may balance a smaller one pushed farther away (Figure 3.26). No measurement indicates at what point these different items must be placed; the point at which balance is achieved must be sensed. Asymmetrical balance:

- Tends to shift the focus from the center and achieves balance by visual tension created between dissimilar objects
- Is predominant in contemporary interiors (Figure 3.27)
- Tends to be informal
- Is generally more active than symmetrical balance
- Provides a more spacious appearance

Radial Balance

In **radial balance** all elements of the design radiate from a central point like the spokes of a wheel radiating out from the hub. This balance can be seen in a room where chairs surround a round table, in flower arrangements, and in chandeliers. Radial balance is often used in large congregating areas such as hotel and office lobbies (Figure 3.28) and central areas in shopping malls. Radial balance is often a visually pleasing alternative and combines effectively with the other two types of balance.

All rooms require balance, and most rooms combine symmetrical, asymmetrical, and radial balance in different proportions. The combination of all three creates a pleasing effect that will remain interesting over time.

FIGURE 3.27 A 120,000-SF warehouse served as the base for this corporate office's marketing and field operations departments. Bold geometric shapes, such as the whimsical curved conference wall, create an asymmentrical balance and are juxtaposed to the angular reclaimed wood paneled wall. Polished concrete floors reflect the warehouse feel and contrast with warm color pallet, area rug, and oversized leather chairs.
(Designer: Smallwood, Reynolds, Stewart, Stewart)

FIGURE 3.28 The domed ceiling, floor pattern, and furniture arrangement in this investment office lobby indicate the use of radial design.
(Architect/Designer: VOA Associates, Inc. Photograph by Steven Hall/Hedrich-Blessing)

Rhythm

Rhythm assists the eye in moving easily about a room from one area to another, creating a flowing quality. Rhythm can be achieved through repetition, transition, and gradation or progression (Figure 3.29). The effective application of rhythm creates continuity and interest.

Repetition is rhythm established by repeating color, pattern, texture, line, light, or form. For example, a color in the upholstery fabric of a sofa can be repeated on a chair, the drapery, and a pillow, thus introducing rhythm. The repetition may also include alternating an object or pattern in a sequence (Figure 3.30). Repetition is a common means of achieving rhythm in a room because it is a relatively easy approach, although too much repetition can produce confusion, dullness, or lack of stability.

Transition, a type of repetition, is found in a curved line that carries the eye easily over an architectural element, such as an arched window, or around items of furnishings, like drapery swags. A curved chair placed in the corner of a room beside a round table will soften the sharp angle of the merging wall planes, allowing the eye to flow through the space. In Figure 3.31, the curved window softens the corner of the room, thereby providing a transition.

FIGURE 3.29 Types of rhythm: Repetition, transition, and gradation.

Gradation or *progression* is rhythm produced by the succession of the size of an object from large to small or of a color from dark to light. Radiating lines are not only a form of balance (as previously discussed), but may also be a form of gradation (note the ceiling recesses in Figure 3.28). Other examples include the progression of one step up to another step, the gradation of a small salt container to a medium-sized sugar container up to a large flour container, and a rug that might have a dark border, a lighter inner border, and a very light interior area.

Emphasis

Emphasis in a room refers to the focal point and supportive furnishings that create the center of attention. In every well-planned room, it is effective to have one feature repeatedly draw the eye. This emphasis or focal point can bring a feeling of order and unity into a room, with all other groupings subordinated to it (Figure 3.31). When there is a lack of emphasis in a room, the space is uninteresting. Too much emphasis (i.e., more than one or several centers of interest) can produce chaos and unrest.

Emphasis is greatly affected by visual perception. Our eyes naturally scan a room and seek out the focal point to provide a sense of repose. When scanning an image, our eyes are first drawn to the lower right-hand corner. In advertising, a company's logo is frequently located in this area. Natural axes (as part of an alignment or grid) also are created through focal points, drawing a person to an appointed location. Analyzing a room and determining what components to emphasize and subordinate can be a challenging task. A general approach includes viewing the room on four basic levels of emphasis and then determining what components will be featured.

1. *Emphatic.* These features may include a dramatic view, fireplace, or architectural feature. For example, if a fireplace is

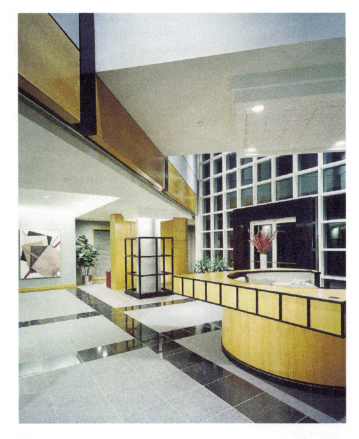

FIGURE 3.30 In this commercial interior, the designer repeated a square motif from the architecture into the interior lobby. Grids demarcate columns and floor tiles, and are repeated through the use of contrasting woods on the desk.
(Designer: Godwin Associates. Photograph by Gabriel Benzur)

FIGURE 3.31 In this large room, the curved window bay and large sofa soften the edges of the converging architectural planes. The focal point of the architecture is the fireplace wall. The stunning painting by J. D. Challenger commands attention as a result of its location and the elements of design used to draw the eye to this feature from any area in the room.
(Photograph by Mark Boisclair. Interior Designer: Carol Conway. Architect: Kevin Bain)

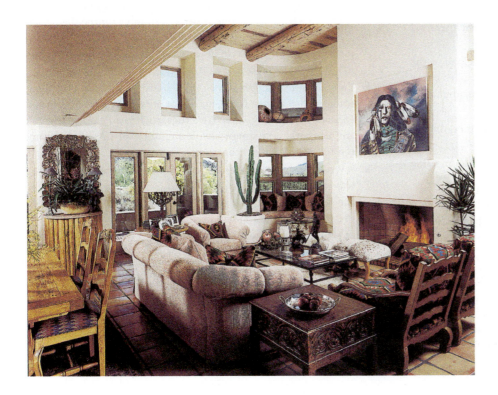

prominently placed and designed, it naturally becomes a focal point; in addition, a burning fire radiates warmth, movement, color, and hospitality—a natural site for a main seating arrangement. Many rooms, however, may not have an emphatic feature.

2. *Dominant.* In many instances, this is the level where most designers begin. In the absence of dramatic features in a room, a dominant focal point may exist or be created. A fireplace in this case may not be an architecturally dramatic feature, but it certainly can be played up and designed to dominate a room. Other dominant features might include a wall of books, a composition of paintings, a beautiful piece of furniture, or a garden view.

3. *Subdominant.* This category includes the level of furnishings that support the focal point and may include large pieces of furniture or the window, ceiling, and floor treatments. This might include an arrangement of furniture in front of a fireplace that supports the dominant focal point of the fireplace.

4. *Subordinate.* This level most often includes accessories such as lamps, plants, art objects, and small furnishings.

This method of analyzing a room and breaking it down into various levels of importance can aid the designer. Furnishings and architectural features can be rearranged within this framework depending on the desired outcome. The emphasis of the room may be planned or manipulated by the use of the elements and principles of design, such as the following:

- *Color* is probably the most important element by which a grouping may be brought into immediate focus. Color can be used artfully to achieve the desired amount of emphasis.
- *Form* usually involves arranging furniture within the space—placing furnishings so they focus on the point of emphasis. Unusual or strong form used for furnishings or architectural background can be dominant or even dramatic.
- *Texture*, whether rough, smooth, shiny, or dull, can help draw the eye to a particular item. The designer can use this tool to create dominance or to allow a component in the room to blend into the background.
- *Lighting* can be used creatively to tie the group together, dramatize, attract attention, or create a focal point.
- *Pattern*, especially a distinctive design with strong color or value contrast, can attract the eye to a desired focal point.

Because emphasis in a room is planned and even manipulated through the use of the elements of design, it is essential that all parts relate to and support each other.

Harmony

All the other elements and principles work together to promote *harmony.* Harmony is the unique blend of *unity* and *variety.* A unifying theme or common denominator should run through all component parts and blend them together (Figure 3.32). Exteriors and interiors are attractive when there is a pleasant relationship that provides unity, yet the aspect of variety is essential to provide interest. Variety can create the focal point or add the spark that enlivens the room. Following are some of the most common and important considerations when seeking a harmonious living environment:

- In every room, the *interior architecture* is a determining factor. Just as the exterior and interior architecture should be consistent, the furnishings of a room must also be in harmony with the background. For example, molded plastic chairs do not belong against formal eighteenth-century paneling, nor is a classic Louis XVI chair desirable against a heavy concrete block wall. A surprising juxtaposition of seemingly unrelated objects may occasionally add relief, but this practice requires sophisticated judgment.
- *Furniture* in the room should appear to belong there. Whether the room is large or small, furniture should be scaled accordingly. For example, if the architectural background is strong—perhaps with exposed beams and masonry construction—the furniture should reflect the same feeling.
- *Colors* appropriate to the style and scale of furnishings should be considered; however, today's interiors often show great flexibility in color usage. A sensitive approach to color harmonies in relationship to furnishings, background, and style is important in achieving an appealing result.
- The *textures* of surfaces (i.e., smooth, rough, shiny, or dull) help determine the success of a room's harmony. Textures should be compatible with the design and style of all furnishings. For instance, a heavy homespun fabric is generally not suitable on a formal Hepplewhite chair, nor is delicate silk damask usually at home on a rough-hewn ranch oak chair.
- A *window treatment* can contribute to the room's total harmony; planning a hard or soft line treatment suitable for the theme and style is essential. For example, ruffled cottage curtains are out of place in an Oriental-style house, and elegant damask swags are inappropriate for a country cottage.
- Carefully selected *floor coverings* help unify the scheme. Hard floor surfaces such as wood, tile, and stone are extremely versatile and enhance most living areas. Area rugs, such as a Persian Oriental, are appropriate in almost any decor, and wall-to-wall carpeting can tie an entire room together.
- *Accessories* can enhance a room or completely destroy the desired effect. If an accessory is not beautiful, useful, or meaningful to the person using it, it does not belong. The final touches added to a room reveal individual personality more readily than do any other items of furnishing and cannot be overlooked in creating rooms of beauty and interest. Items that are essentially attractive and well designed, however, can lose their charm when not well used. For example, a gracefully scrolled wrought-iron wall sconce can add much to a room of Spanish or Mediterranean styling but would look heavy and out of place in a pastel room with delicate furnishings. (Chapter 13 discusses accessorizing in greater detail.)

■ Consistency or harmony is achieved by carrying out a basic *style*. The style need not be followed slavishly, but a general feeling of unity should be maintained throughout (see the last section in the pictorial essay, Style Selection). This allows the designer to combine good design from many periods, with one dominating. Within this overall style, an occasional surprise to give variety and interest can provide charm and individuality. Consistency or harmony is also achieved when a *concept* has been established and followed. The concept may incorporate the basic style, but extends beyond the concrete elements to include abstract characteristics appropriate to the design solutions.

SUMMARY

The elements of design (space, line, shape and mass, texture, light, color, and pattern) and the principles of design (scale and proportion, balance, rhythm, emphasis, and harmony) form the foundation for all designs. The ordering of these elements and principles creates a visual literacy that, when combined with the design process discussed in Chapter 1, helps to ensure a quality design that satisfies the needs and desires of the client. All of these elements and principles, including color and light (which are discussed in following chapters), help the designer create an interior that is physically and psychologically comfortable, as well as uniquely attractive.

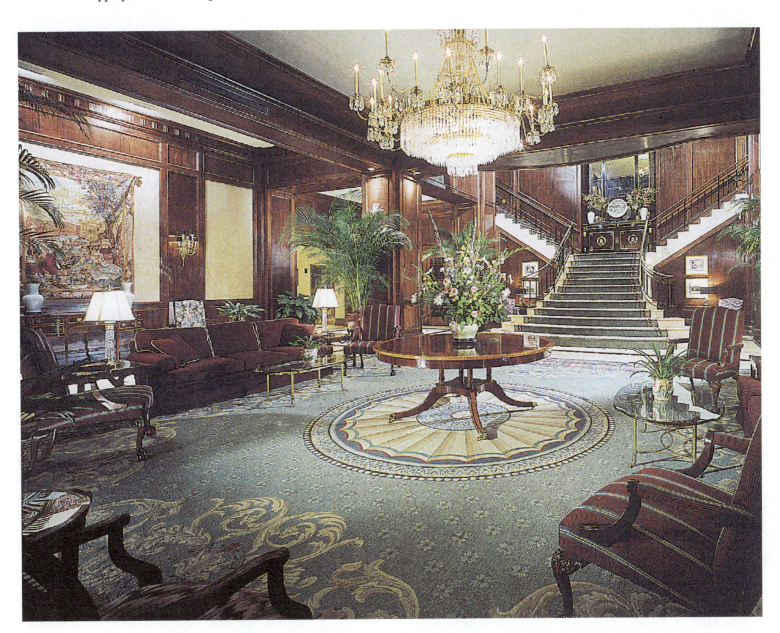

FIGURE 3.32 In this hotel lobby, color, form, texture, light, and pattern all creatively support the central focus. Plants soften architectural edges, and a custom carpet defines the seating area and grand staircase. The elements and principles of design work together to create a harmonious interior bridging unity and variety.
(Designer: Marcia Davis & Associates, Inc. Photograph by Peter Paige. Courtesy: Lacey-Champion, Inc.)

4 Color

FIGURE 4.1 This vibrant restaurant uses brilliant color of intense chromas. Color defines this interior space.
(Architect/Designer: Engstrom Design Group and To Design. Photograph by Dennis Anderson ©)

The great nineteenth-century writer and critic John Ruskin said, "Color is the most sacred element in all visual things." Designers agree that color is the most vital and expressive of the elements of design, as demonstrated in Figure 4.1. Therefore, it is essential that designers have a thorough knowledge of the properties and character of various colors, color theory, color schemes, color associations, and other considerations of color for use in planning both residential and commercial interiors.

Color can have psychological effects; it can enliven a room or create a subdued mood. Color's elemental partner—light—can do the same thing. Light affects the colors we see. In bright afternoon sun, colors are crisp and clear. In evening sunsets, red and orange tones cast a warm glow. In candlelight or moonlight, colors are muted and dulled. It is essential when studying about color to understand first that the source of color is light.

■ LIGHT IN COLOR

Light is a form of energy that is part of the electromagnetic spectrum. Daylight, or the light that humans are able to see in the *visible spectrum*, is a mixture of wavelengths in a narrow band of this field. Infrared waves, X rays, and even radio waves are also forms of energy in this spectrum, but are not visible to the human eye. Color is light broken down into electromagnetic vibrations of varying wavelengths. The longest

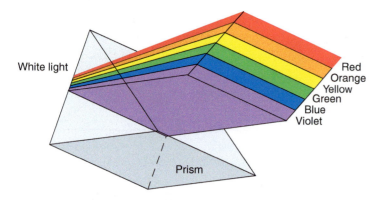

FIGURE 4.2 A ray of white light passed through a prism separates into distinct bands of color. The longest wavelength in the visible spectrum is red, followed by orange, yellow, green, blue, and violet, the shortest visible wavelength.

wavelengths form the reds, followed by oranges, yellows, greens, blues, and violets. This effect can be seen in a rainbow or when light is shown through a prism, which separates or splits the spectrum (Figure 4.2). Artificial lighting that is designed to mimic the sun's light is called white light. Other types of artificial lighting create different combinations of wavelengths that change the color or *look* of an object. Lighting is discussed in greater detail in Chapter 6; however, it is important to realize that without light, color would not exist.

The color that we actually see in an object is the color of light that is not absorbed by the object, but reflected into the eye from the object's surface. A particular surface, depending on its composition, absorbs or reflects a color of the spectrum. This is referred to as **subtractive color** because the objects *subtract* all the wavelengths except those that are seen. For instance, a teal rug subtracts all the wavelengths except for some of the blue and green wavelengths, which it reflects back. A black tiled wall subtracts all the wavelengths.

The colors in objects are referred to as pigment colors. Pigments are various substances that can be ground into fine powder and used for coloring dyes and paints. Pigments are combined to produce certain colors, such as when red and yellow are mixed to obtain orange. Pigments may be naturally occurring (as discussed in the feature on sustainable design), artificially created, or a combination of both.

■ WARM, COOL, AND NEUTRAL COLORS

Colors are grouped into categories. The simplest division categorizes all colors as warm, cool, or neutral.

Warm Colors

The *warm colors* of the spectrum include red, red-orange, orange, yellow-orange, and yellow. Generally, these warm colors are considered engaging, active, positive, cheery, cozy, and stimulating. Warm colors tend to advance and can enclose space. If used in strong intensity in large areas, warm colors may cause individuals to feel irritable.

Cool Colors

The *cool colors* are blue, blue-green, green, violet, and blue-violet. Cool colors are generally felt to be relaxing, restful, and soothing. Cool colors

recede and tend to expand space. Cool-colored rooms may be perceived as cold and unfriendly, and may lack variety.

Neutral and Neutralized Colors

Technically, the *neutral colors* are gray, white, and black because they are without an identifiable **hue** (another word for a color). These neutral colors are often called "achromatic," which in Greek means "without color."

Colors falling midway between the warm and cool color groups, such as beige, brown, taupe, cream, ivory, off-black, and off-white (white with a small amount of any color added), are called *neutralized colors*. Neutralized colors are generally important to every color scheme. They tend to be restful, tranquil, livable, unobtrusive, and supportive. If not used effectively, however, neutral and neutralized colors can produce feelings of boredom and weariness.

■ THE STANDARD COLOR WHEEL

Warm and cool colors can be distinguished most easily using the standard color wheel (Figure 4.3). This theory of color is known as the Palette theory, the Prang theory, or the Brewster color theory; it is the simplest and best known of the color theories or systems. The standard color wheel system is based on three *primary colors:* yellow, red, and blue (Figure 4.4). Primary means that these colors cannot be mixed from other pigments, nor can they be broken down into component colors. Theoretically, with five tubes of paint—the three primaries plus black and white—one could produce the entire range of colors, although the degree of precision needed makes this almost impossible. By using the three primaries, however, the twelve colors of the complete wheel can be derived.

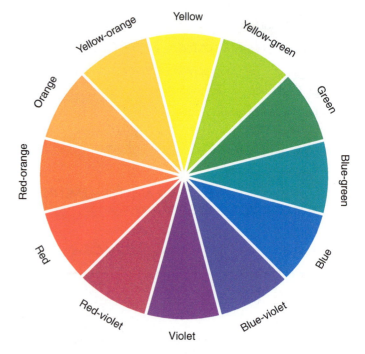

FIGURE 4.3 The standard color wheel. It is often referred to as the Prang color wheel, but was originally developed by David Brewster for the Brewster color theory.

FIGURE 4.4 Primary colors.

FIGURE 4.5 Secondary colors.

FIGURE 4.6 Tertiary or intermediate colors.

Equal amounts of any two of the primary colors result in a *secondary color* (Figure 4.5). The wheel has three such colors: green, which is produced by mixing yellow and blue; violet, by mixing blue and red; and orange, by mixing red and yellow. Each secondary color lies midway between the primary colors from which it is formed.

In similar fashion, a *tertiary color*, or intermediate color, is created by mixing equal amounts of a primary color and a secondary color (Figure 4.6). These hues also are situated midway between the two hues that produced them and are identified by hyphenated names such as blue-green, red-orange, and red-violet.

■ COLOR'S THREE DIMENSIONS

The three dimensions of color (hue, value, and intensity or chroma) can be accurately measured and are essential in visualizing and describing any color.

Hue

Hue, or the color name, is a singular characteristic that sets each color apart from all the others. A color may be lightened or darkened, made more intense or less intense. If blue is the hue used, the result will be light blue, dark blue, bright blue, or gray-blue, but each will be of a blue hue. In all, about 150 variations of full chroma of hue exist, of which only 24 basic hues of full chroma have enough variation to be of practical use.

Value

Value is the degree of *luminosity*, or *lightness or darkness* of a hue in relation to black and white. Nine such gradations are easily visible to the

eye (Figure 4.7). The value of any hue can be raised by adding white; this forms a **tint**. The value is lowered when black or another darkening agent is added; this is called a **shade**. For example, a tint of red is pink; a shade of red is burgundy.

In addition to shades and tints, a third classification is **tone**. A tone is formed by adding both black and white to the hue. These grayed hues are extremely useful in creating color schemes in which muted colors are necessary to tone down the brighter hues (Figure 4.8).

FIGURE 4.8 Although black and white pigments are not considered true colors, their addition to colored pigments produces tints, shades, and tones. Adding black to a pigment color produces a shade; adding white produces a tint. Adding gray (a mixture of black and white pigments) to a color produces a tone.

FIGURE 4.7 In the nine gradations of value from white to black, the small circles are identical in shade, demonstrating that the eye perceives color not in itself but in relation to its environment.

A B

FIGURE 4.9 In this example, the green on the left exhibits a high intensity, but when green's complementary color red is added, the intensity is lessened.

Intensity or Chroma

Intensity or **chroma** is the *degree of saturation* of pure color. It describes the brightness or dullness and strength or weakness of the pure color that a hue contains. Just as any color may be raised and lowered in value by the addition of white or black, its intensity may be strengthened by the addition of pure chroma or lessened by the addition of its complement (the color directly across from it on the standard color wheel). The more of the color's complement that is added, the less pure color the original hue contains. Two colors may have the same hue and the same value, yet be markedly different because of their different color strength or intensity (Figure 4.9). Strong chroma visually enlarges objects.

The skillful application of color, value, and intensity can play a vital role in creating exciting and livable interiors. Even when all the hues in a room work together, it may lack interest. Adding a contrasting value or intensity to the color harmony can provide interest and variety.

More info online @
www.sherwin-williams.com/do_it_yourself/paint_colors/paint_colors_education/color_theory/index.jsp Sherwin-Williams color theory

■ CREATING COLOR SCHEMES

Planning and organizing color schemes can be a challenging and satisfying task. Endless color possibilities are available. Individual color preferences are naturally a consideration. Harmonizing colors from the standard color wheel is a popular approach.

The basic color schemes are achromatic, monotone, monochromatic, analogous, and complementary. Color schemes may also emphasize international influences, as seen in the shibui and feng shui color palettes. Although professional interiors seldom fit a specific scheme perfectly, most rooms can be classified into one of these categories.

Achromatic

An **achromatic** color scheme is created by utilizing black, white, or variations of gray. It contains no identifiable hue, only values (Figure 4.10). Accent colors in art or foliage may enhance achromatic interiors, but do not affect the color scheme.

FIGURE 4.10 This achromatic color scheme is an effective choice in the kitchen and dining room, allowing for the color of the foods to dominate.
(Designer: Pineapple House. Photography by Scott Moore)

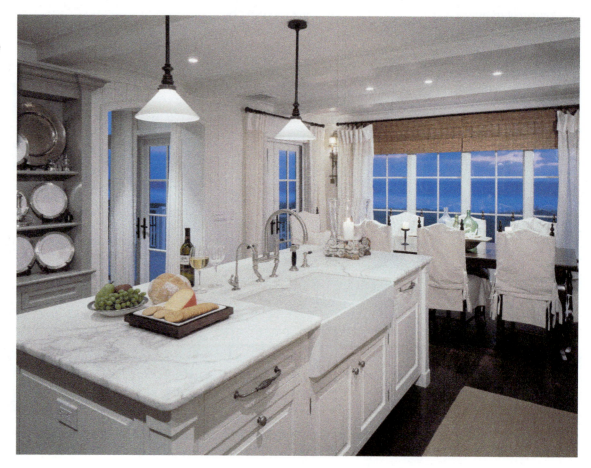

Monotone

Monotone color schemes are created from a color with low chroma. In other words, they contain some chroma as opposed to the achromatic or no-chroma scheme. Neutralized colors fall halfway between warm and cool colors and can be employed as tints, tones, or shades. The most typical neutralized or monotone colors include off-white (white with a small amount of any hue), off-black (a rich brown-black), beige, cream, tan, and brown (Figure 4.11). Accents of stronger chroma may be used for smaller furnishings and accessories without changing the neutral scheme and can add visual interest.

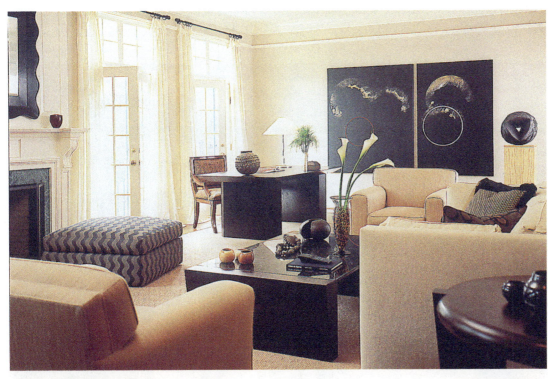

FIGURE 4.11 Monotone colors have been applied in this sophisticated yet relaxed interior. A hint of yellow adds warmth to the contemporary living space. Strong art adds accent and interest.
(Designer: David Mitchell. Photographs by Scott Frances. Courtesy of Southern Accents)

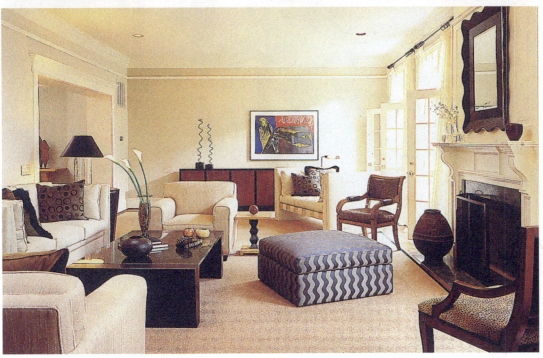

Monochromatic

Monochromatic color schemes are developed from a *single hue*, but with a range of values and different degrees of intensity. Unity is probably the most notable element in this type of scheme, and if light values predominate, space will appear to be expanded. A danger in the one-color scheme may be monotony; however, looking to nature, where monotony is never present, the guidelines are clearly apparent. When examining the petals of a rose, one may see shadings from soft, delicate pink to deep red. The variety of tones, tints, and chroma of a green leaf can be combined in a room using the subtle neutralized tones for large wall areas, slightly deeper tones for the carpet, medium tones for large furniture, and vivid chroma for accents.

Monochromatic schemes are often further enhanced by the use of textures such as fabric, wood, stone, metal, and glass (Figure 4.12). Pattern also can add variety and character to the one-color scheme. Black and white can be used without changing the character and, in fact, may sharpen the scheme and add interest.

FIGURE 4.12 In this dramatic monochromatic room, the interior designer was presented with a plain vanilla interior and awkwardly placed clerestory windows. Floor-to-ceiling draperies provide window camouflage, and the red fabric serves as the stimulus. A variety of textures adds to the room's ambience.
(Designer: Jackie Naylor Interiors. Photograph © Robert Thien)

Analogous

Analogous color schemes are produced from any segment of colors that are adjacent, but contain no more than half the colors on the standard color wheel, as seen in Figure 4.13. Harmony is easily established with analogous colors because generally one dominant color should be present. Yellow, for example, is the common factor in orange and green, and by using the intermediate colors of yellow-orange and yellow-green, an interior designer can achieve a close relationship among a great variety of values and intensities.

Complementary

Complementary or contrasting color schemes also are widely used because they offer variety. Values and intensities may vary depending on the use and the amount of area to be covered. All contrasting hues placed side by side enhance each other and, if they are of similar intensity, each makes the other seem more intense. Complementary schemes always contain warm and cool colors because they are opposite on the color wheel. In strong chroma they are lively and vigorous; in grayed tones they may be subtle and restful. One dominant hue usually sets the mood.

FIGURE 4.13 This warm and inviting room is the result of conscientious design decisions. The table, for instance, is a custom height to fit the client's stature. Faux-finished walls add depth and texture. Antique and conventional lighting are combined to enhance the analogous color scheme. *(Designer: Tory Winn, IIDA, RID, Agora Studio, Inc. Photograph by Brian Gassel)*

| Monochromatic (one-color plan) | Analogous (three- to six-color plan) | Direct complement (two-color plan) | Split complement (three-color plan) | Triad complement (three-color plan) | Double complement (four-color plan) | Alternate complement (four-color plan) | Tetrad (four-color plan) |

FIGURE 4.14 Basic color schemes derived from the color wheel.

Six types of complementary schemes are direct complement, split complement, triad, double complement, alternate complement, and tetrad, as illustrated in Figure 4.14. The most commonly used ones are defined next.

Direct Complement

The *direct complement*, the simplest of the contrasting color schemes, is formed by using any two colors that lie directly opposite each other on the color wheel. One of the hues should dominate. Used in equal amounts and in strong intensity, complementary colors clash, thus creating an unpleasant element in a room. The secondary color, therefore, works best when neutralized or used in small areas (Figure 4.15).

Split Complement

The *split complement* is a three-color scheme composed of any hue plus the two hues next to its complement. For example, if yellow is selected as the dominant color, red-violet and blue-violet are the complementary colors. These colors contrast less than the direct complement, which is violet. Red has been added to one and blue to the other, giving softness to the scheme and at the same time adding variety.

Triad Complement

The *triad complement* is another three-color contrasting scheme. The triad is made up of any three colors that are equidistant on the color wheel. These colors may be sharp in contrast, using strong chroma such as the three primaries—red, yellow, and blue, or red-orange,

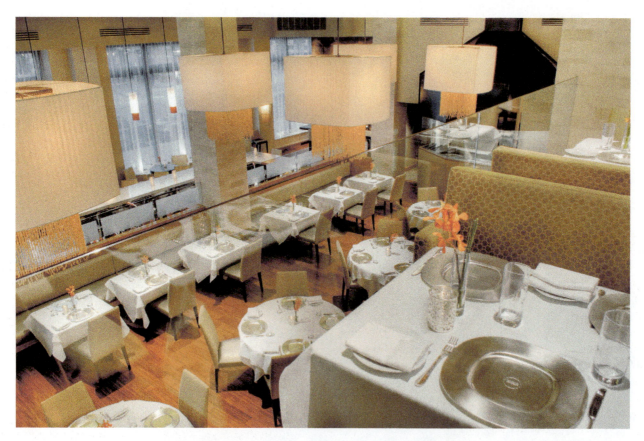

FIGURE 4.15 The color scheme for this Indian cuisine restaurant is a based on a direct complement. A cool olive green textile is complemented by warm teak wood floors and banquettes. The limestone columns, steel accents, and marble floors are softened by custom light fixtures, copper accents, and fabric table cloths and sheers. A mezzanine level offers an exceptional overlook.
(Architect/Designer: Wid Chapman Architects. www.widchapman.com. Photograph by Bjorn Magnea)

yellow-green, and blue-violet—or they may be neutralized, raised, or lowered in value to produce a tranquil scheme.

Shibui

Shibui (pronounced shih BOO ee) or shibusa expresses in one word the Japanese approach to beauty as well as the intrinsic nature of Japanese culture. No single word in the English language precisely describes shibui. It suggests an appreciation of *serenity* and a protest against ostentation. Belief in the power of the *understated and unobtrusive* dominates this sophisticated philosophy.

To produce a shibui effect, colors are brought together to enhance each other in a harmonious whole that will be deeply satisfying to live with for a long time. Schemes must have depth and complexity, or they will soon become tiresome. The following ideas are incorporated in achieving a shibui effect:

- Pattern and texture in nature are everywhere, but they have to be discovered through close examination.
- The shibui concept of color is based on nature. Colors found in the largest areas are quiet and undemanding (neutralized). Bright, vibrant colors are found in a small proportion.
- Nature has thousands of colors, but none of them match or are uniform. In nature, the darker, more solid colors occur underfoot. As one looks upward, colors become lighter and more delicate.
- Most of the natural landscape shows a matte finish with little shininess or glitter, such as the sun sparkling on a ripple in a stream.
- No two patterns are identical, yet unity prevails. Although natural colors, textures, and patterns appear simple, on close scrutiny they prove highly complex.

American architect Frank Lloyd Wright greatly admired the shibui design philosophy and incorporated its concepts into many of his works.

Feng Shui

The feng shui (pronounced fung shway) color scheme is based on several ancient Chinese philosophies and practices. One such system, the compass mythology, is rooted in the Pa Kua (pa gwa), an eight-sided symbol that corresponds to the four compass directions and their sub-directions.

Feng shui color schemes are interpreted differently for each individual based on the birth year, which also relates to the person's basic elements of earth, water, wood, fire, and metal. For instance, green represents wood; therefore, someone born in the year of wood might use green as a color scheme. The person would avoid red, which is associated with fire, because fire destroys wood.

In a feng shui color scheme, white is highly valued because it is associated with light. Black is used selectively. Because it represents water and money, black is valuable, but it is also the opposite of light and therefore should be applied carefully.

Another overlying principle of feng shui is the appropriate balance of the yin and the yang, which represent a balance of complements or dualisms. Successful feng shui color schemes create a harmony of these balances.

■ COLOR THEORISTS AND THEORIES

A number of color theories, or color systems, have been developed and are used by interior designers. Some incorporate psychological as well as physical factors. Johannes Itten (1889–1967) originated his ideas on color while a teacher at the Bauhaus in Germany during the 1920s. One of his theories, "Four Seasons—Personal Color Analysis," is based on color palettes associated with the four seasons of the year. Josef Albers (1888–1976) was a pioneer of modern design and a teacher and color theorist at the Bauhaus in Germany and later at Yale University. He is known for his theories on color perception. Albers's series of paintings entitled *Homage to the Square* demonstrates how one color reacts when placed next to another color. He found that color changes greatly as a result of its environment.

A variety of color systems have been produced, each based on a different group of basic colors. The three most common are:

- The **Brewster color theory/system**, **Prang color wheel**, or Palette system (already discussed), based on three hues: yellow, red, and blue
- The **Ostwald color theory/system**, based on four principal hues: yellow, red, blue, and green, plus black and white
- The **Munsell color theory/system**, which begins with five hues: yellow, red, blue, green, and purple

The Ostwald System

The Ostwald system was named after its creator, Friedrich Wilhelm Ostwald (1853–1932). The Ostwald color wheel, which uses yellow, orange, red, purple, ultramarine blue, turquoise, sea green, and leaf green, is based on hue plus the white content and the black content of the hue. Theoretically, 24 hues can be derived from mixing these hues plus pure white and black. There are 28 variations of these 24 hues, resulting in a total of 672 hues and 8 neutrals. The cool group of hues is on one half of the circle and the warm group of hues on the other half of the circle. Ostwald arranged the hues in a conical configuration with a value and chroma scale similar to Munsell's system (Figure 4.16).

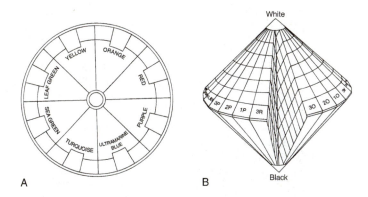

FIGURE 4.16 The Ostwald color system. (A) The Ostwald color wheel is based on 24 hues that are either a pure hue or mixed with a pure hue plus white and black. The principal hues are yellow, orange, red, purple, ultramarine blue, turquoise, sea green, and leaf green. The other 16 hues are intermediate hues of these colors. (B) The hues and their ranges of value and chroma are arranged to form a three-dimensional double cone.

The Munsell System

The Munsell system of color notation is essentially a scientific concept of describing and analyzing color in terms of the three dimensions of hue, value, and chroma. The designation of each color is written as H v/c (Figure 4.17). Hue is indicated by the capital letter H, followed by a fraction in which the numerator represents the value and the denominator indicates the chroma. In the figure, hue is indicated by the circular band.

Value is indicated by the central axis, which shows nine visible steps from darkest value at the bottom to lightest value at the top, with 5/ for middle gray. Pure black would be designated as 0/ and pure white as 10/.

In the Munsell system, chroma, the Greek word for color, is used instead of intensity. The chroma notation is shown by the horizontal band extending outward from the value axis. It indicates the degree of departure of a given hue from a neutral gray of the same value.

Related Color Systems

No one color system is universally accepted. Most industrial nations have their own systems of color classification and, regrettably, these systems are not interchangeable. Those working with color generally use the type of color system that best suits the needs of a particular project. In addition to the Brewster, Ostwald, and Munsell systems, other color systems are available to the designer. Two of the best known are the *Gerritsen color system*, based on color perception and six primary colors, and the *Kuppers color system*, based on six primary colors: blue, green, yellow, red, cyan (a blue-green), and magenta.

In addition, many major paint manufacturers have made available convenient color systems, color keys, and color codes that coordinate colors in particular ways with their products. The colors usually are coded according to cool, warm, and neutral harmonies.

Computer Applications

The computer is capable of performing many design-related tasks including color analysis and color matching. Currently a number of corporations offer designers and other clients color matching based on the latest computerized matching technology. These systems contain thousands of color samples for project specifications. Computerized colorant formulation systems can reproduce and record approximately 16 million colors. Furthermore, they can accurately combine and reproduce these colors, showing such criteria as light reflection and textural effects, and can even deal with **metamerism**—the tendency of samples that match under one light to appear mismatched under a different light. Printouts can show how the specified colors will appear in a particular setting—a valuable tool for the designer.

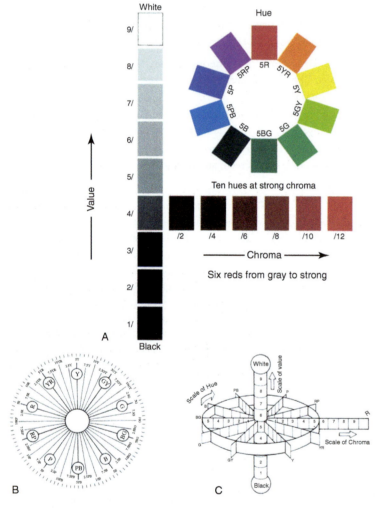

FIGURE 4.17 The Munsell color system, including hue, value, and chroma relationships. (A) The circular band represents the hues in their proper sequences. The upright center axis is the scale of value. The paths pointing outward from the center show the steps of chroma increasing in strength, as indicated by the numerals. (B) Hue notations of the five principal and the five intermediate hue families are encircled. A breakdown into 100 hues is indicated by the outer circle of markings, and the breakdown of each hue family into four parts (2.5, 5, 7.5, and 10) indicates the 40 constant-hue charts appearing in the Munsell Book of Color. (C) Hue, value, and chroma are shown in relation to one another. The circular band represents the hues in their proper sequences. The upright center axis is the scale of value. The paths pointing outward from the center show the steps of chroma, increasing in strength as indicated by the numerals. *(Courtesy of Munsell Color Company, Inc.)*

◼ PSYCHOLOGICAL AND PHYSIOLOGICAL EFFECTS OF COLORS

Color creates powerful psychological and physiological (or physical) effects. Psychological effects are sensed in the mind; physiological effects actually cause a change in the body. It is important to note that people may react differently to the same color, based on their previous experiences or learned behavior. Research studies have shown that:

- Color affects an individual's moods or feelings in regard to space. Light and cool colors seem to expand space; dark and warm colors seem to enclose space.
- Color affects the eye's perception of weight and size. Dark and bright colors seem heavier than light and cool colors. However, it is interesting that the opposite effect is true in fashion design. Dark colors tend to slim the figure, whereas light colors are usually thought to make one look heavier.
- Color affects a person's perception of temperature. Studies have indicated that body temperature actually fluctuates in response to various colors. For example, red, orange, and yellow can raise one's temperature; cool colors have the opposite effect.
- Color can cause feelings of boredom and calmness, or stimulation and liveliness. Colors may cause the nervous system to become agitated, and the body reacts in negative ways to this stimulus.
- Colors can affect one's reaction to sounds, taste, odors, and time perception.
- Colors can improve the rate of recovery of sick patients.

Feelings and Reactions to Individual Colors

Emotional reactions associated with color are spontaneous. The reaction, often due to the perception of a color rather than to the color itself, may be positive or negative. The following section discusses typical feelings and reactions that may be created by colors; however, remember that clients may react differently to the same color.

Red (Warm Group—Primary Color)

Psychological and physiological associations Courage, passion, love, excitement, danger, martyrdom, anger, fire, strength.

Application Red is conspicuous wherever it appears, and because it is lively and stimulating, it should be used with care. Red mixes well, and most rooms are enhanced by a touch of one of its tones. A variety of popular colors are derived from red when it is lightened, darkened, brightened, or dulled. For example, when red is darkened and muted it becomes maroon, and when it is lightened it becomes pink (Figure 4.18). Pink, a delicate and flattering color, is often enhanced by a stronger contrasting color and blends especially well with grays, browns, greens, blues, and purples.

Orange (Warm Group—Secondary Color)

Psychological and physiological associations Cheerfulness, stimulation, sunset, excitement. When lightened and muted, the peach tone may appear cool or refreshing.

FIGURE 4.18 In this guest suite, the dominating rosy pink carpet is cooled by white walls and cream furnishings. A hint of pink is seen in the striped drapery treatment, accent pillows, art, and trim on the chairs. Antiques blend with contemporary furnishings to create a stunning room.
(Designer: Pineapple House Interior Design. Photography by Scott Moore)

Application Like red, orange has stimulating properties but is not as demanding. Peach tones enhance human skin tones. Peach also serves as a cross between a warm and a cool color, partly due to its association with the fruit.

Yellow (Warm Group—Primary Color)

Psychological and physiological associations Cowardice, deceit, sunlight, optimism, warmth, enlightenment, and communication.

Application High-noon yellows are the most revealing and demanding and merit careful attention. Gray-yellows of early dawn are foils for more fragile colors—pinks, blues, and pale greens. Warm afternoon yellow is a foil for rich, warm woods. The burnished yellows of brass give a cast of copper gilt and bring life to a room. Gold provides an elegant and luxurious touch, especially for accents or accessories. All yellows are reflective, take on tones of other colors, and add flattering highlights (Figure 4.19).

Blue (Cool Group—Primary Color)

Psychological and physiological associations Honesty, truth, loyalty, masculinity, formality, repose, tranquility, sobriety, sky, depth of sea.

FIGURE 4.19 A warm color palette of golds and burnt oranges welcomes guests to this hotel lobby at the Chicago Hyatt McCormick. Warm tones are known for their optimism, cheerfulness, and excitement. The palm trees and vibrant setting are an intentional contrast to the wintry environment of the Windy City.
(Photo by Brian Gassel/tvsdesign)

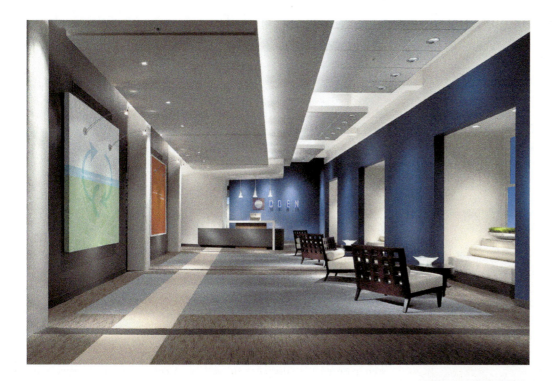

FIGURE 4.20 Cooler tones of deep blue and gray create a professional image for this marketing firm. The neutral carpet strip draws visitors to the reception desk, while art on the left-hand side balances the large windows on the right. A dynamic play in ceiling planes creates an illusion of height.
(© Jeffrey Jacobs)

Application Blue is cool and soothing, recalling sky, water, and ice (Figure 4.20). It is difficult to mix and varies greatly under different lighting. More than any other color, blue is affected by the different materials it colors. Lacquer and glass, for example, have a reflective quality that intensifies blue. In deep-pile carpet, blue has great depth. Nubby fabrics soften blue. Shiny materials make blue look frosted. Light blue can give a ceiling a cool and celestial appearance. Blue can be somber, cold, and even depressing if not used effectively.

Green (Cool Group—Secondary Color)

Psychological and physiological associations Nature, serenity, hope, envy, safety, peace, passivity, security.

Application Fresh and friendly, green is nature's color and is a good mixer, especially yellow-green and spruce or forest green (Figure 4.21). White brings out green's best qualities. When grayed, warmed, or cooled, green makes an excellent background. When lightened, it is retiring and restful. Green is particularly pleasing in food areas. Deep, dark green is a favorite color for floor coverings.

Violet (Cool Group—Secondary Color)

Psychological and physiological associations Royalty, nobility, snobbery, power, drama, opulence, mystery, worship, dignity.

Application Naturally a dark value, violet is a blend of blue and red. When pink is added, it becomes warm, and a touch of blue makes it cool. It combines well with both pink and blue. A light value of violet produces lavender. Other violet hues are plum, eggplant, and lilac. Often violet is used in small amounts as accents. It can be dramatic or even disturbing when used on large surfaces.

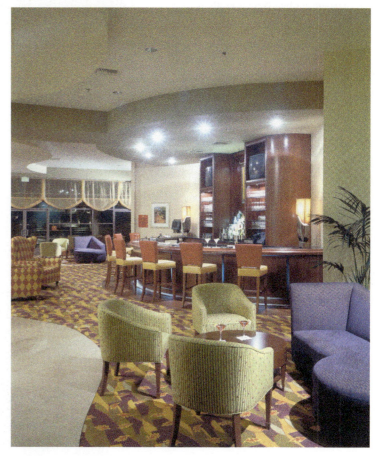

FIGURE 4.21 Crisp, cool yellow-greens are married with deep blue-purples to create an upbeat lounge area in this resort hotel. Curved floors, sculpted ceiling drops, and comfortable rounded furniture define the lively interior. The area rug provides a vibrant and playful accent.
(Designer: Design Directions, Inc. Photography by Neil Rashba)

White (Neutral Color—Achromatic) and Off-White (Neutralized Color)

Psychological and physiological associations Purity, cleanliness, sterility, sophistication, freshness.

Application White and off-white have the quality of making all colors in a room look cleaner and livelier. Warm off-white is considered unequaled as a mellow background color and works wonders in blending furniture of different woods and styles. Changes of light from day to night are kind to off-white and give it quiet vitality. White and off-white can create a mood of sterility and emptiness if used alone.

Black (Neutral Color—Achromatic) and Off-Black (Black-Brown—Neutralized Color)

Psychological and physiological associations Mourning, sorrow, depression, sophistication, mystery, magic, night.

Application Black and off-black (a rich black-brown) in furniture finishes, small areas of fabric, or accessories add an important accent that makes other colors crisp and clear. When used for larger areas, black can be extremely dramatic but can also be oppressive and claustrophobic.

Gray (Neutral Color—Achromatic)

Psychological and physiological associations Penance, gloom, storm, fog, depression, wisdom, intelligence, business, high-tech, sophistication.

Application Gray is used when a neutral appearance is desired. It may be tiring or monotonous without colorful accents for other furnishings. Gray is a good mixer with other colors, especially pinks, purples, and blues. Dark gray on large areas may be depressing. Light gray provides a pleasant background color.

Brown (Neutralized Color)

Psychological and physiological associations Earth, wood, warmth, comfort, security, support, stability.

Application The homeyness of brown tones makes them universal favorites, especially for furnishings made of wood. Ranging from pale cream beige to deeper chocolate brown, these tones, tints, and shades can be used together in a room to give infinite variety. Light browns, such as beige, make excellent supportive backgrounds.

Studies in Color

Knowledge of the psychological and physiological effects of color is immensely valuable to the designer when planning both residential and nonresidential spaces. For example, responding to the generally accepted notion that red will excite one to action and blue will calm one's nerves, some athletic directors have painted their players' dressing rooms in bright reds and oranges and visitors' dressing rooms in pale blues. The directors claim that it works.

In another example, a *Los Angeles Times* article by John Dreyfuss reported that a meat market in Chicago lost business when the walls were painted a bright, cheerful yellow. A color consultant quickly informed the owner that the yellow walls caused a blue afterimage. It gave meat a purplish cast, making it appear old and spoiled. The walls were repainted bluish green, creating a red afterimage that enhanced the appearance of meat, and sales zoomed.

Some color studies have revealed the following:

- Workers function more efficiently in surroundings painted in pleasant colors than they do in drab environments (Figure 4.22).
- Young people in detention homes responded more positively when dull-colored walls were repainted in a bright color.

FIGURE 4.22 The brightly accented conference room enlivens the work environment. A space for presentation displays and storage area are also created by the accent wall. Circular conference tables also promote impartial dialogues. *(Architect/Designer: Cooper Carry. Photograph by Gabriel Benzur)*

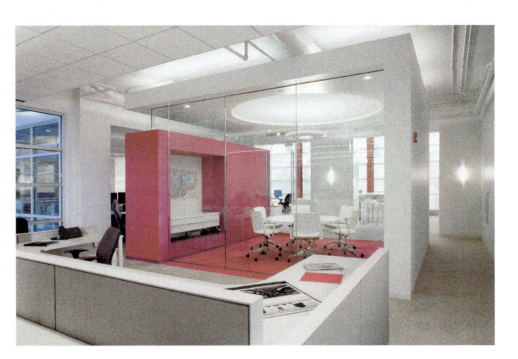

- Most people prefer to eat from a white dinner plate rather than a colored one.
- Doctors' offices painted in soft, calming colors, as opposed to stark white, make patients feel more comfortable.
- Fast-food restaurants tend to use bright, warm colors for interior surfaces to stimulate the appetite and hurry patrons through their meals.
- Warm color tones are best in hospitals and nursing homes; cool, calming colors are more appropriate in intensive care facilities.
- After factory workers complained how heavy their black boxes were to carry, a color expert painted the boxes light blue. The workers then congratulated management on making the boxes lighter.

The knowledge on which popular assumptions about color are based is often superficial. But color and emotion are closely related, people react differently to color, and individuals have definite color preferences. Authorities do not agree on the emotional effects of color, nor do they know whether emotional reactions to colors are inherent or learned.

Multiculturalism and Color

Color, like music, is an international language. Throughout the world, many objects are identified by their coloring. However, colors may have different meanings in different cultures. Green is universally accepted as a sign of nature, freshness, or ecology. Green Day in Japan is celebrated for the Emperor Hirohito because he loved gardens. To Muslims green is a sacred color, and to the Celts green was associated with fertility.

According to *The Indian Tipi* by Reginald and Gladys Laubin, to Native Americans, white used during one ceremony may symbolize the north, yet in the next ceremony the north may be represented by blue; the significance of color originates in the visions of the individual.

In Western culture, white is associated with purity and piety; however, in many Asian cultures, white is the color of mourning. This is true in China, but white is also symbolic of light and therefore very auspicious in that country. Red symbolizes happiness and is used at weddings.

In ancient China, yellow had religious significance. In ancient Greece and Rome, red was believed to have protective powers. Purple was the imperial color of the ancients and was restricted for the use of the nobility—hence the term "royal purple." When the remains of Charlemagne (742–814) were disinterred in the middle of the twelfth century, the coffin was found to contain robes of sumptuous purple velvet.

African cultures place much significance on color and how it is used in patterns. The palette is derived from the desert surroundings, such as savanna green, ivory, maze, and bright yellows. According to Rodemann in *Patterns in Interior Environments*, these colors represent strength and independence to the Africans.

Designers working with clients from different cultures need to be sensitive to cultural color associations. Careful observation, thorough research, and comprehensive programming will help prevent cultural color mistakes.

Reflecting Personality

Color is a valuable design tool for reflecting personality. Obviously, the problem of selecting colors that reflect personality is compounded when a number of individuals are to use the same interior space. The opinions of all occupants should be considered before final color decisions are made. Current trends may be taken into account but need not be the determining factor. Regardless of what colors are in fashion, the personal preferences of the occupants should always be the primary consideration.

Reflecting the Character of the Room

More than any other element, color is capable of setting the general mood of a room. Strong chroma tends to create a feeling of informality; soft neutralized hues are generally reserved for a more formal atmosphere. Because rooms are backgrounds for people, color is generally most pleasing when not too demanding. The psychological effect of large areas of intense color can be irritating, so it may be wise to select colors in softly neutralized tones for large background areas in rooms where the occupants spend considerable time. General color moods can be evoked for specific areas of the home or office.

The *entrance hall* introduces the home the same way a *reception area* introduces an office space or hotel lobby. The entrance area can effectively set the feel of the space.

Living areas, boardrooms, or *conference rooms* used for more formal purposes generally have neutralized color schemes that tend to produce an atmosphere of tranquility (Figure 4.23).

Dining areas are at their best when the color schemes are unobtrusive, permitting a variety of table decorations as well as a serene dining atmosphere. In theme restaurants, color schemes vary greatly.

Informal living areas such as *family* and *recreation rooms* are often treated with stimulating color schemes that create a cheerful and casual environment. *Kitchens* and *breakrooms* are usually more desirable when large areas of color are light, fresh, and clean looking.

Bedrooms are private areas, and personal preference should be the determining factor in the choice of colors. As a general rule, the master bedroom should be completed in restful tones pleasing to the occupants. Children can be given the opportunity to select colors for their own rooms.

Private offices are like bedrooms, and personal preferences should be the deciding factor; however, bays or groups of offices should relate to one another. *Examination rooms* in doctors' offices should be comfortable. Colors should be warm and inviting.

Color schemes for *bathrooms* usually reflect the style and mood of adjoining rooms. Warm colors in muted tones enhance skin tones. Bathroom fixtures, sinks, toilets, bidets, and showers are difficult and costly to replace when trends in colors change, so select these fixtures in light neutrals. (Dark neutrals are difficult to maintain and require daily cleaning.) Add the color in the walls, rugs, and other finishes and decorative elements.

Color also interacts with the elements and principles of design. The next section discusses the relationships between color and these design guidelines.

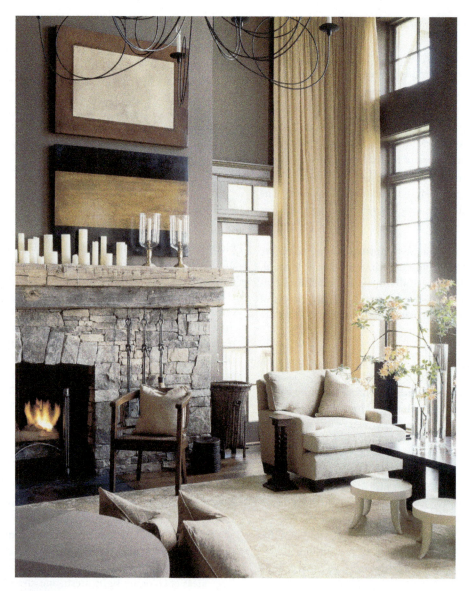

FIGURE 4.23 The warm browns coupled with the soft apricot-colored drapery fabric create a calming effect in this interior. The mood of the room is also reflected in the textural elements, comfortable chair, and combustion light sources.

(Architect: Harrison Design Associates. Designer: Phillip Sides Interior Design. Photograph by Tria Giovan)

■ INTERACTIONS BETWEEN COLOR AND THE ELEMENTS AND PRINCIPLES OF DESIGN

Space

Colors look different depending on space and distance. Near colors appear darker and more brilliant than the same colors at a greater distance. Brighter and darker colors used in large rooms therefore seem less demanding than the same colors used in small rooms. Colors appear stronger in chroma when covering large areas. For example, a small color chip may be the exact color preferred for a room, but when that color is painted on four walls, it looks much darker and brighter because the area of that color chip has been multiplied many thousands of times. When selecting a wall color from a small color chip, it is best to choose a color several tints lighter than the color desired for the completed room. A good approach is to paint a sizable area of color on walls in opposite corners of the room and observe them at different times of the day and night before completing the application.

Texture

Color appears different when the texture is varied. Smooth surfaces reflect light. Fabrics with a deep, textured surface, such as pile carpet, velvet, and all manner of nubby weaves, cast tiny shadows. These materials appear darker than a smooth fabric dyed with the same hue, in the same value and chroma. A rough-textured wall may appear grayed or soiled under artificial light because of shadows cast from the uneven

surface. A dull or matte surface absorbs color, and if it is also dark, may absorb much of the light.

Size and Proportion

An object that attracts the eye usually seems larger; therefore, furniture may appear larger if painted or upholstered with colors in strong chroma. A small room may seem even smaller if demanding colors, which fill space, are used on backgrounds and furniture. Light, cool colors expand a room and seem to create more space. Through the skillful application of color, a room's dimensions may be altered significantly and architectural features and furnishings can be highlighted or minimized.

Balance

Because that which attracts the eye seems larger and therefore appears heavier, a small area of bright color balances a large area of softly muted color, and a small area of dark color balances a larger area of light color. For example, a small bouquet of bright flowers placed near one end of a long console table balances a large lamp of soft color placed near the other end. A small, bright blue chair balances a much larger gray-blue sofa. Entire areas of rooms may also be balanced through the use of color. A large end wall treated with bright or dark colors may be balanced on the other side of the room with a dark, massive piece of furniture.

Juxtaposition of Colors

Color is not important in itself. What is important is what happens when different colors are brought together. The eye perceives color in relation to its environment. Physiologists have shown that people are not color blind to one color only, but to two or four; the eye is sensitive to colors not singly, but in pairs. The familiar afterimage effect demonstrates this perception. If a person looks at any one color for about 30 seconds, then looks at a white page, the complement of that color appears (Figure 4.24). Also, when the eye sees a colored object, it induces the color's complement in the environment. For example, when a green chair is placed against a light neutralized background, the eye sees a tinge of red in that background.

When two primary colors are placed side by side, they appear tinted with the omitted primary; red, for example, when placed near blue takes on a yellow tinge. When contrasting or complementary colors in strong chroma with the same value are used against each other, they clash, producing a vibration that is fatiguing (Figure 4.25). When contrasting colors with strong differences in value are used side by side or one against the other, the colors stand out but do not clash. For example, a painting with predominantly orange hues seems more orange

FIGURE 4.24 Complementary afterimage. Stare at the black dot just above center in the image on the left for 30 seconds, then look at the black dot in the white space on the right. Prolonged concentration on any color reduces eye sensitivity to it, and the reverse (complementary) color, remaining unaffected, dominates the afterimage for a brief period until balance is restored.

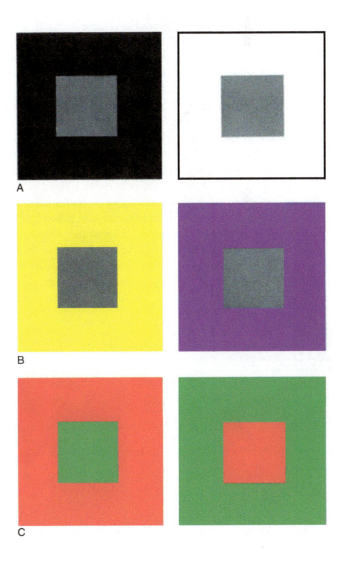

FIGURE 4.25 These diagrams illustrate the effect of adjacent colors: (A) Gray looks much darker against white than it does against black; (B) A gray or neutral against a colored background appears to be tinted with the complement of the color; (C) When placed side by side, complements of equal intensity create visual conflict. Complements of varying intensities enhance each other.
(Courtesy of Large Lamp Department, General Electric Company)

FIGURE 4.26 Additive spatial fusion. The green dot pattern in the shape of the United States merges into solid gray when viewed from a distance of 6 to 8 ft. At that distance, the eye no longer distinguishes the individual colors.
(Courtesy of Large Lamp Department, General Electric Company)

if hung against a blue wall. Harmoniously blended colors of middle value used against each other tend to blend together, and at a distance the difference becomes almost indiscernible (Figure 4.26). The latter combination is the basis for most shibui color schemes.

Black and white have a strong visible effect on other colors when brought together. Black tends to make adjacent colors look richer. White reflects light into adjacent colors. Rooms that seem lifeless may be given sparkle and interest by the addition of black, white, or both.

The juxtaposition of colors affects not only hue but also value. The change of value may be seen when a gray circle is placed on a white background. As black is added to the background, which becomes progressively darker, the gray circle appears progressively lighter, showing that colors may be made to appear either lighter or darker according to the tonal value of the adjoining or background color. The use of sharp value contrast emphasizes an object. When black and white are placed side by side, the white looks whiter and the black looks blacker. For example, the fine lines of a dark piece of furniture are accentuated if placed against a light background. Colors closely blended conceal an object; contrasting colors emphasize an object. A piece of furniture seems unobtrusive if it is the same value as the background (Figure 4.27).

Value may be applied in many ways when designing and furnishing a room. As an object is raised in value, its apparent size increases. A fabric colored in low value makes a chair seem smaller than one in high value. Because light colors recede and dark colors advance, one may, with skill, alter the apparent size and proportion of individual items or of an entire room. In small rooms, light values expand walls and ceilings. In long, narrow rooms, colors in darker value pull in end walls and make the room appear shorter.

The apparent size and proportion of a room or object may also be altered through the use of chroma. Color in strong chroma visually enlarges an object; walls in strong chroma, as with dark value, seem to advance and make a room appear smaller.

Light

As previously discussed, without light, color does not exist. Because light is so closely tied to color, a brief discussion on light's interaction with color is in order. (Chapter 6 elaborates on lighting.) A major consideration in planning the color scheme for a room is the study of the quantity and quality of light and the method of lighting.

The level of illumination affects the appearance of color. When the light is bright, the color can be stimulating; low light can produce a relaxing feeling. Color may become dull, lifeless, and dreary with insufficient light, however, and too much light can wash out a color. In general, as illumination increases, color becomes more vibrant. A room with low light levels is enhanced by light-reflecting colors. A room with high light levels may be more pleasant with a predominance of darker light-absorbing colors.

One concern for the designer is how various qualities of natural and artificial light can change the visual perception of a surface, the phenomenon known as metamerism. For example, two fabrics that match in color during daylight may not match under artificial light at night. All types of lighting (natural lighting and artificial lighting such as incandescent, fluorescent, halogen, etc.) produce unique effects. The quality of natural light depends on the direction from which it comes and the time of day. The color of artificial light is determined by the type of light and fixture used. Therefore, it is important when selecting colors for backgrounds and furnishings to view each surface under all types of lighting conditions to ensure that the colors will match or be harmonious.

Review of the color wheel demonstrates that to gray or neutralize a color, some of its complement must be added; to intensify a color,

FIGURE 4.27 Value effects—three treatments.

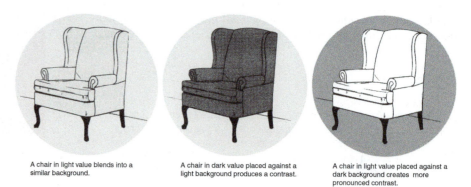

A chair in light value blends into a similar background.

A chair in dark value placed against a light background produces a contrast.

A chair in light value placed against a dark background creates more pronounced contrast.

more of the basic hue must be added. Light produces the same effect. Warm light accentuates warm colors and neutralizes cool colors. Cool light intensifies cool colors and deadens warm colors. For example, a yellowish light brings out the yellow in yellow-green and yellow-orange. A cool light brings out the blue in blue-green and blue-violet. Warm light is friendly and tends to unify objects. Cool light expands space, produces a crisp atmosphere, and tends to make individual objects stand out.

Color is also affected by the method of lighting. Light rays that fall directly from the source onto a surface can create a warm glow over an area. An indirect light reflecting from a cove onto the ceiling produces an overall light resembling the light of midday.

When understood and used with skill, light may alter, subdue, highlight, or dramatize the colors of a room in a way that no other decorative medium can. Because any situation has many variables, it is impractical to set down definite rules for the use of light and color. Therefore, before making a final choice, try each color in the environment in which it will be used and observe it during different hours of the day and after dark.

■ APPLICATION OF COLOR TO INTERIOR BACKGROUNDS

Applying color to a room's architectural backgrounds requires careful consideration. For instance, a common notion is that off-white in itself is a specific color and complements any decor. This concept needs refinement. Off-white is white tinted with a hue—any hue. To be compatible, however, off-whites must contain only a hue the same as or similar to that used in other areas of the room. Warm off-whites are more easily blended than cool off-whites, recalling a basic characteristic of warm and cool colors.

Ceilings

The ceiling is the largest unused area of a room, and its color is important to the general feeling. If the objective is to have the wall and ceiling look the same, the ceiling should be a tint of the wall, because the reflection from the walls and floor tends to make the ceiling look several shades darker than it actually is. If the walls are papered, the ceiling may be a tint of the background or the lightest color in the paper. Where walls are paneled in dark wood, the ceiling can be effective when painted white or a light tint of the wood color. If the wood trim is painted white, a white ceiling can work well. If the ceiling is too high, a darker shade or brighter hue makes it appear lower. For a low ceiling, the opposite treatment can help make it appear higher.

Paneled Walls

In a room with dark wood paneling, colors of intense chroma can be used because deep wood tones tend to absorb color. If paneled wood walls are light and a blended effect is desired, colors may be light and less intense. More formal wood paneling calls for a more formal color scheme; if wood paneling is informal, colors should enhance that casual effect.

Window Treatments

The success of any room depends largely on the window treatment and the color used for draperies, curtains, blinds, screens, shades, shutters, or other window decor. If the objective is to have a completely blended background, the window treatment should be the same hue, value, and intensity as the wall. If a contrasting effect is desirable, a color that contrasts with the wall can be used, but it must relate well with other colors throughout the room. Remember to consider how the drapery lining or sheers will look from the outside. Sheers are usually more pleasing when white or off-white.

Wood Trim

The color of wood trim around doors, ceilings, floors, and other architectural features is important to the general color scheme of the room. When painted, trim may be (1) the same hue, value, and intensity as the wall (which tends to cause molding to disappear into the wall); (2) a darker shade of the wall hue (which allows the molding to stand out); or (3) a color that contrasts with the wall (which accentuates the molding). Many professional designers maintain the same wood trim color throughout the interior environment for an effective color transition from room to room.

Color in Wood

Because wood has color and each type of wood has a particular beauty, wood should not be overlooked when planning a color scheme. Heavily grained woods generally call for heavier textures and stronger colors than do fine-grained woods, as seen in Figure 4.28. Mixing woods can add interest to a room, but when using woods in close proximity it is wise to choose ones that are similar in feeling. For example,

FIGURE 4.28 Fine-grain woods, shown in this custom interior office space, blend with warm, refined fabrics creating an upscale interior.
(Designer: Martha Burns. Photograph by Peter Paige)

rough-grained golden oak and formal reddish-brown mahogany are not particularly good companions, but finely grained light-brown maple and brownish walnut usually combine well.

All of these items should be taken into consideration when planning the colors for an interior environment. The next section should help the beginning designer start the process of choosing a color scheme.

■ SELECTION OF A COLOR SCHEME

When deciding on a color scheme, designers must first consider the needs and desires of the client. Many times clients select a specific color on which to base the interior environment. Other starting points for color schemes may include an attractive fabric or wallpaper, an area rug, or a prized painting or work of art. Commercial office or hospitality environments may also begin color schemes based on a corporate logo or patterned carpet. As discussed earlier, the color scheme may be derived from, and should enhance the concept for the interior. No matter where the designer begins, the color selections for the room must also allow for the appropriate distribution of color and a transition from one room to another.

Distribution of Color

Color is the most unifying element available to the interior designer, and its skillful distribution is essential to a feeling of unity. Color distribution can be achieved in two major ways:

1. Planned value distribution is a necessary step. Each room can be enhanced with some light, some dark, and some medium values used in varying amounts according to the effect desired. In most cases the darkest values are used in the smallest amounts, and the less intense or more neutralized hues used in the large areas. The remaining areas are in medium values. This application of values is called the **law of chromatic distribution**. When applying the law of chromatic distribution to a room, backgrounds such as floors, walls, and ceilings will be in the most neutralized values, large pieces of furniture will have medium intensity, and accents such as small chairs and accessories will be in the strongest chroma.

2. Many successful rooms are planned around one dominant hue. This color need not be used on all major pieces of furniture, but it should be repeated at least once to give a feeling of unity. Unity may also be achieved by using colors containing one hue common to all. For example, hues on the color wheel going clockwise from red-orange to blue-green all contain yellow and combine well together. The color that is common to all—yellow—recedes and the other colors stand out.

Although the preceding guidelines describe the safest way to color scheme a room, deviating from them is possible and sometimes desirable (as seen in Figure 4.14). For example, dark walls can create a feeling of comfort, warmth, and security and unify the room's furnishings. A light floor visually expands space, and when adjacent to dark walls creates a dramatic effect. Under most conditions dark ceilings decrease the feeling of space and are oppressive. On the other hand, depending on the architecture, a ceiling may be painted in a dark value to give the

illusion of viewing the infinity of the night sky. In commercial design, dark ceilings are frequently used to conceal the network of **HVAC** (heating, ventilating, and air-conditioning), plumbing pipes, and electrical cables (as seen in Figure I.4C).

Color Transitions from One Room to Another

Whenever two rooms adjoin, their colors should relate. One or more colors carried from one room to the other—but not necessarily used in the same manner—will make a pleasing transition. For example, the accent color in the wallpaper of an entrance hall may be neutralized and used on the walls of the adjoining living room or may be emphasized in a piece of upholstery fabric.

Where one room may be seen from another, as in conference rooms and reception areas, closely related colors establish color unity. Following are some of the most common and successful methods of achieving color transition.

- Many professional designers keep the floor covering consistent from room to room. For example, a gray carpet might be used for all rooms with the exception of hard floor surfaces for entries, conference rooms, or utility areas.

- Similar or matching wall and ceiling colors from room to room create a continuity of color transition.

- The consistent use of moldings and architectural trim throughout the home helps provide unity.

- Related colors employed on various pieces of furniture and for window treatments should be considered for effective color transition.

- Accessories carry colors from one interior space to another and aid in creating an effective flow of colors.

Developing the skills to bring a color scheme together while thoughtfully employing the law of chromatic distribution and considering the transitions required from room to room takes time and patience. The goal of all designers is to develop the skill to visualize the room before it is completed.

Visual Communication

Forming a mental picture of how colors appear when juxtaposed is not easy, and students and clients may need visual aids. Visual communication skills help the designer prepare presentation boards, charts, and plans that help the client, as well as the designer, visualize the completed space. Following are three methods used for visual communication of a color scheme. They are usually completed during the conceptual design and design development phases discussed in Chapter 1.

1. A chart using approximate proportions of various elements such as walls, floors, ceilings, furniture, and accents is developed. Fabric, paint, and hard material samples are attached to the chart. This method does not show exactly how the completed project will appear, but it is helpful.

2. A setup with actual samples of all items to be used, in approximate proportions, is assembled. This method more closely approximates the look of the completed room.

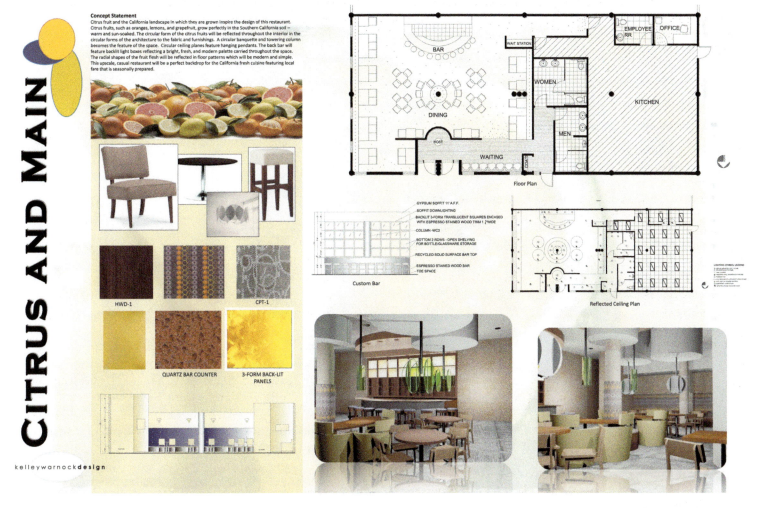

FIGURE 4.29 For the visual presentation of this restaurant, the designer included a floor plan, elevation, perspectives, and reflected ceiling plan to help the client understand the 3D interior environment. Color, textile, and furniture images are also included along with the overall design concept. *(Designer: Kelley Warnock Interior Design)*

3. Many professional designers develop presentation boards that include rendered floor plans, elevations, and perspectives of the interior (Figure 4.29). The boards also include pictures of the furniture with samples of fabrics. Additionally, finishes are shown for all walls, floors, and other surfaces.

Other color tools are also available to designers. Paint companies have interior and architectural sample kits, with paint samples that are 2" × 5" or larger. Pantone, a standard in commercial color identification, also produces color sample books that may assist designers in communicating colors to clients. Whatever method is used, it is important to remember that the goal is to visually explain to the client the final appearance of the color scheme.

■ COLOR FORECASTING

Organizations that help determine color preferences for American residential and nonresidential design include the Color Marketing Group, the Color Association of the United States, the Home Fashions League, the International Colour Authority, the National Decorating Products Association, and Colorcast. Color forecasts are drawn from the latest research conducted by color stylists and authorities, and they provide annual predictions that help consumers, professional designers, and merchandising experts.

The Color Marketing Group is forecasting that colors will combine with new technologies to produce colors with dimension and a sense of depth. Colors will include metallic, pearlescent, lacquered, and even sueded appearances. The Color Marketing Group researches color based on sociological, economic, and political effects.

The Sherwin-Williams Company completes an annual color trend forecast called colormix.™ Their latest forecast includes deep greens that include a strong amount of blues, a turn away from the yellow-based greens of the recent past. Blues relate to water and are more muddy and a bit pastel, rather than crisp. Reds lean to the burning colors of orange and gold, while the neutrals have a warm yellow base.

FIGURE 4.30 Variations in texture and light play a significant role in the warmth and richness of this interior living environment. The designers were particularly observant of the effects of light as it changes throughout the day. Reflective surfaces on the floor and ceiling add to the character of the space and contrast with the rough stone walls.
(Designer: Gandy/Peace, Inc. Photograph by Chris A. Little)

When reviewing color forecasts made by various professional sources, it is important to remember that there are no absolute color rules that can be applied at any particular time. It is good to be aware of color trends, but, ultimately, personal preferences for comfortable and pleasing colors are the most valuable consideration. The interior designer's responsibility is to help the client select colors that are right for a personal environment.

More info online @

www.colormarketing.org Color Marketing Group
www.colormatters.com This is a creative and fun hobby website
www.colorassociation.com Color Association of the United States
www.internationalcolourauthority.org International Colour Authority
www.swstir.com/videos Sherwin-Williams *Stir* website

SUMMARY

The interaction between light and color creates great opportunities for designers as well as unique challenges (Figure 4.30). Planning and accurate programming are required to determine a client's personal tastes relating to a color scheme. Color schemes can be developed based on the mixing or blending of colors from the color wheel, from nature, or from another color source such as a work of art or a patterned rug, but they should also support the concept. The final development of the color scheme must also take into account the juxtaposition of different colors to each other, the desired effects from the elements and principles of design, and the appropriate distribution of color. Ultimately, the greatest challenge to any designer (and possibly the most satisfying reward) is to achieve beautiful and livable schemes that meet the client's needs.

Community Concept—UPS Innoplex

The following project illustrates the thorough development and execution of a concept. The Atlanta offices of Gensler (an interior design and architectural firm) worked closely with their client, United Parcel Service, to develop Innoplex.

PROJECT DESCRIPTION

The existing 200,000-square-foot building had housed a furniture manufacturing plant. The building renovation would accommodate 650 employees in a new venture for UPS. The employees include software developers, inventors, information technology professionals, and investment advisors working together to help UPS become one of the top global e-commerce companies. These individuals were brought together for one purpose—to "get the product to market faster."

Programming

The design team worked in sessions with UPS employees, called the "e-Commerce Founders," to define the goals and clarify the direction for the new center. As a result of these programming sessions, Gensler produced a bound volume describing the business goals based on actual quotes from the Founders. Additionally, Gensler researched current and historical literature to help support and define goals. The document *UPS e-Solutions Facility: Building Program* was referred to throughout the design process, thereby providing project direction.

Goals included the following:

- Maximizing real estate investment through effective long-term planning and development
- Providing an environment that would attract and maintain high-quality information technology professionals
- Providing an environment that fosters and nurtures creative thinking and promotes flexibility and excitement

Figures DS4.1 through DS4.3 illustrate pages pulled from the *Building Program* document.

FIGURE DS4.2 The programming document also graphically outlined the existing and new product development process.
(Architect/Designer: Gensler)

FIGURE DS4.3 After observing the work patterns of various employees, Gensler developed a timetable indicating a "Day in the Life" of each division employee.
(Architect/Designer: Gensler)

	Year end 2000	Year end 2001	Year end 2002	Hard Office Year end 2002	Type of work
Service Parts Logistics	70	75	80	4	Internet/other software development
Ups Capital	30	45	60	3	
PSI	30	50	50	5	
eVentures Core	30	30	30	12	Incubation
eVentures Team X	12	12	12		
eVentures Team Y	12	12	12		
Consumer Direct	115	120	150		
eLogistics	120	120	120		
Worldwide Logistics	60	80	100	5	IT Developers, WWL and transportation developers
eSolutions Development	131	300	450	23	
Interactive Communications	15	20	25	1	
Interactive Marketing	5	5	5	0	
EC Marketing					
Document Exchange					
CIM/eDeployment	10	15	18	1	
CIM/Functional Requirements	23	53	87	5	
CIM/Implementation & Support	25	30	33	1	
Human Resources	5	7	8	3	
Facilities	2	2	2	0	
Enterprise Support	3	4	6	0	
Total	698	980	1248	63	

FIGURE DS4.1 As part of the programming document, a staffing plan was developed indicating the anticipated number of employees per division.
(Architect/Designer: Gensler)

Schematic or Conceptual Design

As the designer/client collaboration continued, design requirements emerged for the center. Specific requests included indirect and natural lighting, no fluorescent lighting, recreational and break areas, multipurpose collaboration areas to invite spontaneity and encourage "cross pollination," user changeable workspaces, a "green" building environment, quality acoustics and security systems, and the ability to have quiet space. As the discussions continued, a concept began to build. It circled around the word *community*. Figures DS4.4 and DS4.5 illustrate the conceptual plans centered on this community concept.

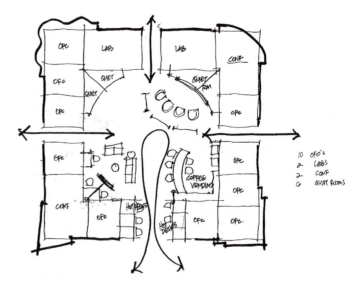

FIGURE DS4.5 In a more specific conceptual plan, offices, labs, conferencing areas, and quiet rooms create a framework for the Common Centers.
(Architect/Designer: Gensler)

FIGURE DS4.4 The concept plan illustrates the idea of community. The Town Center is surrounded by Neighborhoods (work areas) and Common Centers (collaboration areas).
(Architect/Designer: Gensler)

Design Development
The design development phase for this project continued seamlessly from the schematics. Figure DS4.6 illustrates a presentation furniture plan forming a strong network of office neighborhoods and community centers. Figure DS4.7 depicts the community feel planned for the interior, including the (A) Main Street Corridor, the (B) Open Office Neighborhood, and the (C) Community Break Area.

FIGURE DS4.6 Placing the community concept into the specific building plan created a presentation furniture plan illustrating potential walls, open office plans, and corridors.
(Architect/Designer: Gensler)

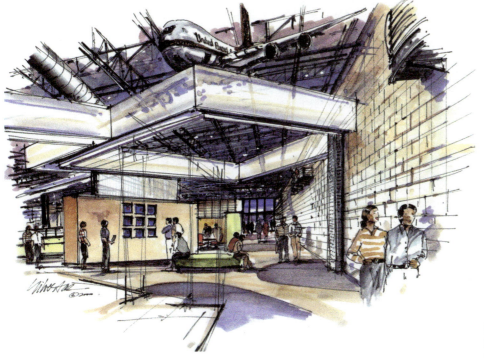

FIGURE DS4.7A Presentation perspective of the Main Street Entry.
(Architect/Designer: Gensler)

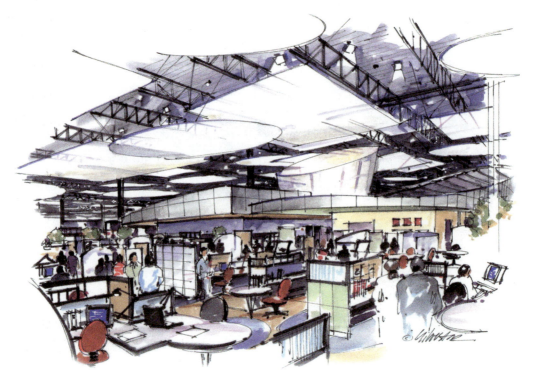

FIGURE DS4.7B Presentation perspective of the Open Office Neighborhood.
(Architect/Designer: Gensler)

FIGURE DS4.7C Presentation perspective of the Community Break Area.
(Architect/Designer: Gensler)

Contract Documentation

Developing construction drawings for this project required a vigilance to community details and an adherence to the design requests identified in the programming and conceptual design phases. Figures DS4.8 through DS4.10 represent a sample of the documents used in the process.

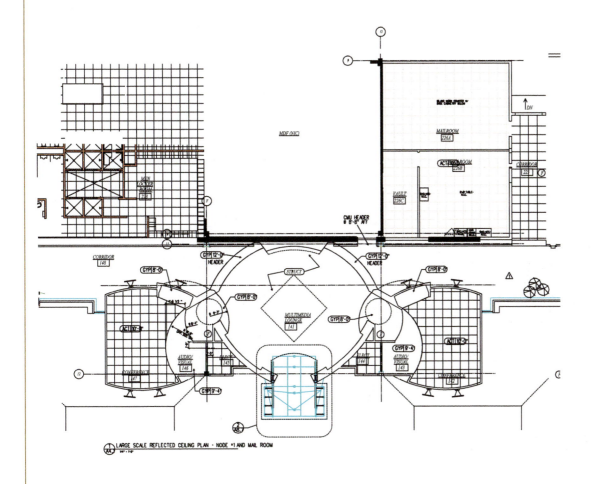

FIGURE DS4.8 Partition plan of the War Room.
(Architect/Designer: Gensler)

FIGURE DS4.9 Partition plan of the Multimedia Lounge.
(Architect/Designer: Gensler)

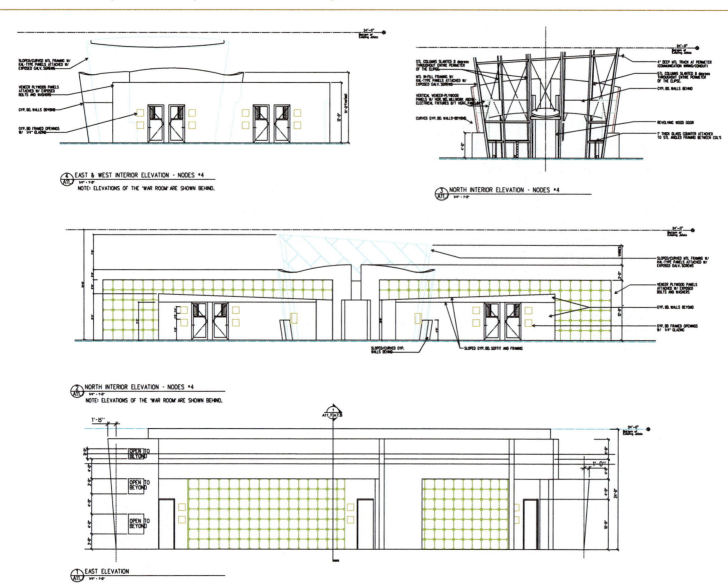

FIGURE DS4.10 Elevations of the Main Entry Corridor.
(Architect/Designer: Gensler)

UPS Innoplex

Completed interior spaces are illustrated in Figures DS4.11 through DS4.15.

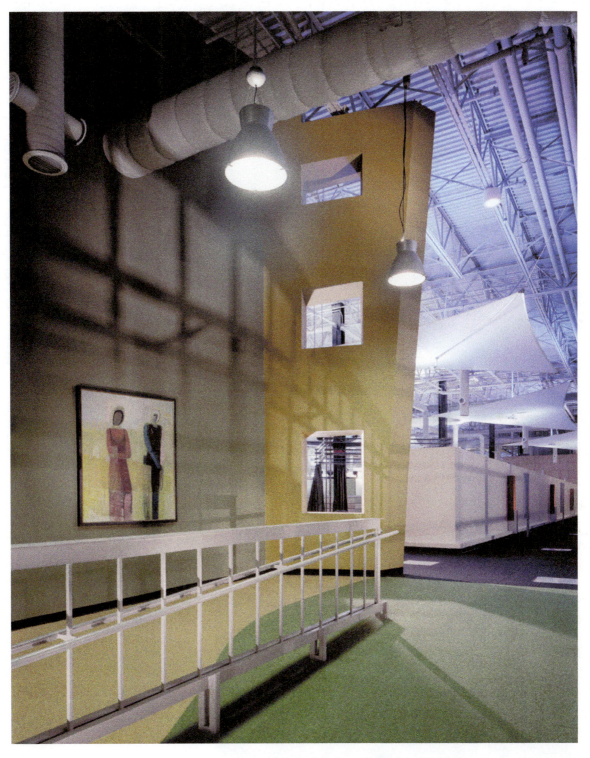

FIGURE DS4.11 In the Main Street Corridor, bold colors, intersecting planes, and a strong axis set the tone for a fun and exciting interior environment.

(Architect/Designer: Gensler. Photograph © Robert Thien)

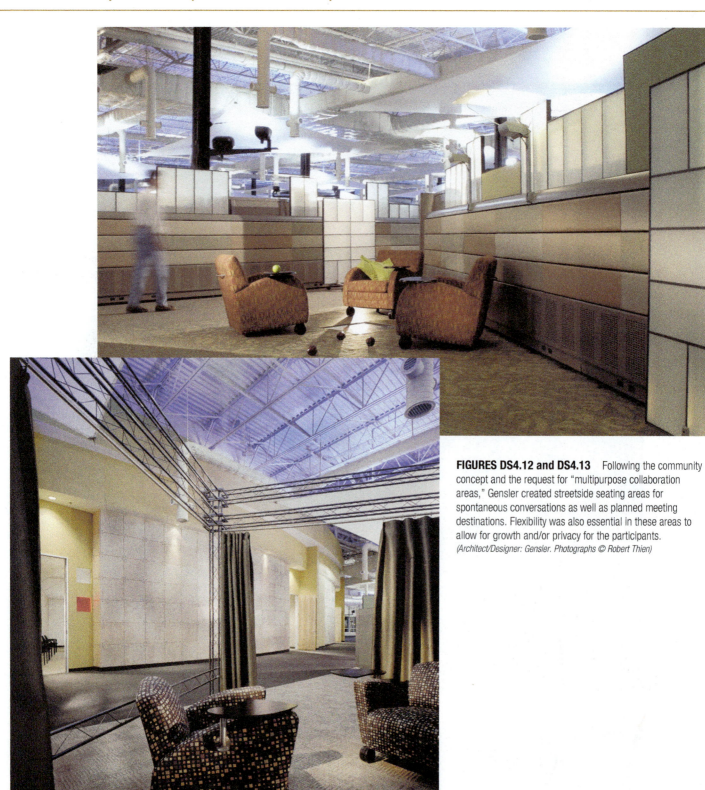

FIGURES DS4.12 and DS4.13 Following the community concept and the request for "multipurpose collaboration areas," Gensler created streetside seating areas for spontaneous conversations as well as planned meeting destinations. Flexibility was also essential in these areas to allow for growth and/or privacy for the participants.
(Architect/Designer: Gensler. Photographs © Robert Thien)

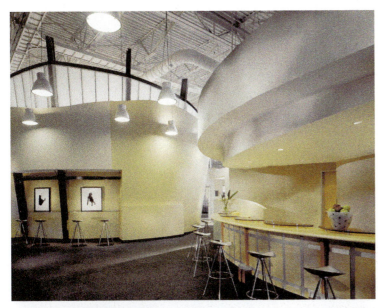

FIGURE DS4.14 In another open community zone, employees are encouraged to gather at the "bar" for informal discussions. Strong chromas, curved walls, and playful art add to the enlivened interior space.
(Architect/Designer: Gensler. Photograph © Robert Thien)

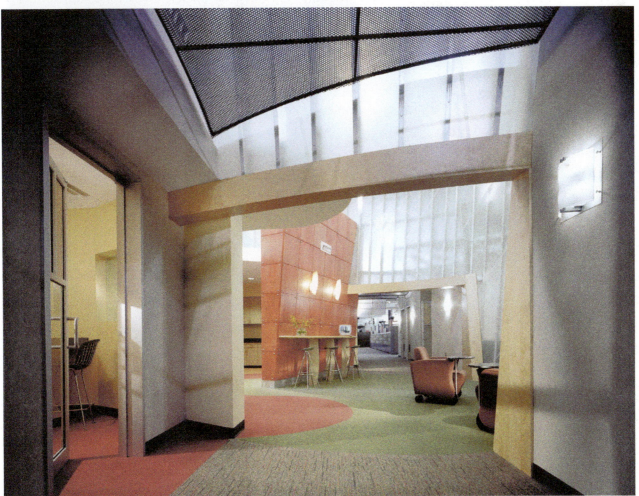

FIGURE DS4.15 Looking through a portal into one of the Common Centers, one can see that the environment continues to stimulate creativity. The intersecting planes and strong chromas continue, but the lowered ceilings and enhanced enclosures dictate more formality and a stronger sense of order.
(Architect/Designer: Gensler. Photograph © Robert Thien)

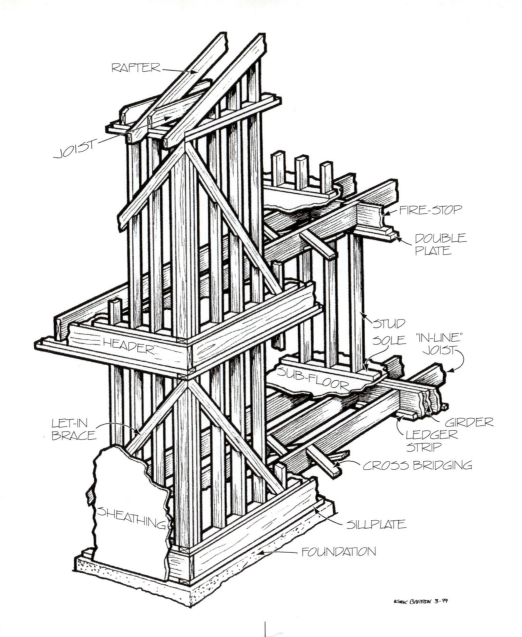

RAFTER

JOIST

FIRE-STOP

DOUBLE PLATE

STUD

SOLE

"IN-LINE" JOIST

HEADER

SUB-FLOOR

LET-IN BRACE

GIRDER

LEDGER STRIP

CROSS BRIDGING

SHEATHING

SILLPLATE

FOUNDATION

KIRK BARTON 3-79

Part III

Building Systems

The play seems out for an almost infinite run. Don't mind a little thing like the actors fighting. The only thing I worry about is the sun. We'll be all right if nothing goes wrong with the lighting.

—Robert Frost

CHAPTER 5

Construction Components, Systems, and Codes

CHAPTER 6

Lighting, Electrical, and Communications

FIGURE III.1 This two-story framing diagram illustrates platform or western frame construction. Note the terms for the various construction components.

The building system components that are usually hidden in the walls, ceilings, or floors form the basis for human comfort in interior environments. The heating, ventilating, and air-conditioning (HVAC); electrical; lighting; communication; and plumbing systems (to name a few) are integrated into the construction of a building. Knowledge of how these systems work together and an understanding of when they are installed during the construction process allow the designer to accurately guide the client during construction or remodeling.

The interior designer is a member of a design team. Although the designer should be familiar with the construction process, he or she is actively working with (and in many cases relying on the expertise of) the allied design professionals (see Chapter 1). Communication, collaboration, and cooperation: These three Cs are essential among design team members in order to create successful environments. Understanding system terminology and recognizing standard architectural symbols enhance the designer's ability to communicate effectively with colleagues and clients.

THE CONSTRUCTION PROCESS

The process of building or remodeling a structure has several steps. The **critical path** is a timetable (or schedule) that charts this process. For example, a small remodeling job may require only four or five weeks to complete, whereas a typical residence may take four or five months; a large commercial building may take one to three years to finish.

For almost all projects, the order of the steps is similar; steps that are not required are simply skipped. The scheduling of the project usually becomes the responsibility of the general contractor. The following explains the construction process for a residential project using wood frame construction. Refer to the figures for further understanding.

More info online @

www.b4ubuild.com/resources/schedule/6kproj.shtml A sample residential construction schedule

Site Selection and Development

Site selection is the first step in the construction process. The site frequently dictates the style of house to be built. Site work also contributes significantly to the flow of traffic and physical location of the building. Once a site has been selected and an appropriate house designed to fit it, the site must be prepared. Utility lines are buried (or strung) to meet local codes. Vegetation is removed or protected from large earth-moving machines, and a hole is excavated for the footings, foundation walls, and basement or crawl space. Site work continues throughout the entire construction process and does not end until drains, lawns, shrubs, trees, driveways, sidewalks, decks, patios, and parking areas are installed.

More info online @

www.b4ubuild.com/resources/index.shtml#sitework Information on site work

Footings and Foundations

After the initial site work is complete and the initial hole is dug, careful measurements are made and forms are placed to hold the concrete that will be poured to form the footings. **Footings** are the structural foundation of the building. In colder climates, footings must be placed below the frost line.

Foundation walls are built on top of the footings. The walls may be poured concrete or concrete block (Figure III.2). (Note: *Cement* is a dry ingredient of concrete. Concrete is a mixture of cement, composed of lime, silica, and other materials, along with gravel and water.) Space must be allowed for basement windows (which must meet fire egress codes) or crawl space air vents in the foundation walls.

Some buildings have concrete slab floors. The floors are reinforced with rebar (strong steel rods) or wire mesh. In a building with a concrete slab, all plumbing, electrical, or mechanical ductwork that will penetrate the floor must be in place before pouring the concrete slab floor. It is wise for the architect or designer to make a site visit during this time to ensure that

FIGURE III.2 Left, a poured footing and foundation wall. Right, also a poured footing, but its foundation wall is formed using concrete masonry units (CMUs), commonly called concrete blocks.

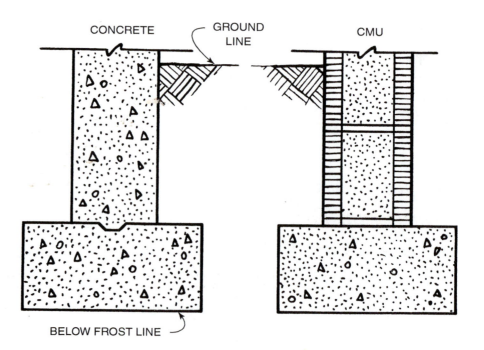

electrical and plumbing components are installed as noted on the blueprints. Chiseling or coring a slab for ductwork after the concrete slab has set is possible, but costly. In remodeling jobs, however, this may be the only solution.

Once the concrete has set and the forms are removed, the holes are backfilled with dirt and compacted. The building is ready to be framed.

More info online @

www.b4ubuild.com/photos/footing/foot_p01.shtml Images of installing concrete footing

Framing

In wood frame construction, the first item to be framed is the floor. A **sillplate** secures the floor to the foundation (Figure III.1). Horizontal wood members are attached to the sillplate, and a subfloor is laid over the top. The vertical load-bearing walls are added to support the weight of the roof, transferring the load to the foundation walls, which transfer it to the footings. Not all walls are load bearing. In a remodeling job, before specifying the removal of a wall, the designer must consult with an architect or engineer to determine which walls are load bearing. Load-bearing walls can be moved after proper alternative structural support is in place; however, the work must first be documented by the licensed architect, engineer, or builder.

The vertical walls are formed by 2" × 4" or 2" × 6" studs. Rough openings in the wall are made for doors and windows (Figure III.3). A **header** is placed over the opening to transfer the load to a supporting stud. Again, the architect or interior designer should carefully survey the construction as walls are being built. Improperly located doors, windows, and walls are easier to move the sooner a mistake is noticed. Check the blueprints to make sure they are followed.

Next, the roof is framed and attached to the vertical stud walls (Figure III.4). The angular wood pieces are called rafters. Many wood-frame roofs are made from prefabricated truss systems constructed off-site (Figure III.5). Although more economical, truss systems do not allow for attic use.

More info online @

www.b4ubuild.com/photos/contents.shtml#framing Images of framing

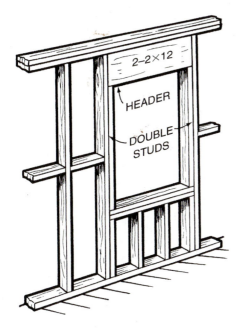

FIGURE III.3 Additional support in the form of double studs and a header strengthens the rough opening that will eventually house a window.

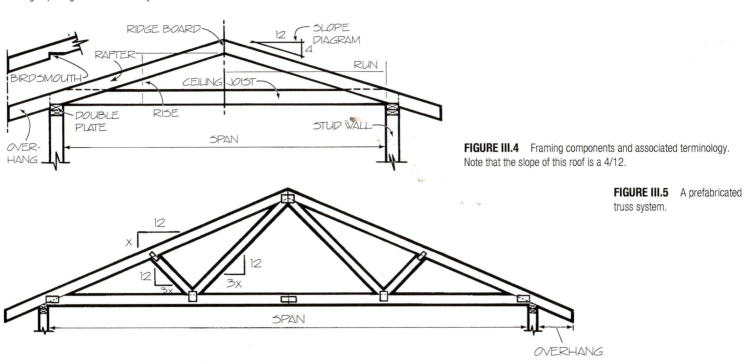

FIGURE III.4 Framing components and associated terminology. Note that the slope of this roof is a 4/12.

FIGURE III.5 A prefabricated truss system.

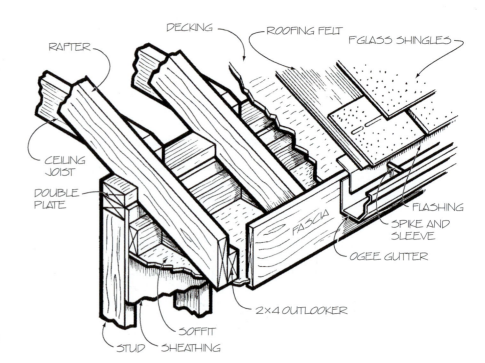

FIGURE III.6 This cutaway section illustrates the construction components where the roof meets the walls. Finish materials such as shingles are applied over the roofing felt and decking.

Sheathing, Roofing, and Interior Building Systems

As the framing is completed, *sheathing* (rigid wallboard, plywood, or similar material) is added around the perimeter of the building and to the roof. The sheathing (sometimes called decking on the roof) adds structural support and insulating qualities. It also may serve as a nailer for the finish materials (see Figure III.6).

As the roofing material is placed on the decking, windows and doors are installed and rough plumbing (sometimes called top-out plumbing), HVAC, and electrical lines are run in the walls and basement (if applicable). Shower stalls and tubs are installed so that interior finishes cover the seams. Central vacuum units, security systems, and intercom systems also are installed at this point. Once again, the locations of the outlets, switches, overhead lighting, HVAC vents, intercom systems, and other specified components should be carefully checked. After wall material is applied over the studs, it is more costly and difficult to make changes. Last, insulation is added to the walls and ceilings.

Finish Materials

The exterior of the building receives its final material, such as wood clapboard, brick, stucco, or siding, and it is finished appropriately. **Soffits** (the area below the eaves) and **fascia** (the front of the eaves) are completed (Figure III.6). Trim is installed around windows and doors. Concrete porches and walks, wood decks, and railings complete the site work. Exterior hardware is installed.

Interior finish materials are applied to the walls. (These options are discussed in Chapter 12.) Other construction components such as trim, bookshelves, closet systems, and doors are installed. Painting and staining are completed. Cabinets, countertops, tile floors, and backsplashes are installed. Wallcovering is hung, and plumbing and lighting fixtures are placed. The interior door hardware, appliances, carpets, and

window treatments are installed. Finally, the furniture is delivered. Artwork and accessories are arranged.

The last step is the final walk-through, noting tasks yet to be completed on the punch list. Inevitably, the movers will dent a door frame or the carpet installers will mar a wall. Electrical outlet covers and heater vents will be misplaced. Lightbulbs will burn out or break. The architect or interior designer needs to ensure that all items are fixed before approving the final payment to the contractor.

Once the contractor's work is completed, the interior designer continues the coordination by overseeing the installation of the furnishings. The furniture presentation plan is frequently the part that clients understand best (Figure III.7). Although technically not part of the building systems, a furniture plan shared with the contractors assists in understanding the future layout of the rooms.

The construction process is complex, and it is only through proper planning that a building is completed in a given time frame. Attention to detail and a collaborative effort by all allied professionals ensure a space that meets the needs and desires of the client.

The following two chapters provide more detailed information on building systems. Recognition of building symbols and an understanding of each system's components and requirements will assist designers in working with clients and communicating with construction professionals.

More info online @

www.homebuildingmanual.com/Glossary.htm Glossary of building construction terms
www.b4ubuild.com General residential building site
www.nahb.com National Association of Home Builders
www.nahbrc.org National Association of Home Builders Research Center
http://products.construction.com Construction resources guide from Sweets Catalog

FIGURE III.7 This residential furniture presentation plan illustrates the first and second floors. The walls are **poeched** (darkened) to delineate the different rooms. Furniture is heavily outlined, whereas details such as flooring materials are indicated with thinner lines. The goal of the drawing is to create a three-dimensional appearance in a two-dimensional drawing.
(Designer: David Michael Miller Associates)

Construction Components,
5 Systems, and Codes

FIGURE 5.1 Timberframe construction affects the systems in the building. Electrical, mechanical, and plumbing lines must be routed around structural beams. Designers work closely with the engineers to ensure all systems work together. This style of decorative truss is an adaptation of a hammer beam truss.
(Designer: Pineapple House Interior Design. Photograph by Chris Little)

The technical aspects of interiors help to define design possibilities. Understanding how construction systems fit together and developing a working knowledge of how these systems are visually communicated help the designer achieve the desired outcome (Figure 5.1). This chapter reviews the visual components in a set of construction drawings, defines and illustrates systems in the built environments, and outlines the codes and federal regulations relating to interior design.

◼ CONTRACT DOCUMENTS

Contract documents consist of construction drawings and a set of written specifications defining the quality of materials and craftsmanship.

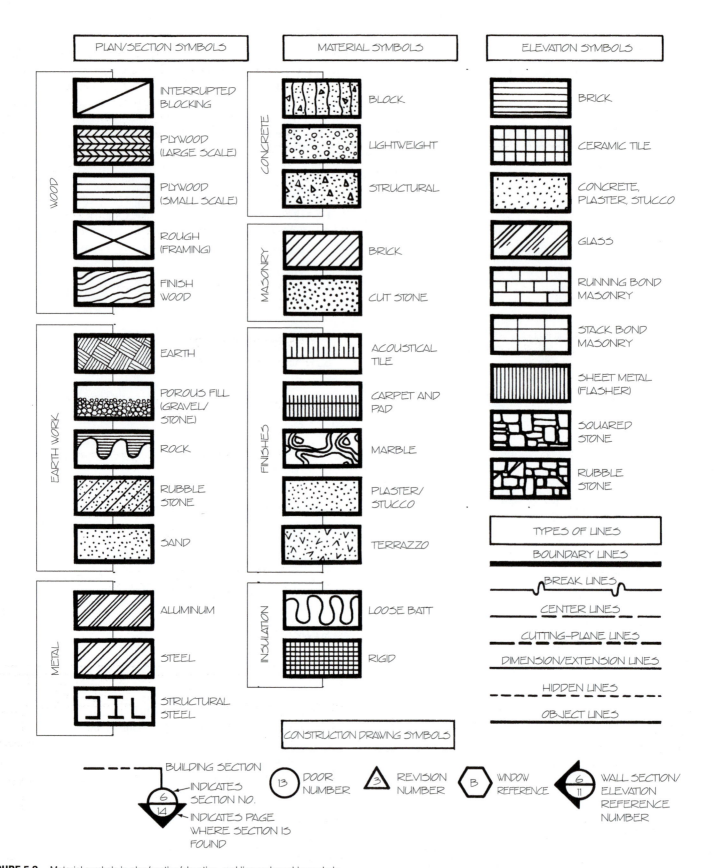

FIGURE 5.2 Material symbols in plan/section/elevation, and line and graphic symbols.

Construction drawings (explained throughout this chapter) generally include the following information:

- Cover sheet, used as a table of contents
- Site and grading plans
- Landscape plans
- Foundation plans
- Floor plans, generally starting with the lowest floor and rising
- Lighting location plans
- Electrical and communication location plans
- Finish plans
- Exterior elevations
- Interior elevations
- Sections
- Schedules
- Details and custom cabinetry
- Roofing plans
- Engineering drawings, including lighting, electrical and communications, plumbing, HVAC, fire protection, and security.

Drawings are deleted or inserted as required for the specific project. The written specifications (developed into a complex booklet) include requirements for each area listed above. For example, the specifications may list the acceptable tolerances (or gaps) between parts in wood construction. The construction specification booklet is organized based on the standard numbering system of the Construction Specifications Institute called the MasterFormat.

Furniture, finish, and equipment specifications also may be developed and are considered part of the contract documents (see Chapter 1). The following section describes these various drawings. Appendix C illustrates a small set of construction drawings.

Plans

Plan drawings show the layout of a site or building when viewed from above, looking into the various floors of the building. Plans are generally drawn to 1/8" = 1'-0" scale or 1/4" = 1'-0". (This means that 1/8" or 1/4", respectively, on the drawing is equal to 1'-0" in real-life dimensions.) Designers need to be able to interpret the standard symbols used in plan drawings. Figure 5.2 shows typical architectural symbols.

More info online @
www.constructionwork.com/resources.php See "How to Library" and "Glossary" for technical information
www.hometime.com/Howto/projectlist.htm Hometime website includes a glossary and images for specific home construction products
www.csinet.org/masterformat Construction Specifications Institute MasterFormat

Site, Grading, Landscape, and Foundation Plans

Site and grading plans and landscape plans, although rarely used by the designer, are helpful in orienting the design to the landscape and the direction of the sun. Foundation plans for residences may also show the location of HVAC and plumbing lines.

Floor Plans

Floor plans are critical to the designer. These plans define locations of walls, doors, windows, and other built-in components such as cabinets, built-in shelving, stairs, and kitchen and bathroom fixtures. Wall designations define the type of wall and its construction material. Figure 5.3 illustrates some of the options, including components in the walls such as a fireplace. Standard symbols for kitchens illustrate built-in components such as dishwashers and cabinets, as well as loose equipment such as refrigerators. Figure 5.4 illustrates the variety of kitchen symbols. Bathroom floor plan symbols are illustrated later in this chapter in the plumbing discussion. Stairways can be bold and dramatic or simply functional. Often the stairway functions as a focal point and can be aesthetically stimulating as well as serviceable, as demonstrated in Figure 5.5. Stairways, a common component on floor plans, also have a specific visual vocabulary.

FIGURE 5.3 Wall symbols.

FIGURE 5.4 Kitchen symbols.

FIGURE 5.5 The Arts and Crafts movement (see page 75) inspired this spiral staircase designed for the American Forest & Paper Association.
(Architect/Designer: Greenwell Goetz Architects. Photograph by David Patterson)

The stairway consists of the horizontal portion, called the **tread**, and the vertical portion, called the **riser** (Figure 5.6). The depth of a tread should accommodate the entire length of the foot (11" is generally used).

In a residence, the tread is often carpeted for additional safety. The riser should be no more than 7" high. Treads and risers should be consistent in size. A person expects and needs each step to be the same height and depth. Headroom clearance should be planned for the top and bottom of the staircase; 6"–8" is considered a minimum clearance.

A handrail (or **banister**) is usually mounted at 34" above the steps. The upright supports for the handrail are called **balusters**; they must be spaced close enough to prevent toddlers from falling though the supports. A **balustrade** is the handrail together with its balusters.

Designers may produce the floor plan on their own, but must collaborate with an architect or builder on structural components. Furniture plans, although not part of the formal construction drawings, are generated from the floor plans. Figure III.7 illustrates the first- and second-floor furniture plans of a residence.

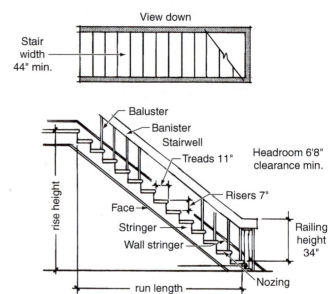

FIGURE 5.6 Stairway terminology.

FIGURE 5.7 Typical elevation of a fireplace wall.

Lighting Plans

Lighting plans may be produced by designers in collaboration with engineers. Lighting plans are slightly different from the other plans because they are drawn as if looking up at the ceiling instead of down at the floor. In residential design, lighting plans are commonly combined with electrical and communication (telephone) plans. In commercial design, lighting plans are called **reflected ceiling plans** and include

HVAC and sprinkler information. Chapter 6 discusses lighting fixtures and design, along with electrical and communication systems.

Finish Plans

Finish plans, drawn by designers, define what as well as where finishes are placed on floors, walls, and ceilings. Some designers use finish schedules instead of plans. The schedule is a chart indicating the finish and its location on each surface.

Elevations

Elevations are drawings of the walls. Exterior elevations delineate the outside of the building and define finish materials, as well as heights and locations of exterior components. Interior elevations are necessary to show custom cabinet or wall designs (Figure 5.7).

Sections

A **section** is a cut-through view of a building indicating appropriate framing and construction (Figure 5.8). Sections also may be cut-through walls or cabinets (Figures 5.9 and 5.10).

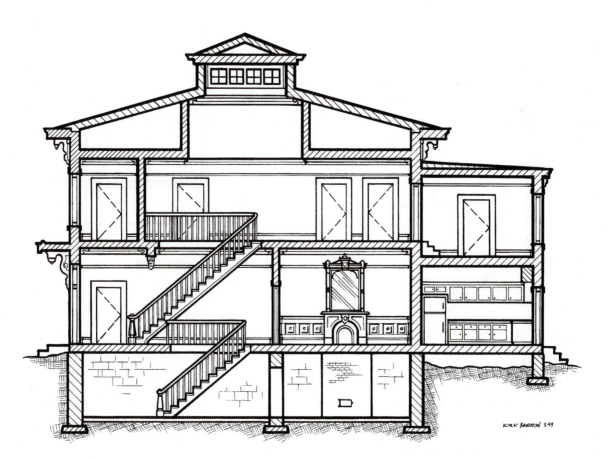

FIGURE 5.8 Transverse section of a three-story building.

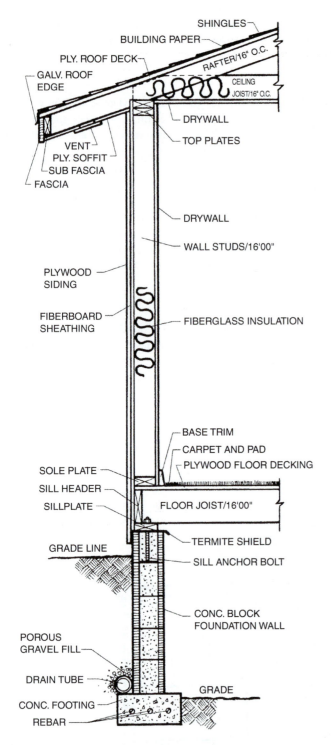

FIGURE 5.9 Typical wall section. Note the terminology and use of construction symbols.

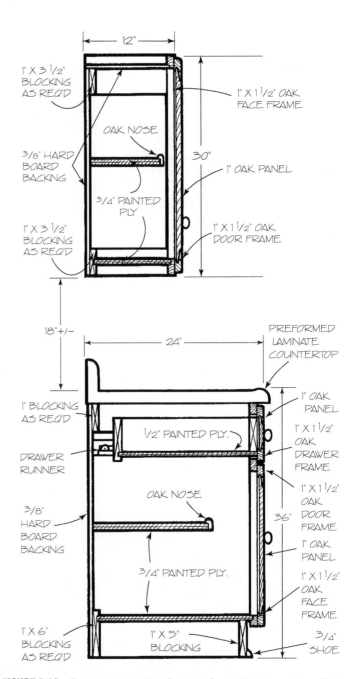

FIGURE 5.10 Typical cabinet section. Designers frequently create custom cabinetry not only for kitchens, but also for media rooms, libraries, and family rooms.

Schedules

A schedule is a table that indicates the material to be used in a specific building process, such as a chart indicating window and door information (Figure 5.11). Schedules also may be used to list hardware for windows and doors, as well as finish materials for floors, ceilings, and walls.

Details

Details are enlarged drawings indicating how components are to be constructed. Interior designers may design particular furniture pieces and wall moldings or trim. The most common interior details relate to the design of custom cabinetry such as bookshelves, media centers, built-in computer desks, and custom storage and kitchen units. Details are keyed to an elevation. Figure 5.12 illustrates a perspective sketch of a built-in workstation. Figure 5.13 illustrates a detail of the workstation in the form of a section.

Key	Quan	Rough Opng.	Type	Mfg. No.	Mullion	Remarks
W-1	3	2'-11" × 2'-6"	SASH	3W 1748	NONE	Painted
W-2	8	3'-10" × 2'-6"	"	3W 1783B	1'-3$\frac{1}{3}$"	Stained
W-3	7	3'-9" × 2'-6"	"	3W 1785	2'-3$\frac{1}{3}$"	Stained
W-4	2	4'-11" × 3'-2"	CASEMENT	3W 1880	NONE	See Detail
W-5	4	4'-5" × 2'-3$\frac{7}{8}$"	CASEMENT	AA6 1440	NONE	Stained

FIGURE 5.11 Window schedule.

FIGURE 5.12 Perspective sketch of workstations at a sports medicine center.
(© Elizabeth Thompson)

FIGURE 5.13 Detailed sections through the workstation. The circle labeled 11-A8.3 indicates a further detail of the transaction top located elsewhere in the set of construction documents.
(© Elizabeth Thompson)

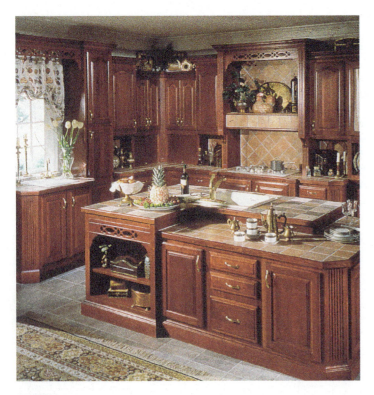

FIGURE 5.14 In this interior, faceframe cabinet construction was used to give a warm, traditional look.
(Courtesy Quality Cabinets, Division of Texwood Industries, Inc.)

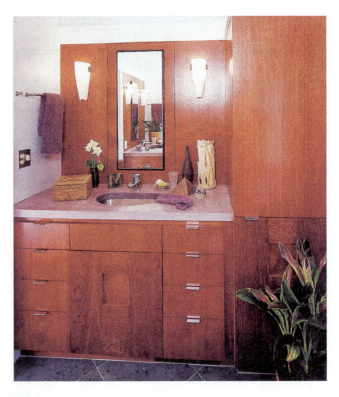

FIGURE 5.16 This bathroom cabinet utilizes frameless construction to achieve its sleek, clean appearance. Cherry wood with chrome drawer pulls accentuates the image.
(Architect/Designer: Lippert & Lippert Design, Palo Alto, CA. Photograph by Don Roper Photography)

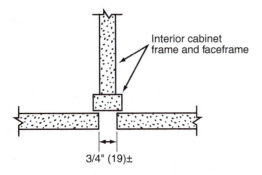

Interior cabinet
frame and faceframe

3/4" (19)±

FIGURE 5.15 Section looking down on two cabinet doors. Note recessed faceframe in construction.

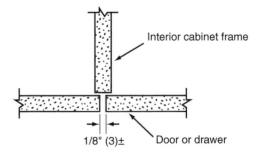

Interior cabinet frame

1/8" (3)± Door or drawer

FIGURE 5.17 Section looking down on two cabinet doors. Note flush front appearance in frameless construction.

More info online @ www.awinet.org Architectural Woodwork Institute
http://kcma.org Kitchen Cabinet Manufacturers Association
www.kitchens.com General website on kitchen design and construction

Roofing Plans and Engineering Drawings

Roofing plans and engineering drawings provide designers with insight into building systems. In general, designers should check that electrical, lighting, communication, and emergency lighting systems are placed where specified by the engineers. Where possible, emergency lighting and alarms should be selected and placed to blend with the interior finishes.

Interior designers must be able to read, interpret, and in many instances assist in preparing construction drawings for non-load-bearing walls. Terminology and specific processes in building systems follow.

One of the key design elements true to all cabinet construction involves construction style. The two broad divisions are *faceframe construction* and *frameless construction.*

1. Faceframe construction allows the doors and drawers of the cabinets to be flush (in the same plane). The frame of the cabinet is recessed, forming a reveal, and may be made of the same or contrasting materials (Figures 5.14 and 5.15).
2. Frameless construction is a cleaner, contemporary style of construction. Only doors and drawer fronts are visible. Wood grains can be matched between door and drawer fronts. Plastic laminates are well suited for this style (Figures 5.16 and 5.17).

STRUCTURAL CLASSIFICATIONS

The design of structural systems is based on loads placed on the building. These loads include the weights of the components of the building, furnishings placed in the building, live loads (such as people in the building), and dynamic loads on the building caused by nature, such as snow, wind, or earthquakes. Loads are transferred through the building's structural members to the foundation and ultimately to the earth. Vertical structural members are referred to as columns or posts; horizontal members are called joists, beams, or lintels. Trusses, such as rafters, are a series of smaller members working together in a triangular fashion.

Loads create forces known as compression, tension, and bending. When a load (or force) is placed directly on top of a vertical member (such as a post), the post is said to be in **compression**. Stepping on an upright soda can places the can in compression. Conversely, if a structural member is loaded in such a way that the force is trying to pull it apart end to end, it is said to be under **tension**. For instance, a rubber band pulled at both ends is under tension. When a load is placed on the top of horizontal member (such as a beam) between two supports, the beam receives a bending load. The bending load causes the top of a beam to be in compression while at the same time the bottom of the beam is under tension. In other words, the top of the beam is being forced to shrink while the bottom is being forced to expand. The amount the beam moves from its original position is called the deflection. Figure 5.18 illustrates these terms.

The size of a horizontal member and its material makeup is directly related to its ability to span a section and withstand deflection. Structural systems are typically made of wood, metal (steel), masonry, or concrete.

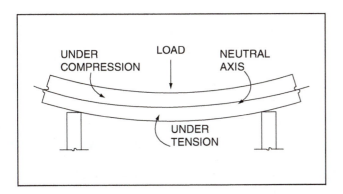

FIGURE 5.18 Load stresses of reinforced concrete beams. Wood beams are similarly affected.

Steel

Steel systems structurally work on the same load basis, but may be welded and/or riveted together. Steel columns and beams, frequently shaped as an I or H, may combine with concrete columns and flooring systems. Steel structures characteristically form a grid pattern (when looking at the floor plan) that supports the building. Therefore, the perimeter wall, called the curtain wall, may or may not be load bearing. Internal steel studs, similar to wood frame studs, are used to create the walls between rooms and are non-load bearing. Just like wood stud walls, steel stud walls house the mechanical, electrical, and plumbing systems and provide a structure to which wall materials are attached.

Masonry

Masonry (brick, block, or stone) may also be used for structural systems, although frequently the brick and stone are used as a veneer, or finish material. Concrete block, however, may serve as a structural wall in addition to its structural use in the foundation. Masonry materials are joined with mortar. Masonry may be laid to form a variety of patterns. Brick patterns are referred to as bonds or courses. Figures 5.19 and 5.20 illustrate some patterns in brick and stone.

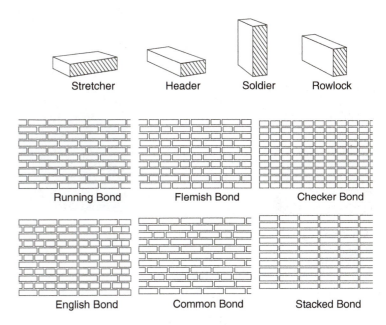

FIGURE 5.19 Stretchers, headers, and brick bonds.

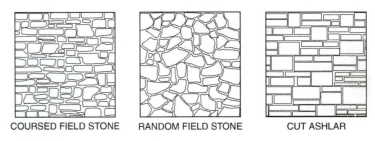

FIGURE 5.20 Patterns in stone.

Concrete

Precast concrete and cast-in-place (poured) concrete are reinforced with rebar in structural applications. Concrete, a combination of cement, sand, gravel, and water, is an extremely strong material and is innately fire resistant. Concrete can be colored, textured, stamped, or scored (Figure 5.21). It is dense and therefore serves as a good acoustical blocker. Like other masonry products, concrete serves as an excellent thermal storage material and is considered a sustainable building product.

FIGURE 5.21 In this contemporary residence, concrete has been used for structural and decorative effects.
(Designer: Gandy/Peace; Designer: Bill Peace, ASID)

Wood

The wood frame construction process, illustrated in Building Systems, Part III, is typical of residential and small office construction. However, designers need to be aware of other structural systems and develop their knowledge of the associated vocabulary encompassing each system. Wood members may be solid, or they may consist of a series of smaller pieces glued and/or secured to each other with metal fasteners. Glue-laminated wood beams are used for spanning large sections.

Wood systems may be based on platform framing (defined in Building Systems, Part III), balloon framing, or timber framing systems. Balloon framing extends the exterior wood frames from the foundation to the roof. Timber framing involves the use of large timbers (8" × 8" thick or bigger) and integrated joinery. Applied in historic structures before the use of concrete and steel, timber framing construction techniques are still used in many western American settings (Figure 5.22A and B).

FIGURE 5.22 (A) Detail of joinery. Wooden pegs and tight joints secure beams to posts. No nails or other metal fasteners are used in true timber frame construction. (B) Timber frame construction. A skin wall of standard 2" × 6" wood construction will surround the timber frame.
(Designer: Jones Interiors. Photography by Philip A. Jones)

▪ DOORS

Fenestration refers to the arrangement, type, and design of openings in a wall or building. For example, many traditional homes built in the 1980s were called "five over four with a door," which referred to the pattern of windows (plus front door) on the **facade** (the front elevation of a building or object) of a two-story house.

In the interior environment, doors, windows, and even fireplaces create fenestration within a room, penetrating the structure's skin. Many times these architectural features are already in place and designers must work around the existing conditions. In other situations, the designer may select the style of the doors and windows.

Doors are powerful design elements in any interior. By their location, doors control traffic flow, which in turn controls the furniture arrangement. Doors provide privacy and sound barriers. They allow for ventilation and temperature control. They also provide a sense of safety and security.

Door Construction

Doors are composed of three basic parts—the *door* itself, the *frame*, and the *hardware*. These components work together to form the design of

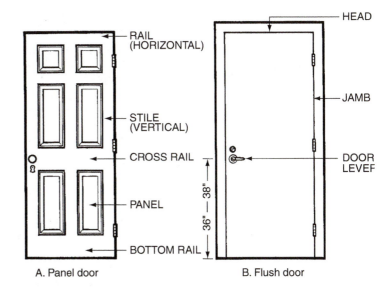

FIGURE 5.23 Door parts and terminology.

the door, and all should be considered when selecting the door style and type. Figure 5.23 indicates the various parts of the door.

Doors are available in a variety of styles. Wood construction includes hollow-core doors or solid-core doors. *Hollow-core doors* are composed of veneers laminated to a frame. *Solid-core doors*, also composed of veneers, have a particleboard, solid wood, or mineral core, all of which provide various degrees of fire resistance. Solid-core doors also provide better insulation and acoustical barriers.

Solid-core doors are the only acceptable solution for commercial interiors and for exterior doors on residences. Metal doors are also used in commercial (and occasionally residential) interiors, particularly in high-traffic areas or in stairwells where fire codes dictate their use. Glass doors are also common in contemporary residential design and are frequently used in commercial design solutions.

FIGURE 5.22B (*continued*)

Doors come in standard widths. The most common are 2'-0", 2'-4", 2'-6", and 3'-0". All exterior doors should be a minimum of 3'-0" wide. Interior residential doors are commonly 2'-6". Standard door height is 6'-8", but doors are available that are 7'-0" and 8'-0". Additionally, doors may be custom designed to fit any space or shape.

More info online @
www.ballandball-us.com/commondoorconstructionterms.html Door construction terms

Frame

The door frame supports the door and provides a *stop*, a *sill*, and a *jamb*, which allow the door to operate properly (Figure 5.24). Door frames are made of wood or molded steel. Wood frames are generally used for residential interiors; steel frames are more often used in commercial construction. The *stop* is the vertical portion that prevents the door from swinging both ways. The *sill* is the horizontal member across the bottom of the opening. The *jamb* refers to the vertical members of the frame that support the door. Some frames also include trim around the jamb. In steel construction, the jamb may actually serve as the trim.

Hardware

The selection of the appropriate hardware is often left to the builder, who usually chooses the least expensive product available. This may not be the best design solution. Door hardware includes *latchsets* or *locksets* (handles), *push plates* or *pull bars, panic hardware, closers, hinges*, and *kick plates*.

Functional hardware *Latchsets* and *locksets* are usually shaped in the form of a knob or lever. They include a mechanism to operate the door and to hold it closed, and in the case of a lockset, to lock the door. Knobs are common in residential environments, but lever handles are much easier to operate. A lever does not require a person to grip and rotate a knob to open a door, but simply to push the lever up or down. Because of their ease in manipulation, lever handles are required in commercial spaces. Many high-end residential interiors incorporate lever handles. They also are beneficial in homes for the elderly. These handles meet universal design standards.

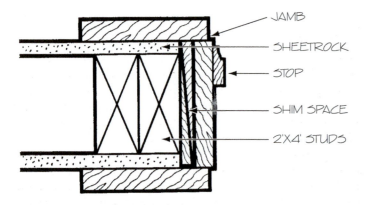

FIGURE 5.24 Detail of standard wood door frame.

Push plates or *pull bars* serve the same function as a knob or lever, allowing occupants to enter or exit a room. Push plates and pull bars, however, do not require the release of a latching mechanism.

Panic hardware and *closers* are usually used in commercial environments. *Panic hardware* includes a push bar that extends across the width of the door. When pushed, it releases the latches at the top and bottom of the door, allowing it to open. *Closers* automatically close a door and are required by some building codes. Residential environments commonly use a similar hydraulic device to close storm doors.

Hinges attach the door to the frame and permit the swinging movement of the door. *Kick plates* protect the lower portion of the door and also can add a decorative touch.

Decorative hardware Hardware is obviously functional, but the selection of proper hardware also affects the character of the interior. Hardware can be finished in brass, antique brass, bright chrome, satin chrome, and a variety of other specialized finishes specific to each manufacturer. Flat-finished chrome hardware reflects a more contemporary interior, whereas a bright brass finish is more traditional. Hardware also can be highly decorative, sleek, or finely crafted. Because the same hardware is normally used throughout the interior spaces, it adds a unifying element.

Hardware should also "feel good to the touch." This is referred to as the hand of the object (as discussed in Chapter 12 on textiles). Sharp edges and rough corners are inappropriate; a firm smooth finish would welcome a visitor.

More info online @
www.bernards.co.uk/door_furniture_period_styles_faq.htm Historic decorative door hardware

Types of Doors by Operation

As seen in Figure 5.25, the three basic types of doors are swinging, folding, and sliding. These doors and their components may be constructed of wood, steel, aluminum, plastic, glass, or a combination of these materials, depending on design, location, and function.

Swinging doors are easy to install and operate, and are available in standard sizes. Most doors are single-hinged and swing only one way; a double-hinged door swings both ways. The latter is convenient between kitchens and dining rooms. A swinging door placed near a corner, with the arc swinging toward the adjacent wall, preserves wall space and directs traffic along the side of the room. Pairs of **French doors** are glass-paned, single-hinged swinging doors that open the same way, leading to an outside area or an adjoining room. The **Dutch door** is a single-hinged door divided horizontally, making it possible to have ventilation and visual communication from the upper half while the lower half is closed.

Swinging doors are considered right-hand or left-hand. To determine the swing, walk through the door so that you are pushing the door open. If the hinges are on the right, it is a right-hand door, and vice versa (Figure 5.26).

Folding doors save space in a residential setting. They are available in sizes from a single door to a full wall divider, and they may be

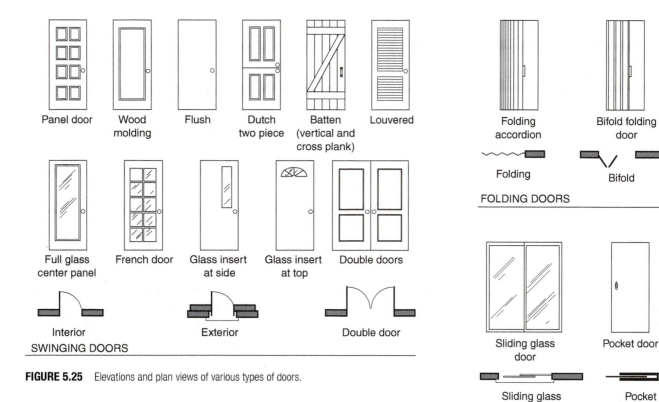

Panel door | Wood molding | Flush | Dutch two piece | Batten (vertical and cross plank) | Louvered

Full glass center panel | French door | Glass insert at side | Glass insert at top | Double doors

Interior Exterior Double door

SWINGING DOORS

FIGURE 5.25 Elevations and plan views of various types of doors.

Folding accordion | Bifold folding door

Folding Bifold

FOLDING DOORS

Sliding glass door | Pocket door

Sliding glass Pocket

SLIDING DOORS

LEFT-HAND DOOR SWINGS RIGHT-HAND DOOR SWINGS

FIGURE 5.26 Plan view of left-hand and right-hand door swings.

attached at both top and bottom or only at the top. Made in a wide variety of styles (such as louvered) and materials (including plastic and fiberglass), they are flexible and relatively inexpensive.

Sliding doors used on the exterior may be part of a glass wall or installed in pairs that slide one behind the other. They are popular in contemporary houses to make the patio or garden a visual part of the living area. Sliding glass doors should be made of safety glass.

Interior sliding doors (known as *pocket doors*) slide into a pocket in the wall, or when paired may slide one behind the other. Although not as flexible as folding doors, sliding doors (like folding doors) are great

space savers for residential use. They can provide complete or partial privacy, depending on their material, but they can be difficult to operate, especially for the physically challenged. The traditional Japanese shoji sliding panel is appropriate in both traditional and modern interiors, serving multiple uses (Figure 5.27). Sliding doors installed on an exposed track are called barn doors. The Design Scenario at the end of Chapter 6 illustrates this solution (see Figure DS6.5).

More info online @
www.selectmillwork.com Images of door styles

Door Design and Placement

If doors are well placed to preserve wall space and direct traffic efficiently, they present no problem. But if a room has a surplus of doors, it may be necessary to camouflage them. One option (if other passageways exist) is to remove the hinges and fill the opening with shelves for books and small art objects. Relocating a door is also possible, and the result may be worth the effort and expense.

Door treatment depends on the design and style of the room. Doors are often painted to blend with the walls; wood doors may be stained or left natural. If a door has a particularly good design, painting it a contrasting color may augment the room's decoration. When walls are paneled, doors may conform to the walls or be painted in a contrasting

color. A door may not be a door at all, but serve as an opening (Figure 5.28). If it has molding around it, the walkway is called a cased opening. The main entrance door is generally the most important element and focal point in the facade. Traditional paneled period doors and leaded glass panels continue to be popular. Many contemporary exterior and interior doors are plain and flush, sheathed on both sides with a veneer. Metal exterior doors with insulating cores are effective in saving energy.

As will be discussed in Chapter 7, barrier-free design requires doors to have a clear opening of 32". To obtain this dimension, doors used in handicap-accessible areas must be 36" wide. Additionally, the pull side of the door must have at least 18" clear of any obstruction; the push side needs 12" clear (as seen in Figure 2.15).

FIGURE 5.27 In this master suite addition, the client requested the serenity of a Japanese setting. Shoji screens, sliding along an 1/8" slot recessed into the wood floor, were used in place of a typical door. Woods, warm colors, and clean lines accentuated the Zen-like retreat.
(Architect: Bernard Zyscouich, AIA. Designer: Dennis Jenkins Associates, Inc. Photograph by Nancy Robinson Watson)

FIGURE 5.28 In this image, the large opening between the kitchen and the dining room is outlined by a heavy wood frame and includes two walkways on either side of the countertop. The frosted glass pane serves as an interior window and provides a psychological separation of room functions.
(Designer: Toby Long of Clever Homes. Photo © Robert Thien)

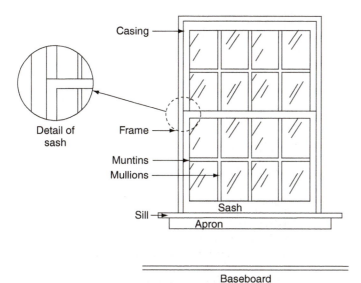

FIGURE 5.29 Window parts. Note how the lower sash is drawn in front of the upper sash when looking from the inside to the outside.

■ WINDOWS

Although glass walls were known to the ancient Egyptians and Romans, historically, windows (or the "wind's eye") were merely small cutouts in the walls of a house. Over the years, many types of windows have been planned as an integral part of the structural design of a building.

Windows perform three primary functions: They admit light, provide ventilation, and enhance visual communication. Even though light and airflow can now be mechanically controlled, and windows are not absolutely necessary, planning an interior without windows seems inconceivable. There are no substitutes for fresh air, natural light, and an outdoor view to create a psychological association with nature and provide a sense of well-being.

The window is a conspicuous element in both the exterior and interior design of a house. As a source of interior light, the window is the first point to which the eye is drawn during the daytime, while at night, a lighted window is the first thing seen from the outside.

The window is an important architectural and decorative element in a room. Traditionally, windows with small panes were often symmetrically placed in the facade of the house. With the development of modern architecture and technology, new types of window openings were planned as integral parts of the basic design.

Window Construction

Window terminologies are identified in Figure 5.29. Windows are composed of panes of glass. A casement window has only one pane, whereas a sash window is composed of at least two panes, one at the top and one at the bottom. Some sash windows have several panes and may be referred to based on their number of panes, such as six over six (written "6/6"). Originally, these panes were separated by wood **mullions** and **muntins** (Figure 5.29). *Mullions* form the vertical divisions of the panes; *muntins* form the horizontal divisions. It is a common practice today to divide the panes with pop-in plastic mullions and muntins. Although the plastic versions are not as rich looking as the wood, they do make cleaning the panes easier.

Architectural glass is available in single, double, or triple panes and is technically termed *annealed glass*. When the window consists of double or triple panes of glass that are separated by a layer of gas (air) that serves as an insulator, the glass is termed *insulated glass*. The air space also helps to prevent condensation on the glass. Insulated glass is sometimes called *thermopane glass*. For a further discussion of energy-efficient glass, see Sustainable Design: Low-E Glass, on page 172.

Glass can also be *tempered*, meaning that if it were to break, it would shatter into pebble-sized pieces instead of large sharp-edged pieces. *Laminated glass* is actually put together with a thin film laminated between the layers of glass. This is an excellent choice for overhead glazing.

In fire corridors or other hallways that are designed for fire egress, *wired glass* is used. Wired glass holds together when subjected to high temperatures or impacts.

Glass panes are supported by wood, metal, or plastic frames. Each has particular advantages and disadvantages. *Wood* shrinks, swells, requires a protective finish, and is the most expensive. It discourages moisture condensation, however, and emits less heat than does metal. Wood also has a richer appearance than does metal or plastic. *Metal* is strong and does not shrink or swell perceptibly. Except for aluminum and stainless steel, however, it requires protective paint and causes moisture condensation in cold weather. Newer metal windows are designed to eliminate excessive heat loss and condensation. *Plastic* or *vinyl* is stable and resists heat and cold, but may look inexpensive.

More info online @

www.onlinetools.com/cwd/vinylcut.html Cut section of a window and glossary of window terms

Types of Windows

Windows are available in standard sizes and can be movable, stationary, or a combination of both.

Movable Windows

Movable windows open to permit ventilation. Some of the most common movable window designs are illustrated in Figure 5.30.

Double-hung windows are made up of two **sashes** that may be raised or lowered to provide 50 percent ventilation. They are simple and inexpensive. *Casements* may swing inward or outward and permit up to 100 percent ventilation. (In-swinging casements must have special window treatments designed not to interfere with the window's operation.) *Horizontal sliding windows* may use two sliding panes or a large stationary central pane with a sliding pane on either side or other combination. These windows work like a sliding glass door. *Awning* (or louvered) and *jalousie windows* consist of strips of glass, hinged at the top or bottom, that open outward or inward. Strips in jalousies are narrower than in the awning type. *Single-pivoting windows* are raised for ventilation by means of a hinged side. These windows are most often used as skylights or in light wells.

Fixed glazing (another name for a flat window) is a common feature of today's contemporary homes and may extend from floor to ceiling or begin a short distance above the floor. Hexagons, circles, and other geometrically shaped windows are occasionally used to provide a point of interest and additional light, and are also considered fixed glazing. The

Bow bay **Arched** **Fixed**

FIGURE 5.31 Various types of stationary windows.

bow window is a smooth, sweeping curve of multiple panes. In *arched windows* the upper part of a rectangular opening is topped by an arch.

Stationary Windows

Stationary windows are built as an integral part of the wall construction. They may be made of plain or nonglare glass. Common stationary windows include fixed glazing, bow, and arch (Figure 5.31).

Combination and Custom Windows

Many window types combine movable and stationary sections (Figure 5.32).

The *picture window* is composed of fixed glazing, usually with movable end sections. *Palladian windows* feature a central arched window flanked by two smaller windows, often with movable sections. This window type is associated with the Federal style and today is used in

FIGURE 5.30 Various types of movable windows.

Fixed glazing with movable end sections

Palladian

Angled bay

Strip

Clerestory

Slanted clerestory

Corner

Dormer

Skylight

FIGURE 5.32 Combination window types.

a wide variety of settings. The *angled bay window* is made up of three or more windows that angle out of the room. The central pane may be stationary with movable side panes.

Clerestory windows may be straight or slanting windows set at the ceiling or high in a wall. Operable windows at this level provide for excellent air circulation when combined with windows opened at lower levels. The *corner window* consists of two windows of any style that meet or almost meet in a corner. A single corner window can be thought of as a double window and treated accordingly. *Ranch* or *strip windows* can be any style and are wide and shallow. They are set far enough above the floor to allow furniture to be set against the wall, but they are not flush to the ceiling. *Dormer windows* are located in alcoves projecting out from the roof. Any style of window may be located in the dormer.

Skylights (windows placed in the ceiling) may be single or grouped panels of clear or translucent glass or plastic, either flat or domed, and fixed or movable for ventilation. Skylights in kitchens, laundries, and bathrooms have the special advantage of providing adequate daylight for inside rooms. In small areas, light from above can expand visual space and make the sky and trees part of a room. The skylight window has a number of disadvantages, however, including problems with water seepage, insulation, and cleaning. Also, skylights present a security problem unless protected by safety-wired glass or other measures.

Architects and designers often create custom-designed windows for clients, as shown in Figure 5.33. They can be of various sizes and shapes and may be movable, stationary, or combinations of both types.

Window Design and Placement

The selection and placement of windows creates a powerful design statement. Poorly placed windows impede furniture arrangement and may allow for undesirable views. Whenever possible, designers should work with architects prior to construction. Furniture laid out in the schematic design and design development stages can help the architect determine where to locate windows. Window openings, however, are not always planned with indoor function in mind. A clever designer must work around these obstacles.

More info online @

www.pella.com/learn/glossary Pella's glossary of terms for doors and windows
www.hometime.com/Howto/projects/window/win_1.htm Glossary of residential door and window terms

FIGURE 5.33 These custom floor-to-ceiling windows allow the residents to view their Japanese garden. The second row of windows includes operable awning windows. Floor-to-ceiling shoji screens glide on tracks and can close off the corner window. The fireplace adds warmth and a focal point. The Peacock chairs, designed by Hans Wegner, complement the crisp, clean, and inviting interior. *(Architect: Bernard Zyscouich, AIA. Designer: Dennis Jenkins Associates, Inc. Photograph by Nancy Robinson Watson)*

SUSTAINABLEdesign

LOW-E GLASS

Some windows can save energy without being bulky and heavy. Manufacturers are making glazed windows with a transparent, nonglare coating on the inside layers to help slow the transmission of heat energy through glass. Such windows are made with low-E (low-emissivity) coatings. They help interior environments stay more comfortable.

Low-E glass treats sunlight's different wavelengths in different ways. The sun's energy spectrum is divided into three ranges of wavelengths: ultraviolet, visible light, and infrared, which can be felt as heat. (These heat-generating infrared rays are further divided into long wavelengths and short wavelengths.) The challenge is to let in visible light and to control infrared transmittance.

Low-E glass, with its low-emissivity pyrolytic coating, lets in approximately 95 percent as much visible light as ordinary insulated glass, allowing the interior to look bright and the window to appear transparent. However, low-E glass reflects most of the long-wave infrared energy back toward its source, helping to keep summer heat out and winter heat in (Figure SD5.1).

Performance can be even better with the addition of argon gas (a superinsulator) between the layers of glass in the window unit. As a result of these new energy-efficient developments, windows can be practical as well as beautiful.

FIGURE SD5.1 (A) Low-E glass, coated on the inside layers, allows natural light and short-wave heat energy to enter freely. (B) In summer, long-wave heat energy radiating from objects is reflected, lowering cooling costs. (C) In winter, internal long-wave heat energy is reflected, lowering heating costs. *(Courtesy of PPG Industries)*

More info online @
www.efficientwindows.org Energy-efficient window site

■ FIREPLACES

The fireplace has served important functional roles through the centuries as a source of warmth and a place to cook meals. In simple homes the fireplace was the focus of the home and a place where the family congregated. In today's homes the fireplace may be a visual luxury, serving primarily as a room's focal point, or it may provide a source of heat.

Fireplaces can be expensive and hard to clean. They also require space for fuel storage. Gas fireplaces have become a common alternative, as have wood-burning heaters and stoves. A fireplace, however, is still considered a desirable asset; fireplaces in residential living spaces can add to a home's market value (Figure 5.34). Fireplaces in public settings such as restaurants, hotels, and clubs can be particularly inviting, offering a friendly and intimate atmosphere. A fireplace alcove large enough to accommodate people and seating is called an **inglenook**. (See Figure DS14.6B.)

Fireplace Construction

Fireplaces may be constructed of masonry or prefabricated from metal. Masonry fireplaces require space away from combustible materials. Some prefabricated units require no space between the fireplace and combustible materials and can be installed within a regular stud wall. Models are available with openings on one, two, three, and even four sides.

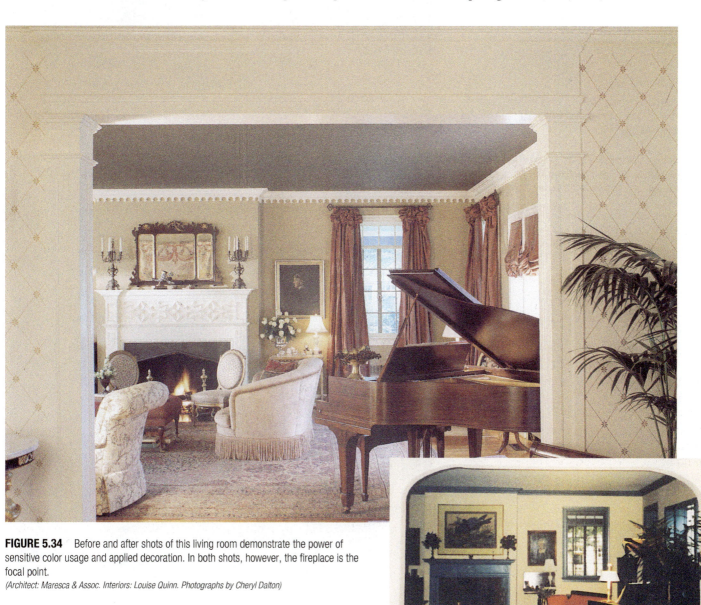

FIGURE 5.34 Before and after shots of this living room demonstrate the power of sensitive color usage and applied decoration. In both shots, however, the fireplace is the focal point.
(Architect: Maresca & Assoc. Interiors: Louise Quinn. Photographs by Cheryl Dalton)

FIGURE 5.35 In this contemporary setting, a wood stove enhances the interior architecture and provides a backup heating system.
(Courtesy of Vermont Castings/Majestic Products Co.)

FIGURE 5.36 In this commercial office space located in Minnesota, the designers recognized the need for added warmth in the break area. The contemporary fireplace surround complements the design and provides a sense of contentment.
(Architect/Designer: Perkins + Will. Photograph by Chris Barrett © Hedrich Blessing)

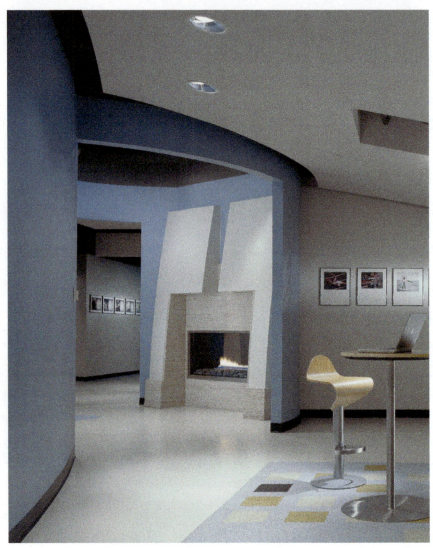

The most common materials for fireplace surrounds include the following:

- *Brick*, available in many sizes, textures, and colors and laid in simple or intricate arrangements
- *Stone* of all types (marble, travertine, terrazzo, quartzite, fieldstone, granite, etc.)
- *Wood* of all varieties, either in strips (laid in numerous patterns and directions), panels, planks, or elaborately carved members, used on decorative surfaces
- *Facings* of plaster or stucco, painted or left plain
- *Concrete*, plain or with exposed aggregate accents
- *Tile* in a variety of colors, textures, and patterns

Fireplace design often includes combinations of these materials. For example, a stone fireplace may have a handsome wood mantel, or a plaster fireplace may be outlined around the opening with colorfully patterned tile.

Types of Fireplaces

The wood-burning fireplace is the most prevalent fireplace design. However, faced with deteriorating air quality as well as wood-burning restrictions, many designers are choosing alternatives to the wood-burning fireplace, such as *wood-burning heaters* and *stoves*. The Environmental Protection Agency (EPA) establishes strict codes for wood-burning heaters and stoves: They may emit no more than 8 grams of particulate per hour. (By comparison, an average wood-burning fireplace emits up to 1,000 grams of particulate per hour.) Today only certified wood heaters that meet the emission limits may be sold. Additionally, no person may install or operate a wood-burning heater or stove except in a manner consistent with the EPA's guidelines. Heating homes with these heaters and stoves instead of fireplaces can drastically cut down on air pollutants.

Wood-burning heaters and stoves are also much more energy efficient than wood-burning fireplaces. With the high cost of heating, wood-burning stoves and heaters have become popular and are available in a large range of styles (Figure 5.35)

Other alternatives to the traditional wood-burning fireplace are *natural gas fireplaces, fireplace inserts*, and *log sets*. These gas-burning devices provide the ambience of wood-burning fireplaces and stoves with none of the inconveniences. Compared with its wood-burning counterpart, natural gas fireplace equipment is cleaner burning, simpler to start, easier to keep clean, and has lower fuel costs. Although gas does not burn as hot as wood, a gas insert adds a substantial amount of heat to a room. Flueless gas logs are also available that require no venting to the outside.

Another fireplace option is the gel-fuel fireplace. Gel fuel is alcohol based, requires no venting, and produces a smokeless, odorless flame. This option is ideal for residential and commercial settings in which a wood-burning stove is not practical (Figure 5.36). Some models can be mounted into a wall cavity or hung directly on the wall. The fuel also can be used for portable fireplace units, even those surrounded in glass or stone.

Fireplace Design and Placement

The style of a fireplace is generally traditional or modern. Traditional styles for fireplace design provide charm and a feeling of authenticity. Modern fireplaces are often custom designed for particular spaces.

Modern fireplaces may soar vertically, expand horizontally, or create a circular form. The fireplace may or may not have a mantel, the hearth may be on the floor or raised, and the fireplace may be set against the wall or project outward. The style of a fireplace is generally most successful when it complements the room's furnishings and background.

The size of the fireplace within a living space is flexible. Small fireplaces can have charm; an average- or medium-size fireplace can be a focal point without overwhelming a room; and a very large fireplace can be a dramatic feature (Figure 5.37).

Designers may incorporate the fireplace as part of the total wall composition by using shelves or built-in furnishings, extending the fireplace material the full length and height of the wall. The fireplace may also be freestanding, independent of any wall. As with doors and windows, consideration of the scale and proportion of the room, the style, the materials to be employed, and the effect and function desired help to determine the most appropriate fireplace construction for a particular space.

More info online @

www.maconline.org/tech/design/fireplace1/fireplace1.html Masonry Advisory Council's fireplace design webpage
www.buffaloah.com/a/DCTNRY/fireplace/fireplace.html Glossary of fireplace terms
www.hpba.org/index.php?id=73 Hearth, Patio, & Barbecue Association's glossary of terms
http://hpbef.org Hearth, Patio, & Barbecue Education Foundation

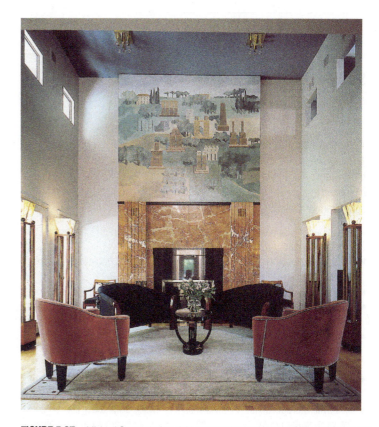

FIGURE 5.37 Michael Graves designed this postmodern residence in New Jersey in 1986. In the living room, the fireplace wall dominates the space. The placement of classic Villa Gallia chairs, designed by Josef Hoffman at the turn of the century, complements the fireplace wall. *(© 2011 Taylor Photo)*

■ HEATING, VENTILATING, AND AIR-CONDITIONING (HVAC) SYSTEMS

HVAC systems are designed to maintain human comfort. In addition to controlling temperature, HVAC systems should also regulate the humidity, air quality, and air movement through a space. The most common heating systems are forced air heat, radiant heat, and solar energy. (Also see Sustainable Design: Solar Energy.)

Forced Air Heat

Forced air heaters require a furnace and ductwork. The furnace heats air, which is then forced through the ductwork by a fan. Return vents draw cool air back into the furnace for recirculation (Figure 5.38). A heat pump works in conjunction with a furnace by extracting heat from the outside air.

In residential design the ductwork is concealed in the walls, ceiling, or floor. In commercial design the ductwork is typically located above the ceiling, but below the floor, in an area called the **plenum**.

Radiant Heat

Radiant heat is available through steam heating systems, electric baseboards, portable space heaters, and wood stoves.

In a steam heating system, water is heated in a furnace or boiler and then carried by a water pump through pipes. Thin metal fins surrounding the pipes radiate the heat into the room. Electric or gas baseboard heaters and portable heaters work in a similar fashion by heating strips or coils, which in turn radiate the heat into the surrounding space. Both forced air and radiant heating systems may require the use of a separate humidifier to control the level of humidity.

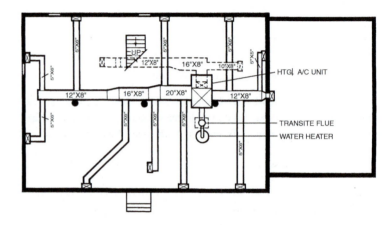

FIGURE 5.38 In this HVAC plan, numbers indicate pipe sizes. Boxes with Xs indicate registers. Dotted lines indicate the return airflow system.

SUSTAINABLEdesign

SOLAR ENERGY

Solar buildings are built to capture the sun's energy and conserve conventional fuel.

The passive solar energy system

The **passive solar energy system** is a nonmechanical method relying on the building itself to absorb and store the sun's heat. (Note: All compass directions are given relative to the Northern hemisphere; for Southern hemisphere applications, substitute north for south.)

- Buildings are space planned so that frequently used spaces are on the south side.
- Windows are generally limited to the south wall, with occasional east and west wall use.
- The north side of the building is slightly **bermed**, or buried under dirt.
- Evergreen trees are planted to the northwest of the building to block cold winter winds.
- Deciduous trees (those that lose their leaves in winter) are placed to the south to block the hot summer sun, yet allow winter sun to reach the building.
- Overhanging eaves are designed in accordance with the angle of the sun to allow winter sun to enter a building, while blocking summer sun.
- Thermal storage units, such as masonry walls, fireplaces, stone floors, or large water containers (such as an indoor pool), are located to absorb solar energy during the day. At night, the stored heat is released into the building.

- Exterior doors enter into small passageways that serve as an air lock.
- Highly efficient stoves may function as auxiliary heating devices.
- In the summer, lower windows may be opened to draw in cooler air, while skylights, ceiling fans, and upper windows are used to draw the warmer air up and out of the building.
- Low-growing vines and shrubs are planted on the south side of the building to prevent glare.

The active solar energy system

The **active solar energy system** relies on mechanical means—photovoltaic (or solar) panels, fans, and pumps—in addition to the principles of passive solar design to trap and use energy from the sun.

Active solar systems can also provide electricity for the building. Photovoltaic panels convert sunlight to DC electricity, which is stored in a series of batteries (or converted to AC electricity and sent to the power grid). An inverter changes the electricity stored in batteries from DC to AC, the type used in conventional building designs. Batteries are generally housed in a utility room with a small vent to the outside for gases to escape. A solar batch water heater can be used in sunbelt areas. This type of water heater provides hot water by mid-morning on sunny days, and keeps it hot until well after sunset.

More info online @

www.ises.org/ises.nsf International Solar Energy Society
www.seia.org Solar Energy Industries Association

Ventilation

Ventilation refers to the exchange of air inside a room. Natural ventilation occurs when windows and doors are left open to allow breezes to enter the building.

Hot, stale air rises in a room and should be vented via skylights, high windows, or exhaust fans. Ceiling fans also help to circulate air.

Cooler, cleaner air is drawn in from windows and doors as hot air is eliminated. Cross-ventilation is also helpful wherever possible.

When fresh air is not brought into buildings, stale air and toxins emitted from plastics, chemical finishes, smoke, and other airborne pollutants can lead to **sick building syndrome**. (See Sustainable Design: Indoor Air Quality.)

SUSTAINABLEdesign

INDOOR AIR QUALITY

Most people are familiar with the detrimental effects of outdoor air pollution, but indoor air pollution may be equally (if not more) hazardous to one's health. Indoor air quality, or **IAQ**, has come under close scrutiny because it is estimated that Americans spend 90 percent of their time indoors.

In general, indoor air pollution results in what has been termed *sick building syndrome* or SBS. SBS defines a building where inhabitants complain of health problems, such as respiratory, sinus, and digestive problems; irritability; and fatigue. The sources of indoor air pollution are complex but can be divided into three general types of pollutants:

1. Biological—organic toxins such as bacteria, molds, dust mites, and insects.
2. Earth elements—harmful naturally occurring materials such as sheetrock dust, asbestos, and radon.
3. Volatile organic chemicals (VOCs)—chemicals that are emitted into the air from building materials, furniture, fabrics, or finishes, and other building processes. Typical VOCs include formaldehyde, styrene, and benzene.

According to the American Society of Interior Designers' *Indoor Air Quality Two-Part Program*, pollutants may stem from a variety of sources throughout a building, including the following:

- Construction products such as sealers, insulation, paint, caulks, and adhesives.
- Fixtures and furnishings such as carpet, carpet pads and adhesives, furniture, finishes, and chipboard.
- Waxes, polishes, solvents, and insect repellents.
- Machines and electronics such as computer screens, printers, and lasers, which may emit electromagnetic fields.
- Photographic processes, perfumes, and sprays.
- Operational equipment, inadequate air filtering, poorly designed HVAC systems, or standing water.

As a member of the construction team, a designer should be familiar with IAQ issues and products. For instance, the Carpet and Rug Institute (CRI) has developed a testing program for carpet, cushions, and adhesives. Products that meet low levels of emissions of VOCs are allowed to carry its label. CRI also makes the following installation recommendations:

- Carefully plan the carpet installation using the manufacturer's installation guidelines and/or the *CRI 104 Standard for Installation of Commercial Textile Floorcovering Materials*.
- Ensure adequate fresh air ventilation during the entire installation process and for 48–72 hours afterwards.

- Vacuum the old carpet before removal to minimize airborne dust.
- Vacuum the subfloors before carpet installation.
- Use low-VOC adhesive in glue-down installations.
- Use low-emitting carpet cushion.
- Vacuum the new carpet with a high-efficiency vacuum, using a high-efficiency particulate filter bag to minimize airborne particles. Make sure that all moisture and cleaning agents are removed with each cleaning.

In addition to the proper selection of products, designers should remember the following:

- Avoid blocking air intakes and vents with window treatments or furnishings.
- Install exhaust fans in smoking areas, bathrooms, kitchens, and other areas where chemicals or sprays may be used.
- Provide humidity controls.
- Encourage proper maintenance.
- When installing open office systems, allow airflow at the base of the partition (1"–6").*
- Arrange computer terminals so that users are seated 30" away from the computer screen to avoid the electromagnetic fields.*

*From Grazyna Pilatowicz, in *Eco-Interiors*.

One part of an IAQ program is the installation of live plants, which act as air filters by absorbing indoor air pollutants. For example, the philodendron and the spider plant absorb formaldehyde, and the common peace lily absorbs benzene. Through the process of photosynthesis, plants trap airborne contaminants, as well as regenerate the air with oxygen. However, plants are not a quick fix for a sick building. They do require maintenance and proper light.

Finally, designers should monitor the market for advances in IAQ research and should maintain documents regarding IAQ design decisions.

More info online @

www.eeba.org Energy and Environmental Building Alliance
www.sbicouncil.org Sustainable Buildings Industry Council
www.energybuilder.com/greenbld.htm Green Building Guide
www.epa.gov/iaq/atozindex.html EPA Indoor Air Quality Index
www.envirosense.org The Envirosense Consortium, a nonprofit organization that addresses IAQ
www.rmi.org Rocky Mountain Institute
www.carpet-rug.org Carpet and Rug Institute
www.healthhouse.org Information on how to build a healthy house sponsored by the American Lung Association

A ventilation standard has been set by the American Society of Heating, Refrigeration, and Air Conditioning Engineers. The standard, called ASHRAE #62-1989, although primarily applied by HVAC engineers, establishes airflow minimums for interiors. A building's HVAC ductwork typically carries the exchange of air.

Air-Conditioning

Air-conditioning refers to the cooling of a building. With central air-conditioning, a forced air heating system's ductwork is used in conjunction with a separate cooling unit. Individual units may be installed in the wall or window to cool separate rooms or areas. In humid climates, a dehumidifier should also be installed.

In dryer climates, evaporative coolers, called swamp coolers, force air through moistened filters and pads, thereby removing heat and providing cooled air.

With all HVAC systems, designers must avoid blocking supply and return air vents; otherwise, the systems will not function as designed. In new construction, vents should be located away from possible furniture arrangements and window treatments. In commercial applications, the plenum may also house light fixtures, sprinkler systems, and structural beams in addition to the HVAC ductwork. Designers must work closely with engineers to avoid systems running into each other.

Central Vacuum Systems

In some residential interiors, central vacuum systems may be routed through the interior walls. Designated closets on each floor conceal the hoses and attachments. These units are particularly beneficial in multi-story homes to eliminate the need to move vacuum cleaners from floor to floor. These systems are also a valuable asset in homes for individuals with limited mobility.

◼ PLUMBING

Plumbing systems include the supply system for bringing water to the building, the system for heating the water, the fixtures involved in distributing the water, the removal of wastewater (black water from commodes and gray water from all other sources), and the required venting of the system. Plumbing also may include sprinkler systems in high-rise buildings and public places. Typical plumbing symbols are shown in Figure 5.39.

Supply Systems

Water may be supplied via a county or city water system, or it may be received from a well. In remote arid regions, rainfall may be collected in a large reservoir and piped to a house. No matter what system is used, water must be pressurized to flow from the faucet.

Water containing a high concentration of minerals may need to be softened or purified to prevent laundry problems and accumulated deposits in pipes. Minerals also may add a particular taste to water.

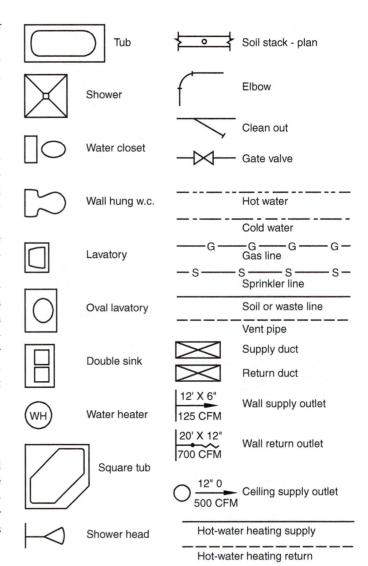

FIGURE 5.39 Plumbing and heating symbols.

Heating Systems

Water may be heated via a gas, electric, wood, or solar water heater. (Gas and electric are the most common.) Water heaters should be reasonably close to their source of use. On-demand water heaters are placed immediately next to their source of use; they have no holding tank. These small units fit in walls or under sinks and heat water only as needed.

Plumbing Fixtures

Fixtures for commodes, bidets, and lavatories are available from many manufacturers. Porcelain fixtures are the most common and are available in many different colors. White or neutral colors serve clients best because black and other dark-colored fixtures show soap rings easily.

As color preferences change, paint and wallcoverings can be adapted to coordinate with white or neutral fixtures.

Contemporary bathrooms may also use the fixtures as sculptural forms (Figure 5.40 and Figure 3.10). Handles that do not require gripping are preferred. All lavatories, including freestanding pedestal sinks, need a surface nearby for the placement of toiletries.

Shower stalls and bathtubs are commonly made from fiberglass. These fixtures should have smooth corners and no crevices where dirt can collect. As with the commode and lavatory fixtures, white or light neutral colors are usually the wisest choice (Figure 5.41).

Custom fixtures may be designed to meet a variety of shapes and styles. Materials may include tile, glass, stone, marble, cultured marble, solid surfacing material, and metals. Sinks may be mounted flush with the surface or below the surface or integrated into the counter material.

FIGURE 5.40 This glass sink is artfully suspended from the wall and balanced on top of a flush front cabinet. Note the hardware recessed into the wall, combining a mix of hot and cold water. The level handle not only meets universal design criteria, but also is easily used even with soapy hands.
(Courtesy of Vitraform)

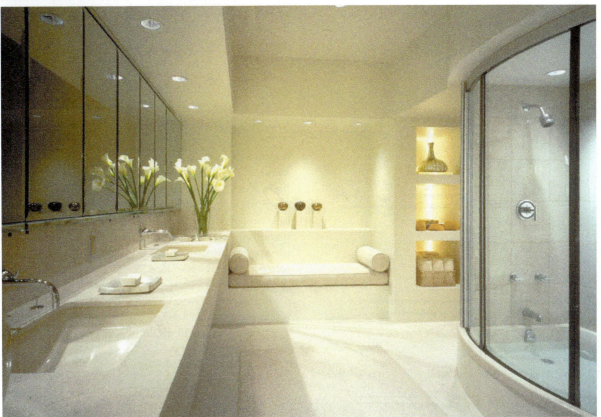

FIGURE 5.41 In this custom design for Kohler, the designer selected a neutral color palette. Lighting is plentiful and varied to allow for a variety of tasks or relaxation. A seating area is ideally located, and ample countertops allow for practical use.
(Designer: Gandy/Peace. Photograph Courtesy of Kohler Co.)

Waste Removal

The removal of wastewater, as illustrated in Figure 5.42, involves three important concepts:

1. Wastewater from commodes (called black water) requires a minimum 4" pipe, which will not fit in a standard 2" × 4" stud wall. Wastewater plumbing on upper floors must be routed through a wider 2" × 6" stud wall, or carried down a **chase** (a concealed column usually located in the corner of a room).

2. All waste lines (both black and gray water) must tie into air vents that ensure proper drainage and containment of odors.

3. Wastewater relies on gravity to flow to the septic tank or municipal sewer system. Consequently, all wastewater pipes must have a downward slope of 1/4" for every horizontal foot of length. In high-rise buildings and commercial spaces with poured concrete floors, commodes must be located near predetermined sanitary lines and wet columns (columns with hidden supply and sanitary water lines). If a drain is located in a basement that is below the level of the septic tank or municipal sewer system, a sump pump is installed in the floor of the basement to pump the wastewater up and out of the building.

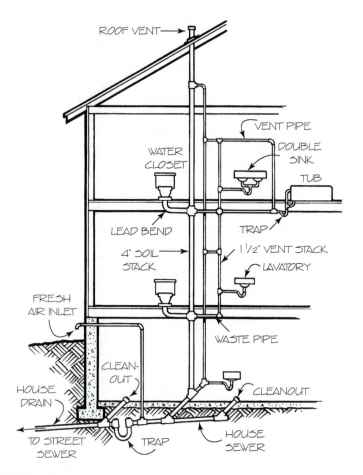

FIGURE 5.42 Multistory residential wastewater system.

■ ACOUSTICS

Sound can travel directly through the air and also may be transmitted through objects. Designers can assist in controlling sound through proper space planning and material usage.

Sound is measured in **decibels** (dB). Zero dB is the quietest sound an average human can hear, and 130 dB is the threshold of painfully loud sounds. A private office or home generally has noise levels at about 30 dB—the maximum level at which most individuals can concentrate on work.

Residential and commercial spaces are generally zoned so that noisy and quiet activities are separated. For instance, closets and bookshelves may buffer noisy areas (see Chapter 8). Walls may be constructed with additional layers of gypsum board, dense insulation, alternating studs, or a combination of all three to prevent sound transmission.

Sound may also be controlled by using materials that absorb its energy. Hard surfaces such as concrete floors and tile are dense, and although they are good at preventing the transmission of sound, their hardness causes sound waves to reflect back into the room. Carpeting, soft window treatments, upholstered furniture, and acoustical ceiling tiles absorb sound waves and thereby help to quiet a room.

According to "Sound Solutions," published by ASID, the proper selection and installation of four important design elements help achieve an acceptable level of conversational background noise. These four elements are ceiling systems, systems furniture, sound-masking systems, and carpeted floors.

Ceiling systems are best when they have an articulation class rating of 180–200. Articulation class rating measures a ceiling material's ability to absorb sound. Ceiling design should not include hard acrylic or small 1/2-inch cube lenses over light fixtures. The 3-inch to 8-inch cell fixtures function better to reduce noise.

Systems furniture (freestanding office furniture is discussed in Chapter 11) also should meet criteria to be acoustically effective. For instance, panels are acoustically best when they are at least 65 inches high. They should have a sound transmission class rating, or STC, of 18 or higher, and a noise reduction coefficient, or NRC, of .60 or more. Additionally, designers of open office areas should avoid planning direct line-of-sight layouts between workers. Designs may incorporate smaller 60- to 80-square-foot enclosed spaces that open into community areas. (See Design Scenario: UPS Innoplex at the end of Chapter 4.)

Sound-masking systems provide an ambient background sound that masks conversational noise. Systems are generally set at about 48 dB. This is louder than 30 dB, but because the sound is consistent, it helps mask other sounds.

The final primary design element to help reduce conversational noise is the addition of a jute or polyurethane carpet cushion. Both greatly enhance the acoustical privacy of an interior environment.

Additional design solutions to conceal noise include variations in wall angles to direct sounds to different areas. Avoiding the use of right angles and parallel surfaces will improve sound attenuation. Acoustical engineers consult on theater, concert hall, and large auditorium designs to enhance and distribute reverberating sounds.

SECURITY

Security systems, typically concealed in the walls and ceilings, are important attributes in the design of residential and commercial buildings. These systems are best installed before the final layer of interior materials, though buildings can be retrofitted when necessary. Security systems in residences may consist of motion detectors, light sensors, and other devices that are triggered by sound (Figure 5.43). The sensors may sound an audible alarm and/or automatically contact the security company or local authorities.

In the wake of 9/11, the growth of the security industry has skyrocketed. According to Gary Stoller in his article "Homeland Security Generates Multibillion Dollar Business" in *USA Today*, sales in the industry have increased 600 percent between 2000 and 2007 and have reached $59 billion annually. "The homeland security industry now includes chemical, biological, and radiological detection, as well as border, rail, seaport, industrial, and nuclear plant security." (Retrieved from: www.usatody.com/money/industries/2006-09-10-security-industry_x.htm.)

Commercial security systems vary greatly according to the needs of the client and the project. The most prevalent security system used in all buildings is the door lock. A door locking system includes the latch set, door handle, and escutcheon (the back plate). Locks may include a variety of deadbolts, key locks, or simple passage systems. Designers work closely with the client and hardware company to ensure that the master key plan fits the client's needs.

More elaborate security systems, however, are needed in most commercial structures. For instance, libraries use security systems to monitor materials that are to be checked out. Retail stores tag merchandise with security devices that alert store security should someone attempt to steal an item. Some dormitories and other high-rise housing units require electronic pass codes or magnetic cards at entry points to unlock doors. Cameras are installed in many commercial establishments to monitor sales and prevent petty theft. Public buildings, such as courthouses, include systems that scan each individual entering the building. Companies with extensive research and development labs, or those that store sensitive data or potentially lethal products, may require fingerprint or voice scans before entry into secure areas.

Designers must work closely with security companies to allow for the secure and concealed routing of wires and equipment (Figure 5.44).

FIGURE 5.43 Motion detectors used in residential and commercial design.
(Andy Crawford © Dorling Kindersley)

The systems also must work in conjunction with other internal systems such as electrical, communication, lighting, HVAC, and sprinkler systems.

EMERGENCY: EGRESS AND SPRINKLERS

Emergency egress systems are required in commercial buildings as part of the life safety and fire codes (illustrated in Table 5.1). Emergency systems include smoke and heat detectors, automatic sprinklers, emergency exit signage, battery-operated emergency lighting, and visual and audible alarm systems.

Sprinkler systems are typically concealed in the ceiling, with the sprinkler head exposed just below the surface. If the sprinkler system uses water, it contains its own plumbing systems; some sprinkler systems emit fire-retardant foam, particularly in areas where water may damage precious resources (such as in museums), or where the contents of a building are such that water would not extinguish a fire. Careful coordination is required to ensure that the layout of sprinkler heads, lines, and other emergency components meets codes while also meshing with the electrical, communication, lighting, HVAC, and security systems.

Residential design homes are equipped with smoke detectors and, where propane, natural gas, or heating oil is used, carbon monoxide detectors. These detectors emit loud noises (and where necessary flashing lights) to alert occupants of fires and dangerous leaks. Detectors should be placed in laundry rooms, kitchens, family rooms, bedrooms, utility areas, and basements.

CODES AND FEDERAL REGULATIONS

Interior designers are legally responsible for awareness and implementation of applicable local, state, or federal codes. Federal regulations are mandated by law and required regardless of local codes. Codes can be divided into the following general categories: model building codes; specialty codes such as energy, electrical, fire, plumbing, and mechanical codes; life safety codes; and residential codes.

The International Code Council (ICC) formed in 1994 to create a single set of codes, the International Codes (I-Codes). The code includes the International Building Codes (IBC), and a multitude of specialties such as energy, fire, and others; however, the ICC did not adopt a new electrical code, and it references the National Electric Code. The ICC is the most common code in the United States; as of the printing of this text the IBC is adopted at the state or local level in all 50 states and Washington, DC. Nevertheless, because not all states have adopted the same code, local officials may adopt codes different from the state code, and because codes are continually updated, designers must check with local officials to determine which code, and which year of the code are currently adopted by the local community. Codes for projects in other countries are also different. See the websites below for further information.

The I-Codes include prescriptive codes (codes that define exact requirements) as well as performance-based codes. Performance-based codes allow for more flexibility in design solutions, but require the designer to research information in order to convince code officials of the design solution's appropriate use. See Table 5.1 for more detailed descriptions.

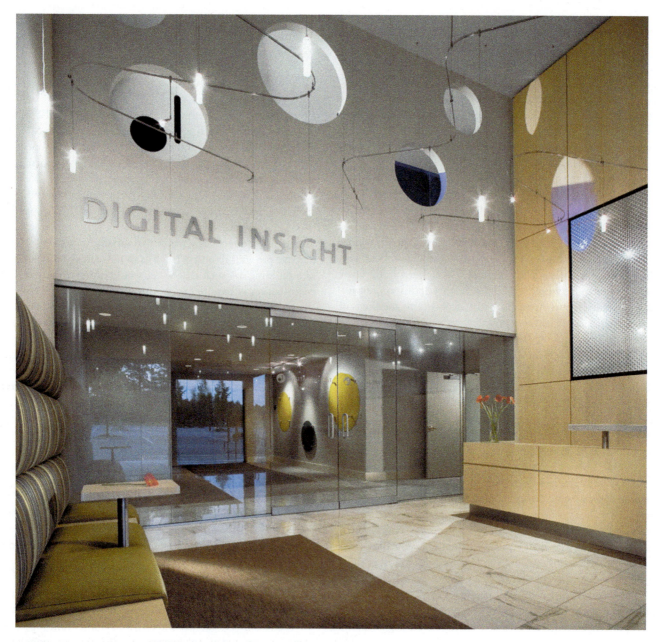

FIGURE 5.44 Computer and software companies may require secure checkpoints to maintain trade secrets or to protect the confidentiality of their clientele. However, the systems are cleverly concealed in walls and ceilings, requiring close collaboration between the designers and engineers. *(Architect/Designer: Jova/Daniels/Busby. Photograph by Robert Thien)*

Federal Requirements

The federal government has passed several laws that relate to the design of interiors. The most common include the Americans with Disabilities Act (ADA), the Fair Housing Act (FHA), and the Occupational Safety and Health Act (OSHA).

The ADA, as discussed in Chapter 2, regulates the design of commercial spaces to meet the needs of individuals with disabilities. According to their website, the ADA "ensures equal opportunity for persons with disabilities in employment, state and local government services, businesses that are public accommodations or commercial facilities, and in transportation." The ADA also mandates the establishment of telephone relay services for people who use TTYs (teletypewriters, also known as TDDs—telecommunications devices for deaf persons).

According to the Department of Housing and Urban Development's (HUD) website, "Title VIII of the Civil Rights Act of 1968 (Fair Housing Act), as amended, prohibits discrimination in the sale, rental, and financing of dwellings, and in other housing-related transactions, based on race, color, national origin, religion, sex, familial status (including children under the age of 18 living with parents or legal custodians, pregnant women, and people securing custody of children under the age of 18), and handicap (disability)."

TABLE 5.1 Building Codes in the United States

Type	Purpose	Common Codes
Model building codes	Define construction requirements and limit use of hazardous materials.	■ International Building Code (I-Code) published by the International Code Council ■ Building and Construction Safety Code (NFPA 5000), published by the National Fire Protection Association (not widely adopted)
Electrical codes	Define construction requirements for these specialties.	■ National Electrical Code (NEC), published by National Fire Protection Association (NFPA)
Energy codes	Establish minimum requirements for energy-efficient buildings. Codes reference the ASHRAE 90.1 and 90.2 and the EPAct (see Sustainable Design: Energy Codes and LEED in Lighting - Chapter 6).	■ International Energy Conservation Code (IECC), published by International Code Council ■ NFPA 900 Building Energy Code
Fire codes	Establish minimum requirements for fire safety, hazardous materials. Also includes egress, which will overlap with Life Safety codes (see below).	■ International Fire Code (IFC), published by International Code Council ■ NFPA 1
Life safety	Establish minimum requirements for the evacuation of a building by the occupants. Referred to as the building's egress.	■ Life Safety Code (LSC, or NFPA 101®), published by NFPA
Mechanical codes	Define construction requirements for these specialties.	■ International Mechanical Code (IMC), published by International Code Council ■ Other codes still in use such as the Uniform Mechanical Code (UMC), published by the NFPA (set of C3-Codes)
Plumbing codes	Define construction requirements for these specialties.	■ International Plumbing Code (IPC), published by International Code Council ■ Other codes still in use such as the Uniform Plumbing Code (UPC) published by the NFPA (set of C3-Codes)
Residential codes	Define construction requirements in one- and two-family dwellings.	■ International Residential Code (IRC), published by International Code Council

Note: Designers must always check with local officials to determine which codes to apply.

The mission of the Occupational Safety and Health Administration (OSHA) is to "assure the safety and health of America's workers by setting and enforcing standards; providing training, outreach, and education; establishing partnerships; and encouraging continual improvement in workplace safety and health." OSHA guidelines mainly affect the contractor during the contract administration, or project construction, phase.

More info online @
www.iccsafe.org International Code Council
www.iccsafe.org/gr/Documents/stateadoptions.pdf A pdf listing the I-Codes adopted by each state. Updated periodically
www.nationalcodes.ca/nbc/index_e.shtml National Building Code of Canada
www.irccbuildingregluations.org Inter-jurisdictional Regulatory Collaboration Committee
www.hud.gov/offices/fheo/FHLaws Department of Housing and Urban Development
www.osha.gov/oshinfo/mission.html Occupational Safety and Health Administration
www.usdoj.gov/crt/ada/adahom1.htm Americans with Disabilities Act
www.nfpa.org/index.asp National Fire Protection Association

SUMMARY

This chapter has emphasized the designer's responsibility to understand construction processes and components, building systems, and related codes. The symbols and terminology relating to the mechanical, plumbing, acoustic, and other concealed systems must be understood in order to communicate with allied professionals and to share accurate information with the client.

Designers have an ethical responsibility to inform clients of alternative design solutions that may conserve energy or lower utility costs. Additionally, designers must take into account the effects that furnishings and finishes may have on indoor air quality. The application of low-emission products helps to ensure a safer interior environment. Finally, it cannot be emphasized strongly enough that interior designers are legally responsible for complying with local and state codes and federal regulations.

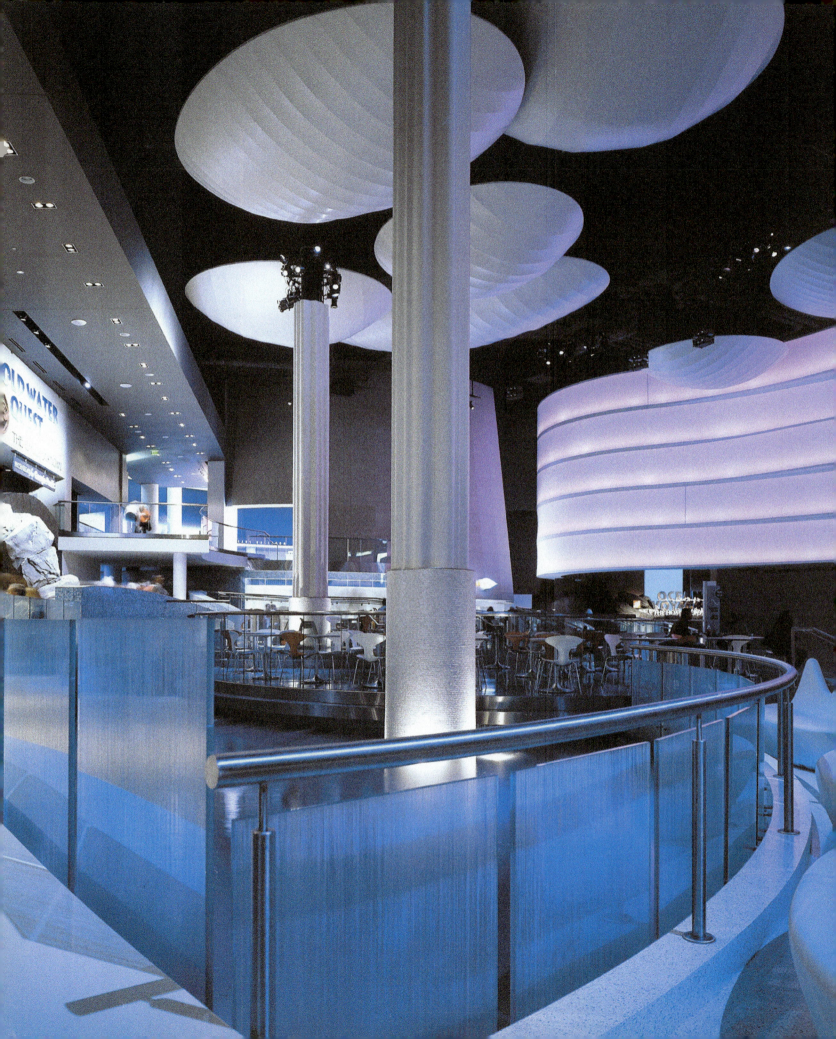

Lighting, Electrical,
6 and Communications

FIGURE 6.1 This dramatic lighting is the result of extensive research and several mockups completed during the design development phase. A programmable color-changing LED fixture by Color Kinetics backlights the Newmat wall material. This creates the saturated color appearance of the space. The Georgia Aquarium is an excellent study in lighting design possibilities and attention to the needs of visitors.
(Photo by Brian Gassel / tvsdesign)

Lighting, as discussed in relation to color in Chapter 4, is an essential element in all interiors. Lighting can be one of the most creative avenues in the field of interior design. Light, like color, can alter psychological and physiological reactions. Additionally, the fixtures that house the actual light source can be designed to serve as decorative art or sculpture, adding character and sometimes whimsy to the interior (Figure 6.1).

The quantity and quality of light affect the apparent size, shape, and character of an object. Interior designers can alter the perception of space in a room, focus attention, set moods, define texture, or create a specific atmosphere through the appropriate use of light. Understanding the scientific basis of light, applying this to an interior to create the desired effect, and communicating the plan to engineers and contractors are essential skills of interior designers. The Illuminating Engineering Society of North America (IESNA) guides the industry as the definitive source. However, because it is an engineering reference, its information is well beyond the scope of this text. Nevertheless, to begin to understand how to use light, designers must be familiar with basic lighting terminology, the goals of successful lighting design, and fundamental principles of the *quantity* and *quality* of the light source.

■ GOALS OF LIGHTING DESIGN

The professional terminology for light fixtures and lamps differs from everyday language. The lightbulb itself is called the **lamp**. It is the source of light. The physical structure that holds the lamp and other necessary and decorative accoutrements (such as the shade, reflector, or lens) is called the **fixture**. The lamp and the fixture form the **luminaire**. All light fixtures in an interior must be selected based on their intended function and the human factor, their aesthetic qualities, and their economic and ecological factors. These goals were introduced in Chapter 1 and are addressed here with respect to lighting design.

FIGURE 6.2 Three major functions of artificial lighting.

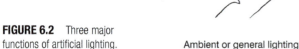

Ambient or general lighting Task or local lighting Accent lighting

Function and the Human Factor

Light sources serve three functions to meet human needs (Figure 6.2).

1. General or **ambient lighting** is background or fill light that spreads an even, overall luminosity and reduces harsh contrasts between pools of concentrated light.

2. **Task lighting** is functional and localized for a particular activity such as office work, reading, writing, preparing food, or grooming. Task lighting is placed near the activity but is aimed to avoid glare and minimize shadows (Figure 6.3).

3. **Accent lighting** employs a concentrated beam of light focusing on a particular object or area. The lamp or light fixture itself may also be used as a decorative source (Figure 6.4).

Most interiors will include a combination of these lighting types in each room.

The size and shape of the lamp, along with the fixture style, produce a typical light distribution pattern. To help determine the correct fixture for a particular function, light distribution charts (or photometric charts) are included in manufacturers' catalogs (Figure 6.5). These charts also indicate the approximate quantity of light, depending on the height of the light. By reading the charts, designers can determine the appropriate fixture and lamp.

Lighting, like color, greatly affects our perceptions of our surroundings. Light is a basic human need. Without it, the world is black; color does not exist. Poor lighting can produce glare, causing headaches and eyestrain. Inadequate lighting can affect the safety of the occupants or simply make completing a task impossible. Quality lighting systems eliminate these concerns while providing a design that adheres to the following goals:

- Meets the needs of the occupants, both physically and psychologically

- Acknowledges the importance of energy efficiency and provides accountability for the economic impact on natural resources

- Creates an aesthetic environment that is pleasing to its occupants while enhancing the interior architecture

Lighting also affects people's emotions. Successful lighting provides a sense of well-being. With respect to human psychological needs, light has the following attributes:

- Light is associated with the exuberance of life itself and with human well-being.

- Light can convey a sense of security, warmth, and comfort.

- Light can evoke a mood. For example, low-level lighting can be intimate, cozy, and relaxing; bright light can be stimulating and active.

- Lack of light or insufficient light may provoke feelings of depression, gloom, or even fear. Seasonal affective disorder (SAD) is a medical condition that occurs in some people when they are deprived of natural sunlight.

FIGURE 6.3 Luminaires for task lighting should be placed to minimize glare and shadows.

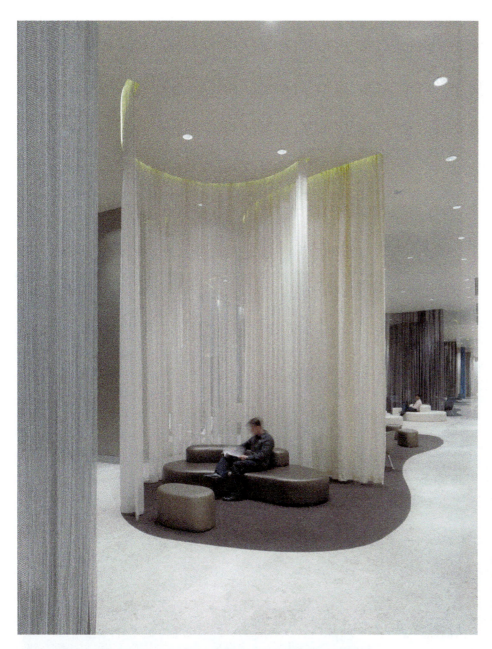

FIGURE 6.4 In this waiting area at the Dubai Mall Medical Center, ceiling tracks conceal LED lights that add a wash of color to the sheer dividers. Sofas and ottomans without sharp edges were selected to avoid catching on the traditional flowing Arab clothing.
(Architect/Designer: NBBJ. Photograph by Tim Griffith)

FIGURE 6.5 Typical photometric guides. Many manufacturers, including GE, offer these guides on computer disc.
(Courtesy of GE Lighting)

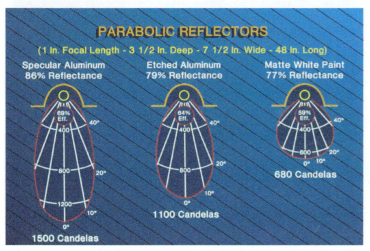

PARABOLIC REFLECTORS

(1 In. Focal Length - 3 1/2 In. Deep - 7 1/2 In. Wide - 48 In. Long)

Specular Aluminum
86% Reflectance
69% Eff.
1500 Candelas

Etched Aluminum
79% Reflectance
64% Eff.
1100 Candelas

Matte White Paint
77% Reflectance
59% Eff.
680 Candelas

■ Too much light or glaring light can be agitating, discomforting, and annoying, even resulting in physical ailments and an inability to function adequately.

It is essential, therefore, when planning light requirements for either residential or commercial interiors to take into account the physical as well as the psychological impacts of light.

Additionally, lighting must be durable. For example, fragile neon fixtures would be inappropriate in a childcare center. Lighting also figures in safety. Emergency light fixtures, operated by batteries, are particularly important during power outages or fires and are required in contract design.

Because vision tends to diminish with age, older people and those with visual impairments may require higher levels of light. Designers should provide higher light levels or portable task lighting for individuals with special needs.

Aesthetics

Aesthetically, lighting should reflect and enhance the style of the interior. The scale and proportion of a fixture should be considered in relation to other furnishings and to the size of the room. Decorative fixtures generally work best when their design is simple, unobtrusive, and suitable to the room's design. Some lighting fixtures serve as a focal point (Figure 6.6).

FIGURE 6.6 The wash of light on the ceiling creates a focal point in this restaurant lounge. LEDs wrap the perimeter of the light cove to imitate the glow of the "night sky" and set a festive mood. *(Designer: Design Directions, International. Photograph by Neil Rashba)*

Designers can create many decorative effects when lighting is properly selected and placed:

- *Spotlighting* accentuates a particular object or point.
- A *pool of light* also focuses attention on a particular area, but a much larger one than that produced by spotlighting.
- A *wash of light*, between a spotlight and a pool of light, generally covers a particular piece of art or other objects on a wall. An entire wall could be washed with light (Figure 6.7).
- *Grazing* is similar to a wash of light, but the light barely skims the wall. This is usually applied to bring out a wall texture or pattern.
- *Perimeter lighting* is frequently used to expand a space (Figure 6.8).
- *Silhouette lighting* creates a decorative outline of an object. Sometimes plants or decorative ironwork are silhouetted to produce an interesting shadow effect on a nearby surface.

Economics and Ecology

The designer's selection of lighting fixtures must not exceed the client's budget. In addition to the initial cost of purchasing and installing the fixtures, light also has continuous costs due to the use of electricity and the maintenance of lamps. Lighting must be analyzed based on the life-cycle costing. Knowledgeable planning and purchasing can give a space sufficient lighting and still save watts and dollars.

As part of the universal need for sustainable interiors and the conservation of energy, many electric codes set minimum light levels for interiors that affect the selection of the light source. The Energy Policy Act of 1992 required that all states adopt standards to limit energy consumption and led to the ASHRAE/IESNA Standard 90.1 2001, adopted by all states as of July 2004. Although the standard applies to many areas of energy conservation, with regard to interior design, it specifically addresses requirements for energy conservation by interior lighting design in commercial buildings. Additionally, lighting

FIGURE 6.7 A 5,600-square-foot carriage house was converted into a development center. Using a combination of design characteristics, the designers meshed the old with the new. *(Architect/Designer: HOK. Photograph by Steve Hall/Hedrich-Blessing)*

selection and placement are major factors in a LEED-certified building (see Sustainable Design: Energy Codes and LEED in Lighting).

The humanization of the interior environment to meet the needs and desires of its occupants is the ultimate goal of all design, including the design of the lighting system. Designers work to enhance the interior environment to improve the quality of life for its occupants.

Lighting charts, calculations, and appropriate product selection provide a basis for the quantity and quality of light in a space; however, the physical reaction to the interior space will vary from individual to individual. To that end, the full study of lighting includes not only the physical human functions associated with lighting, but also occupants' perceptions of, and psychological reactions to light.

FIGURE 6.8 In this vibrant French-styled brasserie, Voila!, the designers used perimeter lighting to visually widen the space and highlight the unique whimsical border. Other decorative pendant fixtures add to the carefree effect.
(Architect/Designer: Knauer, Inc. Photograph by Steinkamp/Ballogg)

SUSTAINABLEdesign

ENERGY CODES AND LIGHTING IN LEED

Energy standards and codes affect design criteria. Energy standards used in design (whether lighting design or other forms of design) continually evolve as society and technology evolve. The International Code Council publishes the International Energy Conservation Code (IECC). First issued in 1998 and updated several times since, the IECC has been adopted by many states. The U.S. Energy Policy Act (EPAct) of 1992 (also updated frequently), individual codes adopted by states, and the commercial energy codes found in ASHRAE/IESNA Standard 90.1 2001 (also updated periodically) have had a great impact on lighting design criteria. General building codes relating to electrical requirements and regulations regarding accessibility also affect lighting designs. The following information introduces these codes and regulations and serves as an overview of their effect on lighting systems. Because codes evolve, websites should be accessed for the most current information.

EPAct

Perhaps the most significant impact on the use of energy occurred in the provisions of the 1992 EPAct. This act continues to have far-reaching effects on many aspects of energy management. The provisions of the EPAct have directly or indirectly been responsible for the current status of many aspects of lighting design, from electric power generation and distribution, to lamp and luminaire design, to energy standards used in building lighting design. The major changes in lighting that the EPAct set in motion include the following:

- Mandatory energy efficiency standards for selected lamps and luminaires
- Labeling rules concerning light output and energy consumption of many commonly used lamps and luminaires
- Mandatory state adoption of energy codes

The greatest change regarding lighting in the EPAct 2005 allowed an updated dollar-amount-per-square-foot tax deduction to building owners who invest in energy-efficient building systems, such as lighting systems.

ASHRAE/IESNA STANDARD 90.1

The most stringent model used in commercial energy codes is found in ASHRAE/IESNA Standard 90.1 2001. Two of the major provisions related to limiting power consumption in building interior lighting include the use of controls (electrical controls such as switches) and restrictions set on the lighting system, including power used by the lamps, ballasts, controls, regulators, and other power drains. The limit on power consumption is defined as a maximum allowable power usage, stated in watts per square foot, for lighting in commercial buildings. Allowable lighting usage is determined by using either the building area method or the space-to-space method. Each method has distinct advantages and is used when determining power allowances for various occupancies.

LEED

As discussed in Chapter 2, LEED includes five main areas and two additional categories of credits. While lighting design and selection could be addressed in all categories, the most influential include the following standards based on LEED for New Construction:

Sustainable Site – SS Credits SS 8.1 Light Pollution Reduction - minimizes nighttime light trespass from interior and exterior lighting.
Energy and Atmosphere - EA Credits Prerequisite 2 for this standard addresses minimum energy performance criteria that are influenced by lighting. Two specific credits relate to lighting.
EA 1 Optimize Energy Performance - Up to 19 points are possible for this credit. Use of energy-efficient lighting and design as well as other means to reduce energy consumption affect this credit.
EA 5 Measurements and Verification - Requires implementation of measurements and verification of results after building occupancy.
Indoor Environmental Quality – IEQ Credits IEQ 6.1 Controlling of Systems - Lighting - Requires individual control of lighting for comfort and well-being.
IEQ 8.1 Daylight and Views – Daylight - Provides for occupants to be connected to daylight and views.
IEQ 8.2 Daylight and Views – Views - Same as above but with direct line of site.

More info online @

www.sylvania.com/AboutUs/EnergyAndEnvironment/RegulationsLegislation/Energy/EPACT Osram Sylvania's outstanding guide to understanding the EPAct
www.usgbc.org United States Green Building Council

■ ORGANIZATIONS AND REGULATIONS

Lighting is a complicated component of the interior environment. Design professionals must be aware of light safety requirements related to the egress of a building during emergencies. Lighting also affects the health of inhabitants. Additionally, new products and products that are more energy efficient are frequently introduced into the market. Professional organizations exist to help designers.

The IESNA's goal is to advance knowledge and disseminate information for the improvement of the lighted environment to the benefit

of society. The International Association of Lighting Designers (IALD) is a professional organization for independent lighting consultants. The International Commission of Illumination (CIE) is the global organization for technical lighting concerns.

As a certification measure for industry professionals, the National Council on Qualifications for the Lighting Professions (NCQLP) was developed in the 1990s. Through experience, practice, and testing, design professionals can (but are not required to) receive certification.

As with other building systems, lighting systems are regulated by codes. Lighting applications must comply with the National Electric Code (NEC), and all selections must meet the Underwriters Laboratory (UL) standards. Codes, such as the ANSI code, also relate to lighting for emergencies. Battery- or generator-operated fixtures must route people safely through corridors, stairways, and fire exits.

More info online @

http://ashrae.org/technology/page/63 Interpretation for ASHRAE/IESNA Standard 90.1 2001's affect on interior lighting (See pdf of Section 9.3.1.2, relating to interior lighting power allowance)
www.iald.org International Association of Lighting Designers
www.iesna.org Illuminating Engineering Society of North America
www.ncqlp.org National Council on Qualifications for the Lighting Professions

■ THE QUANTITY OF LIGHT

Determining the quantity of light needed to complete a task can be as simple as referencing a chart; however, designing a lighting solution that meets those criteria is based on a multitude of factors regarding not only the quantity of light, but also the direction of travel and the surface reflecting the light source.

- **Candela.** This is the fundamental basis for measuring light, but understanding it requires an extremely technical background. For the purpose of this text, know that it is a measurement of the intensity of light in a specific direction of a given angle.

- **Luminance flux** or *luminous flux.* This is the measurement of the total light output that leaves the light source (lamp) in all directions (Figure 6.9).

- **Lumens.** This is the unit of measurement of the flow of light. Lamps are rated in lumens, which indicate the total light output of the lamp. For instance, a typical 100-watt lamp produces approximately 1,750 lumens. Luminance flux and lumens are frequently used interchangeably.

- **Efficacy.** In lighting terminology, the *efficiency* of the lamp is measured by its *efficacy*. To determine the efficacy of a lamp, divide the lumens by the watts (the amount of energy consumed by the lamp). For example, suppose that a new 75-watt incandescent lamp produces 1,180 lumens; 1,180 lumens divided by 75 watts equals an efficacy rating of 15.7. The higher the efficacy rating, the more efficient the lamp. In practice, to select the most energy-efficient lamp, select the lamp with the lowest wattage and the highest lumens.

- **Illuminance.** Also called *illumination*, this is the quantity of light from the source that strikes a surface. It is expressed in

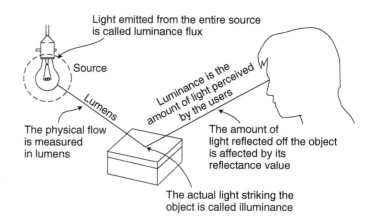

FIGURE 6.9 The measurements of light: Luminance flux is the quantity of light from the source. The flow is measured in lumens. The light hitting the object is the illuminance, measured in footcandles or lux. Luminance is the amount of light perceived and is affected by the reflectance value of objects.

footcandles (or lux in metric terms). One footcandle is expressed as the portion of one lumen that falls on one square foot of surface (historically produced by one candle). A lux is expressed as the portion of one lumen falling on one square meter. A lux is approximately ten times dimmer than a footcandle; in other words, it takes just over 10 lux to equal 1 footcandle. The following are recommended footcandles for specific tasks:

Task	Footcandles
Theater passage	1–2
Passage through a corridor	3–5
Passage though stairwells	5–10
Restaurant dining	5–20
General office work	10–20
Reading	20–30
Intense reading, kitchen preparation, shaving	40–60
Detail work	50–100+
Surgery	500+

- **Luminosity.** This is the ability of a surface to reflect light. It is measured as a light reflectance value on a scale of 0 to 100 percent. For example, a light-colored, shiny wall may reflect 80 percent or more of the footcandles; a dark-colored, rough-textured wall may reflect less than 2 percent of the footcandles. The following are reflectance values of common colors:

Color	Reflectance
White	89%
Ivory	87%
Light gray	65%
Sky blue	65%
Intense yellow	62%
Light green	56%
Forest green	22%
Coconut brown	16%
Black	2%

- **Luminance**. This is the general term for the amount of light the user perceives entering the eye. It is referred to by the user as the brightness. (Historically, this was measured in footlamberts, the use of which is discouraged by the IESNA.)

More info online @

www.archlighting.com/architecturallighting/al/glossaries/terms.jsp *Architectural Lighting*'s glossary; excellent, understandable source
www.eere.energy.gov/consumer/your_home/lighting_daylighting/index.cfm/
mytopic=11990 Energy efficiency and renewable energy terms from the U.S. Department of Energy
www.iesna.org The Illuminating Engineering Society of North America
www.sylvania.com/BusinessProducts/Glossary Sylvania's glossary of light terms

■ THE QUALITY OF LIGHT: COLOR AND LOCATION

Light is created by wavelengths emitted from a light source (such as the sun or a lamp). Long waves produce warm colors; short waves produce cooler colors.

Natural daylight (the highest quality light) produces a linear color spectrum that evenly distributes the colors we see (Figure 6.10). Artificial light sources do not exactly mimic natural light's color spectrum, although some come close. For instance, a typical incandescent lightbulb's color spectrum emphasizes the warmer red wavelengths.

As discussed in Chapter 4, the human eye sees the color of an object when light of mixed wavelengths is reflected into the eye from the object's surface. For instance, if an object is yellow, the surface reflects wavelengths found in the yellow section of the spectrum and absorbs wavelengths of the other colors.

Color Rendering Index

The closer a lamp's color spectrum is to natural light, the higher the quality of light it produces. One measurement of this quality is called the **color rendering index** (CRI). The CRI is based on a scale of 0 to 100. A CRI of 80 or better is necessary when color rendering is critical, such as when inspecting printing proofs or selecting clothing. A CRI of 60 to 80 is average; a CRI below 60 may be appropriate for street lighting or other lighting when color selection is not important. Note that a higher CRI requires more energy to support the broader color spectrum.

Color Quality Scale

The **color quality scale** (CQS) is a new measurement for the quality of the color of light that was recently proposed by the National Institute of Standards and Technology (NIST). CQS was developed to address shortcomings in the CRI that affect, in particular, the quality ratings of light-emitting diodes (discussed later in this chapter). Although the lighting industry has accepted the CRI for more than 40 years, it is based on only eight medium saturated colors. The CQS is based on 15 highly saturated colors. CQS is currently under review to replace the CRI as the primary basis of a lamp's color measurement (Figure 6.11).

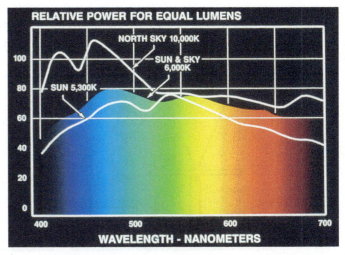

A

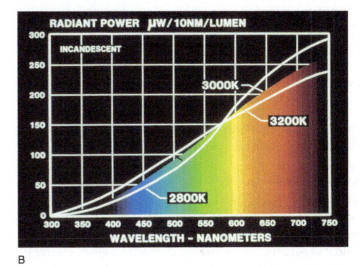

B

FIGURE 6.10 (A) The color spectrum of natural light. (B) The color spectrum of incandescent light.
(Courtesy of GE Lighting)

Kelvin Temperature

Another measurement of light quality is the light's temperature or **kelvin** rating, also called **chromaticity**. This measurement places a candle flame on the lower temperature range around 2,000°K, and an incandescent lamp at about 2700°K. A typical sunny day measures around 6,000°K, and a northern night sky is said to be at about 8,500°K or

The eight color samples used by the CRI:

The 15 color samples used by the CQS:

FIGURE 6.11 Color sample basis for the CRI and CQS.

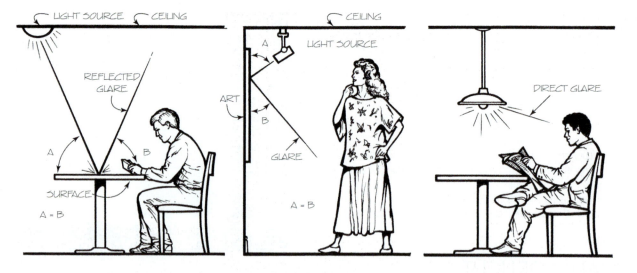

FIGURE 6.12 Light is reflected off a surface at the same angle as it was received. In these diagrams, this means the angle of A equals the angle of B. This is referred to as the *angle of incidence*. Indirect glare occurs when a viewer intercepts the reflected light; direct glare occurs when a viewer looks directly into a lamp.

greater. This concept seems backwards, but it is best related to the heat of a gas fire or burner. Cooler flames burn red, warmer flames are yellow, and the hottest flame is blue. A kelvin rating between 3,000°K (typical of a quality fluorescent lamp) and 6,000°K (a sunny day) is considered the natural benchmark.

Lighting Location

The quality of light also depends on the physical location of the light source and its mix with other light sources. Designers must carefully locate the light source so that it illuminates the appropriate surface, object, or required task; otherwise, the resulting glare, whether direct or indirect, causes eye fatigue and general irritability.

Direct glare occurs from unshielded sources of light. Bright lights through windows and exposed lamps are the most common sources; however, glare can also occur when light levels are dramatically different. For instance, low-level lighting may be appropriate in the bedroom, but the adjoining dressing room may require a brighter interior. This contrast can produce unwanted direct glare.

Indirect glare occurs when light is reflected from surfaces. Glossy surfaces, glass, and mirrors are particularly problematic. Options to help prevent glare include the following:

- Use similar levels of illumination in adjoining spaces.
- Shield direct light sources with shades, louvers, or other diffusers.
- To avoid indirect glare, ensure that the light source does not reflect directly off a surface into the occupant's eyes. This is referred to as the angle of incidence (Figure 6.12).
- Avoid the use of glossy surfaces where they may cause indirect glare.
- Use a greater quantity of low-level lights instead of a few high-level lights. This allows for better lighting placement.
- Install glare-reducing window treatments such as sheers or shades (see Chapter 13).

The quantity of light, its color quality, and its location are the elements needed to meet the goals of lighting design. These elements must be carefully selected from the multitudes of light sources and manufacturers' fixtures.

More info online @

www.schorsch.com International website of lighting information. Includes a glossary
www.lrc.rpi.edu Lighting Research Center for universities published by Rensselaer Polytechnic Institute
www.archlighting.com Lighting information published by *Architectural Lighting* magazine
http://lightsearch.com Source for lighting specifiers and buyers; includes a resource center
http://nist.gov/pml/div685/grp05/vision_color.cfm Source for information on the Color Quality Scale compared to the Color Rendering Index

■ NATURAL LIGHT SOURCES

Although light is regarded as a single form of energy, it is commonly divided into two categories: natural and artificial. The main source of natural light is the sun. Its properties, including ultraviolet light, warmth, and radiant energy, are important to people's health and well-being. Sunlight emits all visible wavelengths of radiant energy, as well as invisible infrared wavelengths (long rays felt as heat) and ultraviolet wavelengths (short rays, as seen in Figure 4.2).

Often, the designer's challenge is to control natural light in a living space. Natural light changes from morning to evening. Therefore, a designer may treat a south- and west-facing room with muted, cooler, and darker colors to counter the sun's afternoon warmth and glaring rays. The designer can also determine the most suitable window treatment after considering the position on the site, geographic location, and climate. Natural light can be allowed to enter a space in a manner that enhances the environment and minimizes glare (as seen in Figure 4.30).

FIGURE 6.13 The Canlis Restaurant, a dining landmark in Seattle, was updated from its 1950s origins. The designers used combustion lighting in the Penthouse dining room.
(Architect: James Cutler Architects. Designer: Doug Raser. Photograph by Michael Jensen)

The secondary source of natural light is combustion, produced by fire, oil lamps, candles, and gaslights. Until the development of electric lighting, combustion was the only method of producing supplementary light.

Combustion lighting still deserves consideration as a decorative element in residential design and for some commercial projects such as restaurants (Figure 6.13). Candles and a gas or wood fire are frequently used as supplementary lighting or heat. Their main value is in their soft glow that sheds a flattering light and creates an atmosphere of warmth and intimacy.

■ ARTIFICIAL LIGHT SOURCES

Artificial lighting is a manufactured source of illumination derived from electricity. The electrical energy is transformed into visible light and is identified by its wattage. The most familiar artificial light sources are incandescent, electric discharge (which includes fluorescent) lamps, and a relatively new lamp on the interiors market—the LED, or light-emitting diode.

Incandescent Lamps

Incandescent lighting originated with the familiar light bulb invented by Thomas Edison in the latter half of the nineteenth century. All **incandescent lamps** provide light by heating an element (usually metal) to a kelvin temperature of approximately 2,500–3,000°K, at which point the lamp glows. Incandescent lamps include the typical general service lamp, tungsten-halogen, reflector, low-voltage, and xenon lamps (Figure 6.14).

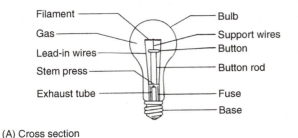

Filament
Gas
Lead-in wires
Stem press
Exhaust tube

Bulb
Support wires
Button
Button rod
Fuse
Base

(A) Cross section

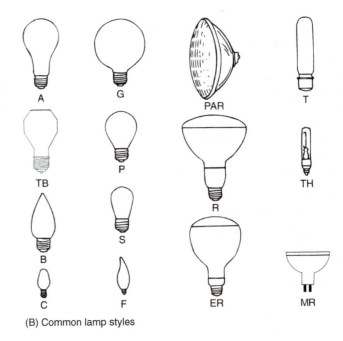

(B) Common lamp styles

FIGURE 6.14 The incandescent filament lamp. (A) Cross section. (B) Common lamp styles. A: standard (arbitrary); TB: Teflon bulb (used like an arbitrary); B: oval or ovoid; C: candelabra; G: globe; P: pear; S: straight side; F: flare; PAR: parabolic reflector; R: reflector; ER: elliptical reflector; T: tubular; TH: tungsten-halogen; MR: multifaceted reflector (low voltage).

Lamps are designed by a letter identifying their style. The number following the letter indicates the diameter of the lamp in eighths of an inch. (For example, an MR16 is a lamp that is 2" wide.) Lamps are usually clear or frosted (also called soft white). The frosted lamp emits a more diffused light.

Incandescent lamps:

- Are available in a wide variety of sizes, shapes, colors, and types
- Are small and adaptable
- Produce white light that casts a slight red and yellow hue
- Are generally considered complimentary to most skin tones
- Effectively highlight textures and forms
- Can be easily dimmed
- Permit precise optical control for effective accent and task lighting
- Can cause glare when lamp is exposed
- Can neutralize cool colors
- Are relatively inexpensive to purchase, but are costly to run because of their low efficacy
- Produce heat, which can burden air-conditioning systems

Because of their poor efficacy, 100 watt incandescent lamps will not meet the energy standards enacted by the U.S. Congress; therefore, beginning in 2012, 100 watt incandescent lamps will no longer be manufactured or imported. Incandescent lamps of 40 watts or higher will also be prohibited beginning in 2014.

A tungsten-halogen lamp is a type of incandescent lamp, but instead of a filament, the halogen lamp has a piece of hard quartz in a small enclosure. When heated the quartz attains higher temperatures, therefore providing a more intense light and a better performance output. Tungsten-halogen lamps also come in various styles (Figure 6.15). In addition to the preceding attributes, tungsten-halogen lamps also:

- Run warmer (approximately 3,000°K), producing a more intense light

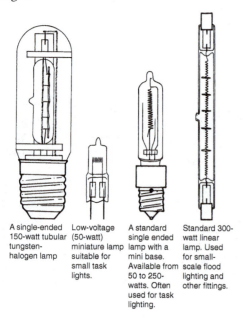

A single-ended 150-watt tubular tungsten-halogen lamp.

Low-voltage (50-watt) miniature lamp suitable for small task lights.

A standard single ended lamp with a mini base. Available from 50 to 250-watts. Often used for task lighting.

Standard 300-watt linear lamp. Used for small-scale flood lighting and other fittings.

FIGURE 6.15 Styles of tungsten-halogen lamps.

- Last two to four times longer than a general-service incandescent
- Are more expensive to purchase
- Must not come in contact with the oils on skin; gloves must be worn when changing a lamp
- Emit high levels of heat and therefore should not be placed near flammable objects
- Must be shielded and therefore cannot be used as a direct light source

Reflector lamps or parabolics have a hard-pressed glass covering and, as the name implies, a built-in reflector to enhance light distribution. Reflector lamps are generally 3 1/2" to 6" wide. The typical residential exterior flood lamp is an example of a common reflector lamp.

Low-voltage lamps are basically miniature tungsten-halogen lamps commonly used to enhance retail displays. The lamps run on 12-volt or 24-volt electricity and therefore require a separate transformer concealed in the ceiling or walls. (Transformers reduce the standard 120-volt electricity into 12- or 24-volt electricity for use in these lamps.) The transformer must be accessible for maintenance.

Xenon is another type of incandescent lamp. The lamp produces a brilliant white light, like that of the tungsten-halogen, and is used because of its high output of lumens in low-voltage and low-wattage applications. It is frequently applied as accent lighting around countertops or in curves (Figure 6.16). The World Trade Center "Towers of Light" were produced by xenon lamps.

Discharge Lamps

Discharge lamps produce light by passing electricity through a gaseous tube. The most common discharge lamps are fluorescent, HID, and cold cathode.

Fluorescent Lighting

Fluorescent lighting, in wide use since World War II, is produced in a glass tube lined with a fluorescent coating, filled with mercury vapor and argon, and sealed at the ends. When gases are activated by an electric current, ultraviolet rays stimulate the phosphorous lamp coating, which emits visible light. Fluorescent lamps are made in a variety of shapes and sizes (Figure 6.17). The most familiar type is the T5 tubular lamp, which is 5/8" in diameter and comes in lengths from 2 to 8 feet.

- Fluorescent lamps emit less heat than do incandescent lamps.
- Fluorescent sources can create broader areas of light than can incandescent lights.
- Fluorescent lights provide diffused, shadowless light.
- Fluorescent lights are particularly efficient for commercial uses, especially in hospitals, schools, offices, stores, factories, and other large public spaces.
- Fluorescent light can distort colors and details if not color corrected.
- Fluorescent light is not as flexible and as easy to control as incandescent light.
- Fluorescent lamps require a ballast to provide a stronger starting voltage and to regulate the flow of current. Ballasts add costs; poor-quality ballasts can create a humming noise.
- Fluorescent lamps contain mercury, which is harmful to the environment.

FIGURE 6.16 In this contemporary residence, emphasis has been placed on the curve. Areas are defined by changes in flooring materials and ceiling design. The glow of light is produced by xenon lamps. The custom-built light fixtures on the bar are handblown to resemble olives.
(Designer: Charles Greenwood, IIDA, of Greenwood Design Group, Inc. Photograph by Robert Thien © 2001)

Circline T9

Mod-U-Line® T8

Trimline™ T8

PG17 Power Groove®

T12

Low Watt Biax

High Lumen Biax

Double Biax

Triple Biax

2D

FEA/2D

Performance Biax

Triple Biax

FLG/E

FLG

FLB

FLA

FIGURE 6.17 Fluorescent lamp styles, regular and compact (not to scale).
(Courtesy of GE Lighting)

FIGURE 6.18 The SPX41 fluorescent lamp has a good efficacy and a good CRI rating. Its Kelvin temperature is about 4,000°K.
(Courtesy of GE Lighting)

- Although fluorescent fixtures are more expensive, they have a much higher efficacy rate (Figure 6.18). The tubes last up to 15 times longer than incandescent lamps and require about one-third as much energy.

Historically, fluorescent lamps produced a low CRI, but this has improved. Designers need to specify "color corrected" lamps to obtain the best color distribution.

HID Lamp

Another source of discharge lighting is the **HID** (high-intensity discharge) lamp, which incorporates some of the desirable qualities of both incandescent and fluorescent lighting. The discharge lamp is similar to the fluorescent in operational design, but in appearance it resembles an incandescent, only slightly larger (Figure 6.19). Three types of HID lamps are mercury (which tends to produce bluish light), high-pressure sodium (which tends to produce orange light and is the most efficient of the three types), and metal halide (which renders colors most accurately).

Characteristically, HID lamps:

- Last from 16,000 to 24,000 hours
- Are highly efficient with about ten times the output of incandescent lighting
- Are suitable for commercial and institutional settings that demand energy-saving lighting
- May show color poorly
- Are noisy and therefore have limited use in small commercial and residential spaces

FIGURE 6.19 Common HID lamp styles. A: standard (arbitrary); T: tubular; PAR: parabolic aluminized reflector; E: elliptical (conical or dimpled); BT: bulbous tubular; R: reflector.

- Require up to nine minutes to reach full light capacity from startup
- Require a ballast

Because of their intense light, HID lamps can cause strong glare if not shielded properly. These lamps are commonly used in very high ceilings to distance their intense glare from the occupants.

Cold Cathode

The neon lamp or cold cathode is a low-pressure discharge lamp. It runs even cooler than a fluorescent, but requires a high-voltage transformer that can be noisy. Cold cathodes have a high efficacy rating, but because of the transformer noise and heat, require thoughtful wiring plans. Tubes can be shaped into many decorative forms including curves (Figure 6.20).

Tubes are filled with gases that produce various colors. Neon gas produces a reddish glow, and argon gas produces a blue-green glow. Tubes can also be coated with phosphors that allow the lamp to produce a variety of colors from blue to pink to a warm white. Cold cathode lamps are useful where long stretches of low-level continuous light are required.

FIGURE 6.20 Cold cathode lighting adds a playful quality to this pediatric surgery center. Curved ceiling forms and stars enhance its lighthearted atmosphere.
(Designer: Kathy Helm & Associates, Inc. Photograph by Quandrant)

Solid-State Lamps

Solid-state lighting (SSL) uses semiconductors to convert electricity to light. Lamps include organic light-emitting diodes; light-emitting polymers; and, the most common, light-emitting diodes.

Light-emitting diode lamps or *LEDs* have entered the mainstream interior design lighting market. For years, LEDs have been used as indicator lights on electronic equipment or on car dashboards. LEDs typically are rated to over 100,000 hours and run without a heated filament. LEDs are not lamps, but rather a chemical computer

FIGURE 6.21 Examples of LED lamps.
(Courtesy of Matrix Lighting, Inc.)

FIGURE 6.22 Example of LED strip lighting.
(Courtesy of Edge Lighting)

FIGURE 6.23 Example of 2' × 2' lay-in light fixture with LED lamps.
(Courtesy of Cooper Industries.)

chip embedded in plastic. When the chip is energized, it emits light, the color of which is based on the chemical in the chip. Heat that is produced is minimal and is absorbed by a material called a heat sink at the base of the fixture. Lenses and diffusers guide the light source. Like low-voltage lamps, LEDs require a transformer because they run on DC power.

Characteristically, LED lamps:

- Are available in sizes and shapes like those of common incandescent and fluorescent lamps and are even smaller and more flexible than their predecessors (Figure 6.21)
- Are available in strips of light for under-counter or other decorative trim uses (Figure 6.22)
- Produce a good spot light and can be used for general lighting (Figure 6.23)

- Produce light in a variety of colors including amber, blue, green, red, and a cool white (Figure 6.24)
- Are expensive to purchase but inexpensive to operate
- Have a life expectancy of 50,000 hours or more
- Require a ballast
- Work well for accent and decorative lighting
- Are available in a wide range of kelvin ratings
- Are energy efficient, durable, and safe

More info online @
www.sylvania.com/LearnLighting/LightAndColor/BeyondtheBulb Sylvania's information on LEDs
www.colorkinetics.com LED information

FIGURE 6.24 A variety of lighting solutions have been applied in this retail setting. Through an electronically controlled system, LED lamps produce a variety of colors on plain vanilla walls and ceilings. Columns covered in a metallic finish add to the brilliance of movement in the interior.
(Designer: Charles Greenwood, IIDA, of Greenwood Design Group, Inc. Photograph by Robert Thien @ 2001)

■ LIGHTING FIXTURES

Fixtures house the light source. All fixtures cast the light either *down* (onto an object or into a room) or *up* (onto the ceiling). **Downlighting** also may be called **direct lighting**; **uplighting** also may be referred to as **indirect lighting** or reflective lighting. The fixtures or luminaires for artificial lighting sources are either architectural (built in) or portable.

Architectural Lighting

Architectural lighting, which includes wall-mounted, ceiling-mounted, and custom-designed fixtures, is closely correlated with the structure of

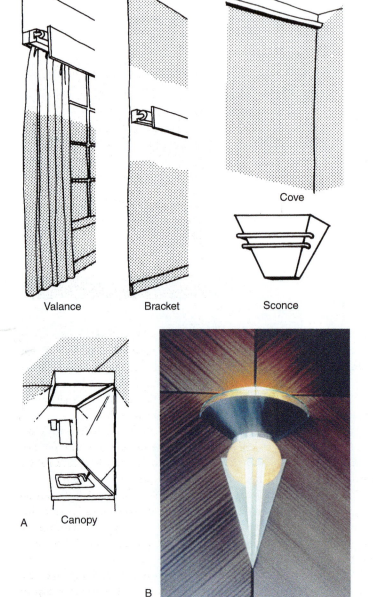

FIGURE 6.25 (A) Common types of wall-mounted fixtures. (B) This decorative sconce was custom designed to meet the needs of the space. Etched glass and metal are combined in this Starfire Select fixture.
(Courtesy of Starfire Lighting)

the room. This type of lighting is included in the lighting and electrical plans of the building as an integral part of the complete design. See Figure 6.37 for the standardized symbology for lighting fixtures.

Wall-Mounted Fixtures

Several types of wall-mounted fixtures are shown in Figure 6.25. A *canopy* overhead provides general illumination. This lighting is used mostly in baths and kitchens.

Cove lighting is placed near the ceiling, directing light upward and giving a feeling of height. When used around a perimeter, it can increase the apparent size of the room.

Sconces are decorative lighting fixtures permanently attached to the wall. They may be modern or traditional in style and can be positioned to provide direct or indirect lighting. Commercial sconces must be designed and located to meet ADA requirements.

Valance lighting is positioned over a window. A lamp is placed behind a valance board and the light shines on the drapery. If the valance is open above the lamp, the light produces both indirect (reflected) and direct (downlight) lighting.

Wall-mounted lighting also includes *under-counter lighting* to provide a direct source of illumination to the surface below or to provide a soft glow of light (Figure 6.26).

Ceiling-Mounted Fixtures

Ceiling-mounted fixtures are attached to the ceiling by one of three methods:

1. Recessed fixtures are hidden in the ceiling. The lamp (or a lens over the lamp) is the only visible component.

2. Surface-mounted fixtures are attached flush to the ceiling, but the fixture itself is exposed below the ceiling.

3. Suspended fixtures hang from the ceiling.

Figure 6.27 illustrates several kinds of ceiling-mounted fixtures.

Can lights (as they are commonly referred to in the industry) house lamps in cylindrical cans. Can lighting may be recessed or surface mounted depending on the design of the fixture. Can lights may be

FIGURE 6.26 Strip LED lighting was attached to the wall below the cabinets to create a warm glow of illumination at this bathroom lavatory.
(Courtesy of Edge Lighting)

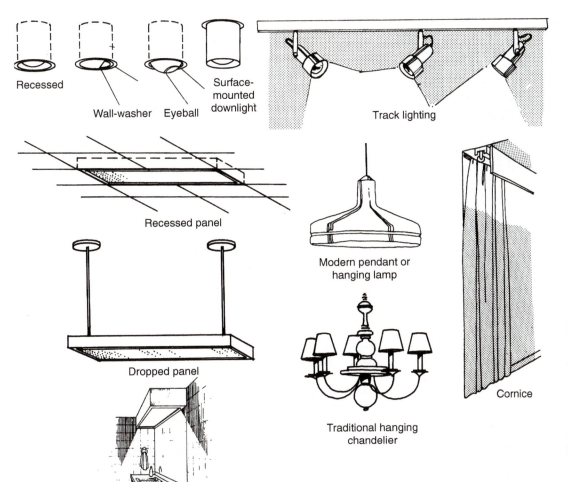

Recessed　Wall-washer　Eyeball　Surface-mounted downlight

Track lighting

Recessed panel

Dropped panel

Soffit

Modern pendant or hanging lamp

Traditional hanging chandelier

Cornice

A

B

C

FIGURE 6.27　(A) Common types of ceiling-mounted fixtures. (B) This custom hanging pendant was designed and scaled for a retail mall. Colored neon accentuates the contemporary columns. (C) This suspended fixture of cone-shape glass is available with one, three, eight, or twelve pendants to fit the scale of the space. *(Architect/Designer: Anthony Bellucchi Architects Ltd. Lighting design by Roeder Design, a subsidiary of Pacific Lightworks. Photograph by Robt. Ames Cook.) ("Fucsia" courtesy of Flos USA)*

called downlights, wall-washers, or eyeballs. Downlights may focus on a definite object or produce general lighting when used in sufficient numbers. Figure 6.20 shows can lights combined with neon lighting. A **wall-washer** is an adjustable unit that can be directed at any angle to "wash" the wall with light. An **eyeball** is similar to a wall-washer but can swivel, allowing light to be focused where desired.

A *cornice* is usually built on the ceiling to direct the light downward. Cornices are fairly similar to valances. The difference is the physical location of the mounted lamp. When used over a window, it can aid in eliminating the black mirror or glare effect produced at night.

Panels may be recessed, surface mounted, or suspended. Panels are frequently used in 2' × 2' squares or 2' × 4' rectangles because they are economical. Lenses are available in a variety of options to diffuse the light and soften the glare. This is especially important in environments where computer screens or VDTs are used (Figure 6.28).

Pendants and *chandeliers* (pendants with arms) are hung from the ceiling. Styles and lamp options are limitless (and sometimes custom designed). Pendants and chandeliers, when used over dining surfaces, should be suspended approximately 30 inches above the table in an 8-foot-high room, and raised 3 inches for each additional foot of ceiling height.

FIGURE 6.28 LED lights have traditionally been used in electronics as indicator lights; they have also been used in interiors as accent and spot lighting. The most recent development has allowed LEDs to be used as overall general lighting as shown in this training/lecture room. Diffusers prevent the lamp from producing glare on glossy surfaces.

(Courtesy of Cooper Industries)

FIGURE 6.29 In this gallery space, track lighting suspended from fine cables illuminates the sculpture and framed art. Incandescent halogen lamps pinpoint the selections.

(Designer: Ambiance Interiors. Photograph © Robert Thien. As seen in Atlanta Homes & Lifestyles*)*

A *soffit* consists of an enclosed light attached to the ceiling and is designed to provide a high level of light directly below. This light is effective in bathrooms, in niches, and over built-in desks.

Track lighting consists of a track surface mounted to or suspended from the ceiling. It comes in a broad array of sizes, shapes, and finishes. Fixtures clip or slide along the track or wire frame to create a precisely designed optical system with a vast range of lighting effects. Layout configurations are practically infinite (Figure 6.29).

Custom Fixtures

Custom-designed architectural lighting may be created to highlight steps or handrails, or for other design effects. Recessed floor lighting may be used in airplanes, in theaters, or at the base of steps as a safety device.

Fiber-optic fixtures are a type of decorative lighting that often meets custom needs (Figure 6.30). Fiber optics are not in themselves a light source but rather a type of hardware for transmitting light, similar to a hose, which is hardware for transmitting water. The light source is typically a halogen lamp. A fiber-optic light fixture is composed of a bundle of thin cylindrical fibers. A ray of light passed through the fibers produces an intense pinpoint of light at the opposite end. Fiber optics can be concealed in handrails and retail display cabinets, or used for spot or downlighting. Fiber optics can be used to produce a curved glow similar to the cold cathode lighting effect.

More info online @

www.americanlightingassoc.com American Lighting Association (retail association)

FIGURE 6.30 Fiber-optic decorative lighting was used in this interior to create a starry sky effect. Strass Crystal fiber optics from Swaro Lite Crystal Architecture defines the delicate appearance.
(Courtesy of Starfire Lighting)

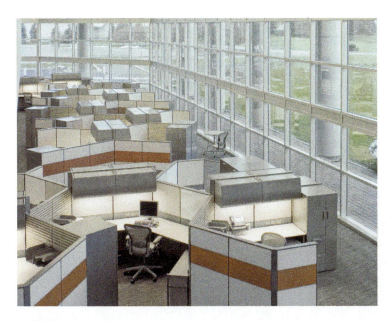

FIGURE 6.31 Under-cabinet lighting attached to the open office systems supplies task lighting for individual workstations.
(Courtesy of Herman Miller, Inc.)

Systems Furniture Lighting

Furniture systems (as discussed in Chapter 11) can be purchased with attached lighting systems. The electrical and lighting systems are concealed within the panels of the furniture system. Light may be directed below the upper cabinets onto the desk surface, similar to canopy or soffit lighting (Figure 6.31). Pendant fixtures may be suspended from the furniture system's walls to provide direct lighting. Lighting may also be directed upward. The area on top of the upper cabinets may conceal a light source that directs light onto the ceiling, similar to the lighting concept of a torchère.

Portable Lighting

A portable luminaire is a fixture that may be transported from one location to another. Portable fixtures (both table and floor models) are the oldest forms of electrical interior lighting. They provide flexible lighting in residential or public environments and may be purely functional, decorative, or both (Figure 6.32).

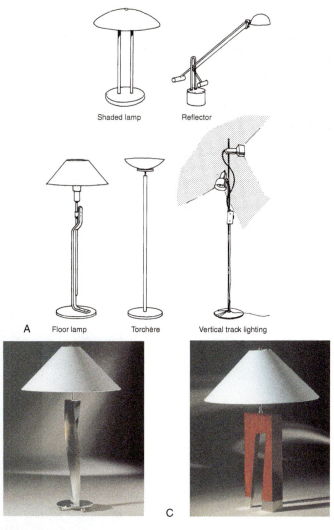

FIGURE 6.32 (A) Typical portable lamp fixtures. (B) "New Twist" table lamp. (C) "Derby" table lamp.
(Courtesy of HRS Design, Inc.)

■ LIGHTING FOR AREAS AND ACTIVITIES

The selection and placement of the appropriate fixture is a complex process. This section is a general guide to lighting goals for particular areas or uses.

In the lobby or entrance area, which is the keynote of an interior, lighting plays an important role. During the day, the entry or lobby should be bright enough to allow a reasonable transition from the bright outdoors to the darker interior. Illumination needs to be at a lower level at night to aid eyes in focusing, but strong enough to enable visitors to see and be seen. The entrance is an ideal place to try a dramatic lighting effect such as an accented art object. Often the reception desk is more brightly lit to draw visitors.

Waiting rooms and living rooms need soft general background lighting supplemented by special area task lighting. Both direct and indirect lighting sources are desirable, although an excess of indirect lighting may result in a washed-out appearance. Well-chosen portable fixtures at necessary locations add a feeling of comfort and accent a room's focal point.

Conference rooms and dining areas deserve versatile lighting around the table area that can be adjusted for a variety of functions. General lighting can provide a low-level background. Dimmer controls allow for a change of mood or for an audiovisual presentation. In residential or restaurant settings, candles give a flattering glow to skin tones. Creative use of accent light helps to avoid flat downlighting and adds interest in both residential and commercial settings (Figures 6.33 and 6.34).

Offices, libraries, and studies require general lighting. Where computers are used, overhead lighting should be well diffused to prevent glare. Parabolic louvers that cover fixtures function particularly well. Task lighting is also essential for reading and studying. Refer to Figure 6.3 for a review.

Family and recreation rooms accommodate a variety of activities and thus require particularly flexible lighting. General lighting is essential, with task lighting supplied for specific activities. Television viewing is most comfortable when general lighting is at a low level with no strong contrasts or glare. The television or computer screen itself reflects light and contributes to the total lighting effect.

FIGURE 6.33 In this dining room, a Holly Hunt chandelier includes candle-like pillars that are hollowed out and electrified to look like burning candles. The steel pan conceals the wiring and hides downlights that serve as task lighting at the table. Accent lighting highlights the art. All light sources are dimmable. Flat linen panels, hung from a ceiling-mounted track, can be repositioned for solar control or privacy.
(Designer: Pineapple House. Photography by Emily Followill)

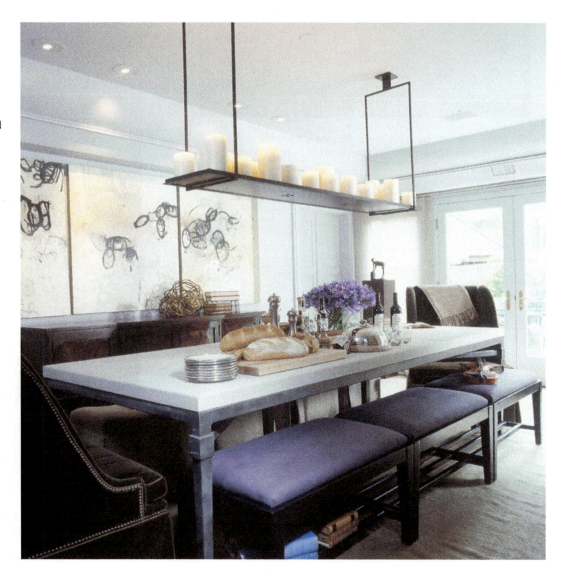

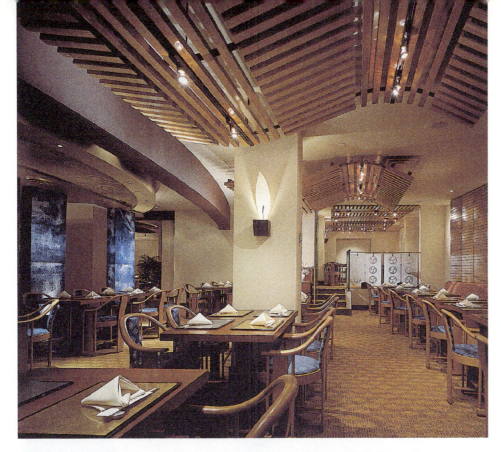

FIGURE 6.34 In this Japanese restaurant located in New York City, a variety of lighting techniques have been incorporated. Track lighting is concealed in the wood slat ceiling. Decorative sconces, chandeliers, cove lighting, downlighting, and uplighting define this elaborate use of the stylized yin-yang symbol. Frosted panels diffuse the downlighting over the bar.
(Custom lighting by Adam D. Tihany. Architect/Designer: Adam D. Tihany International, Ltd. Photographs by Peter Paige)

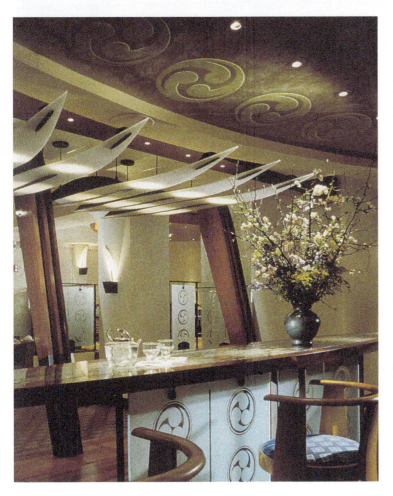

FIGURE 6.35 In this contemporary kitchen, lighting has been designed to create interest while serving the importance of function. The 3-inch-thick glass shelves, lined with low-voltage incandescent lamps, provide task lighting. *(Designer: Steven J. Livingston, owner, Studio Snaidero San Francisco. Photograph by Ellen Perlson)*

Workrooms, kitchens, classrooms, and utility rooms function best when generous overall lighting for safety and efficiency is planned. Ceiling- or surface-mounted fixtures such as recessed downlights or track lighting can give adequate general light and eliminate shadows. It is also important to provide recessed or shielded lights over work areas and mounted under wall cabinets to illuminate counters (Figure 6.35). Classrooms, like conference areas, also require a low light level option, suitable for slide or video presentations.

Bedrooms need comfortable general lighting with appropriate task lights for reading, grooming, deskwork, and other activities. Direct lighting is also helpful when placed over chests of drawers, in closets, close to seating, and over beds. Dim circulation lighting for safety at night is a basic requirement. Accent lighting can be effectively used to focus on a painting or wall unit.

Bathrooms require shadowless lighting for shaving and grooming, which can be supplied by light from overhead and from both sides of a mirror, and by light reflected upward from a light-colored basin or countertop. Mirror lighting is usually sufficient to illuminate an average-size powder room; however, general lighting is necessary with the addition of a tub or shower stall. Lighting in the shower needs to be enclosed and certified for use in a wet environment.

Stairways require overall illumination for safe passage. Stairways should be well lit with treads and risers clearly defined. Well-shielded light fixtures that avoid blinding glare at the top and bottom of stairs are another safety factor.

Corridors require minimum lighting for passage. Art and other objects can be accented to create dramatic effects.

Outdoor lighting at night enhances exterior architecture, gardens, decks, patios, walkways, and other outdoor living areas and provides visual pleasure. This is true in residential, commercial, and institutional settings. Additionally, outdoor lighting helps alleviate the black glass look seen from inside by balancing and extending the lighting to the outside (as seen in Figure 3.3).

Weatherproof luminaires for outdoor use can be attached under the eaves and on exterior walls. Custom lighting often includes exposed and concealed fixtures placed at various important areas of the garden that throw light upward, downward, or in both directions on trees, plantings, a garden sculpture or fountain, a gazebo, or other garden features to create a visually exciting experience. Front entries commonly serve as focal points (Figure 6.36).

FIGURE 6.36 This unique light fixture draws visitors to the front entry. Formed from colored bottles, this fixture is lit by a fluorescent lamp with energy supplied by the sun (see Sustainable Design: Solar Architexture and the Earthship in Chapter 14).
(Designer: Jones Interiors. Photograph by Philip A. Jones)

■ POWER AND COMMUNICATION

Closely related to the selection and placement of luminaires is the selection and placement of power systems (including light switches and electrical outlets) and communication systems (including telephones, intercoms, and internal computer connections). As with all building systems, lighting, power, and communication symbolism is standardized. Figure 6.37 indicates the most commonly used symbols. Power and communications are frequently combined with lighting systems

FIGURE 6.37 Electrical, communication, and lighting symbols.

ELECTRICAL/COMMUNICATION SYMBOLS

Symbol	Description
⊖	DUPLEX OUTLET
⊖GFI	GROUND FAULT INTERRUPT OUTLET
⊖WP	WEATHERPROOF OUTLET
⊖R.	RANGE OUTLET
⊖220	220 VOLT OUTLET
⊕F	FAN OUTLET
◀	TELEPHONE
⊙	FLOOR DUPLEX OUTLET
▲	TELEPHONE FLOOR OUTLET
□	TELEVISION OUTLET
□∘	BELL
▮	ELECTRICAL PANEL
S	SINGLE POLE SWITCH
S₃	THREE WAY SWITCH
S₄	FOUR WAY SWITCH
⌒	CONNECTS LIGHTS TO SWITCHES

LIGHTING SYMBOLS

Symbol	Description
⊖	WALL LIGHT FIXTURE
⊕	CEILING LT. FIXTURE
○	CAN LIGHT
◑	WALL WASHER
◎	EYE BALL
▱	2' X 4' FLUORESCENT FIXTURE
◨	2' X 2' FLUORESCENT FIXTURE
▭	STRIP FLUORESCENT
⊶⊷	TRACK LIGHTING
⊠	HVAC DUCT
⊗	EMERGENCY LIGHTING

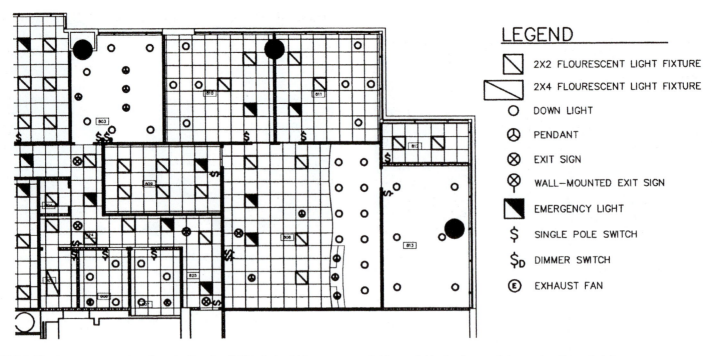

LEGEND

▨	2X2 FLOURESCENT LIGHT FIXTURE
▨	2X4 FLOURESCENT LIGHT FIXTURE
○	DOWN LIGHT
⊗	PENDANT
⊗	EXIT SIGN
⊗	WALL—MOUNTED EXIT SIGN
◪	EMERGENCY LIGHT
$	SINGLE POLE SWITCH
$D	DIMMER SWITCH
Ⓔ	EXHAUST FAN

FIGURE 6.38 This partial view of a reflected ceiling plan (RCP) indicates lighting, emergency lighting, switching locations, and changes in ceiling materials. *(Designer: Katherine M. Hill)*

and are documented in construction drawings in one of the following three ways:

1. Lighting location plans indicate where and what kinds of fixtures are used and switch locations.
2. Power and communication location plans indicate where telephone, electrical, and computer outlets are located.
3. Reflected ceiling plans, which are similar to lighting plans, are used mainly in commercial design. They also indicate HVAC and emergency lighting locations and ceiling materials and heights (Figure 6.38).

Some projects are small enough or simple enough to combine items 1 and 2 above. (Figure 6.39).

In commercial buildings, raised flooring systems may be installed to house complicated communication and electrical systems. The floor is literally raised approximately 6 to 12 inches, and cabling networks are concealed beneath the floor. Some flooring systems can be left exposed as a finished flooring material with an industrial appearance (Figure 6.40A), or the system may be covered with carpet tile (Figure 6.40B). The advantage of the raised flooring system is its ease of maintenance and flexibility for change. (These benefits would be lost if wall-to-wall carpet were installed over the raised floor.) The height changes in the floor must meet ADA requirements and therefore require ramped access.

Switches

All rooms require at least one light switch. This switch may control an overhead light or provide electricity to an outlet into which a portable luminaire is plugged.

Switches are most commonly placed on the latch side of the door approximately 44" above the finished floor (**A.F.F.**). Switches are also

necessary at both ends of hallways and at the top and bottom of stairways. Where task lighting is necessary, switches should be placed within easy reach of the task and not at the entry to the room. Dimmers on switches are effective for incandescent lights but do affect the color of the light as they are dimmed. (Fluorescent dimmers are limited.) Dimmers allow great flexibility for various levels of lighting; they are ideal for creating a mood and also for conserving energy and the life of the lamp.

One switch may operate a single outlet, a series of outlets, a single luminaire, and/or a series of luminaires. A one-switch system is technically called a *single-pole switch*. Adding a second switch to the same source, however, changes the name to a *three-way switch*; adding a third switch changes the name to a *four-way switch*, and so forth. (The term *two-way switch* does not exist.) Note that the number of outlets and/or luminaires powered by a switch system has no relationship to the actual number of switches or their respective terminology (as seen in Figure 6.39).

More than one switch system may be needed in a space. For instance, one switch may be used to power accent lighting, another switch to operate a ceiling fan, and a third to operate a series of luminaires that also need to be accessed from the other side of the room. These switches, ideally grouped together under one cover plate, are said to be *ganged*.

When installing switches, designers need to communicate clearly which switch activates which series of luminaires or outlets. This is particularly evident in commercial interiors. A ganged series of switches should operate the luminaires in some obvious order. For example, the switch closest to the door should operate the luminaires closest to the door.

Outlets

Typical electrical outlets are technically referred to as duplex outlets (because they have two receptors). Duplex outlets are used for 120-volt appliances. Some high-powered equipment, such as copying machines, require dedicated outlets or must have their own circuit.

42" AFF
G.F.I.

SWITCH CONTROLS
OUTLET

G.F.I.

42" AFF

3'

FIGURE 6.39 A floor plan, called an electrical, lighting, and telephone plan, or ELT, indicates the wiring and location of electrical outlets and switches as well as light fixtures. This information aids the designer in determining a functional furniture arrangement.

Indoor outlets located near water sources (such as the bathroom or the kitchen sink) and all exterior outlets are required to be protected with a ground fault circuit interrupt or GFCI. Waterproof outlet covers are also required on exterior outlets. Electric ranges, clothes dryers, and other 220-volt equipment require a 220-volt outlet.

Throughout interior spaces, outlets should be plentiful and located for specific tasks. Outlets should be easily accessible for computer and desk accessories and for appliances in kitchens, utility areas, and bathrooms. When a room's function is determined, outlets can be conveniently located in accordance with local building codes. Outlets placed at regular intervals (approximately 6 feet apart between doorways and floor-length windows) decrease the need for hazardous extension cords. Outlets are usually mounted 15 inches A.F.F. in barrier-free environments, but can be placed at other heights as needed.

Communication Systems

Technological advances have expanded this once relatively simple system, formerly limited to telephone lines. In commercial design and, in many cases, residential design, components of communication plans now include the following:

- *Intercom systems.* These may include low-level sound attenuation, or white noise systems (as discussed in Chapter 5), or may allow for music and other announcements to be fed throughout a building. Retail establishments, medical facilities, and educational institutions require elaborate systems for internal communications.

A

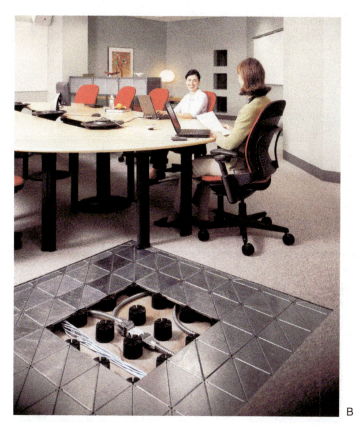

B

FIGURE 6.40 In (A), the raised flooring conceals the cabling beneath a conferencing area. The metal ramp and flat floor are exposed as a design element. (B) illustrates how the flooring and cables appear beneath the carpet. Carpet tiles are used in the entire conference room to conceal the metal raised floor and to allow for easy access.
(Courtesy of Steelcase Inc. Product: Pathways)

- *Internal computer systems.* These are sometimes referred to as intranet systems. These computer-based connections allow for the sharing of software and data within an organization without the use of the Internet. Internal systems may also be required for routing documents to printers or copy machines.
- *Telephone systems.* Despite the expanded use of cell phones, hard-wired telephone systems are still the standard. Telephone systems are also used for fax communications as well as DSL and dial-up Internet connections.
- *Internet systems.* Wiring connections to the Internet will vary by firm and location. Some may still use dial-up Internet connections (ideally on separate dedicated telephone lines); others may use DSL, as noted previously. Still others may use cable connections or commercial-grade adaptations. Although wireless service is available, power and Internet connections to the wireless router are still required.
- *Cable systems.* In residential and commercial design, cable systems supply access to entertainment, business reports, news and information, and sometimes Internet connections.
- *Satellite systems.* Again, both residential and commercial clients may have a need for satellite connections for business and/or pleasure.

Locations of communication outlets are similar to locations of electric outlets, typically 15" A.F.F.; however, built-in desks and countertops may better be served by locating the outlets just above the work surface. It is more cost effective to install a few additional outlets during initial construction (or during a major renovation) than to add them later (Figure 6.41).

DESIGN GUIDELINES FOR LIGHTING, POWER, AND COMMUNICATIONS

Lighting, power, and communication plans require immense oversight by the designer to ensure that design criteria are not interfering with required codes. On the other hand, designers must be vigilant to ensure that engineering components do not interfere with critical design issues. Many designers have had to move an HVAC thermostat that was inadvertently located in the center of a display wall. The following guidelines are essential:

1. Engineers determine the number of circuits required for the fixtures and outlets. The designer specifies only the style, location, and quantity of fixtures and outlets.
2. Designers need to be vigilant that the HVAC and plumbing systems do not interfere with critical lighting and outlet locations; sometimes a compromise may be required for practical or economic purposes.
3. Lighting design is a collaborative effort among allied professionals. Small residential projects may require only minor assistance from an electrical engineer; larger commercial projects frequently employ a lighting designer or consultant to assist with lighting decisions.
4. All electrical components must meet local, state, and national codes.
5. Lighting design software is available to assist designers with quantity and quality lighting requirements.
6. Creative solutions to lighting problems add depth and distinguish one space from another (Figure 6.42).

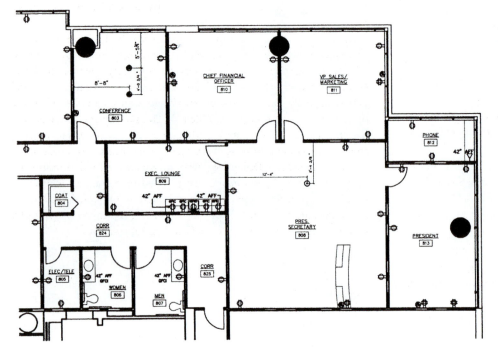

LEGEND

⌀ DUPLEX OUTLET

⊙ FLOOR DUPLEX OUTLET

⌗ QUADRAPLEX OUTLET

Ⓐ DUPLEX/PHONE/DATA OUTLET
NOTE: IS A FLOOR OUTLET IF DIMENSIONED

▽ WALL MOUNTED PHONE OUTLET

⌀ DEDICATED DUPLEX OUTLET
DED

FIGURE 6.41 In the same project as Figure 6.38, this partial view of a communication plan indicates electrical and telephone outlet locations and types.
(Design by Katherine M. Hayes)

FIGURE 6.42 This residential space in Nangang, Taiwan, includes sliding translucent panels between the living room area and the bedroom. The panels allow light to permeate the rooms but also provide for privacy. Under-counter lighting is built into the shelving for accent and to provide a warm glow against the dark wall

(Photograph by Marc Gerritsen © BUILT Images/Alamy)

The economic and energy-efficient use of lamps, fixtures and luminaires, and related power and communication equipment is important in sustainable environments. The following guidelines can help conserve energy.

- Lighting should fit specific needs. Task areas such as kitchen counters or desks require more light than do nonworking areas such as circulation space.

- Dimmers are useful in adjusting light levels, increasing lamp life, and saving energy.

- Installing multiple switches and switches at every exit makes it convenient to use only the amount of light required in a specific area. Three-way incandescent lamps also allow selectivity in the amount of light used.

- Fixtures that can be adjusted and placed where light is needed are a wise choice. For instance, track lighting has great flexibility and permits the light to be directed where it is desired.

- A reflector lamp is good for accent or task lighting. Low-voltage spotlights are especially effective where a tightly controlled beam is required.

- Light sources should be efficient. Light output varies in efficiency according to wattage and color. For example, fluorescent or LED lamps use as much as 80 percent less energy, produce 5 to 30 times as much light, and last 20 times longer than incandescent lamps.

- Where appearance is not a consideration, as in garages and some basements, industrial reflectors are an economical option.

- Ceilings, walls, floors, and furniture that have light-colored finishes reflect more light. Rooms designed in dark colors absorb light and require more lighting.

- Keeping reflectors, diffusers, and lamps clean helps to maintain lighting equipment.

SUMMARY

Interior designers must be familiar with many aspects of light, including the quantity of light, the quality of light, the proper selection of the lamp, and the proper selection of the fixture. All of these aspects must work together to meet the function of the space in an aesthetically pleasing and economically efficient manner. To accomplish this, designers have many resources including recommendations for footcandles, reflectance values for various surfaces, CRI or the new CQS ratings, kelvin temperatures, spectrum patterns, distribution charts, and so on.

Absorbing all this information and correctly applying it can be overwhelming. Many designers may delegate lighting design to a consultant. On larger projects, this may be especially appropriate; however, remember that the consultant is an assistant to the project and still needs direction as to the character and atmosphere desired in the space. Designers should be confident in completing the selection and placement of lighting, power, and communication needs on projects, and visually communicating these needs to engineers and builders.

In the following Design Scenario, a beachfront condominium has been refurbished. This scenario was selected to be located in Part III Building Systems because the designer carefully integrated custom details and lighting to transform the interior space. Review it carefully, giving special attention to the plans and custom features.

design SCENARIO

Beachfront Condominium

In this renovation, the designer's challenge was to update the coastal builder-grade condominium and furnish it with the client's traditional pieces, creating a casual environment. The empty-nester clients were downsizing from a traditional home to the compact condo. The designer's goal was to create a "charming architecture for a beachfront cottage in the high rise building."

Throughout the interior, custom details, built-in cabinets, and alterations to interior walls, ceilings, and doors created a livable floor plan (Figure DS6.1A and B). One of the most dramatic changes included a dropped coffered ceiling. The ceiling not only adds rich character to the interior, but functions discretely as the plenum for the electrical wiring. This plenum allows for updated light fixtures without drilling into the existing concrete ceiling structure (Figure DS6.2A and B).

A new ebony breakfast and entertainment bar near the dining area serves as an espresso station and discretely houses a wine cooler and small refrigerator behind metal screens. Storage was added via a 12-door, built-in, floor-to-ceiling pantry near the kitchen island.

Ornate dining chairs were transformed by using simple short skirts and upholstering the backs. Two wooden barstools increase the dining seating

capacity to ten. The dining table also serves as an office desk. Locking file drawers are incorporated under each end of the custom banquette. Nearby plugs accommodate laptop power requirements without infringing on traffic patterns (Figure DS6.3).

In the living room, the client's existing (different) sofas were unified by upholstering them in the same fabric. Sofa heights were matched by altering the sofa's legs. Swivel mechanisms were added to the bases of the client's club chairs to allow viewing in all directions. The draperies were installed on a hidden flexible ceiling track for optimal functionality. The television console is the base portion of the client's hutch.

FIGURE DS6.1A and B (A) indicates the original floor plan. (B) illustrates the final furniture presentation floor plan shared with the client.
(Designer: Pineapple House Interior Design.)

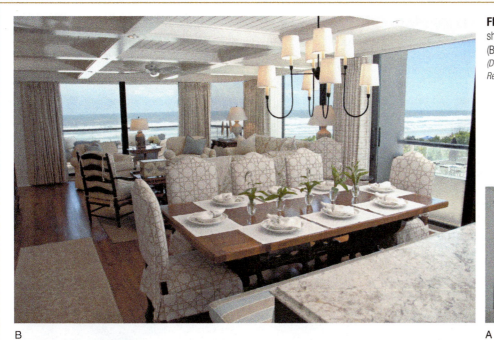

B

A

FIGURE DS6.2A and B (A) indicates the before shot looking into the dining room and living room area. (B) is the after shot.
(Designer: Pineapple House Interior Design. Photograph by Aubrey Reel Photography.)

FIGURE DS6.3 Custom details include a hidden file drawer beneath each end of the built-in banquette.
(Designer: Pineapple House Interior Design. Photograph by Aubrey Reel Photography.)

The master bedroom's entry door was relocated and the master bedroom opened to the master bath, allowing light to enter the interior space. The client's desk became a vanity, providing sophistication to the integrated area (Figure DS6.5A, B, and C). The old living room's bar and cabinetry area was converted into a luxurious closet.

Looking from the master bedroom towards the ocean, two barn doors slide along an iron track and cover the room's new entry. In addition to providing privacy, when spread wide, the doors move out of the way or adjust to cover the television (Figure DS6.4A and B).

A

FIGURE DS6.4A and B These photos illustrate the custom sliding barn door added at the master bedroom. When open, the door allows a view to the living room and ocean front while hiding the television.
(Designer: Pineapple House Interior Design. Photograph by Aubrey Reel Photography.)

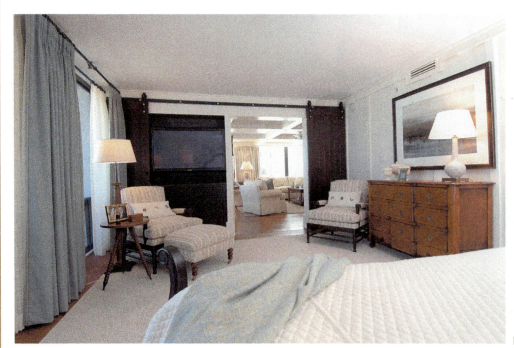

B

FIGURE DS6.5A, B and C (A) indicates the before shot of the enclosed narrow master bath. (B) and (C) illustrate the custom details and lighting designed to create an open and luxurious master bath in a relatively tight space including a custom vanity.
(Designer: Pineapple House Interior Design. Photograph by Aubrey Reel Photography.)

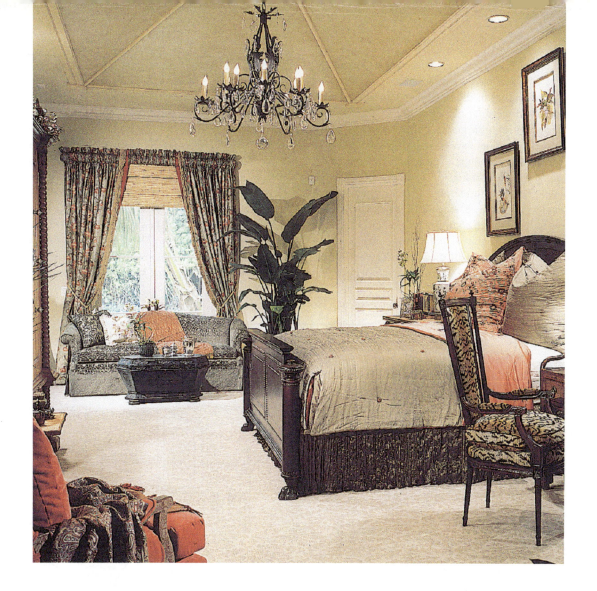

Part IV

Space

When arranging furnishings, I always seek the spaces in between. I am just as concerned about what I leave out of an interior as what I put into it.

—John Saladino

CHAPTER 7

Space Planning: Furnishings to Rooms

CHAPTER 8

Space Planning: Rooms to Buildings

FIGURE IV.1 This opulent bedroom balances the use of vertical space by placing a tall, narrow armoire opposite the larger, yet lower bed. Art over the bed also adds height to the room. Figure IV.2 shows the design progression.
(Designer: Marc-Michaels Interior Design. Photograph © Kim Sargent ArchitecturalPhotography. Residence: Private home, Phipps Estates, Palm Beach. Developer: Addison Development. Courtesy of On Design)

As discussed in Chapter 3, space is one of the most important elements of design; its appropriate use determines the success of an interior. Well-planned space should be given top priority to ensure an interior where human activity can be carried on with a minimum of frustration. An interior may have exquisite fabrics, brilliant colors, and comfortable seating, but if a person does not have enough space to function (to work behind a desk, for example), the beauty of the furnishings is wasted.

Space is not limited to the area arranged on a floor plan. The designer must also arrange the space in elevation. Upper cabinets that protrude in front of windows, chair arms that will not fit under tables, or countertops that are too low or high complicate the client's life. The creation of an environment that promotes comfort and convenience requires the designer to analyze the use of all the planes. The horizontal, vertical, and in-between space is known as **volume**. Understanding and visualizing space in three dimensions are the keys to using space appropriately (Figures IV.1, IV.2, and IV.3).

In the field of design, the placement of furniture and the arrangement of rooms are part of space planning. As discussed in Chapter 1, in the commercial environment, space planning is a career track. Commercial interior designers may spend days, weeks, or even months working with a client to determine space needs and requirements. In the residential environment, a designer may work with the architect and builder to ensure that rooms are the correct shape and size to meet the client's needs. If the residence is already built, the designer must cleverly select and place furniture to utilize the space most efficiently, and as just seen in the Beachfront Condominium Design Scenario, some walls may need to be relocated. As always, the sooner the designer is involved with the design team on a project, the more successful the design solution will be.

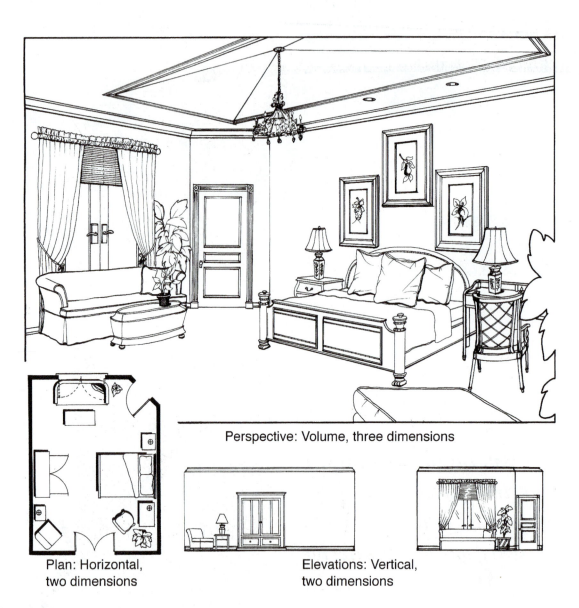

Perspective: Volume, three dimensions

Plan: Horizontal,
two dimensions

Elevations: Vertical,
two dimensions

FIGURE IV.2 These drawings show the progression of design from plan view and elevations to a drawing of volume. The photo in Figure IV.1 illustrates the finished room.
(Interpretive design drawings by Carol Platt)

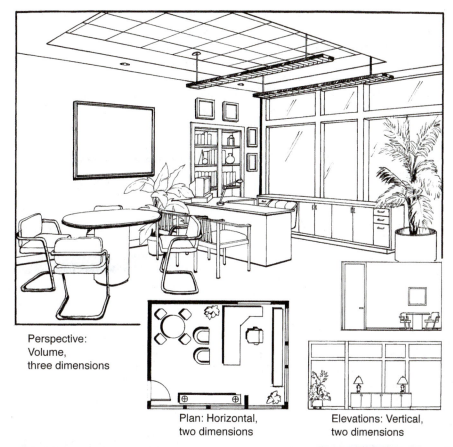

Perspective:
Volume,
three dimensions

Plan: Horizontal,
two dimensions

Elevations: Vertical,
two dimensions

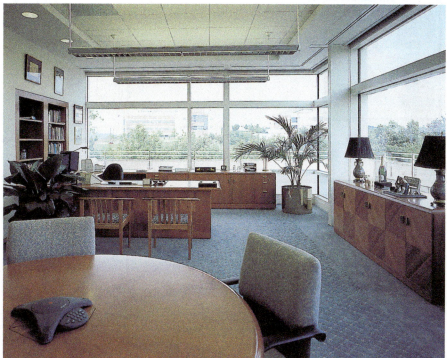

FIGURE IV.3 Drawings show a progression from plan view and elevations to a drawing of volume. The photo illustrates the finished room. This custom design for a president's office included a flood of exterior window light balanced by a series of bookshelves.

(Architect/Designer: Flad & Associates. Photograph © Norman McGrath. Interpretive design drawings by Carol Platt)

FORM AND SPACE

Spaces that designers create form positive areas (the space occupied by the actual furniture pieces) and negative areas (the empty space between pieces). The negative spaces form the pathways or *traffic lanes* that allow people to move throughout a space (Figure IV.4). Hotel lobbies require an immense amount of negative space in order to accommodate the variety of activities and quantity of people moving about the space. Residential dining rooms require less negative space based on the decreased level of activity in the room. In all cases traffic lanes should not interrupt conversation groupings (Figure IV.5).

Underfurnishing a room is often more attractive than overcrowding. Studies reveal that overcrowding a space can actually have a negative psychological effect on the occupants. Some empty spaces between groupings help give an uncluttered effect. An occasional open space or empty corner enhances a room and gives the occupants breathing space. On the other hand, a severely underfurnished room may be stark and uninviting. Avoid either extreme.

SPACE PLANNING

In many situations, particularly in residential design, the clients may purchase a home and then call upon the services of an interior designer to make the existing space fit their needs. This approach, which may be described as designing from the *outside in*, is taken when the clients fall in love with the look of a home without having assessed its practical layout. They may have utilized their entire budget for the purchase and may resort to substandard interior selections. Although the exterior of the home or building has aesthetic appeal, the interior, the space where people spend 90 percent of their lives, is left to awkward furniture arranging and mediocre design. The designer is required to alter apparent room sizes via clever furniture placement, finish and fabric selection, or portable lighting. In commercial situations, particularly in large spaces, the client often recognizes the need for professional help before the selection of the building and therefore avoids this mistake.

The alternative school of thought is to design the home or office from the *inside out*. For many clients this requires a paradigm shift in thought. The designer is contacted before a home or building has been selected, then works with the client to analyze spatial needs. The designer can assist the client in locating an appropriate building or home, or designing a new one that meets the client's needs *and* budget. The following two chapters explore space planning from this inside-out method. Furnishings are planned as part of activity areas. Activity areas are grouped into rooms. Rooms are grouped by interior zones, which then establish the perimeter of the interior environment. Throughout this process, attention is given to the vertical nature of space. Remember that interiors are planned in volumes.

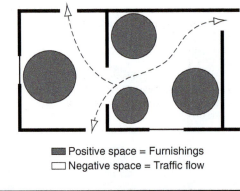

■ Positive space = Furnishings
☐ Negative space = Traffic flow

FIGURE IV.4 In these drawings the negative space has been left open to allow for traffic flow. (A) Use of a bubble diagram; (B) furnishings have been placed in the positive space.

Poor arrangement.

Better arrangement.

FIGURE IV.5 Appropriate furniture layout to redirect traffic.

SQUARE FOOTAGE CALCULATIONS

Interior designers must be able to figure the square footage of a space. Residential clients want to know many square feet are in their home. Commercial clients have to know the square footage as their space is frequently leased and their rent payment is based on the number of square feet they occupy. The information in the following table can be applied in most situations to assist in figuring square footage.

Figuring Square Footage

Square footage is determined by multiplying the length of a room by the width. Therefore, $L \times W$ = square footage or □. For example, if a room were 10′-0″ × 12′ × 0″, it would contain 120 □.

The following charts may be helpful in figuring these problems.

Inches to Decimal Foot Conversion Chart

1″ = .08′	7″ = .58′
2″ = .16′	8″ = .67′
3″ = .25′	9″ = .75′
4″ = .33′	10″ = .83′
5″ = .42′	11″ = .92′
6″ = .50′	12″ = 1.0′

Conversion Chart

1 inch = 2.54 centimeters (multiply the number of inches by 2.54 to determine the number of centimeters)

1 centimeter = .3937 inches (multiply the number of centimeters by .3937 to determine the number of inches)

1 foot = 12 inches = .3048 meters (multiply the number of feet by .3048 to determine the number of meters)

1 meter = 3.2808 feet (multiply the number of meters by 3.2808 to determine the number of feet)

1 □ = 144 square inches = .0929 square meters (multiply the number of square feet by .0929 to determine the number of square meters)

1 square meter = 10.764 □ (multiply the number of square meters by 10.764 to determine the number of square feet)

1 square yard = 9 □ = .8361 square meters (multiply the number of square yards by .8361 to determine the number of square meters)

1 square meter = 1.196 square yards (multiply the number of square meters by 1.196 to determine the number of square yards)

Determining Square Footage in Feet and Inches (Does Not Apply to the Metric System)

If a room is 10′-3″ × 12′-9″, the process requires the following steps. (A calculator is useful here.) To figure the square footage:

• Using the inches to decimal conversion chart, change the inches to a decimal:
10′-3″ becomes 10.25′ and
12′-9″ becomes 12.75′
• Multiply the length by the width:
10.25′ × 12.75′ = 130.6875 □
• Square footage or areas are usually figured in whole numbers. Simply round up or down to the nearest whole number, in this case, 131 □.

Determining Square Footage in Odd-Shaped Rooms

It is more complicated to figure square footage when the room has an odd shape. The room below is L-shaped. To figure the square footage complete the following steps:

• Divide the room into two separate rectangles.
• Figure the square footage of each space:
The square footage of A = 10′-0″ × 20′-0″ = 200 □
The square footage of B = 10′-0″ × 8′-0″ = 80 □
• Add the totals. The total square footage is 200 □ + 80 □ = 280 □.

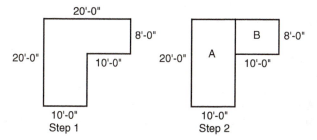

To figure the square footage of a room with an angle, such as in the following figure, more geometry must be used.

• Divide the room into as few rectangles and triangles as possible.
• Figure the square footage of the rectangular spaces:
A = 16′-0″ × 14′-0″ = 224 □
B = 6′-0″ × 8′-0″ = 48 □
Hint: 20′-0″ − 14′-0″ = 6′-0″
• To figure the square footage of C, it is important to know that a triangle is simply a rectangle divided in half. Therefore, multiply the length by the width and divide the answer by 2:
6′-0″ × 8′-0″ = 48 □ ÷ 2 = 24 □
• Add the totals of the spaces together to arrive at the total square footage:
224 □ + 48 □ + 24 □ = 296 □

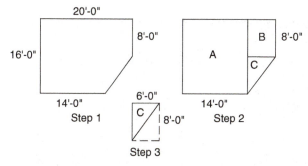

In all cases, convert the inches to a decimal before multiplying. Remember to round off the decimal to the nearest whole number when finished.

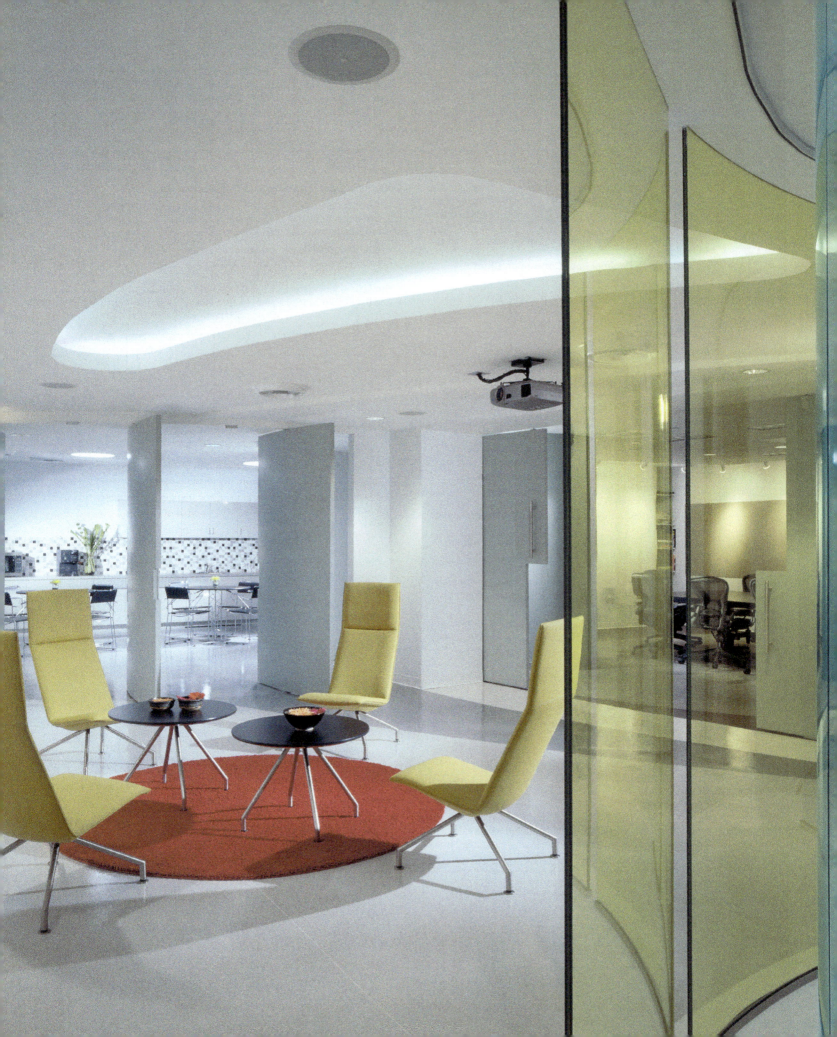

7 Space Planning: Furnishings to Rooms

To be livable, an interior must meet the needs of its occupants. The goals of interior design, as discussed in Chapter 1, include function and the human factor, aesthetics, and economics and ecology. These goals must be applied to space planning. Economics and function dictate spatial needs and are addressed before fabrics, furnishings, and finishes are specified (Figure 7.1).

■ PROGRAMMING INFORMATION FOR SPACE PLANNING

Economic Concerns

Whether clients are searching for a new office space or a new home, the building and its furnishings are probably the most expensive investments they will make. They want the best value possible for every dollar spent. The designer should study costs and look carefully at such criteria as available budget, client needs, materials and components required, time limits, building requirements, and codes.

The cost of a structure varies depending on many factors: its size, structure, geographic location, materials specified, cubic footage or volume (the three-dimensional measurement of the height, depth, and width of the space), special construction features (such as raised ceilings, angled or curved spaces, custom windows and doors), and the cost of local labor. Average building costs per square foot, exclusive of the price of the land, depend on the region where the structure will be built. An excellent source for determining construction costs is the *Means Cost Estimation* series of texts by Robert S. Means.

Costs also relate to the selection of furnishings. A good-quality, low-budget sofa could cost $1,200, whereas the price of an elaborate custom-upholstered sofa could reach into the thousands of dollars. Designers must determine what level of furnishings will work within the client's budget. The deciding factor is the quality of the product, not necessarily its price. If a client cannot afford a quality product, it is better to wait until the product can be purchased. Placing inexpensive, low-quality furnishings in a space almost always results in an unhappy client and a poor design solution. It is better to have a few well-spaced quality pieces of furniture than a room full of cheap substitutes.

FIGURE 7.1 In this prefunction area, a contemporary conversation grouping is placed outside the conference room and break area. Pivoting doors allow overflow space during major company events, or they can be closed off for private meetings. The overhead projector allows for multimedia presentations to groups of all sizes. *(Gandy Peace/Designer: William B. Peace, ASID)*

More info online @

www.get-a-quote.net/quickcalc Cost-estimating resource with calculator
http://architecture.about.com/od/buildingcosts/Building_Cost_Estimators.htm
Proprietary website on cost estimating

Function and Human Factors

During the initial client contact and programming phase, the designer determines the function of an interior and the client's design preferences and space needs. The designer working with a residential client may complete a *personal profile* of each occupant and ask questions regarding the client's lifestyle. Nonresidential projects may require interviews with executives of the company and some individual staff members. (Appendix A is an example of a typical initial residential programming questionnaire.) In essence, the designer must understand the intricacies of the household or the firm in order to carefully plan for spatial needs.

As discussed in Chapter 2, the requirements for space planning vary with the physical as well as the psychological and cultural background of the client. Designers must be able to apply anthropometric and ergonomic data in a given situation. ADA, universal design, age, and ability considerations are addressed not only to meet federal regulations, but also to provide the best solution to meet the client's needs. Additionally, designers hone their intuitive sense to take into consideration

cultural proxemics and personal value systems. A review of Chapter 2 may be appropriate before proceeding with this chapter.

Guidelines for Furnishing Dimensions

Once the functions have been determined and the human needs of each occupant evaluated, the designer determines how much space is required to meet the client's needs. This is a component of programming. In order to accomplish this, designers must have a working knowledge of the actual sizes of furniture pieces and the clearances necessary to move about the space. Study Tables 7.1 and 7.2; refer to them often.

Traffic Patterns

Once the furniture (positive space) has been determined, the designer analyzes the clearances (negative space) required for major and minor traffic lanes. Study Table 7.3 on clearance requirements.

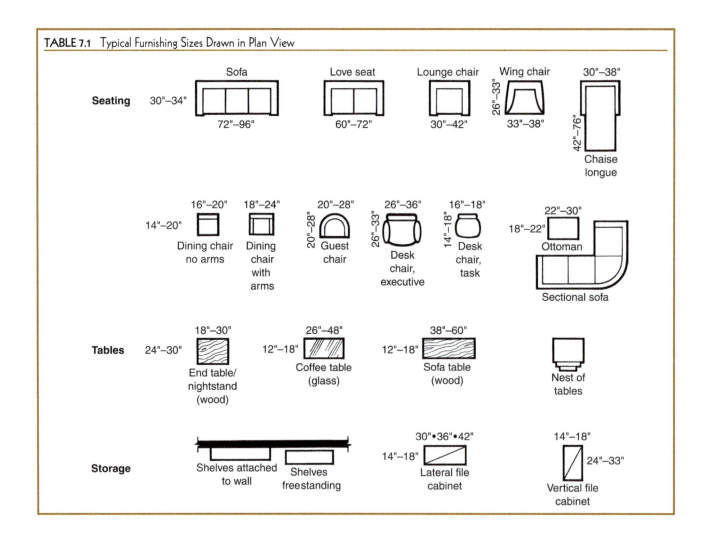

TABLE 7.1 Typical Furnishing Sizes Drawn in Plan View

TABLE 7.1 Typical Furnishing Sizes Drawn in Plan View (*continued*)

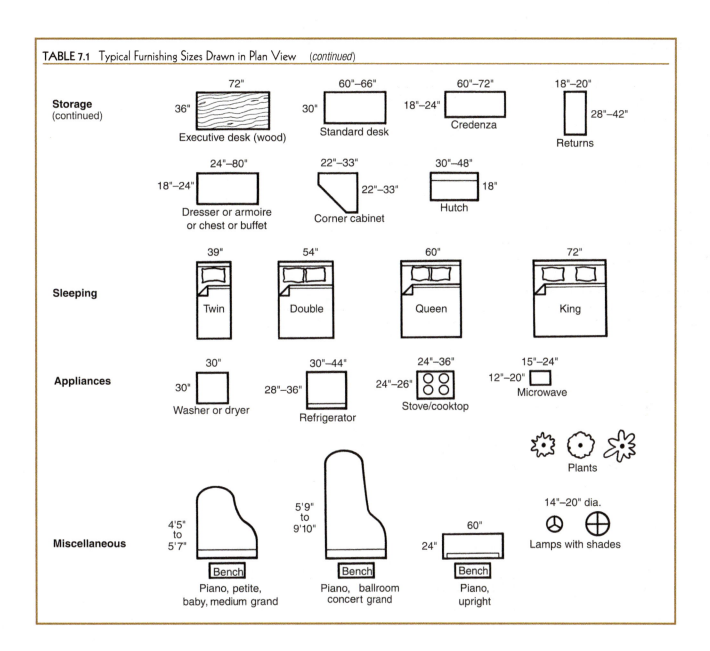

Storage
(continued)

Executive desk (wood) — 72" × 36"
Standard desk — 60"–66" × 30"
Credenza — 60"–72" × 18"–24"
Returns — 18"–20" × 28"–42"

Dresser or armoire or chest or buffet — 24"–80" × 18"–24"
Corner cabinet — 22"–33" × 22"–33"
Hutch — 30"–48" × 18"

Sleeping

Twin — 39"
Double — 54"
Queen — 60"
King — 72"

Appliances

Washer or dryer — 30" × 30"
Refrigerator — 30"–44" × 28"–36"
Stove/cooktop — 24"–36" × 24"–26"
Microwave — 15"–24" × 12"–20"

Plants

Miscellaneous

Piano, petite, baby, medium grand — 4'5" to 5'7" [Bench]
Piano, ballroom concert grand — 5'9" to 9'10" [Bench]
Piano, upright — 60" × 24" [Bench]
Lamps with shades — 14"–20" dia.

TABLE 7.2 Critical Heights and Depths

Heights		Depths (and Heights if Critical)	
Chair seat:	18"	Kitchen base cabinet/counter:	24"D × 36"H
End table:	Matches arm of sofa	Kitchen wall cabinet:	12"D × 24"–36"H
Sofa arm:	Varies with style	Space between counter and cabinet:	15"–18"
Desk:	29"–30"	Bathroom counter:	22"D × 28"–36"H
Keyboard:	26"–27" (Should be at user's elbow height when seated with arm bent)	Bookshelf:	8"–18"
Table:	29"–30"		

TABLE 7.3 Clearance Requirements

Traffic Paths	
Major commercial	60" or more
Major residential	48"–60"
Minor commercial	36"–60"
Minor residential	18"–48"
Physically challenged	32" minimum allowed, but only for a length of 24"
One-way passage	36" minimum
Two-way passage	60" minimum
Corner turn	42" minimum
Wheelchair turnaround	5'-0" diameter

Conversation Areas	
Foot room between sofa or chair and edge of coffee table top	12"–15"
Floor space in front of chair for feet and legs	1'-6" to 2'-6"
Chair or bench space in front of desk or piano	3'

Dining or Conferencing	
Space for occupied chair	1'-6" to 1'-10"
Space to get into chairs	1'-10" to 3'
Space for person to assist in seating	4'-6"
Traffic path around table and occupied chairs	1'-6" to 2'

Workspaces	
Space between desk and credenza	42" to 48"
Space in front of files	30" to 36"
Space for guest chairs in front of desk	42" to 48"

Sleeping Areas	
Space for making bed	1'-6" to 2'
Space between twin beds	1'-6" to 2'-4"
Space in front of chest of drawers	3'
Space in front of dresser	3' to 4'

Food Preparation	
Workspace in front of cabinets	3' to 6'
Counter space between equipment	3' to 5'
Ventilation for attachments in back of some appliances	3" to 5"

Bathing Areas	
Space between front of tub and opposite wall	2'-6" to 3'-6"
Space in front of toilet	18" to 24"
Space at sides of toilet	12" to 18"
Space between fronts of fixtures	2'-6" to 3'

SPACE PLANNING FOR SPECIFIC ACTIVITIES

There are essentially eight activity or functional areas required in interior settings. Table 7.4 illustrates their use in commercial and residential environments. Understanding the specific space requirements for each of these areas allows a designer to space plan an entire room.

Ideally, the designer works with the architect and builder to determine room sizes. Specific functions and space requirements are similar

TABLE 7.4 Specific Activity Areas in Commercial and Residential Design

Specific Activity	Commercial Use		Residential Use	
Conversation area	Hotel and health care lobby Waiting room	Breakroom Reception room	Living room Family room	Bedroom
Dining/conferencing/lecturing	Restaurant Hotel ballroom Corporate office	Presentation room Cafeteria Classroom	Dining room Breakfast room	
Video/television viewing and presentation	Hotel and health care lobby Executive or typical office Classroom Waiting room	Breakroom Hotel guest room Conference room Hospital room	Living room Family room	Bedroom Media room
Clerical, studying, and computing	All areas of contract design		Home office Library	Study Child's room
Sleeping	Hotel room Health care patient room	Executive suite	Bedroom	Guest room
Storage	All areas of contract design		All areas in a residence	
Food preparation	Restaurant Hotel	Hospital Cafeteria	Kitchen	
Bathroom	All areas of contract design		Bathroom	

for commercial and residential environments; however, commercial environments typically require wider traffic lanes. The following groupings should be considered when determining square footages. The information in the box on page 221, Figuring Square Footage, also may be helpful.

Conversation Area

In both residential and commercial environments, conversation groupings provide the critical backdrop for communication. Conversation groups should be designed out of the line of traffic and planned so that people can hear and be heard. There must be adequate space to access (or walk into) the grouping. The maximum conversation distance is 10'-0", whereas 6 to 8 feet is ideal. Figure 7.2 illustrates the six basic conversation groupings.

1. The *straight-line grouping*, although not conducive to intimate conversation, may work well for public places such as waiting rooms.
2. The *L-shape grouping* is good for conversation and lends itself to both large and small areas.
3. The *U-shape grouping* is comfortable and attractive but requires considerable space. Both the L- and U-shapes may be repeated several times in a large hotel, hospital, or office lobby.
4. The *box-shape grouping* is popular where space is ample. Allow space for a sufficient opening to present an inviting entry.
5. The *parallel grouping* emphasizes an existing focal point such as a fireplace or a special wall feature and provides a pleasant arrangement for conversation.

6. The *circular grouping* may encompass an entire room or an area of a large room. This arrangement can be inviting because it provides an enveloping seating element (as seen in Figure 7.1).

Once the furniture grouping is established, the designer can determine the size of the room (Figure 7.3). If other functions are required in the room, or if special architectural or artistic features are requested, these will be added to the square footage requirements.

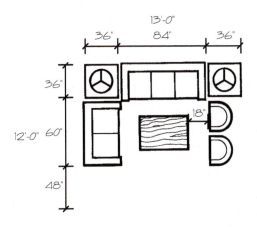

FIGURE 7.3 If a U-shape grouping to seat seven people is selected, the designer totals the perimeter dimensions to determine the size of the room. This space requires a minimum area of 12'-0" × 13'-0" or 156 ☐.

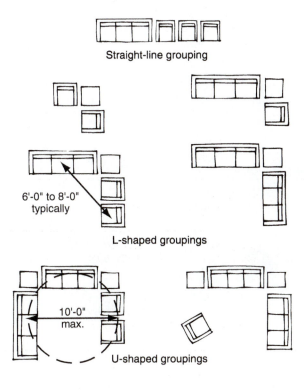

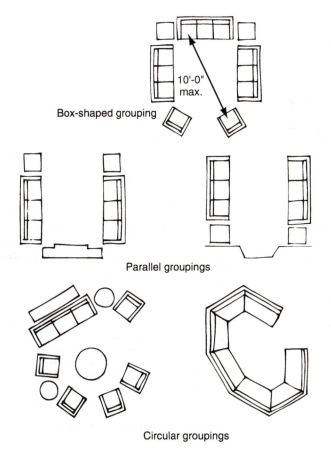

FIGURE 7.2 Six basic conversation groupings.

Dining/Conferencing/Lecturing

Designers must know how many individuals are to be accommodated in a dining, conference, or lecture area. An area planned for two to six guests is substantially different from an area planned for two to six couples; an area planned for 200 people requires an even greater sensitivity to the human scale. The goal is to plan a space that accommodates all the guests, but does not feel austere when used by a lesser number.

Conference and dining tables may be round, square, rectangular, oval, or boat-shape, and in very large conference rooms may form a U-shape. Many tables are custom designed to fit a client's needs (Figure 7.4).

Each occupant requires approximately 2'-0" to 2'-6" of space on the table in front of the chair as a work surface or for dinnerware. Approximately 3'-6" to 4'-0" is required between the table and the wall. Typical arrangements are shown in Figure 7.5.

The process to determine the size of a conference or dining room is the same as for the conversation area (Figure 7.6). When tables are grouped together, such as in a restaurant or cafeteria, a minimum of 44" is needed between them. Additional space is required for serving areas and storage, and in conference rooms and classrooms for presentation areas.

FIGURE 7.4 The custom square dining room table is designed to comfortably seat eight people. Notice that the arms of the chairs clear the bottom of the table.
(Designer: Linda Seeger Interior Design. © Pam Singleton / Image Photography, LLC)

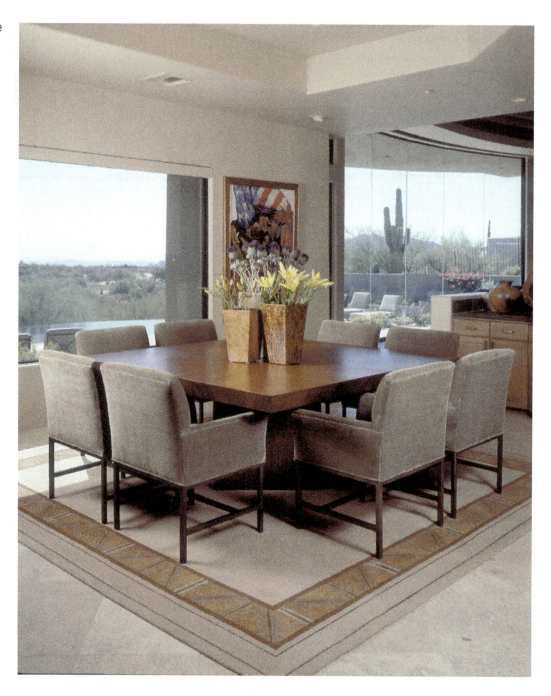

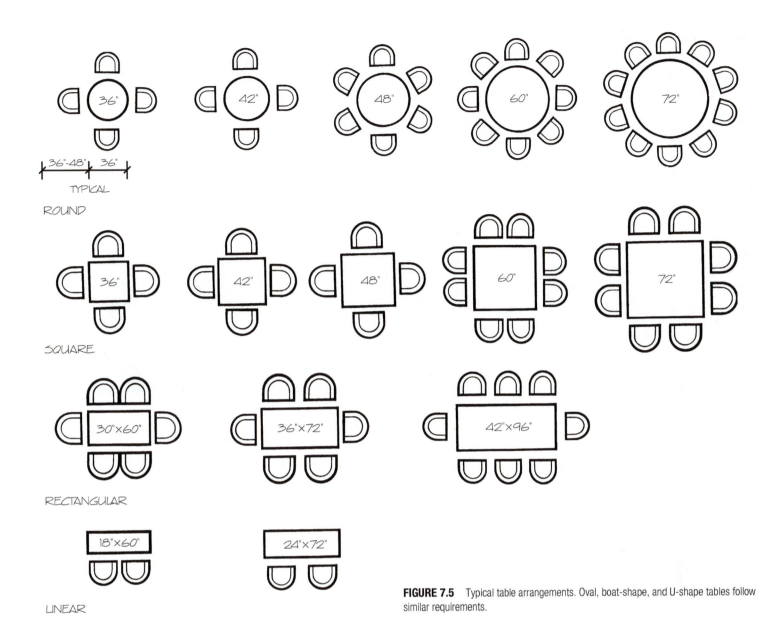

36"–48" 36"
TYPICAL

ROUND

SQUARE

RECTANGULAR

LINEAR

FIGURE 7.5 Typical table arrangements. Oval, boat-shape, and U-shape tables follow similar requirements.

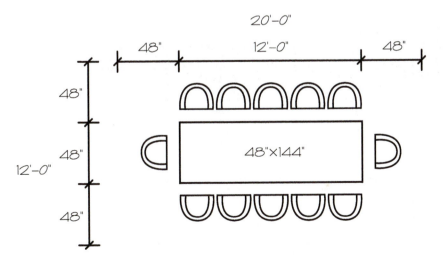

20'–0"

48" 12'–0" 48"

48"

48"

12'–0"

48"

48"x144"

FIGURE 7.6 If the room must seat twelve, the designer first establishes the minimum table size: 2'-0" to 2'-6" is allowed for each person (depending on the chair size desired), plus an additional 12" to 18" on each end. Then distance is added for chairs and traffic lanes. The smallest room possible would be 12'-0" × 20'-0" or 240☐.

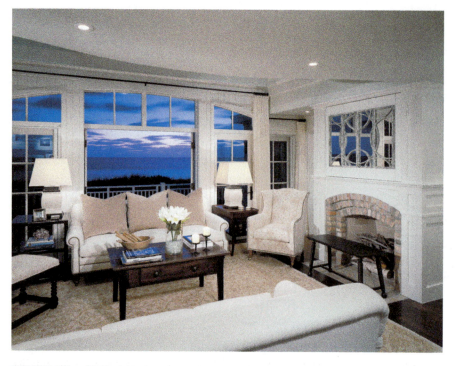

FIGURES 7.7 and 7.8 In this living area, the television is hidden behind a folding mirror placed over the mantel.

(Designer: Pineapple House Interior Design. Photograph by Scott Moore Photography)

Video/DVD/Television Viewing and Presentation

Multimedia viewing has become an important aspect of daily work and home environments. Multimedia centers are custom designed to accommodate stereo equipment, DVDs, computers, and televisions, including HDTV.

Depending on the size of the screen, televisions are best viewed from a distance of 6'-0" to 12'-0". The viewer should be able to look directly at the screen. Straight line, L-, and U-shape groupings allow for this arrangement. If a parallel grouping is selected and the media center is not the focal point, the media screen may have to be concealed (Figure 7.7 and Figure 7.8).

In offices, the electronic systems may also be concealed. Classrooms may require custom mounting systems or portable carts. When televisions are used in lobbies, breakrooms, or waiting rooms, the video/television areas should be separated from conversation areas.

In a conference room, a projection screen should be placed on the narrow wall of the room. A projector for slide viewing or satellite receiving may be concealed in the ceiling or located in another room providing rear screen projection capabilities. Chairs should be on casters to allow ease of movement during presentations.

Clerical, Studying, and Computing

All areas of commercial design, from health care to hospitality, require workspaces to complete daily tasks. The home office is also becoming a standard. According to the U.S. Census, published in 2003, more than 60 percent of American households have a computer; that number is expected to grow to approximately 80% by 2013. Using the Internet is becoming as commonplace as making a telephone call. Hotels are also

catering to these needs. Thus, both residential and commercial designers must have a working knowledge of office design.

The most efficient workspace is the combination of the desk, return, and credenza as shown in Figure 7.9. This allows a clear space on the desk for work. A monitor and keyboard can sit on the return or on the credenza. A printer can sit on or in the credenza. Some clients prefer a pullout keyboard tray in the credenza, or may not want the return. As laptops continue to enter the market, keyboard trays will become obsolete. In either case, the space requirements are the same. The office space may also need shelving, guest chairs, filing cabinets, storage space, or a conferencing area (Figure 7.10). The designer adds square footage as necessary to meet these needs.

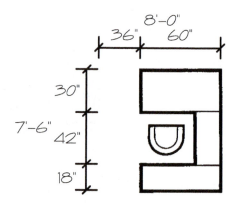

FIGURE 7.9 To figure the space required for a typical office arrangement, draw the furniture, allow for a traffic lane, and total the dimensions. The overall minimum space required is 8'-0" × 7'-6" or 60▢.

Sleeping

Whether designing a master bedroom suite or a hotel room, designers must be knowledgeable about the space requirements for sleeping areas. Remember that, although beds come in standard sizes, ample space must be allowed to move around the bed (Figure 7.11).

Allowances need to be made for storage and seating areas, and television viewing if requested by the client. In hospital design, space should also be allocated to accommodate medical equipment, patient personal care, visitors, and ample traffic areas for mobile equipment.

Storage

Dressers, armoires, chests, filing cabinets, and shelving units come in various sizes as noted in Table 7.1. In planning areas for these spaces, always allow ample room in front of the unit to open the drawers and doors. (A space 2'-6" wide is usually adequate.) Closets need to be at least 2'-1" deep to accommodate hangers.

Food Preparation

In residential design, food preparation areas encompass many subactivity zones relating to the refrigerator, sink, and stove or cooktop. Because most of the kitchen layout is based on built-in features, kitchen

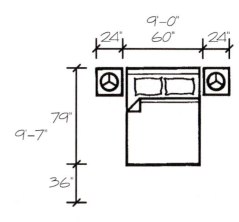

FIGURE 7.11 In this plan for a queen bed, the minimum space needed would be 9'-0" × 9'-7" or 86.22 ☐, or approximately 86 ☐.

design is discussed in Chapter 8. Commercial kitchen design is a specialty area of design and requires advanced study.

Bathrooms

Chapter 5 illustrated typical symbols for bathroom fixtures. Table 7.3 reviews minimum clearances and layouts. Appropriate bathroom layouts, like kitchen layouts, are based on built-in features and are discussed in Chapter 8.

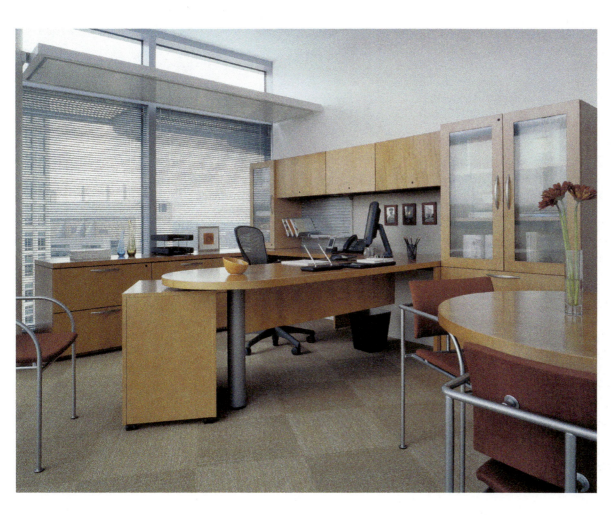

FIGURE 7.10 In this commercial office space, ample storage and work surfaces have been provided. Guest seating and a conference table have been added for small group meetings. The office furniture is from Kimball.
(Photo by Brian Gassel / tvsdesign)

■ SPACE PLANNING FOR SPECIFIC ROOMS

Once the spatial needs for each activity area have been determined, the designer places these areas into specific rooms. The furniture plan, as mentioned in Chapter 5, is used as the presentation tool, in conjunction with perspective drawings, to illustrate the proposed interior environment. Each room of a home or commercial space presents unique challenges. Because the activities in rooms vary greatly, each room is studied separately; however, throughout the home or office, a sense of harmony must prevail.

The next section illustrates several presentation floor plans and perspective studies of proposed interiors.

Reception, Lobby, Entry Hall, or Foyer

The design of the home or building should be reflected in the details and furnishings of the entry. In a reception area, the client will usually request workspace for a receptionist and a waiting area, which may need to accommodate only three or four guests. A waiting room for a doctor's office, however, may require seating for ten or more.

The receptionist may serve more than one function. He or she may operate the switchboard and serve as the office manager and secretary. In a doctor's office, the receptionist may double as a nurse or a business accounting employee. It is critical that accurate information be obtained before designing this important workspace. Many times a receptionist works behind a desk that has a *transaction top*. This allows the receptionist a sense of privacy, keeps the paperwork on the desk from looking cluttered to the waiting guests, and serves as a shelf where guests can rest items while speaking with the receptionist. The ledge is usually placed 12 inches above the desk, or at approximately 42 inches above the floor; however, a lowered area is also needed to be accessible to those in wheel chairs (Figure 7.12)

A guest who enters a reception area should immediately be able to make eye contact with the receptionist. The waiting area should adjoin or be part of the reception area, yet should be out of sight of the workings of the office. Figure 7.13 represents an acceptable reception area solution.

Lobby areas may serve many functions. For instance, a hotel lobby needs adequate room for seating, luggage, bellhops, a reception desk, a concierge, and a directory; the hotel lobby also requires a focal point for ambience, such as a fountain or sculpture. On the other hand, an office lobby may require only a conversation area. The intricacies of these layouts are beyond the scope of this book, but the basics of space needs remain the same.

In a residential setting the entry serves as a passageway, and like all good design, should not be cluttered. An *easy flow of traffic* is essential. Ample storage areas need to be designed to accommodate coats, shoes, packages, and so on. Furnishings that may be appropriate in an entry include a console or narrow table, a mirror, a coat rack, and accessories. Many clients require a bench or small chair for sitting while changing shoes.

Where the front door opens directly into the living room, a desirable plan is to create an unobstructed entrance to redirect traffic and

FIGURE 7.12 In this commercial office space, a lowered transaction top was cantilevered from the reception desk.
(Architect/Designer: HOK. Photograph by Gabriel Benzur)

provide some privacy. One successful way to set off an entrance is with a built-in or freestanding storage wall. If space is available, a deeper storage wall may provide closet space for outer garments on one side, and open shelves for books or display on all or part of the opposite side. The storage divider may be a decorative as well as a functional element (Figure 7.14).

Where space does not permit a heavy divider, a screen (either freestanding or attached) may serve as a partial divider. In a small room where any type of divider would cut needed space, the furniture may be arranged to redirect traffic by turning a sofa, desk, or chairs toward the room and at right angles to the door, leaving a passageway for traffic (Figure 7.15). Such devices provide limited privacy and create the feeling of an entranceway.

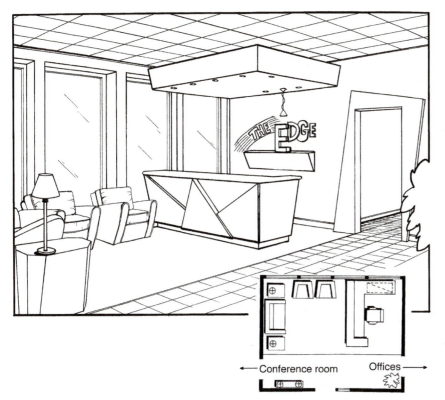

FIGURE 7.13 Programming needs: reception workspace for telephone, computer, keyboard, and printer; waiting room seating for four; access to conference room; privacy from offices.

This plan offers many advantages: guests are immediately greeted by the receptionist; the waiting area easily accommodates four guests; there is a telephone for guest use; the company's name and logo are displayed behind the desk, balanced on the opposite wall by a piece of art over the love seat; the custom receptionist's desk has an ample work surface and file storage; a tall plant, door and sidelight, console table, and mirror help to balance the window wall opposite.

The conversation area requires approximately 96 ☐; the work area, approximately 60 ☐. The total area for the room is approximately 240 ☐. A room that is approximately 16'-0" × 15'-0" satisfies the needs of this client. The hard-surface flooring area delineates the entry, provides durable flooring, and gives a pleasing proportion. The carpeted area is 10'-0" × 16'-0", meeting the approximate proportions for the golden rectangle.

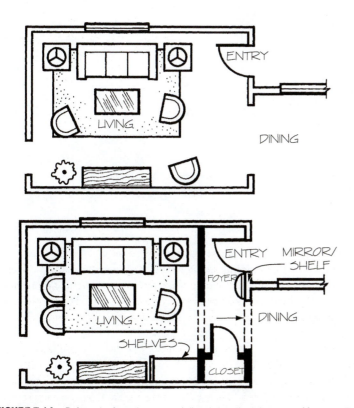

FIGURE 7.14 Before, the front door opened directly into the living room. After, a wall was added, giving a more private entry. A closet provides necessary storage. A mirror and shelf were added for convenience. The furniture was slightly rearranged to pull the conversation group together. The rug works better in this plan because the chair legs all sit on the rug.

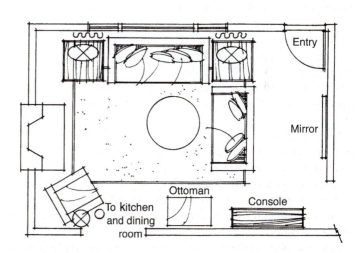

FIGURE 7.15 In this ranch-style home, the furniture was placed perpendicular to the front door, and a mirror and console were added to create the effect of a foyer.
(Designer: Stephens Designs, Kurt Stephens)

Living Room and Conversation Areas

Living rooms may encompass many of the basic activity areas; conversation areas and video and television viewing are the most common. Other functions may include, but are not limited to, reading, listening to music, writing, and possibly casual dining. The conversation area, however, is usually the most important group. It is designed to enhance or combine with the focal point of the room.

Conversation areas are valued in commercial interiors as well. These areas provide opportunities for employees to interact on levels that may not occur in private offices or in open office systems. A conversation area may be near a kitchen, pantry, television, cyber-café, or coffee bar to encourage collaboration. Conversation groupings are also used in waiting areas and prefunction areas (Figure 7.16) and can serve as an overflow area for gatherings (see Figure DS13.7). Furniture groupings in commercial settings have requirements and options similar to those of residential settings.

Once the number of people who will regularly use the room is determined, seating can be arranged or selected. *Built-in seating* is usually not as comfortable or flexible as movable sofas and chairs, which may be regrouped for more intimate occasions or opened out to invite more participants. Rigidly placed chairs can make the guests believe that moving them would be a major calamity, so the best choice is to provide comfortable living room chairs of various types and sizes for flexibility.

Positioning furniture away from the walls in a room is more conducive to intimate conversation than placing it directly against the walls.

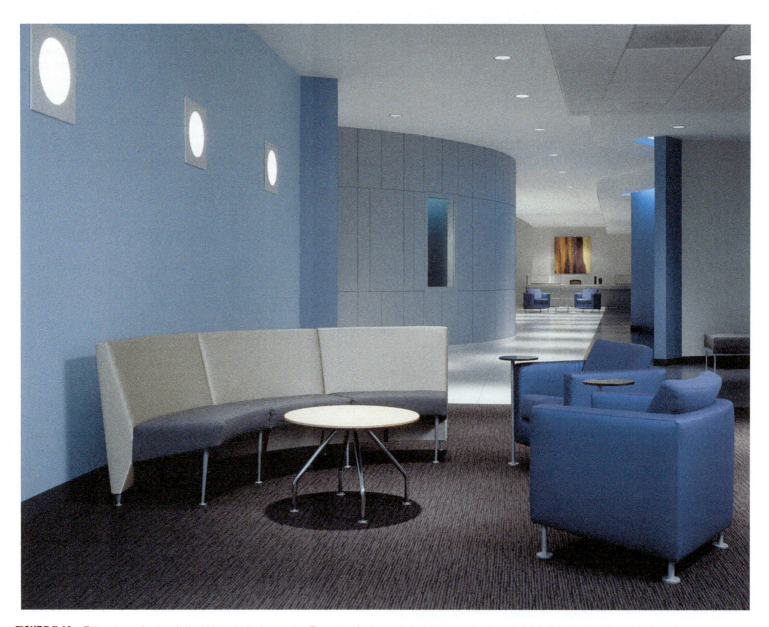

FIGURE 7.16 This conversation area is located in a technology center. The curved furniture relates to the curved walls and circular light fixtures. The seating is pulled away from the walls to allow for an appropriate communication distance. Arm tables, attached to the chairs, serve as laptop holders, writing surfaces, or beverage holders.
(Photo by Brian Gassel / tvsdesign)

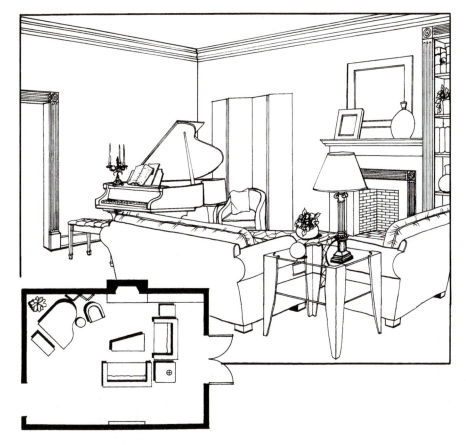

FIGURE 7.17 Programming needs: conversation seating for six; grand piano; fireplace. This plan has these advantages: the conversation grouping complements the focal point of the fireplace; the piano faces into the room, balances the doors on the opposite wall, and is away from the windows; ample tables are placed for beverages and lighting; a console table and large piece of artwork balance the fireplace; a plant softens the corner of the room and provides height on the far left wall; furniture floats in the room, rather than being aligned against the walls; furniture shapes and heights vary.

The conversation area requires approximately 160 ▱; the room is approximately 280 ▱. A room that is approximately 14'-0" × 20'-0" works well for this client's needs. This size also meets the proportions of the golden rectangle.

An angled or slightly curved sofa is more conducive to conversation than is a long, straight sofa. The curve in a sectional sofa is invariably occupied first, just as the corner table in a restaurant is the most popular.

Another solution to providing a flexible seating arrangement is *modular furniture*. Two or three separate pieces that fit together may be purchased at once; others can be added later (although fabric matching may present problems). Modular furniture can be arranged in a variety of ways depending on space and the number of pieces.

Soft, low-level lighting adds a feeling of intimacy to a conversation area; however, the area should not be in semidarkness. People need to see the features of those with whom they are talking. A low-hanging light can pull a grouping together and allow light for reading.

Finding the right wall space for a piano is often a challenge. Direct sunlight and changes in climate can have a damaging effect on a piano, limiting possible placement within the room. An upright piano can be placed against an inside wall. A grand piano may be more difficult to place in the average room because of its size. The curved side should be toward the listeners, not facing a wall or corner, so that when the lid is raised the sound will be projected toward the audience. In addition, the pianist and the listeners should be able to see one another, as shown in Figure 7.17. A bay window furnishes a beautiful setting for a grand piano if temperature and light conditions permit. In a large room a grand piano may be placed to serve as a room divider.

In the conversation area, most tables are placed where a functional need exists. Every seat in a room should have access to a side table. The scale, shape, and height of each table should align with the purpose and size of the chair or sofa it accompanies. A good height for a coffee table in front of a sofa is generally 16 inches. Tables placed next to sofa and chair arms should be the same height as the arm to help people avoid knocking items off the table. *Console tables* can be decorative as well as functional, and when combined with a mirror or picture are assets to almost any room. *Writing tables* may be placed flush or with their short end against the wall.

Large cases or wall pieces are usually located to lend a feeling of balance. If the area is small, careful planning is necessary to place the large piece where it will be most functional and will complement the wall space. A combination of furniture heights in a room provides interest and helps balance architectural features such as columns, windows, doors, and fireplaces.

Pairs can enhance a living room in many ways. Identical items can be a unifying factor; they give balance and pull together unrelated furniture. A pair of chairs can create a conversation grouping in a number of ways: placed side by side to balance a sofa on the opposite side (see Figure 7.18A and C), placed on either side of a fireplace, or angled about a table to give an intimate corner feeling (Figure 7.18B). Where space is adequate, a pair of love seats or sofas may be used in place of single chairs. A pair of tables may be placed in front of a sofa, creating a flexible substitute for a standard coffee table. Two similar chests placed on either side of a doorway or a fireplace enhance almost any room. Pairs of lamps, candelabras, or wall accessories can be pleasing. When carried to an extreme, however, the use of pairs can be monotonous.

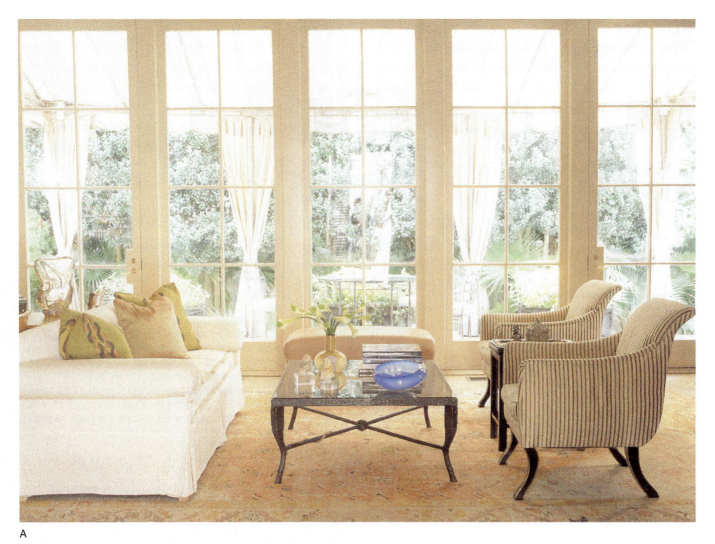

A

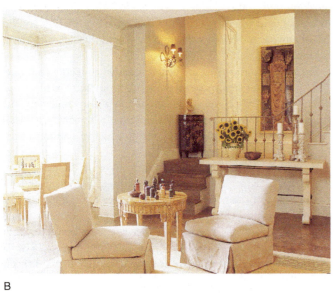

B

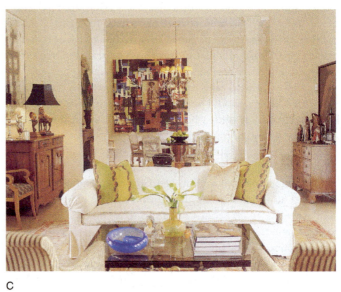

C

FIGURE 7.18 In this nineteenth-century New Orleans cottage, furniture has been placed away from the walls to allow for optimum conversation groupings.
(Designer: Chrestia & Staub, Inc. Photographs by Tria Giovan. Courtesy of Southern Accents)

Family Room

The family room is probably the most used room of the house. Here, family members congregate around an entertainment center, read, converse, play games, and often entertain. More than in any other area of the house, the arrangement of furniture is of utmost importance to accommodate easy adjustment for various activities. Use, convenience, and practicality are guiding principles in arranging furnishings, as shown in Figure 7.19.

- *Seating* for conversation incorporates solutions similar to those discussed for the living room. When television viewing is an important activity, plan seating for easy viewing. Include additional flexible seating for various activities where space permits.

- A number of *tables* can add to the occupants' comfort, including a large coffee table to accommodate beverages and food and side tables for lighting and other necessary items.

- Convenient and adequate *lighting* is essential in a family room and must be comfortable and flexible enough to accommodate all activities (see Chapter 6).

- An *audiovisual entertainment system* is an important part of the family room. Special planning is necessary to place a television set, movie screen, stereo, or complete entertainment center to take best advantage of the space.

- Family rooms may also serve as an area for quiet games. A *game table* can be incorporated into the space.

Family rooms are extremely difficult to design because of their multiple uses. Figure 7.20 illustrates an example of a well-designed family room.

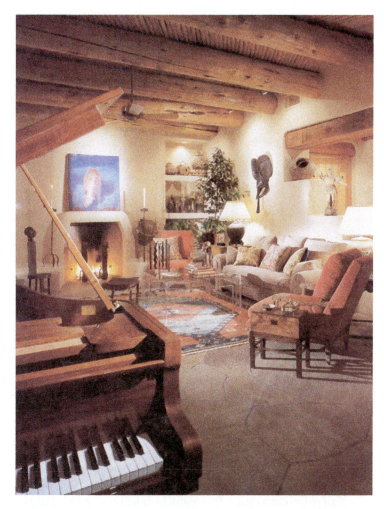

FIGURE 7.19 The warm reds and rich blues of the area rug are picked up in the painting over the fireplace, the chair upholstery, and the accent pillows. A clear Plexiglas table allows the rug to be seen from all angles. A fascinating mix of African tribal pieces and objects from the American Southwest testifies to the personal interests of the owners.
(© Copyright Mark Boisclair)

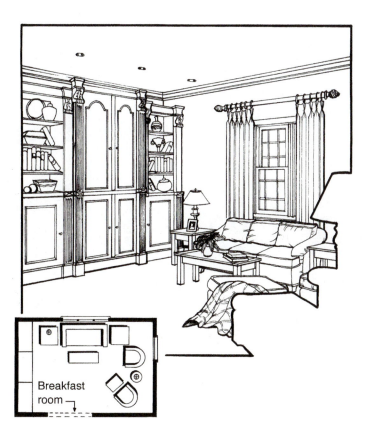

Breakfast room →

FIGURE 7.20 Programming needs: comfortable seating for four to view the television; game area for four; storage and shelving; entertainment area; comfortable reading chair. The advantages of this plan include the following: the adjoining breakfast room is used as the game area to conserve space in the family room; the television is opposite the windows to balance their height; the sofa placed beneath the window balances the archway leading into the breakfast room; there are four oversized seating areas for watching television; one of the seats is canted and has appropriate lighting to serve as a reading chair; extra-large pillows can serve as additional floor seating; shelving and cabinets flank the entertainment system for storage.

The conversation area requires approximately 100 ☐. The room has approximately 150 ☐. Therefore, a room that is approximately 10'-0" × 15'-0" is a good design solution, as long as the breakfast room doubles as the game area. The rectangular room also meets the dimensions required by the golden rectangle.

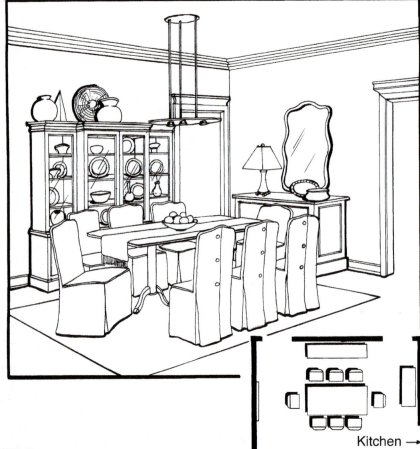

FIGURE 7.21 Programming needs: seating for four to eight; storage and display for china and linens; surface for serving. The advantages of this layout include the following: the buffet is located near the kitchen door; a china cabinet for storage also balances the large windows and adds height and interest to the room; a large painting balances the buffet; there is comfortable seating for eight.

The table area requires approximately 176 ☐. The area of the entire room is approximately 234 ☐. A room that measures 13'-0" × 18'-0" could accommodate this design solution.

Kitchen →

Dining and Conference Rooms

Except for the selection of the actual furniture pieces, the space requirements for dining and conference rooms are very similar. Dining chairs need to be relatively small in width in order to fit around a table. Conference room chairs may be larger, but a larger table also will be required. Conference chairs should be on casters for ease in mobility. A practical pedestal-base table gives maximum knee room, and round and oval tables make it easier to squeeze in an extra person.

A serving area is required in conference and dining rooms. A *buffet* may be placed against a wall to be used for food service or the display of a client's product. Storage pieces also may be needed. A high piece of furniture, such as a *breakfront* or *china cabinet*, can provide space for displays and adds dignity and vertical interest to the room. Corner cupboards are appropriate for storage and displaying items in a residence. Figure 7.21 indicates a design solution for a dining room.

Lighting is a key element in dining and conference rooms. Dimmed lights may be required for presentation purposes in the conference room, and are usually desirable for setting a mood in the dining room. Refer to Chapter 6 for further discussions on lighting options.

Video or web conferencing, slide viewing, and presentation display areas may be needed in conference rooms (Figure 7.22), which may then require blackout draperies or shades. (Window treatments will be discussed further in Chapter 13.) Some conference rooms may include a conversation area for informal discussions.

Dining and conference rooms may also require flexibility for entertaining small or large groups or for gatherings and parties. Tables that can be pulled together and secured allow for flexibility in seating (Figure 7.23A–D).

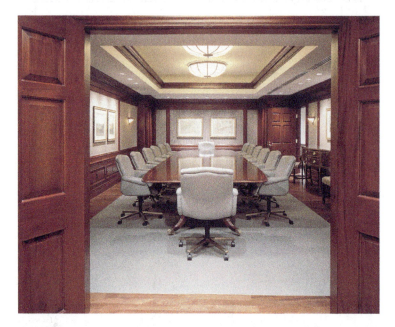

FIGURE 7.22 At Balis & Co., Inc., in Philadelphia, this traditional conference room seats eighteen. The audiovisual equipment is concealed. Lighting is flexible to allow for a variety of presentation needs, and the sideboard functions well for additional service needs.

(Designer: Daroff Design, Inc. Photograph by Elliott Kaufman)

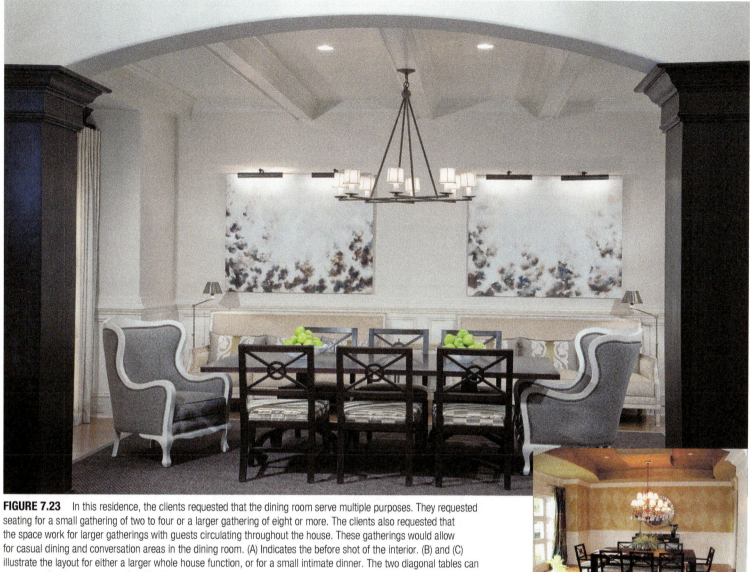

B

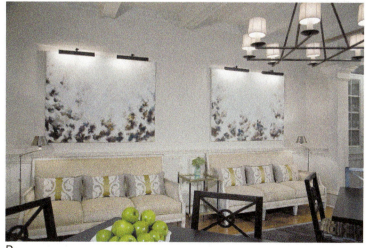

A

FIGURE 7.23 In this residence, the clients requested that the dining room serve multiple purposes. They requested seating for a small gathering of two to four or a larger gathering of eight or more. The clients also requested that the space work for larger gatherings with guests circulating throughout the house. These gatherings would allow for casual dining and conversation areas in the dining room. (A) Indicates the before shot of the interior. (B) and (C) illustrate the layout for either a larger whole house function, or for a small intimate dinner. The two diagonal tables can come together to create a comfortable dining setting for six to eight (D). Interior architectural changes to the ceiling plane, walls, and lighting as well as FF & E updates enhanced the renovation.

(Designer: Pineapple House Interior Design. Photograph by Scott Moore Photography)

C

D

Office

Home and commercial office spaces require much of the same equipment. Aside from the desk, credenza, and desk chair, there needs to be ample shelving and filing storage. Commercial spaces require guest seating, usually for two. The designer needs to know whether the client desires to sit across the desk from the guests or to have guests sit next to the desk. Executive offices may include a conferencing area or a conversation grouping (as seen in Figure IV.3). It is not uncommon in a commercial space for furniture to be placed against a glass window wall. Note that the person sitting at the desk should be able to easily see who is entering the office. It is disconcerting to be seated facing away from the door. Figure 7.24 presents a scheme for a commercial office.

When designing an office, it is best to place the computer at a 90-degree angle to the window to avoid glare. If the computer is placed against the window, the bright contrast between the sun and low-lit screen causes eye fatigue. When the screen faces the window, an immense amount of glare is created on the screen.

Also consider the placement of electrical and telephone outlets. Cords should not be strung across the room or hidden by the base molding. In a residence, a reading chair or two may be requested, as well as substantial shelving for the client's personal library. There should be a comfortable, ergonomically designed desk chair to fit the occupant. In a residence, the chair may be used by various family members and therefore should be easily adjusted. Open office arrangements may be grouped together to form a workstation for two or more people. In offices in which desks are shared, referred to as *hoteling*, an adjustable chair is also an important ergonomic consideration (Figure 7.25).

Some work environments require a different style of work surface, such as a drawing table or easel (Figure 7.26). Sometimes these are requested at standup heights to adjoin other work surfaces. In this case, a chair that can be raised to meet the height of the standup table should be added.

FIGURE 7.24 Programming needs: desk and credenza; two guest chairs; filing and shelf storage. This layout provides the following advantages: ample storage and shelving space; view of the door by employee; seating for two guests; ease in accessing file cabinets and shelving. These items, with the door, balance the long window wall. The computer can be placed on the credenza at a 90° angle to the windows. An accent furniture piece adds interest.

The work area requires 68 ▢. The entire room requires 120 ▢. A room that is approximately 10'-0" × 12'-0" will accommodate this typical office.

FIGURE 7.25 Substantial daylighting, generous countertop surfaces, and closed and open storage create a quality work environment in the open office system. Fabric-covered panels with sound-absorbing qualities and including tackable surfaces can be specified. Additional storage may consist of units suspended beneath the counters or mobile pedestals, as shown, which also serve as additional seating. The chair backs, seats, and arms are adjustable to accommodate a variety of users. *(Courtesy of Steelcase, Inc.)*

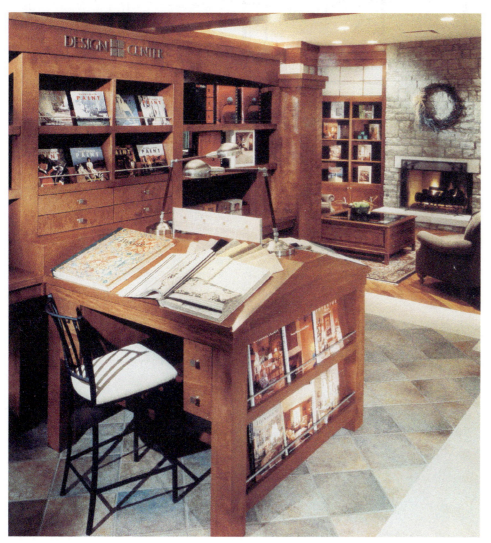

FIGURE 7.26 A standup-height, slanted table serves as the work surface in the design center of a carpet and wallcovering showroom. The custom table, reminiscent of the Arts and Crafts era, includes task lighting and a lightweight side chair. *(Architect: White Associates. Designer: Chute Gerdeman. Photograph by Michael Houghton Studio. Courtesy of Stanley Steemer International)*

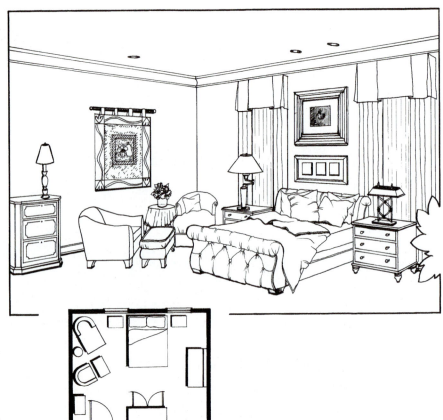

FIGURE 7.27 Programming needs: queen-sized bed; triple dresser; seating area for two; television in armoire (viewed from bed). Advantages of this layout include the following: clothing storage near the closets and bath; the tall armoire, door, and cased opening into the closet and bath balance the bed and window wall; the triple dresser with mirror provides storage and balances the seating group on the opposite wall; ample walking space for making the bed and accessing drawers and storage units; lighting at the sitting area and on both sides of the bed.

The sleeping area requires approximately 86 ☐; the sitting area, 60 ☐. The room requires 204 ☐. A space approximately 12'-0" × 17'-0" would accommodate this master bedroom suite. This is close to the ideal size of the golden rectangle.

To closet
and bath

FIGURE 7.28 Located on St. John, Virgin Islands, Caneel Bay Hotel boasts simple, elegant, and sophisticated rooms in the tropical style.
(Designer: Vision Design Dallas. Photograph by Mike Wilson)

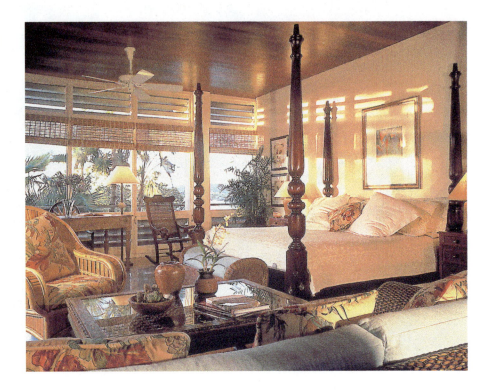

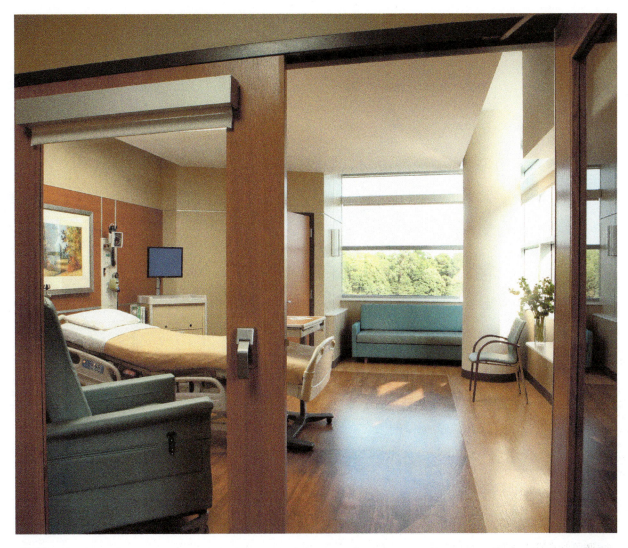

FIGURE 7.29 This medical surgical room provides ample space for the medical staff to perform necessary procedures, but also allows space for family members to stay with the patient. Patients can easily note nurses' and aides' names; views to the outside enhance the interior space and healing process. *(Chris Little Photography)*

Bedroom

Whether in a home, hospital, or hotel, bedrooms are a place of retreat. Because of its size, the bed usually becomes the focal point of the room. Traffic lanes are established around the bed, with careful attention to nighttime walking. Built-in units or nightstands placed beside the bed are essential to accommodate necessary items. Like tables next to sofa arms, nightstands should be the same height as the top of the mattress.

In residential settings, chests, dressers, storage chests, or other case pieces are essential for storage. Built-in, under-the-bed drawers can convert unused space into storage. A cedar chest can serve as storage and also works well as a bench for sitting. It is practical to have at least one chair or seat in the room. A master bedroom may incorporate an intimate seating group for two, or possibly a *chaise longue* (an elongated chair that supports the feet and legs). Some clients may also request a place for writing area or small table dining area (see Figure 8.11). If a television is requested, the designer must know whether it is to be viewed from the bed, seating area, or both. Figure 7.27 shows an acceptable layout for a small master bedroom suite.

Children's and teenagers' bedrooms require special attention. Work areas, play areas, and toy storage areas need to be accommodated. The bedroom furniture should also grow with the child. Hotel rooms require minimal storage facilities, but do require a writing surface and seating area (Figure 7.28). Careful consideration is given to the location of the television, so that it can be viewed from the seating area and the bed. There should also be ample room to place luggage.

Hospital rooms require an immense amount of attention to the location of medical equipment. Hospital rooms also require areas for family members and friends, out of the way of the medical staff. Information regarding the patient's status should be easily viewed, as should a television. All patient bathrooms are designed to be accessible. Views to the outside assist in the patient's recovery (Figure 7.29).

All bedrooms require a mirror. It can be freestanding, mounted on the wall, or attached to a piece of furniture or a closet door. Also, all bedrooms should have lighting conveniently located next to the bed.

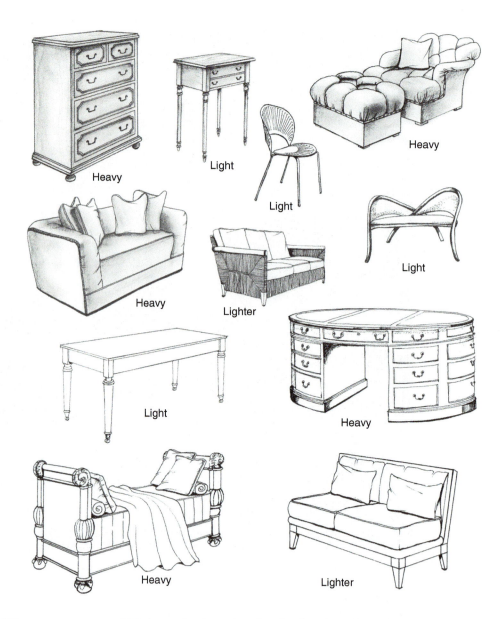

FIGURE 7.30 These line drawings indicate heavily and lightly scaled furniture. Lightly scaled furniture creates the feeling of a more spacious room.

■ MAKING THE MOST OF SPACE WITH FURNITURE

In many instances, designers are required to work with an existing space and do not have the option of increasing or decreasing the actual room size. Through the clever use of the principles and elements of design, however, a small room can be made to appear much larger than it is, or a large room smaller than it is. The designer should first examine the room carefully and define the traffic lanes, then apply space planning principles to expand or contract the apparent size of the room.

Lightly scaled furniture can be accommodated more readily in a small space than can heavily scaled pieces (Figure 7.30). Lightweight furniture is usually supported on legs rather than flush to the floor. It may have rounded corners and clear glass or plastic tops. Lightly scaled seating lacks arms and has backs and sides that are see-through or made of caning.

Upholstered pieces covered in a plain or small allover patterned fabric blended to the room's background provide visual space. Repeating the same fabric on other pieces helps unify furniture and has a space-making effect.

Upholstery that is neatly tailored and without skirts also gives an uncluttered look. Furniture aligned with walls leaves the center of the room free.

Floor-to-ceiling shelves and high, shallow storage units add visual height and, if terminated approximately one foot from the floor and two feet from the ceiling, allow the perimeter of the room to be seen, adding to the sense of space. Smaller storage units such as serving tables, consoles, buffets, and desks can be wall hung, eliminating the need for space-using legs (Figure 7.31).

It may be possible to add a projecting window or a skylight. Space could also be arranged so the eye can easily travel through a room to outside areas such as a garden, terrace, or view. Finally, rooms should be free of clutter, with an occasional empty corner.

The challenge of making a big room livable is not a common one, but it does occur. The most important consideration is *scale*. Massive furniture, overscaled patterns, and large pictures can be chosen; all furnishings, however, need not be big. After large pieces have defined the grouping of the room, lighter pieces can be used to complement the spaces.

FIGURE 7.32 In this expansive living area designed by Michael Kreiss, vibrant art accents the interior. Built-in furnishings as well as Egyptian chairs bring human scale to the grand room. Furnishings and fabrics from the Kreiss Collection add warmth and soften the powerful architectural edges.
(Designer: Michael Kreiss of Kreiss Design)

Too little furniture in a big room can result in a cold, uninviting interior. More important than quantity, however, is arrangement. The best technique is to plan separate areas of varying sizes. Utilize the architectural elements, such as flooring and ceiling changes, to create human-scaled spaces within the big area. Some may be small and intimate; others, more open (Figure 7.32). Occasional chairs may be moved from one group to another, forming a link between groupings.

FIGURE 7.31 A wall-hung shelf with rounded corners requires little space.

SUMMARY

When space planning furnishings for clients, successful designers remember the following key philosophies:

- Design to meet the function(s) of the space.
- Design for the client's needs and within the client's budget.
- Allow for ample traffic lanes and clearances.
- Follow the principles and elements of design as they relate to space and space planning.
- Scale the furniture to match the scale of the room or the desired feel of the room.

Whenever possible, design from the *inside out*. In new construction, work with the architect or builder to establish the appropriate room sizes and shapes before construction starts. In existing construction, move walls (where possible) to meet the needs for the function of the space, but be prepared to use space planning and design principles to make the most of an existing space. And above all, *space plan furniture in the third dimension*. Think in 3D.

Space Planning:
8 Rooms to Buildings

FIGURE 8.1 In this warm contemporary environment, the foyer sets the tone. The simple, elegant lines and refined finishes are restful.
(Designer: Gandy/Peace, Inc. Photograph by Chris A. Little. Courtesy of Southern Accents.)

In the previous chapter, furnishings were the smallest elements of the interior space planning puzzle that were grouped together to define activity areas. Activity areas were then grouped together based on the functional needs of specific rooms. This chapter explains how these rooms are grouped together into *interior zones* that are combined to form residences and commercial working environments.

When space planning rooms into buildings, a designer frequently works in collaboration with the architect on a design team to establish appropriate zoning and massing of spaces. An interior designer is not qualified to design the structural, electrical, or mechanical components of the building; however, the designer is positioned to strongly recommend changes to the structure, electrical, and mechanical components of the building if they are not in keeping with the client's best interest for the interior environment. Defining basic areas in residential and nonresidential projects is helpful to the designer during the space planning process. Zoning interior spaces for a project depends on their intended functions. (Note in this chapter that the term *interior zoning* is used as it relates to spatial assessment; this should not be confused with zoning established by building codes and regulations.) Broad categories of zoning include divisions between public and private places. For instance, in a restaurant, "back of house" refers to the kitchen and storage areas; the "front of house" is where the guests eat. In commercial office design, the public spaces include the reception, waiting area, and conference rooms. Executive offices, accounting areas, copy rooms, and the like are considered the private spaces. In residential design, a similar division exists in private and public zones.

FIGURE 8.2 The warm yellow hues in this foyer add casualness and give a fresh, informal look to a typical traditional setting. The dining room glimpsed here is shown in detail in Figure 12.3.
(Designer: Drysdale Design Associates. Photograph by Antoine Bootz. Courtesy of Southern Accents.)

FIGURE 8.3 In this formal traditional foyer, a limestone floor with oak inlays sets an elegant tone.
(Designer: Ewing-Noble Interiors. Photograph by Tria Giovan. Courtesy of Southern Accents.)

■ RESIDENTIAL ZONES

The zones in residential design combine related activities. Public or social zones include formal areas such as the entry, living room, and dining room. Informal public areas include the kitchen, breakfast room, and family or recreation room. Private zones include bedrooms, dressing areas, bathrooms, studies, and laundry rooms. Offices may be considered part of the public zone if open to visitors; otherwise, they are part of the private zone. Zones should be viewed as a whole and should have compatible spatial organization. Analyzing and designing for individual differences, lifestyles, and activities that take place within the spaces contributes to the smooth functioning of the residence.

Public Zones

The public zone is where people meet for various activities. In years past, many of these areas, such as kitchens, may have been "off limits" to guests. However, kitchens and recreation rooms are now common gathering places.

The Entry

The entry is usually placed to allow for access into the formal and informal areas of a residence. The entry may be open to the formal social zones, but it is best when it provides a visual block to informal rooms. Entries may include a large closet for occupants' and guests' coats, a mirror, and seat. A bathroom or powder room should be near (see Figures 8.1–8.4).

Living room The transition from the entry to the living room is important. The entrance area should flow easily into the living room with a smooth transition of design elements.

The formal living room works well when placed away from major traffic lanes. It may be planned for privacy as well as various functions such as conversation, listening to music, reading, relaxing, and other activities (Figure 8.4).

A fireplace in the living room is often a natural focal point. It can be emphasized through such elements as texture, color, lighting, and the arrangement of other furnishings.

If the living room lives up to its name, it will provide for all household members and guests as well. The space may be relatively large or a cloistered parlor area, depending on requirements, preferences, and budget restrictions. In many homes, the formal living room or dining room may be converted into a library, study, or music room. The room then functions as a quiet sanctuary where owners can relax.

A

B

FIGURE 8.4 (A) This space shows a successful transition from the foyer to the dining area and the conversation area. (B) Emphasis is on the conversation grouping; the fireplace serves as a backdrop. A soaring ceiling, warm lighting, and plants add to the comfortable yet sophisticated character of the space.
(Interiors: Fine Decorators, Hallandale, FL/Ted Fine with Robert Perlberg. Photograph by Brantley, Ocean Ridge, FL. Courtesy of On Design.)

Dining room An inviting formal dining area requires privacy from informal areas. It should be close to the food preparation area but shut off from the clutter of the kitchen. As seen in the previous chapter, dining areas should be flexible to accommodate large or small gatherings (as seen in Figure 7.23A–D). When space does not permit the separation of space, designers may create dividers to provide for privacy (see Figure 11.34). If the dining room is an alcove or part of a living room, any number of treatments can set it apart. Walls may be papered or painted a different but coordinated color. Freestanding screens, a plant grouping, or an area rug can help define the space. Keeping the dining room in the same basic theme and mood as the living room makes a pleasing transition (as seen in Figure 8.4A).

Kitchen In many residences, the kitchen has become the hub of the home—an area where food preparation, serving, eating, and other socializing takes place. The kitchen needs to be adjacent to the formal dining room, but also screened from its view. The kitchen also should be adjacent to the breakfast room, family room, and pantry. Additionally, the kitchen should be near the garage or the door where groceries are brought into the home; however, it is very important that the kitchen not be part of a major traffic lane. The location of the kitchen is obviously central to the residence.

The layout of the kitchen should be based on household needs, the physical limitations of the client, and the number of cooks working at the same time. The basic kitchen shapes are U-shape, L-shape, island, parallel, and one-wall, as illustrated in Figure 8.5.

The kitchen is generally planned around three work centers, which may also include subcenters.

■ The *refrigerator/storage area* is generally the first area used as items are removed for preparation. An 18"-wide counter adjacent to the handle side of the refrigerator is needed for holding items.

■ The *sink area* (preparation and cleanup) is truly multipurpose and therefore is usually positioned between the other two centers. The sink center may include a dishwasher, a garbage disposal or trash bin, cabinet space, and a minimum of 18" of counter space on both sides of the sink. Lighting is particularly important over this area.

■ The *cooking area* (stovetop or range, oven, convection oven, and/or microwave) receives particularly heavy use just before a meal. In a kitchen designed for two cooks, the microwave or oven may be separated from the stovetop. Eighteen to 24" of space should be included on either side of the cooktop. Ventilation should be provided for the range and oven. When the oven door is open, it should never obstruct a main walkway.

Subactivity zones include the *mixing area* (which is often located between the refrigerator and sink and includes an uninterrupted counter space of 36") and a *serving center* (usually located near the eating space out of the general work triangle). The serving center is particularly convenient when it is near the dishwasher and away from the cooking

U-SHAPE KITCHEN
U-shape kitchens are generally considered the most comfortable and efficient. Work centers are out of the way of traffic and more conveniently located. Accommodate one person best.

L-SHAPE KITCHEN
L-shape kitchens are a little more efficient than the parallel since traffic lanes do not intrude into the space. Work centers are conveniently located. Can accommodate two people.

ISLAND KITCHEN
The island kitchen has similar qualities as the U-shape, but with the unwelcome addition of possible traffic through the space. Can accommodate two people.

FIGURE 8.5 Basic kitchen arrangements.

PARALLEL KITCHEN
Parallel kitchens provide undesirable traffic, especially when doors are located at each end. Work centers are more convenient than one-wall kitchens. Best with one person.

ONE-WALL KITCHEN
One-wall kitchens economically use one plumbing wall, can be concealed with folding doors, and do not take up much space. They are usually most suitable for apartments and small living spaces. They have very little counter space, and the workspace pattern is long. Best with one person.

area because the table is frequently set while the final cooking is completed. Cabinets and counter space of at least 24 inches are important features.

Efficient and adequate cabinet storage is necessary for a successful kitchen plan (Figure 8.6). There must be storage for food (dry food, perishables, staples, and canned food), tableware (flatware, dishes, tablecloths, napkins, etc.), cleaning supplies (floor cleaners, soaps, paper products, towels, etc.), and cooking utensils. Portable appliances such as blenders, food processors, mixers, juicers, coffee grinders, and other task-related appliances may be placed in lower cabinets, hung from upper cabinets, or concealed in appliance garages. Portable appliances should have a convenient and concealed home and not be left to clutter countertops that are needed for food preparation.

More info online @
www.nkba.org National Kitchen & Bath Association site

Breakfast room Informal eating areas for quick snacks and everyday family meals are most conveniently located in or near the kitchen. The eating area close to the kitchen can vary depending on the space and shape allocated. Some kitchens may have the eating area in a bay window or alcove. Other kitchens have eating areas at a bar or counter, often with bar stools or attached seats (Figure 8.7).

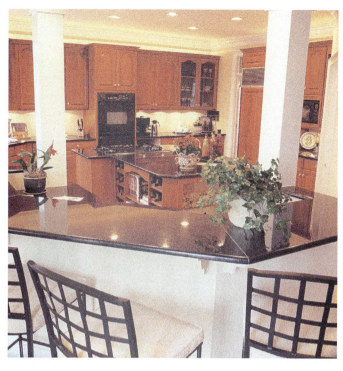

FIGURE 8.7 This transitionally styled kitchen includes a breakfast bar for quick meals and snacks. Particular attention was given to the clean lines and contemporary finishes. *(Designer: Burns Century Interiors. Photograph by Billy Howard. Courtesy of Brenau University.)*

FIGURE 8.6 This kitchen work zone is designed in a parallel arrangement. Ample storage has been provided in this relatively small space. *(Designer: Pittman & Associates. Photograph by Chris Little.)*

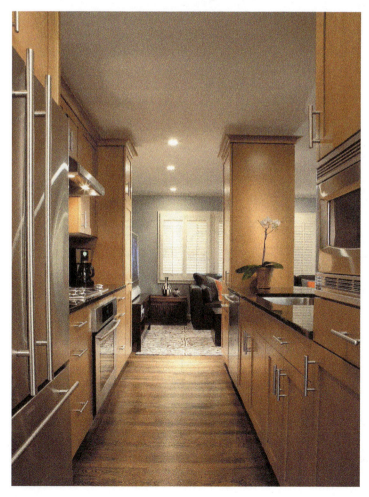

FIGURE 8.8 Audiovisual equipment is tastefully displayed in a custom cabinet. The television and fireplace function together in this angled arrangement.

(Interiors: Marc-Michaels Interior Design. Photograph ©Kim Sargent Architectural Photography. Residence: Private home, Phipps Estates, Palm Beach. Developer: Addison Development.)

Family or recreation room Family rooms should be located near the kitchen and away from quiet areas of the home, such as bedrooms, living rooms, and studies. Family rooms also should have immediate access to the outside. Of all the rooms in a house, the family room probably needs the most well-planned storage to take care of such items as a card table, folding chairs, games, CDs, books, or even a screen and projector. Freestanding walls, built-ins, or wall systems may be set up to provide floor-to-ceiling banks of drawers, cabinets, and shelves.

The television and DVD are generally standard equipment in a family room. Locating the television in a central section of a wall of built-ins is an excellent way to incorporate this piece with other furnishings (Figure 8.8). Another good solution is to place the fireplace and television in an L-shape (Figure 8.9). With this arrangement, the television and fireplace are not in competition as the focal point. The television should always be placed so that several people can view it comfortably.

As discussed in Chapter 7, family rooms may have different activity areas for dining and game playing, television viewing, and conversation. The designer's goal is to allow for ample free-flowing and flexible space that can accommodate a variety of activities.

Bathroom

A half-bath or powder room (one that includes a toilet and sink) should be located in the public zone, so guests do not have to enter the private zone to use the restroom. Typical bathroom layouts are discussed later in this chapter.

Laundry rooms and utility rooms Function and convenience are major considerations when locating laundry and utility areas. Laundry rooms are best placed near the dressing and bathing area. Unfortunately, laundry rooms are frequently relegated to a space close to the kitchen or garage, requiring occupants to haul clothes up and down stairs or across the social areas of the home. Some clients prefer to have the laundry area near the kitchen to facilitate daily activities. Designers should check with clients to determine their preference. Placing the washer with easy access to water lines is also important. A laundry tub or sink, adequate counter surfaces, space for the dryer and ironing board, sufficient storage, hanging space, and good lighting are also desirable.

Sewing, workshop, office, garden, and other work areas should be conveniently located with well-arranged space for required storage, furnishings, equipment, and lighting.

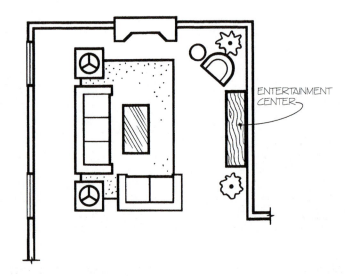

FIGURE 8.9 This floor plan illustrates a quality solution in a family room that has both a fireplace and a television.

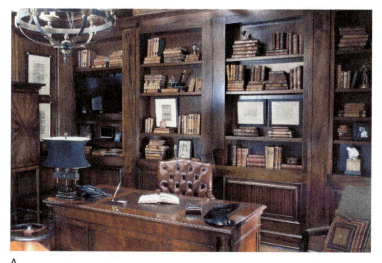

A

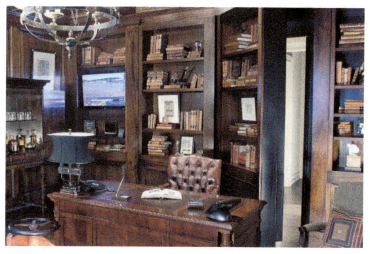

B

FIGURE 8.10 This in-home office provides a "secret" passage to the master bedroom suite. The custom bookcase cleverly conceals the passage, allowing the office to be near the private zone, but also usable by visiting clients.
(Designer: Pineapple House Interior Design. Photograph by Jennifer Lindell Photography.)

Libraries, studies, and offices These areas, when used by visitors, may be part of the public zone. As more people operate businesses from their homes, clients may be invited there. If this is the case, the office should be located near an entry that is easily accessible from the front of the house, away from noisy rooms, and screened from the formal social areas. If only the occupants use the office, library, or study, the room should be located in an area away from noisy areas such as family rooms, kitchens, and utility rooms (Figure 8.10A and B). Adequate storage is necessary for filing, books, and electronic equipment.

Most households have computers, which are becoming central to daily household operations. In many families, children have their own computers and study spaces. Furthermore, the laptop computer has allowed virtually any surface to become an office. Although the study may be located in the private zone, additional computer stations may be located near the kitchen or family room and also in children's rooms.

Private Zones

For maximum quiet and privacy, sleeping, dressing, and hygiene areas function best when located away from the social zone of the residence. Guests, except for those in the guestroom, rarely visit this zone of the home.

Master Bedroom

The master bedroom has become a refuge from the pressures and stress of everyday living—a place for relaxation and sleeping. Often the master bedroom is a luxurious part of the home. There may be space for a fireplace, a bar, a dining area, a television set, a study, a conversation arrangement, an office, and even a physical fitness area (Figure 8.11A and B). The master bedroom is best located at a distance from all other rooms. It does not have to be adjacent to any other room except the master bath and, if appropriate, a nursery.

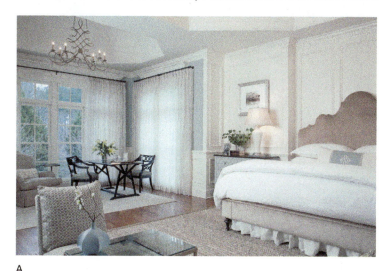

A

B

FIGURE 8.11 The clients for this residence requested a breakfast area in the bedroom. Note the attention to interior details in the ceiling and wall planes and how in conjunction with the area rugs, they serve to define the functional spaces of the room.
(Designer: Pineapple House Interior Design. Photograph by Scott Moore Photography.)

Bedrooms for Children and Young Adults

These rooms, like the master bedroom, should be located in quiet areas of the house. Children's rooms require ample storage, access to a bathroom, and perhaps a study or computer area. Designers should also be sensitive to the needs of children in blended families. When possible, the designer should talk directly with the children to determine their needs and desires in this specialty area of design.

Dressing and Clothes Storage

The dressing area may be in a separate space, in a closet, in the bedroom itself, or adjacent to or in the bathroom. Storage for clothing should be close to the dressing area and bathroom and planned for convenience. Closets should not protrude into the bedroom (Figure 8.12). A space for soiled clothing should be conveniently located. Storage for clothing, jewelry, and other dressing items is generally limited, so using space to an advantage is a challenge.

Guestrooms

Rooms set aside for guests are many times considered a luxury; however, where space permits, a warm and inviting guestroom is a welcome retreat for visitors. As in other bedrooms, traffic lanes should be allocated around the bed. A side chair for reading and a television are also appreciated. Minimal storage is needed for clothing and other personal items.

Guestrooms should be located away from noisy activity areas and private zones and need to have access to a bathroom. Guests may desire access to public areas, such as the kitchen or family room.

Bathrooms

Since the beginning of the twentieth century, the bathroom has undergone many changes. Originally, it was one shared room at the end of the hall; then it became a personal adjunct to the bedroom, and became smaller and more utilitarian. Today, utility and luxury are combined, and the bathroom—once hidden behind closed doors—is frequently exposed to sky, garden, terrace, and sometimes to other rooms of the house (Figure 8.13). What was once a small, sterile room with three basic plumbing fixtures (lavatory or sink, toilet, and tub or shower) has become a powder room, dressing room, and even sitting room, often with additional luxury features such as a whirlpool, sauna, spa, hot tub, television, or fireplace (Figure 8.14).

Most homes have more than one bathroom. Some may have half- or three-quarter baths (with a sink, toilet, and shower stall) as well. The designer must determine the space available, the needs of the users, and the most efficient arrangement of plumbing fixtures and supportive furnishings, storage, and lighting for each hygiene area in the residence.

Bathroom design is still centered on the three basic fixtures—the tub, toilet, and sink. Ample storage for towels, medicines, and grooming and cleaning aids is essential. A place for soiled clothing is also desirable. Master bathrooms commonly contain two sinks, a separate area for the toilet, and a shower stall in addition to the tub. Tubs may be located almost anyplace, including the center of the room. They are available in all shapes, designs, colors, and sizes. Sometimes tubs are placed beside large windows to take advantage of a view. It is safest for the user if the tub is sunken because steps up to the tub can be treacherous when wet. Figure 8.15 illustrates some common bathroom layouts.

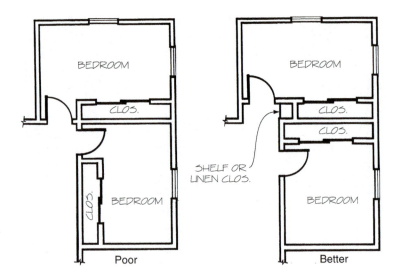

FIGURE 8.12 Poor and proper placement for closets.

More info online @ www.nkba.org National Kitchen & Bath Association site
www.abathroomguide.com General website with links on bathroom design

General Zoning Guidelines

Allowing enough space for each member of the household is an essential requirement in planning interiors. Space requirements vary for each individual, and in some cases may reflect clients' preferences rather than their needs. Generally, 1,000 square feet of space meets the needs of one person; and an additional 500 square feet per person provides sufficient space; however, this would be generous in a metropolitan area where real estate costs are high. Designers must be able to guide clients and meet their essential needs while staying within financial boundaries.

FIGURE 8.13 This master bedroom suite on a 70' yacht includes an adjacent master bath designed to complement the master bedroom. Note that radius edges, built-in cabinetry and attached furniture all necessary components of transportation design. *(© Radius Images / Alamy)*

FIGURE 8.14 Drama is created in this bathroom through rich materials, vivid lighting, and powerful art. The wallcovering adds a textural relief and sheen. The oval mirror, suspended from a narrow dropped soffit, is juxtaposed on the square wallcovering pattern. *(Architect/Designer: Jackie Naylor. Photograpy by Robert Thien.)*

FIGURE 8.15 Typical bathroom layouts. (A) and (B) are appropriate for half-bath layouts. (A) is extremely tight, but acceptable when a closet is converted to a bath; (B) is a better solution. (C) is the most compact three-fixture layout. (D) is a common inexpensive solution for a larger master bath. (E) illustrates one of an endless variety of solutions for an upgraded master bath.

◼ COMMERCIAL ZONES

Like residential zones, commercial zones also are divided into broad categories of private and public spaces. The myriad options for the specialty areas of design, such as hospitality, health care, and institutional design, require separate study beyond the scope of this text. It is, however, feasible to consider the space planning needs of a typical commercial office. As was discussed in Chapter 7, commercial buildings must also consider accessibility standards, from the entry to the snack bar at the rear of the office complex. Space planning can be greatly affected by these requirements. (Figures 8.18 through 8.22 on the following spread illustrate a successful corporate office design and are used throughout this section as examples.)

Public Zones

The public zone consists of the area where clients, or guests, arrive. Clients should feel welcome but should not be aware of activities in progress in the private spaces.

Reception Room

As illustrated in Chapter 7, the reception room includes two activity areas—the conversation/waiting area and the office workspace for the receptionist. The reception room needs to be adjacent to the front door and therefore also serves as the entry or foyer. The reception room should be near the public conference room and be easily accessible to other private office areas (see Figure 3.28 and Figure 8.18). The reception room needs access to a breakroom or coffee area so that guests may be served refreshments while waiting. A storage area for coats and umbrellas and a small room for private calls may be required.

Conference or Presentation Room

This room also should welcome clients. Access should be directly off the reception area (see Figure 8.20). In some conference rooms, an adjacent audiovisual area conceals equipment and doubles as a storage area for presentation materials.

Private Zones

In commercial spaces, private zones could more accurately be called semiprivate zones because clients and guests may frequent almost all areas of a commercial office.

Offices

Offices are grouped together based on the company's division of departments. In large commercial establishments, entire floors may be dedicated to a particular division. Offices may also require flexible spaces; for example, individuals may share an office space, and at other times work at home or on the road. Offices should be in quiet zones of a building away from breakrooms and near the support staff.

Executive offices may comprise a suite of rooms that includes a private administrative assistant's office, private conference room, office, bathroom, and storage closet. Executive suites are generally located in private areas of a building, frequently on the top floor (see Figure 8.21).

FIGURE 8.16 The purpose of this open office environment is flexibility. The design team's goal was to equip "teams and individuals with choices about how they prefer to work." The "workplace neighborhoods" can be reorganized for single groups or cross-disciplinary teams. Single users can adapt their spaces to fit their personal creative needs.
(© Michelle Litvin. Architect/Designer: Hellmuth, Obata & Kassabaum.)

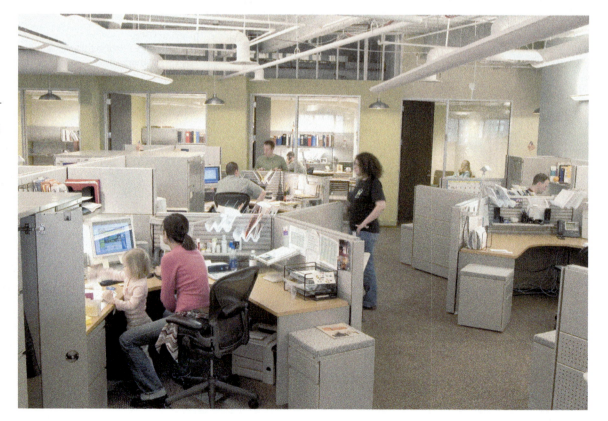

Open Offices

In many commercial establishments, employees work in open offices or systems furniture environments (see Chapter 11). Open office areas should be grouped by department away from noise and adjacent to support staff (Figures 8.16 and 8.19).

Support Staff

In many firms, the support staff, secretaries, or administrative assistants serve more than one individual. Locating support staff to meet the needs of those they serve can be difficult. Support staff also must be near copy, file, and storage areas. In very small firms, the receptionist may be the support staff for the entire firm. In larger corporations, support staff may be in an area of their own, sometimes referred to as a "secretarial bay."

Ancillary Areas

Ancillary areas include copy, mail, file, and other related rooms necessary for processing various tasks. These areas are generally used only by the employees, but need to be centrally located to expedite the flow of work. Noisy copiers and printers should not interfere with the need for a quiet office.

Breakrooms

Although the size of this room varies greatly depending on the client's needs, the space planning remains the same. Breakrooms are potentially noisy areas that need proper sound attenuation. They also should be separated from the public zone. Because most breakrooms require a sink, they must be located near plumbing lines (Figures 8.17 and 8.22).

Bathrooms

In commercial design, the location of the bathroom depends on the location of plumbing lines. In high-rise buildings, bathrooms are located in a central core that serves the entire floor. In smaller offices, the bathroom should be located between the public and private zones to accommodate both employees and guests. Commercial bathrooms must meet universal design requirements (see Chapter 2).

FIGURE 8.17 This breakroom, part of the same work environment as Figure 8.16, was designed to encourage collaboration and interaction among employees. Folding glass doors expand or close in the conference room as needed.

(Architect/Designer: Hellmuth, Obata & Kassabaum. Photograph by Michelle Litvin.)

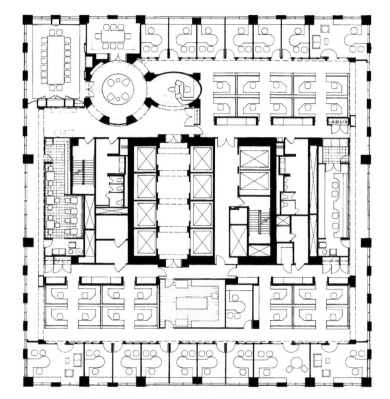

FIGURE 8.18 Figures 8.18–8.22 illustrate an excellent solution to a commercial office space. The radial lobby (see Figure 3.28) defines the interior and sets the tone for the entire office.
(Architect/Designer: VOA Associates, Inc.)

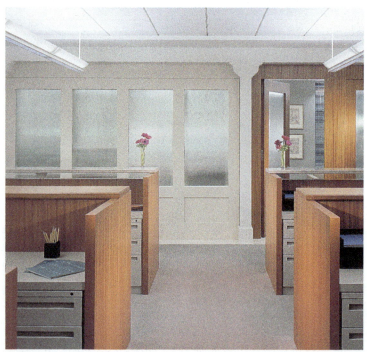

FIGURE 8.19 Open office spaces and support staff areas maintain the formal design characteristics. Employees are provided ample lighting.
(Architect/Designer: VOA Associates, Inc. Photograph by Steve Hall/Hedrich-Blessing.)

FIGURE 8.20 Two conference rooms are located directly off the reception area.
(Architect/Designer: VOA Associates, Inc. Photograph by Steve Hall/Hedrich-Blessing.)

FIGURE 8.21 Private offices are located out of sight from the main public areas.
(Architect/Designer: VOA Associates, Inc. Photograph by Steve Hall/Hedrich-Blessing.)

FIGURE 8.22 Ancillary areas are centrally located and out of public view, yet even the lunchroom maintains the character and classical design details found throughout the office.
(Architect/Designer: VOA Associates, Inc. Photograph by Steve Hall/Hedrich-Blessing.)

■ GENERAL ZONING REQUIREMENTS

Whether designing for a residential or commercial client, the designer should consider the principles of design, as well as various space and traffic flow guidelines.

The Principles of Design in Relation to Space

Space, like all the elements of design, affects the principles of design. When arranging furniture or space planning rooms, designers should consider the following points.

- The *proportions* of a room can be altered through appropriate space planning. For instance, long, tall pieces can divide a room into smaller areas. Dropped ceilings and area rugs can delineate an area needing a more intimate space (Figure 8.23). Furniture placed perpendicular to a wall can define a smaller area.

- The *scale* of a room is greatly affected by the room's furnishings. As discussed in Chapter 3, the scale of the furniture must be in line with the scale of the room. If the furniture is too large, the room will appear cramped; too small, and the room will appear stark and uninviting.

- Furnishings should be arranged to give the room a sense of *balance*. Large architectural features, such as picture windows and fireplaces, require heavier furniture opposite them. In rooms with slanted ceilings, heavier furniture should be placed against the taller wall.

- Balance also can be achieved through a mixture of high and low pieces of furniture and furnishings. Exclusive use of tall pieces makes a room appear heavy and overbearing, whereas a

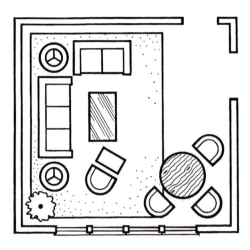

FIGURE 8.23 In this square room, a rectangular rug was added to define the seating area and to control the proportions of the room.

consistent use of low pieces makes a room look squatty, as if designed for children.

■ Achieving *rhythm* in an interior allows the eye to move easily about the room. The repetition of a side chair or end tables adds continuity. A person may be drawn from the living room to the dining room through a progression of steps. An architectural detail, combined with furniture and carpet placement, may form an axis drawing the person to an appointed location (Figure 8.24). In large office buildings, hotels, and airports, corridors should be placed in systematic locations to aid visitors' directional sense. In retail design, this repetition is intentionally altered to encourage shoppers to wander through the store.

■ All rooms or groups of rooms must have a *focal point*. The center of interest may be an information desk, painting, sculpture, coffee table, or panoramic view. In a group of rooms, the main conference room, reception area, living room, or great room may serve this purpose. Once the focal point of a room is decided, it should be supported by the arrangement of furnishings and corridors.

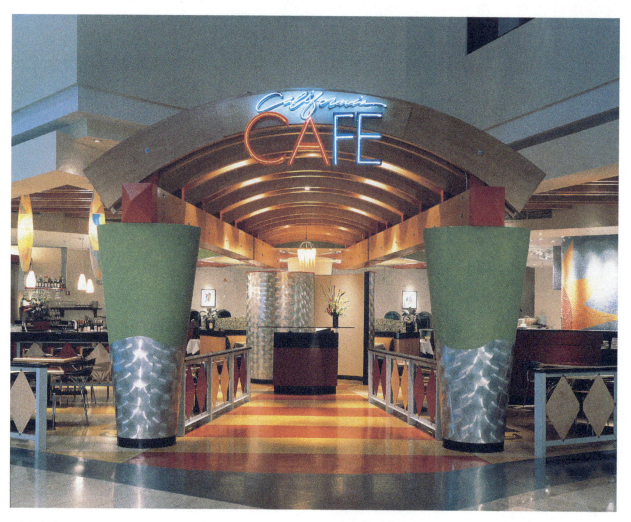

FIGURE 8.24 In this casual café in a shopping mall, patrons are led to the maître d' stand through the use of an architectural axis, accentuated ceiling, and lighting.
(Architect/Designer: Engstrom Design Group and To Design. Photograph © Greg Murphey.)

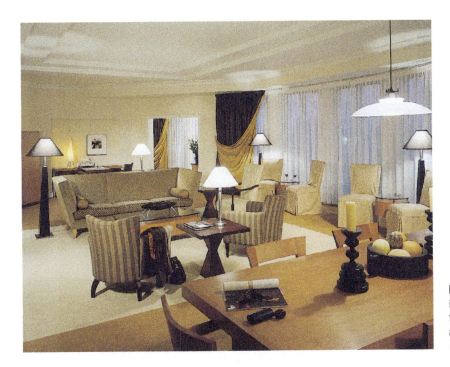

FIGURE 8.25 This presidential suite located in the Westin Grand Hotel illustrates harmonious use of the principles and elements of design. Warm tones, soft lighting, and contemporary furnishings provide unity. Black accents and a sweeping window treatment create drama and variety.
(Architect/Designer: NBBJ. Photograph by Assassi Productions.)

- *Harmony* can be achieved only when space planning utilizes unity and variety. Offices need desks and chairs; living rooms require sofas and end tables. Bathrooms should be located near bedrooms, and reception rooms near the front door. It is this typical placement of furnishings and rooms that allows the client to feel comfortable in a space; however, it is the unusual juxtaposition of a wall, chair, accessory, or architectural element that enhances a room and keeps the client's interest elevated (Figure 8.25).

Space and Traffic Flow Guidelines

Arranging space to meet clients' needs requires general guidelines that should be applied in all situations.

- The style of the home or office may guide the layout of the rooms. Some clients prefer a formal design balanced in all dimensions with distinctly defined interior zones. Other clients may prefer open planning and an informal approach to interior zoning.

- Floor and wall space must be adequate to support large pieces of furniture, shelving, files, and art. Doorways, although convenient, cannot encompass every wall.

- Traffic patterns should not cross conversation groupings, television viewing, workspaces, or the kitchen preparation area.

- A view to the outside should be accessible from every major room or workspace. Only storage rooms, closets, baths, file rooms, movie theaters, and similar spaces should be without natural daylight.

- Windows should be located to preserve the function of the wall space. Properly placed windows allow for ease in operation and for placement of window treatment; windows should provide balance in a room and not be placed in a corner (Figure 8.26).

- Doorways should not be located at the end of corridors. A corridor should end with a wall or other focal point.

- Bathrooms, bedrooms, kitchens, breakrooms, copy rooms, and offices, along with any other private or back of house function, should not be visible from an entry.

- Sufficient storage should be located throughout a house or office building.

- Rooms that require plumbing save costs when grouped near or on top of each other.

- Rooms should have the most pleasing proportions possible. Ancillary areas such as closets, stairwells, and bathrooms should not protrude into a room (as seen in Figure 8.12).

- Designers must adhere to federal, state, and local building codes (see Chapter 5). Understanding these codes before initial space planning may prevent having to make changes later in the design process.

- Designers should consider the need for future space. A good plan can effectively accommodate projected expansions.

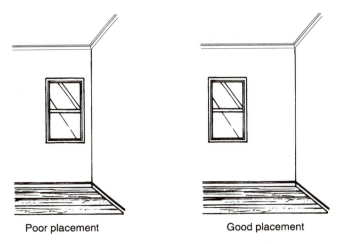

Poor placement Good placement

FIGURE 8.26 Window placement.

Site Orientation and Selection

The selection of the site must work in conjunction with the selection of a floor plan. Although the physical placement of a building is not the responsibility of the designer, on certain projects the designer may have input into selecting the site. Before making a selection, the architect and designer should have the general plan of the structure in mind. Not until the site has been analyzed should the plan be finalized. For example, when selecting a site for a residence, many factors should be considered including such criteria as location of schools, transportation, availability of police and fire protection, quality of the neighborhood, availability of utilities (water, sewer, power, garbage collection),

taxes, and building codes and restrictions. Depending on the building's intended function, criteria when selecting a site for a nonresidential structure might include public convenience, efficiency, accessibility, and aesthetic appeal.

A gently sloping lot that provides good natural drainage and allows sewer lines to be connected easily is desirable. A steep lot may cost less initially but may require expensive retaining walls and have other hidden costs; however, a view or a wooded site may be what the client wants. Effective positioning of the structure on the site and orienting it to take advantage of solar properties are also important. Sustainable Design: The Economy of Space Planning addresses additional space planning and site selection criteria.

SUSTAINABLEdesign

THE ECONOMY OF SPACE PLANNING

One of the most important aspects of a sustainable environment is the physical layout of the building. Several design criteria assist in the conservative use of materials and energy.

- Fireplaces can be planned to take advantage of a common chimney (Figure SD8.1).
- The more square the shape of the exterior walls, the less the cost per square foot. Cost does not increase in direct proportion to a structure's square footage—jogs and angles drive construction costs higher, as illustrated in Figure SD8.2. Two stories cost proportionally less than a low, rambling plan, because the roof and foundation can serve twice the space, and the second story provides extra insulation against summer heat and winter cold.
- Adequate insulation reduces heating costs, as do wood- or coal-burning stoves that meet strict EPA requirements.
- Locating the structure to take the best advantage of the climate saves on heating and air-conditioning bills. The winter sun should strike long walls and large windows, but in the summer, large areas of glass should be screened from the afternoon sun (Figure SD8.3). Positioning the house wisely also reduces the cost of connecting other utilities from the road to the house.
- Centralized plumbing saves energy. Bathrooms can be placed back to back (Figure SD8.4), or one above the other. Kitchen and utility room plumbing can be located to take advantage of the same major drains.
- Materials found on-site in the construction area, called **indigenous materials,** offer great savings. Flawed materials may cost less, and character can be gained by making a feature out of a fault.
- Consider the cost of upkeep of building materials over a long period of time. This is called life cycle costing. Some items that are more costly initially are the most economical in the long run. For example, brick may cost more than frame facades, but it never needs painting and the building's resale value is usually higher than for one made of wood. Hardwood balusters are more expensive than pine, but pine balusters are easily broken and replacement may soon add up to more than the cost of the hardwood.

FIGURE SD8.1 Two fireplaces can be combined to share the same chimney.

FIGURE SD8.2 Price and square footage. The three enclosures, each requiring the same number of linear feet of exterior wall, illustrate how the price per square foot increases as the space deviates from the square.

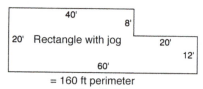

Rectangle 20'
60'
= 160 ft perimeter
= 1200 sq ft floor space

(A loss of 400 sq ft of floor space with the same wall perimeter)

Square 40'
40'
= 160 ft perimeter
= 1600 sq ft floor space

40'
8'
20' Rectangle with jog 20'
12'
60'
= 160 ft perimeter
= 1040 sq ft of floor space

(A loss of 160 sq ft of floor space plus the extra expense of the jog)

FIGURE SD8.3 A well-designed roof can permit the warm winter sun to flood the interior spaces in December and block out the hot summer sun in July.

Winter Summer

FIGURE SD8.4 Back-to-back plumbing.

SUSTAINABLEdesign

THE ECONOMY OF SPACE PLANNING—cont'd

More info online @ www.southface.org Southface Energy Institute

www.ases.org American Solar Energy Society

www.ises.org/ises.nsf Open International Solar Energy Society

www.seia.org Solar Energy Industries Association

A simple solution in sustainable design environments is to design spaces that meet the client's needs and are "not so big." The Not So Big residential concept has been popularized by architect Sarah Susanka. Many of the Not So Big design philosophies follow sustainable design principles as well. The overarching goal is to create interior spaces based on quality, not quantity (Figures SD8.5 and SD8.6). Other design principles include the following:

- Expression of the client's personality
- Attention to detail

- Combination of formal and informal living spaces
- All spaces used daily
- Custom tailoring
- Personal quiet spaces referred to as "Away Rooms"
- Diagonal views and axes to views
- Niches and window seats
- Access to daylight and exterior views
- Efficient use of space, similar to a sailboat or quality motor home
- Mail center near the main entry
- Welcoming family entry (not through the laundry room)

More info online @

http://notsobighouse.com Not So Big House website

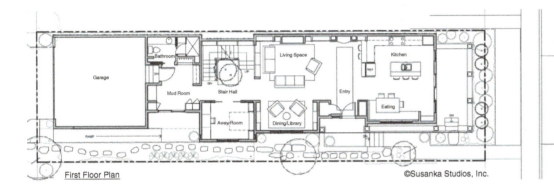

First Floor Plan

©Susanka Studios, Inc.

FIGURES SD8.5 AND SD8.6 In this residence, many of the Not So Big principles are evident. Note how a storage area in the mudroom creates a focal point from the main entry. The Away Room provides for a quiet area, whereas the informal and formal public spaces are joined. A large expanse of windows ties the exterior to the interior. Niches, window seats, and custom cabinetry are tailored to meet the family's needs and provide for efficient space utilization.

(Designed by Sarah Susanka, FAIA, architect and author of The Not So Big House *series. Photo by Barry Rustin.)*

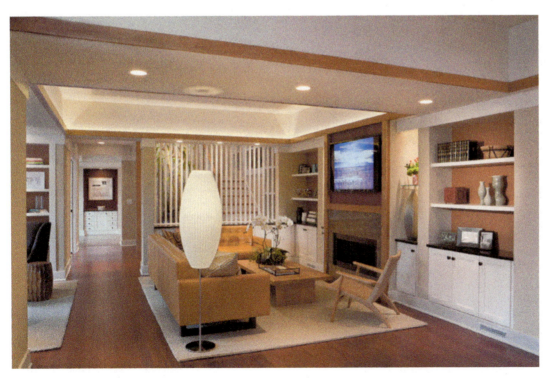

■ ORGANIZING SYSTEMS

Floor plans traditionally follow geometry lines based on 90° or 45° angles and simple compass curves. The construction industry evolved around these shapes, manufacturing products that meet common construction dimensions. Floor plans and the three-dimensional structures placed on top of these plans are organized based on a variety of organizing systems that guide the designer. Gestalt and perceptual theories, discussed in Part II, and the effects of negative/positive space relationships, discussed in Chapter 3, closely relate to these organizing systems.

Alignment

Alignment—gridded, linear, clustered, radial, and centralized—not only serves as a visual literacy tool (see page 89), but also functions in the spatial layout of residential and commercial planning. For instance, the floor plan seen in the RidgeWorth Investments project follows a strong linear and gridded organization (Figure 8.27A–E). The image in Figure 8.28 emphasizes a linear alignment.

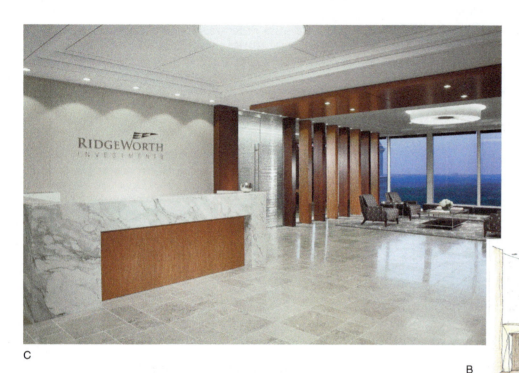

FIGURE 8.27 (A) indicates the design development furniture plan for this commercial office building based on a strong linear organizing system. Note that the linear features are carried through in the 3-dimensional development of the reception and waiting areas (B) and the final finished spaces (C) and (D). A strong axis is also present in the ceiling plane, guiding visitors to the main conference room (E). *(Architect/Designer: Hughes|Litton\Godwin. Photographs by Gabriel Benzur.)*

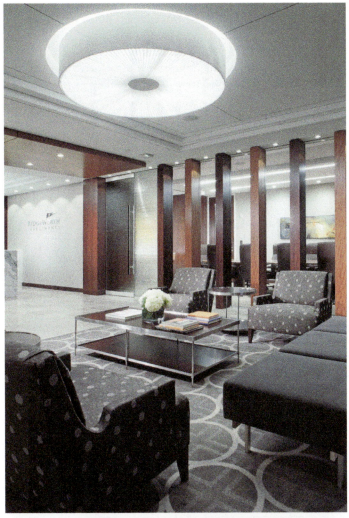

D

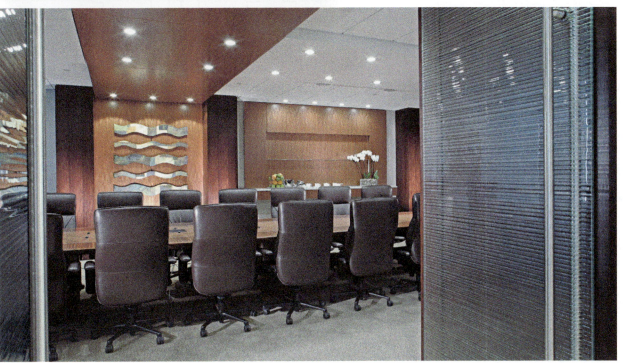

E

FIGURE 8.28 Strong linear arrangements are incorporated in the commercial office interior. A floor-to-ceiling glass wall allows light to flood into the interior spaces. Open office workstations covered in a wood veneer and a dropped ceiling soften the severe lines. *(Courtesy of Knoll, Inc.)*

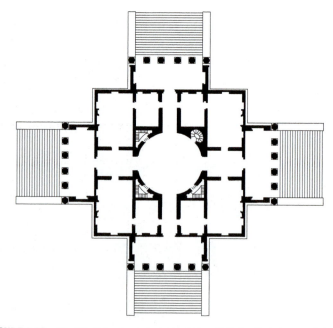

FIGURE 8.29 The Villa Rotunda, designed by Andrew Palladio, illustrates a radial design in its floor plan. The plan draws visitors to the central rotunda.

Clustered formations form groups of elements that are interconnected. The Design Scenario at the end of Part II (UPS Innoplex) was initially conceived based on clusters or, in the firm's words, "communities" (see pages 139–143). Radial groupings are common in airport terminals where baggage processing and internal workings are centrally located and the concourses form the spokes of the wheel radiating from this central area. Elementary schools may also find their space planning based on a radial organization. Common-use facilities such as the cafeteria, gymnasium, art, and/or music rooms may be located in a central pod with various age/grade levels radiating from this central hub. Centralized plans focus on one area. The Villa Rotunda, (Figure 8.29) and as seen on page 59, is a Renaissance example of a centralized plan.

Manipulation

The plan, however, is also affected by the clever manipulation of the basic shape to create variety and interest in the building and ultimately the floor plan. Forms of manipulation include addition or aggregation, subtraction or segmentation, and distortion, or a combination that may include multiplication, overlapping, and fragmentation or division (Figure 8.30).

Addition or aggregation is the expansion of the form beyond its original boundaries. Subtraction or segmentation is the removal of a portion of the original form (as seen in Figure 8.27A). Distortion is the intentional bending, angling, or misshaping of the original form (Figure 8.31A and B). These forms may also be overlapped, multiplied, or divided into other geometric shapes. More information on these terms can be found in Rob Krier's studies on form and urban environments, as well as Wucius Wong's studies on two-dimensional and three-dimensional design.

Organizational systems create strong axes that naturally lead the eye to an appointed location (as seen in Figure 8.27E). Designers develop their interiors to help lead an occupant through the space by carefully planning patterned organizations. Designers work with a variety of alternative schematic solutions, manipulating the spaces and elements to create the most effective solution, not necessarily the most predictable one. The following section reviews floor plans in residential and then commercial environments, including their three-dimensional, volumetric development.

Addition or Aggregation

Subtraction or Segmentation

Distortion

Multiplication and Overlapping

Fragmentation or Division

FIGURE 8.30 Examples of manipulation.

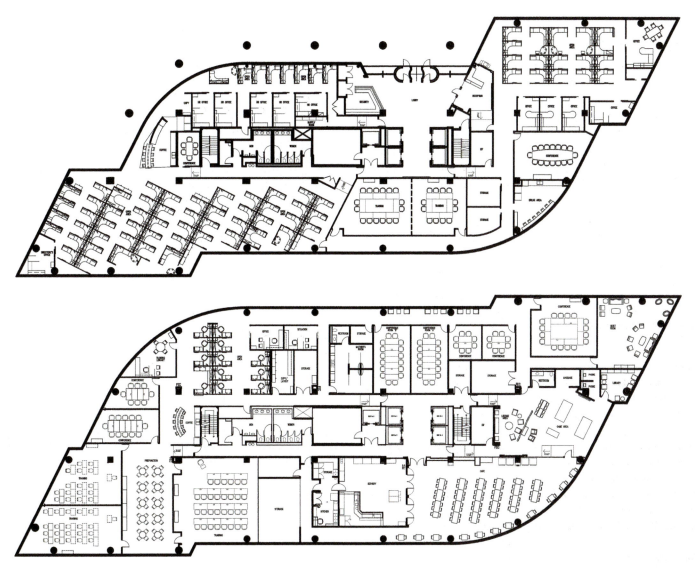

FIGURE 8.31 The floor plan of this multistory office building uses a combination of addition/aggregation and distortion. The two plans illustrate the variety of space planning layout using linear and gridded alignments.
(Architect/Designer: Hughes\Litton\Godwin)

■ ANALYZING RESIDENTIAL FLOOR PLANS

Floor plans for residential design come in a variety of shapes, such as square, rectangular, L-shape, or H-shape, each based on the organizing systems. Each shape has benefits and complications, which affects the function and aesthetics of the interior environment. To serve the client better, the designer should keep the following points in mind:

■ A residence should be positioned on the site to enhance the landscape. For example, square and rectangle shapes can be more difficult to position and landscape attractively than shapes with more interesting angles.

■ Each angle and jog of a floor plan shape adds to the expense of the structure.

■ The shape of the residence may affect the interior arrangement of activities. For example, it is more difficult to arrange various functions in a square plan because of the limitations to the exterior.

■ Traffic patterns are usually more efficient in shapes with more angles than a square or rectangle offers.

■ Heating and cooling costs are higher with added wings.

■ Shapes with more wings or extensions, segmentation, or aggregation allow additional light and ventilation in the residence.

■ Some shapes offer more interesting ways to arrange furnishings—the T, U, H, L, and atrium shapes, for example.

■ Private outdoor living space is possible with shapes like the T, U, H, L, and atrium, but very difficult with a square.

■ Aesthetically, garage doors should open from the side of the residence instead of the front; however, such an arrangement may require a larger lot and therefore is more expensive.

Square Plan

The square plan, similar to the rectangular plan, is a simple and inexpensive arrangement of space with distinct advantages and disadvantages. Most designers try to minimize or even change the boxy shape—both for interiors and exteriors—through creative manipulation of the elements of design (Figure 8.32). Some considerations when employing the square plan include the following:

- The square plan is one of the least expensive to build because corners are limited to four. It requires only a simple roof and foundation—generally the most costly elements in house construction.

- Rooms should be arranged so that traffic can flow freely. The placement of an entrance and hallways can be a challenge in the square plan.

- Good planning should provide adequate light and air circulation—often a problem with the square plan. The center may be poorly lit. A centrally located skylight is one method of eliminating this condition.

- The square plan generally does not provide interesting and inviting outdoor living spaces; however, through skillful landscaping this problem can be eliminated. Sometimes the square plan is turned on an angle to the lot, providing a diagonal or diamond shape.

- Good separation of interior living spaces, such as the sleeping and activity areas, is more difficult to arrange in the square plan.

FIGURE 8.32 This relatively small house plan, based on the square, efficiently utilizes less than 1,300 square feet. The soaring living room ceiling adds the feeling of a grander space. *(Designer: Wolff-Lyon Architects)*

Rectangular Plan

The simplest floor plan is the rectangle. The more the plan departs from this shape, the more complicated and costly it becomes. Each jog and additional roof angle mean added expense, and thus more dollars per square foot of floor space. The rectangular plan is readily adapted to both traditional and contemporary exteriors. The rectangular plan seen in Figure 8.33 incorporates many open planning concepts in its interior, including the following:

- An entrance hall routes traffic to all areas of the house.

- Basic private and social zones are well defined and conveniently located.

- The house was designed to fit its beachfront site. Upper-floor windows provide an ocean view.

- The garage is enclosed and attached.

- Public and social zones are well defined.

- Closets and storage areas are incorporated into the plan.

- First- and second-floor bathrooms are stacked.

- Rear steps provide a secondary entry/exit to the second and third floors.

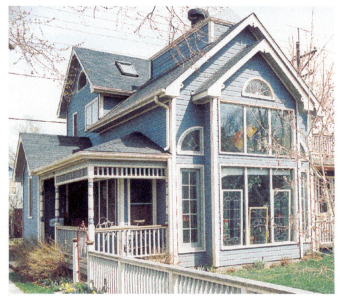

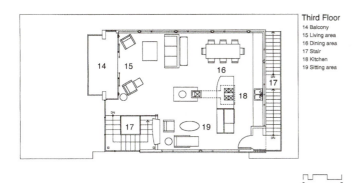

Third Floor

14 Balcony
15 Living area
16 Dining area
17 Stair
18 Kitchen
19 Sitting area

0 8

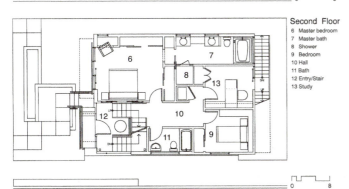

Second Floor

6 Master bedroom
7 Master bath
8 Shower
9 Bedroom
10 Hall
11 Bath
12 Entry/Stair
13 Study

0 8

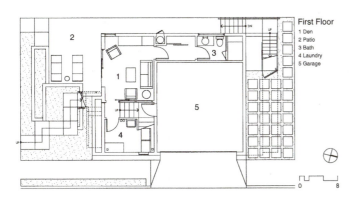

First Floor

1 Den
2 Patio
3 Bath
4 Laundry
5 Garage

0 8

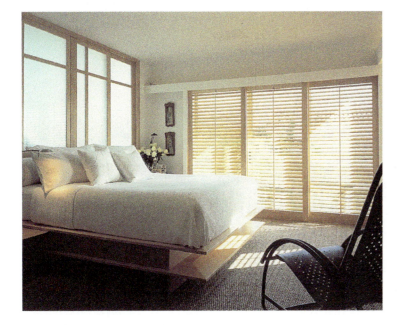

FIGURE 8.33 This unique plan was developed to fit the site. Public areas are on upper floors for the best view of the ocean. An open stairway unites the floors. Closets, storage areas, and bathrooms do not infringe upon the space. In the master bedroom, the custom bed sits in front of a set of shoji screened doors. The sliding doors can be opened to allow a full view into and through the stairwell.
(Architect/Designer: Rockefeller/Hricak Architects. Photograph by David Glomb.)

Multistoried Plan

A multistoried plan provides living space on two or more levels, which allows versatile living. Features of the plan in Figure 8.34 include the following:

- The basically rectangular plan and the addition over the garage eliminate most unnecessary jogs.
- All zones are well defined on two levels.
- An entry hall channels traffic through the house.
- Doors and windows are well placed.
- Traffic lanes permit easy access. The rear stairway is particularly important for a large family home.
- Closets and storage areas generally do not infringe on basic room shapes.

- The laundry room is well placed upstairs.
- As with the rectangular plan, the garage doors could be relocated to the side of the home if the lot permits.

T, U, H, and L Plans

The T, U, H, and L plans allow additional space extensions beyond the rectangular plan, with advantages including more variety in room arrangement, easy separation of noisy and quiet areas, effective traffic lanes, opportunity for more efficient natural lighting and cross-ventilation, and more interesting landscaping possibilities. Disadvantages may include additional costs for heating and cooling; added expenses for foundation, roof, and jogs; and the need for a larger lot to accommodate these shapes. Figure 8.35 illustrates a U-shape plan with the split bedroom design.

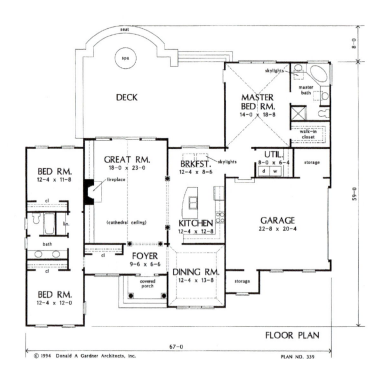

FIGURE 8.34 A well-designed multistory home with five bedrooms.
(Architect/Designer: Cooper Johnson Smith Architects)

FIGURE 8.35 A well-designed U-shape plan with a split bedroom arrangement.
(Plan #/339 ©1994, Donald A. Gardner Architects, Inc.)

Loft Plan

In urban and suburban communities, vacant warehouses, outdated factory buildings, and abandoned retail spaces are finding new life as renovated loft apartments and condominiums. A form of historic preservation (adaptive use), these renovations create unique residences. High ceilings, broad expanses, skylights, and exposed structural components characterize these spaces (Figure 8.36). These renovations also assist in urban renewal by bringing people back into downtown communities.

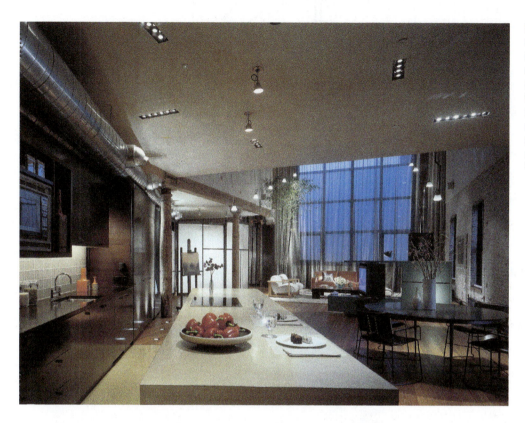

FIGURE 8.36 In this loft renovation in New York, a substantial amount of demolition occurred before the designer began. Dropped ceilings, recessed lighting, and drywall covering brick walls were removed. The unique angular shape of the building and the 25' × 15' window formed an outstanding backdrop for the residence. Note the movable translucent wall in the master bedroom, built-in cabinetry, and retreat or guest bedroom on the loft's second floor.
(Floor plan courtesy of Ike Kligerman Barkley Architects. Photograph © Durston Saylor.)

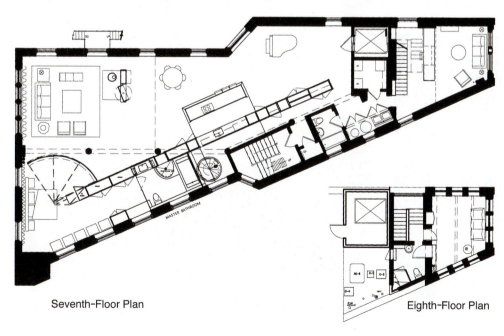

Seventh-Floor Plan

Eighth-Floor Plan

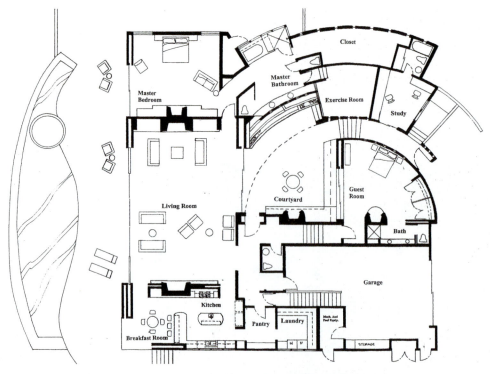

FIGURE 8.37 In this atrium plan, the architect and interior designer created a unique floor plan that accentuates the ocean view. The open courtyard, used as a dining room, also allows a view to the ocean from the guest bedroom. Built-in fireplaces, curved walls, and a variety of ceiling height changes add clarity and crispness to the clean lines. The client's personal art collection has been highlighted through thoughtful placement and appropriate architectural lighting. *(Designer: Mindy Meisel. Architect: Ken Ronchetti Designs. Photograph by Christopher Dow.)*

Atrium Plan

The atrium plan (Figure 8.37), with its inner courtyard, was used by the ancient Romans and is common in locations with a pleasant climate. This courtyard can be completely enclosed as the central focus of the entire house or built within a U-shape or to one side. The atrium can be open to the sky or topped with a skylight.

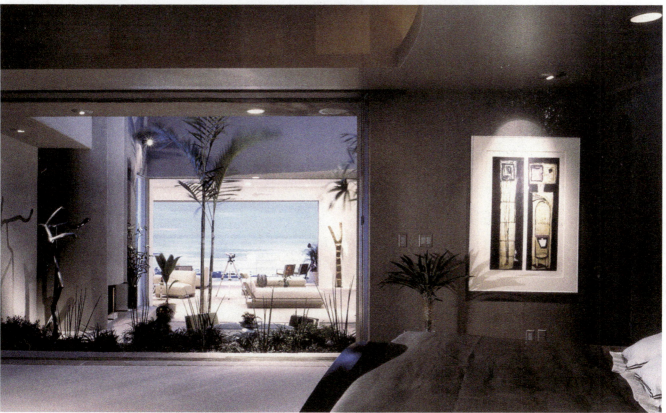

FIGURE 8.38 The sweeping arrangement of these interior spaces gives fluidity and movement to the interior. Curvilinear design features are repeated in chair backs, bathroom cabinets, and ceiling details. *(Architect: The Steinberg Group. Designer: Brukoff Design Associates. Photographs by Richard Barnes.)*

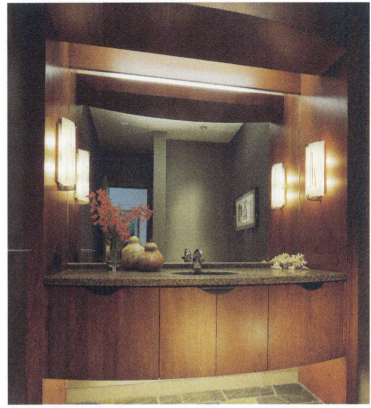

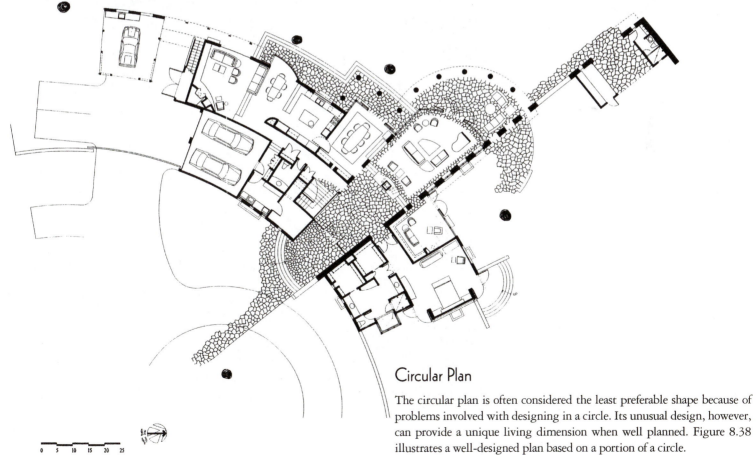

0 5 10 15 20 25

Circular Plan

The circular plan is often considered the least preferable shape because of problems involved with designing in a circle. Its unusual design, however, can provide a unique living dimension when well planned. Figure 8.38 illustrates a well-designed plan based on a portion of a circle.

Attached and Multifamily Plans

High-density housing units accommodate a variety of lifestyles and tastes. Main concerns include efficient use of space, noise control, privacy, easy upkeep, security, and energy conservation. Apartment houses, duplexes, garden apartments, clustered condominiums, and townhouses are planned inside much like single detached houses. Floor plans for attached and multifamily housing may vary from large, two-level multiroom units to compact one-room arrangements.

The one-bedroom unit in Figure 8.39 illustrates a well-arranged space that is convenient, albeit tight, for a couple or for a single person. In a *tandem arrangement*, the individual units can be placed side by side or one behind the other.

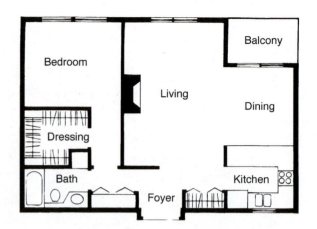

FIGURE 8.39 One-bedroom unit.

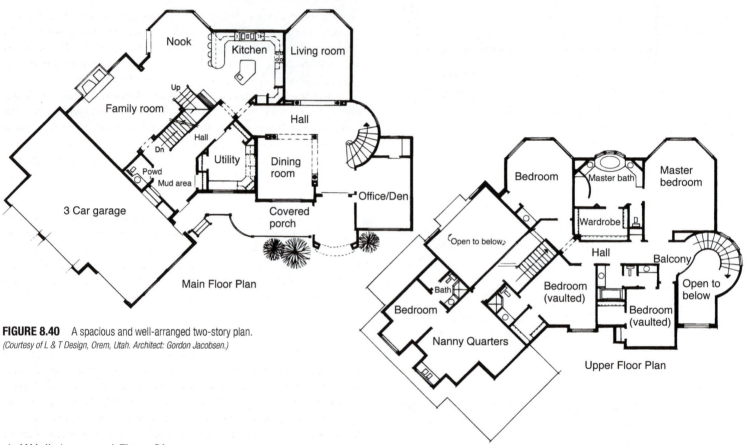

FIGURE 8.40 A spacious and well-arranged two-story plan.
(Courtesy of L & T Design, Orem, Utah. Architect: Gordon Jacobsen.)

A Well-Arranged Floor Plan

The well-arranged plan in Figure 8.40, although expensive because of numerous shapes, angles, and jogs, meets many requirements for a successful and livable residential space. Some positive advantages of this plan include the following:

- Well-defined and spacious public (both formal and informal) zones and private zones
- Creative and unusual arrangement of space to meet individual needs of occupants with the use of both open and closed planning
- Well-placed and convenient wall space and openings; adequate space for required furnishings
- Well-arranged traffic patterns; easy access to outdoors from social zones; spacious hallways throughout; large entry area
- Garage conveniently located to the kitchen; garage doors face away from the street side

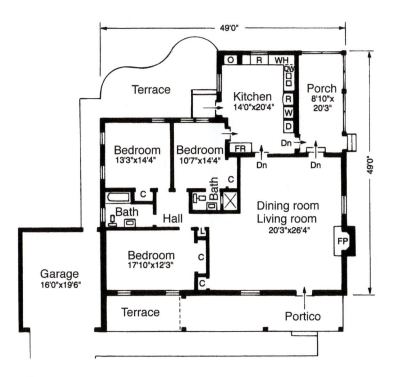

FIGURE 8.41 A poorly arranged floor plan.

A Poorly Arranged Floor Plan

Figure 8.41 illustrates a poorly arranged plan that includes the following undesirable features:

- Lack of an entranceway makes the living room a major traffic lane
- Poorly located front door causes traffic-pattern problems and prevents a private conversation area around the fireplace
- No privacy in eating areas
- Inconvenient placement of garage makes transporting groceries a chore
- Necessity of crossing through a bedroom to reach three-quarter bath from kitchen
- Uneconomical placement of plumbing
- Inconvenient location of washer and dryer in kitchen
- Window size and placement undesirable; window in small corner bedroom abutting the wall; windows in living room too small, providing inadequate light
- Noisy and quiet areas not adequately separated
- Private informal living space ignored; for example, a television set would have to be placed in the living room.

■ ANALYZING COMMERCIAL FLOOR PLANS

Like residential floor plans, different styles of commercial office buildings meet clients' needs in varying ways. Major considerations include the location and type of establishment, the flexibility of utilities and systems, and the design, shape, and style of the base plan. As always, the cost for the structure must meet the client's budget.

Location

Stand-alone buildings provide clients with opportunities to design and own the building to meet a specific need. Stand-alone buildings may be leased, or the land and building may be owned.

A strip shopping center location is leased from an owner who usually takes care of exterior maintenance and parking. Strip shopping centers allow for drop-by customers and easy access. The hours of strip shopping centers are flexible.

Location in a mall, a leased facility, provides many of the same benefits as the strip shopping center and encourages even more drop-by customers; however, the hours may be restrictive. The mall is also seen as a retail establishment, where strip shopping centers may also include offices, healthcare facilities, or other nonretail businesses.

Multistoried buildings are common for commercial businesses, health care and hospitality facilities, and condominiums, and typically are also leased facilities. Clients may occupy a partial floor, an entire floor, or several floors within the building. Restroom facilities are centrally located and maintained by others. Cleaning services may be provided by the building owner.

Systems

HVAC, plumbing, acoustics, and security systems need to be evaluated to meet the client's needs. For instance, a medical facility requiring extensive plumbing may find it restrictive to function in a strip shopping center that has only one waste line location. A financial office may find it too noisy to be located adjacent to a restaurant or bar if sound attenuation options are limited between tenants.

Design

The exterior building design may add prestige to the firm. Buildings may have multifaceted walls that allow for many corner offices, which may be suitable for a law firm or other business that requires extensive private office space. Curved walls in buildings lend themselves to open office layouts or other designs that require large expanses, such as classrooms or conferencing areas. Multistoried buildings are frequently manipulated to provide interest. Curved or angled walls add interest and style to the interior (Figure 8.42A and B).

In the accompanying design scenarios, the clients are considering relocating to a multistory, historic building. In the first scenario, the client wants to use the space for a residence. In the second, the client wants to use the space for a commercial real estate office. Both clients' floor plans are developed from programming information. As part of the design process, the information is gathered, the facts analyzed, and several ideas and plans generated from this information. Once a solution has been selected, a final plan is developed.

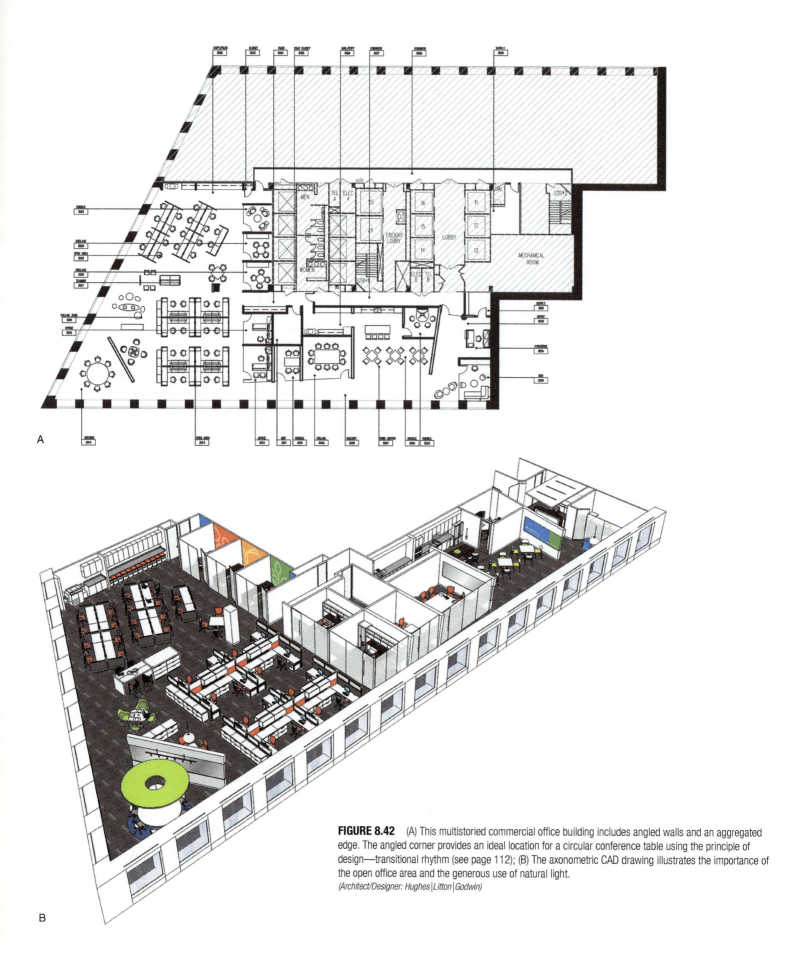

A

B

FIGURE 8.42 (A) This multistoried commercial office building includes angled walls and an aggregated edge. The angled corner provides an ideal location for a circular conference table using the principle of design—transitional rhythm (see page 112); (B) The axonometric CAD drawing illustrates the importance of the open office area and the generous use of natural light.
(Architect/Designer: Hughes | Litton | Godwin)

SUMMARY

Analyzing furnishing options, grouping them into areas, and synthe-sizing those areas into zones begins the space planning process. Sketch-ing and resketching various options is the essence of analyzing space usage that eventually leads to the design of the *volume* of space. Figure 8.43 graphically illustrates this process.

Designers are fluent in the use of space and organizing systems and understand the relationship of space to volume. Space planning is simi-lar to putting together a puzzle; however, there is no predetermined solution. Designers create the solution to fit the design parameters unique to each client.

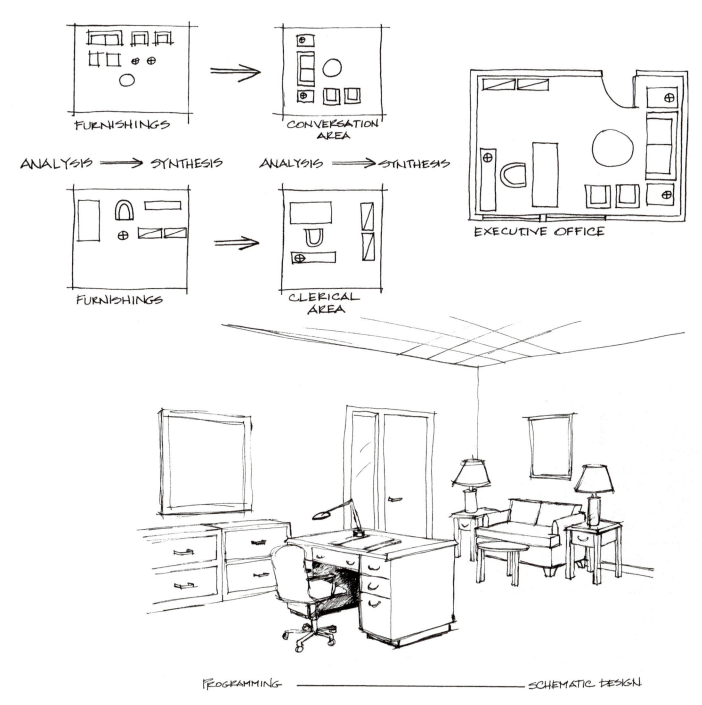

FIGURE 8.43 In the space planning process, furnishings are analyzed based on the client's needs. The furnishings are grouped in specific activity areas, allowing for ample passageways. Activity areas are then analyzed and grouped in rooms. Through the use of the design process and the elements and principles of design, the volume of space is composed.

designSCENARIO

Residential Loft and Commercial Real Estate Office

In these two design scenarios, a space in a historic building will be converted into a residential loft and then into a commercial real estate office. The two projects illustrate how a designer analyzes and then synthesizes the client's spatial needs.

RESIDENTIAL LOFT

In the first scenario, a single woman is looking into purchasing space in a historic building that she could convert into a residential loft. She recognizes that she will not be allowed to move any windows or exterior walls, or infringe upon the corridor. She was also told by the listing agent that there were plumbing restrictions. Not wanting to sign the official papers until she knew whether her space needs could be met, she placed a deposit on the space and then hired a designer to analyze her residence's spatial needs and develop a floor plan for the residence. After meeting with the client, the designer determined the following programming requirements:

Entry
- Should feel like a foyer
- Needs closet

Living Area
- Minimum seating for four
- To be used as a guest bedroom
- Exterior view required
- View to television from all four seats
- Bar sink

Dining
- Can be open to kitchen and living room
- Seating for four
- Needs exterior view

Kitchen
- Major appliances, refrigerator, stove, and sink
- Needs dishwasher and microwave
- Needs pantry

Master Bedroom
- Minimum queen-size bed
- Storage allowance for clothing
- Seating/reading chair
- Shelf for reading books—minimum 20 lineal feet
- Needs exterior view
- Closet for clothing and miscellaneous storage

Bath
- Needs to accommodate needs of guest and owner

Laundry Area
- Washer and dryer (could be stacked)

Office Area
- Room for computer, printer, fax, and files.

Using the space planning guidelines for specific activity areas (as discussed in Chapter 7 and this chapter), the designer developed the spatial needs assessment (Figure DS8.1). The designer allocated 20 percent additional square footage for hallways and circulation areas.

The designer now needed a floor plan of the proposed new tenant space (Figure DS8.2). Because the total needed square footage, 830 square feet, was less than the existing 860 square feet, the designer knew that the client's request for the various activity areas could be accommodated in the space.

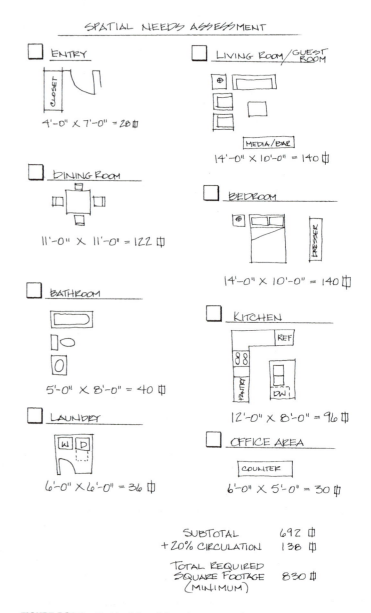

FIGURE DS8.1 Residential spatial needs assessment.

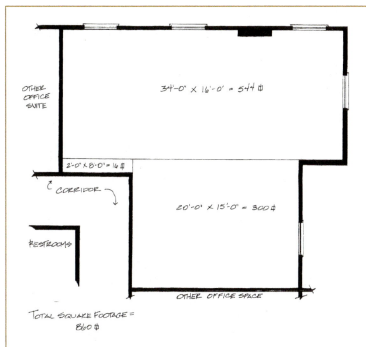

FIGURE DS8.2 Proposed tenant space. The designer determined that the space contained approximately 860 square feet. Other offices or tenants were located on either side of the proposed space. A central core area contained a public restroom and elevator.

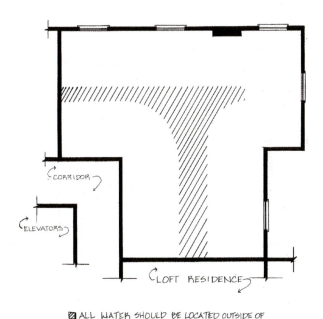

FIGURE DS8.3 In order to allow for appropriate slopes in black water plumbing lines, all toilet fixtures needed to be located outside the shaded area.

The designer also needed to know where black water plumbing lines could be located. The purchasing contract specified that all black water plumbing lines had to be located within 8 feet of the corridor or an exterior wall. Figure DS8.3 was therefore created to indicate the appropriate plumbing locations.

Additionally, the designer needed to analyze the relationships among the various activity areas. For instance, because there is only one entry to the residence, the designer recognized that this needed to be near the kitchen and the living room. Also, the bathroom needed to be visually screened from the living room. Figure DS8.4 illustrates the bubble diagram developed for this project.

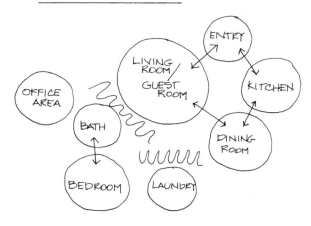

FIGURE DS8.4 Residential bubble diagram. Relationships are indicated by proximity of the bubbles. Arrows indicate stronger, direct flow requirements. The wavy lines indicate areas that need privacy or screening.

Once this preliminary information has been obtained, the designer is now prepared to begin the synthesis of this information. Beginning with blocking diagrams, the designer "blocks" in the various activity areas and decides to further develop both Option A (Figure DS8.5A, Step 1) and Option B (Figure DS8.5B, Step 1).

The next step (Figure DS8.5A and B, Step 2) illustrates the process of defining the walls. The designer indicated with notations areas of concern, or good points about the option. For example, in Option A (Figure DS8.5A, Step 2), the designer was not pleased with the front door opening into the side of the kitchen; no vista exists.

The designer then continued the space planning process by completing final presentation plans (Figure DS8.5A and B, Step 3). Ultimately, the client decided to proceed with Option B (Figure DS8.5B, Step 3).

FIGURE DS8.5A STEP 1 Blocking diagram for Option A.

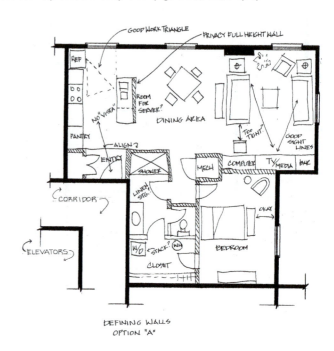

FIGURE DS8.5A STEP 2 Defining walls for Option A.

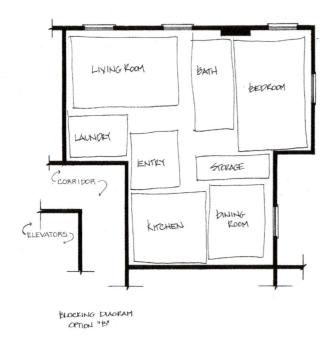

FIGURE DS8.5B STEP 1 Blocking diagram for Option B.

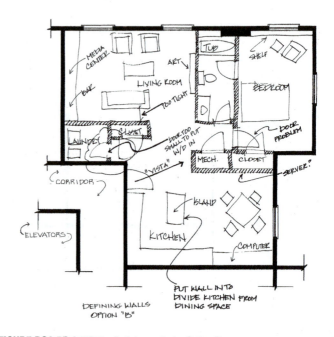

FIGURE DS8.5B STEP 2 Defining walls for Option B.

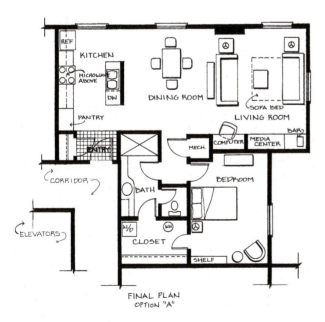

FIGURE DS8.5A STEP 3 Final plan for Option B as presented to the client. This is the plan selected by the client.

FIGURE DS8.5B STEP 3 Final plan for Option A as presented to the client.

COMMERCIAL REAL ESTATE OFFICE

In this second design scenario, a commercial real estate firm specializing in historic properties has found tenant space in a historic building (as seen in Figure DS8.2). A designer was hired to analyze whether the space would meet the firm's needs. As with the residential loft client, the designer first met with the real estate firm's employees and gathered the following programming requirements:

Reception Area
- Needs secretary/reception desk with room for computer/printer, type-writer, and 200 linear inches for filing, telephone
- Needs room for four guest chairs
- Receptionist must be able to receive guests, and guests should not see the workings of the office when seated
- Receptionist must work closely with president

President/Marketing Representative
- Needs desk, credenza, and two other chairs for seating
- Needs some bookshelves and wants a window

Three Assistant Marketing Representatives
- Need office space for desk, credenza, and two other chairs for seating
- Need some bookshelves and window exposure

Conference Room
- Needs comfortable seating for six
- Needs display area to show presentation boards and facility to show slides and videos of real estate

Supply Room/Breakroom
- Needs access to deliveries, copying machine, small refrigerator, counter for postage machine
- Needs cabinets for storage of paper and stationery supplies, coffee, etc.
- Needs to be close to receptionist.

The designer then develops a spatial needs assessment based on the client's requests (Figure DS8.6).

After comparing the existing square footage, 860 square feet, with the requested needs, 877 square feet, the designer informed the client that the space would be a bit tight but that all requests could be accommodated.

Because the firm was new and currently had only three employees (but planned to add two more assistant marketing representatives in the next three to five years), the prospective owner requested that the designer proceed with the space planning analysis.

In order to better assimilate the client's needs and the relationships between activity areas, the designer developed a compatibility matrix (Figure DS8.7) and a bubble diagram (Figure DS8.8).

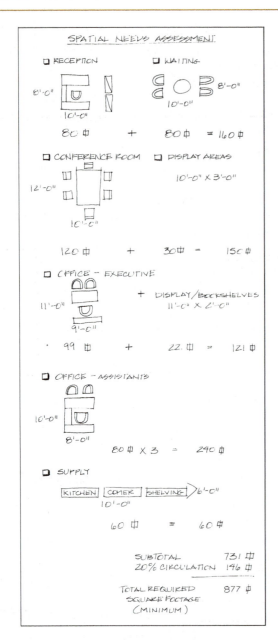

FIGURE DS8.6 Spatial needs assessment.

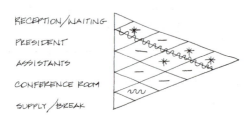

FIGURE DS8.7 Compatibility matrix.

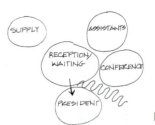

FIGURE DS8.8 Bubble diagram.

Blocking

The designer then began the blocking process as the first step in the space planning analysis. Figure DS8.9A and B illustrate two options that the designer decided to develop further.

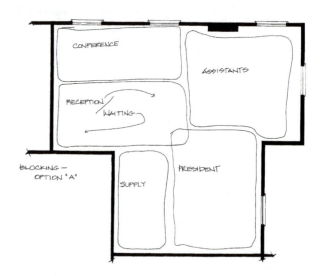

FIGURE DS8.9A Blocking diagram Option A.

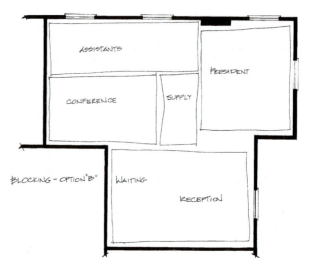

FIGURE DS8.9B Blocking diagram Option B.

Option A

Defining walls in this commercial setting proved to be more of a challenge than it was for the residential loft. For Option A, the designer worked through three different defining wall stages before stopping at Step 4 (Figure DS8.10A, Steps 1–4). Throughout this process, the designer added notes to the plan indicating areas of concern.

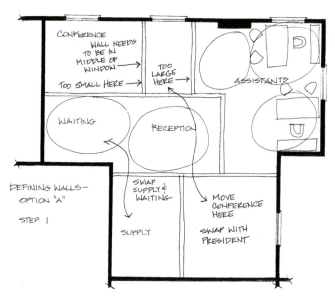

FIGURE DS8.10A STEP 1 Defining walls for Option A.

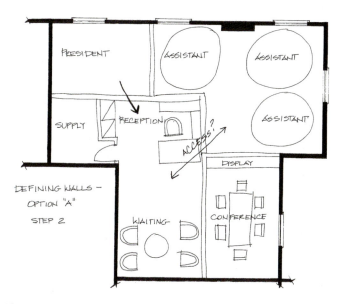

FIGURE DS8.10A STEP 2 Analyzing wall placement for Option A.

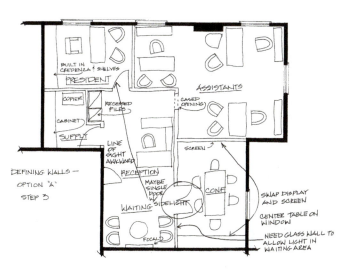

FIGURE DS8.10A STEP 3 Further analysis and refinement of Option A.

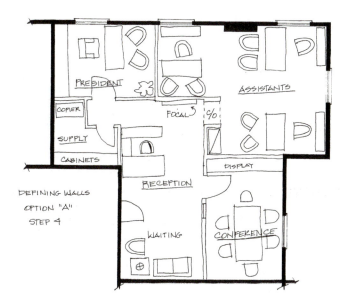

FIGURE DS8.10A STEP 4 Establishing final furniture and wall placement for Option A.

Option B

Defining walls for Option B proved to be less complicated. The designer developed Steps 1 and 2 (Figure DS8.10B, Steps 1 and 2) and decided to proceed with a presentation furniture plan, Figure DS8.11, to share with the client.

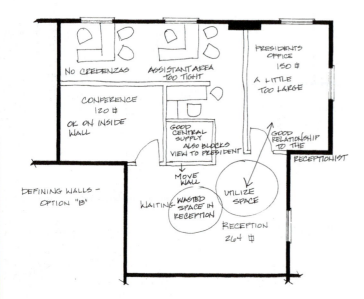

FIGURE DS8.10B STEP 1 Defining walls for Option B.

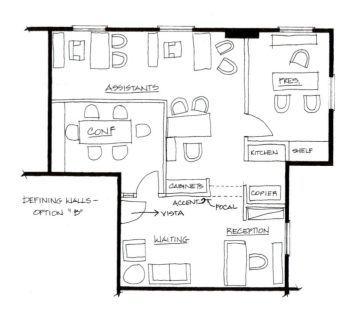

FIGURE DS8.10B STEP 2 Establishing final furniture and wall placement for Option B.

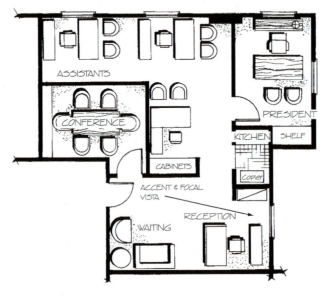

FIGURE DS8.11 Final presentation drawing.

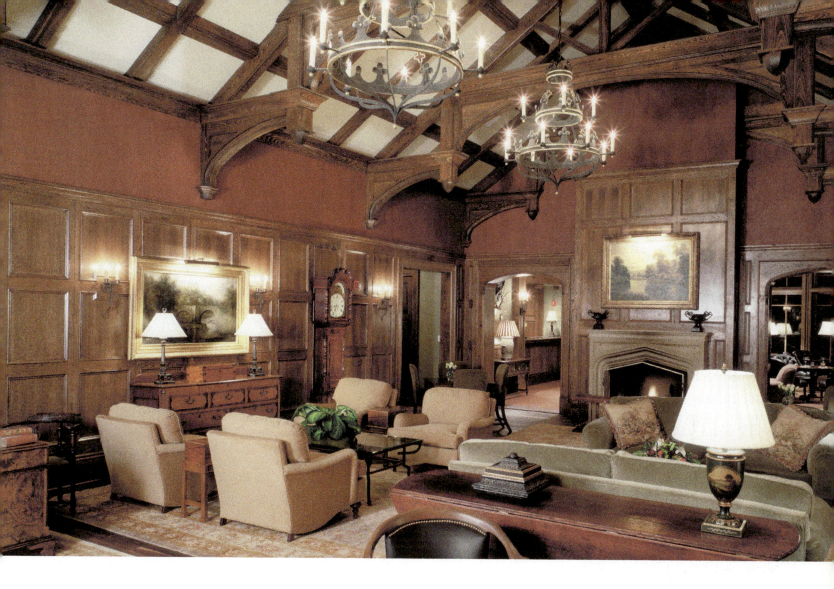

Part V

Materials, Furnishings, and Fabrics

Have nothing in your house that you do not know to be useful or believe to be beautiful.

—William Morris

FIGURE V.1 For this clubhouse, the client requested an "authentic English Tudor" interior. The designers selected plush fabrics, Oriental rugs, English antiques and reproduction furniture, and oak paneling to set the tone of the main gathering area. The timber frame structure, contrasting with the white ceiling and tiered candlelight chandeliers, completes the ambiance. *(Ferry, Hayes & Allen Designers, Inc.)*

Part V encompasses five chapters that review the material and finish options and characteristics available for floors, ceilings, and walls as well as the design options available in furniture and textile selection. The final chapter elaborates on window treatments, accessories, and art. In all interiors, these varied components must work together to create a harmonious, unified environment and to set the mood for the room (Figure V.1).

As was discussed in Chapter 1, the goals of design include *function and the human factor, aesthetics,* and *economics and ecology.* Designers have these same goals when selecting furnishings, fabrics, and background elements.

FUNCTION

The interior materials and components in an environment must meet the functional needs of the space. The functional needs of the space are intermingled with *the human factor, durability, safety,* and *acoustics.*

The Human Factor

In the selection of all interior materials, designers must be aware of the client's needs in order to meet the goal of the human factor. Different individuals require different furnishings to complete the same task. Meeting the needs of the specific individual is particularly important when selecting furniture. Like clothing, what fits one client does not necessarily work with the next. In furniture, one size does not fit all. Designers must pay special attention to the ergonomic needs of the client (see Space, Part IV).

For example, in order to make it easy to get up, elderly clients may require chairs with high armrests and firm cushions. Younger clients may desire overstuffed sofas for lounging. Commercial office clients may require chairs that can be adjusted to suit various employees (Figure V.2). Suitable furniture may be required to meet the functional needs of users who are physically challenged.

Durability

Products selected must be durable; this is particularly important for flooring. White carpet may look great in a master bedroom suite, but it would be a disaster in a reception area, for example.

Equally important is the durability of wall finishes and fabrics. Washable wallcoverings, for example, are critically important in public corridors, but may not be as important in a library. Fabrics must also meet cleaning and durability requirements.

Furniture must withstand expected wear and tear. Residential dining room chairs may look good in a commercial conference room, but without proper bracing, they will quickly begin to fall apart. File cabinets that may be appropriate for occasional residential office filing will not withstand the rigors of an accounting office.

Safety

Products must also meet safety and fire regulations. Designers must consider regulations relating to flame resistance, slip resistance, and accessibility in order to meet functional requirements.

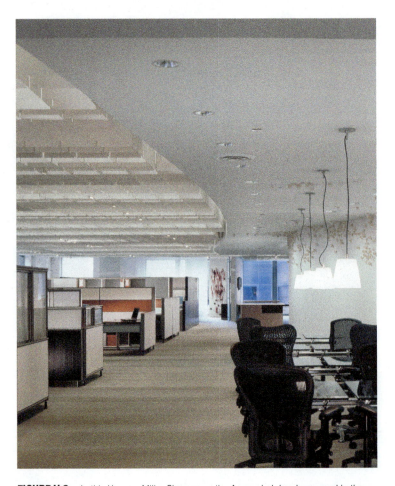

FIGURE V.2 In this Herman Miller Showroom, the Aeron chair has been used in the conference area. The Aeron chair is extremely adaptable, with adjustable back, arms, seat, and height; it is also 94% recyclable. The showroom uses a variety of lighting options to adjust to the functions required in different work areas and at different times of the day. The change in ceiling plan defines the open office work spaces. Acoustical panels on the open office system reduce ambient noise. Bill Stump, a noteworthy furniture designer who worked with Herman Miller, discusses the design of the Aeron chair at http://www.hermanmiller.com/products/seating/work-chairs/aeron-chairs.html *(Photograph Courtesy of Herman Miller Inc.)*

Acoustics

Textiles, wallcoverings, and floor coverings greatly affect the acoustics of an interior environment. These materials serve as a transition, softening the edges (both physically and visually) of the hard architectural elements. Proper selection is particularly relevant in restaurant design, where the noise from clattering dishes in the kitchen is not desirable in the dining room (Figure V.3). Other areas of concern include private offices, studies, libraries, classrooms, and conference areas. Theaters and recital halls require a collaborative effort with acoustical engineers.

AESTHETICS

The selection of the furnishings, fabrics, and background materials must be in line with the basic principles and elements of design; however, the client's personal preferences also must be considered. Just as the function of the room conforms to the human factor, so must the aesthetics. Client preferences are particularly important in residential design. The designer

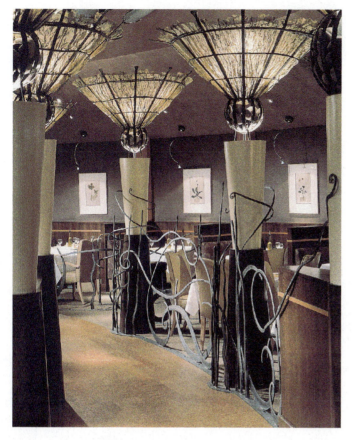

FIGURE V.3 Unique torchères and custom ironwork add warmth and vibrant character in this restaurant. Suspended accent lighting focuses on a series of botanicals. Control of unwanted noise is critical in this upscale environment.
(Architect/Designer: Engstrom Design Group and To Design. Photograph by Andrew Kramer AIA.)

FIGURE V.4 The designers worked very closely with the clients to create a dining space encircled by art. The custom glass inset flooring makes a visual delineation between the dining room and the living room.
(Designer: Stevenson Design Group. Photograph by Robert Brantley.)

must not only listen to the client's requests, but also observe the client, ideally in his or her personal surroundings (Figure V.4).

The color, texture, and feel of the finishes and materials help to define the character of the space. Each component of the design needs to support the overall theme and architectural background of the space. As discussed in Chapter 1, designers develop a discerning eye through careful observation and experience.

ECONOMICS

The value of a particular furnishing, fabric, or background element must be considered with respect to the *quality, cost*, and *ecological nature* of the product.

Quality

How a piece of furniture (or any other architectural component) is made and the quality of the materials used are of vital concern to both the designer and the end user. The quality of construction, materials, and finishes varies, and designers often depend on the integrity of the manufacturer and the word of a salesperson. A good manufacturer takes great pride in the skilled fabrication and detail that compose the product because the company's reputation depends on it.

Cost

The client's budget is a necessary consideration when planning and furnishing a space. The cost of the furnishings must be in line with the budget allocation. Almost all design projects have a spending limit that must be respected.

In addition to the initial cost, the costs over the life of the product (life cycle costing) must be considered: the cost of maintenance, repairs, and replacement parts. Fine quality and good design are always wise investments and, if carefully selected, can be obtained at a reasonable cost.

Ecology

The designer is also responsible for encouraging the use of products and materials that do not harm the environment or create health hazards through the emission of toxic fumes. See the special sections on sustainable design in the following chapters on furniture and accessories, textiles, and backgrounds.

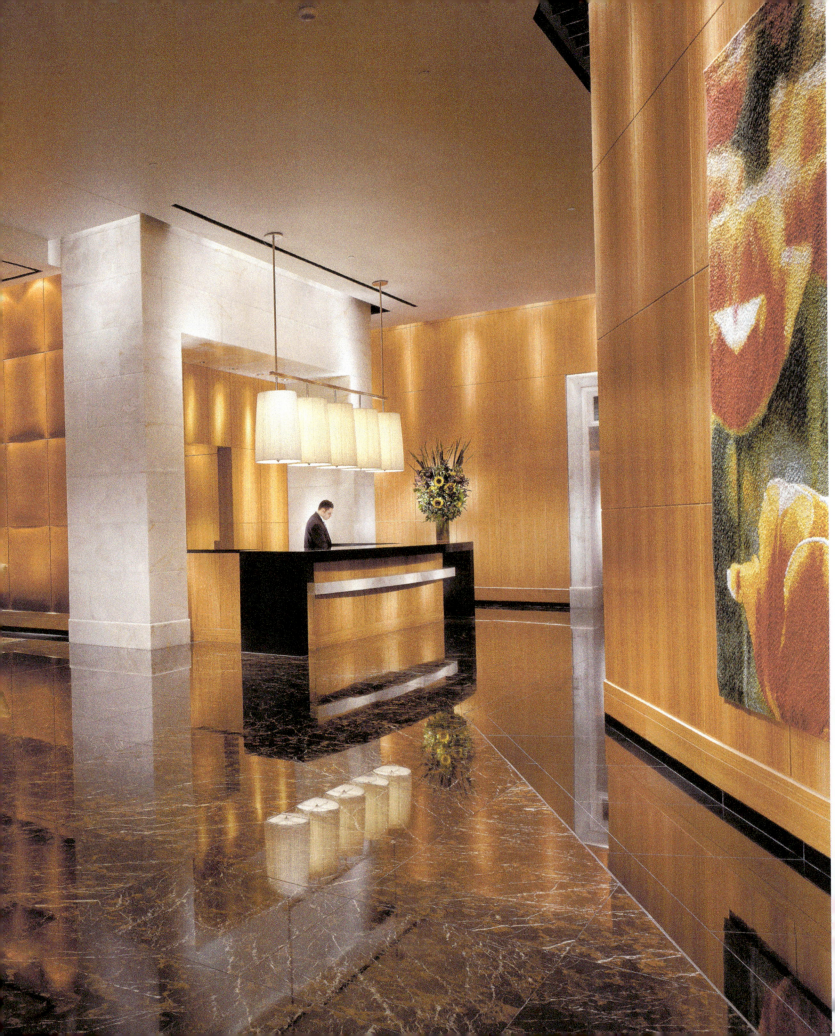

9 Floors

FIGURE 9.1 This commercial hotel lobby is defined by its marble floor. The highly polished design characterizes the formality of the hotel. The angled wall, reflected in the cut-tile flooring, leads the visitor to the reception desk. A suspended series of accent lights also helps to identify the reception desk and serves as task lighting for the reception counter.
(© Jeffrey Jacobs)

The general scheme of any room is established by the interior background: floors, ceilings, and walls, as well as other items discussed in Chapter 5 such as doors, windows, and fireplaces. The decorative treatments added to these backgrounds (as well as to the movable objects in the room) should be in keeping with the overall feeling to give the room harmony and unity (Figure 9.1). This chapter focuses on the material and finish options for floors.

Floors are designed primarily to be walked on and to provide a foundation for furnishings; therefore, floors must be made from or covered with durable, stain-resistant materials. Due to improved technology, developments in old and new materials, and methods of production, today's flooring materials are both beautiful and practical. The decision to select a specific type of flooring is based on the same criteria discussed in the introduction to Part V: *function and the human factor, aesthetics,* and *economics and ecology.*

■ HARD FLOORING

Recent decades have witnessed a renaissance in hard-surface floor coverings, both nonresilient and resilient. The term *resilient* refers to a material's ability to spring back when pressed. In contrast, *nonresilient* materials lack flexibility.

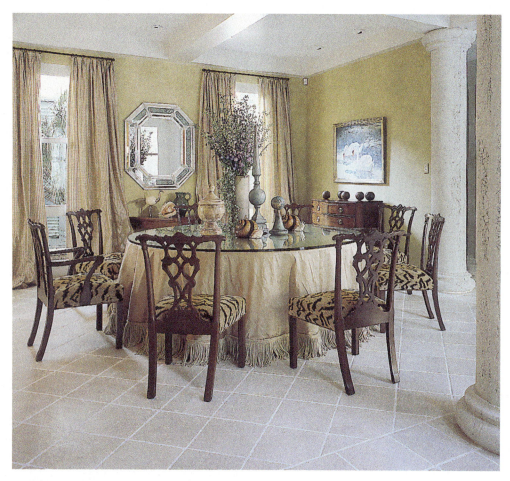

FIGURE 9.2 A travertine floor and rusticated columns provide an interesting contrast to the fringed tablecloth, glass top, and faux animal print.
(Design and Architecture: Wells Design. Photograph by Hickey-Robertson. As seen in Southern Accents.*)*

■ NONRESILIENT FLOORING

Masonry

The initial cost of nonresilient flooring is generally high; however, hard-surface **masonry** flooring materials such as brick, stone, and tile remain popular because of their extreme durability, versatility, low maintenance requirements, and timeless character. Masonry floors are installed in either thin or thick mortar. They also require **grout**, a material used to fill in between the individual masonry pieces. The color of the grout greatly affects the design. Grout that is selected to blend with the flooring unifies the look of the floor (see Figure 9.8). Grout that contrasts with the floor material will accentuate the shapes of the individual tiles (Figure 9.2).

Masonry materials may be derived directly from the earth through quarrying, or they may be fabricated from a combination of natural material and additives. Marble is a naturally occurring stone. It is formed from limestone that has undergone changes due to pressure or heat. In the quarrying and cutting processes, small pieces of marble break apart; these "chips" are used to make terrazzo. Travertine, another natural stone, is more porous and therefore requires a cement fill to even out the surface. Other natural stones used for flooring include flagstone, granite, and slate.

Masonry floors that are fabricated from natural materials include brick, ceramic tiles, terra-cotta, quarry tiles, and exposed aggregate. Bricks and tiles are typically baked to create a hard, nonporous surface. They may be fired at a higher temperate to create a glazed finish. Exposed aggregate consists of small tumbled stones placed into concrete before it sets.

The durable qualities of tile, stone, and other masonry floors allow these materials to be used throughout the home and commercial environment. In the home, masonry floors may flow from the entrance hall to the porch or patio, thus providing unity and minimizing upkeep (Figures 9.3 through 9.6). Designers of restaurants, hotel lobbies, and shopping malls find masonry flooring an extremely durable and creative solution.

Table 9.1 contains information on the most commonly used nonresilient hard floor coverings, their characteristics and uses, and suggestions for treatment and care.

FIGURE 9.3 Ceramic tile offers a broad range of finishes from aged and weathered stone to polished marble. The square on the left is Cerdomus Ceramiche, the rectangle is Graniti Fiandre, and the top two squares are Emilceramic and Vives Azulejos y Gres.
(Courtesy of Interiors & Sources)

FIGURE 9.5 This tile creates a **trompe l'oeil** (three-dimensional) effect: Astra from Wholesale Tile & Accessories.
(Courtesy of Interiors & Sources)

FIGURE 9.4 Natural stone borders are available in intricate designs. Shown from left are waterjet-cut marble borders from the Corolla and Victoria collections by Stoneworks, and the Wrought Iron border in carved St. Croix travertine by StoneArt.
(Courtesy of Interiors & Sources)

FIGURE 9.6 This rich, vibrant color palette of ceramic tile is offered by Briare Tile.
(Courtesy of Interiors & Sources)

TABLE 9.1 Hard-Surface Flooring: Nonresilient

Material	Characteristics	Uses	Treatment and Care
Brick	Durable, little upkeep needed Comes in many textures, sizes, and colors Transmits moisture and cold readily and absorbs grease unless treated Absorbs and stores solar energy, but not sound Rough to the touch	Walks, patios, foyers, greenhouses Adds a country look or historical appearance	Careful waxing softens rugged effect and produces soft patina Coating of vinyl protects from grease penetration Dust with dry mop, wash occasionally For stubborn stains, use trisodium phosphate

(continued)

TABLE 9.1 Hard-Surface Flooring: Nonresilient (continued)

Material	Characteristics	Uses	Treatment and Care
Ceramic tile (see Figures 9.3, 9.5, 9.6)	Has unique aesthetic quality One of the hardest and most durable floor and wall coverings Versatile Common type using small squares is called mosaic May be glazed or unglazed; comes in many colors, patterns, and textures Glossy surface squares, usually 4 1/2" New developments producing handsome tiles 12" square with variety of designs, textures, and colors Pregrouted tile sheets up to 2' × 14' now available Absorbs and stores solar energy, but not sound Expensive	Especially attractive for bathrooms and may be suitable for any commercial interior	Unglazed: may be waxed to give soft sheen Glazed: dust with dry mop, wash when needed with soap and warm water
Concrete	May be solid or in squares, smooth or textured, polished or unpolished Color may be added before pouring or after Absorbs and stores solar energy, but not sound Easy upkeep Inexpensive Tends to give cold, industrial feeling when brought inside	Particularly desirable for some hard-use areas and for support of heavy equipment Usually used commercially	Heavy waxed surface necessary for maintenance Do not use lacquer, varnish, or shellac Special finishes available Wet before cleaning and use detergent Easy to maintain
Epoxy Resin	Extremely durable. Comes in a variety of finishes. May yellow with exposure to ultraviolet rays. Complicated installation. Water based, so not as harmful.	Industrial flooring; Extremely heavy-use areas. Commercial application.	In industrial applications, sweep daily. Scrub in heavy-use areas to maintain gloss.
Exposed aggregate	Stones are laid in concrete and polished to smoothness, but surface remains uneven Absorbs and stores solar energy Can be too uneven and difficult to walk on	Especially appropriate for exterior walks	Dust, wash occasionally
Flagstone	Any flat stone; varies in size, thickness, quality, and color Versatile, durable, handsome Easy upkeep Colors range from soft grays through beiges and reddish-browns May be cut geometrically or laid in natural shapes Surface slightly uneven Absorbs solar energy, but not sound Expensive Difficult to repair if damaged Cold when not heated	Walks, patios, foyers, greenhouses, any heavy-traffic area May be dressed up or down, making it appropriate for wide range of uses	Treatment and care same as for brick
Granite	An igneous hard stone of cooled molten rock Has a fine- or coarse-grain (crystal or grain) texture Main colors are variations of gray, brown, black, pink, green, yellow, or combinations of these Has a coarse finish or can be polished until it shines Easy to cut for various uses Harder than marble Expensive Cold to touch Difficult to repair if damaged Does not absorb sound	Floors, walls, tabletops, countertops, and steps Highly durable and excellent for heavy-traffic areas Especially popular for commercial use	Easy maintenance: sweep clean, wipe with water when necessary

TABLE 9.1 Hard-Surface Flooring: Nonresilient (continued)

Material	Characteristics	Uses	Treatment and Care
Marble (see Figure 9.1)	Extremely hard Available in many varieties, colors, and veining Gives feeling of elegance, luxury, and formality More expensive than most other flooring materials, but is permanent New stone-cutting techniques make it lighter and less expensive Tiles are reinforced by epoxy-fiberglass coating Cold to touch Difficult to repair if damaged Does not absorb sound Slippery when wet	Wherever elegant durability is needed Especially appropriate with classic styles of furnishings Not appropriate in settings where water may be prevalent	Wash with soap and warm water Easy maintenance
Mexican tile or terra-cotta	Crude base made of unrefined clay Hand shaped and sun dried Allows little control of color and shape Durable, informal, inexpensive Absorbs solar energy, but not sound Easy upkeep Difficult to repair if damaged Cold when not heated	Wherever a hard, cement-like surface is desired or wherever solar energy storage is desired	Dust with dry mop, wash occasionally with detergent Surface seldom waxed
Quarry tile	Type of ceramic tile One of the hardest and most durable tiles May be glazed or unglazed Heat and frost resistant, easy upkeep, durable Both ceramic and quarry tiles are practically impervious to grease and chemicals Absorbs and stores solar energy, but not sound Variety of shapes to select Inexpensive Difficult to repair if damaged Cold when not heated	Suitable for many period rooms, especially Italian, early English, and rooms with Mediterranean feeling Can be used wherever hard surface is appropriate Coolness makes it desirable in hot climates	Care same as for ceramic tile
Slate (specific type of stone)	More formal than flagstone Qualities similar to flagstone except for color, which runs from gray to blue-green to black Absorbs solar energy Easy upkeep if sealed Expensive Difficult to repair if damaged Cold when not heated Shows dust easily when polished	May be used in traffic areas in formal rooms Appropriate for some period rooms Particularly appropriate for sunrooms, foyers, and greenhouses	May be polished or unpolished, but more often waxed and highly polished
Terrazzo	Consists of cement mortar (matrix) into which marble chips (aggregate) are mixed Custom or precast; large or small marble chips Larger chips give more formal appearance Available in limited range of colors Sanitary, durable, and easy to clean Cold to touch Difficult to repair if damaged Does not absorb sound Slippery when wet	Patios, foyers, halls, recreation rooms, bathrooms, or wherever traffic is heavy	Care same as for Mexican tile Some varieties need occasional waxing
Travertine (see Figure 9.2)	Porous limestone characterized by irregular cavities filled with either clear or opaque epoxy resin Clear resin has three-dimensional appearance Cold to touch Difficult to repair if damaged Does not absorb sound Slippery when wet	Formal settings where durability is required	Wash with soap or detergent and warm water

Concrete

Concrete floors or slabs are common base floors in commercial office structures. Left plain, the floors can give a harsh or institutional feel to the interior; however, concrete floors can be etched or scored into a variety of patterns. Concrete floors also can be faux painted and imprinted to resemble marble, brick, or other decorative motifs (Figure 9.7). Bits of stone or gravel can be added to the cement mixture to create a rough surface; however, these surfaces can be difficult to negotiate.

Epoxy

Epoxy poured floors (EPFs) are commonly used in industrial applications such as stadiums or warehouses, or in areas where water may be an issue such as large public restrooms. EPFs are created by combining two ingredients, an epoxy resin and a hardening agent. Different combinations affect the curing time, durability, and resistance to chemicals and heat. EPFs are susceptible to yellowing when exposed to ultraviolet rays. Additives can help prevent this, as can the use of darker colors. Antimicrobial properties, static control, and light reflectancy can also be improved with additives. Surfaces may be smooth or textured depending on the user's needs.

More info online @

www.tile-assn.com National Tile Contractors Association
http://ctdahome.org Ceramic Tile Distributors Association
www.cr.nps.gov/hps/tps/briefs/brief40.htm National Park Service, Historic Preservation Brief on Restoring Ceramic Tile
www.vanguardconcretecoating.com/index.html Information on coatings for concrete floors

FIGURE 9.7 The creative use of concrete has greatly evolved since its beginnings in Roman history. Concrete floors can be custom colored and patterned, as seen here, or they may also be textured. Patterned floors help to delineate space. Designs can be applied to existing or new floors, both inside and outside.
(Courtesy of Bomanite Corp.)

FIGURE 9.8 The flooring in this entry foyer is bleached oak. The opulent, dramatic design complements the owner's collection of black-and-white photographs.
(Designer: Dilger-Gibson. Photograph by Cheryl Dalton. As seen in Southern Accents.)

■ WOOD FLOORING

Wood has both resilient and nonresilient properties; it is considered the most versatile of all flooring materials. Wood combines beauty, warmth, resistance to indentation, durability, and availability. It also has resistance to cold, which gives wood flooring the additional advantage of comfort over masonry floors. Wood floors can provide an attractive background for any style of furnishings, as seen in Figures 9.8 and 9.10. New methods of treatment have made wood a practical flooring choice for many environments.

Methods of Laying Wood Floors

The three basic methods of laying wood floors are in strips, planks, and parquetry. In the *strip* method, pieces of wood, usually about 2" wide with tongue-and-groove edges, are nailed in place. In the *plank* method, the planks may be uniform or random, varying in width from 3" to 7". Some have square edges; others are tongue and groove. The *parquetry* method makes use of short lengths of boards, arranging them in various designs such as checkerboard and herringbone (Figure 9.9). For economy and ease of installation, 9" to 12" squares are assembled at the factory.

With the use of a laser for cutting, floors can also be designed in a multitude of patterns. Medallions, starbursts, rosettes, pinwheels, or even the Greek key can be produced in wood and inlaid into wood floors. Frequently, exotic woods are used to create these patterns. It is imperative that designers confirm the source of the wood through the Certified Forest Products Council.

Random plank Checkerboard parquet Herringbone parquet

FIGURE 9.9 Patterns of wood flooring.

Stained and Stenciled Wood Floors

Wood flooring is available in a variety of colors in addition to the familiar tones of natural wood. Stain may be applied without obliterating the natural grain of the wood. (Some stain tones even emphasize the pattern in the wood.) A colored wood finish can be achieved by a *stain and sealer method*, in which the surface is stained and then sealed with polyurethane, or the *stain wax method*, in which the stain penetrates into the wood, leaving a wax residue on the surface. When the latter process is repeated and the wood is thoroughly rubbed, the surface has a soft, protective patina.

Stained and sealed wood floors require vacuuming and occasional damp mopping with a vinegar and water solution. Waxed floors must be protected from water and do require occasional rewaxing.

Stenciling, a process of applying paint through a stencil, was used historically as a substitute for expensive carpets. Today, stenciled floors are still an attractive alternative for residential environments.

Alternatives to Wood Flooring

Bamboo is an alternative to wood flooring. Bamboo, imported mainly from China's Hunan province, is technically a grass. The blades or grass canes are split lengthwise, planed, dried, and glued into strips under heat and pressure. Bamboo is harder than oak and does not absorb water as easily as most woods (Figure 9.11). It is considered a green product, but (as of this writing) must be imported from overseas.

Laminate flooring was introduced from Sweden. The flooring consists of a moisture-resistant particleboard core and a melamine top layer with a matte or glossy finish. Beneath the finish is a photographic layer that reproduces the pattern and color of wood. Laminate floors have many of the same warm characteristics of wood, but have a greater resistance to water. Additionally, they may capture the appearance of rare woods, some of which may no longer be available. Laminate floors are a cross between nonresilient and resilient floors. Their properties are reviewed in Table 9.2.

More info online @

www.nwfa.org/member Wood Flooring Association
http://maplefloor.org Maple Flooring Manufacturers Association
www.nwfa.org/member/mag.aspx Magazine of the National Wood Flooring Association

FIGURE 9.10 Chinese slate and bleached pine flooring are combined in this retail store. Note how traffic is directed by the changes in flooring material.
(Architect/Designer: Area Design, Inc. Photograph by Jon Miller/Hedrich-Blessing.)

FIGURE 9.11 This commercial office waiting area employs bamboo flooring. Note the blue leather Barcelona chair and subtle cove lighting. The floor and ceiling design leads visitors between the reception and waiting areas.
(Architect/Designer: Hughes|Litton|Godwin. Photograph by Robert Thien, Inc.)

■ RESILIENT FLOORING

As previously mentioned, resilient hard-surface flooring has the ability to "spring back." The majority of resilient floors are made of vinyl and rubber; however, cork and leather also are used. Table 9.2 lists characteristics, uses, and methods of care for resilient hard-surface floors.

Vinyl and Linoleum

Sheet vinyl is one of the most common forms of vinyl flooring. The sheets are available in rolls 6', 9', and 12' wide for installation with as few seams as possible. Sheet vinyl is available in various grades and qualities. Some high-grade varieties have antimicrobial finishes and resistance to urine and bloodstains, which makes them a good choice for medical facilities.

Vinyl composition tiles, or *VCTs*, are a type of resilient flooring commonly used in commercial environments. The tiles are available in a variety of colors and textures. Laying the patterns on the tiles in the same direction gives a uniform appearance; a checkerboard effect appears when the pattern tiles are alternately turned. Different colors and textures of tiles can create a pattern, define an area, or lead to a destination.

Because tile floors have seams where bacteria can collect, they are not recommended for health care areas. VCTs resist water, but should not be used in pool areas where extensive water damage could cause loose tiles. A type of vinyl tile called *conductive tile* is made especially for hospitals and chemical and electronics laboratories to protect against static electricity.

New products continue to be developed by vinyl manufacturers. Plynyl, by Chilewich, was recently introduced as a woven vinyl with a polyurethane cushion. Vinyls produce VOCs during their manufacturing process. Manufacturers are working to create safer methods of production. Some VCTs, for instance, are made with recycled vinyl content.

Linoleum, a natural flooring product manufactured since the 1850s, is receiving renewed interest due to its environmental friendliness. An updated version called LonEco by Lonseal is composed of 35 percent recycled materials and has the maintenance characteristics of vinyl. Linoleum is nontoxic, biodegradable, and durable.

More info online @
www.vinylinfo.org The Vinyl Institute

TABLE 9.2 Hard-Surface Flooring: Resilient

Material	Characteristics	Uses	Treatment and Care
Cork tile	Provides maximum quiet and cushiony comfort underfoot Cork with vinyl or urethane surface highly resistant to moisture and stains, but natural cork not suited for abuse of kitchen traffic, water damage, etc. Colors range from light to dark brown Dented by furniture Rich color and texture Good insulation properties Shows dust easily Fairly expensive	Especially appropriate for studies and other rooms with little traffic Good green design alternative	Maintenance not easy Dirt hard to dislodge from porous surface Wash with soap and water, coat with wax Vinyl coating protects surface and eases maintenance
Laminate	Available in a variety of patterns and finishes Offers the beauty of wood with greater durability Easy to install Very durable As much as 25 times tougher than laminate countertops	Appropriate in any environment except in areas with a lot of water, such as bathroom or poolside	Vacuum and damp mop
Leather tile	Resilient but expensive Natural or dyed colors Quiet Luxurious look and feel Cleans well Rich colors, can be embossed	Studies and other limited areas with little traffic	Warm water and mild soap
Linoleum	Natural linoleum made from linseed oil, tree resin, cork, wood flour, ground limestone, and pigments Jute backing provides good resiliency Available in a variety of patterns and colors First resilient flooring material (manufactured since the mid-nineteenth century)	Can stain if liquids are allowed to soak in Good green design alternative	Warm water and mild soap
Rubber tile	Tiles available 9" × 12", thickness 3/16" and $1/2$" Usually marble or dot pattern Sound absorbing, durable, nonskidding Safe when wet Raised surface knocks off dirt Relatively expensive	Kitchens, bathrooms, utility rooms Any commercial environment with heavy traffic	Easy to clean Wash with soap and water Avoid varnish or shellac
Sheet rubber	Available in 36" × $3/4$" untrimmed widths Plain or marbleized Durable, nonskidding Safe when wet Raised surface knocks off dirt Relatively expensive	Hard-traffic areas Safe covering for stair treads	Same as for rubber tile
Vinyl composition tile or sheets	Excellent all-around, low-cost flooring Resists stains and wears well Hard and noisy Tiles may have self-adhesive backing	May be used in any interior environment	Exceptionally easy to maintain Wash with soap and water
Vinyl, cushion backed	Vinyl chips embedded in translucent vinyl base Has pebbly surface Shows no seams Has cushion backing, making it resilient May tear or dent	Wherever desired in residential setting	Same as for other vinyl
Vinyl, sheet	Lies flat with adhesive only on edges	Wherever vinyl flooring is desired in residential setting	Same as for other vinyl
Vinyl tile	Tough, nonporous, resistant to stains, durable Comes in clear colors or special effects, including translucent and three-dimensional effects The more vinyl content, the higher the price Comes in great variety of patterns and colors	Extremely versatile, may be used in any room depending on grade of vinyl	Easy care Some varieties have built-in luster and require no waxing

Rubber

Rubber tiles, with a raised dot or other dimensional surface, are designed for high-traffic areas or areas around water. The raised areas allow dirt and water to settle below the walking surface. This surface is commonly used in airports and near pools (Figure 9.12).

Cork

Although technically a wood product, cork is best described as resilient flooring. Cork is the bark of the cork oak tree. Large slabs of it are removed from the tree approximately every ten years without killing the tree. The slabs are cut and used in the beverage industry for stopping bottles; recycled stoppers and other cork graduals are mixed with resin and molded into flooring tiles (Figure 9.13). The flooring may be sealed or varnished. Cork is a natural insulator, is naturally resilient, and is considered a sustainable product. Frank Lloyd Wright used cork flooring in Fallingwater (see page 76).

FIGURE 9.12 In this interior, raised rubber flooring was used for its durability and resistance to water.
(Courtesy of Roppe Corporation)

FIGURE 9.13 An example of cork tile.
(Steve Gorton © Dorling Kindersley)

SOFT FLOOR COVERINGS

Soft floor coverings are valued for their practicality, relatively low cost, and design characteristics. They insulate the floor, muffle noise, and create a feeling of comfort. A well-anchored soft floor covering gives sure footing and helps prevent accidents; it is also easy to maintain with regular vacuuming.

Essentially, there are two types of soft floor coverings: carpets and rugs. *Carpets* are sold by the yard from a roll (generally 12' wide) and are called **broadloom**. (Some broadlooms between 27" and 18' wide are available as are 15"-wide goods.) Pieces of broadloom are taped or seamed together where necessary and attached to the floor to form wall-to-wall carpet. Carpets may also be sold in tiles 12" to 24" square.

Rugs come in standard sizes or can be custom sized. They have edges finished with a binding thread, fringe, or other material and are generally not attached to the floor.

A room's décor may be based on the soft floor covering. It can bring furnishings into harmony, create personality and a feeling of luxury, and alter the apparent size and proportion of a room (Figure 9.14). The same carpet carried throughout an interior can serve as a transition from room to room (Figure 9.15), providing a feeling of unity, whereas an art rug may be a room's focal point (Figure 9.16).

More info online @

www.carpet-rug.com Carpet and Rug Institute
www.carpetinfo.co.uk Carpet information from the United Kingdom

■ HISTORY OF RUGS AND CARPETS

Carpets were used in Egypt as early as 3000 B.C. Writers of the Bible and poets of early Greece and Rome allude to rugs, although walking on such floor coverings was usually the privilege of royalty. Colorful Oriental rugs have been produced in Persia (Iran), Turkey, China, and other Asiatic countries for centuries, where they were the principal item of home furnishing. In the Middle Ages, the later Crusaders came

Wider Larger

Longer Smaller

FIGURE 9.14 Carpet can change the apparent size and proportion of a room.

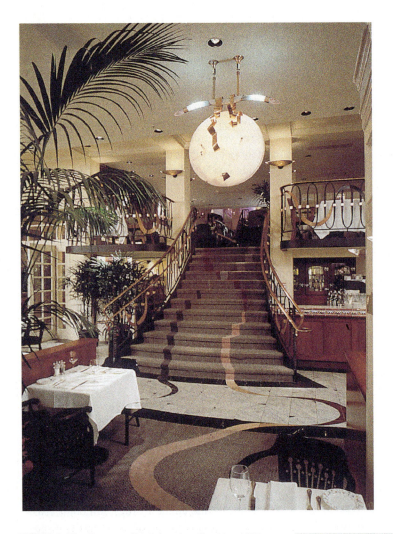

into contact with Constantinople, Antioch, and other Eastern cities. They carried back many fine rugs, which created a great demand in the West. These floor coverings soon became a symbol of status in Europe and America. Since the time when the first rug looms were established in Aubusson, France, the weaving of fine floor coverings has been a continuously growing industry. In the twentieth century, the introduction of machine-made carpets revolutionized the floor covering industry.

More info online @
www.carpetinfo.co.uk/all_about_carpet/history_of_carpet.htm History of carpet, timeline from United Kingdom

■ DESIGN CHARACTERISTICS

The selection of carpet and rugs is based on an understanding of carpet terminology and several design characteristics. Carpet quality is determined by the combination of several components including the *fiber, yarn, construction, backing,* and *surface characteristics.*

When evaluating the quality of carpet, designers should look for products that are resilient; are resistant to abrasion, soil, and moisture; are easily cleaned; and do not produce static electricity. Soft floor coverings (particularly carpets and their padding) should also be environmentally friendly (see Sustainable Design: Flooring Materials). Overall, carpets and rugs should be durable and maintain their appearance.

FIGURE 9.15 The combination of flooring materials creates a playful pattern of ribbons in this restaurant. The custom broadloom carpet has been inset with an accent solid that intertwines with a custom-cut marble floor. The ribbon feature is continued up the stairs to draw the diner's eye onto the second level and provide unity in the space. The ribbon motif is also added on the light fixtures and in the metal work on the balustrade and railings.
(Designer: Kuleto Consulting and Design. Photograph by Cesar Rubio. Courtesy of Kimpton Group.)

FIGURE 9.16 The rug, a Tabriz from Iran (Persia) c. 1850, forms the color source for this room.
(Designer: Francis ❑ Russell. Photograph by Peter Vitale. As seen in Veranda.)

FLOORING MATERIALS

A variety of options are available when specifying flooring materials that help protect the environment. Carpet can be one of the most costly finishes in an interior and creates a disposal problem when it must be replaced. A major carpet recycling initiative is called the Carpet America Recovery Effort (CARE). According to its website, CARE "is an industry-government effort to increase the amount of recycling and reuse of post-consumer carpet and reduce the amount of waste carpet going to landfills." CARE's mission is to foster market-based solutions for recovering value from discarded carpet. CARE established goals based on a "Memorandum of Understanding for Carpet Stewardship" developed and signed by its members, which include the carpet industry; representatives of government agencies at the federal, state, and local levels; and nongovernmental organizations. "CARE is funded and administered by the carpet industry, which agrees to use CARE to:

- Enhance the collection infrastructure for post-consumer carpet.
- Serve as a resource for technical, economic, and market development opportunities for recovered carpet.
- Develop and perform quantitative measurement and reporting on progress toward the national goals for carpet recovery.
- Work collectively to seek and provide funding opportunities for activities to support the national goals for carpet recovery."

CARE's national goals are for a 40 percent reduction in landfill carpet waste.

As discussed in Chapter 5, another common problem with carpet and carpet pads is that they may emit volatile organic compounds, or VOCs, some of which are harmful to breathe. The Carpet and Rug Institute (CRI) has developed an Indoor Air Quality Testing Program, which evaluates carpet, carpet cushions, and floor covering adhesives, and labels products that have been tested and that meet stringent indoor air quality (IAQ) requirements (Figure SD9.1A and B). Carpet pads made of felt or a natural fiber such as jute are the best choice because they are low-emission products. Specifying low-emitting adhesives or selecting the strip method of installation also may limit the emission of VOCs (see Sustainable Design: Indoor Air Quality in Chapter 5).

Vinyl tiles and sheet vinyls can produce high levels of VOCs. Natural linoleum is a better choice. Cork flooring from renewable sources is also an appropriate environmental choice. Cork is taken from the bark of live trees that continue to grow after the cork is harvested. Although not appropriate for all situations, a cork floor is warm and resilient.

One of the best solutions to improve indoor air quality and to diffuse VOCs is to install the flooring materials three to four weeks before an interior is occupied. Recognizing that in many situations this is next to impossible, it is wise to consider installing flooring materials late in the week and then opening the building or home to the fresh air over the weekend. Many businesses are closed on weekends, and residential clients possibly could relocate for a weekend. In general, designers should look for labels that mark the product as "low emission" and remember that natural products are generally a more renewable resource.

FIGURE SD9.1 CRI launched the Green Label program in 1992 to test carpet, cushions, and adhesives. Only those products that have very low emissions of VOC are allowed to carry the Green Label shown in Figure A. A recent upgrade to the Green Label program is the Green Label *Plus*, shown in Figure B. This enhanced label sets even higher standards for IAQ and low-emitting chemicals.
(Courtesy of the Carpet and Rug Institute)

More info online @

www.carpetrecovery.org Carpet America Recovery Effort (CARE)
www.carpet-rug.org Carpet and Rug Institute
www.lafiber.com Carpet and Textile Recycling Plant

Fiber

Over the years, virtually every type of fiber has been used in carpets. Today, however, almost all carpeting sold in the United States is made of synthetic fibers, principally *nylon, acrylic, polyester,* and *olefin. Wool* is the most-used natural fiber. Fibers are often blended to bring out the best characteristics of each type.

Wool

Wool is the luxury fiber and has long been regarded as the top carpet fiber. Other fibers express their aesthetic qualities in relation to how nearly they resemble wool. Great resilience accounts for the vital quality of wool in retaining its appearance. Wool has warmth, a dull matte look, durability, and soil resistance. It takes colors beautifully, cleans well, and when cared for, keeps its new look for years. Although

more expensive than synthetic fibers, natural wool is the fiber of choice for many designers. Wool is, however, susceptible to insect and water damage and may mildew.

Nylon

Nylon is the single most important synthetic fiber, accounting for about 90 percent of carpeting sold today. Nylon has excellent abrasion resistance; resists crushing and matting; and reduces static electricity, pilling, and fuzzing. When regularly vacuumed, it maintains its soil repellency. It is nonallergenic and is mold-, mildew-, and mothproof.

Acrylic

Acrylic's outstanding characteristic is its wool-like appearance. Resistance to abrasion and soiling is good. It is also fairly resilient.

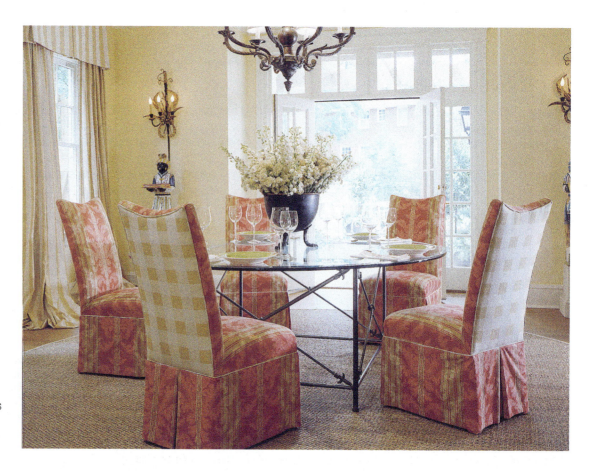

FIGURE 9.17 A rug made from seagrass delineates the circular dining area. *(Designer: Oetgen Designs. Photograph by Antoine Bootz.)*

Polyester

Polyester is an exceptionally soft fiber offering good abrasion resistance, but lacks resiliency. Stain and soil resistance are good, and it is easily cleaned.

Olefin

Olefin (or polypropylene) is predominant in needle-punch carpets, which are especially popular for indoor-outdoor use. Ease of care and a nonabsorbent nature are its outstanding characteristics. Most stains lie on the surface, making it the easiest fiber to clean. However, olefin melts easily and, when poorly constructed, lacks resilience.

Cotton

Although not as durable or resilient as wool and synthetic fibers, cotton is soft, takes dye well, and is less expensive. It is used most often for flat woven area rugs like *dhurries* from India. Cotton fabric strips are braided into rugs and used in informal settings.

Sisal, Jute, and Hemp

Sisal, jute, hemp, and other grasses are inexpensive floor coverings generally limited to area or room-size rugs (Figure 9.17). These fibers can be woven into simple or intricate designs, and are often made in sections and assembled. Although they provide a natural look, they are not as comfortable underfoot. Japanese tatami mats are made from grasses. Grass flooring is flammable and not particularly durable.

Yarn

The performance of a carpet also depends on the quality, height, density, and quantity of the yarn. Yarns are produced by twisting fibers together into tufts. A tight twist helps the yarn spring back, creating a resilient carpet. Proper heat setting of the yarn holds the twist in place.

The pile height is the length of the yarns; the pile density is the number of tufts per square inch. Taller carpets with greater density contain a greater quantity of yarn. The combination produces a face weight measured in ounces per square yard. Face weights are commonly between 24 and 48 ounces.

A simple test to determine the quality of a piece of carpet is to fold the carpet back on itself. If there are wide spaces or gaps between rows and large amounts of backing show (called the "grin"), the carpet probably will not wear well. A short pile carpet will require a denser pile (more tufts per inch) than a taller pile carpet to pass this test.

In theory, a tightly twisted yarn, properly heat set, with the appropriate combination of pile height and pile density produces the best carpet. In addition to fiber and yarn composition, other factors such as construction, backing, and surface characteristics also affect the outcome of these combinations.

Construction

Because of technological developments, the old carpet construction methods (weaving, needle-punching, flocking, and handmade construction) are not often used. Most carpets on the market today are tufted.

Tufting

Tufting accounts for approximately 90 percent of all carpet construction. Based on the principle of the sewing machine, this method involves inserting thousands of threaded needles into a backing material. Heavy latex coating is applied to the backing to permanently anchor the tufts. Some tufted carpets have a double backing for greater strength.

Weaving

The three types of woven carpets are Wilton, Axminster, and velvet, illustrated in Figure 9.18. The *Wilton* carpet takes its name from the town in England where it was first made in 1740. It is woven on a loom with a special Jacquard attachment. The yarns are carried along the background of the carpet until they are drawn to the surface to form loops. After more than 200 years, the Wilton carpet is still regarded as a standard of high quality.

The *Axminster* carpet also derives its name from the town in England where it was first manufactured in 1755. Originally a hand-knotted carpet, it is now made on a specialized loom in which yarns are set in a crosswise row, permitting each tuft to be controlled individually. This process makes possible an almost unlimited combination of colors and patterns. High-end residential clients and many hotels may require or request the Axminster technique to achieve the desired appearances and quality (Figure 9.19).

Axminster carpet. Top diagram shows different colored yarns. Bottom diagram shows use of curled down yarns for multilevel effect in face of carpet. (Courtesy of James Lees and Sons Company.)

Wilton carpet (loop pile). Pile is woven over strips of metal, which are removed during weaving process.

Velvet carpet (cut pile). Backing of jute and cotton holds pile yarn in place.

FIGURE 9.18 Three types of woven carpets.

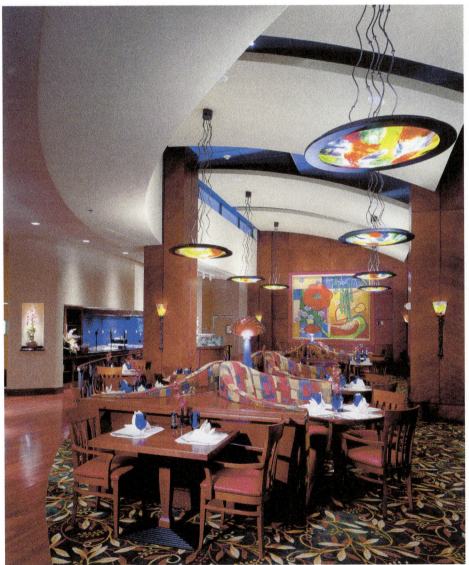

FIGURE 9.19 The carpet in this hotel lobby bar is a custom Axminster. The patterned design is reflected in the upholstery and in the decorative chandeliers. The massive curved ceiling and solid wood walls bring form and simplicity to the vibrant patterns.
(Designer: Design Directions International. Photography by Neil Rashba.)

Velvet, the simplest form of carpet weaving, is traditionally a smooth-surface pile, cut or uncut, in a solid color. The pile loops of velvet carpet are woven over long wires extending the full length of the carpet.

Needle-Punching

In the needle-punching process, an assembly of corded fiber webs is compacted and held together by felting needles that mechanically interlock the fibers. The back of the carpet is coated with latex or other weather-resistant materials. This method can produce a wide variety of textures, and the carpet sells at a low cost.

Flocking

Flocked carpets have short clipped fibers providing the appearance of velour. They may be produced by three basic methods: *beater bars, spraying,* or an *electrostatic method* (the latter accounts for most flocked carpets). In the electrostatic method, chopped fibers are introduced into an electrostatic field where they become charged. The charged fibers are then projected toward a backing fabric coated with adhesive, where they become vertically embedded. Flocked carpets have a low level of abrasion resistance and are not readily available.

Handmade Construction

Various types and styles of rugs are made by hand. These methods are discussed later in this chapter.

Backing

The unseen parts of a carpet—the backing and the glue that hold the backing—are important. Together they secure yarns to the foundation and prevent stretching, buckling, and shrinking. Polypropylene and jute are the most common backing materials. Jute is strong but may mildew and therefore is not suitable where floors may be damp. Polypropylene resists mildew and is also strong. Tufted carpets may have a secondary backing applied for extra strength. It may be jute, polypropylene, rubber latex, or vinyl.

Surface Characteristics

Carpets are described by their surface characteristics as either an uncut *level loop* or a *cut pile* (Figure 9.20). The length of the yarn and the texture or design created by the uncut or cut yarns produce these characteristics.

Level Loop

Level loop carpets are tufted or woven with looped tufts. Because the yarns are not cut, level loops wear extremely well when produced from durable fibers. Level loop carpets are available in solids, heathered solids, and a variety of geometric, stylized, and abstract patterns. Level loops are used in many commercial environments (Figure 9.21). When the heights of the loops are varied, the carpet is called a multilevel loop.

Berber carpets, a type of level loop carpet, utilize thick, relatively untwisted yarns. Strong fibers must be used to compensate for the lack of twist. Berbers are found in neutral tones and occasionally soft pastels.

Cut Pile

Cut pile carpets are formed when the loops of yarn are cut or sheered. Various designs have the following characteristics:

- *Plush* or *velvet carpets*, the original style of cut piles, have a dense upright and evenly cut pile under 1" in height. The carpet is

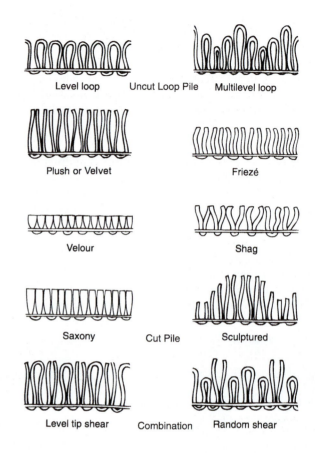

FIGURE 9.20 Surface characteristics of carpet: Level loops: level loop; multilevel loop. Cut piles: plushor velvet; friezé; velour; shag; Saxony. Combinations: sculptured; level tip shear; random shear.

enhanced by highlights and shadings, which provide an extra dimension. Plush carpets are generally more appropriate for formal areas with little traffic. Plush carpets are more resilient and appropriate in short pile heights, under 3/8", for commercial wear. A short, fine, dense plush is called a velour.

- A *friezé carpet* has a tightly twisted yarn, giving a rough, nubby appearance. Friezés are resilient and resist abrasion.
- *Shag carpets* have pile yarns that are more than 1" in height and low in density. The tufts are designed to lie flat, giving a shaggy, informal appearance.
- A *Saxony carpet* is similar to a plush, but has more yarns twisted together. The surface of the Saxony appears rougher than that of the plush.

Combination Loops and Piles

Sculptured carpets combine various heights of cut pile and/or level loops to create a design. Sculptured carpets, such as the *random shear*, are most effective when the design is subtle. Too much variety in the heights of the yarns can cause poor resiliency. Yarns that are left all the same height and then selectively cut produce subtle patterns and are called *tip shear carpets*.

Custom-designed *hand-sculptured carpet* is one in which part of the surface has been cut away to form a pattern, or the pattern itself has been cut away from the background. This carpet style is often custom made and expensive.

FIGURE 9.21 In this high-tech interior, a multilevel loop carpet adds warmth and tactile interest to the sleek wood and metal finishes.
(Photograph courtesy of Holey Associates and Cesar Rubio Photography)

Flat Woven

Flat-woven cellulose fiber rugs are machine-made of coarse flax fiber, paper pulp or "kraft" fiber, sisal, hemp, and other grasses and rushes. They come in full-sized rugs or in one-foot squares to be sewn together. Fiber rugs are usually in natural colors but are sometimes dyed. Popular in warm climates, they also provide inexpensive year-round floor coverings in many contemporary settings. Other flat-woven styles include *dhurries* from India, *Navajo rugs* from America, and *Rollikans* from Scandinavia.

Special Features

Additional design features may be necessary when selecting carpets for specialty commercial uses. To control static electricity, synthetic fibers can be altered during the **viscose** stage (further discussed in Chapter 12, Textiles) or covered with a special coating after they are manufactured. A low static electricity rating, usually less than 3.5 kilovolts, is required in all areas where computers or electronic equipment will be used. An antimicrobial treatment is necessary in health care environments. Advanced soil-resistant treatments may prove beneficial in areas with extremely high traffic.

More info online @

www.carpet-rug.org/residential-customers/selecting-the-right-carpet-or-rug/carpet-and-rug-construction.cfm Carpet and Rug Institute's site on fiber and construction
www.carpetinfo.co.uk/all_about_carpet/how_carpet_is_made.htm Carpet construction information from the United Kingdom
www.carpetguru.com/const.html General information on carpets, pads, and fibers
www.carpetbuyershandbook.com Hobby site on carpet selection

■ HANDMADE RUGS

Oriental Rugs

The making of Oriental rugs is a great art, and these rugs have been coveted possessions for hundreds of years. During the eighteenth and nineteenth centuries, rugs from China and the Middle East were in great demand among wealthy Americans who wanted to adorn their Georgian- and Federal-period mansions.

With the advent of wall-to-wall carpeting, Oriental rugs were in less demand, but during the past few decades they have been rediscovered and are again desirable for contemporary use, regardless of style. To meet the current demand, manufacturers are duplicating authentic Oriental designs in loom-woven rugs retailing at a fraction of the cost of the handmade ones. These rugs are called "Oriental design rugs" to distinguish them from the hand-loomed rugs made in the Orient called "Oriental rugs."

Oriental Rugs from Persia and Turkey

The great majority of Oriental rugs come from Persia (Iran) and Turkey. These rugs are made by hand-tying a knot in each weft thread as it crosses the warp. The knot is either the *Ghiordes* (Turkish) or the *Sehna* (Persian) type, depending on the area in which it is made (Figure 9.22). Rugs are frequently made by members of a family who use the same pattern generation after generation. The name of the particular rug is usually that of the family or is taken from the name of the village or area in which the rug was made.

Given the myriad types with distinct design origins from different areas, towns, tribes, and families, the study of Oriental rugs can be a lifelong pursuit. A logical beginning is to become familiar with the three Oriental rugs from the Near East: the Kirman, Sarouk, and Tekke, commonly called Bokhara.

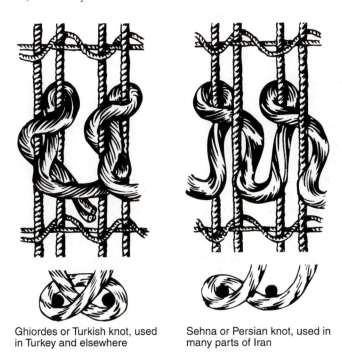

Ghiordes or Turkish knot, used in Turkey and elsewhere

Sehna or Persian knot, used in many parts of Iran

FIGURE 9.22 Principal knots used in making Oriental rugs.

A top-grade *Kirman* is among the most costly of Oriental rugs. A common type has a central medallion surrounded by a plain ground with a wide border of intricate design (Figure 9.23). Sometimes the entire ground is filled with delicate blooms. This rug is one of the few Oriental rugs that are available with an ivory background.

The predominant colors in the *Sarouk* are exotic jewel tones of red, rose, and deep blue, with black and ivory as accent colors. Although the pattern is predominantly floral, it does feature some geometric devices. The Sarouk may also have a vibrant medallion outlined in dark colors. The pile is usually heavy (Figure 9.24).

The *Bokhara*, originally from Turkistan, is made in many Middle Eastern countries. The background of the Bokhara may be red, cream, or blue, but the predominant color is always red. The easily recognizable design is made up of octagons or polygons called *guls* (roses), which are repeated uniformly about the field. When the guls are quartered by narrow lines running the length and width of the field, the design is popularly called *Royal Bokhara*.

Oriental Rugs from China

The art of rug making has been practiced in China for more than twelve centuries. The oldest known rugs were from the T'ang dynasty (618–906). The oldest existing rug dates from the Ming dynasty (1368–1644). Early designs were taken from ancient Chinese silk weaving and are symbolic of ancestor worship. Ancient symbols, of which there are over 100, fall into a number of categories. Chinese rugs can be recognized by the following characteristics:

- Colors of Chinese rugs are typically blue and white (often used for the field), with yellow-orange, red-orange, gold, and cream also used in various combinations.
- Geometric designs are used primarily as border ornamentation. The Chinese T, key, or fret designs are the most familiar. The circle with a square in the center and two curved cells within a circle, symbolizing male and female, are common motifs.
- Religious symbols are commonly used, including the dragon, which symbolizes God and emperor, and waves and closed bands (eternity). Among the mythological symbols are the lion (authority), horse (strength), fish (abundance), and stag and crane (longevity).
- Flowers most commonly used are the lotus (purity), peony (prosperity), and chrysanthemum (fidelity).

Chinese rugs are made from complete paper models, and the design is outlined on a cotton warp. The pile is higher than on rugs made in the Middle East, and designs are sculptured by clipping the yarns along the contour of the pattern.

Rugs made in eastern China usually have allover patterns reflecting the Middle Eastern influence. The two most familiar Chinese rugs are the *Mandarin*, which has no border, an open ground, and a different asymmetrical floral spray in each corner, and the *Peking*, which has a wide border, similar corner motifs, and a round central medallion. Peking design rugs made in India are called *Bengali* (Figure 9.25).

Oriental Rugs from India

Today, many rugs of excellent quality are handmade in India and exported worldwide. Rugs employing old and authentic designs from China, Iran, Turkey, and France are made from top-quality wool (mostly from New Zealand) and sell at moderate prices.

Numdah rugs, used in India for centuries, have been imported into the United States for many years and recently have revived in popularity (Figure 9.26). This rug is an informal type made of felt. The wool surface is traditionally enriched with bird and floral motifs worked with a long, open stitch.

Dhurries are flat-weave rugs hand-woven in India (Figure 9.27). They are tightly woven in wool or cotton and incorporate both stylized and geometric designs. Colors are frequently pastels and medium tones on a natural field.

FIGURE 9.23 A common Kirman design includes an open ground, a wide, uneven border, and a medallion center.
(© Ksenia Palimski / Shutterstock)

FIGURE 9.24 This highly contrasted Sarouk rug is covered in floral patterns set in a geometric frame.
(© The Print Collector / Alamy)

More info online @

www.mathforum.org/geometry/rugs Information about and images of Oriental rugs
http://oria.org Oriental Rug Importers Association

FIGURE 9.25 A Bengali rug from India, made in the Chinese Peking design.
(Courtesy of Stark Carpet Corporation)

FIGURE 9.26 This Numdah rug is made of rough felt with wool embroidery in the "tree of life" design.
(Photograph by Mark K. Allen)

FIGURE 9.27 The dhurries were used originally as sleeping bags for travelers. The thin wool or cotton rug could be rolled up and easily carried.
(Courtesy of Designer Rugs Limited)

French Rugs

Two French-style rugs have been produced with little interruption since the seventeenth century: the Savonnerie and the Aubusson.

The *Savonnerie* is a pile carpet made by hand with knotted stitches in the manner of Orientals but with French patterns (Figure 9.28). The Savonnerie factory, established in France in 1663 by Louis XIV, was an outgrowth of a workshop founded earlier in the Louvre. Although it was the first factory to produce tapestry-like rugs, it is best known for its velvety pile rugs, usually made in strong colors on a dark ground with elaborate designs sometimes taken from formal French gardens.

Aubusson rugs are distinctive. During the late seventeenth century when the upper classes of France became interested in beautifying their homes, long-established, privately owned workshops at Aubusson strove to imitate the weaving completed at Savonnerie. Some of the oldest Aubusson rugs have an Oriental flavor, but later ones follow the French textile designs employing small-scaled, stylized floral themes. Colors are usually soft, muted pastels, giving a faded effect (Figure 9.29).

FIGURE 9.28 The French Savonnerie is a velvety pile carpet, typically with intricate French designs.
(Courtesy of Designer Rugs Limited)

FIGURE 9.29 Aubusson rugs are made of tapestry weave, usually with French designs in pastel colors.
(Courtesy of Stark Carpet Corporation)

Other Types of Rugs

Moroccan Rugs

The Moroccan is a type of Oriental rug made primarily in Northwest Africa. The character of the rug has changed little in 1,000 years. Its distinctive informality has made it a favorite in contemporary decor. The most common Moroccan rug is the Berber.

Berber rugs are traditional types made primarily by Berber tribes in the Atlas Mountains. The designs are abstract and geometric. Some are primitive, often of natural wool color with simple black or brown designs; others are vividly colored.

The Spanish Matrimonia

The Spanish matrimonia, the traditional bridal gift in Spain, is the fringed, bold-figured Manta rug. Woven on the Jacquard loom, these rugs have subtle shadings, a handcrafted-like texture, and a three-dimensional quality. Patterns are brightly colored and inspired by medieval motifs, classic Aubussons, Far East Orientals, mythical figures, and the tree of life (Figure 9.30).

Navajo Rugs

The Navajo rug is a hand-woven rug or blanket made by the Navajo in the American Southwest. Those of finest quality are made of wool and colored with vegetable dyes. Designs are usually geometric with frequent zigzag, chevron, and diamond motifs combined with stripes (Figure 9.31). Stylized representations of birds, animals, and human figures are sometimes used.

Rya Rugs

Rya is a name derived from an old Norse word meaning "rough." This hand-hooked rug is a traditional import from Scandinavia, where it has been used for centuries. The rya is a high-pile shag rug combining a blend of multicolored yarns forced into a wool backing with a rug hook. The yarns are cut at an angle and at various heights, creating the "shaggy" appearance. Geometric designs of all types are often combined with stylized nature themes. Rya rugs are ideally suited for use as area or art rugs in contemporary settings.

Rag Rugs

Rag rugs were one of the first floor coverings made by American colonists. Scraps of cotton, linen, or wool fabric were cut in narrow strips and then sewn together to form long strands, then woven in a plain weave on a cotton or linen warp. The craft of making rag rugs is still practiced.

Braided Rugs

Braided rugs were originally made in the home from scraps of clothing and blankets. They are still a favorite for rooms with a provincial atmosphere, especially in colonial American and country French rooms. Strips of rags are stitched together (on the bias), then braided into long ropes, which are either sewn or woven together in rounded or oval shapes (Figure 9.32). Rugs of this type are also produced commercially at reasonable cost.

Hooked Rugs

Hooked rugs are made by hooking colored rags or yarns through a tightly stretched piece of burlap, canvas, or wool to form a design. The foundation fabric and the type of material used for filling determine the degree of durability.

Needlepoint Rugs

Needlepoint rugs were originally made by embroidering wool yarn on a heavy mesh canvas. Designs range from simple to highly complex floral motifs in a wide array of colors.

More info online @
www.hometime.com/Howto/projects/flooring/floor_1.htm Do-it-yourself website on flooring

FIGURE 9.30 The elaborately woven matrimonia rugs are created based on the bride's status. Handed down through generations, the fine rug is used in the marriage ceremony and may be made of linen, cotton, wool, silk, or gold and silver threads.
(Courtesy of Designer Rugs Limited)

FIGURE 9.31 This Navajo rug is characteristic of much of the art of Native Americans and is similar to Peruvian rugs.
(Photograph by Mark K. Allen)

FIGURE 9.32 A braided rug can be used in any setting where a country look is desired.
(Dave King © Dorling Kindersley)

◼ PADDING

Most carpets and rugs require a quality pad or cushion, which provides tremendous value for the initial cost. Cushioning improves and helps to maintain the appearance of the carpet and enhances its resiliency. Carpet pads absorb noise, help to control the room's temperature, and create a feeling of luxury. Padding is particularly beneficial in areas where the subfloor is uneven because the pad assists in smoothing out the floor. There are three general categories of padding: fiber, rubber, and urethane foam.

- *Fiber cushions* can be made from natural products (such as animal hair or jute), synthetics (such as nylon or polyester), or recycled textile fibers. A fiber cushion creates a "firm" feel.
- *Rubber cushions* can be either flat or ribbed. The flat gives a firm feel and the ribbed a stiffer feel.
- *Urethane foam cushions* come in a variety of types. *Conventional* and *grafted prime urethane* foams are manufactured from a chemical mix and are available in a variety of densities. *Densified polyurethane* has undergone a further process to meet specific guidelines. *Bonded* foam is made by fusing shredded pieces of urethane foam together. *Mechanically frothed urethane* foam was originally developed as a cushion attached to the back of carpet. It typically has a higher density and firmer feel.

When selecting a pad for residential use, designers should keep in mind the following recommendation from the Carpet Cushion Council (CCC): "The heavier the traffic, the thinner the cushion." For commercial use, the CCC has developed a labeling system based on volume of traffic. Pads with a Class I rating are acceptable for moderate traffic, those with Class II for heavy traffic, and those with Class III for extra heavy traffic. According to an independent testing organization, carpet padding helps to reduce interior noise. The noise reduction coefficient doubled in interiors with carpet cushion when compared with areas with no cushion.

In some commercial office environments when level loop carpet is used, no padding is laid beneath the carpet. The carpet is said to be "direct glue" and is literally glued to the plywood or concrete subfloor. Thick padding is inappropriate in commercial environments because it gives the appearance of a luxury residence and can be difficult to negotiate.

More info online @

http://carpetcushion.org Carpet Cushion Council
www.afpf.com/carpetwhypoly.html Alliance for Flexible Polyurethane Foam

◼ DESIGN CONSIDERATIONS

Aside from the performance characteristics of the carpet and pad, designers must also consider aesthetic factors. These factors include the *size and space, color and pattern*, and *texture*.

Size and Space

The size of the carpet or rug depends on the characteristics and intended use of the particular space. For instance, wall-to-wall carpets have distinct uses, but may also be bordered to give the appearance of an art or area rug.

Wall-to-wall broadloom carpet has some distinct advantages: It creates continuity within a room or from room to room, makes rooms look larger, adds warmth and a feeling of luxury, requires only one cleaning process, and provides maximum safety from accidents. This carpet treatment also has some disadvantages: It must be cleaned in place, and it cannot be turned for even wear.

Carpet tiles have many of the same benefits as wall-to-wall carpet with the additional advantage that a tile can be replaced should it become soiled or damaged. Carpet tiles are glued directly to the floor. They allow for greater flexibility in design and access beneath the floor (see Figure 6.40B).

A *room-sized rug* is one that comes within a foot or so of the walls, leaving a marginal strip of floor exposed. The room-sized rug has most of the advantages of wall-to-wall carpeting, plus some extra benefits. It can be turned for even distribution of wear and removed for cleaning. Two processes, however, are necessary for complete cleaning—one for the rug and the other for the exposed flooring material around it.

An *area rug* does not cover the entire floor but is used to define an area of a room according to its function. The area rug should be large enough to accommodate all the furniture used in the area grouping. This type of rug is versatile and may easily be changed for different grouping arrangements.

An *art rug*, which is usually smaller than an area rug, is generally handcrafted and used as an accent or treated as a focal point. This rug is often placed so that furniture does not encroach on it, enabling it to be admired like a piece of art on the floor. Sometimes an art rug functions as an area rug.

Scatter or *throw rugs* are smaller rugs often used as accents or as protection for a spot that receives hard wear. Care should be taken to ensure that throw rugs have a slip-resistant backing so they do not to "throw" the user.

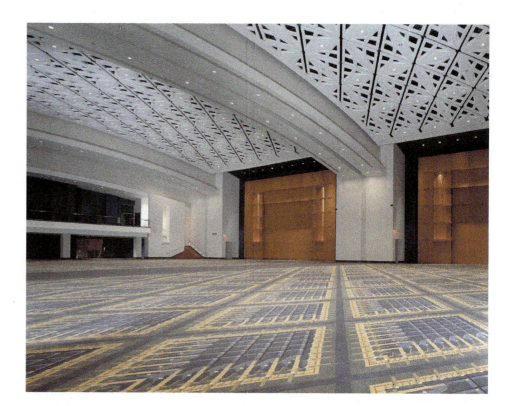

FIGURE 9.33 The angular carpet and ceiling patterns juxtapose the sweeping arched beams in this exciting convention center. The large patterns are necessary to fit the scale of the room; however, it is the intricate details in the patterns that create the character of the interior environment and form a human scale. The carpet is by Ulster, and the ceiling is Formglas GRG (glass-reinforced gypsum). *(Photo by Brian Gassel / tvsdesign)*

Color and Pattern

Color is a critical factor in the selection of a carpet. As with textiles, discussed in Chapter 12, dyeing processes vary and some fibers accept color better than others. Generally, the earlier the color is added in the manufacturing process, the longer the color will remain.

Neutral color carpet allows for a variety of changes in other finishes. In apartments, tenant offices, and other places with frequent turnover rates, neutral colors are the best choice. In restaurants or other high-traffic areas, patterns and colors in middle values hide dirt the best. A light color will easily show stains, whereas a dark color will show lint and dust.

Lighting also affects the carpet's color. Fibers, style characteristics, and textures of carpet absorb and reflect light differently. A sunny room may call for a carpet in cool colors, whereas a northern exposure or dark room may require warm colors in lighter tones. Carpets should be tested for color in their final environment.

Wall-to-wall carpets in solid colors or overall texture give a feeling of spaciousness. Large patterns tend to fill up space and are usually best reserved for larger areas (Figure 9.33). If the carpet selected has a pronounced pattern, then walls, drapery, and upholstery tend to be complemented when plain colors or unobtrusive patterns are employed (as seen in Figure 9.16). Carpets with a plain overall effect permit a wider choice of furnishings.

Texture

Each carpet or rug type has a unique texture, such as smooth, shiny, dull, rough, and so on. The surface quality of the carpet should be aesthetically compatible with other furnishings. The considerations discussed in Chapter 12 for selecting textures of textiles also hold true for the selection of carpet textures. A carefully chosen carpet or rug can coordinate all furnishings of the room and provide unity.

■ CODES AND REGULATIONS

Federal, state, and local laws or codes and regulations set particular standards (especially for flame resistance, flame spread, and smoke generation) regarding the performance and quality of a floor covering. There must be a label attached to the floor covering indicating the name of the manufacturer, the Federal Trade Commission number, the fiber content, the weight of the fiber, and flame-resistance qualities. Building codes vary in different areas; therefore, the designer must be knowledgeable about local codes and regulations before specifying a particular floor covering. Commercial projects require carpets rated for commercial installations.

■ MEASURING AND INSTALLING

Before purchasing the selected floor covering, it is necessary to figure the amount of material needed to complete the job. Although some carpet is priced by the square foot, carpet is historically priced by the square yard and designers need to be able to determine the amount of product required. To arrive at an estimate, designers must determine the square footage of the space to be covered and divide by 9 (the number of square feet in a yard). This will give the approximate square yardage needed; however, additional yardage is required for

piecing the carpet and for matching pattern repeats. Many designers prepare a cut or seaming diagram to guide the installation and to assist in figuring the correct yardage (Figure 9.34). Carpet seams should be avoided in major traffic areas. The *nap* of the pile (sometimes called the *pile sweep*) must be laid in a uniform direction to prevent light variation.

When specifying carpet for a residential or commercial project, the designer indicates installation methods and techniques. There are two basic installation methods: the stretch or tackless strip and pad method, and the glue-down method. In the *stretch and pad method*, a 1-inch-wide plywood strip with small projecting metal pins is nailed around the perimeter of the room, and the pad is nailed, glued, or stapled inside the strip. The carpet is stretched over the pad and then attached over the pins of the strip. TACFAST, by Karastan Bigelow, also offers a hook-and-loop technology that secures carpet to the floor through a system similar to Velcro. In the *glue-down method*, glue or adhesive is applied to attach the carpet to the floor.

SUMMARY

The decision to select a particular floor covering forms an important piece of the interior environment puzzle. Broad design decisions must first address the need for a hard or soft flooring material. The floor covering can create the interest or focal point, or serve as the neutral element unifying a room or series of rooms (Figure 9.35). Carpet selection requires close attention to design characteristics and construction methods to ensure durability. Considerable time should be devoted to selecting the proper floor covering that not only looks great, but also maintains its appearance through years of foot traffic.

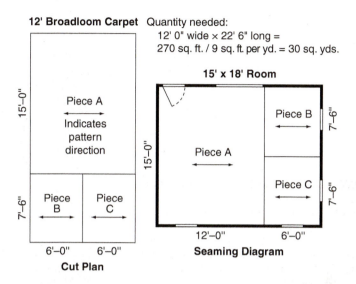

FIGURE 9.34 A seaming diagram for a 15' × 18' room covered with 12'-wide broadloom carpet and a cut plan for the 12'-wide roll of broadloom carpet.

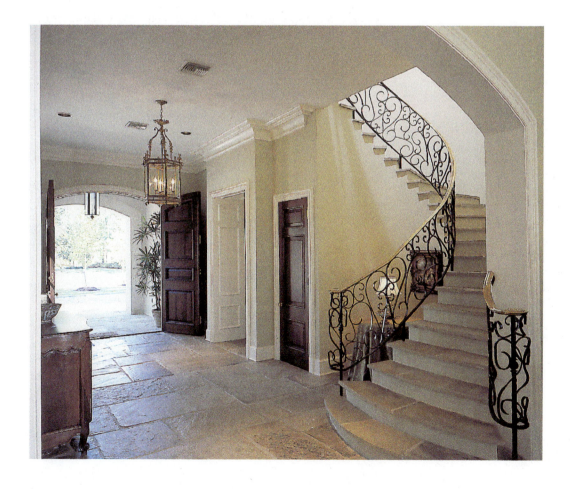

FIGURE 9.35 This foyer sets a formal, masculine tone for the residence. The stone flooring unifies the interior and is an excellent selection for the high-traffic area. *(Courtesy of Renaissance Reclamation)*

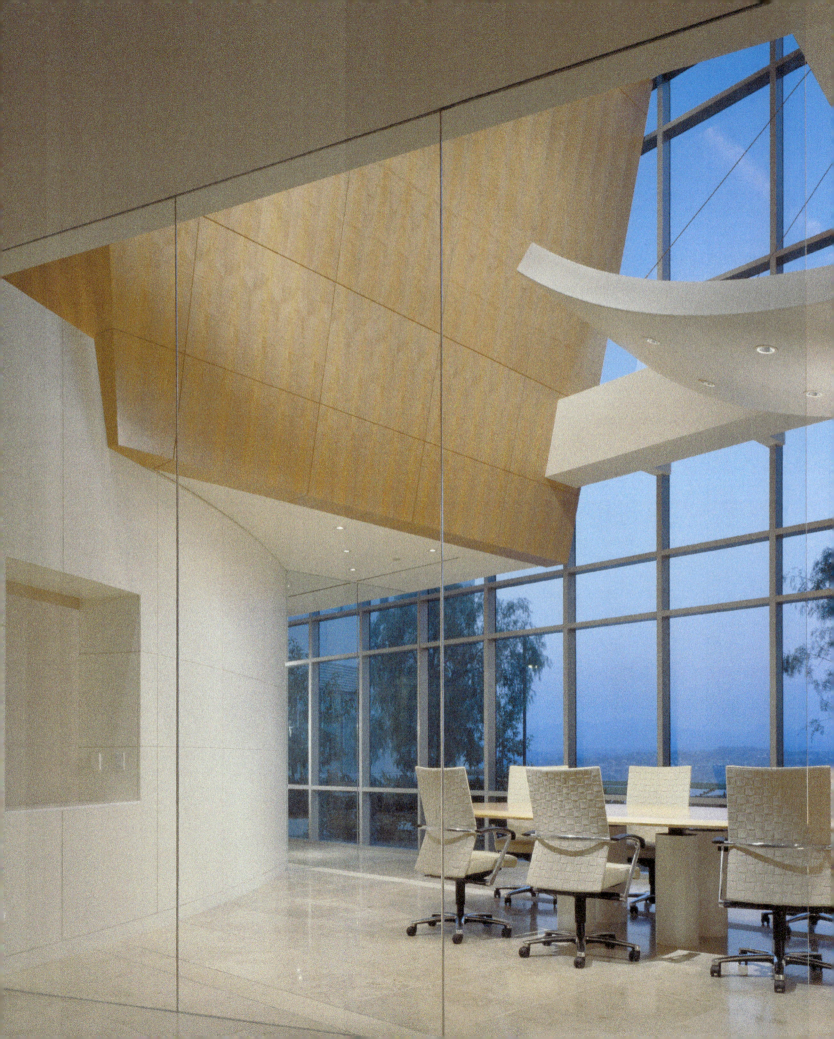

10 Ceilings and Walls

CEILINGS

The ceiling—the largest unused area of a room—has been given special attention for hundreds of years. The ceilings of Renaissance palaces were magnificently sculpted and adorned with decorative plaster. Ceilings during the settlement period in America were usually low and plain with visible support beams. During the Georgian, Federal, Greek Revival, and Victorian periods, ceilings were generally not as ornately designed as in earlier periods in Europe, but did include some decorative treatment. Ceilings continue to receive special attention, as illustrated in Figure 10.1.

The functions of the ceiling include providing (1) protection from the elements, (2) insulation for heating and cooling, (3) a source for artificial lighting (and natural lighting, when skylights are used), (4) an acoustic barrier for absorbing or reflecting sound, (5) a flame-resistant barrier that meets standard fire codes, and (6) an important element of the character and atmosphere of a room.

In many current interiors, the ceiling's potential to add character and atmosphere to a room has been neglected. It has been covered with gypsumboard (a type of wallboard) and painted white. The following section discusses some of the various types of ceilings that designers can use.

■ TYPES OF CEILINGS

Ceiling designs can be distinguished according to various structural forms and their placement or direction.

- The *flat ceiling* is usually plastered, painted, or covered with wood strips. The flat-beamed ceiling is one in which the structural beams are exposed or lightweight beams have been applied.

FIGURE 10.1 Soaring ceilings, while dramatic, also need to relate to the scale of the individuals gathered in the interior. In this spacious conference room, a suspended ceiling helps to define the human scale and supports the task lighting. The play of angular and curved planes is reflected in the background elements, as well as in the selection of the conference room chairs. The formality of the interior defines the importance of a meeting's content for both the employees and the employees' clients.
(Architect/Designer: Gensler. Photography by Chris Barrett at Hedrich Blessing.)

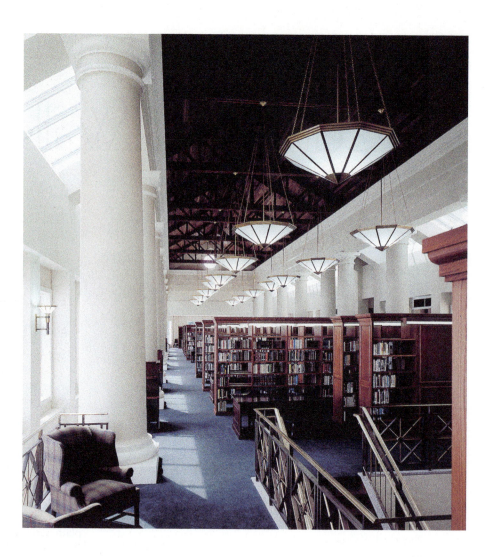

FIGURE 10.2 In this library, located at Culver Academy in Culver, Indiana, the designers used a gabled and beamed ceiling to contrast with the refined traditional columns.
(Architect/Designer: Hellmuth, Obata & Kassabaum. Photograph by Balthazar Korab Ltd.)

- The **shed** or *lean-to ceiling* rises diagonally to one side in a single slope. The furnishings in a room with this ceiling must be arranged carefully to achieve a comfortable balance.

- The *gabled, double-pitched*, or **cathedral** *ceiling* expands vertical space, especially when beams extend upward (Figure 10.2). Placing beams horizontally emphasizes the room's length.

- A ceiling whose middle portion extends vertically up about 6 to 18 inches is called a **tray** ceiling. Trays may be formed in many shapes and may conceal lighting around the perimeter (Figure 10.3).

- The *sculptured, custom-designed ceiling* may call attention to itself as the room's focal point. Sometimes designed in highly dramatic ways, sculptured ceilings follow no set pattern and usually require ample space for construction and effect (Figure 10.4).

- The **coved ceiling** meets the wall with a curve instead of a right angle, so the ceiling and wall flow into each other. Sometimes the perimeter is made to accommodate recessed lighting, allowing light to shine upward on the ceiling surface.

- **Vaulted** and *domed ceilings* are arched structures as opposed to flat planes and can be considered a complete extension of the coved ceiling (Figure 10.5).

- **Coffered ceilings**, popular in past centuries, are constructed of wooden members in a grid manner, often with moldings and sunken decorative panels.

- A *dropped ceiling* has a portion or its entire area lowered below the main structure (as seen in Figure 10.4). This type of ceiling can define an area of a room (a dining area in a dual-purpose living room or a reception area in a lobby, for example), provide indirect lighting, and add interest to a living space.

- In many commercial settings, the ceiling is actually nonexistent and is formed by the exposed structure above. This type of ceiling allows for extensive flexibility in lighting placement. Furniture showrooms and other retail establishments use this method of ceiling treatment to accommodate the great variety and abundant changes in the merchandise displayed. Restaurants may use this design to create an informal or high-tech feeling. In residential settings, this type of ceiling may be used to add drama (Figure 10.6).

More info online @

www.armstrong.com/commceilingsna/article22542.html Armstrong commercial ceilings glossary

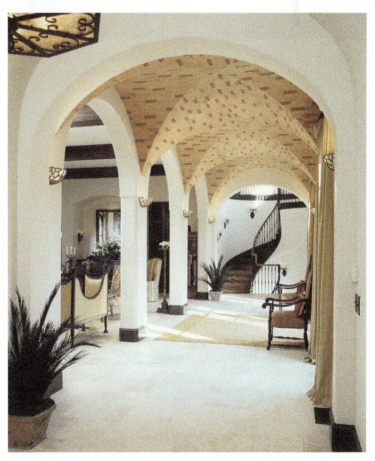

FIGURE 10.3 In this home theater in Boca Raton, Florida, the designer created an amorphous ceiling recess to add interest and conceal the light source. Walls were designed to look like concrete and are complemented by overstuffed furniture and a plush fabric. *(Designer: Charles Greenwood, IIDA, of Greenwood Design Group, Inc. Photograph © Robert Thien.)*

FIGURE 10.4 This sculptured ceiling in a mall food court area adds rugged interest and limits the scale of the very tall ceiling. The stepped-down ceiling allows for a variety of lighting effects between the levels and brings the tall ceiling into a more human scale. The lower ceiling areas define the location of food service. *(Photo by Brian Gassel / tvsdesign)*

FIGURE 10.5 This entryway includes a series of vaults that establishes the corridor to the winding stairway. The vaulted ceiling was used extensively in Gothic cathedrals and is an unexpected treat in a residential environment. *(Designer: Pineapple House. Photograph by Scott Moore.)*

FIGURE 10.6 To give the illusion of endless space, designer Harry Stein painted the beams and part of the ceiling black and strategically placed numerous lamps. Other sections of the ceiling are mirrored, adding to the effect of depth in this New York penthouse.
(Photograph © Norman McGrath)

■ CEILING CONSTRUCTION AND MATERIALS

Ceiling materials may be divided into two general categories: those that attach directly to the structure (such as plaster, gypsumboard, glass and plastic panels, stamped metal, fabric, and wood) and those that hang from the structure (such as suspended ceiling tiles).

Plaster and Gypsumboard

Plaster is the most versatile of all ceiling treatments. Plaster is a thick mixture of gypsum, water, lime, and sand. This mixture is applied to a metal lattice, a special hardboard, or any rough masonry surface. The finished surface may be smooth, textured, wallpapered, or painted. Sometimes a plaster ceiling is stenciled or has applied decoration or moldings. Plaster has been used for centuries, but currently the cost is relatively high.

Because of the high cost of plaster, gypsumboard is more commonly used. The 4' × 8' panels have a finished surface like plaster. Gypsumboard provides insulation and is available in many thicknesses. When layered, it is highly fire resistant. Gypsumboard also forms the main element for unique sculptured designs (Figure 10.7).

Glass-reinforced gypsum, known as GRG, is a lightweight composition of high-strength gypsum reinforced with glass fibers. The product is manufactured in molds in a variety of standard sizes and shapes, or it can be custom designed for particular applications. The product is brought to the site and installed, then the final finish work is completed to create the appearance of a monolithic structure. It can be used to create domes, intricate patterns, molding details, and columns (as seen in Figure 9.33).

More info online @

www.formglas.com/home.html Formglas site on background materials
www.gp.com/build/product.aspx?pid=1572 Georgia Pacific site on glass reinforced gypsum

Glass and Plastic

Glass or plastic panels, either translucent or transparent, are sometimes used in ceilings to provide overhead light—either natural daylight or recessed artificial light. These panels may provide overall illumination or striking lighting effects from high-up windows. Skylight views add a new dimension to any interior.

Stamped Metal

Stamped metal ceilings were popular during the nineteenth century and add a historical feel to interior environments. These ceilings are used in the restoration and construction of Victorian buildings and are commonly seen in commercial interiors such as restaurants and retail spaces. This treatment involves stamping or pressing designs onto metal panels, providing a unique embossed effect.

Fabric

Fabric, although not commonly used, can be stretched, shirred, or pasted (like wallpaper) to the ceiling surface. Its softness provides a comfortable, warm feeling and, when used as a repeating fabric in the room, can unify the interior. Figure 1.6A illustrates an unusual treatment of a fabric ceiling.

Wood

Wood, in strips, panels, beams, or planks, can provide a warm, inviting atmosphere. Because of its visual weight, wood tends to lower the ceiling and may create a feeling of heaviness unless the ceiling is higher than average. Often, wood is used in combination with plaster; for example, wood beams can stretch across a plaster ceiling. Wood can be left natural, stained, or painted. Where natural beams are not feasible, ceiling beams of polyurethane (which simulate hand-carved wood to a remarkable degree) can be glued to the ceiling.

Suspended Ceilings and Tiles

Suspended ceilings are common in commercial construction. Metal tracks are suspended from the structure, forming a 2' × 2' or 2' × 4' grid pattern, which is then filled with tiles. The tiles come in a wide variety of materials, colors, and patterns. Many have acoustical properties for absorbing noise. Others have a foil backing, which cuts

FIGURE 10.7 In this refined restaurant, Adam D. Tihany utilized gypsumboard in a multilevel sculptured grid pattern to create a bold, yet simple architectural statement. The texture of the materials provides warmth and adds depth to the interior. *(Architect/Designer: Adam D. Tihany International, Ltd. Photograph by Peter Paige.)*

down on air-conditioning and heating costs. Some manufacturers wrap ceiling tiles in fabric to create a warm, plush look. Another type of suspended ceiling system is the 1' × 1' concealed spline. Although this ceiling is more difficult to install, it gives a more uniform appearance than do the larger grids.

Suspended ceilings are versatile. Lighting and HVAC are concealed above the grid system in the space called the plenum. As interior furnishings are moved, the ceiling lighting may be moved to adjust to the new needs. Additionally, if HVAC or plumbing systems need to be upgraded, repaired, or moved, they are easily accessed.

■ CEILING ILLUSIONS

If a ceiling is much above or below the average main-floor height of 8 to 9 feet, it alters the general feeling of the room. A high ceiling emphasizes space and tends to create a feeling of dignity and formality. A low ceiling, which decreases space, can produce a warm, informal atmosphere. Designers should note the ceiling height with respect to the width and length of the room. A low ceiling in a very large room can be confining, whereas a high, tall ceiling in a small room can create the impression of living in a barrel. To accommodate the human factor, ceilings may be made to appear higher to suit an owner's preference for a more spacious feeling, or lower to provide a cozy, intimate atmosphere. To create the illusion of height, observe the following guidelines:

- Run the wall color or covering a short distance onto the ceiling, especially when the corners are coved. This treatment causes the eye to move upward and makes the ceiling appear higher (Figure 10.8). Use a light color on the ceiling.
- Use a predominance of vertical lines in the architecture of the room and in the decorative elements, like patterned wallpaper.
- Add a skylight to open up space.
- Use diagonal beams, which draw the eye upward, to make gabled ceilings appear even higher (as seen in Figure 10.2).

FIGURE 10.8 Wallpaper extended beyond the walls and into coved ceilings gives the appearance of greater height.

To create a lowered ceiling effect:

- Paint the ceiling a darker color or use a patterned finish.

- Extend the color or covering down onto the wall a short distance and end it with a border or a small molding. As attention moves upward, it stops at the molding and the ceiling seems to begin at that point. In this way the ceiling can be psychologically lowered as much as three feet.

- Use a predominance of horizontal lines in the room's architecture and decorative elements.

- Use wood ceilings and horizontal beams, particularly in natural wood or a bold or dark color.

In recent years, changing interior styles have produced exhilarating ceiling designs, which add new dimensions to interior spaces. Through the use of creative materials and finishes, and by incorporating a variety of ceiling heights within a residence or commercial setting, the ceiling can become the focal point or an important backdrop for other interior elements (Figure 10.9).

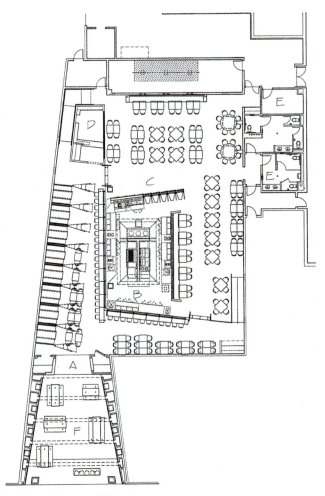

A: Entry/Maitre d'/Cashier
B: Exhibition Kitchen
C: Cart Loading
D: Service Station
E: Restrooms
F: Video Garden and Picnic Tables

FIGURE 10.9 Patrons are treated to visual as well as gustatory delight in this interactive restaurant. The designer altered the original cavelike appearance (caused by the 30' ceiling and minimal windows) by creating a focal point with the translucent hood over the kitchen. The hood also conceals the HVAC and exhaust fan systems. LCD screens and mirrors distributed throughout the restaurant allow all patrons to view the chefs at work. The concept of "restaurant as theater" creates drama and draws return customers.
(Designer: Jeffrey Beers International. Photograph by Troy Forrest.)

WALLS

The vertical background elements of a room are important factors in setting and maintaining the concept. Walls, windows, doors, and fireplaces are all part of the room's enclosure and provide the background elements for furniture and fabrics; however, their most important function is to provide a background for people.

Walls occupy the largest area of a room, define its size and shape, and serve purposes of both function and beauty. Functionally, walls provide protection and privacy from the exterior surroundings and create interior areas of various shapes and sizes for particular activities. Walls also provide space for plumbing pipes, electrical and telephone wires, and HVAC, as well as insulation against heat, cold, and noise. Aesthetically, they contribute significantly not only to the success of a room but also to its general atmosphere and personality.

◼ WALL CONSTRUCTION

Walls are generally defined as load-bearing or non-load-bearing. Load-bearing walls support other parts of the structure such as the roof or upper-level floors. Non-load-bearing walls function as dividers and do not support the structure, but may support shelves, cabinets, or other interior elements. Before moving or cutting an opening in a load-bearing wall, a designer must consult with a builder, engineer, or architect to determine alternative structural requirements.

Some non-load-bearing walls are freestanding, stopping at desk or counter height or just short of the ceiling. These walls provide some degree of privacy, but permit the flow of air, light, and sound from one area to another.

Non-load-bearing walls may also be moveable and part of an entire interior wall system. Many systems are manufactured by furniture companies and include connections to desks, shelving, accessories, and so on. These walls slide in below the finished ceiling and on top of the flooring and include chases for systems such as electric and plumbing. Materials and finishes vary, including the use of glass, wood, and metal (see Sustainable Design: Moveable Wall Systems).

◼ NONRESILIENT (RIGID) WALLCOVERINGS

Many materials are available for wall treatments. Each type has advantages and disadvantages with regard to appearance, cost, upkeep, noise, insulation, and longevity. Some wall treatments are extremely versatile; others belong to certain period styles or are used to evoke certain moods. When selecting materials for wall backgrounds, designers should consider aesthetics, function and the human factor, economics, and ecology, as discussed in the introduction to Part V.

Table 10.1 lists the most frequently used nonresilient wallcoverings, plus information on their general characteristics, fire ratings, insulation properties, and uses and care.

SUSTAINABLE design

MOVEABLE WALL SYSTEMS

Moveable wall systems can be considered a sustainable alternative to traditional construction techniques. As companies adapt to the economy and market needs, departments shrink and/or grow. The original spaces change. It is costly and messy to move traditional walls to meet these needs. Construction also creates a disturbance in the work flow—downtime—and traditional drywall construction ends up in the landfill.

One system in particular, created by DIRTT (Doing it Right This Time), has been developed with environmental sustainability in mind. DIRTT's wall system uses medium-density fiber board (MDF), which can be reused when a company needs to change the layout of its offices. As a bonus, DIRTT's wall hanging tile system can adapt to many different manufacturers' furniture and accessories, so clients may be able to reuse their existing furniture systems. Initial costs for the systems are more expensive in areas where labor costs are relatively low, but DIRTT's system actually can be cheaper where labor costs are high.

As with most moveable wall systems, doors can be installed into the walls. Internal chases carry electrical and other mechanical systems. Glass, wood, and other high-end finishes allow for a variety in design (Figure SD10.1).

More info online @
http://dirtt.net Website for Doing It Right This Time

FIGURE SD10.1 This moveable wall system includes floor-to-ceiling sliding doors and upgrades in wood walls and door hardware. The linear grooves, or tiled walls, allow for hanging accessories such as shelving.
(Designer: Michael Wirtz FIIDA. Courtesy of DIRTT.)

TABLE 10.1 Nonresilient Wallcoverings

Material	General Characteristics and Cost	Finishes	Fire Rating	Insulation Properties	Uses and Care
Brick (fired clay)	Solid and durable Variety of sizes, shapes, and colors Old, natural brick has feeling of warmth May be laid in regular or varied patterns Pleasant texture High cost	No finish necessary May be painted or waxed	Fireproof	Reflects noise Conducts heat and cold	Interior and exterior walls Appropriate for large- or small-scale rooms, and for fireplace facings and hearths Little or no upkeep
Concrete	Can be formed into a variety of shapes Substantial cost	Sealer is best for smooth inside finish, can be polished smooth, or left rough	Fireproof	Fair insulator	Interior and exterior walls, countertops, fireplace facing
Concrete blocks (lightweight aggregate)	Substantial, cold, regular shape, large scale, textured Moderate cost	No finish necessary May be painted Waterproofing necessary for exterior	Fireproof	Fair insulator	Interior or exterior walls, fireplace facings Best in large-scale rooms Lacks domestic warmth Little or no maintenance
Ceramic tile (clay)	Comes in a variety of shapes, sizes, colors, and patterns, and in pregrouted sheets Durable, resists water and stains, but may crack or break Moderately high cost	No finish necessary, but generally finished with a glaze to improve moisture and stain resistance Do not use glaze on floor; it is too slippery	Fireproof	Reflects noise Poor insulator	Bathrooms, kitchens, utility rooms, breakrooms Particularly appropriate for walls and dadoes in Spanish- and Mexican-style rooms Minimum upkeep
Ceramic tile (porcelain)	A type of ceramic tile made from a different clay. Same as above, except more durable and more resistant to moisture.	Same as above	Same as above	Same as above	Same as above, but better for outdoor use as it resists frost better. Can be better for flooring because it is harder.
Fiberglass (panels)	Translucent panels of reinforced fiberglass Most often ribbed or corrugated Also available in flat sheets and in several thicknesses Moderate cost	No finish necessary	Fireproof	Good insulator	Room dividers, folding screens, tub enclosures, translucent lighting panels for ceilings, built-ins, and sliding doors Easy upkeep
Glass (architectural)	Can be clear, rubbed, corrugated, pebbled, frosted, colored, or curved Metal mesh core will prevent breakage May be tempered Moderately high cost	No finish necessary	Fireproof	Poor insulator	Sliding doors, screens, room dividers, clinical purposes, numerous other uses Mirrors expand space and add dramatic element to rooms One-way glass has many functional uses
Glass (block)	Excellent light transmission High-impact strength Moderately high cost	No finish necessary	Fireproof	Solid glass blocks conduct heat Hollow blocks are good insulators	Contemporary settings Suitable to lighten most dark areas Easy upkeep
Metal (panels and tiles)	Stainless steel: plain or grained (nonreflective finish) Serviceable, sturdy, not affected by acid, steam, or alkalis Solid copper: attractive May be plain, hammered, or antiqued Sealed to prevent tarnish or corrosion Aluminum glazes: solid aluminum Coated with permanent vitreous glaze of porcelain, enamel, or epoxy enamel Sturdy, easy to maintain Lightweight and strong, but subject to dents that are difficult to repair Moderate cost	Factory finished with grain, or enameled in a variety of colors	Fire resistant	Reflects heat	Kitchens, bathrooms, utility rooms, and wherever sturdy wall is desired Unusual decorative uses residentially and commercially Easy maintenance

TABLE 10.1 Nonresilient Wallcoverings *(continued)*

Material	General Characteristics and Cost	Finishes	Fire Rating	Insulation Properties	Uses and Care
Plaster and stucco	Smooth or textured, no seams or joints Tends to chip and crack Moderately low cost	Paint, paper, or fabric		Special types have good insulation against noise	Versatile: appropriate for any room and any style Washable
Plastic (sheets)	Durable, resilient Comes in variety of colors, patterns, and textures Moderately high cost	No finish necessary	Poor Some do not burn but emit noxious gas	Poor insulator	Wherever durable, resilient walls are needed Resists stains and cuts Easy maintenance
Stone	Great beauty If covering too large an area, may appear cold, depending on color Natural colors and textures Feeling of strength and durability Improves with age High cost	Waterproofing sometimes required	Fireproof	Poor insulator	Fireplace surround or entire wall No upkeep
Wallboard (gypsum, drywall, or Sheetrock)	Surface may be finished in attractive colors and patterns, or imprinted with wood-grain appearance Lowest cost	Same as plaster: paint, paper, or fabric	Fire resistant	Excellent insulator	Any room in which low cost is primary consideration Care depends on finish
Wallboard (hardboard, pressed wood)	Extremely durable, dent resistant, available in many wood grains and colors Wood grain applied via high-fidelity photo process Factory coated, virtually indestructible, easily installed Also available in embossed and textured surfaces simulating fabrics Moderate cost	May be stained, painted, or waxed	Surface melts Pressed wood burns	Reflects noise Insulation depends on thickness of pressed wood	Any area in which wood paneling of low cost and durability is required Wash with damp cloth
Wallboard (plastic laminate)	Extremely durable Surface of laminate similar to plastic countertop Photo process can produce textured appearance, wood grains, colors, or patterns	Finished at factory Needs no additional finish	Smokes and melts	Reflects noise Fairly good insulator, depending on density and thickness	Hard-use areas of house Resists stains and moisture Scratches are irreparable Wash with damp cloth
Wood (plywood)	Matte or shiny surface High cost Thin surface of wood veneer bonded to rugged and inexpensive panel backing Appears much like solid wood, but less expensive Comes in 4' × 8' sheets for easy installation May or may not have vertical grooves Moderately high cost	Same as solid wood—usually not considered a finished look	Susceptible to burning	Good insulator and noise reducer	Depending on type of wood and method of installation, will go in any room—period or modern Beauty improves with age and care Dust only
Wood (solid)	Natural grain throughout Comes in variety of natural grains from rough barn wood to rich grains for formal rooms Can be installed tongue and groove, plain edged, flush joint, or grooved Natural colors vary, but may be stained any color Subject to denting, but can be refinished indefinitely High cost	Needs protective finish to seal against stains and water	Susceptible to burning	Good insulator and noise reducer	Same as plywood

Plaster and Wallboard

In addition to its use as a ceiling material, plaster makes a versatile, albeit costly wallcovering. It can be applied to create a smooth or rough finish (Figure 10.10). A less expensive alternative is wallboard, which may be made of gypsum, pressed wood, or plastic laminate. Gypsum wallboard—called drywall or by its brand name of Sheetrock—is the most common and is used extensively.

Drywall and pressed wood are inexpensive wallboard treatments that come in 4' × 8' panels that are secured to the wall's vertical stud supports. Wallboard provides insulation against heat, cold, and noise, and when painted produces a variety of effects from rough to smooth. Rough, plasterlike walls are appropriate for informal rooms and for some period rooms (such as those in the Spanish style). Smooth surfaces can be used in any style room and with any style furniture.

FIGURE 10.11 Mosaic tiles in this kitchen were imported from Spain. The Zellige tiles are a Moroccan fired clay glazed tile with a semitransparent color and tone of pearl. Irregularities in shape and luminosity enhance the handmade characteristics.
(Courtesy of Pineapple House Interior Design. Photograph by Scott Moore Photography.)

Wood

Wood walls have been a favorite background treatment for centuries. Wood may be applied to walls in boards or panels (see Figure 10.17). Boards can be of any wood type; cut in various widths; stained any color; and laid vertically, horizontally, or diagonally. They can be joined with tongue-in-groove, butted, or beveled edges. A wide variety of wood sheet panels (known as *paneling*), some with thin veneers, are also available with numerous finishes, colors, and styles; paneling is considerably less expensive than boards.

Masonry

Masonry used for walls includes brick, tile, concrete, concrete block, and stone. Brick, which has been used since the time of the ancient Babylonians and the pharaohs, has a timeless quality of warmth and

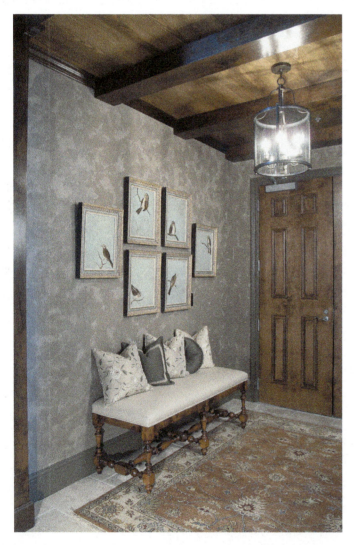

FIGURE 10.10 The plaster wall in this foyer has an Italian finish called stucco lugano. The technique uses a skip trowel on the top plastered finish, allowing portions of the original base plaster coat to emerge. The final appearance mimics aged, broken plaster. The final coat is then painted.
(Courtesy of Pineapple House Interior Design. Photograph by Gary Langhammer Studios.)

adaptability. Its natural look is equally at home in traditional or modern settings and in residential or commercial spaces. Ceramic and porcelain tiles (a harder type of ceramic tile), available in many shapes, sizes, colors, patterns, and finishes, can be used for almost any style and room. They are especially popular and useful in kitchens and bathrooms (Figures 10.11 and 10.15).

Concrete and concrete block walls are contemporary solutions in residential and commercial design. Concrete can be formed into many different shapes (Figure 10.12) and embedded with a variety of materials. Concrete is frequently used on countertops, where it is polished and sealed.

Marble, travertine, limestone, slate, fieldstone, flagstone, and quartzite, all types of stone, are available in a variety of textures and colors (Figure 10.13). Some stones, such as marble, can provide a formal and elegant look, and some, such as fieldstone, give an informal and casual feeling. Stone is popular for fireplaces, and in contemporary homes it is widely used for walls. For additional stone characteristics, see Table 10.1.

FIGURE 10.12 Surprise! This decorative tufted wall called TUCKER™ is actually made of interlocking concrete panels.
(TUCKER™. Courtesy of © modularArts.)

FIGURE 10.13 Masonry tiles have been used throughout the space in this ASID award–winning bathroom. A glass wall insets into the masonry to define the shower. Note the curved island (including custom cabinetry) to house the pedestal sinks. A double-sided mirror is suspended over the island.
(Designer: Bruce Benning, ASID/CID, Benning Design Associates. Photograph by David Duncan Livingston.)

Other Wallcoverings

Mirrors

Mirrors can expand an area visually—an advantage in smaller living spaces. Mirrors are available in large sheets and precut panels ready to install. They can cover an entire wall or be spaced on a wall for function or aesthetic appeal. Mirrors also have great light-reflecting qualities and can be used to brighten a room (Figure 10.14).

Metal

Metals such as stainless steel, copper, and aluminum are available in sheets and tiles. Finishes may be smooth and shiny, or brushed. The latter has easier upkeep. Metal interior walls are contemporary in feel and provide a strong textural quality (see the gridded wall design on the left-hand side of Figure 10.7).

Plastics

Plastics are available in either sheets or tiles in a wide range of colors and styles. They are easy to clean and are completely waterproof. Manufacturers produce materials made from plastics that can be slightly transparent and may include textures and decorative designs. Plastic materials are also appropriate for partial room dividers (Figures 10.15 and 10.16).

FIGURE 10.14 In this guest bedroom, a large mirror located behind the dressing table/desk expands the apparent size of the interior. The layered effect adds depth to the interior, while the smooth surface contrasts texturally with the woven seating.
(© Andrew Twort / Alamy)

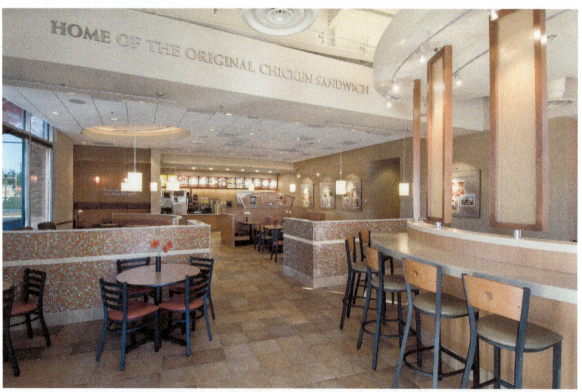

FIGURE 10.15 Partial panels separating the bar area are created using a plastic product made by 3 Form. Tile on the half walls is porcelain glass, and the floor is also porcelain. All products are durable and easily cleaned as necessary for a restaurant.
(Architect/Designer: Hughes|Litton|Godwin. Courtesy of CFA Properties, Inc.)

Plastic laminate wallboards are available in a wide range of colors and simulate a variety of textures. Although durable, plastics may appear inexpensive if used to simulate marble, wood, or other natural finishes.

Glass Block

Glass block may be used for interior walls as well as exterior window applications (see Figure 13.22). Available in a variety of sizes and textures, it is used in areas where diffuse light is required, while eliminating a direct view (Figure 10.17). Typically, glass block is used in contemporary design settings but also may reflect a 1950s interior.

FIGURE 10.16 Curved plastic panels line the front of this open office workstation. The panels are decorative in nature, but also protect the wood beneath.
(Courtesy of Herman Miller, Inc.)

FIGURE 10.17 In this commercial office setting, the custom wood-grained panels are accentuated by wall-washers. A glass block wall separates the conversation area from a corridor. The interior of the wall, lit from the floor, creates a warm radiance.
(Architect/Designer: Hellmuth, Obata & Kassabaum. Photograph by Gabriel Benzur.)

■ MOLDINGS

Moldings are used throughout the walls and on ceilings. Moldings are used most often where walls meet ceilings and floors. The molding hides the joinery at these corners and also provides a transition from one surface to another. Moldings may also be used as a decorative treatment on walls. Figure 10.18 illustrates typical molding terminology.

Wall Moldings

A *chair rail* divides the wall horizontally, usually about 3 feet above the floor. Chair rails may be decorative or, when used in a health care setting, may provide protection for the wall and a secure handhold for patients (as seen in Figure 6.20). These plastic moldings are referred to as *bumper guards*. The area between the chair rail and the base molding is called the **dado**. *Base moldings* usually consist of a *baseboard* (the taller portion) and a piece of quarter-round (usually called *shoe molding*).

Wainscoting, a common practice in medieval interiors, is ornately carved wood paneling that extends partway to the ceiling. A *picture rail* usually runs around the top of the wall, or may extend 1 to 2 feet down the wall in a room with a 10- to 14-foot ceiling. The picture rail traditionally was used to suspend wires for hanging pictures. It also may be used as a decorative element (Figure 10.19).

Panel moldings may be achieved in one of two ways. True panel molding is created by applying wood in various layers on the wall and by applying strips of molding at the intersections. A simpler form of panel molding consists of a flat drywall or plaster wall with strips of moldings added to create frames. A series of panel moldings is commonly used in traditional dining rooms and conference rooms. **Boiserie** is a French term describing ornately carved paneling.

Crown Moldings

Ceiling moldings are called **crown moldings**. Crown moldings may have three parts. The uppermost is called the **cornice**, the middle the **frieze**, and the lower the **architrave**. Together they are referred to as the **entablature** (see page 58).

Moldings come in a variety of styles and shapes (Figure 10.20). By combining these individual pieces, more ornate forms of moldings are

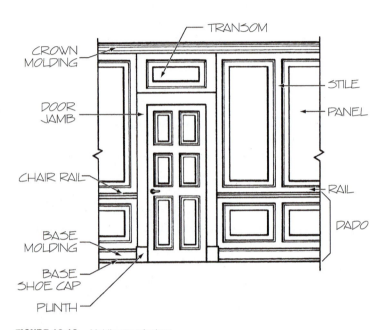

FIGURE 10.18 Molding terminology.

FIGURE 10.19 In this historic courthouse, the designer re-created the custom picture rail and used it for its traditional function of holding pictures.
(Architect: Office of Jack Pyburn, Architect, Inc. Designer: Jones Interiors. Photograph by J. J. Williams.)

developed. Higher ceilings (those above 8 or 9 feet) may accommodate a series of moldings. Ornate moldings add a feeling of dignity and grandeur (Figure 10.21), but if a ceiling is already low, a heavy crown molding may cause it to appear even lower. Chair rails and base moldings also may consist of one or more pieces of trim.

Trims are manufactured in wood, fiberglass, and foam. The latter are more versatile in design than wood and are lighter in weight (see Figures 10.22 and 10.23). When properly installed and painted, they are difficult to distinguish from their wood counterparts.

More info online @
www.wmmpa.com Wood Moulding & Millwork Producers Association

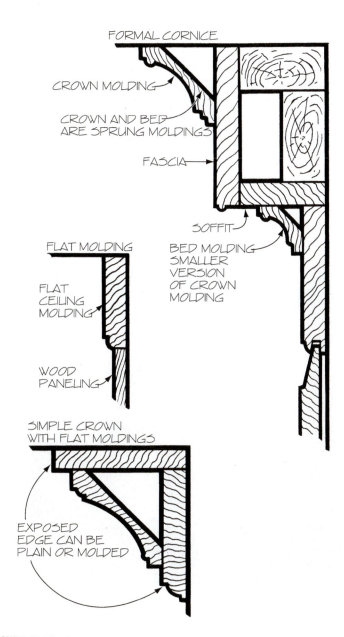

FORMAL CORNICE
CROWN MOLDING
CROWN AND BED ARE SPRUNG MOLDINGS
FASCIA
SOFFIT
BED MOLDING SMALLER VERSION OF CROWN MOLDING
FLAT MOLDING
FLAT CEILING MOLDING
WOOD PANELING
SIMPLE CROWN WITH FLAT MOLDINGS
EXPOSED EDGE CAN BE PLAIN OR MOLDED

FIGURE 10.20 Stock moldings add architectural interest.

FIGURE 10.21 This extravagant opulent drawing room in the Kips Bay Showhouse is graced with compound molding, applied poster details, and a plaster ceiling. The elegant finishes clearly establish a formal eclectic French style and support the eighteenth- and nineteenth-century furnishings.
(Antique Aubusson courtesy of F. J. Hakimian, Inc., NY. Designer: Juan Pablo Molyneux. Photograph by Peter Vitale.)

FIGURE 10.22 This traditional sunburst design can add formality to a front door. It is sturdy, lightweight, and easily installed.
(Courtesy of Focal Point.)

FIGURE 10.23 This exquisite fretwork cornice, made of tough, lightweight modern material, is molded directly from notable wood or plaster originals.
(Courtesy of Focal Point)

■ PAINTS AND FINISHES

To change the character of a room quickly with a minimum of expense, nothing works as well as paint. Of all wall treatments, paint is the easiest to apply. It is made to adhere to any surface and is appropriate for any room or any style. Some paints resist rust, fading, and fire. Paints come in numerous colors, producing unlimited shades, tones, and tints. A painted wall surface can be smooth or given the illusion of texture by use of a stiff brush, sponge, or special embossed roller. Paints are made from a vast array of synthetic and natural materials.

Types of Paints

Alkyd Paint

Alkyd paint has virtually replaced oil paint. It is resin enamel that is fast drying, resists yellowing, and cleans better than latex. Depending on the color, one coat is generally sufficient. Alkyd paints must be thinned with solvent. They are recommended for moldings, woodwork, trim, and anywhere moisture, fingerprints, or scuff marks may be a problem. They are probably the best choice for painting metal.

Acrylic Paint

Acrylic paint is a water-based synthetic resin paint. The more acrylic the paint contains, the higher the quality. Acrylic is extremely durable, odorless, easily applied, quick drying, and washable. Some acrylic paints resemble baked-on enamel and are almost impervious to damage. Straight acrylic paints are not commonly used on interior finishes.

Latex Paint

Latex is a type of acrylic and is frequently used on interior finishes (Figure 10.24). It is a water-based paint, so cleanup is easy during application. Latex leaves no overlap marks and dries quickly, and the characteristic odor soon fades. Latex, however, does show brush marks. A difference between indoor and outdoor latex is that outdoor latex "breathes," thus allowing moisture to escape, which eliminates blistering. Latex paints are recommended for plaster, gypsumboard, masonry, wood siding, acoustical tile, and occasionally metal.

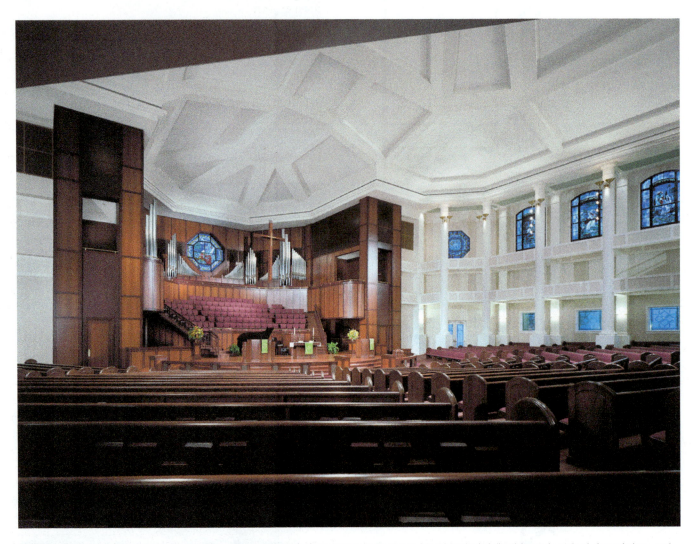

FIGURE 10.24 Sometimes, the most appropriate applied paint finish for a ceiling is "ceiling white." In this cathedral, the rich woods, stained glass windows, and massive formed ceiling structure are contrasted with the simplicity of a white ceiling.
(Architect/Designer: Jova Daniels Busby. Photography by Robert Thien.)

Enamel Paint

Enamel is a special type of paint similar to oil paint and is made with varnish or lacquer. Its finish is exceptionally hard and durable.

Epoxy Paint

There are two types of epoxy paint. The first type is ready-mixed in a single can. The second type is a two-stage finish, or catalyzed epoxy, which puts a tilelike coating on almost any surface. Once it hardens, this coating can be scratched, struck, or marked with crayon or pencil and still be washed back to a high gloss. Epoxies can be used on such surfaces as basement walls, shower stalls, and swimming pools.

Types of Finishes

Sealers and Fillers

Sealers and fillers are special substances applied to new surfaces as a base coat, ensuring a more professional finish.

Paint Finishes

Most paints are available in various finishes. Different manufacturers use different terms, but essentially there are three variations—*gloss*, *semigloss* or *eggshell*, and *matte* or *flat*. The higher the gloss, the easier it is to clean; however, higher-gloss paint also shows the most imperfections in the wall.

Flat finishes tend to look richer than semigloss finishes; however, a matte or flat finish is easily marred by furniture, fingerprints, and spills. A semigloss or eggshell finish will prevent some scarring, and for an active family room or office space, it is the best solution.

Stain

Stain penetrates wood pores and contains various colorants that can enhance natural color or give a different color to wood. Stains should be tested on an inconspicuous area first because different woods react differently to the same color stain. A varnish is generally required over the stain to seal it.

Varnish

Varnish is a word sometimes used as a generic name for all clear resinous finishes. A resin is a natural or synthetic substance that, when dissolved in a suitable solvent, leaves a hard, glossy film. Natural resins are the saps of certain trees or deposits of insects that feed on the sap. Synthetic resins are also available that duplicate natural ones. Varnish is made from natural resins with alcohol or a drying oil, and volatile thinners and dryers. A varnish is usually a transparent coating and is commonly used on wood to protect the surface and allow the natural grain to show through. Some varnishes have a colorant added to darken the wood, but the result is usually less satisfactory than staining before applying clear varnish. Varnish comes in high-gloss or matte finishes.

Shellac

Shellac is a protective coating similar to varnish. It is made of a resinous substance called lac, which is deposited on trees in India and Asia. Its solvent is alcohol. Shellac dries more quickly than varnish but is less durable and is subject to water spots. Clear shellac does not discolor when applied to a light-colored surface.

Lacquer

Lacquer is a superior, quick-drying, varnish-like finish made from resin from an Asiatic sumac (Chinese or Japanese lacquer) or from a synthetic nitrocellulose resin. The finish ranges from matte to high gloss and comes in white, black, brown, or beige. Commercially made furniture may be finished with lacquer.

Polyurethane

Polyurethane is a varnish-like finish that provides an exceptionally tough plastic surface coating. It comes in a matte, medium-gloss, or high-gloss finish. It is an excellent protective surface for hardwood floors in heavy-traffic areas and walls where moisture is a problem. Polyurethane is also used to protect furniture surfaces and wood paneling.

Paint Textures

There are several methods of achieving unusual textures with paint. The following techniques involve applying one or more colors of wet (often thinned) paint over a dry base coat of another color:

- **Sponging:** Paint is applied with a sponge over a base coat, giving a mottled or blotchy texture.
- **Spattering:** Paint on a brush is flipped onto the base coat, giving a speckled appearance.
- **Stippling:** Similar to sponging, but a more delicate effect is achieved by using a stippling brush to apply a colored paint lightly over the base color.
- **Ragging:** One or more colors are applied over the base coat, then partly removed by blotting or rolling with a rag to achieve a marbleized effect.
- **Color washing:** A coat of thinned paint or glaze is lightly applied over a base coat of another color.
- **Glazing:** Layers of one or more transparent colors are applied on top of a base coat. The result gives the illusion of various depths on the wall.

Decorative Finishes

Faux is French for "false." **Faux finishes** simulate the look of another material, such as stone or wood, by using various techniques to apply paints to a surface. Among the more popular finishes are marble, granite, and wood grains. More exotic faux finishes include tortoiseshell and malachite. In addition to being used on walls, faux finishes are used on ceilings, moldings, doors, mantelpieces, and furniture (Figure 10.25A–E).

Trompe l'oeil is a delightful wall treatment, especially for those who desire an unusual effect or perhaps want to inject a note of humor into their design. The French term literally means "to fool the eye." Trompe l'oeil is a hand-painted wall or wallcovering, in almost any subject matter, giving a three-dimensional look. Very simple or extremely complicated designs can be used (see the ceiling in Figure 10.21).

A (Before)

D (Before)

B (During)

C

E

FIGURE 10.25 In this living room renovation, changes through the use of faux painting and applied wall surface modifications dramatically altered the interior. The original white painted coffered ceiling (A) was faux finished (B) into a wood-grained ceiling (C). The removal of the boiserie (D) around the fireplace (reused in the master bedroom) made way for a tapered fireplace mantle and arched wall surface (E). The new interior creates a more relaxed environment and yet is also more formal. Updates to the main conversation area of the room may be seen in Figure 13.28.
(Courtesy of Pineapple House Interior Design. Photographs by Scott Moore Photography.)

FIGURE 10.26 In this residential foyer, a painted faux finish creates a Renaissance courtyard illusion. Wisteria falls over the garden wall; bluebirds and robins gather in the sky.
(Designer/Artist: Shannon Pable. Photograph by John Orth.)

Painted scenes, patterns, and borders that do not attempt the illusionistic effects of trompe l'oeil can be created either freehand (Figure 10.26) or with stencils. A stencil is a masking sheet with a pattern cut out so that the pattern can be repeated. Stenciling is especially popular for rooms with an informal or country look. Stenciling designs can be purchased or personally created.

Gilding is a finish, added to any surface, that includes a precious metal; gold is most often used, but gilding can also refer to silver or some other less expensive metal. Gilded walls and ceilings may have a powdered metal applied to a substrate and then have paint applied onto the surface. Furniture from the French Rococo and Neoclassic eras (as seen in the pictorial essay following Chapter 2) includes gilded wood frames. Domes of state Capitol buildings, both interior and exterior, may be gilded.

More info online @

www.benjaminmoore.com/en-us/for-your-home/faux-and-decorative-finishes
Info on decorative finishes
www.sherwin-williams.com/do_it_yourself/faux_finishing/index.jsp
Sherwin-Williams decorative finishes

■ RESILIENT (FLEXIBLE) WALLCOVERINGS

Wallpaper

Using decorative paper as a wallcovering has been important in enhancing interiors since the late sixteenth century in Europe and early colonial times in America. Although wallpapers have been more fashionable during some periods than others, they have always been esteemed as a valuable tool in transforming the visual aspect of interior space.

History of Wallpaper

Hand-painted wallpapers were made as early as 200 B.C. in China, where they were used for decorating tombs. The first manufacturer of wallpaper on an organized basis was in France toward the close of the sixteenth century. The first papers were painted in a marbleized effect—a design copied from imported Persian papers—and were made for facing book covers and lining boxes. These were called *domino papers*.

The introduction of flocked papers (wallpaper with a three-dimensional fuzzy texture) during the early seventeenth century made it possible for people to simulate the elegant damasks used in the homes of the wealthy. In the latter half of the seventeenth century, a new printing method developed by Jean Papillon produced wallpaper that could be matched to make the pattern continuous around the room.

During the latter half of the eighteenth century, pictorial murals became popular through the works of Baptiste Reveillon in France and John Baptiste Jackson in England. During the eighteenth century in America, hand-painted papers from China were in vogue for the great Georgian mansions built along the Atlantic seacoast (Figure 10.27).

Copper printing rollers turned by a rotary machine were invented in northern England in the second quarter of the nineteenth century. Although wallpaper was frequently used during the nineteenth century, it was not until the Industrial Revolution that the wallpaper industry flourished in America. When the industry developed a new method of silk-screen printing in the mid-twentieth century that produced papers of high quality at affordable prices, the demand multiplied. *Documentary wallpapers* are used in replicating historic interiors.

More info online @

www.blonderwall.com/historyofwallpaper.html Timeline of wallpaper history
http://membres.lycos.fr/museedupapierpei/english/collections_uk.html Collections from the Musée Du Papier Peint, a wallpaper museum in Rixheim, France

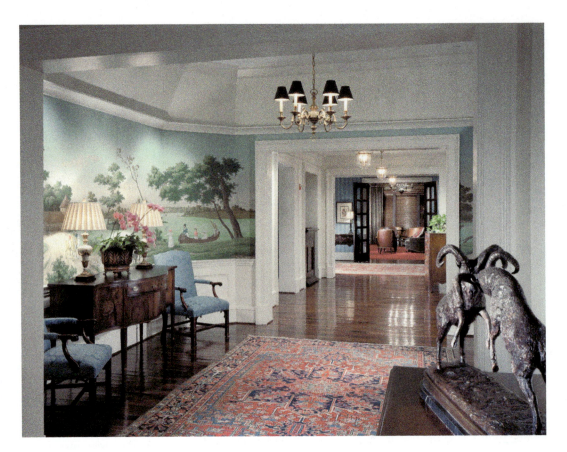

FIGURE 10.27 This interior lobby of the Belle Haven Country Club includes a hand-painted scenic wallcovering from Paul Montgomery Studios. It reflects the Virginia countryside of the 1800s. The rug, a Heriz, is named after a city in northwestern Iran where the rugs are woven. *(Designer: Ferry, Hayes & Allen Designers, Inc. Photograph by Gabriel Benzur.)*

Methods of Producing Wallpaper

The three most common methods of producing wallcoverings are roller printing, hand blocking, and silk-screen printing. *Roller printing* is the most common process and the least expensive. It is a cylinder process in which each color is applied in rapid succession. In *hand blocking*, each color is applied separately after the preceding one is dry. This method is slower and more costly than the roller method. *Silk-screen printing* is a more complicated process in which a wooden or metal frame tightly stretches a silk, nylon, or metal screen made for each color of the pattern. Portions of the pattern not to be printed are heavily varnished or bleached out. Each repeat is made by applying pigment, which seeps through the screens as it is pushed across by a squeegee. Each color is allowed to dry before the next frame is printed. This method produces a high-quality wallcovering at reasonable cost.

Embossed and flocked wallcoverings have unique surface qualities. *Embossed* paper is made by a machine process producing high and low surfaces. This method is used where texture and three-dimensional effects are desired. *Flocked paper* is produced by a method in which the design motif is outlined and covered with glue or an adhesive material. Fine wool-like fuzz is then blown onto it, producing a surface resembling cut velvet.

Common Wallpaper Terms

Following are the most commonly used wallpaper terms:

- **Washable:** Usually refers to a wallcovering that may be washed with lukewarm mild suds, but not scrubbed excessively.

- **Scrubbable:** Refers to a wallcovering more resistant to rubbing than washable types. Stains such as crayon marks can generally be removed from scrubbable wallpaper with cleaning agents recommended by the manufacturer or with soap and water.

- **Pretrimmed:** Refers to rolls of wallpaper from which the selvage has been trimmed.

- **Semitrimmed:** The selvage has been trimmed from only one edge of the wallpaper.

- **Prepasted:** Paper that has had paste applied during the manufacturing process. Detailed instructions for hanging are usually included. Generally, prepasted paper is soaked in water and applied to the wall while the paper is still wet.

- **Single roll:** Wallpaper is always priced by the single roll, but usually is sold by the double or triple roll. Regardless of width, a single roll usually contains 36 square feet. Eurorolls (wallcoverings produced in Europe and often used in the United States) typically contain 28 square feet per single roll.

- **Double and triple roll:** Regardless of width, a double roll (two single rolls) contains approximately 72 square feet, and a triple roll (three single rolls) contains 118 square feet. Generally, 18- and 20-inch-wide wallpapers come in triple rolls. Double or triple rolls are used to minimize waste when cutting wallpaper into strips.

- **Dye lot:** Refers to the production schedule of a color or colors. Each dye lot has a number. Because of color variations in different dye lots, all the wallcovering for a single space must come from the same dye lot. Designers should ensure that a sufficient quantity has been ordered to meet the client's needs. Attempting

to reorder during installation may be impossible because the particular dye lot may be sold out.

■ **Pattern repeat:** When a wallcovering has a pattern or motif, the pattern repeat is the distance from the beginning of the pattern to the point where it starts again. The patterns in the horizontal direction of the motif should match from the top to the bottom of the wall. The larger the pattern, the greater the wallcovering waste.

■ **Sizing:** A liquid that is painted on the wall before the wallpaper is applied. Sizing prevents the wallpaper from absorbing too much paste or adhesive and helps the wallpaper adhere better to the wall.

More info online @
www.wallpaperinstaller.com/index.html Wallpaper installation information and terminology

Vinyl-Coated and Vinyl Wallcoverings

Numerous flexible wallcoverings are available that have been treated with varying thicknesses of vinyl. They are waterproof, highly durable and stain resistant, and may be washable or scrubbable. They can be used on nearly any type of wall and for any style. Vinyl-coated wallcoverings are applied using the same method appropriate for wallpaper (Figure 10.28).

Vinyl-Coated Wallcoverings

The following are the most common vinyl-coated wallcoverings:

■ *Vinyl-protected wallcovering* is ordinary wallpaper with a coating of vinyl plastic to make it washable.

■ *Vinyl-latex wallcovering* is a paper impregnated with vinyl, laminated to lightweight fabric or paper, then vinyl coated. The thickness of the vinyl may vary. This process produces a durable, scrubbable wallcovering.

■ *Coated fabric* is a wallcovering with a woven cotton backing treated with an oil or plastic coating before the design is applied. This durable, tough, scrubbable material is ideal for kitchens and bathrooms.

■ *Plastic foam* is a soft, flexible material available in rolls, squares, or rectangles. It absorbs sound, resists stains, and insulates. It is easy to clean with soap and water. Although more expensive than some wallcoverings, plastic foam is ideal for television rooms or apartments with thin walls, and is particularly useful in commercial and institutional settings.

Vinyl Wallcoverings

True vinyl wallcoverings are composed of a backing, a vinyl layer, and a finish layer. Vinyl wallcoverings are commonly applied in commercial environments where building codes dictate their use.

Vinyl wallcoverings are rated based on their total weight per ounce. Type I wallcoverings weigh from 7 to 13 ounces per square yard and are best used in light-traffic areas. Type II wallcoverings weigh from 13 to 22 ounces per square yard and can be used in high-traffic areas such as hotel and commercial office corridors. Type III wallcoverings weigh more than 22 ounces per square yard and are used in

FIGURE 10.28 In the renovation of this historic residence, the designer adapted the building to commercial office use. Vinyl-coated wallpaper was used between the chair rail and the picture molding. The dado was painted with a semigloss latex.
(Designer: Jones Interiors. Photograph by Michael Wood.)

extremely high-traffic areas such as cafeteria lines and elevator lobbies (Figure 10.29). Type II and Type III wallcoverings are usually 54" wide to expedite installation.

More info online @
www.doityourself.com/stry/commercialwallcovers Commercial wallcovering terminology

FIGURE 10.29 In this children's ophthalmologist's office, a ribbed vinyl wallcovering in strong colors creates nonstop movement and provides durability.
(Architect/Designer: Stuart Narofsky Architecture. Photograph by Ron Solomon.)

Other Resilient Wallcoverings

Grass cloth or *hemp* wallcovering is flexible, long lasting, and easy to care for and provides suitable backgrounds for a variety of styles. Colored grass cloth, however, fades over time. Other woven reeds such as *sisal* can provide handsome and practical wallcoverings.

Wood veneer with fabric backing, another method of "papering" walls, produces a true wood surface and, once adhered to the wall, is difficult to distinguish from solid wood. One advantage over wood paneling is that this material can fit around corners or curves. It is available in sheets up to 24 inches wide and 12 feet long. The cost, however, is high.

Leather tile, made of top-grain cowhide, provides a soft, warm, rich surface. It comes in a variety of fade-resistant colors to blend with traditional or modern decor. The leather is permanently bonded to an aluminum tile base that has preapplied adhesive for easy installation. It is highly resistant to scuffing, and the only maintenance required is an occasional washing with mild soap and water. Leather tile in suede is also available on a custom-ordered basis. The depth of the brushed nap provides an interesting texture, but its high cost limits extensive use.

Cork is a moderately priced textured material that produces a warm atmosphere in natural colors of brown. It is particularly adaptable for studies or rooms in which sound insulation is important. Unless plastic-impregnated, cork is not suitable for bathrooms, kitchens, and other moisture-prone areas.

A historical wallcovering embossed with intricate designs dating from the Victorian era is marketed under the trade name of *Anaglypta*. This wallcovering is commonly used on dadoes. It is neutral in color and is intended to be painted (Figure 10.30).

Fabrics may also be used for wallcoverings and are discussed in Chapter 12, Textiles.

FIGURE 10.30 This historic building was renovated into a fine arts gallery. Anaglypta was used on the dado and painted a pale peach.
(Designer: Jones Interiors. Photograph by J. J. Williams.)

■ ESTIMATING WALLCOVERING QUANTITIES

When working on a project, designers need to be able to estimate the quantity of wallcovering needed in order to calculate a budget. There are two generally accepted methods used to figure the quantity of wallcovering for a room.

The *general estimation method* is particularly helpful for quick "on the spot" estimates.

1. Total the wall area in the room. To do this, multiply the height and width of each wall and then add the figures together.
2. Divide the total wall area by 30 square feet (slightly less than the average quantity per roll of wallcovering) to get the number of rolls of wallcovering necessary to cover the room.
3. Subtract one roll for every two openings such as doors and windows. Remember that wallcovering is usually packed in double rolls. Rolls cannot be split.

The *strip method* is more precise and should be used before making final purchases. It requires converting all dimensions into inches or centimeters. The designer will also need to know the *width, length,* and *pattern repeat length* of the selected paper. Once these dimensions are determined, proceed with the following steps:

1. Total the horizontal wall length for the entire room. To do this, measure the width of each wall in the room, add them together, and convert to inches.
2. Divide this amount by the width of the wallcovering. The answer indicates how many strips are needed to completely wrap the room in wallcovering. The next three steps will determine how long each strip should be to allow for a pattern repeat.
3. Determine the height of the room. Convert this to inches and divide by the pattern repeat. Round this number *up* to the nearest whole number.
4. Multiply the number of repeats (answer to Step 3) by the repeat length. This answer determines the cut length for each strip of wallpaper.
5. Divide the total roll length (single, double, or triple roll length) by the length required for each cut (answer to Step 4). Round this number *down* to the nearest whole number. This determines how many strips will be available from each roll of wallcovering.
6. Divide the total number of strips (the answer from Step 2) by the number of strips per roll (answer to Step 5). Round this number *up* to the nearest whole number. This final answer determines how many rolls (either single, double, or triple) will be needed. Remember, double and triple rolls cannot be split.

■ SELECTING WALL MATERIALS AND FINISHES

When selecting a finish for a wall, designers need an understanding of the functional, aesthetic, and economic requirements of the space. From a functional viewpoint, the amount of use or traffic in the area is a

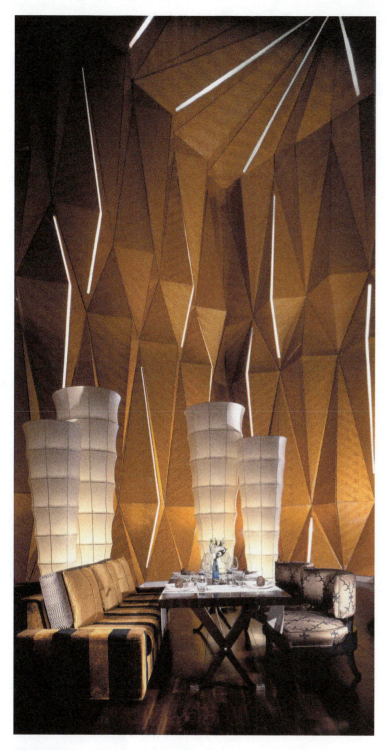

FIGURE 10.31 This extraordinary wall forms the focal point in this restaurant at the Park Hyatt in Dubai. The feature, dubbed the "geo-wall" by the designers, is backlit and extends over three stories in height. The sculptural form creates a geodesic futuristic feel that surrounds the diners.
(Interior Architectural Design by Wilson Associates. Photography by Michael Wilson.)

critical factor. For example, hospital, hotel, or other corridors frequented by large carts or wheelchairs require Type II or Type III wallcoverings. Chair rails made of molded plastics or metal also are appropriate in these areas (as seen in Figure 7.29A and B).

Some rooms may require sound-absorbing wallcoverings. Libraries, studies, music rooms, and offices benefit from soft, absorbent wallcoverings. Large classrooms with hard surface flooring benefit from the use of cork walls or fabric panels, which also double as display areas.

In historic buildings, the designer may need to use materials that hide imperfections. Flat paint conceals flaws better than does a semigloss. A vinyl wallcovering or product such as Anaglypta may also be appropriate.

Aesthetically, the architectural details of the room may direct the selection of the wall finish. An adobe fireplace would allow for a more casual finish, as would the use of a nubby material. A traditional fireplace may call for a more subdued wallcovering or paint. A traditional setting also may require an elaborate pattern or trompe l'oeil print. A strong contemporary structure may dictate the use of sleek metals and poured concrete walls. Large expanses of glass or glass block also may be appropriate.

Designers need to know whether the wall will serve as a focal point or as a backdrop for other objects (Figure 10.31). A strong, brilliant wallcovering may be appropriate for a kitchen; however, in a gallery the wall material should be neutral so the focus is on the art.

When selecting patterned wallpaper, it is important to consider the scale of the room and select a pattern compatible with it. A small pin dot or petite floral may function well in a bathroom, but would be out of scale for a dining room or foyer. A wallcovering with a vertical stripe will increase the apparent height of a room, whereas a horizontal stripe will make the ceiling feel lower. Diagonal stripes on a wall can create confusion and disorientation and are not recommended unless vibrancy is the goal.

From an economic point of view, if the client is on a limited budget, or if time is a major consideration, a new coat of paint is probably the best solution. Paint is the least expensive and easiest interior wall finish to change. A new coat of paint will dramatically alter a room's presence. Accentuated moldings or doors also will create a new energizing effect.

Finally, designers concerned with environmental issues (or whose clients are) may wish to specify environmentally friendly products.

SUMMARY

In any interior environment, the ceilings and walls create a backdrop for the inhabitants. These surfaces provide security, enclose the mechanical systems, and create a comfortable living environment. Designers specify the materials and finishes that are applied to these surfaces. Care should be taken to ensure that the products used are durable, meet the functional needs of the space, and are sustainable. Designers must also utilize the principles and elements of design when selecting surface finishes so that they coordinate with the architectural components and enhance the human experience.

11 Furniture

FIGURE 11.1 The 1920s and 1930s industrial era was blended with a progressive flavor to form the concept for this resort. The hammered bronze fireplace wall speaks of the past, while the custom hand-tufted wool rug articulates the present. A clever play of texture and color allows this massively tall interior to morph into an inviting, welcoming lobby. The large wood beams shelter the visitor under their curved expanses; the decorative chandelier's light dances off the metallic wall above the fireplace. The over-scaled leaf-patterned rug balances the rich ornate timbers and unites that brilliant display of color in furniture, finishes, and drapery. Mosaic tiles surrounding the fireplace and imbedded in the floor support the contemporary direction, while leather chairs and antique accessories support the Old World flavor. *(Designer: Keith Interior Design. Architect: M2K Architecture. Client: Dubai World Africa. Photography by Ryan Plakonouris.)*

Selecting furniture for residential and commercial projects is a major responsibility of the designer. Furniture is used to meet a range of human needs in a variety of spaces. Furniture can function as a simple utilitarian item (such as a barstool or bench) or it can serve as an artistic focal point. Furniture must work with the flooring and wall selections, while also meeting the functional needs of the interior environment (Figure 11.1).

Furnishing a space can be a rewarding experience, and furniture can last a lifetime. Careful study and planning enable the designer and client to make wise purchases. This approach requires time and effort but pays long-term dividends. The ability to discriminate between long-lasting and faddish designs is a necessity. Different styles of furniture can be used together provided there is similarity of line, shape, proportion, and so on. Knowledge of the principles and elements of design and understanding how a fine piece of furniture is made aid in the selection process. A well-designed piece of furniture will always be a quality piece.

■ TYPES OF FURNITURE

Furniture has evolved from pure function to an important art form. By the time of the ancient civilizations of Egypt, Greece, and Rome, furniture was elegantly formed and decorated, satisfying the need for both function and beauty. In later periods, various styles have had lasting influence on following generations. English and French designs are particularly influential in North America. Built-ins, modular units, and systems furniture emerged on a grand scale during the twentieth century. Tables 11.1 and 11.2 on pages 350-351 illustrate many furniture types.

Chairs

People use chairs every day for a variety of functions; they are essential pieces of furniture. Materials generally include wood, metal, plastic, leather, and textiles. Sizes range from simple and lightly scaled side chairs to oversized upholstered lounge chairs, with styles from all periods available to suit any taste. Generally, a variety of chair sizes and designs are required within an interior environment. Figures 11.2 through 11.8 illustrate examples of different types of chairs.

When selecting chairs, consider the following:

- The height, depth, and width should comfortably accommodate the human form.
- An adjustable chair gives flexible service to a variety of users.
- Ergonomic designs, based on extensive anthropometric studies, provide maximum comfort.

FIGURE 11.2 This Queen Anne "wing chair," so named for the curved half-sides that rise to the height of the high back, originally offered protection from the drafts and chills of poorly heated rooms. The arms are made up of two scrolls, one vertical and one horizontal, which meet to outline a graceful, flat, C-shape scroll.

(Courtesy of Kindel)

FIGURE 11.3 This reproduction of a Philadelphia Chippendale side chair, originally made between 1760 and 1780, features heavily carved acanthus leaf clusters with cabriole front legs that terminate in claw-and-ball feet.

(Courtesy of Kindel)

FIGURE 11.4 Charles and Ray Eames experimented with various wood forms. The Eames DCW chair (1943–1953) is an early example of a molded plywood chair design.

(Courtesy of Herman Miller, Inc. archives)

FIGURE 11.5 This lounge chair by Loewenstein, called the Royale, is upholstered in fine, tight-fitting leather. The chair is appropriate in commercial office lobbies, lounges, and contemporary residences.

(Courtesy of Loewenstein)

FIGURE 11.6 This classic chair, designed by Eero Saarinen, is called the Tulip Chair. Popular in the late 1950s, the chair has made a come-back in residential and commercial interiors, particularly for dining areas. The original chair was made completely of fiberglass; however, for durability the base is manufactured of cast aluminum. A plastic resin covers the entire chair to make it appear as one material.

(© Prisma Bildagentur AG / Alamy)

FIGURE 11.7 This ergonomic desk chair, called Aeron, is designed to support the lower lumbar region of the user's back. Adjustable arms, seat, and back, along with a variety of sizes, provide personalized comfort for the user.

(Photograph by Nick Merrick/Hedrich-Blessing. Courtesy of Herman Miller, Inc.)

FIGURE 11.8 The Maestro by KI is one of many styles of stacking chairs for corporate training areas, auditoriums, and offices. The chairs have polypropylene seats and chrome legs. The stackers allow for ease in storage and mobility.
(Courtesy of KI)

Sofas

Sofas are upholstered seating units that usually accommodate two or more people (Figure 11.9). Through the ages, particular terms have been associated with certain designs, although many times the terms are used interchangeably.

- The *Lawson* is a type with flat armrests lower than the back support (Figure 11.10).
- The *chaise longue* accommodates one person and is a cross between a sofa and a chair plus ottoman.
- The *tuxedo* is a completely upholstered piece with armrests the same height as the back (Figure 11.11).
- The *chesterfield* is a large, tufted, upholstered sofa with upholstered ends and no exposed wood.
- The *divan*, a low sofa without arms or back, is derived from stacked rugs used in Turkey for seating. It is commonly placed against the wall and piled with cushions.
- The *love seat* is a smaller sofa for seating two people.
- The *settee*, also generally for two people, is a lightly scaled piece, often with some upholstered sections (Figure 11.12).
- *Settles*, completely constructed of wood with very high backs, originally were used in early American homes to retain heat from fireplaces.
- *Davenport* is an old term for a sofa that converts into a bed. It originally referred to a small writing desk named after its designer.

FIGURE 11.9 When Le Corbusier designed the Grand Comfort Collection in 1928, he eliminated the traditional construction of an upholstered piece and used a light support of tubular steel with loose cushions.
(Courtesy of Cassina USA, Inc.)

FIGURE 11.10 Lawson arm sofas.

FIGURE 11.11 Tuxedo arm sofas.

- *Modular* and *sectional* sofas consist of several units placed side by side to form one large sofa unit.
- Classic chairs, such as the Swan chair, may also be stretched into a sofa (Figure 11.13).

Sofas, like chairs, should be selected to comfortably accommodate the user. Care should be taken to ensure that the stiffness of the seat is appropriate for the intended use. For example, an elder care center would require firm furniture seats with high arms to assist patients in standing up. An environment for individuals using wheelchairs might include a firm sofa without arms to allow a person to transfer easily from the wheelchair to the sofa.

FIGURE 11.12 "Old Hickory" settee, used in historic lodges since the early 1900s.
(Courtesy of Old Hickory Furniture Company. As seen in Fine Furnishings International.)

FIGURE 11.13 In the commercial showroom for Interface Carpets, the designer selected the classic Egg chair and Swan sofa. A lighted dome ceiling defines the seating area. Murals of the client's products produce artwork for the facility.
(Photo by Brian Gasse / tvsdesign)

Desks and Credenzas

Desks, credenzas, and associated computer furniture are particularly important because of the surge in home offices and the increased understanding of the importance of ergonomic furniture. A desk is a combination of a storage unit and a table. Typically, desks are 29"–30" H. Desks (as discussed in Chapter 7) are available in a variety of sizes; however, the most common is 30" W × 60–66" L. Some desks are accompanied by left- or right-hand returns. Returns, which are surfaces to the left or right of the desk, are approximately 20" D and 30"–42" L. Like credenzas, they commonly house computer equipment. Credenzas are thinner than desks, but usually the same length, commonly 20" W × 60–66" L. They are usually placed behind the desk (Figure 7.9 illustrates a typical layout).

Clients who are still using desktop computers may also need an articulating keyboard tray (Figure 11.14). Ideally, the tray is at the same height as the bent elbow when the person is seated at the computer. Keyboard trays, however, should be adjustable.

Desk drawers should vary in size. There should be a drawer to accommodate hanging file folders; at least one shallow drawer for pencils, paper clips, and other office supplies; and a medium-depth drawer appropriate for storing stationery, memory sticks, and CDs (Figure 11.15). Desks also may contain grommets that conceal channels for routing computer cables, telephone wires, and electrical cords.

Desks used in reception areas should also contain a transaction top. This top is usually 42"–48" H and serves two functions. It allows a

FIGURE 11.14 This retractable keyboard tray is adjustable and provides a wristrest and an attached mousepad holder. All three features assist with healthful ergonomic designs. *(Courtesy of Inwood Office Furniture)*

person standing to rest materials on the ledge, and it conceals papers from the view of visitors (see Figure 11.27). To meet the needs of visitors in wheelchairs, transaction tops need to have a lowered area not to exceed 36" H.

FIGURE 11.15 This unique desk is called a Partners Desk. It is designed for two individuals to work from either side of the desk. Common in law firms during the late 1800s and early 1900s, the design currently is more novel. This contemporary version, designed by Dakota Jackson, includes ebony veneer, a leather inset writing surface, and stainless steel legs. *(Courtesy Dakota Jackson, Partner's Desk, Circa 2000)*

FIGURE 11.16 This occasional table, the Vector from Carolina Business Furniture, is available in wood or metal. The pinwheel top defines its distinctive character.
(Courtesy of Carolina Business Furniture)

FIGURE 11.17 This custom-designed end table cleverly meets the needs of the high-armed sofa and the armless side chair.
(Designer: Gandy/Peace, Inc. Photograph by Chris A. Little.)

Tables

Tables, like sofas, come in many forms, including dining and kitchen tables, coffee tables, end or occasional tables (Figure 11.16), game tables, and sofa tables All tables should be sturdy and of an appropriate size and height.

- End tables should match the height of the arm of the sofa as closely as possible (Figure 11.17).
- Dining, kitchen, and game tables are usually 29"–30" high (Figure 11.18).
- Tables may also be attached to a chair for conferencing or educational purposes (Figure 11.19).

Sofa tables sit behind a sofa and should match the height of the back of the sofa or fall slightly below it (as seen in Figure V.1). Coffee tables sit in front of the sofa and are about the same height as the seat cushions on the sofa.

Pool tables come in variety of sizes from 3' × 6' to as big as 6' × 12'. Typical residential pool tables are 4' × 8'. No matter what the size, the table is always twice as long as it is wide. Ample room around the table is required for the cue, which ranges from 48" to 60" long. A distance approximately equal to the cue length should be provided around all sides of the table (Figure 11.20).

FIGURE 11.18 This comfortable deck furniture is designed to endure harsh weather elements while folding to allow for portability. Tables are available in a variety of sizes.
(Courtesy of Smith & Hawke)

FIGURE 11.19 This chair and attached side table/arm combination is one of the earliest designs that functions as an upholstered mobile writing surface for use in a conversation area, conference room, or lecture hall. It takes its inspiration from the high school classroom wood arm chair and side table, but with human comfort in mind. Migrations is designed by Michael Shields.
(Photograph courtesy of Brayton International)

FIGURE 11.20 Based on their sheer size, pool tables typically become a focal point of a room. This one, located at the Waldorf Astoria Hotel Syon Park Isleworth, Middlesex, England, is further emphasized by its purple felt.
(© Renato Granien / Alamy)

FIGURE 11.21 A modern casepiece, Sideboard 2, designed by Charles Rennie Mackintosh at the beginning of the twentieth century, was put into production in 1974. The piece, made of ebonized wood and contrasted with pearlized and stained glass, can be used for a variety of functions.
(Courtesy of Cassina USA, Inc.)

Storage

Many innovative pieces designed for functional storage are available. Built-in systems house stereos, televisions, and DVRs. Chests, cupboards, hutches, secretaries, china cabinets, shelves, armoires, and filing systems provide convenient and efficient storage (Figures 11.21 and 11.22).

Beds

A bed may be built-in or freestanding. It may serve dual purposes, such as a daybed or convertible sofa. Different styles include four-poster beds, decorative canopy beds, Murphy beds (a type of bed that folds down from the wall), trundle beds (a bed that pulls out from under another bed), bunk beds, and waterbeds. Beds may also be designed without the traditional mattress and box springs (Figure 11.23).

Built-in Wall Units

Built-in furnishings may function as seating, tables, beds, and storage space and are integrated with wall construction. Built-in units have the

FIGURE 11.22 Dakota Jackson, New York furniture designer, created these unique storage units called the Nuevo Tango Series.
(Courtesy of and design by Dakota Jackson)

advantage of providing architectural unity and a more spacious feeling; a disadvantage is the inability to move the components.

Moveable Furniture

As telecommuting becomes more prevalent and employees share office space, flexibility in design becomes more important in furniture design. Offices may be wheeled from one department to another based on current needs. Filing cabinets may move from one department to another as hardcopy forms are routed through an office. A studio apartment may also benefit from a mobile office (Figure 11.24).

FIGURE 11.23 In this ASID award–winning bedroom, the designer created a Zen-inspired interior. The cool, crisp walls, glass, and woods are balanced by the area rug's texture and the coarsely woven chair.
(Designer: Bruce Benning, ASID/CID, Benning Design Associates. Photograph by David Duncan Livingston.)

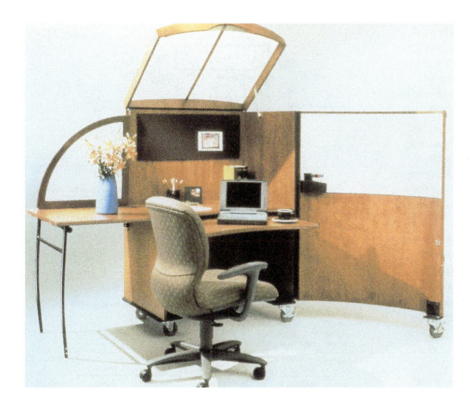

FIGURE 11.24 With this self-contained portable office, a corner of any room can become an office space. When opened, this system provides 12 square feet of work surface, a keyboard tray, a markerboard, and a tackboard.
(Courtesy of Knoll, Inc.)

■ SYSTEMS FURNITURE

Systems furniture consists of modular pieces used for open office design (Figure 11.25) and, in some cases, residential office spaces. The purpose of systems furniture is to provide flexibility in facilities design. The layout of the cubicles assists with internal communications, allowing employees to engage in conversations without "leaving their offices." Junior employees also are trained through observation of adjacent seasoned employees. The layout of the furniture systems assists in organizing departments via grouping into pods or zones, thereby encouraging employee interaction. The open office systems require informal conferencing areas to allow for private conversations when needed (as seen in Figure 8.40A and B).

FIGURE 11.25 This open office system encourages collaboration on design projects. Note the extensive work surface areas and the under-counter storage unit that doubles as extra seating for team work.
(Architect/Designer: Cooper Carry. Photograph by Gabriel Benzur.)

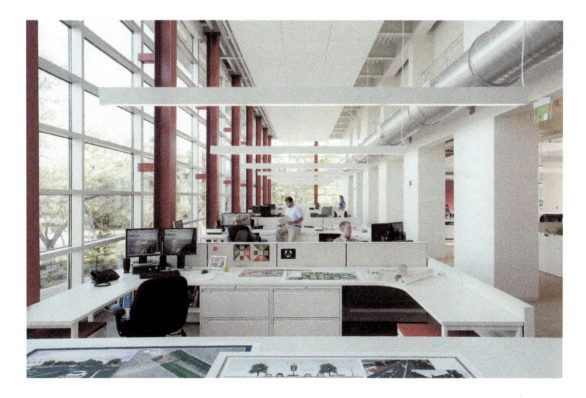

The systems consist of vertical panels that serve as walls. As seen in Chapter 10, some of these vertical panels may extend from the floor to the ceiling, creating full-height walls; others may extend only to work-surface height, or many heights in between, depending on the need for privacy, sound attenuation, or vertical hanging or display surfaces.

The wall panels can include hidden channels for running electrical and communication cables, and may include standard duplex outlets. Panels may be sound rated to assist with noise attenuation. They may be covered in standard or custom textiles or wallcovering; have a metal, plastic, or wood finish; or be painted. Some systems include panel inserts of glass or plexiglass, marker boards, peg board, or other tackable surfaces (Figure 11.26). Panels may include horizontal tracks for hanging bins and other paper and office organizing accessories (Figure 11.27).

Work surfaces can be hung at a variety of levels for use as a desk top, credenza, return, or bookshelf. Units may also be used as reception desks and have dropped surfaces for accessibility (Figure 11.28). Additionally, storage units may be hung from the walls for use as under-counter bins, overhead bins, or even small closets. Overhead bins may include task lighting below the unit, or ambient lighting above (as seen in Figure 6.31).

Most systems include movable pedestals that slide beneath the work surface for storage. These are particularly useful for files that may need to be moved between employees. Furthermore, these mobile units may be pulled out slightly for an additional work surface, while some include padded tops for additional seating (as seen in Figures 11.25 and 11.27).

Systems furniture is used by executives and management, as well as support staff. The modular nature of systems furniture allows for myriad configurations of heights, angles, and pieces to fit the space available, as well as the flexibility to meet the needs of changing work requirements (Figure 11.29 and Figure 12.14).

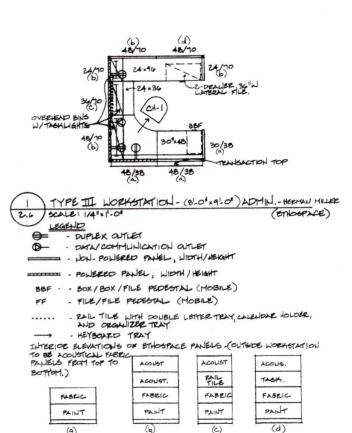

FIGURE 11.26 This specification drawing of an open office workstation illustrates the diversity of custom options. Note the variations in panel materials and heights, the selection of overhead bins and lighting, and the addition of electrical outlets and under-counter storage units.
(Architect/Designer: Godwin Associates)

FIGURE 11.27 This contemporary office space illustrates the use of the open office furniture system. Wires and cables are concealed in the system's walls. Fabric-covered panels are available in a variety of options with or without tackable surfaces. Custom rails provide areas for suspending notes, files, and desk supplies. Mobile carts provide storage under the surfaces.
(Courtesy of Knoll, Inc.)

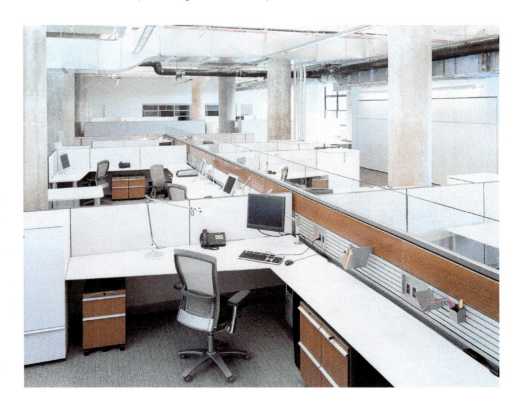

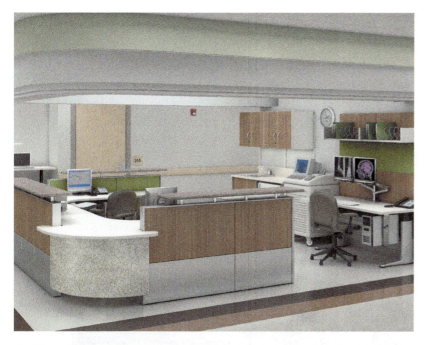

FIGURE 11.28 This nurse's station has been designed using open office systems furniture. Perimeter areas can be used for transactions of information, including a lowered section that is accessible. Changes in flooring color help to define the private areas, as does the dropped ceiling.
(Courtesy of Herman Miller, Inc.)

FIGURE 11.29 This nurse's station in a hospital also uses an open office system. Glass panels allow for a semiprivate work area, while still permitting views to patient rooms. Rounded edges on the transaction top allow for a safer environment. Electrical and communication cabling is concealed in the system walls. Ergonomic chairs are lightweight and mobile, while providing ample back, thigh, and arm support. Note how lighting and materials alter the feeling from Figure 11.28.
(Courtesy of Herman Miller, Inc.)

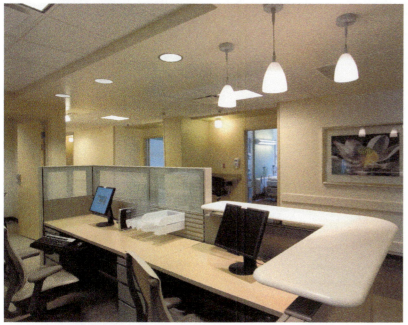

■ GENERAL CLASSIFICATIONS OF FURNITURE STYLES

Furniture styles typically are referred to as traditional or contemporary; however, designers should be familiar with the following terms:

- **Antique**—A piece of furniture or work of art that, according to U.S. law, must be at least 100 years old.

- **Reproduction**—A copy of an original period piece. Some reproductions are made so meticulously that only the well-trained eye can detect the difference; other modern reproductions are far from exact copies.

- **Adaptation**—A piece in which some elements from the original have been adapted into a new design.

- **Period style**—A term used to designate a single item or a complete interior, including the architectural background, furniture, and decorative arts, prevalent in a specific country or a particular time in history. This type is often referred to as traditional.

- **Contemporary style**—A term referring to designs that to some degree have been adapted from historical or modern influences. Usually considered a clean and elegant twentieth- or twenty-first-century design.

- **Modern style**—Anytime in history a new art form emerges, breaking ties with previous design forms—whether in music, architecture, or furniture—it is referred to as modern.

TABLE 11.1 Furniture Types: Seating and Beds

Ladderback chair

Windsor chair

Spoon back chair

Side chair

Open arm chair

Lawson lounge chair

Skirted chair

Tub chair

Wing chair

Channel back wing chair

Loveseat

Camelback sofa

Lawson sofa

Tuxedo sofa

Chesterfield sofa

Chaise longue

Studio couch

Ottoman

Four poster bed

Canopy bed

Convertible sofa

TABLE 11.2 Furniture Types: Tables, Case Goods, and Pianos

Nested tables

Harvest table

Pedestal table

Butterfly table

Gateleg table

Queridon table

Tilt-top
pedestal table

Tier table

Lamp table

Pembroke table

Double chest

Chest of drawers

Desk with
right return

Sideboard

Block-front chest

Chest on chest

Secretary

China cabinet

Breakfront

Armoire

Welsh cupboard

Spinet piano

Baby-grand
piano

■ QUALITY AND CRAFTSMANSHIP

The quality of construction and craftsmanship of a piece of furniture help to define the value of the item. Designers need to understand the nature of furniture construction in order to purchase wisely for clients. Construction features to consider include the following:

- Furniture should be well proportioned and comfortable. Sit on a chair or sofa to test its comfort. Check the depth of the seat and the height of the back and arms. If a chair is being chosen for a particular person, have that person try it out.
- A fine-quality finish is smooth and evenly applied, with no spotting, sticky areas, running, or buildup of coats. Good wood furniture has the look of a fine **patina** (a mellow, refined appearance) resulting from much rubbing, a practice requiring time and effort, therefore adding to the cost.
- Back panels should be recessed and smoothly finished.
- Movable parts such as drawers and door panels must be durable and easily operated (Figure 11.30). Drawer runners are best when made of metal, plastic, or durable hardwood. Well-made drawers have solid sides, three-ply nonwarp bottoms that are sanded and sealed against snags, and dovetail joints, and are separated by dust barriers. All drawers should have drawer stops to prevent the drawer from being completely pulled out.
- Hardware, such as drawer pulls and handles, should be securely fastened.
- Furniture with flat areas, such as tables, cabinets, and desktops, should be constructed of durable material to maintain function and appearance. Although some materials are practical, each may have a particular hazard; for example, marble may stain, glass may break, plastic may chip, and hardwood may scratch.
- The edges of tables and other pieces are especially susceptible to damage and wear. Rounded edges, reinforced strips, and edges made of solid hardwood are more practical.

In general, all sections of furniture must be securely joined. The following pages discuss some of the specific materials and methods used in furniture construction.

FIGURE 11.30 Inner characteristics of furniture determine durability: selected hardwoods; mortise-and-tenon joints; heavy-duty center drawer guides; drawers dovetailed front and back; durable dust panels between drawers; durable drawer bottoms held in grooves; strong casebacks recessed into ends; well-mounted top and sides; drawer interiors sanded and sealed.

Wood

Wood is the major material used for furniture construction. Furniture is made from both hard and soft woods. Table 11.3 lists the most common woods and their uses. Hardwoods come from deciduous trees (those that drop their leaves), such as oak and maple. Hardwoods are more durable and dent resistant than softwoods, but because they grow slowly, they cost more. Hardwoods are preferred for fine furniture (Figure 11.31). Softwoods come from coniferous trees (those with needles that are mostly green year round), such as pine and spruce. Softwoods are used for less-expensive furniture and in combination with hardwoods.

The woods most widely used in furniture construction are birch, maple, oak, cherry, walnut, mahogany, beech, pecan, and teak. Labels describing the finish, such as "fruit wood finish" or "walnut finish," refer to the color only, not to the species of wood used. Each wood has its own special properties. Wood selected for a particular furniture piece should be properly dried; well suited for its intended construction, purpose, finish, size, and style; and resistant to warping, splitting, swelling, and shrinking.

TABLE 11.3 Most Common Wood Types

Wood Type	Characteristics	Uses in Interiors
Acacia	Hardwood. Light brown.	Furniture. Woodwork. Often used for religious decorations.
Alder	A light, weak wood. White to light browns.	Furniture. Framing for construction.
Ash	A blond hardwood. Texture resembles oak. Relatively inexpensive.	Cabinetry and furniture. Furniture framing. Flooring.
Bamboo	A tropical tubular woody plant with a raised joint. Considered a green alternative.	Asian-style furniture. Decorative accessories. Flooring.
Beech	A blond hardwood. Fine-grain texture. Strong.	Informal furniture. Popular in Scandinavia. Flooring.
Birch	Subtle wavy grain. Hard and durable. Takes stain well, but also beautiful in natural finish.	Furniture. Popular in Scandinavia. Flooring, doors, and cabinetry. Furniture framing.

TABLE 11.3 Most Common Wood Types *(continued)*

Wood Type	Characteristics	Uses in Interiors
Cedar*	Reddish-brown, often with yellow streaks. Soft. Lightweight. Strong odor. Moth repellent.	Closet lining, chests. Informal furniture. Shingles, siding, paneling.
Cherry	Reddish-brown hardwood. Resembles mahogany. Durable. Strong.	Used in small quantities. Inlay and marquetry work. Popular for early American furniture.
Cypress	Color varies from light yellow to darkish-brown. Soft. Warp resistant. Inexpensive. Weathers silver gray.	Particularly used as a finish wood. Outside finish work. Doors, shingles, and siding. Some informal furniture.
Ebony*	Exquisite dark hardwood with brownish-black streaks. Ebony, sometimes red or green. Hard and heavy.	Modern and Asian furniture. Inlay and marquetry designs.
Elm	Light brown with gray overtones. Takes stain well. Slight undulating grain. Hard and heavy.	Particularly used for veneers. Furniture. Interior finish work. Furniture framing.
Fir*	Strong and durable. Wavy grain. Takes stain well. Resembles pine.	Plywood and laminated sheets. Cabinetry. Trim pieces. Inexpensive furniture.
Gum	Reddish-brown. Medium hard. Resembles mahogany. Interesting grains.	Veneers. Doors. Interior trim. Furniture parts.
Mahogany*	Reddish or reddish-golden brown with fine grain. Can be beautifully finished.	Fine, expensive furniture. Especially popular for Queen Anne, Chippendale, and other eighteenth-century furniture. Paneling and cabinetwork.
Maple	White to pale yellowish-brown. Fine grain. Hard and heavy. Resembles birch. Relatively inexpensive.	Informal furniture. Popular for early American style. Flooring. Cabinetwork. Furniture framing.
Oak*	White oak is light to golden brown. Red oak has pinkish tones. Straight to strong wavy grain. Hard and durable.	Most important wood for furniture, trim, and cabinetwork. Quarter-sawn (straight grain) usually preferred for fine furniture and paneling.
Pecan	White to reddish-brown. Refined grain, often with darkish streaks. Hard, strong, and heavy.	Fine furniture. Furniture parts. Cabinetwork, paneling, and trim.
Pine	Off-white to pale yellow. Soft. Not strong. Lightweight. Inexpensive. Close grain with occasional wavy grain.	Flooring, doors, and trim. Early American or provincial furniture and paneling. Cabinetwork.
Poplar	Off-white to yellowish-brown. Softwood. Lightweight. Subtle straight grain. Inexpensive.	Informal furniture. Works well painted. Trim, cabinetwork, and exterior siding. Furniture framing.
Rattan	A jungle vine from Asia. Pale yellow to light brown. Soft and pliable.	Informal furniture with Asian feeling. Can be nicely painted and stained.
Redwood*	Uniform red color. Grays when exposed to weather. Available in large planks.	Exterior finishes. Beams, paneling, etc. Cabinetwork. Outdoor furniture.
Rosewood*	Fine-textured reddish-brown hardwood with black streaks. Beautiful when highly polished.	Popular for fine eighteenth-century furniture. Inlay designs. Danish modern furniture.
Satinwood*	Pale blond color with smooth satin finish. Unique grain. Expensive.	Fine furniture and finish work. Inlay and parquetry designs.
Teak*	Yellow to reddish-brown with fine black streaks. Strong and durable. Beautiful with oiled finish.	Popularly used for Asian- and Danish-designed furniture. Decorative and functional accessories.
Walnut	Light to dark golden brown. A variety of beautiful grains. Hard, strong, and durable. Expensive.	Used for fine furniture in many styles. Especially used during eighteenth-century Queen Anne period, called the "Age of Walnut." Paneling.
Yew*	Dark reddish-brown hardwood particularly found in England. Close grained.	Cabinetwork and some furniture.

*Make sure these woods are obtained from companies with sustainable forest practices before specifying.

FIGURE 11.31 In this contemporary kitchen, a custom wood table has been raised to countertop height to serve as a work surface and double as a dinner bar. Hardwood stools are contoured to fit the shape of the human body.
(Architect/Designer: Rozanne Jackson. Photography by Chris Little Photography.)

Solid Wood and Veneers

Solid wood refers to the parts of the piece of furniture made from one piece of wood, such as legs in chairs or tables, the frames, and trim. A **veneer** is a thin layer of finishing wood applied to the body of a less-refined wood or a polymer (a material added to wood to strengthen it). Veneers may be cut in different methods that result in characteristic wood grains (Figure 11.32). With advanced methods of cutting and adhering veneers, a piece of veneered furniture can be stronger and more

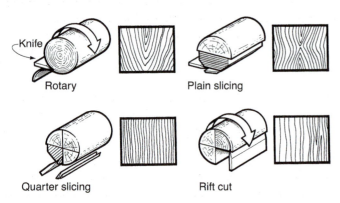

FIGURE 11.32 Veneer cutting patterns.

resistant to warping than a solid wood piece. The label *genuine* indicates that all the exposed solid pieces and the veneers are made from the same wood species.

More info online @

http://fscus.org Forest Stewardship Council
www.forestworld.com Sustainable Forest Products resource
http://afandpa.org/whatwebelieve.aspx?id=1902 Principles of Sustainable Forests by the American Forest and Paper Association
www.hardwoodcouncil.com The Hardwood Council

Other Forms of Wood in Furniture

Plywood, commonly used in building construction, is made by laminating together a number of thin layers of wood, with the grain of each layer turned 90 degrees. In furniture design, plywood is sometimes used on the inner core of veneers.

Particleboard (also known as chipboard) is made by combining chips of wood with resin and compressing the mixture to form a larger piece of wood. Because high-quality particleboard does not warp as easily as plywood, it is commonly used as a base in veneer furniture construction.

Fiberboard, most commonly known as medium-density fiberboard (MDF), comes in various densities. Through a steam pressure process, wood is broken down into fibers and then mixed with resins and pressed into panels. Fiberboard is frequently used for cabinet door panels and moldings and as a base for laminated surfaces.

Hardboard, a high-density fiberboard, is commonly used in the bottoms of drawers, in dust panels, and on furniture backs. It is thinner than particleboard and gives the appearance of a thin sheet of solid wood. Masonite is its common trade name.

Bentwood is made by placing thin strips of wood under pressure and softening them with steam to fit around molds. Michael Thonet's bentwood chairs, developed in the 1800s, remain popular (see page 74).

Wheatboard, produced from surplus or waste straw, can be stained and finished for use in custom-built cabinets, countertops, and shelving. Considered a "green" product, wheatboard can also be used on interior furniture framing and is formaldehyde-free. Wheatboard is currently difficult to find; however, designers should continue to search for green alternatives. For example, *kirei board* is a woodlike product constructed from the stalks of the sorghum plant.

More info online @

www.elements-of-green.com Wheat-Board-Plywood.html Images and information on wheatboard

Construction Methods

The quality and type of wood joining indicate the durability and aesthetic appeal of a piece of furniture. The most common construction methods for joining wood follow (also refer to Figure 11.33):

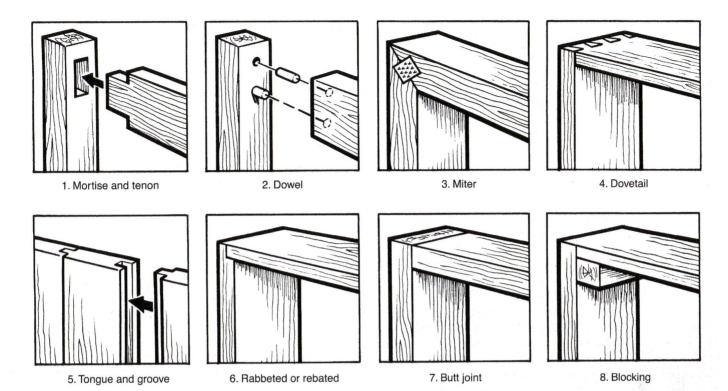

FIGURE 11.33 Types of wood joining.

1. Mortise and tenon
2. Dowel
3. Miter
4. Dovetail
5. Tongue and groove
6. Rabbeted or rebated
7. Butt joint
8. Blocking

- **Mortise and tenon:** The mortise (hole) joins with a piece that has a projecting piece (tenon). This forms a strong joint used particularly where arms and legs join the frame.

- **Dowel:** Rounded dowels (pegs) are joined and glued into corresponding holes. The strength of this design relies on the strength of the dowel.

- **Miter:** Edges are cut at a 45-degree angle and must have a supportive strip straddling the joint to be strong.

- **Dovetail:** Semitriangular or fan-shaped protrusions fit into notches of the same size and shape. This type of joint secures drawer fronts and sides.

- **Tongue and groove:** The tongue-and-groove joint is similar to the mortise-and-tenon joint but runs the entire length of the joint.

- **Rabbeted or rebated:** One edge has a groove cut the entire width to accommodate a straight-edged piece.

- **Butt joint:** This type of joint is not used for fine furniture. The joints are merely glued or screwed together. It is sometimes found on inexpensive furniture, but it must have cross-supports or corner blocks to reinforce it.

- **Blocking:** Corner blocks or hidden blocks of wood help to reinforce joints such as those at table or chair legs.

More info online @
www.taunton.com/finewoodworking Taunton Press page on fine woodworking; links to articles and videos.
www.awinet.org Architectural Woodwork Institute

Types of Finishes

Principal types of finishes applied to wood furniture include stain, paint, oil, varnish, shellac, lacquer, and polyurethane (see Paints and Finishes in Chapter 10). Special or unusual finishes include stenciling, faux finishes (simulating other materials such as marble and granite), spattering, stippling, glazes, sponging, and hand-painted designs.

Metal

Metal is a common material in furniture construction and can be shaped in many forms. It can be riveted, bolted, or welded, providing great flexibility of design. The most common metals used for furniture construction are aluminum, chrome, iron, and steel.

Aluminum appears in tubes, cast leg frames, and sections of angles and channels. It requires a unique finishing process called anodizing to prevent corrosion. Aluminum is relatively weak in strength.

Chrome or *chromium* is used as a metal finish on furniture. It is characterized by its highly polished sheen, but is also available in a satin finish. Quality chrome plating is difficult to achieve and should be backed by a reputable manufacturer.

Iron, a black metal, is commonly used in outdoor furniture and on railings or grills. "Wrought" iron simply means "worked" iron.

Steel, a combination of iron and carbon, is the most commonly used metal in furniture construction. When formed into sheets, this metal is used in office furniture, cabinetry, shelving, and other products. The *gauge* or thickness of the steel determines its quality. Thin sheets are flimsy and easily dented, and may produce a drumming noise when struck. Quality metal furniture should be able to withstand normal

dents and dings. Tubular steel furniture was perfected in the late 1920s through the work of several Bauhaus designers (see Figure 11.36).

Steel rusts, and therefore must be finished with paint or be chrome plated. Stainless steel, a combination of steel and chromium, is used in hardware and trim. Other metals used in furniture, such as *brass, copper,* and *tin*, are primarily decorative elements.

Plastics

Over 15,000 types of plastic are available to the consumer. Plastics may be derived from animal protein, plant fibers, or, most commonly, petroleum-based minerals. Plastics are composed of chains of molecules, called polymers. The basic makeup of the polymers determines the type of plastic and its qualities. **Thermoset plastics** maintain their shape through a heat-set process and, once manufactured, are permanently hard. Conversely, **thermoplastics** can be reshaped by reheating them and are therefore recyclable.

A common thermoset plastic used in furniture is melamine, more commonly referred to as laminate. Low-pressure laminates are frequently used for the interiors of cabinets. High-pressure laminates are much more durable and are used on cabinet surfaces and writing surfaces. Available in a wide variety of colors, thicknesses, textures, and patterns, laminates are actually sheets of paper glued together with plastic resin. Glossy laminates may be used on vertical surfaces, but will not maintain their glossy appearance if used in a horizontal plane. Additionally, textured laminates are not appropriate on a horizontal plane, where a smoother surface is desired.

Other thermoset plastics used in interior design include polyurethane foams and gels (used in cushions), silicones (used in water-repellent finishes), epoxies (used for sealers), and gel coats (used in cultured marble countertops). Polyester resins also are merged with glass fibers to form fiberglass, which is used to make molded furniture. However, some polyesters, such as polypropylene, are thermoplastics and may also be used in textiles.

Thermoplastics such as nylon, polyolefin, and vinyl also are used in the textile industry. Thermoplastics used in furniture design also include acrylics, such as Lucite and Plexiglas, and polycarbonates, such as Lexan (Figure 11.34). They are common lightweight, nonyellowing substitutes for glass. *Cast resin* is a type of thermoplastic polyester that can be colored, shaped, and formed into translucent panels. These panels have multiple uses as walls, floors, room dividers, and other architectural solutions (Figure 11.35).

Solid surfacing materials, such as those sold under the trade name Corian, are acrylic polymers combined with natural materials. They mimic stone, marble, or granite. Unlike laminate countertops, their color penetrates the entire depth of the product and they provide a seamless surface. These materials are used most commonly for countertops (as seen in Figure 11.35), but also may be used on vertical surfaces. Solid surface materials marred or stained from cigarette burns, alcohol, food, lipstick, hair dye, shoe polish, iodine, and even marking pens can be repaired by using a gritty cleanser.

Plastics are durable and easy to keep clean; however, some may dull over time, break, or scratch. Some plastics are flammable and, when

FIGURE 11.34 In this contemporary high-rise condominium, the designer uses thermoset plastic panels to provide a division of space. The Ghost chairs are made of polycarbonate, a thermoplastic. *(Designer: Carson Guest. Photograph by Gabriel Benzur.)*

FIGURE 11.35 A solid surfacing material called Polystone, a thermoplastic, was used on the makeup counter of the Facial Cosmetic Surgery Office. It creates a seamless finish and allows for a gently rounded nose edging and curved inset. The mirror is lit around its entire perimeter to minimize shadows on the viewer. The decorative treatment on the door is designed from Ecoresin panels. *(Architect/Designer: LeVino Jones Medical Interiors. Photography by Thomas Watkins.)*

damaged, can rarely be repaired. Because plastics are mainly petroleum based, they use up nonrenewable resources. Not all plastics are biodegradable; however, some can be recycled. Plastics used as upholstery fillers are discussed in the section on upholstered furniture.

More info online @
www.3-form.com/index.php 3-form website on translucent resin panels

Glass

Manufactured by combining sand, soda ash, limestone, dolomite, and a small amount of alumina, glass is a common element in furniture design, particularly for tabletops. Designs can be etched or sandblasted into the glass (as seen in Figure 11.14), or the entire surface may appear slightly frosted or opaque. A variety of beveled edges are available;

edges without a bevel should be avoided due to the sharp nature of glass. Additionally, tabletop glass should be at least 1/2" thick and tempered to prevent sharp edges if broken.

Clear glass tops, as seen in Figure 13.1, are artful and help to expand a space. Glass also brings an element of sparkle to the interior, thereby adding contrast and interest to the space. Glass can be cut to virtually any shape and is sometimes used on the top of antiques or fine wood furniture to protect the finish. Glass is also used in the bathroom industry to provide sculptural basins and countertops.

Palms and Grasses

Bamboo, rattan, cane, rush, and the materials used in wicker come from natural sources such as palms and grasses. Because of their nature, rattan, wicker, cane, and rush are compatible with an informal setting; in an eclectic formal room, they can add interest to the decor (as seen in Figure 11.12). These materials can be used effectively in both inside and outside spaces.

FIGURE 11.36 Marcel Breuer combined cane with tubular steel for his famous Cesca chair while he was a faculty member at the Bauhaus design school during the 1920s. He was the first designer to use tubular steel for furniture construction.
(Courtesy of Knoll, Inc.)

Bamboo is a grass characterized by woody, hollow stems and ringed joints. It is used in lightweight furniture.

Rattan poles are cut from the rattan palm and can be bent to form a variety of designs. They are used mainly for chairs, tables, and beds.

Cane is split rattan or bamboo that is woven to form a mesh. Cane was introduced into England about 1660. It was used for chair seats and backs and some outdoor tabletops (Figure 11.36).

Rush is tightly twisted long grass (paper is often used as a substitute) made into a cord. The cord is then woven and used mainly for seats and backs of chairs.

Wicker (or basketwork) is a *method* of woven chair construction rather than a specific material. Used since ancient times, wicker chairs can be made of rushes, twigs, or reeds.

■ UPHOLSTERED FURNITURE

People in ancient civilizations first created "upholstered furniture" by stretching textiles, animal skins, or other natural materials over a sturdy frame. Chairs with fabric stretched over seat and back frames are still used for lightweight pieces. During the Renaissance, simple cushions were placed on top of the stretched fabric. Later, fabrics were stretched over those cushions. By the sixteenth century, padding made of horsehair, feathers, wool, and down made cushions deeper and more comfortable. In the nineteenth century, springs were introduced and modern upholstered furniture had arrived. After that, little change occurred in upholstery construction until the introduction of synthetics during the 1930s, which had a tremendous impact on the furniture industry. There are two basic types of upholstered furniture: overstuffed (furniture that has padding or stuffing attached over the frame) and partially exposed (furniture that has some exposed frame pieces). The padding or stuffing is covered with a fabric or natural hide, which is referred to as upholstery.

Parts of Upholstered Furniture

Hidden beneath the upholstery are the components that should produce durability, comfort, and quality in upholstered furniture (Figure 11.37). Because these elements are hidden, the designer must rely on the manufacturer's written specifications.

Frame

A frame is constructed of metal, plastic, or kiln-dried hardwood such as maple, poplar, oak, ash, birch, or elm. (Softwoods tend to split.) The wood frame should be firmly assembled and usually joined by double dowels that are spiral grooved and then glued in place. Reinforcement braces of metal or wood should be glued and screwed to the corners. Nails are never used in the frames of good-quality furniture. Frames should be smooth to prevent the fabric from sagging.

Webbing and Felt

Generally made of linen, jute, plastic, or rubber, the webbing is arranged in a basketweave to provide support for the springs and cushions. Good-quality webbing measures 3 to 4 inches in width and is tightly woven with little to no space between the bands. Cotton felt may also be used to protect springs and other materials.

Springs

Springs are constructed of sinuous wire, formed wire, or coils. The sinuous wire spring is attached to the frame and forms a zigzag pattern. Formed wire springs are also attached to the frame but create boxed shapes instead of zigzags. Sinuous wire springs are more desirable for slim-line modern furniture and lightweight occasional chairs.

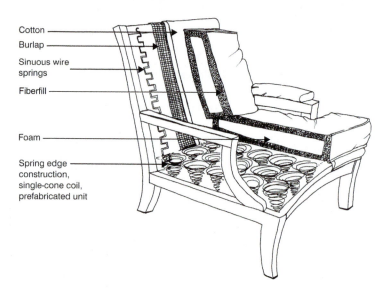

FIGURE 11.37 Upholstery construction.

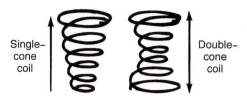

Single-cone coil

Double-cone coil

FIGURE 11.38 Single- and double-cone coils.

The cone coil comes in both single and double cone (Figure 11.38). The single-cone coil is a prefabricated all-wire unit. To create a spring cushion, single coils are tied to each other and attached to top and bottom border wires. Double-cone coils are affixed to a resilient base such as strips of webbing or metal and are hand tied at the top to prevent slipping. This construction provides maximum comfort and is used in more-expensive deep-seated upholstery. In fine-quality furniture, individual coil springs are contained in muslin; in most furniture, however, burlap is used to protect and cover springs and prevent the filling from working into the springs.

Filling, Stuffing, and Padding in Cushions

Filling, stuffing, or padding materials of various types and qualities are used for cushioning, either alone or in combination. These materials are listed on the label. The most commonly used fillings include the following:

1. *Polyester* is lightweight, resilient, and odorless, and it resists mildew and moths. It may be used alone or combined with cores of foam, down, or innersprings. Polyester or fiberfill fillings should be wrapped with fabric (such as muslin) to retain their shape and prevent abrasion on the final covering.

2. *Polyurethane foam* is commonly used and is available in a variety of densities. It is often wrapped with polyester fiberfill to add softness. Polyurethane resists liquids, moths, and mildew and is very resilient.

3. *Down* or *feathers* are used in seat cushions, usually in combination with polyester and a thin foam core for shape. Although historically considered luxurious, 100 percent down is expensive and, because it is not resilient, it requires frequent plumping.

4. *Rubberized fibers* (which have less resiliency than the previously mentioned filling materials) are used in moderately priced furniture.

5. *Shredded fibers* from natural sources (such as certain types of leaves) or synthetic felts are generally used in low-price furniture.

6. *Cotton* is occasionally used for small pieces.

Upholstered cushions may be used on some or all of the construction of the furniture piece. Seat and back cushions and pillows are added to complement the furniture's style, and cushions may be fastened or loose, depending on the style and preferred degree of flexibility. Cushions may also be tufted, a process in which the final covering is securely tied to the inner springs. Tufting is often accented with fabric-covered buttons. Cushioning should be comfortable, resilient, and durable and should stay in place. Three types are shown in Figure 11.39.

Fabrics and Finishing Touches

Upholstery fabric is used to cover the cushions and other parts of the furniture frame as dictated by the style. Guidelines for selecting durable, stylish, and functional upholstery fabrics are discussed in Chapter 12. Finishing touches add character and detail to upholstery pieces. Welts (a cord around the edge of cushions and/or wood trim wrapped with fabric) can be applied in single or double rows in the same or contrasting fabrics. Cording, a wrapped decorative piece of rope, may also be added in these places. Nail heads (usually brass) give a masculine feel to a piece of furniture. Decorative trims and fringes create interest in a design.

Labeling

As mentioned previously, federal and state laws require labels providing specific information about the piece to be attached to furnishings. Reputable manufacturers warranty the materials used, and guarantee that the furniture's performance will meet the specifications outlined on the label.

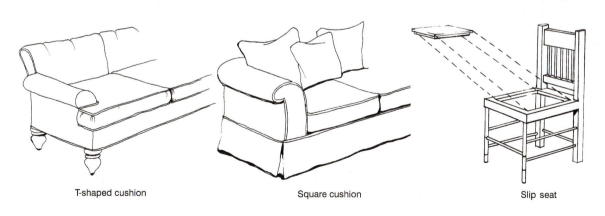

T-shaped cushion

Square cushion

Slip seat

FIGURE 11.39 Types of cushions.

Selecting Quality Upholstered Furniture

In selecting a piece of upholstered furniture, consider the following criteria:

- Precise tailoring is necessary for a well-finished appearance. Seams, welts, and cording should be smooth, straight, and firmly sewn with no loose threads. Hems and pleats should hang evenly.

- Large patterns should be carefully centered and matched on each cushion and skirt.

- All patterns, including those on the sides of the seat cushions, should run in the same direction.

- When fabrics are quilted, smaller stitches prevent snagging.

- Cushions should fit snugly.

- If zippers are used, they must be sewn straight with no puckering, and they must operate easily.

- If a nap is present, it should run in only one direction.

- Fabric should be smoothly stretched over the frame with no buckling.

- Back panels should be firmly and neatly tacked or stitched.

- Exposed wood parts should be of well-finished hardwood.

- Select green furniture. See Sustainable Design: Selecting "Green" Furniture and LEED-CI and E3-2010 for more information.

More info online @
www.homefurnish.com/livingroomdecor/chairsseating/upholsteredfurniture.aspx
Information on upholstered furniture construction
www.upholstery-supplies-guide.com/upholstery-yardage-chart.html Chart of approximate yardage quantities for upholstered goods
http://interiordec.about.com/od/furnconstruction/a/upholsteredfurn.htm General information on upholstered furniture

SUMMARY

Knowledge of the various furniture types and their proper construction will aid the designer in the development of a successful interior. Furnishings that withstand years of use will be remembered by the client and produce positive referrals; conversely, furniture that falls apart will also be remembered by the client, most likely in the form of negative referrals. Because of the financial investment, longevity is the expected outcome and designers must be able to recognize and specify quality construction.

SUSTAINABLEdesign

SELECTING "GREEN" FURNITURE

FIGURE SD11.1 The ergonomic H03 chair with seat and back made from recycled plastic bottles and car bumpers. *(Courtesy of HAG, Inc.)*

The process of furniture manufacturing, if not carefully undertaken, can harm the environment. When selecting "green" furniture, designers should look for products that utilize lumber from renewable wood resources or should select furniture made from recycled materials.

Many furniture companies have strict policies regarding the use of wood from threatened or endangered species of trees, many of which are found in rain forests. In some cases, federal and state laws restrict the use of certain woods for furniture construction. Some species, such as maple and oak, are easier to replenish than other rare woods, such as mahogany, teak, and rosewood. Wood species that are endangered but are grown specifically for furniture industries and replenished are often used only as fine thin veneers. These woods may be farmed as plantation-grown lumber or in a sustainable forest. More plentiful wood by-products, such as particleboard, are used for the veneer backing.

According to *Design Solutions* magazine, the Tropical Forest Foundation is one organization that works to educate consumers and producers about the benefits of conservation and forest management. One of its primary goals is to educate individuals and companies on the benefits of low-impact logging.

Another alternative is to select furniture made from recycled products. For example, HAG, a German furniture manufacturing company, has designed the adjustable H03 chair whose seat and back are made of recycled bottle caps (Figure SD11.1). The *Life* chair design from Knoll creates minimal environmental impact during its manufacture and includes as much as 64 percent recycled products (Figure SD11.2).

Proper selection of green furniture also includes ensuring that items have safe, environmentally friendly finishes. The process of applying paint to furniture can cause the release of toxic volatile organic chemicals, or VOCs, into the air. These solvents are carried into exhaust stacks and released directly into the atmosphere. VOCs contribute to smog and harm the ozone layer, allowing damaging ultraviolet rays to reach the earth.

The Clean Air Act, passed by Congress in 1990, requires companies to reduce these harmful emissions. Some companies have developed alternative painting processes to reduce

FIGURE SD11.2 The *Life* chair is considered a sustainable design product.
(Courtesy of Knoll, Inc.)

emissions. At an Interior Design Educators Council conference, Elizabeth Rylan and Gordon Kerby outlined several ways this can be accomplished. For example, paint can be applied to wood as it rides on a conveyor belt, reducing the VOCs emitted into the air; metal furniture can be given an electrical charge and coated with paint of the opposite charge, bonding the two together electrically. Additionally, substituting water-based stains and natural coatings for paint and using carbon filters can also lessen the release of VOCs.

In order to help protect the environment, designers should ask manufacturers for their policies and statistics on sustainable forestry as well as their compliance with the Clean Air Act before specifying their products. LEED-CI and E3-2010 further reviews the need for environmentally sensitive design and illustrates one business's solution.

More info online @

www.knoll.com/environment/env_pro_life.jsp Knoll's *Life* chair site
www.tropicalforestfoundation.org Tropical Forest Foundation
www.epa.gov/air/caa/peg EPA's Clean Air Act in "Plain English"

LEED-CI AND E3-2010

As introduced in Chapter 2, the United States Green Building Council (USGBC) developed the Leadership in Energy and Environmental Design (LEED) program. It is a voluntary, market-driven rating system quantifying a building's greenness. Their mission is "to transform the way buildings and communities are designed, built, and operated, enabling an environmentally and socially responsible, healthy, and prosperous environment that improves the quality of life." http://communicate .usgbc.org/usgbc/2006/08.15.06_guiding_principles/guidingPrinciples

Programs are in place for commercial and residential structures. Through a self-certified points system, buildings can achieve bronze to platinum ratings. LEED's checklist evaluates several areas including the following:

- Sustainable sites
- Water efficiency
- Energy and atmosphere
- Indoor environment quality
- Materials and resources
- Innovation and design process

LEED originally focused on the architectural components of a building; however, in 2002 they launched LEED-CI for commercial interiors. The commercial interiors program is applicable to tenant spaces in new or existing buildings. The format complements the original LEED green building rating system, but is expanded to recognize the environmental impact of interior furnishings. Of particular interest to interior designers are ratings related to efficient lighting design, low VOC emissions, use of materials from recycled sources, and use of regionally manufactured goods.

On a similar note, the Business & Institutional Furniture Manufacturer's Association (BIFMA) worked with manufacturers across many disciplines to develop a set of sustainable furniture standards. The result is the ANSI/BIFMA e3-2010 Furniture Sustainable Standard. The standard is modeled after the LEED system with six prerequisite and optional credits. Of the 90 possible points, 32 must be achieved to meet the minimum level.

The following project is an example of a building that adheres to LEED guidelines.

FIGURE SD11.3 In this Romanesque turn-of-the-century building, Greenpeace relocated its USA headquarters to the upper floors. The 15,500' project focused on sustainable design. Greenpeace's mission—to protect the environment—needed to be incorporated into the design solutions. The LEED green building rating system served as a guideline.
(Architect/Designer: Envision Design, PLLC. Photograph © Michael Moran.)

More info online @

www.usgbc.org LEED website
https://bifma.org/secure/orderform.html BIFMA e3 order form

LEED-CI AND E3-2010—cont'd

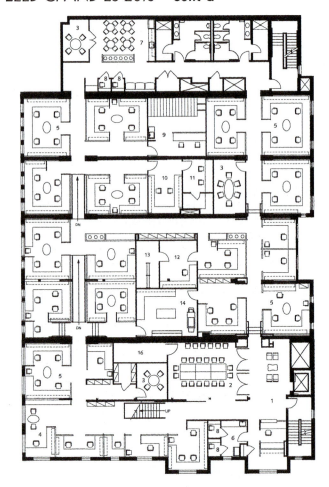

FIGURE SD11.4 These two floor plans indicate the complexity of joining buildings. Note that ramps have been installed to accommodate various floor levels and allow for accessibility. Ceiling heights varied greatly. To allow for uniformity and to conceal HVAC and electrical systems, dropped ceilings were set at 9'-6" above work areas and 8'-0" in the corridors.

The design also incorporates solar panels on the roof for electricity and heating water, as well as light sensors and energy-efficient lighting. The open office system allowed for 45 percent savings in unused drywall, 61 percent savings in unused doors, and 39 percent savings in lighting. The result is an aesthetically pleasing interior built of sustainable materials in an adaptive-use historic building.
(Architect/Designer: Envision Design, PLLC)

1	Reception	
2	Conference Room	
3	Huddle Area	
4	Director	
5	Work Station	
6	Pantry	
7	Break Room	
8	Phone Booth	
9	Archives	
10	Photo Workroom	
11	Edit Suite	
12	M.I.S. Workroom	
13	Computer Room	
14	Copy Room	
15	Library	
16	Electrical	
17	Light Well	

10'-0"
4th Floor

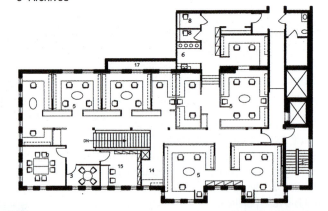

FIGURE SD11.5 The reception area on the third floor opens into the main conference room, allowing for flexible gathering space. Doors are made from wheatboard. The main corridor connects to the adjoining buildings. All woods used are certified by the Forest Stewardship Council (FSC), including the wood used in the Rison reception chairs, custom-made by Knoll for this project.
(Architect/Designer: Envision Design, PLLC. Photograph © Michael Moran.)

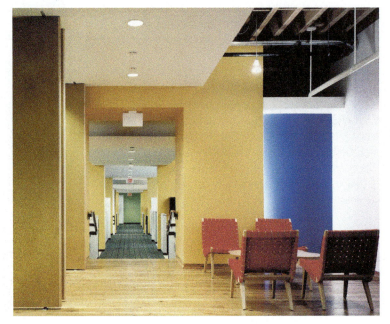

LEED-CI AND E3-2010—cont'd

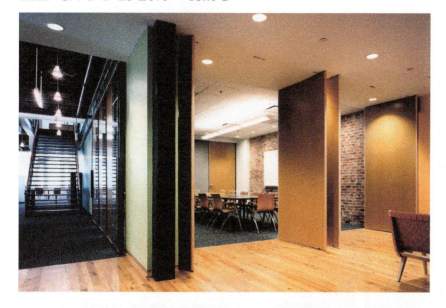

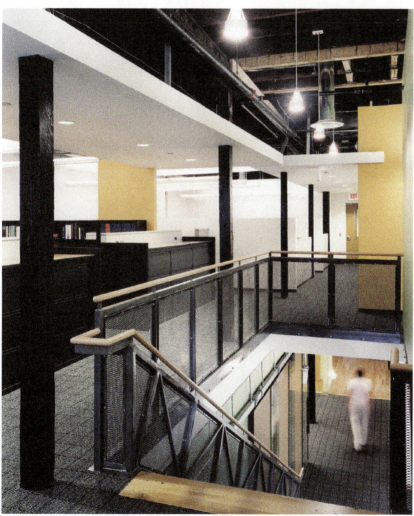

FIGURE SD11.6 Another view of the reception area. The stairway leads to the fourth floor. To allow more light to filter into the stairway, risers are transparent. Existing masonry walls were exposed where possible to avoid adding more building materials. Solid-surface countertops, made from yogurt containers, were used in the pantry area, as was a refrigerator that runs on less butane than two cigarette lighters.
(Architect/Designer: Envision Design, PLLC. Photograph © Michael Moran.)

FIGURE SD11.7 The fourth floor opens to the roof structure and, like the rest of the facility, uses an open plan concept interspersed with small conference rooms. Open office systems are built from wheatboard and an FSC-certified particleboard, and finished with VOC- and formaldehyde-free coatings. Natural cork is used for tack surfaces. Furnishings, such as filing cabinets, have been refurnished from previous uses.
(Architect/Designer: Envision Design, PLLC. Photograph © Michael Moran.)

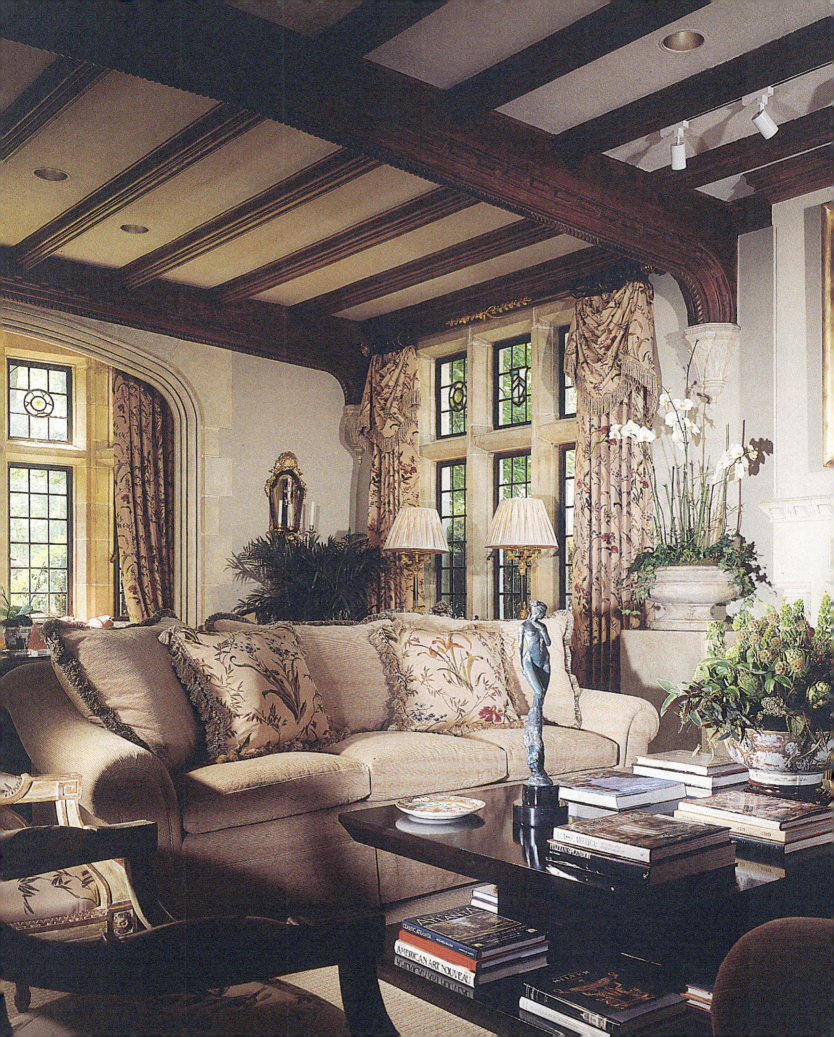

12 Textiles

FIGURE 12.1 In this masculine Tudor home, warm tones were selected by the designer to humanize the interior. Note the addition of trims and fringes on draperies and pillows.
(Designer: James Essary & Associates. Photograph © Robert Thien. As seen in Atlanta Homes & Lifestyles.*)*

Textiles enhance both residential and commercial interiors; they are probably more versatile than any other element used for interior design. Textiles are pliable; they can be sewn, draped, bent, folded, wrapped, pleated, gathered, and stretched. Textiles are used in every room for upholstery, window treatments, slipcovers, pillows and cushions, bedspreads, blankets and throws, towels, table linens, wallcoverings, ceiling coverings, lamp shades, and trim.

As discussed in the introduction to Part V, there are several basic considerations in the selection of interior materials: function, aesthetics, and economics. One of the primary purposes of textiles, however, is to humanize living spaces. Textiles provide a transition between architecture and furniture, bringing comfort, warmth, and softness to homes and public places (Figure 12.1).

Textile is an overall term used to describe a fiber, yarn, or fabric. The terms *fibers, yarns, fabrics,* and *textiles* are often used interchangeably in the profession and are defined as follows:

- **Fibers** are the raw materials, either natural or synthetic, that produce yarns and fabrics.
- **Yarns** are fibers that are twisted or assembled to form the strands that produce fabrics.
- **Fabrics** are the results of the weaving, knitting, twisting, felting, or lacing of fibers and yarns. Fabrics also may be formed from plastics.

FIBERS

Fibers, such as raw cotton, silk, and polyester, are the most basic element of a fabric. A perfect fiber that will adequately serve every general design purpose does not exist. Each fiber has its own advantages and disadvantages. Manufacturers have found that by blending certain fibers, the most desirable qualities of each can be incorporated into a single fabric.

Yarns are made by spinning various lengths of fibers into strands used for fabric construction. A fabric's performance and appearance are affected by the method and the amount of twisting of the fibers. A high twist produces more strength and durability but takes away some of the luster. Long filaments with little twist generally maintain a high luster but lose much of their stability. *Ply* is the result of twisting two or more single yarns together before weaving to give added strength or to create a surface effect.

Natural Fibers

Fibers that come from nature fall into four classifications: cellulose, protein, metallic, and mineral.

Cellulose Fibers

Cellulose (or vegetable) fibers come from the stems, leaves, and seed hairs of plants. The two most common cellulose fibers are cotton and linen (or flax) (Figure 12.2).

Cotton is believed to have been grown in India during the fourth century B.C. and used in early Rome; it is the most plentiful of the natural fibers. Its advantages are that it takes and holds color well, washes easily, and can be woven to produce sheer or heavyweight fabrics. Its flexibility allows it to be adapted for such functions as upholstery, floor coverings, and window treatments. Its disadvantages are that it is not as durable as other fibers, and it wrinkles. It can mildew and fade. The cost of cotton varies according to the quality of the fiber, weave, and finish.

Linen, made from flax fibers, is the most ancient of all fibers. It was used for weaving in Egypt as early as 4000 B.C. Its advantages are that it is strong, pliable, lustrous, and washable, and it takes and holds color. It is absorbent. The disadvantages of linen are that it wrinkles readily unless chemically treated, which then reduces its wear potential; it

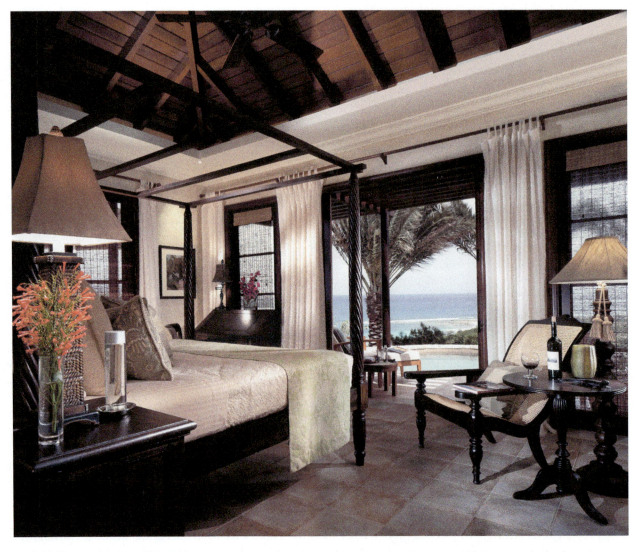

FIGURE 12.2 In this custom-designed residence in Anguilla, British West Indies, the designer selected natural fabrics to complement the environment. Sheers are of linen, and the upholstery is cotton canvas. The wood finish on the ceiling is ipe wood (cumaru), also known as Brazilian teak.
(Interior Architectural Design by Wilson Associates. Photography by Michael Wilson.)

FIGURE 12.3 This dining room incorporates a simple cotton checked pattern on its seat cushions contrasted with a faded antique wool rug. The combination provides a refreshing casual setting in a formal interior. See Figure 8.2 for the foyer attached to this room. *(Designer: Drysdale Design Associates. Photograph by Antoine Bootz. Courtesy of Southern Accents.)*

fades; it is stiff; and it is difficult to clean. Linen is used for upholstery, drapery, table linens, and slipcovers.

Protein Fibers

Wool and silk are the most important protein, or animal, fibers.

Wool is the fleece of sheep, Angora goats (known as mohair), camels, and other animals. It has been used since the seventh or eighth century B.C. In early Egypt, Greece, Asia, and the Middle East, it was used for clothing and some household articles. Wool has several advantages. It is resilient and flame retardant, resists abrasion, is a good insulator, and can be woven in a variety of textures. It can be dyed from the palest to the deepest colors, cleans well, resists dirt, and can absorb up to 20 percent of its weight in moisture without feeling damp. Its disadvantages include a tendency to yellow with age (particularly when exposed to sunlight), shrink, and be damaged by moths and other insects. Additionally, wool can be expensive, and it requires professional cleaning. It may also cause allergies. Wool is used for both residential and commercial applications including upholstery, carpeting, draperies, and wallcoverings (Figure 12.3).

Silk is an ancient fiber that, according to legend, was discovered in China about 2540 B.C. The process of producing it from the larvae of silkworms, known as sericulture, was kept secret for many years but gradually became known in countries around the world. The advantages of silk are that it is a beautiful, long fiber that is soft and luxurious and surpassed in strength only by nylon. It takes and holds dye well and drapes beautifully (Figure 12.4). One disadvantage is that the sun's rays break down the fiber, requiring it to be protected from direct sunlight. Silk also is susceptible to deterioration by soil, beetles, and moisture. It is expensive as well.

Raw silk, or uncultivated silk, is a shorter and coarser fiber with less luster. Both types of silk fibers are used for draperies, some upholstery applications (when backed), wallcoverings, trim, and fabric art.

FIGURE 12.4 Donghia's Sleight of Hand collection of four silk fabrics includes Abracadabra (a silk shantung), Hocus Pocus (a stripe), Shazam! (a zigzag design), and Presto! (a quilted matelassé). *(Courtesy of Donghia Textiles. As seen in Fine Furnishings International.)*

Mineral and Metallic Fibers

Mineral and metallic fibers are created from naturally occurring minerals, including metals. *Metallic fibers* include strips of gold, silver, or copper that are used chiefly as accents in decorative fabrics (Figure 12.5). Metallic fibers glitter without tarnishing and are washable.

Manufactured Fibers

Manufactured fibers are derived from either synthetic chemicals or natural solutions chemically treated. Manufactured fibers are designed to improve the quality, durability, and ease of care of natural fibers, as well as their resistance to soil, mildew, and insects. Although costs vary, manufactured fabrics tend to be less expensive than those made from natural fibers. Manufactured fibers are made by creating a liquid or viscose out of the original substance, then forcing it through holes in a showerhead-like device called a **spinneret**. Varying the size and shape of the holes in the spinneret changes the characteristics of the fiber. *Microfibers* are manufactured fibers that are finer than all natural fibers, including silk. They are used because they provide a luxurious drape, are lightweight, and resist wrinkling and pilling. Manufactured fibers fall into two categories: regenerated cellulose and synthetic fibers.

Regenerated cellulose fibers are produced by changing the physical and chemical properties of cellulose (plant and wood fibers). Some examples are rayon, acetate, and triacetate. *Synthetic fibers* are produced from chemicals and carbon compounds. Some examples are nylon, acrylic, modacrylic polyester, olefin, and glass (Figure 12.6A and B).

During the past six decades, the production and consumption of manufactured fibers has steadily increased. In 1940, manufactured fibers accounted for only 10 percent of the fibers used. Today, over 80 percent of fibers used are manufactured fibers. Table 12.1 lists

FIGURE 12.5 Touches of metallic gold add opulence to this patterned fabric from Girmes, a German manufacturer.
(Courtesy of Fine Furnishings International.)

the most common manufactured fibers, their qualities, their most important decorative uses, and recommendations for care to maintain appearance.

More info online @

www.fibersource.com Educational link to fiber sources
www.fabrics.net/fabricsr.asp Fabric information and facts
http://nationaltextile.org National Textile Association

FIGURE 12.6A This collection of fabrics is called Streetsport. It includes a variety of manufactured and natural fibers, the majority of which are polyesters and acrylics. All meet commercial application standards.
(Courtesy of Carnegie, www.carnegiefabrics.com)

FIGURE 12.6B This collection of fabrics is called In Motion. The product is made from 70% Repreve® post-consumer recycled polyester. The fabric resists stains, moisture, and bacteria.
(Courtesy of Momentum Textiles)

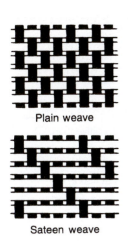
Plain weave

Basket weave

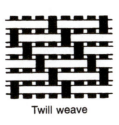
Twill weave

Satin weave

Sateen weave

Jacquard weave

Cut pile

Uncut pile

Leno weave

FIGURE 12.7 Common types of weaves.

■ FABRIC CONSTRUCTION

The history of textile arts is almost as old as the history of humanity. The exact origin of the loom is not certain, but evidence suggests that it was used in Mesopotamia before 5000 B.C. Although modern mechanization has brought great changes in textile production, weave structures are much the same as they were at the beginning of the Renaissance; these simple weaves are still standards in the industry. More intricate weaves that originated in Asia, such as damasks and brocades, are now produced on special **Jacquard** looms. Invented in France in 1801 by Joseph-Marie Jacquard (1752–1834), a Jacquard loom can create multicolored fabrics with intricate patterns.

Woven Textiles

This section discusses the most common weaves (illustrated in Figure 12.7), as well as some more-intricate ones used in decorative fabrics.

Plain Weave

A plain weave is made by the simple interlocking of **warp** (vertical or lengthwise) threads and **weft** or filling (horizontal or crosswise) threads, and may be single or double, regular or irregular. In the *plain single weave*, one weft thread passes over one warp thread and under the next. When the warp and weft differ because of different weights or textures of yarn, the weave is called irregular or unbalanced. In the *basket weave*, two weft threads are interlaced with two warp threads. This weave may also be irregular from variations of weight or texture.

Twill Weave

Twill weaves are those in which two or more threads pass over or under another set of threads, skipping at regular intervals to produce a diagonal effect. Twill weaves may be regular or irregular. Irregular twills are used for many decorative fabrics such as denim, gabardine, and herringbone.

Satin Weave

The satin weave floats one warp yarn over four or more weft yarns. This combination produces a fabric with luster, softness, and drapability, especially when the fiber is smooth, as with satin and sateen.

Jacquard Weave

The Jacquard weave requires an intricate series of hole-punched cards that tell the machine which threads to raise and which threads to drop. Some of the most common fabrics created on the loom include damask, tapestries, and brocades (Figure 12.8).

Pile Weave

Pile weaves are produced by additional threads in the weft or warp that form loops or tufts of yarn that stand out from the surface of the fabric. These loops may be cut, uncut, or a combination. Pile weaves are used in a wide variety of fabrics. The basic weave of the carpet industry is the raised-warp pile. Numerous fabrics are produced using pile weaves, including terry cloth, corduroy, and friezé. Velvets, originally woven by this method, are generally made today in a double cloth that is cut apart to produce the pile.

Double-Cloth Weave

Double-cloth weaves are woven in two attached layers, often resulting in a quilted appearance. These fabrics, known to the ancient Peruvians, are both durable and beautiful. The Jacquard loom is used to weave these fabrics for commercial applications.

Leno Weave

The leno weave is a loose, lacelike weave in which the warp threads are wound in half twists around each other, alternating positions on each row. Sheers, semisheers, and casements (coarsely woven sheers) use these weaves.

Nonwoven Textiles

Knitting

Knitting is a process of interlocking a series of yarn loops by means of blunt needles. Through a variation of stitches, patterns are formed. Knitted fabrics, either hand- or machine-made, range from loose, open construction to a close, fine mesh. Finely knit fabrics are used for many home furnishing needs because of their wrinkle resistance, tight fit,

TABLE 12.1 Properties of Manufactured Fibers

Generic Name	Appearance	Abrasion	Resilience	Heat Tolerance
Acetate (regenerated cellulose)	Smooth; silky; drapes well; holds shape well	Fair	Poor	Poor
Triacetate (a subdivision of the acetate group)	Crisp; smooth; silky; drapes well; strong colors	Fair	Good; resists wrinkling; retains pleats	Less sensitive than acetate
Acrylic	Wool-like; soft; bulky; warm; may squeak; rich colors; pilling depends on quality	Good; needs treatment for static	Good; holds heat-set pleats	Sticks at 450°F
Modacrylic (modified acrylic)	Similar to acrylic; good color retention	Good	Fair to good	Does not melt
Aramid	Stiff and smooth	High; exceptional strength	Excellent; low stretchability	Not affected
Fiberglass	Soapy; lustrous; silky; color range fair; Beta Fiberglas has remarkable sheerness	Strongest of all fibers	Excellent	Fireproof
Nylon (polyamide)	Squeaky; silky; cold; natural luster; good color range; drapes well	Excellent	Very good; resists wrinkling; can be heat set to hold shape	High resistance
Olefin (propylene and ethylene)	Waxy; wool-like; color range fair	Good to excellent	Good; resists wrinkling	Poor; heat sensitive
Polyester	Silky, cotton, or wool-like; drapes well; color range fair	Good to excellent	Excellent; resists wrinkles	Sticks at 400°F
Rayon (regenerated cellulose)	Soft; drapes well; excellent color range; bright	Fair to good	Low to medium; crease retention poor	Excellent; does not melt
Saran	Soft; drapes well	Tough	Crease retentive	Shrinks in intense heat
Vinyl (thermoplastic resins)	Smooth; variety of weights; expanded vinyl closely resembles leather	Good	Low	Shrinks at 212–230°F in dry heat, less in moist heat
Lyocell (cellulose derived from eucalyptus trees)	Cross between rayon and cotton; luxurious hand and luster; drapes well	Fair, particularly if finished smooth or rubbed when wet	Fair; will wrinkle	Does not melt, but scorches
Ingeo PLA (corn based, processed with polylactic acid)	Excellent hand; extremely soft; good drape and luster	Good	High	Melts at 360°F

Notes: All manufactured fibers are resistant to moths and mildew. Insulation depends on construction and is primarily a function of thickness. Hollow polyester fibers provide particularly good insulation. Costs are variable, depending on construction.

and ease of care. The tendency of knitted fabrics to stretch is being overcome by new methods of production.

Twisting

Twisting, interlocking, and knotting of yarns account for various types of mesh construction, such as nets, laces, and macramé.

Felting

Felting is a process of subjecting a mass of fibers to moisture, heat, and pressure, which produces a compact sheet that does not fray, absorbs sound, and provides good insulation against heat and cold. Felt was formerly made from wool and hair fibers. Through modern technology, new fibers and fusing methods are employed to produce a variety of nonwoven materials.

Flammability	Light Tolerance	Decorative Uses	Care
Slow	Long exposure weakens fiber; colors fade unless protected by special finish	Curtains, drapery, upholstery, rugs, for shower curtains in blends with other fibers	Fair soil resistance; wash in lukewarm water or dry-clean, depending on dyes, finishes, decorative designs; quick drying; iron at moderate heat
Slowly combustible	More resistant than acetate	Same as acetate	Same as acetate
Resists fire; burns with yellow flame	Good	Rugs, carpets, blankets, curtains, drapery, upholstery	Keeps buoyancy when washed with warm water; machine dry; does not shrink, sag, or stretch; steam pressing reduces loft
Self-extinguishing	Excellent	Curtains, drapery, in carpet blends, furry rugs, blankets	Similar to acrylic; resists chemical stains; washable; use warm iron; shrinks unless stabilized; does not dry-clean well
Low flammability	Weakens with long exposure	Carpets	Not affected by moisture
Nonflammable	No loss	Curtains, drapery, bedspreads; Beta Fiberglas used for bedspreads	Impervious to moisture; hand wash; drip-dry; needs no ironing
Melts slowly	Poor	Upholstery, bedspreads, carpets	Washable; quick drying; use warm iron; resists soil; easy spot removal; static electricity unless treated
Slow to burn	Good	Rugs, blankets, upholstery, webbing, seat covers	Wash or dry-clean; iron at very low heat; good soil resistance
Burns slowly	Loses strength in prolonged exposure	Curtains, drapery, upholstery, carpets and rugs, pillows, blankets	Soils easily; machine wash in warm water; dries quickly; use warm iron; resists stretching and shrinking
Burns quickly	Fades when not solution dyed	Curtains, upholstery, drapery, table linen, rugs; probably most versatile fiber	Same as acetate; fair soil resistance
Nonflammable	Excellent	Outdoor furniture, upholstery, and screening; curtains, drapery, wallcoverings	Excellent ease of care; resists wrinkling and stains; water-repellent
Burns with difficulty	Weakens with long exposure	Shower curtains, wallcoverings, upholstery when backed with fabric	Stain resistant; waterproof; wash and wipe clean
Burns with a feathery ash	Good	Good green choice; is biodegradable and recyclable; very strong when wet; household linens, sheets, and bedspreads	Varies based on manufacturing process; some shrinkage when washed; may require ironing to remove wrinkles
Low flammability	Excellent	Fiberfill, carpet fiber, upholstery; outstanding green source; totally recyclable	Wrinkle resistant; washable; stain resistant

Bonding

A bonded fabric results when two fabrics are adhered (or bonded or laminated) together chemically or with heat. By bonding a layer of fabric to the underside, the face fabric can be stabilized. If care is not taken, however, cleaning may cause separation of the layers. Bonded fabrics may be used as interfacing in upholstery to add stability.

More info online @

www.fabriclink.com Educational resource on fabrics
www.ntcresearch.org National Textile Center; links to current articles

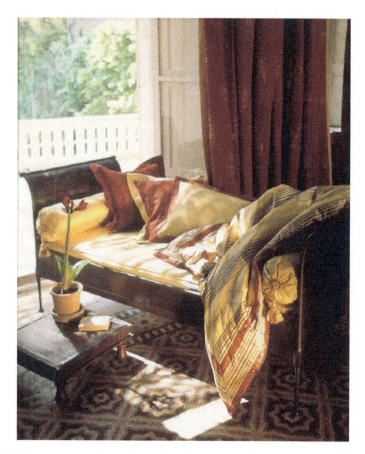

FIGURE 12.8 This fabric selection includes a Jacquard drapery fabric of 74/24 viscose/acrylic, a cotton/silk bed cover, and pure silk decorative pillows from Zimmer & Rohde, Germany.
(Courtesy of Fine Furnishings International)

■ TEXTILE COLORING/DYEING

Fibers are dyed or colored throughout the various stages of textile fabrication. In general, the most colorfast products are dyed early in the manufacturing process; however, greater color variety, and therefore more design options occur when dyes are added later in the process. The various methods of dyeing fibers, yarns, and fabrics include the following:

- **Solution dyeing**—The coloring agent is added to the viscous liquid of the synthetic before it is forced through the spinneret to be formed into a fiber.
- **Stock dyeing**—The dye is applied to the fibers before they are processed into yarns.
- **Yarn dyeing**—The skeins or hanks of yarns are dyed before they are woven into fabrics.
- **Piece dyeing**—Fabrics are dyed after they are woven.

Each time a new dye solution or dye bath is mixed, it may vary slightly in color from the previous one. Each solution is called a *dye lot*. When using a fabric from more than one bolt for a certain project, it is important to make sure that the bolts are from the same dye lot or that the colors still match. A unique alternative to dyeing is to select fibers

in the desired colors to produce the fabrics (see Sustainable Design: Colored Fibers and "Green" Textiles).

■ FINISHING

The finish is a treatment that may be applied to the fabric before or after construction to change its appearance and performance. When the unfinished fabric comes from the loom, it is referred to as **gray goods** or **greige**. Before the cloth is ready for the market, it may go through a series of finishes: *prefinish*, *functional finish*, or *decorative finish*. Another type of finishing process explained at the end of this section can best be described as *engineered*.

Prefinishes

Prefinishes and preparation of the gray goods consist of a variety of treatments including the following:

- Beetling or pounding to give luster
- Bleaching to whiten
- Boiling to rid the fabric of grease or other unwanted substances
- Calendering to provide a smooth finish and tighten the weave
- Durable finishing to strengthen the textile
- Gigging or napping to produce a flannel-like texture
- Heat setting to add stability, especially for permanent pleating
- Preshrinking to shrink the textile and make it ready for finishing, and prevent fiber contraction when exposed to moisture
- Singeing to remove surface fuzz or lint

After the prefinishing, the cloth is ready for the functional and decorative finishes.

Functional Finishes

Functional finishes are applied to improve performance. These standard textile finishes include the following:

- Antimicrobial finishes to help prevent mold and mildew
- Antistatic finishes to help guard against static
- Carefree finishes to help resist creasing or wrinkling
- Flame-retardant finishes to help retard burning
- Insulating finishes to improve insulation qualities; a coating of foam or other material is bonded to the fabric
- Mothproofing finishes to help prevent damage by insects
- Soil-repellent finishes to help resist soiling
- Water-repellent finishes to resist stains and moisture

Soil-resistant finishes are particularly important. Water-repellent, soil-resistant or soil-repellent, and soil-release finishes are all chemical finishes that increase a fabric's resistance to dirt and stains and help make cleaning easier. For example, Scotchgard is a trade name for a finish that makes the surface of the fabric stain resistant. This finish is best applied to the fabric at the mill; however, it is possible to purchase the soil-resistant or water-repellent finish separately and apply it manually. Manufacturers' labels or instructions accompanying the fabric inform the consumer about what to look for, how often to clean, and how effective the finish is.

SUSTAINABLEdesign

COLORED FIBERS AND "GREEN" TEXTILES

One of the purest means of ensuring environmentally safe interior textiles is to use natural, untreated, nondyed organic fibers. Designers developing "green" interiors need to consider the source of the fibers and their hidden environmental costs. For instance, according to Natural Cotton Colours, Inc., the process of dying fibers can be five times more expensive in the United States than in other countries. This is because government agencies in the United States require the residue from the dyeing process to be purified. While this should be required worldwide, other countries do not apply these restrictions and thereby pollute the environment.

Other textiles that have emerged as quality green products are Lyocell (Table 12.1) and Xorel. Xorel is a durable polyethylene fiber–based fabric that is used for commercial wall-coverings and upholstery. It creates no harmful by-products during its production, does not off-gas, and is no more toxic than wood when burned (Figure SD12.1). Penny Bonda, FASID, a leader in environmentally sensitive design, has placed Xorel on her "Top 10" list according to *ISdesigNET*.

Momentum Textile's (a division of Momentum Group) goal is to exclusively offer "products classified as Reduced Environmental Impact (REI) by 2017." By 2013, they hope that all their new product introductions will be REI. Two of their products that currently meet those criteria include Silica and Naked Nylon.

Silica was created as an alternative to vinyl and polyurethane. It was developed over the course of two years, and is produced from 51% silicone and 49% PLA (polylactic acid). It has zero polyvinyl chlorides and zero solvents (Figure SD12.2).

Momentum Textiles partnered with Unifi, Inc., a producer and processor of multifilament polyester and nylon textured yarns and related raw materials, to produce a nylon fiber. Their goal was to produce a recycled and recyclable nylon that was solution-dyed, bleach cleanable, and made with 100% postindustrial nylon. Additionally, it had to meet or exceed the aesthetics and hand requirements of existing nonrecycled nylons. One of the resulting products was Naked Nylon (Figure SD12.3).

More info on online @

www.xorel.com Xorel information
www.memosamples.com Momentum Textiles information

FIGURE SD12.1 This traditional upholstery fabric is made from Xorel. The fiber is considered a sustainable product because of its manufacturing techniques.
(Courtesy of Carnegie, www.carnegiefabrics.com)

FIGURE SD12.2 Silica can be cleaned with up to a 4:1 bleach solution or Virox (as preferred by some healthcare facilities). Silica has a high UV resistance and does not retain heat, and therefore can be used outside. It is produced from silicon and has an impressive 365,000 double rub rating.
(Courtesy of Momentum Textiles)

FIGURE SD12.3 Naked Nylon can be counted towards the recycled content materials outlined in LEED-CI and LEED-NC in Materials & Resources. It exceeds 100,000 double rubs and can also be recycled.
(Courtesy of Momentum Textiles)

Decorative Finishes

Decorative finishes include printing by hand or machine, custom finishes, and needlework.

Printing (Hand Processes)

In general, printing is completed after the fabric is woven. Obviously, hand processes require human labor. Some popular hand processes are the following:

- **Batik printing:** Sections of the cloth that are not to be colored are blocked out with wax; then the cloth is immersed in a dye solution. The wax is then removed, revealing the pattern.
- **Hand block printing:** A carved wooden or linoleum block is inked and stamped onto a piece of fabric to create the design.
- **Tie-dye:** A resist process that employs strings or knots tied on the fabric. The fabric is then immersed in dye, creating abstract patterns.
- **Silk-screen:** A specially prepared fabric screen resists the color penetration except in desired areas. Dye in paste form is forced through the screen onto the fabric below. A separate screen is prepared for each color used in the design. Only the silk-screen process produces hand-printed textiles on a commercial scale.

Printing (Mechanical Processes)

Many prints are produced mechanically by the transfer of color from an engraved copper roller onto the fabric. This process is called *roller printing*. A separate copper roller must be engraved for each color of the design, but once prepared, the rollers can be used in a variety of color schemes on thousands of yards of fabric. Other types of roller printing include the following:

- **Embossing:** Engraved rollers produce a pressed high-low design into the fabric.
- **Moiré:** A type of embossing in which rollers press a watermark design into the fabric.
- **Warp printing:** Printing is completed on the warp yarns of a fabric before it is woven.

Printed fabrics come in designs of unlimited styles, including documentary prints (designs copied from patterns of a particular historical period). These designs help establish an authentic feeling in a room.

Custom Finishes

Some examples of custom finishes include the following:

- **Etching:** Acid burns out one fiber, resulting in a design on a sheerer fabric.
- **Flocking:** Small fibers are bonded to the fabric in a patterned design.
- **Softening finishes:** Chemicals are added to a fabric to soften the feel.
- **Texturing:** Chemicals applied to the fabric create a puckered surface.

Needlework

Needlework, embellishing fabrics with intricate stitchery, is an ancient art form. A wide variety of needlework, such as embroidery, needlepoint, candlewicking, appliqué, and quilting, is utilized, usually in residential applications.

Engineered

A relatively new category of upholstery fabric that is extremely durable, heat and stain resistant, and breathable is called Crypton. Rolls of fabric that meet the company's standards are impregnated with a complex chemical in a heat setting process that renders the final fabric nonporous. Crypton fabrics prohibit the growth of molds like *Aspergillus niger* and bacteria such as *Staphylococcus aureus*. Resistant to moisture and stains, Crypton fabrics are easily cleanable and strong, all while maintaining a high quality of *hand* (discussed later in this chapter).

The Crypton process may be used on other textiles such as carpet and leather. Crypton Green fabrics are also available; this process avoids the use of environmentally harmful elements.

More info online @

www.surfacedesign.org Surface Design Association
www.cryptonfabric.com/commercial-textiles Information on the Crypton Process

■ FABRIC TESTING AND SAFETY CODES

Fabrics, particularly those for commercial uses, must meet standard tests for *durability, colorfastness*, and *flammability* (Figure 12.9).

Durability

Durability generally refers to the fabric's resistance to abrasion. The Wyzenbeek test is commonly used to indicate the number of double rubs, or revolutions, required before a fabric is damaged. A typical commercial-grade fabric may sustain 25,000 or more double rubs. Residential fabrics are also coded based on double rubs. Heavy Duty, HD, sustains 15,000 double rubs; Medium Duty, MD, sustains 9,000–15,000; Light Duty, LD, sustains 3,000–9,000; and Delicate Duty, DD, sustains fewer than 3,000 double rubs. About 3,000 double rubs represents one year of residential use.

Another way to test durability is to measure the fabric's stability, its resistance to sagging or elongation, its flexibility, and its resistance to tearing (its *tenacity*). Fabrics also should be *resilient*, which means they return to their original shape after stretching or crushing.

Colorfastness

As previously discussed, the colorfastness of a fabric is partially a function of its dyeing method. Colorfastness measures a fabric's resistance to fading from the sun's rays and from various cleaning methods. Fabrics

FIGURE 12.9 Manufactured from polyester, this Crypton fabric meets all commercial tests for durability, colorfastness, and flammability. It exceeds 100,000 double rubs on the Wyzenbeek test. This combination creates an excellent commercial product.
(Courtesy of Pallas Textiles)

also may be tested for crocking (the color rubbing off onto another fabric or the skin).

Flammability

The speed at which a fabric will ignite and spread flames, its ability to extinguish itself, and the quality of the fumes emitted are all measurements of flammability (Figure 12.10). Fabrics used in most commercial applications are subjected to two tests of flammability: the Tunnel Test (ASTM 84) and the Vertical Flame Test. Interior finishes are rated from Class A (the most flame resistant) to Class C (the least flame resistant).

Labeling

To help consumers differentiate among the huge array of manufactured fibers, the Federal Trade Commission (FTC) established the Textile Products Identification Act. Under these regulations, each manufactured fiber is defined in specific terms and given a *generic name*, which along with the company's trade name must appear on the label attached to the fabric. The generic name is the term assigned to a chemical family of which all members exhibit certain traits. For example, all members of the nylon family are characterized by unusual strength and resistance to abrasion, but they will not hold up well under direct sunlight. The polyester family is known for its drip-dry quality and resistance to sun deterioration. The *trade name* identifies the manufacturer. Because manufacturers need to give specific names to their products, there are hundreds of trade names for manufactured fibers, making it virtually impossible for the consumer to recognize them all. Familiarity with the general properties of each fiber family, however, and checking the label to make sure of the fabric content help when selecting the fabric that best serves specific needs. The label alone, however, does not ensure good performance if the construction, dyes, and finishes are not properly handled.

Textiles used for most commercial applications should be labeled to indicate their flammability and their fiber content (with percentages of natural and manufactured fibers when applicable), and whether they have been treated with protective finishes such as Scotchgard.

The Association for Contract Textiles (ACT), founded in 1985, has established performance guidelines to make fabric specification easier. Table 12.2 defines these specifications (which were updated in 2007) and shows their accompanying symbols.

FIGURE 12.10 This fabric, Perennial, is designed primarily for cubicle curtains used in the healthcare industry. Perennial is manufactured from 100% recycled polyester yarn with inherent flame retardant properties.
(Courtesy of Momentum Textiles)

More info online @

http://contracttextiles.org Association for Contract Textiles

TABLE 12.2 Association for Contract Textiles (ACT) Performance Guidelines

act.
association
for contract
textiles

ACT has developed the following voluntary Performance Guidelines to make fabric specification easier. The five symbols give architects, designers, and end users a vast amount of performance information in a succinct visual way. Look for these symbols on ACT member company sampling to assure that the fabrics you specify perform up to contract standards and pass all applicable testing. These categories describe a material's performance features as measured by specified methods under standard laboratory conditions.

Flammability

The measurement of a fabric's performance when it is exposed to specific sources of ignition.

Upholstery

California Technical Bulletin #117 Section E—Class 1 (Pass)

Direct Glue Wallcoverings and Adhered Panels

ASTM E 84-03 (Adhered Mounting Method)—Class A or Class 1

Wrapped Panels and Upholstered Walls

ASTM E 84-03 (Unadhered Mounting Method)—Class A or Class 1

Drapery

NFPA 701-89 —Pass

Wet & Dry Crocking

Transfer of dye from the surface of a dyed or printed fabric onto another surface by rubbing.

Upholstery

AATCC 8-2001	Dry Crocking, Grade 4 minimum
	Wet Crocking, Grade 3 minimum

Direct Glue Wallcoverings

AATCC 8-2001	Dry Crocking, Grade 3 minimum
	Wet Crocking, Grade 3 minimum

Wrapped Panels and Upholstered Walls

AATCC 8-2001	Dry Crocking, Grade 3 minimum
	Wet Crocking, Grade 3 minimum

Drapery

AATCC 8-2001 (Solids)	Dry Crocking, Grade 3 minimum
	Wet Crocking, Grade 3 minimum
AATCC 116-2001 (Prints)	Dry Crocking, Grade 3 minimum
	Wet Crocking, Grade 3 minimum

Colorfastness to Light

A material's degree of resistance to the fading effect of light.

Upholstery

AATCC 16 Option 1 or 3-2003	Grade 4 minimum at 40 hours

Direct Glue Wallcoverings

AATCC 16 Option 1 or 3-2003	Grade 4 minimum at 40 hours

Wrapped Panels and Upholstered Walls

AATCC 16 Option 1 or 3-2003	Grade 4 minimum at 40 hours

Drapery

AATCC 16 Option 1 or 3-2003	Grade 4 minimum at 60 hours

TABLE 12.2 Association for Contract Textiles (ACT) Performance Guidelines *(continued)*

Physical Properties

Physical property tests include: Brush Pill, Breaking Strength, and Seam Slippage.
Pilling is the formation of fuzzy balls of fiber on the surface of a fabric that remain attached to the fabric. *Breaking strength* is the measurement of stress exerted to pull a fabric apart under tension. *Seam slippage* is the movement of yarns in a fabric that occurs when it is pulled apart at a seam.

Upholstery
Brush pill ASTM D3511-02, Class 3 minimum
Breaking strength ASTM D5034-95 (2001) (Grab Test)
50 lbs. minimum in warp and weft
Seam slippage ASTM D4034
25 lbs. minimum in warp and weft

Wrapped Panels and Upholstered Walls

Breaking strength ASTM D5034-95 (2001) (Grab Test)
35 lbs. minimum in warp and weft

Drapery

Seam slippage ASTM D3597-02-D434-95 for fabrics over 6 oz./sq. yard
25 lbs. minimum in warp and weft

Abrasion

The surface wear of a fabric caused by rubbing and contact with another fabric.

General Contract Upholstery

ASTM D4157-02 (ACT approved #10 Cotton Duck)
15,000 double rubs Wyzenbeek method

ASTM D4966-98 (12 KPa pressure)

20,000 cycles Martindale method

Heavy Duty Upholstery

ASTM D4157-02 (ACT approved #10 Cotton Duck)
30,000 double rubs Wyzenbeek method

ASTM D4966-98 (12 KPa pressure)
40,000 cycles Martindale method

The marks 🔥 ✋ ✳ ✕ 🄶 🄰, are Registered Certification Marks at the US Patent and Trademark Office and are owned by the Association for Contract Textiles, Inc.

Source: Association for Contract Texts, PO. Box 101981 Fort Worth, TX 76185 817 924-8048 www.contracttextiles.org
Note: This table indicates the overall guidelines. Specific test explanations can be found on their website at www.contracttextiles.org. Quick Time movies illustrating testing methods are informative.

■ TEXTILE CARE AND MAINTENANCE

Although not required, after a design project is complete, interior designers can offer the client a valuable service by providing manufacturers' manuals, booklets, and other care instructions. Knowledge of the cleaning properties of particular fabrics is essential for upkeep. For instance, water-repellent and soil-repellent finishes must be reapplied periodically, especially after a fabric has been cleaned.

The designer also may recommend added protection from the sun for certain fabrics. Many fabrics are susceptible to sun damage, and glass can multiply the destructive element in the sun's rays. Even the winter sun and its reflection from snow can be harmful. Lined and interlined draperies help protect fabrics from sunlight, especially when fragile materials are used. Blinds drawn during the day and exterior awnings are practical. Trees or shrubbery that shade windows can help prevent interiors from damage by the sun. Protective coatings can be applied to glass to prevent harmful UV rays from entering the interior.

■ TEXTILE USES IN INTERIOR DESIGN

Interior designers have a wide choice of textiles with new fabrics always in production. The market is full of fabrics suitable for every taste, style, and decorative purpose in every price range. Adding to the appeal of improved fibers is the seemingly unending variety of designs, ranging from folk patterns from around the world to traditional and contemporary designs. Following is a discussion of the principal decorative uses of fabrics.

Window Treatments

Styles of window treatments are discussed in Chapter 13. Typical fabrics used for these styles are covered here.

Drapery

Fabrics for drapery should have a light to medium weight, such as silk, antique satin, chintz, and damask. Fabric should drape gracefully, clean without shrinkage, and meet the decorative needs of the room in which it is used (as seen in Figure 12.1).

Sheers or Semisheers

Sheers filter the light, giving softness to the room and providing daytime privacy. The fabric should be sunproof but sheer enough to permit light, and should wash or clean well without shrinkage. Batiste, voile, ninon, and chiffon are four popular fabrics.

Casements

Casements are usually made of a coarser weave than a sheer, and are available in a variety of patterns. The fabric should be drapable and sun resistant and should wash or clean well without shrinkage. Leno weaves especially help control sagging and are commonly used in commercial environments.

Linings

Drapery linings are necessary to protect the drapery from sunlight and provide a uniform exterior appearance. Acrylic and modacrylic fibers are particularly resistant to sunlight.

Curtains

Lightweight and decorative curtains are frequently made from cottons and cotton-polyester blends. Curtains used in kitchens and restaurants should be constructed of washable material. Curtains are a relatively inexpensive window treatment solution and will have a shorter useful life than a drapery treatment.

Upholstery

Upholstery is a fabric, animal skin, or other material that covers furniture permanently, adds beauty and comfort, conceals or emphasizes the furniture design, and adds to or sets the theme or mood of the room.

Upholstery Fabric

Fabric used for upholstery should have a tight weave and be durable, comfortable, and easy to clean. Common upholstery fabrics include heavyweight fabrics such as matelassé, tweed, tapestry, velvet, bouclé (Figure 12.11), and friezé; medium-weight fabrics such as damask, brocatelle, and canvas; and lightweight fabrics such as chintz, linen, homespun, and moiré.

When purchasing upholstered furniture, fabric is a primary consideration because it is an expression of personality and individual taste. In selecting the fabric, use is generally the determining factor. Selecting

FIGURE 12.11 This nubby texture is developed using bouclé yarns. The product, called Thunder, is made from 100 percent recycled polyester and boasts over 95,000 double rubs.
(Courtesy of Pallas Textiles)

suitable upholstery fabric involves answering questions such as the following:

1. What type of fiber and weave are employed? An upholstered fabric, for example, will last longer if the warp and fill are the same weight and tightly woven.
2. Is the fabric attractive and comfortable to the touch?
3. Is a patterned or plain fabric preferred? Fabrics with small overall patterns tend to show soil less than do solid colors. If a pattern is chosen, is it in scale with the furniture and the room, and does it support the style?
4. Is the fabric suitable for its intended function? For example, will the upholstery be used by active children in a family room or by a single professional in a seldom-visited area?
5. Is the fabric the best quality the budget will allow, considering long-term wear and maintenance? It is inadvisable to buy expensive fabric for cheap furniture and fabric of lesser quality for fine furniture.
6. What maintenance process is necessary? Does the particular upholstery fabric require a water- and soil-repellent finish like Scotchgard or Zepel?
7. Does the upholstery fabric fit the style, mood, and character of the room? Is the fabric formal or informal? Does it conform to the lifestyle of the occupants and complement its environment?

FIGURE 12.12 A variety of finishes have been developed for these leathers. Some are treated to produce a weathered look; others are given a high-sheen appearance or made to look antique. The velvet-napped leather is shrink-retardant and wear-resistant. The leather second from the right is part of a group of leathers laced into patterns. *(Courtesy of Cortina Leathers)*

Upholstery Leather

Leather (tanned animal skin) is a product that has long been used for aesthetic and utilitarian purposes (particularly the hides of cattle and swine). Its advantages are that it is pliable and durable, may be dyed or used in its natural color, and may be embossed or made into suede (Figure 12.12). Genuine leather can be expensive; simulated leather (vinyl) is available, but needs to be carefully selected to ensure proper aesthetic qualities. The disadvantage of leather is that it is susceptible to marks, holes, and tears. Leather is also used for wallcoverings and floor tiles.

Slipcovers

Slipcovers may cover worn upholstered furniture, protect more-expensive fabrics, and brighten or change a room's atmosphere. Usually, slipcovers are used only in residential settings.

Slipcovers are made of light- to medium-weight fabrics that should be tightly woven. Some manufacturers offer furniture upholstered in muslin or other plain fabrics that can be purchased with several changes of slipcovers to help dress the furniture for seasonal changes. Sailcloth, ticking, chintz, whipcord, and corduroy are all good choices for slipcovers.

Walls

Fabrics can be used on walls to add beauty (as illustrated in Figure 12.13) or to solve a decorative problem.

The best choice, except when using the shirred method of application, is a medium-weight, closely woven fabric. For an informal look, use fabrics such as sailcloth, ticking, Indian head, or glazed chintz; for a formal appearance, use fabrics such as tapestry, brocade, or damask. In commercial environments, flammability codes for wallcoverings must be followed.

Some fabrics come prepared for pasting on walls and are laminated to a paper backing. Nondirectional patterns are easier to use because they require no matching. Like patterned wallpaper, a repeat pattern requires allowance for matching. Fabrics can be applied to walls in a number of ways.

The *double-face masking tape method* is not permanent because masking tape will dry out in time; however, this method may be appropriate for temporary or seasonal applications. Fabric is prepared by sewing panels together. Double-face tape is placed around the edges of the wall

and the fabric is applied to the tape first at the top and bottom, and then at the sides.

The *Velcro method* is similar to the masking tape method, except that one side of the Velcro tape is stitched along the edges of the fabric, then attached to the other side of the tape, which has been secured around the edges of the wall.

In the *staple method* the fabric is prepared as in the masking tape method. The top is stapled first, then the bottom, and the sides last. Exposed staples may be concealed with braid or molding.

The *paste method* is the most professional looking and most permanent method, but it requires special care and a set of wallpaper tools. The wall is prepared by applying a coat of liquid sealing or sizing to fill the pores in the wall surface. After the surface dries, a second coat of sealing is applied to the wall, and the strips of fabric are positioned like wallpaper. The fabric dries overnight and is then sprayed with a protective coating.

The *shirring method* is the simplest way to cover a wall with fabric. A lightweight fabric that drapes well is best. Cut-to-fit rods are fastened just above the baseboard and near the ceiling. The fabric is gathered, pleated, or folded and installed on the rods.

Fabric also can be applied to panels, which are then installed on the wall. Edges are often concealed with moldings.

FIGURE 12.13 Framed fabric on a wall can add interest and style.

System Furniture Panel Fabrics

In commercial interiors, and particularly in commercial offices, panel systems create office spaces. As discussed in Chapter 11, panel systems are an effective solution in offices where employees communicate frequently. One of the design challenges of the open office panel system is the redirection of noise. Covering the panel with fabric assists with noise reduction.

Fabrics on the panels must meet several criteria. First, they must be durable. Employees and visitors will lean their hands and bodies against the panels. Second, the fabric must be able to accommodate pushpins. Although tackboards are incorporated in panel systems, the experienced designer knows that, over time, notes, calendars, pictures, and so on are pinned up everywhere. Finally, the fabric must be cleanable; food and drink stains and marks from fingerprints will occur.

The fabric may be used as a subtle background color or it may be patterned to add interest to a space (Figure 12.14). Sometimes vinyl wallcovering or a painted metal or plastic is used below desktop level and fabric is used above (as seen in Figure 11.26). Fabrics may vary on different sides of the system or from panel to panel. Panel manufacturers

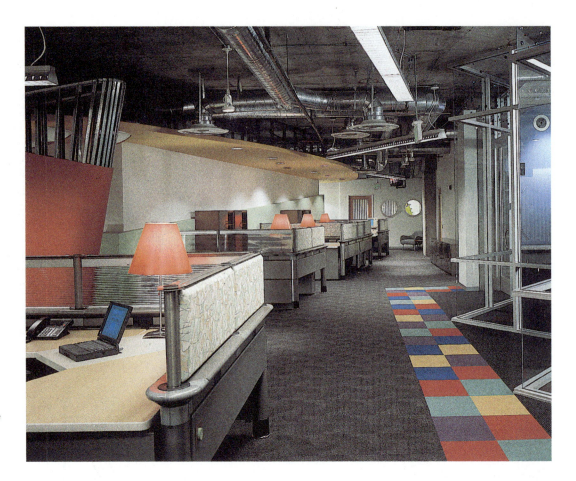

FIGURE 12.14 The open office system designed for MTV employees incorporates a variety of textile choices. Upholstery fabrics add interest to the walls. Colored lamp shades create a warm, friendly glow and contrast well with the crisp metals and geometric edges.
(Designers: Felderman & Keatinge Design Associates)

supply many optional fabrics that have been tested for panel use. If a designer selects a custom fabric, the fabric may require testing to ensure its appropriateness for use on the panel systems.

Health Care Fabrics

Fabrics for the health care industry must pass the flame-resistance test and meet the highest class of colorfastness for crocking and light. When selecting fabrics for cubicle curtains and bedspreads, designers should ensure that the product is reversible. Many cubicle curtain products are fabricated 72″ wide. Materials that drape easily and have a smooth hand are ideal. Polyester Trevira is a common fiber used in health care settings. Materials should be easily cleanable and resistant to molds, spills, and staining, and include antimicrobial treatment (as seen in Figure 12.10).

Accents

Textiles also may be used as accents in a room. Trims, fringes, and braids add character and distinction to an interior (as seen in Figure 12.1). Originally intended to conceal seams and tacks, *passementerie* (decorative trims, cords, tassels, etc.) is used as ornamentation. Passementerie can be found in the tombs of pharaohs and on kings' clothing, but made its historical mark during the reign of Louis IX in France. Guilds of artisans were organized to create passementerie. The development of the machine during the Industrial Revolution brought passementerie to every corner of the Victorian interior. Currently, traditional interiors use many decorative trims, and even contemporary interiors use accent cording and the occasional tassel (Figure 12.15).

Chapter 9 discusses the use of textiles as accent floor coverings and Chapter 13 discusses fabrics as a form of art for wall accessories. Textiles also can be used for accent throw pillows, adding interest as well as comfort and continuity to a room. For instance, a particular silk fabric may not be suitable to cover an entire sofa, but may function well on accent pillows.

■ SELECTING TEXTILES FOR INTERIORS

Perhaps the most common question that clients ask professional interior designers is "What fabric goes with what?" This question has no absolute answer. Combining fabrics is a matter of training and skill. Some people seem to have an aptitude for this; others require much patient study and practice.

Combining Fabrics

Although an unexpected combination of materials may create a feeling of great interest and charm, some general principles will be helpful to the inexperienced designer when combining patterns, textures, and colors.

- The selection of any combination of textiles must coincide with the desired feeling or mood in the room. For example, a formal contemporary studio apartment would have crisp, shiny fabrics, possibly with leather accents; a woven flamestitch upholstery would appear out of place.

- Many designers coordinate textiles based on a patterned fabric or rug, called the *color source* (Figure 12.16). This method is fairly safe because the basic colors of the scheme are already coordinated; however, without careful consideration, this approach can become static or uninteresting.

- Select a textile scheme appropriate for the chosen style. For example, a Victorian-style room would include deep purples, mauves, greens, and reds in rich brocades, velvets, and heavy tapestries.

- To ensure that the colors and fabrics are harmonious, compare textiles under all the natural and artificial lights to be utilized in the interior.

- Often, predictable color and fabric combinations and those that match exactly are not interesting or creative. Trying out fabric combinations trains the eye and helps develop a sense of what fabric selections are complementary and what groupings do not work well together. Some manufacturers develop "mix and match patterns" for wallcovering and fabrics; designers with a discerning eye generally select alternative textures and fabrics to enhance these predetermined schemes.

FIGURE 12.15 This tranquil bedroom is based on a monotone color scheme; however, the variety of textures and accent fabrics on furnishings, window treatments, walls, and floors adds interest and character to the room. A smooth vaulted ceiling and brass and glass accents juxtapose the textural content.
(Designer: C. Weeks Interiors, Inc. Photograph by Chris Little.)

FIGURE 12.16 Contemporary fabrics are mixed with traditional fabrics and furniture styles in this refreshing interior. The color source is found in the antique rug. Simple yellow walls with crisp white trim and floral fabrics contribute to the eclectic blend of old and new. *(Designer: Spectrum Interior Design. Photograph © Kim Sargent.)*

Pattern

Pattern indicates that the design has motifs sufficiently large in scale, or with enough contrast in color or tone, to be distinguished clearly. The skillful use of pattern can camouflage defects and create beauty and glamour. As with color, no absolute do's or don'ts govern the successful use of pattern. A few general guidelines, however, may be helpful:

- Patterns used within the same room should be related. Common elements such as color, texture, or motif tie them together and unify the design.

- The principal pattern need not be repeated in the room so long as one or more of the colors in that pattern are carried over into another area (as seen in Figure 12.16). The pattern, however, may be repeated on furnishings or used on windows or walls, depending on the overall effect desired. Odd pieces of furniture can be unified by covering them in the same fabric, and repetition of the fabric brings continuity to a room.

- Using no more than one bold pattern of the same type of design, such as a floral, is usually more effective. Once the dominant motif is established, it can be interestingly supplemented with more subdued patterns, stripes, checks, or plaids, with complementary plain textures added (Figure 12.17).

- When combining patterned fabrics, consider the scale or size of the pattern. For example, if a bold floral print with a large scale is combined with a plaid, a stripe, or both, a smaller scale pattern in these complementary fabrics will be most effective. If an unobtrusive floral pattern is used, accompanying fabrics with bolder characteristics may blend well.
- Success in combining patterns can be achieved with practice, experience, and consideration of basic guidelines. It is helpful to observe pattern combinations assembled by experienced professional designers in design periodicals, design studios, showrooms, and at home shows.

Texture

The surface quality of a textile is also an important element to consider when combining fabrics in a specific project. Knowledge of what makes a fabric formal or informal is essential for successfully combining textiles.

Formal fabrics are primarily those with smooth and often shiny textures, displaying elegant stylized and geometric patterns. Some examples of formal fabrics are velvet, damask, brocade, brocatelle, satin, shantung, and taffeta. Formal fabrics are often creatively used in both traditional and modern interiors in a wide range of colors and patterns.

Informal fabrics are generally those with a rougher texture and matte finish, such as burlap, canvas, hopsacking, muslin, tweed, and bouclé. Fabrics with a handcrafted quality often fall into this category. If the informal fabric employs pattern, the design may be bold, naturalistic, abstract, or geometric.

Many fabrics can be used in either category. For instance, cottons and linens may have textures, colors, and patterns that fit into a formal setting or are at home in an informal room. Leather also may be used in formal and informal settings. When designing a room, keep in mind that a combination of textile finishes is important to add interest (as seen in Figure 12.15). Some fabrics should be glossy, whereas others

FIGURE 12.17 In this family room and study lounge, the scale of the pattern varies from the massive geometric timbered ceiling, to the large diagonal tiled floor, to the bold strip on the window treatment, to the smaller-scaled plaid pattern on the pillows. The designer selected three silks sewn into a bold stripe for the window treatment. Leather covers the Louis XV chair next to the fireplace and brings smoothness to the interior.
(Designer: Pineapple House. Photography by John Umberger.)

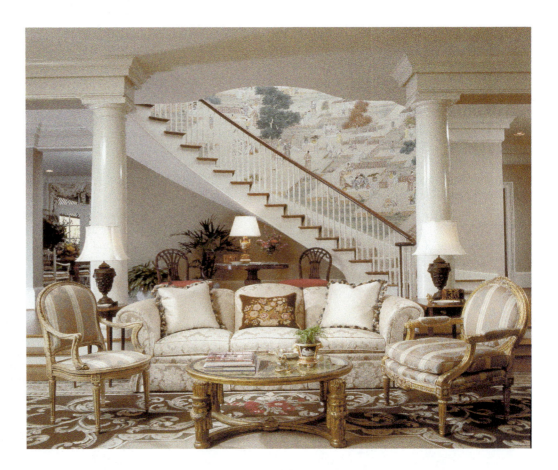

FIGURE 12.18 The hand of the fabrics in this stately living room defines its opulence. Variety is seen in deep trims, corded edges, gilded Louis XVI chairs, textural damasks, high-gloss painted columns, and a focal point wallpaper.
(Designer: Essary & Murphy, Inc. Photography by Chris Little Photography.)

should have a deeper nap or pile. For example, a room of furnishings covered only in cotton chintz lacks depth.

The unique surface quality or *hand* (rough, smooth, hard, soft, shiny, or dull) of each fabric should be considered when coordinating them. The relationship should be appropriate for the room's style and mood (Figure 12.18). For example, informal monk's cloth is not at home in an elegant eighteenth-century English room with smooth and shiny damasks and satins, but is compatible with a wicker chair in a country style.

The character of the texture should be appropriate for its intended use. For example, for a comfortable chair in a family room, a smooth, soft leather would be preferred over a rough burlap.

Color

When coordinating fabrics, another goal is to select colors that are compatible and harmonious. When selecting colors for fabrics, remember from Chapter 4 that color has three dimensions: hue, value, and chroma.

Hues fall into warm or cool color classifications. One of these can be selected to dominate the scheme. The best hues will fit the needs and preferences of the occupants. Such criteria as climate, positioning of the space in relationship to the sun, and lifestyle should be considered.

Fabrics are either light, medium, or dark in value. Most fabric coordination is enhanced by including fabrics in all three levels of luminosity. For example, if the major fabrics in the room are light in value, the fabrics for smaller furnishings or accessories might be medium and

dark in value. Many designers use darker values below, medium values in the middle areas, and lighter values on the upper portions of the space; of course, this method can be reversed for a more unusual effect. Using only dark and light values in a space creates drama, as in a color scheme using black and white.

Fabrics are either muted or bright in chroma. A color scheme is usually successful when varying levels of chroma are selected (Figure 12.19). For example, if the major fabrics for the room are muted in chroma, some accents of bright fabrics are visually interesting. A room with all muted colors can be dull and boring; a room with all intense colors can be tiring or even agitating.

Textiles for Period Rooms

Design in textiles was used in ancient times as a symbolic medium for religious purposes. With the passage of time, fabric became a significant medium for aesthetic expression. The design motifs used in the early rugs of East Turkistan are much the same as the designs used in the early rugs of the Inca and Navajo peoples halfway around the world. This similarity occurred because people represented natural phenomena in their early art forms. For example, the sun and stars were represented in identifiable form. The difference in early textile weaves is minimal because all were completed on simple looms, using natural fibers and dyes. Although each country developed different characteristic styles, a common quality in their early crafts blends them harmoniously.

FIGURE 12.19 In this sophisticated boardroom, the predominant muted tones are accentuated with small amounts of black on chair seats and in furniture details. The bold artwork adds interest to the space.
(Designer: Spector Group. Photograph by Peter Paige.)

A close relationship often existed among the designs of European, Near Eastern, and Asian countries during the Middle Ages and the Renaissance. The conquerors brought artisans of all kinds to their newly acquired lands, where the artisans continued to carry on their trades. In time, they were influenced by the designs of their new environment, eventually blending various methods and motifs. During the Renaissance and the seventeenth and eighteenth centuries, fabrics from Asian countries, with their unique motifs and colors, were in great demand in Europe and America.

Historic designs can establish an authentic feeling of a specific period or style. Documentary fabrics bearing designs from a wide range of historic periods are produced by manufacturers. Seldom, however, does a client wish to create an entirely authentic period room; this is usually reserved for restoration projects and museums.

More info online @
http://textilesociety.org Textile Society of America
http://arthistoryclub.com/art_history/Textile Information on textile history

Textiles for Commercial Interiors

Although the previous discussions on fabric testing and safety codes and on combining patterns, textures, and colors apply to commercial interiors, additional design criteria are important for commercial use as well.

In general, commercial interiors do not have as much variety in fabrics as residential interiors. Fabrics for restaurants, offices, and hospital or hotel rooms will be repeated to obtain unity and flow throughout the interior (Figure 12.20). Corridors or hallways must unite the spaces while allowing for high traffic flow, requiring durable textiles.

FIGURE 12.20 In this restaurant, named Stars, the theme is carried through the clever design on the rug, in the fabric (repeated on chairs and booths), in the lighting, and even in the poster art.
(Architect/Designer: DES Architects + Engineers. Photograph by Paul Bardagjy.)

FIGURE 12.21 In this Seattle medical facility, the children's play area utilizes bold colors and durable fabrics. Upholstered and built-in furniture is sized to meet the children's needs.
(Architect/Designer: NBBJ. Photograph by Steve Keating.)

Commercial interiors in general contain more understated classic materials and colors. Bold colors are reserved for accent walls, children's areas (Figure 12.21), and for use in theme restaurants and hotels. Occasionally, however, a client will request a strong, bold look.

All fabrics must be durable. Designers should select fabrics from reputable commercial manufacturers who have tested their products to meet flammability and abrasion tests.

Fabrics used in commercial interiors should be treated to resist stains. A lovely peach chair will not look so lovely after coffee has sunk into its fibers. At home, the spill may be cleaned within minutes; in a hotel lobby or office environment, it may remain for hours until housekeeping can clean it. Additionally, medical facilities such as hospitals and nursing homes require fabrics that are easily washable as well as highly resistant to blood and urine stains. To help clients, designers should supply maintenance procedures for cleaning all textile products. Some solution-dyed products can be bleached; piece-dyed fabrics are more sensitive.

Finally, remember that in most commercial situations, the design selections are not for the client, but for the client's client (the customer at the restaurant, for example). Sometimes designers must select items in the end user's best interest and gently explain this to the client.

Textiles in Presentations

In order to communicate fabric and furniture selections to a client, designers may prepare a series of presentation boards or electronic images that incorporate the furnishings as well as actual samples of the fabrics and finishes (see Design Development in Chapter 1). Frequently, these boards are combined with presentation furniture plans, elevations, and perspectives, thereby communicating the design to the client (Figure 12.22).

The samples used by the designer are available through manufacturer representatives, as well as decorative arts centers and the Internet. Design firms develop a Source Library of products (discussed in Chapter 14) that fit the needs of their clients. These sources, or custom versions of them, are presented to clients for their review and approval before proceeding with ordering. Although computer-aided plans and elevations and computer-generated images can help explain a project to a client, computer images of textiles lack the warmth of the true fabric. When electronic presentations occur, textiles may be included in a shadow box or presented separately so clients can feel the hand of the products.

■ SOLVING DESIGN PROBLEMS WITH TEXTILES

Design problems often can be solved through the skillful use of fabric. A well-chosen fabric can do the following:

■ Lighten or darken a room. Fabrics in high values can work wonders to visually lighten the room. If the room has too much light, fabrics in low values help darken the room.

■ Emphasize walls, windows, or furnishings to attract desired attention.

■ Provide balance to a room. For example, a bold-patterned fabric at a window or on a small piece of furniture balances a larger piece of plain furniture at the other side of the room. A spot of bright color balances a larger area of muted color.

■ Change the apparent size and proportion of a piece of furniture or an entire room. For example, a sofa covered in a large pattern or bold-colored fabric appears larger than the same sofa covered in a light, plain color, or a small unobtrusive pattern, as illustrated in

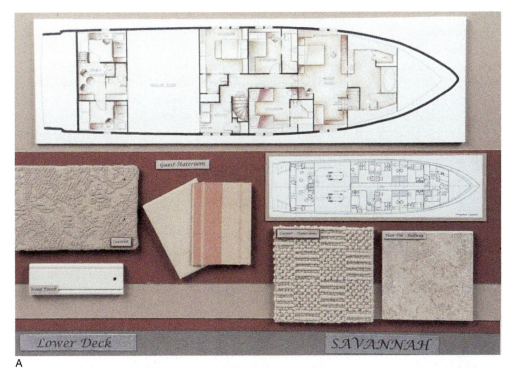

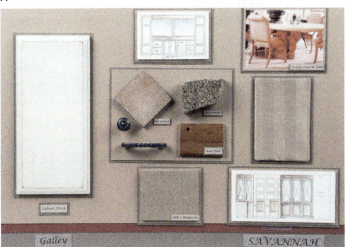

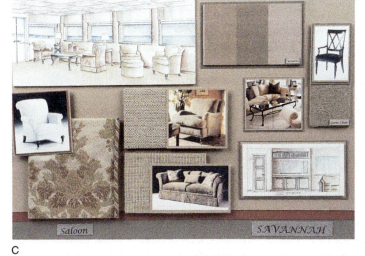

FIGURE 12.22 In this extensive presentation, the designer was hired to convert a charter yacht into a private yacht. In Board (A), the smaller plan indicates the preexisting layout. Boards (B) and (C) illustrate the main living area and dining area, including furniture, finish, and fabric selections. Board (D) illustrates the owner's library. Board (E) indicates the lower deck and master suite furnishings.

(Designer: Susan E. Gillespie. Photographs by Southern Lights Photography.)

Figure 12.23. A chair or love seat upholstered in a vertical stripe looks higher than the same piece covered in a plain fabric.

- Conceal walls, windows, or furnishings. A designer may want to draw attention away from or cover up a particular wall, window, or piece of furniture.

- Bring harmony and unity to a room by repeated use of the same or complementary fabrics.

Large or conspicuous pattern tends to make furniture appear larger.

Small pattern diminishes size.

FIGURE 12.23 The effect of pattern and size.

- Establish the room's color scheme. A successful method by which to color scheme a room is to choose a favorite patterned fabric as a starting point.

- Establish the historic or modern style of a room. If the room is based on a certain period, the fabric, more than any other item or furnishing, can set the desired feeling. Documentary fabrics can provide historically authentic styles.

- Change the look of a room for different seasons. For example, a sofa and chairs in deep warm colors may be slipcovered in light-colored ticking for summer. Heavy winter drapery may be changed to light sheers in summer to create a cool atmosphere.

SUMMARY

All fabrics supply softness and comfort to an interior. Fabrics also add character, absorb sound, and provide for textural enrichment in a space (Figure 12.24). Selecting the appropriate fabric requires knowledge of fibers, fabric construction, coloring or dyeing procedures, finish selections, and product testing and safety codes. Combining fabrics demands careful discernment and an appreciation for the human factor and the elements and principles of design. Careful fabric placement can solve unusual architectural or interior construction dilemmas.

According to Jack Lenor Larsen, "Fabric is one of the principal devices for introducing color, texture, and pattern into interiors and certainly the most easily manipulated one." The beginning designer will find great satisfaction in selecting fabrics that fit the unique needs of each client in each situation.

TEXTILE TERMINOLOGY

The information in this section can assist the designer in getting maximum service from fabrics. The following are common fabrics, their qualities and uses, as well as terms relating to the textile industry. Fabrics are listed under their common decorative name. Pronunciations of difficult terms follow in parentheses.

Antique satin A satin weave fabric with textured horizontal striations that imitate antique silk. Antique satin is lightweight, usually a solid color. Draperies.

Batiste A fine, soft, sheer fabric of plain weave made of various fibers. Sheers.

Bouclé French word meaning "curly." It indicates yarns are curled or looped in a flat or pile fabric. Heavyweight. Upholstery.

Braid A band of lace, embroidery, or metallic thread used as trimming.

Broadcloth A lightweight fabric in a plain or twill weave. Cotton, wool, or synthetic fibers popularly used. Draperies, bedspreads.

Brocade A medium-weight fabric woven on a Jacquard loom. An embroidered multicolored pattern stands out in relief against a satin or ribbed background. Drapery and upholstery.

Brocatelle A medium-weight Jacquard fabric with an extra set of wefts for backing, unevenly twisted, which results in a high-relief embossed appearance on the surface. Upholstery and draperies.

Buckram Stiffened material sized with glue. Reinforcement for draperies and valances.

Bullion fringe A heavy strand of threads forming cords attached to a heading.

Burlap A medium-weight coarse fabric woven of jute in a plain, loose weave. Drapery and lamp shades.

Calico A lightweight plain cotton weave with a small allover print. Curtains.

Cambric Plain weave cotton or linen. Called "handkerchief linen." Originally made in Cambrai, France. Very sheer to coarse. Linings.

Canvas A medium-weight, closely woven cotton. A plain, diagonal weave in solids or prints. Upholstery, drapery, walls.

Casement A broad term covering a relatively coarse fabric used like a sheer. Usually light neutral colors in leno or open weaves. Commonly used in commercial settings.

Challis A lightweight wool, cotton, or synthetic soft fabric in a plain, tight weave. Printed designs or plain. Drapery, upholstery.

Chenille A heavyweight fabric woven with chenille yarns. When woven in a fabric, can create a pile similar to velvet; if woven on a Jacquard loom, can look similar to cut velvet. Upholstery.

Chiffon A translucent fabric. Tight weave, lightweight. Sheers.

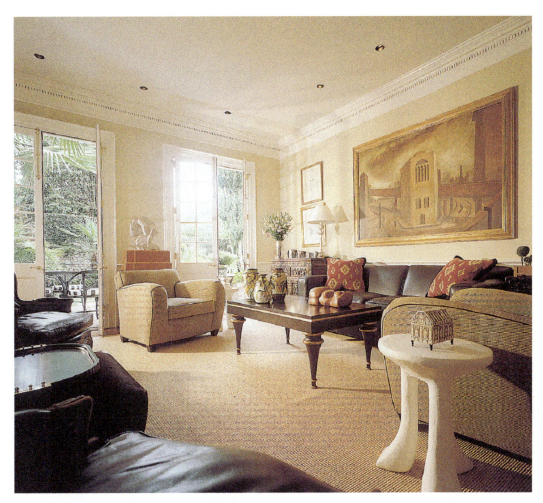

FIGURE 12.24 This living area provides a secluded and comfortable retreat. The warm browns and rich-textured fabrics create a relaxing environment.
(Designer: BRITO Design Studio. Photograph © Robert Thien. As seen in Atlanta Homes & Lifestyles.)

Chintz A plain, tightly woven, lightweight cotton fabric with fine yarns. Sometimes processed with a glazed finish. Can be either a solid color or printed. Draperies, slipcovers, bedspreads.

Color flag The series of clippings attached to a purchased fabric sample to show the colorline.

Colorline The complete color range of a given fabric series.

Colorway The color of an individual fabric.

Cord Threads twisted to form larger-diameter strands. Strands over 1 inch wide are called ropes.

Corduroy A heavyweight cotton or synthetic pile fabric, ribbed or corded lengthwise. Drapery, slipcovers, upholstery, bedspreads, and other uses.

Crepe Crinkled or puckered fabrics of many types. Usually produced by twisting the yarn when weaving or by a chemical process. Cotton, silk, and wool are typical. Plain weave.

Cretonne First made in Creton, France. Similar to chintz but heavier. A cotton fabric with a printed design. Plain or rep weave.

Crewel embroidery A heavyweight plain-woven fabric of cotton, linen, or wool embroidered with fine, loosely twisted, two-ply worsted yarns. Usually worked by hand in the Kashmir province of India. Drapery and upholstery.

Crocking The rubbing off of color from dyed or printed fabrics.

Crypton A patented upholstery formulation manufactured with approved fabrics designed for commercial seating. Extremely strong and durable; resistant to moisture, stains, and bacterial growth. Easily cleanable. Breathable and quality hand.

Customer's own material or COM The "COM" designation is used when designers supply material to the furniture manufacturer. The fabric is purchased separately and shipped to the upholstery company to be used on a particular piece of furniture.

Cutting A sample of a fabric for presentation or design purposes.

Damask A Jacquard-woven medium-weight fabric with patterns providing unique weave effects. Can be woven self-tone, one-color warp, different-color filling, or multicolor in design. Distinguished from brocades because face of fabric is flatter. The color is reversed on the wrong side. Drapery and upholstery.

Denim A medium-weight, tightly woven cotton twill made of coarse yarns. Usually in a solid color, but can be patterned. Drapery, upholstery, bedspreads, walls, and numerous other uses.

Dotted swiss Sheer fabric woven with extra yarns that form dots when clipped. The effect may be produced by flocking. Curtains.

Duck Similar to canvas. Tightly woven and durable cotton textile. Often striped and used for awnings.

Embroidery Needle and thread art. Originally handwork designs. Can also be machine produced.

Faille (fīl) A lightweight, flat-ribbed fabric woven with fine yarns in the warp and heavier yarns in the filling using a plain weave. The ribbed effect is flatter than grosgrain and smaller than rep. Faille can be the base cloth for moiré. Drapery, upholstery.

Felt Wool or mixed fibers pressed into a compact sheet. A heavyweight fabric used for walls, table covers, and other uses.

Fiberglass Fibers and yarns produced from glass and woven into flexible lightweight fabrics. Noted for its fireproof qualities. Beta Fiberglas is a trademarked glass fiber. Curtains.

Film A lightweight thin or thick plastic sheet used for upholstery, shower curtains, or table coverings. Can be textured, patterned, or plain.

Flamestitch Historically a woven upholstery from the early English eras that includes a multicolored flamelike chevron, typically in strong jewel tones. May be copied in printed materials.

Flannel Twilled fabric made of wool or cotton. Soft yarns are brushed to produce a napped texture. Used for interlinings.

Friezé (frê-zā) A strong heavyweight fabric with a fine, cut or uncut, low-loop surface woven on a wire loom to maintain loops of an even size. Upholstery.

Fringe Thin strands of threads or cords attached to heading.

Gabardine Twill fabric with a distinct diagonal design. Durable, lightweight or medium weight, made with natural or manufactured fibers.

Gauze Sheer, thin textile constructed of leno or plain weave or both. Originally silk, now also cotton, wool, linen, and synthetic fibers. Used for sheers.

Gimp Ornamental braid used to cover upholstery tacks.

Gingham Medium-weight or lightweight cotton or cottonlike fabric for informal use. Made of colored yarns forming checks, plaids, or stripes.

Grenadine A leno weave textile similar to marquisette, but thinner. Often woven with dots or patterns. Sheers.

Gros (grō) point Heavyweight needlepoint embroidery. Upholstery.

Homespun Loosely woven lightweight fabric made to resemble handwoven material. Curtains or drapery.

Hopsacking A rough-surfaced medium-weight fabric loosely woven of various fibers in a plain basket weave. Mainly for drapery and slipcovers.

Insulating Fabrics processed with reflective metallic or foam plastic on one side to provide insulating qualities.

Jacquard Damasks, brocades, tapestries, and all fabrics requiring the Jacquard loom.

Khaki A coarse lightweight to medium-weight cotton twill weave dyed an earthy green color.

Lace Open needlework fabric. Originally handmade; now produced by machine. Often has net background with floral and geometric designs. Curtains and tablecloths.

Lampas Fabric having narrow ribs with satinlike figures formed of warp threads and contrasting figures formed of weft thread. Drapery and upholstery.

Leather Animal skin, usually from cows. Upholstery.

Lining A term applied to plain cotton or sateen fabrics that line or back support draperies or other decorative textiles.

Marquisette (mär'-kǐ-zĕt) A sheer lightweight leno woven textile used for sheers. Made of natural or manufactured fibers. Looks like gauze.

Matelassé (măt-1ä-sā¹) A double-woven heavyweight fabric with a quilted appearance. From the French *matelasser*, meaning "to cushion" or "to pad." Upholstery.

Memo sample A sample of a fabric that must be returned to the fabric showroom.

Mohair Napped fabric from the hair of the Angora goat.

Moiré (mwä-raā¹) A wavy, watery effect pressed into a ribbed surface such as taffeta or faille. A lightweight fabric suitable for drapery, upholstery, or bedspreads.

Monk's cloth A coarse medium-weight fabric in a loose weave of flax, jute, or hemp mixed with cotton, generally in neutral colors. May have sagging problems.

Muslin Bleached or unbleached plain, lightweight cotton weave. Has many uses in decorating, especially in Early American and modern rooms. Walls, draperies, slipcovers. Solid colors or printed patterns.

Needlepoint A heavyweight handmade or Jacquard fabric. Fine and delicate effect is known as petit point; larger needlepoint is known as gros point.

Net A sheer lacelike fabric with a consistent mesh texture available in a variety of fibers. Suitable for sheers.

Ninon (nē¹-nǒn) A plain, tight weave. Has a smooth, crisp, gossamer appearance. Sheers.

Organdy A sheer crisp cotton fabric with good pleating qualities. Available plain, embroidered, or printed. Sheers.

Osnaburg A lightweight to medium-weight fabric similar to homespun. A loose, uneven, coarse cotton with solid color or printed motifs.

Oxford A plain-weave fabric. Large filling yarn goes over two warp yarns. An informal fabric with many uses.

Paisley A printed design inspired by original motifs from India and shawl motifs from Paisley, Scotland. Exaggerated curved raindrop or pear shape most typical design. Lightweight to medium weight. Usually cotton.

Passamenterie Fringes, braids, gimps, tassels, and other decorative ornamentation added to upholstery and window coverings.

Percale A tightly woven and durable lightweight textile. Can be plain or printed. Most often used for bed sheets.

Pilling Fiber fuzz balls formed on fabric surface by wear or friction; encountered in spun nylon, polyester, acrylic, cashmere, or soft woolen yarns.

Piqué (pǐ-kā¹ or pē-kā¹) A medium-weight to heavyweight cotton textile with raised cords or geometric designs running lengthwise. Often used for bedspreads and curtains. Many variations of this textile type.

Plissé (plǐ-sā¹) A lightweight fabric with a crinkled or puckered effect created by chemical treatment. Curtains.

Plush A heavyweight pile fabric with greater depth than velvet. Usually has a high sheen. Upholstery.

Polished cotton A plain- or satin-weave cotton cloth characterized by a sheen ranging from dull to bright. Polish can be achieved either through the weave or by the addition of a resin finish.

Pongee (pǒn-jē¹) Term derived from Chinese words for "natural color." Made from wild silk and left in its natural tan color. Lightweight and durable. Used for curtains.

Poplin Lightweight. Similar to rep. Has a lightly corded surface running through the fabric. Made of natural or manufactured fibers. Often used for draperies.

Quilted fabrics A pattern stitched through a printed or plain fabric and through a layer of batting. Outline quilting traces around the pattern of a printed fabric. Loom quilting is a small repetitive design made by the quilting alone. Ultrasonic quilting produces thermally bonded welds in place of stitching threads.

Rep Plain-weave, lightweight fabric with narrow rounded ribs running the width or length of the fabric. Usually a fine warp with heavier filling yarns. Drapery, upholstery, slipcovers, bedspreads, and other informal uses.

Rosette Applied ornamentation fabricated by gathering materials in a circular manner.

Sailcloth A medium-weight fabric in a plain weave similar to canvas. Popular for informal indoor or outdoor upholstery.

Sateen A highly lustrous fabric usually made of mercerized cotton with a satin weave. Drapery lining.

Satin *Plain:* Fine yarns woven to give a more lustrous surface. May be lightweight or heavy enough for upholstery. Has many decorative uses when a formal style of decor is desired. *Antique:* A smooth satin face highlighted by slub (or twisted) yarn in a random pattern. An important fabric for drapery.

Serge Twill weave with a hard clear finish. Made from rayon, silk, cotton, or wool.

Shantung A heavy pongee. Usually made of wild silk and has a textured, striated surface. Antique satin simulates shantung.

Sheer General term for thin, lightweight textiles.

Slub A yarn with an intended slight irregularity—a thick spot.

Suede Leather with a napped surface. Polyester suede washes and wears well. Upholstery.

Swiss A fine, thin cotton textile originally made in Switzerland and often used for sheers. May be plain, but usually is embroidered or designed with dots (dotted swiss) or figures that have been chemically applied. Manufactured fibers also used.

Taffeta *Plain:* Tight, crisp, smooth weave with slight horizontal ribbed effect. When woven of silk, it is a luxury fabric for drapery, bedspreads, and lamp shades. *Antique* or *shantung:* A smooth, soft weave with random slub yarn creating a texture effect. A lustrous fabric with many decorative uses, especially drapery and lamp shades.

Tapestry A figured multicolored fabric woven on a Jacquard loom made up of two sets of warp and weft. The design is formed by varying weave effects brought to the surface in combination with colored yarns. The surface has a rough texture. A heavyweight upholstery fabric.

Tassels Suspended strands of cut or looped yarn or cord attached to a header.

Terry cloth A medium-weight cotton or linen pile fabric. May be cut or uncut. Loops may be on one side or both. Bedspreads, upholstery, and towels.

Ticking A medium-weight, tightly woven cotton or linen fabric. A strong, usually striped fabric in a satin or twill weave. Mattresses, pillows, wallcoverings, slipcovers, and drapery.

Toile de Jouy (twäl d zhwē¹) A floral or scenic design usually printed on a plain cotton or linen ground. Originally printed in Jouy, France.

Trapunto (tr ∂p ʊ n′-tō) Quilting that raises an area design in one color on the surface of upholstery fabric.

Tweed Plain-weave, heavyweight upholstery fabric with a tweed texture because of flake (or knotted) yarn, in multicolors. Upholstery.

Union cloth Half-linen and half-cotton fabric that is plain or patterned. Coarse weave. A variety of uses.

Velour A French term loosely applied to all types of fabrics with a nap or cut pile on one side. Specifically, it is a cut-pile fabric similar to regular velvet but with a higher pile. Heavyweight upholstery fabric.

Velvet A heavyweight fabric having a short, thick warp pile. May be of any fiber. *Crushed:* Most often the fabric is pulled through a narrow cylinder to create the crushed effect. *Cut:* Jacquard design, usually cut and uncut pile on a plain ground. *Antique:* Velvet that has an old look. Upholstery.

Velveteen A heavyweight weft-pile fabric with short pile, usually of cotton. Drapery, upholstery, bedspreads, and innumerable other uses.

Vinyl A heavy nonwoven plastic fabric capable of being printed or embossed to produce any desired finish such as a leather, wood, floral, or textured design. Cloth backing prevents tearing. Walls and upholstery.

Voile (v°oyl) A fine, soft, translucent fabric in a variety of textures, used for sheers.

Webbing Heavyweight jute, cotton, or synthetic strips, generally 1 to 4 inches wide. Interwoven and plain or printed. Particularly used for sofas and chairs. Can also be used to support springs for an upholstered piece.

13 Window Treatments, Accessories, and Art

FIGURE 13.1 The combination of accessories, Barcelona furniture, and dynamic lighting creates an inviting conversation area. Original rough brick walls, cool leather, and a weightless glass table create textural variety. Massive support columns frame the arrangement.
(Designer: Epperson/Gandy. Photograph by Chris Little Photography.)

This chapter reviews the decorative objects in interior design including the use of window treatments, accessories, and art. These items are referred to as applied design elements and are critical in the design of the interior environment. Accessories and art shape the character of the design, adding to its style and personal attributes both in residential and commercial settings (Figure 13.1). Window treatments are functional, but can also enhance the interior character. Accessories, and in particular art, can become the focal point of the interior and may carry strong personal directions from the client.

WINDOW TREATMENTS

Window styles and nomenclature were discussed in Chapter 5; however, how designers treat these windows is important to the interior as well as the exterior design of a building. For instance, strong bold colors used in windows treatments may enhance the interior, but would

FIGURE 13.2 When selecting window treatments, designers must consider how the treatment will affect the exterior of the building. Neutral colors, as shown in this image, typically complement the architecture. Additionally, window treatments should not be in different hues, creating boxes of color, when viewed from the exterior.
(Courtesy of Hunter Douglas window fashions)

need to be lined with a neutral color to avoid visual disorder to the exterior façade (Figure 13.2). In addition to their decorative qualities, window treatments functionally provide visual privacy, thermal control, sound attenuation, and management of exterior light to minimize glare and/or to provide for a darkened interior.

■ HARD WINDOW TREATMENTS

All window treatments fall into two broad categories: *hard* and *soft*. Deciding on an appropriate window treatment from the almost unlimited options available can be challenging.

Blinds

Figure 13.3 shows several types of blinds. *Venetian blinds* were popular in ancient times, in colonial America, and during the Art Deco period. Today, modern adaptations of the blind have again become popular window treatments in both traditional- and contemporary-style homes

and commercial settings (Figure 13.4). In most cases, blinds are constructed of aluminum, stainless steel, plastic, or wood. (The wooden slat blinds are generally known just as *wooden blinds*.) These horizontally or sometimes vertically arranged strips can be adjusted precisely for light and privacy. Blinds can be mounted on the inside or outside of the window casing. They provide a clean, streamlined look and are available in a wide range of colors and sizes.

Miniblinds are narrow (about 1 inch wide) and create a sleek, trim look. Miniblinds are strong, lightweight, and come complete, requiring no supplementary hardware. Used alone, they can add sophistication to a formal interior or be at home in a modest room. They are a common design solution in commercial settings. Miniblinds can be combined with a wide range of draw and side draperies for a more traditional look. These blinds are difficult to dust and clean; however, windows are made with miniblinds enclosed between two panes of glass to help eliminate dust problems (Figure 13.5). This style, although expensive, provides better insulation. *Microminiblinds* have slats that measure about 1/2 inch. They are not as durable as miniblinds.

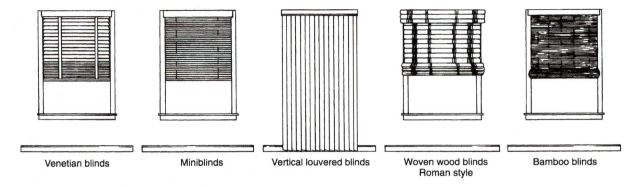

Venetian blinds Miniblinds Vertical louvered blinds Woven wood blinds Roman style Bamboo blinds

FIGURE 13.3 Types of blinds.

FIGURE 13.4 Blinds used in the upper windows mix with sunlight to create playful angular lines on the walls. The strong geometry is accentuated by the horizontal drapery treatment, circular mirrors, decorative suspended sphere lights, and square-patterned throw pillows. This room is part of the same residence as Figure 5.28. The casual, open feeling and powerful use of fundamental shapes are carried throughout the interior.
(Designer: Toby Long of Clever Homes. Photo © Robert Thien.)

Vertical blinds are made of vertical strips that pivot at the top or at both the top and bottom. When drawn, the strips overlap to provide maximum privacy and light control. Usually made of plastic or metal, vertical blinds may have a different color on each side or may be covered with wallpaper or fabric. They are also available in wood. Vertical blinds provide a uniform, tailored appearance, (see Figure 13.22) and work particularly well on sliding glass doors.

Woven split-wood and *bamboo blinds* are slats of wood interwoven with colored or plain yarn. Woven split-wood and bamboo blinds allow some light through, and their warm, natural texture is appropriate for many rooms and various styles (Figure 13.6). They may be used alone

FIGURE 13.5 These blinds are located between the pieces of glass within the window. This design is particularly beneficial for glass doors and anywhere dust is a problem.
(Copyright: Permission has been granted by Hunter Douglas, Inc. to use copyrighted designs. Designs © Hunter Douglas, Inc. Photograph by Joe Stawdart.)

FIGURE 13.6 These hand-woven blinds conform to the arch-shaped window and provide contrast in texture to this formal interior.
(Courtesy of Conrad Handwoven Window Coverings)

or combined with draperies and top treatments. This type of blind is raised by rolling or pleating.

Designers need to be aware that draw cords for blinds should not be used in areas where young children can reach the cords. Unfortunately, children have been known to wrap themselves in the cords, becoming hopelessly entangled, and have even been strangled. Manufacturers have cordless alternatives that should be used anywhere children may be present.

Shutters

Figure 13.7 illustrates several types of shutters. *Louvered wood shutters* have been used since ancient times and are still a quality design solution. They can substitute for drapery, be adjusted (by means of a vertical wooden support) for light and air (Figure 13.8), and are remarkably versatile. Shutters come in standard sizes and can be custom made to fit any window. Dark colors show dust more readily. Shutters can be used in tiers, have panels that are treated in the center with shirred fabric, have raised panel designs, or have vertical louvers. *Plantation shutters* have larger slats and are adaptable to many styles and window types. Although shutters can be expensive, they do provide good insulation.

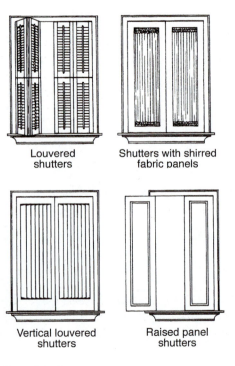

Louvered
shutters

Shutters with shirred
fabric panels

Vertical louvered
shutters

Raised panel
shutters

FIGURE 13.7 Types of shutters.

FIGURE 13.8 This historical interior uses stained wood shutters to blend with the warm, rich interior space.
(Designer: Richard Warholic. Photograph by Gross & Daley)

Shoji Screens

The traditional Japanese shoji window or screen, with wood mullions and muntins supporting rice-paper panes, can slide or be stationary and may be used to establish an Asian or contemporary theme. Like the shoji doors previously discussed, the translucent rice-paper panes do not allow a view but do provide daytime privacy. Shoji screens are often fitted on a track to slide in front of a glass window (as seen in Figure 5.31).

Grills

Widely used in Spain and the Middle East for centuries, the pierced or grillwork screen can be an exotic window treatment. Privacy can be secured while light filters through, creating an appealing effect (Figure 13.9).

Specialty Glass

Art glass, including *beveled* and *stained glass windows*, is common in both modern and traditional environments. *Beveled glass* refers to the angle ground into the edge of plate glass, reflecting the light in colorful ways.

Pierced screens

FIGURE 13.9 Grill used as window or door treatment.

Stained glass is the art of arranging colorful pieces of glass into a pattern. Pieces of beveled or stained glass are joined by lead, zinc, or copper.

Beveled and stained glass panels are available for doors, windows, **sidelights** (windows beside doors), **transoms** (windows over doorways or above larger windows), and skylights. Used for the latter, they bring a brilliant glow into a room. Private craftworkers can provide custom art glass designs (Figure 13.10).

FIGURE 13.10 In this salon, located within a resort, art glass was added to the entry door and windows to provide a sense of privacy. The glass art design also adds a textural interest in contrast to the smooth finishes of the salon. *(Designer: Design Directions International. Photography by Neil Rashba.)*

Glass block (also used for wall construction) is a translucent block of irregular glass, widely used during the periods of Art Deco and International Style in the 1920s and 1930s. Glass block is also appropriate in contemporary commercial and residential environments (Figure 13.11). The blocks come in a variety of sizes and shapes and are made of two hollow half pieces joined together. The surface quality of the glass can be plain, frosted, mottled, or textured. A few companies produce glass block in triangular shapes to provide architects and designers with more design options.

An alternative to glass block is *acrylic block*. It is up to 70 percent lighter than glass block and is available in similar sizes and shapes. Acrylic blocks are joined together with an internal clip system and are sealed with a caulking compound that can include a mold inhibitor. Acrylic block walls are assembled to meet specifications before installation. The lighter weight and ease of assemblage is a great advantage over glass blocks; however, acrylic can be scratched and gouged.

Sandblasted and *etched glass* can create a variety of "frosted" designs. Such glass is often used as a design solution when a client specifies the need for privacy. Manufacturers also supply films that can be placed on existing glass for areas where sandblasting or chemical etching would be too messy. The films are meticulously cut in a variety of designs. *Cast resin*, as discussed in Chapter 9, is a type of polyester that can be colored, shaped, and formed into translucent resin panels to reflect the style of sandblasted or etched glass (Figure 13.12).

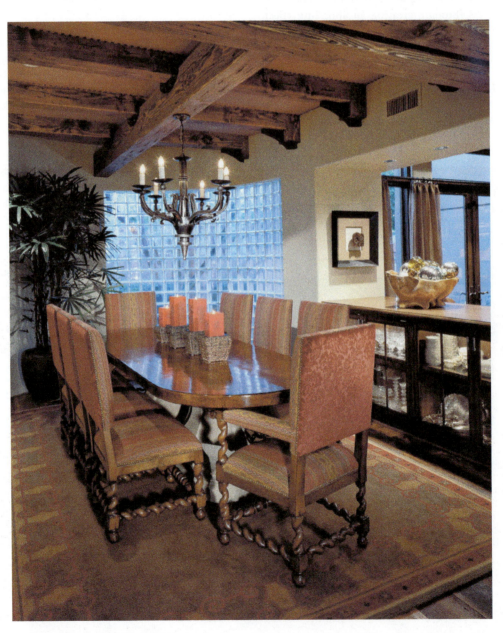

FIGURE 13.11 A curved glass block wall allows daylight and exterior night lighting to filter into the dining room. The heavy timber frame ceiling, wood slab table, and turned chairs complement the robust design of the block wall.
(Designer: Linda Seeger Interior Design. © Pam Singleton / Image Photography, LLC.)

Window films may also be applied to glass to prevent glare or to protect interior furnishings from harmful ultraviolet rays. They can help to keep a room cooler. Window films come in a variety of darkening shades, and the film is also effective for clients who have visual sensitivities to bright light.

Liquid crystal is a glass technology that can change architectural glass from transparent to translucent and back again at the flick of a switch. A thin film coated with liquid crystal droplets is laminated between panels of heat-strengthened flat glass. When electricity is sent through the panel, the liquid crystals align to transmit light and the panel becomes clear like a normal window. When the power is switched off, the liquid crystals scatter and the panel becomes translucent. These glass panels are marketed for use in corporate conference rooms, offices, and presentation facilities where the ability to see through glass normally is desired, but at certain times privacy is required.

Bare windows are sometimes beautiful in themselves and, if privacy is not a problem, concealing them in layers of drapery can be a mistake (Figure 13.13). Triple glazing can help control energy costs.

FIGURE 13.12 Translucent resin panels can be designed in many textures and colors. The inset panel of this door uses an ecoresin product by 3form. The custom design is reflected in the bedspread.
(Architect/Designert: LeVino Jones Medical Interiors, Inc. Photography by Thomas Watkins.)

FIGURE 13.13 The curved window wall and ultimately the scenic vista define the dining experience in this upscale restaurant. Tiered seating provides all diners with a view of the water. The best window treatment, other than glare prevention, is none.
(Designer: Design Directions International. Photography by Neil Rashba.)

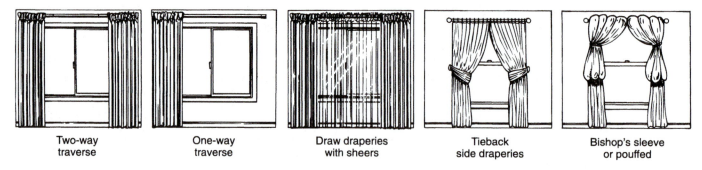

Two-way
traverse

One-way
traverse

Draw draperies
with sheers

Tieback
side draperies

Bishop's sleeve
or pouffed

FIGURE 13.14 Types of draperies.

■ SOFT WINDOW TREATMENTS

Draperies

Draperies are made of a heavier fabric than are curtains. (Curtains are simple, lightweight decorative solutions; see below.) *Draw draperies* are made to draw over a window to control light, temperature, and privacy (Figure 13.14). Draperies may terminate at one of three lengths: the windowsill, the bottom of the apron, or the floor; or they may be cut extra long to form a "puddle" effect on the floor (Figures 13.15 and 13.16). They hang straight and may be used alone or combined with other blinds or shades.

For example, with a combination of draw sheers and draw draperies—the most common usage—the view can be exposed, and light, sound, temperature, and privacy can be controlled. Draperies that draw closed from both the right and left sides are called two-way traverse. Those that draw from one side only are called one-way traverse.

Side draperies or *stationary panels* remain at the sides of the window. Stationary panels may be hung straight or tied back. Their purpose is to bring beauty and style into the room. Because they are not designed to give privacy or provide insulation to a room, they may be combined with other window treatments.

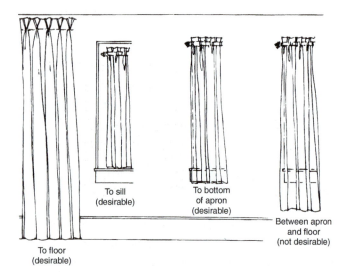

To floor
(desirable)

To sill
(desirable)

To bottom
of apron
(desirable)

Between apron
and floor
(not desirable)

FIGURE 13.15 Drapery lengths.

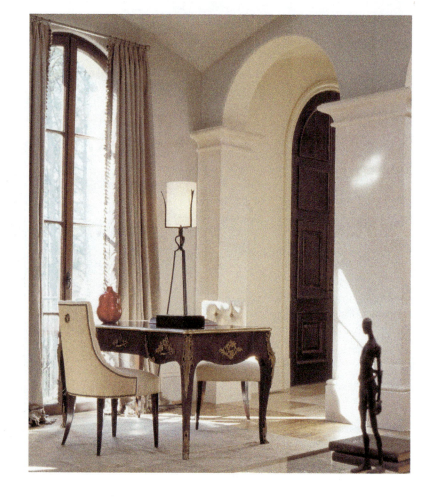

FIGURE 13.16 Windows that dominate a room may be best accompanied with a simple two-way traverse drapery gathered on a rod. The elegance of the fabric, slightly puddled on the floor, accentuates the classic beauty of the arched window. *(Architect/Designer: Robert Brown. Photography by Chris Little Photography.)*

Sheers or *semisheers* are used primarily to diffuse light and provide daytime privacy. They may be hung permanently against the glass or drawn back. Much of their beauty and efficiency depends on their fullness, most often three times the width of the window. When nighttime privacy is desired, sheers can be combined with draw draperies, blinds, or underdraws.

Casements are generally made of a loosely woven fabric and are heavier in texture than are sheers. They may be used in residences, but are most often used singly in commercial environments and drawn to control light.

Underdraws, more commonly called *blackout draperies* or shades, are used in environments that require total darkness. Commercial office presentation and conference rooms may employ blackout window treatments. Some are controlled by mechanical devices. All underdraws should be concealed and are not considered decorative.

Drapery lining serves several functions. Windows are viewed from two perspectives: outside and inside. Drapery lining provides a uniform and attractive view from the outside, covering patterns and colors seen more effectively from an interior perspective. When several windows face the street, it is best to coordinate their appearance through the use of the same drapery lining, especially for windows on the same level. Drapery lining also provides additional thermal insulation, and protects the drapery from ultraviolet rays.

Ready-mades are draperies and curtains made to standard lengths and are available in drapery departments in most retail stores. Although often less full than custom-made draperies, ready-mades frequently give a satisfactory effect that belies their more modest cost.

Curtains

The most common types of curtains are illustrated in Figure 13.17. *Priscilla curtains* are ruffled tiebacks most often used in informal settings. They are usually made of light, sheer fabrics trimmed with a ruffle and shirred to a rod at the top of the window. One type of Priscilla curtain has panels overlapped in a crisscross fashion, and another has a symmetrical arrangement.

Shirred curtains are gathered on a rod and hung at the top of the window, letting the fabric drape softly. The amount of fabric used determines how full the effect of the curtains is.

Sash curtains are usually hung close to the glass. They are shirred at the top and often the bottom on sash rods.

Cafe curtains are hung over the lower part of the window. Usually used for privacy, they may draw or be stationary. Two or more tiers may be hung to cover the entire window, in which case the rods are concealed. Cafe curtains may be teamed with draw or side draperies, shades, blinds, or shutters. Cafe curtains are often embellished with a window top treatment.

Bishop's sleeves or "pouffed" curtains are similar to the stationary drapery type illustrated in Figure 13.14, but employ a sheerer fabric.

Center meet
Priscilla curtains

Crisscross
Priscilla curtains

Shirred curtains

Sash curtains

Cafe curtains, one tier

Cafe curtains, two tiers

Tiered curtains

Bishop's sleeve
or pouffed curtains

FIGURE 13.17 Types of curtains.

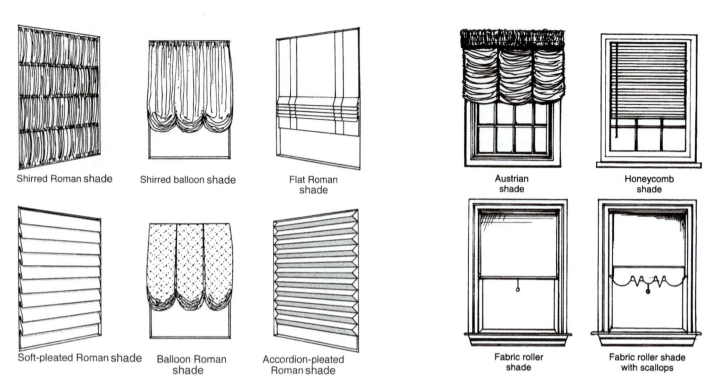

| Shirred Roman shade | Shirred balloon shade | Flat Roman shade |

| Soft-pleated Roman shade | Balloon Roman shade | Accordion-pleated Roman shade |

FIGURE 13.18 Types of Roman shades.

| Austrian shade | Honeycomb shade |

| Fabric roller shade | Fabric roller shade with scallops |

FIGURE 13.19 Other types of shades.

Shades

Some of the most common types of fabric shades are illustrated in Figures 13.18 and 13.19. *Roman shades* have a flat surface when extended down (Figure 13.20). When drawn upward by a cord, the surface overlaps in horizontal folds made possible by a precreased rigid lining or by rings (or ring tape) and cords attached to the back of the shades. Roman shades come in a variety of styles, including shirred Roman, shirred balloon, flat Roman, soft-pleated Roman, balloon Roman, and accordion-pleated Roman.

FIGURE 13.20 Roman shades have been custom designed to fit the angles of this window, allowing a sweeping view of the city. The simple tailored effect complements the architecture and the room's Southwest decor.

(Photograph by Mark Boisclair)

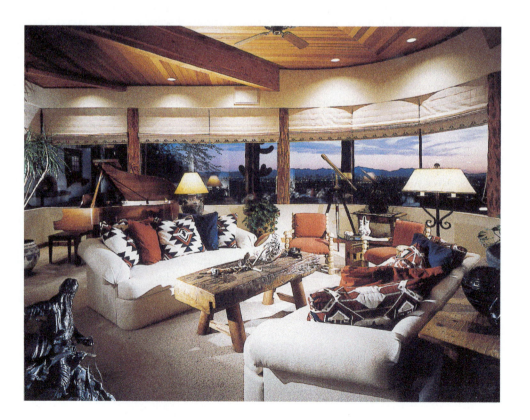

Austrian shades consist of rows of lightweight fabric seamed to fall into deep scallops. The shade is operated by a draw cord and is similar in design to the shirred balloon Roman.

Pleated fabric shades are also called "accordion shades" and "soft shades." Pleated shades are factory manufactured, are available in a wide range of colors and finishes, and can be insulated. Fabrics vary from opaque to translucent and may be patterned or plain. *Honeycomb shades* have smaller pleats and are usually made of a heavy polyester fabric. They operate on the same principle as the single pleated shade except that two pleated shades are bonded together, resulting in a "honeycomb" cross section (Figure 13.21). This construction provides an energy-efficient insulating air space. The exterior side of the shade is white to reflect the sun's rays and provide uniformity on the outside.

The *roller shade* is an inexpensive window treatment. It may be installed between window casings or on the outside of the frame. The most common material is vinyl, which is available in a variety of weights. Traditionally, roller shades were white or off-white, but today they are available in the full spectrum of colors; however, colors do affect the exterior facade. Originally thought of as purely functional, the simple roller shade can be laminated with fabric and trimmed in a variety of ways. When mounted at the bottom of the window and drawn up, it is especially effective for privacy. Roller shades may be light filtering or room darkening, depending on the thickness of the material. Shades are easy to maintain, and insulate against heat and cold. Window quilts or thermal shades are made of additional layers of fabric, often have a decorative stitched pattern, and provide extra insulation.

Whether hard or soft window treatments are used, uniquely sized windows frequently require careful consideration. Circular windows may have a custom pleated blind with a center rosette. Arched windows (as seen in Figures 13.6 and 13.16) can either be accentuated or

FIGURE 13.21 These honeycomb shades provide privacy and insulation while allowing soft light to enter. A variety of pleat sizes, layers, and colors are available. *(Courtesy of Hunter Douglas window fashions)*

softened. Treatments should reflect the size and shape of the window while enhancing the style of the interior (Figure 13.22).

Plants

Plants can be used successfully in lieu of other window treatments. Hung at varying heights and placed on pedestals or the floor, plants can form a border of greenery that softens hard-edged architecture, filters the light, and affords privacy. A built-out window in a sunny location can become a greenhouse. Greenhouse windows are often used in kitchens and can provide a focal point.

FIGURE 13.22 In this interior, simple vertical blinds made of a semi-sheer material were selected to control light and glare while still allowing for the view. This simple architectural treatment accentuates the contemporary design. *(Courtesy of Hunter Douglas window fashions)*

■ WINDOW TOP TREATMENTS

Many windows are embellished with treatments at the top, or at the top and sides of the drapery or curtains. These treatments are of various designs and are made of soft or hard materials (Figure 13.23).

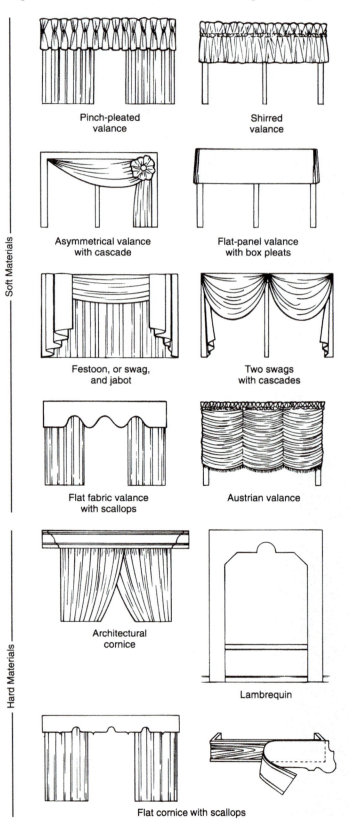

Soft Materials

The **valance** is generally a shirred, pleated, or draped soft treatment across the window top. A valance screens hardware and gives the drapery a finished look. It is used solely for appearance; it does not change the function of the drapery. It can appear to extend the height and width of a window and unify windows of different sizes, thus altering the room's visual proportions. The valance may match the side or draw draperies and is often shaped by a stiff interlining. If the fabric is patterned, the shape of the valance looks best when it conforms to that pattern. The material in the valance should run in the same direction as the drapery.

A *swag* is a type of valance treatment wherein fabric is draped over a rod at the top of the window. A *festoon* is a single-draped member of a swag. A *cascade* drapes down from *under* the corners of the swag. The cascade has a vertical outside edge with an undulating edge closest to the swags. A *jabot* is similar to a cascade, but drapes over the edges of the swag. It is usually pleated and may be of varying lengths. Swags, jabots, and cascades may be hung over sheers, drapery, blinds, shutters, or shades, or at the top of bare windows (Figure 13.24).

Hard Materials

Cornices are generally made of wood, metal, or another hard material and are placed at the top of the window treatment. Often cornices are a continuation of an architectural molding or cornice around the top perimeter

FIGURE 13.24 In this formal dining room, the designer accents the window weight through the use of a swag and cascade window treatment. Gilded tiebacks and rings used in the valance complement the treatment.
(Designer: Miner Details. Photograph by Deborah Whitlaw.)

FIGURE 13.23 Types of top treatments for windows.

of the wall extending outward to accommodate the window top. Cornices may be simple or decorative, such as a scalloped or pierced design. They may be stained, painted, or covered with fabric. A cornice with a fabric valance attached is an effective formal treatment (Figure 13.25).

Lambrequins are similar to cornices, but they also have a rigid treatment that extends vertically down both sides of the window. Lambrequins can be painted or covered with wallpaper or fabric and used with or without draperies, curtains, blinds, or shades. They provide a tailored look and can alter the apparent size of the window.

More info online @

www.wcaa.org Window Coverings Association of America
www.dwconline.com/DWC *Draperies & Window Coverings* magazine

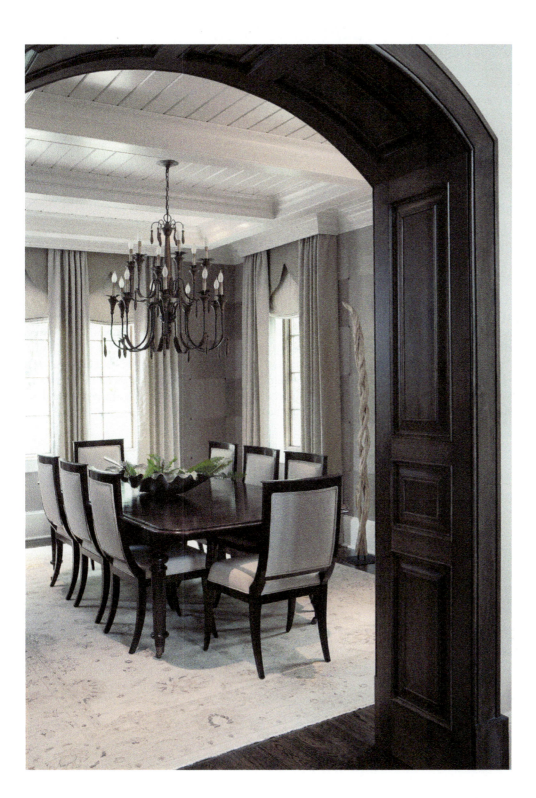

FIGURE 13.25 In this dining room renovation, the designer selected a hard cornice that parallels the crown molding; a curved fabric valance extends below the cornice, but above the window. A fabric shade drops behind the valance, and side panels extend to the floor. *(Courtesy Pineapple House Interior Design. Photography by Chris Little Photography.)*

■ WINDOW TREATMENT HARDWARE

Functional Hardware

Figure 13.26 illustrates types of functional and decorative window hardware. Purely functional hardware should be inconspicuous. *Sash rods* are flat rods attached close to the sash (often both top and bottom) on which curtains are shirred. *Extension rods* are used for stationary curtains and drapery. They extend to various lengths and are available in single and double sets. *Traverse rods* operate on a pulley system. Available as either one- or two-way traverse types, they are used for drawing curtains and drapery. *Spring tension rods* fit inside the casing. *Swinging rods* are mounted on a mechanism that permits the rod to swing backward. These rods are suitable for in-swinging casements, dormers, and French doors. *Extender rods* extend outward to support stationary drapery beyond the sides of the window. *Ceiling tracks* with concealed drawing mechanisms are especially popular in contemporary rooms. Small accessories such as hooks, rings, ring slides, brackets, and draw cords are all part of the unseen draw-drapery system. Rod placement on windows is illustrated in Figure 13.27. As previously mentioned, when drapery treatments are used in areas where children are present, dangling cords (such as those on blinds and shades) present a danger to children and should be secured out of their reach.

Like doors, windows also require security hardware. Locking and opening mechanisms need to be of a durable finish that accompanies the room's style.

Decorative Hardware

Decorative hardware is functional but also adds to the room's style. Rods may be wood (with natural, stained, or painted finishes) or metal (such as pewter, shiny or antique-finish brass, chrome, bronze, or wrought iron). Decorative hardware is equipped with a variety of **finials** (the decorative element attached to the end of a rod) to accommodate any style. Draperies suspended on rings may be cord operated or hand drawn. In the latter case, the rings should be loose. Metal holdbacks that conform to the style of rods add a finishing touch.

FIGURE 13.27 Rod placement on window frame.

■ DRAPERY AND CURTAIN HEADINGS

The *heading* is the pleating or gathering at the tops of curtains and draperies that forms the fold (providing the beauty of fullness for drawing). Headings are made in a number of ways. *French* or *pinch pleats* are made by stitching together three small pleats about 3 inches from the top. The pleats, which are spaced 3 to 4 inches apart, are held upright by an interlining. *Ripplefold* is a simple method of creating gentle, undulating folds by means of a compact track containing snap carriers. Folds are made from flat panels of fabric and are identical on both sides. *Accordion folds* are made by a combination of a compact track with snap carriers and a nylon heading tape. *Tailored pleats* form architectural-like folds. *Easy pleats* are made with a special tape attached to the inside top of the drapery. When pleater hooks are inserted in ready-made pockets, folds are automatically formed.

Shirred headings are made by stitching a pocket approximately 1 inch from the top, in which the rod is inserted. *Tab top headings* are similar to shirred headings, but the tabs are placed 2 to 4 inches apart so that the decorative rod is exposed (see Figure 13.28B).

Tiebacks hold back stationary draperies. They come in a wide variety of materials and styles and may be made of cords, tassels, metal, wood, or matching or contrasting fabric (as seen in Figure 13.24). Designers often tie back drapery somewhere between one-half and one-third from the bottom—employing the proportions of the golden mean (see Chapter 3). *Trimmings*, such as fringes, braids, edgings, cords, and tassels, can give a finished look to draperies, cornices, and valances.

Return

Single curtain rod

Double curtain rod

Spring tension rod

Single traverse rod

Double traverse rod

Bay window curtain rod

Plain traverse rod set

Valance rod kit

Sash rod

Swinging rod

Curved curtain rod

Corner curtain rod

Cafe rod

Decorative traverse rod

FIGURE 13.26 Curtain and drapery rods.

DESIGN AND PLACEMENT OF WINDOW TREATMENTS

The following guidelines are important when selecting a window treatment:

- Architectural features may be enhanced or hidden (Figure 13.28 Before and After).
- The exterior view may need to be enhanced or hidden.
- In commercial settings, the building tenant may have standards for window treatments that need to be followed.
- Privacy may need to be created either at night, during the day, or both.
- Light may need to be altered to prevent glare or to preserve precious furnishings.

- Light may need to be blocked to enhance video viewing or to allow for a completely darkened interior.
- Clients with sensitivities to light may require enhanced glare reductions.
- The window treatment should complement the furniture style and placement.
- The window treatment should complement the exterior of the building.
- The treatment may need to conserve energy (see Sustainable Design: Energy-Efficient Window Treatments).

In many cases, to serve a variety of functions, a combination of treatments is required (as seen in Figure 13.25). These combinations should work together to create one design element.

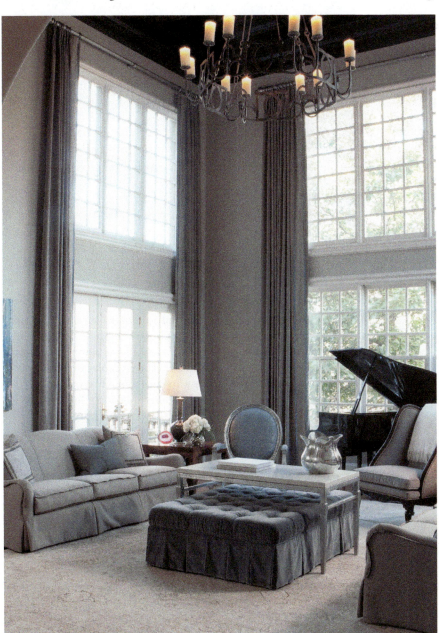

Before

After

FIGURE 13.28 In this renovation, the designer respected the "home's bones" and accentuated the height of the great room with the two-story drapery treatment. The lines of the flowing drapery add dignity and formality to the environment, while allowing visibility to the gardens.
(Courtesy of Pineapple House Interior Design. Photograph by Scott Moore Photography.)

More info online @www.hunterdouglas.com/starter-guide.jsp?so=tn
www.ehow.com/about_5127490_types-drapery-rods.html Info on curtain and
drapery rods www.blindservice.com/glossary.html
www.home-decorating-made-easy.com/window-treatment-styles.html
Glossaries of window covering terms
Lists of questions and other ideas to consider when selecting window treatments
www.jcpenney.com/jcp/howtomeasurehom.aspx?cmAMS_T=H9&cmAMS_C=C3
www.nobrainerblinds.com/control/topic/p,measure Info on measuring and placing
window treatments

FIGURE 13.29 In this bathroom with a 15' ceiling and a view of the Hawaiian mountains, the designers chose lighting and accessories to complement the clean, contemporary lines of the building.
(Architect/Designer: Gensler. Photograph by Marco Lorenzetti/Hedrich-Blessing.)

SUSTAINABLEdesign

ENERGY-EFFICIENT WINDOW TREATMENTS

A window's treatment may reduce heating and cooling costs. Curtain and drapery manufacturers are producing a variety of insulators for windows to save energy. For instance, double-woven multilayered fabrics trap warm air in the room, and insulated shades, draperies, and linings protect against heat and cold.

Generally, natural materials do the finest job of insulating. The more yarn used in the fabric, the tighter the weave, the bulkier the material, and the fuller the drapery, the more air it will trap. Layered window treatments also are effective insulators. One efficient combination is wooden blinds placed near the glass, with drawn sheers and lined draw draperies. To trap cold or hot air, the sides of the drapery may be anchored to the window frame or the wall by double-faced fabric tape. Other effective energy-saving window treatments include quilted blinds, lambrequins, and cornices sealed at the top and sides, and window shades (which can be operated by a mechanical device) equipped with side channels to seal the cracks. Edge sealing is the most critical point for effective energy saving in window treatments.

ACCESSORIES

Accessories articulate and accentuate the style and feeling of a space. Because accessories can greatly enhance a space, the process of selecting and arranging accessories for both residential and commercial settings deserves thoughtful consideration. Accessories add the finishing touches to a room, reflecting the personal tastes and individuality of the client. Accessories may have sentimental value to the client and may incorporate personal collections. Accessories can also be a powerful tool in establishing the concept or expressing a cultural background. Interiors are enriched by the addition of both functional and decorative accessories.

Decorative accessories generally provide no other value than the pleasure derived from looking at them. Decorative items abound in furniture and antique stores, galleries, design studios, art and craft exhibitions or shows, and numerous other sources. Accessories are available in traditional or contemporary styles and may be handcrafted or machine-made, old or new.

Accessories can also serve a utilitarian purpose but may become an interesting display item as well. Some items, such as towel racks, drapery rods, door handles, or accent plumbing fixtures (Figure 13.29), may be attached to the architectural background. Other practical accessories such as mirrors, lamps, clocks, or trays may be moved from one place to another within the space.

The purpose or use of the room should be the prime consideration when selecting functional accessories. For example, if lighting is required beside a lounge chair in a living room, choose an appropriate lamp that will meet the needs of the user. Making a list of accessories necessary in each room will help with the successful selection and placement of each item. Following is a discussion of the basic accessories that complete a room and give it an attractive, desirable, lived-in feeling.

Lamps

Lamps (not to be confused with the light source as defined in Chapter 6) are known in the industry as *portable luminaires*. They are attractive accessories serving the purpose of providing light when and where needed. Common types of lamps include table lamps, floor lamps, sconces, torchères, and pendants (chandeliers). Lamps are available in a wide range of styles—traditional or modern, decorative or structural. A lighting fixture that is carefully chosen for a specific room, style, mood, location, or purpose can be an important contributing element, as shown in Figure 13.30. (Refer to Chapter 6 for further information on lamps and lighting considerations.)

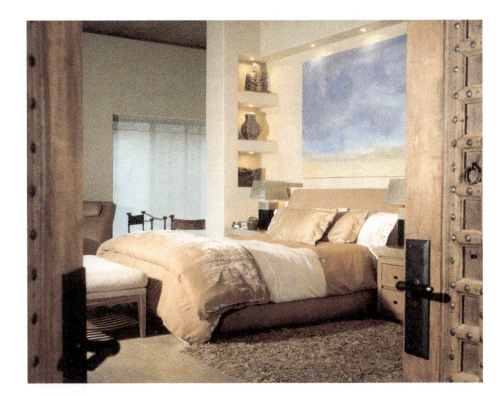

FIGURE 13.30 Blending contemporary lines with historic elements, Michael Kreiss designed his residence to reflect his heritage while incorporating his line of furnishings. Note how the nightstand lamp is at an appropriate height to allow light to fall on the surface of reading materials for someone sitting in bed, but the light is shielded from the person's eyes. Also note the rich variety in textures.
(Designer: Michael Kreiss of Kreiss Design. Furnishings from the Kreiss Collection.)

Books

Cicero said, "A room without books is a body without a soul." Books add friendliness to a home. Usually no room has a mood that precludes their use, or a color scheme so complete that it could not benefit from the warm tones and textures of books. Bookshelves can go into almost any room, require little space, and create a warm, friendly atmosphere. Children need bookshelves in their rooms at a height they can easily reach. Bedrooms can accommodate shelves where space permits—usually close to the bed for nighttime reading. Kitchens need handy shelves for reference books and cookbooks. Conference rooms benefit from shelves used to display company memorabilia, awards, and reference books. Bookshelves often can be fitted into unused spaces and odd corners. They can also work around or over doors and windows, or serve as a space divider.

Additionally, books can add a decorative quality to a room with their textures, colors, and shapes. They also mix well with other accessories; for example, a few books flanked with interesting bookends next to a plant and a small sculpture, or placed on a coffee table with other items, add interest to a room (as seen in Figure 12.1).

Mirrors

Since the fourteenth century, mirrors have been used as functional and decorative objects in homes and public places. Mirrors are available in almost any size and in frames to fit any decor. Mirrors are a helpful tool for the interior designer; they can add beauty, multiply space, conceal unattractive structural features, distribute and double light, brighten dark areas, and bring life into an otherwise drab room. Because of their myriad uses, mirrors have steadily increased in popularity and now play an indispensable role in all styles of interiors (Figure 13.31).

FIGURE 13.31 This custom-designed table is accentuated by the use of a mirror and floral accessories. The table, designed by Jeffrey Jurasky, ASID, is fabricated from steel and slate.
(Designer: Jurasky & Associates. Photograph by Kaminsky Production.)

Clocks

Clocks have long been important accessories in the home and office. From the handsome antique grandfather clock encased in an elegantly carved case to the high-tech clocks of the twenty-first century, timepieces not only serve a necessary function but also can add a calming background "tick-tock" sound to any room. Naturally, a clock must be placed where it can be seen easily. Outdoors, clocks frequently serve as landmarks in metropolitan settings. In smaller communities, the chime of a clock tower helps to define the "sense of place."

Screens

In addition to its decorative value, a screen may serve many functional purposes. Screens can set off an entrance where the front door opens directly into the living area, act as a divider between living and dining areas, close off a kitchen, or set off a private area by making a room within a room. They also can redirect traffic when strategically placed, extend the apparent size of a room by replacing a door, control the flow of air and the direction of light, camouflage an out-of-date radiator or air-conditioning unit, or conceal storage. A decorative screen can give an architectural quality to a room, enhance the room's decor, provide a backdrop for a furniture grouping, substitute for side drapery, or serve as the room's focal point.

Hardware

A contemporary room can be made strikingly modern and a traditional room can take on an authentic feeling through the discriminating use of small accessories such as door knockers, doorknobs, switch plates, curtain rods, and tiebacks. Drawer pulls, **escutcheons** (the plate behind the pull), and hinges can give a piece of furniture the feeling of a particular period (Figure 13.32).

Flowers, Foliage, and Plants

Of all accessories making up the final touches of a residence or commercial space, almost nothing can duplicate the effect of fresh flowers. Three popular flower arranging styles are Oriental (*ikebana*), traditional, and contemporary freestyle. *Ikebana* is asymmetrical with minimum foliage; traditional is more formal in balance and may contain numerous types and colors of foliage; contemporary may be asymmetrical or symmetrical and uses only a few varieties of foliage, sometimes only one species. The container contributes to the total success of the arrangement and generally works best when the texture, pattern, and size complement the surroundings. Glass, metal, porcelain, pottery, and baskets are often used because they can be effectively combined with traditional or modern furnishings.

Living plants placed in interior environments contribute to the total design scheme and help to bring something of the outdoors into the interior (as seen in Figure 13.1). Personal preference for texture, form, color, and size is a consideration in selecting plants, as well as special care requirements for light, water, and temperature.

Dried flowers, branches, pods, and other foliage are often used as alternatives to fresh plants and flower arrangements. They have the advantage of being permanent, and require no upkeep other than dusting. Well-made artificial flowers, foliage, and plants look amazingly natural. They may be manufactured from silk, polyethylene, or polypropylene. (The latter two materials can be cleaned more easily than silk.) Like dried arrangements, they are permanent and require only occasional dusting.

FIGURE 13.32 Finishing touches.

ART

The fifth level of Maslow's hierarchy of needs, self-actualization, can be reached though the application of the arts (as seen in Figure 2.2). Like accessories, art is highly reflective of the individual client and or the philosophy of the corporation.

In residential design, paintings, drawings, original prints, photographs, sculpture, and other types of art are usually selected personally by the client; designers may be responsible for designing around a particular piece or selection. Corporate art collections may be selected by a professional curator. Designers also may work with the client to recommend or actually select an accent piece. Designers should be aware of the following types of art.

■ TWO-DIMENSIONAL ART

While this discussion divides art into two- or three-dimensional classifications, many types of art cross over between these two descriptions.

Paintings, Drawings, Prints, and Photographs

Original *paintings* in oil, acrylic, watercolor, or tempera are usually the most expensive type of art. They range from the works of famous painters to those of local artists, as shown in Figure 13.33.

Original *drawings* are usually executed in ink, charcoal, pencil, pastels, or crayon.

Original *prints* such as etchings, lithographs, woodcuts, steel engravings, and drypoints are *not* photographic copies. They are designed by an artist and usually produced by her or under her supervision. Limited edition prints are numbered and signed by the artist. A piece numbered 27/100, for example, is the 27th of a total of 100 prints made. The fewer prints produced, the rarer the piece. Limited prints are usually less expensive than one-of-a-kind paintings and drawings.

Original *photographs* are also considered fine art and may be signed by the artists and produced in limited editions. Family *photographs* personalize a space.

Posters, originally called "poor man's art," are available at minimal cost. They are usually considered a low-budget accessory but are often seen framed in fine contemporary settings. Photographic reproductions of original paintings, drawings, or prints are inexpensive and widely available. Some early posters are now collector's items.

Frames and Mats

Frames and mats are most effective when they do not detract from the work but complement the medium, colors, and subject. The frame and mat should work with the style and architectural background elements. The size, line, and form of the frame should not overpower the art but enhance the overall composition. *Slip molds*, small gold inserts, are frequently used when a little sparkle is required between the frame and mat, or between mats.

A mat usually complements drawings, etchings, watercolors, and prints of all types. Oil paintings are seldom matted, but may have a liner made from linen, velvet, or leather. Mats protect original art from direct contact with the glass, where condensation can occur when the temperature changes. Quality mats are acid-free, protecting the displayed work from discoloration and serious damage.

Glass is usually used over prints, watercolors, and etchings but is almost never used over an oil painting. Regular glass, nonglare glass, and acrylic are available. Nonglare glass tends to give a clouded appearance but does cut down on reflections. Acrylic works well in environments where broken glass could be highly dangerous. Glass may also be purchased with built-in ultraviolet light protection to preserve colors in original and poster art.

■ THREE-DIMENSIONAL ART

Three-dimensional works of art can be treasured accessories in residential or commercial settings (as seen in Figure V.4). Three-dimensional art typically requires a stand or platform to display the work. This element should visually disappear.

Sculpture

Sculpture is fashioned in many media, including metals, marble and other stone, wood, glass, and ceramics. Placement often depends on the size of the piece. If small, the piece may be best displayed on a shelf, mantel, or tabletop. If the sculpture is large, it can dominate an area or provide a focal point. A pedestal may be used for either a small or large sculpture to give it greater prominence. Lighting that spotlights the art but does not wash it away adds visual interest.

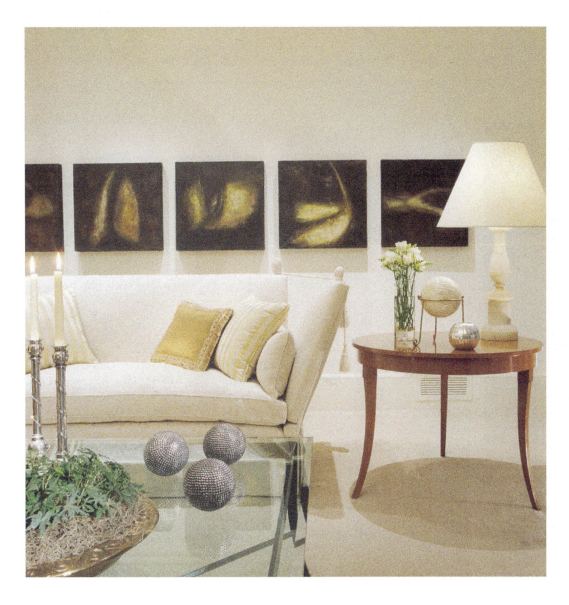

FIGURE 13.33 The series of paintings by artist Alice Nesbitts complements the fine fabric on the racket-arm sofa. Accessories add texture and sparkle to the room.
(Designer: Gandy/Peace, Inc. Photograph by Chris A. Little. Courtesy of Southern Accents.)

Other Arts and Crafts

Ceramics are accessories made of clay and include sculpture, dishes, bowls, platters, pots, and tiles. Clay ranges from coarse to fine and comes in a wide variety of colors. The artisan may create a unique ceramic piece by applying different types of ornamentation, colors, textures, and shapes (Figure 13.34). Ceramics fall into four basic categories—porcelain, china, earthenware, and stoneware.

A *mosaic* is made up of small, usually square pieces (called tesserae) of ceramic, stone, or glass arranged in an artistic design and set in cement. Used for floors and murals in ancient times, mosaics currently are used for a variety of small decorative objects including trays, boxes, and small tables.

Glass art accessories include vases, dishes, bowls, and sculpture. Glass can be blown, etched, colored, enameled, pressed, gilded, cut, and engraved. Production of handblown glass has been a popular art for centuries, and exquisite pieces from many countries, each with its own design approach, have been widely appreciated in America. Modern designs have been pioneered most notably by Italian and Scandinavian artists, who fashion beautiful and unique pieces.

Stained glass, an artistic composition of small pieces of colored glass held together by lead, has also been known through the ages, particularly during the medieval period when stained glass was used to create extraordinary windows in Gothic cathedrals. Stained glass can be made into window and door panels, hung at a window, or designed as a freestanding piece of art.

Weaving and *textile art* have been known for centuries in almost every country of the world, each of which has developed distinctive cultural designs (Figure 13.35). Historically, most weavers have employed a simple handloom, wool yarns, and natural dyes. Tapestry is an intricate, usually pictorial, multicolored handwoven textile design with a ribbed surface. Presently, most tapestries used as accessories are machine-made. Some copy patterns were used in previous eras, and some are more modern in design. Tapestries can be used as accessories in a manner similar to paintings.

Handcrafted and custom-designed rugs and blankets are often used as a focal point in a room or as the basis for a room's color scheme, as seen in Figure 9.16. Rugs may also be hung on walls. Blankets such as those produced by the Navajo Indians and the Finnish add a pleasant decorative touch in a room. The traditional process of quilting involves arranging small pieces of colored, plain, or patterned fabrics into an overall design. Quilts are frequently employed in provincial design.

Animal hides may be hung as paintings, draped over furniture, or used as rugs in low-traffic areas. Before selecting a hide for use, the interior designer must be able to verify that the hide was legally obtained. Designers should be sensitive to ethical treatment and conservative use of all animal products. Endangered species should never be used.

Painted, brain-tanned animal hides such as deer, elk, or bison are a popular art form in Western design. The art form, developed by Native Americans, requires the hide to be tanned using the animal's brain instead of harsh commercial chemicals. The designs painted onto the

FIGURE 13.34 This ceramic sculptural vase, Perianth, was created using the process called *raku*. Originally used in Japan in the sixteenth century for ritualistic tea ceremonies, today *raku* refers to clay pieces fired rapidly and cooled quickly, often by immersion in cold water. The vessel stands 30" high and would serve as an excellent focal point or accent piece in an interior.

(Artist: Mary Jane Taylor. Photograph by Light Sources, Inc.)

FIGURE 13.35 This exquisite weaving protected by Plexiglas complements an antique dragon on a rustic glass cabinet. The textures and form enhance a Thai-influenced interior.

(Designer: Jerry Pair. Photograph by Peter Vitale. Courtesy of Veranda.)

FIGURE 13.36 These painted, brain-tanned hides work well in a contemporary or rustic setting. Hung from custom-designed poles or draped over furnishings, they create an intriguing focal point.

(Artist: Lee Secrest. Photograph by Laurie Lane.)

skin may be inspired by authentic pictographs, geometric designs, or original concepts of the artist (Figure 13.36).

Baskets and the art of basket weaving have changed little since ancient times. Artists have further developed this art by introducing new colors, forms, patterns, and styles. Traditional baskets created by particular cultures display distinctive characteristics and styles that are highly valued.

Handcrafted *candles*, originally used for purely functional purposes, are a highly intricate art form. Candles are created in many colors and in a wide range of textures and forms suitable for both traditional and modern settings. Candles are often used for decorative accents in the interior; when lit, they provide a warm, inviting element in the private or public environment.

More info online @

www.famsf.org Fine Arts Museum of San Francisco
www.louvre.fr The Louvre Museum
www.whitney.org Whitney Museum of American Art
www.metmuseum.org Metropolitan Museum of Art
www.artic.edu Art Institute of Chicago

■ SELECTING ACCESSORIES AND ART

When determining what accessories and art are suitable for a particular space, designers consider a wide range of possibilities. Reviewing an outline of numerous items often sparks an idea of the accessory or art that ties a grouping together. Table 13.1 lists commonly selected accessories and works of art for both residential and commercial settings.

TABLE 13.1 Accessory and Art Idea List

Animal hides	Ceramics	Kitchen and cooking utensils	Serving carts
Aquariums and fish	Clocks	Kites	Shells and rocks
Arms and armor	Coat racks	Lamps	Shelves (a small, decorative, carved
Art (two-dimensional)	Collections (coins, guns, stamps,	Models (airplanes, ships, etc.)	wood shelf, for example)
Artificial flowers and foliage	antique items, etc.)	Maps, charts, and documents	Silverware
arrangements	Cushions	Mirrors	Stools
Ashtrays	Desk accessories (pen and pencil	Mosaics	Tablecloths, mats, and napkins
Baskets	holders, letter holders, desk	Music boxes	Tapestries
Bath accessories (soap dish, tooth-	pad, address book, small clock,	Musical items (instruments, music	Telephones
brush container, towel racks,	etc.)	stands, sheet music, etc.)	Tools (antique spinning wheel, for
towels, washcloths, scales,	Dishes	Needlework	example)
toilet-paper holder)	Doll houses	Pedestals (for displays)	Toy furniture
Birdcages	Dolls	Photo albums	Toys
Blankets	Figurines	Pillows	Trays
Bookends	Fireplace tools and firescreen	Pitchers	Trophies
Books and magazines	Flower and plant containers	Plants	Umbrella stands
Bottles	Flowers	Plates and platters (decorative)	Vases
Bowls	Foliage	Pottery	Wastebaskets
Boxes	Frames (for art, photos, etc.)	Puzzles	Weavings
Brassware	Games	Quilts	Wreaths
Calendars	Glassware	Rugs	
Candles	Hardware (doorknobs, hinges,	Screens	
Candlesticks	racks, pulls, tiebacks, hooks,	Sculpture	
Canisters	escutcheons, rods, etc.)		

FIGURE 13.37 This creative art piece establishes the whimsical feeling in the Galaxy Café. The restaurant, which can seat more than 500, draws 2,500 visitors a day from Boston's Museum of Science.
(Architect/Designer: Prellwitz/Chilinski Assoc. Photograph © 1996 Steve Rosenthal. Artist: David Tonneson.)

The accessories or works of art may be utilitarian or displayed for aesthetic pleasure. The items may be incorporated into the scheme to enhance the background, or they may function primarily as a point of interest (Figure 13.37). The principles and elements of design must always be used. For example, the item must be suitable in texture, color, and form to the style, background, and other accessories and furnishings in the room. The item should be in scale with the other furnishings and the space allocated. The accessory should help to bring balance and harmony to the room.

Accessories can either be authentic to a certain historic style or mixed to support a variety of styles. The latter approach is often considered more creative. Accessories can also support the architectural background. For example, an informal arrangement of flowers in a basket enhances a rustic wood wall, and an elegant porcelain vase enhances a formal French paneled wall.

Designers often play an important role in selecting accessories and art for commercial and institutional spaces. The previous guidelines should be followed, but the art and accessories should be placed so as not to interfere with the function of the facility. Usually, commercial spaces do not incorporate personal items except in private offices; however, accessories in public areas do reflect the corporation's image and character.

Adding art and accessories to a commercial setting can give an inviting, warm character to an otherwise institutional setting. Often the designer is limited in purchasing fine-quality items for the commercial setting because of budget restrictions and the possibility of theft. Obtaining accessories that project an aesthetic appeal and that will last through the years is an additional challenge. Such items as plants and artwork—usually large in scale—are often selected for schools, offices, hospitals, libraries, hotels, retail stores, restaurants, and other public settings. Also, accessories that relate to the function of the facility itself can add character to the space; for example, prints in a restaurant might pertain to the history or theme of the establishment. All accessories selected for the commercial setting should enhance the environment and humanize the space.

More info online @

www.guild.com Excellent source for fine one-of-a-kind art and accessories

GROUPING AND PLACING ACCESSORIES AND ART

The desire to display prized possessions is universal; the challenge for a designer is to arrange these treasured objects into an appealing composition. If the collected items are worth acquiring, they are worth displaying. Successful placement of accessories lies in training the eye to see beauty in color, texture, form, and spatial relationships. Applying the principles and elements of design is helpful when placing each item (Figure 13.38).

Grouping items in an artistic arrangement can be an effective means of creating an interesting display in the room. By themselves, small things may be insignificant, but through skillful arrangement even the simplest items can take on special meaning. When grouping small objects, keep in mind that they are seen against a background of walls and furniture, which should be considered part of the arrangement. Be aware of the relationships of the items to each other. Perhaps a grouping of round objects of varying sizes is pleasing, but adding a rectangle can provide an interesting contrast. In an arrangement with three elements—a horizontal piece, a higher intermediate piece, and a tall vertical piece—the eye moves from the low horizontal to the high vertical, providing a sense of transition. This rhythm is seen in nature when the eye observes the earth, flowering plants, and towering trees. A common color subtly running through each element can add unity to an arrangement; varying colors and textures can create a sense of interest and variety.

Another practice is to rotate the display of objects or art in an appointed location. The Japanese have an alcove for this practice called a Tokonoma. This practice does, however, require a safe humidity- and temperature-controlled storage area for the nondisplayed items.

FIGURE 13.38 The arrangement of the accessories and art forms a cohesive grouping that complements the interior background elements and relates to the furnishings. Artwork is not hidden behind lighting, the table arrangement is grouped by size and shape while including textural interest, and varying sizes of hanging artworks form a unified element.
(Courtesy of Pineapple House Interior Design. Photograph by Scott Moore Photography.)

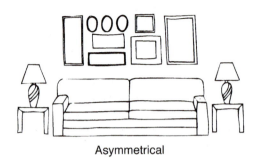

Asymmetrical

Symmetrical

Two-Dimensional Art in Wall Composition

Works of art can be hung individually or in groupings, but they should always relate to the sofa, desks, chairs, tables, or other furnishings constituting the wall composition. Usually a work of art relates best to the composition when it is not "floating" alone on the wall. A table, console, or other piece of furniture beneath the picture can stabilize the artwork. Following are considerations for selecting and arranging two-dimensional works of art for a wall composition.

- Positive spaces are the areas filled with the two-dimensional artwork; negative spaces are the areas between these pieces. Regardless of shape and size, each picture should have an open space surrounding it. In a grouping, these spaces should be consistent. The goal is for the grouping to "read" as one unit from a distance, not a disjointed array of works (Figure 13.39).

- A single picture on a wall may work best when hung at eye level.

- A picture hung above a chair or sofa should be placed high enough so that the head of the seated person does not touch the frame. (If it is hung much higher, the picture lacks continuity with the furniture arrangement.) Approximately 6 to 8 inches above a sofa or chair back provides sufficient clearance. Additionally, pictures are best seen and appreciated when not obstructed by lamps, flower arrangements, or other accessories.

- To assemble an arrangement, lay a large sheet of brown paper the size of the area to be covered on the floor. Arrange the works of art and other objects on the paper until the final composition is created. Trace each object around the perimeter, and mark a point where it will be hung on the wall. Then hold the paper up against the wall with marks made where nails or hooks will be placed. The art works can then be hung easily in the planned arrangement.

Arranging Accessories and Art in Storage Units

The arrangement of accessories and art on wall units, bookcases, secretaries, breakfronts, or even baker's racks requires a sensitive eye. The elements and principles of design are the key to a successful design solution. The following ideas are helpful:

- Taller, heavier pieces look best on lower shelves.

- Books may fill an entire shelf, or be combined with accent plates, ceramics, figurines, photographs, or small plants. Books also may be laid flat and stacked to serve as a bookend. Brass accessories or accent pieces may be placed on top of the books. It is common to group books in relationship to their height in ascending or descending order. Antique books with leather covers may be purchased if a client's collection requires additional character.

- Bookends can add a special character or accent to a row of books.

- Two-dimensional art may be placed on shelves at a slight angle.

- Accents from nature, such as geodes, shells, or driftwood, add warmth and texture.

- Photographs and unusual frames add interest.

- Clear, simple glass objects look best when grouped together and placed at or near eye level.

It is important to remember that the composition of accessories is not a static element in the room. Collections of books and accessories will grow. (Landscape architects continually deal with this dimension of growth.) Designers must allow empty space for new prized objects. Conversely, some objects will be moved to other rooms where the client finds them more useful or appropriate.

SUMMARY

The decorative elements of applied design add interest and humanization and reflect the character of interior environment. Window treatments also perform important functions including light attenuation and building insulation.

Accessories and art should include items of personal value to the client or company. Items for functional or decorative use in all areas of the interior add visual pleasure, whether displayed alone or in groups (Figure 13.40).

Part V focused on the various components applied to an interior to create a space that functions within the client's aesthetic preferences and economic boundaries. The integration of these varying components is key to the creation of a successful interior environment. On the following pages are two living rooms, both in a similar architectural setting. The discussion compares and contrasts the design solutions. Following the living room comparisons is a Design Scenario for Lifetime Television. Note how art and the human experience were carefully integrated into the interior space.

FIGURE 13.40 In this award-winning university president's office, art and accessories from the university's collection add warmth and variety to the traditional setting.
(Designer: Jones Interiors. Photograph by J. J. Williams.)

FIGURE 13.41A Both of these living rooms are the result of understanding the function, aesthetics, and economic requirements of the interior. Knowledge of the elements and principles of design was combined with an observance of visual literacy to define the interior spaces. *(© Copyright Mark Boisclair)*

LIVING ROOM COMPARISON

Carefully examine Figure 13.41A and B. An interior designer must learn to analyze interior spaces and look for possibilities and potential. Note the following similarities:

- Similar size, shape, and volume of space

- Large floor-to-ceiling accent windows with minimal window treatments
- Fireplace used to focus conversation area
- Combination of rug and hard-surface flooring
- Abundance of personal items used for accessories, including plants
- Use of white sofas with accent pillows

FIGURE 13.41B *(continued).*
(© Copyright Mark Boisclair)

From a design perspective, the following differences affect the feeling, mood, and concept of this space:

- Room A utilizes silhouette lighting. Room B's lighting is more uniform.
- Room A focuses on the elaborate mantel and mirror. Room B focuses on the window and expansive view.
- Room A introduces deep values in wall colors. Room B uses a more neutral wall value, but places warm wood tones on the walls.

Consequently, the mood of Room A is more intimate and dramatic; the mood of Room B is set for a gathering of friends. Room A feels more contemporary, even with the traditional fabrics and furnishings; Room B feels more formal. Designers must be sensitive to subtleties that evoke these perceptions. Attention to detail is an essential element, as is perceptive visual awareness.

designSCENARIO

Lifetime Television

This project illustrates a successful design process that took into consideration the human factors of the end users. Located in New York, Lifetime Entertainment Services had overgrown its downtown New York facilities and was relocating its Technical Operations Center and related support staff to an alternate location. The facility, open 24/7, develops programming focusing on women's issues. A description of the company appears on its website as follows:

> Lifetime Entertainment Services is a diverse, multimedia company committed to offering the highest quality entertainment and information programming, and advocating a wide range of issues affecting women and their families. Lifetime Television is the leader in women's television and one of the top-rated basic cable television networks.
>
> From a single cable channel, Lifetime Entertainment Services has now grown to three networks—Lifetime Television, LMN, and Lifetime Real Women—a thriving online business, Lifetimetv.com, and a proliferation of brand extensions, including Lifetime Home Entertainment, and numerous award-winning public advocacy campaigns.

PROGRAMMING OVERVIEW

In the new facility, the company desired a welcoming environment for its employees. A variety of creative and technical professionals work in the facility including engineers, postproduction specialists, editors, broadcast operators, on-air technicians, writers, and graphic artists. The company requested daylight for all offices, where possible. Daylighting would not be allowed in technical studios due to production limitations; therefore, an area was requested to allow for daylight just outside the studios. The client desired to be involved in the design development of the environment. Additionally, the cabling and technical requirements were extensive and had to mesh with lighting, security, electrical, plumbing, and HVAC.

DESIGN OVERVIEW

Conceptually, Meridian Design Associates, Architects based their layout on a neighborhood. Figure DS13.1 illustrates the conceptual location of the Entry, Gallery Walk, Town Square, Café, and Park. Figure DS13.2 illustrates how the three major divisions of the company—Branding, Soft (nontechnical or more office related), and Hard (technical)—overlay into the neighborhood. Figure DS13.3 illustrates how natural daylight was to reach the interior core of the building. The light yellow indicates daylight, light blue indicates low-height work partitions, and dark blue indicates full-height walls. Offices facing corridors include glass walls to help distribute the daylight. Only technical studios, storage, and mechanical rooms were daylight deficient.

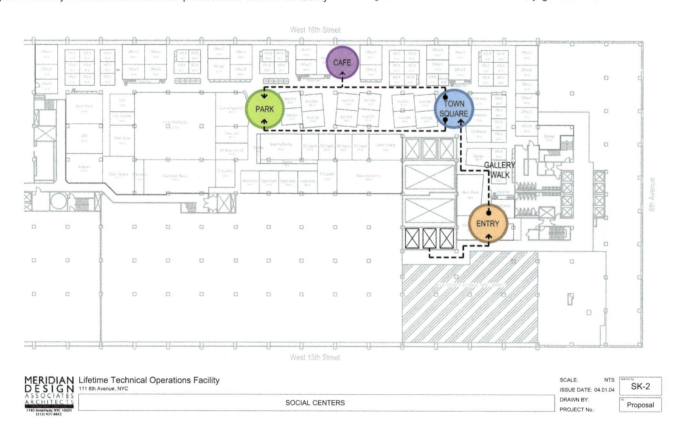

FIGURE DS13.1 Conceptual development of the Neighborhood.
(Architect: Meridian Design Associates)

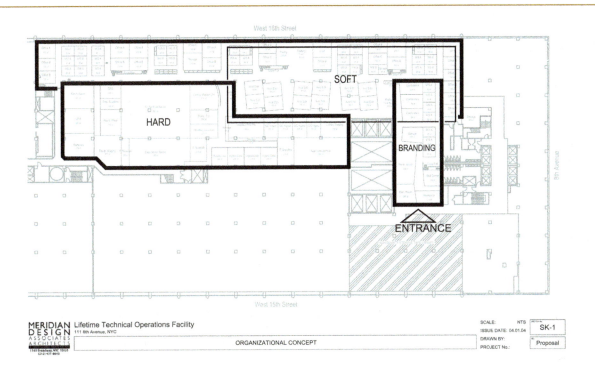

FIGURE DS13.2 Overlay of three divisions of the company: Branding, Soft, and Hard.
(Architect: Meridian Design Associates)

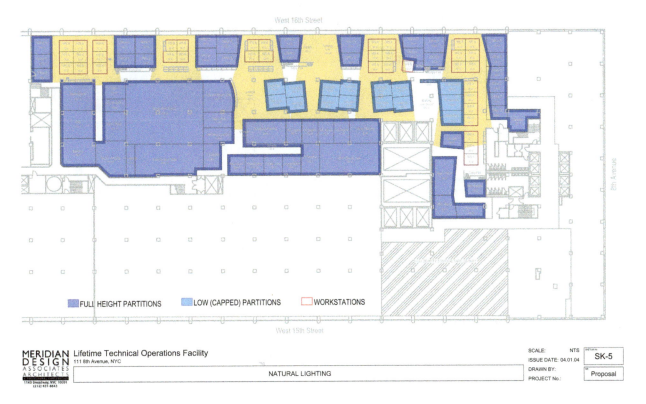

FIGURE DS13.3 Conceptual layout illustrating areas receiving daylight.
(Architect: Meridian Design Associates)

Figure DS13.4 indicates the conceptual floor plan. Colored areas define the various departments. Much care was taken in each of the areas to meet both the functional and psychological needs of the employees.

The Entry required careful consideration because mechanical requirements limited the ceiling height. Employees and clients were to be drawn down a hallway, past the mechanical, mail, and copy centers, to enter the public conference rooms. It was evident early in the design that focal point artwork would be necessary to draw users through the hall and to enliven the corridor. Lifetime commissioned artwork by The Alpha Workshops to touch the hearts of employees.

The Alpha Workshops is a nonprofit organization that trains AIDS patients in the fine arts. Lifetime met with The Alpha Workshops to explain the concept of the Gallery, Town Square, Café, and Park. Lifetime commissioned the artists to complete focal point work that reflects Lifetime's philosophy for each of these spaces. Throughout the design process, Lifetime included employees in the development and presentations. The firm wanted to ensure that employees understood how the design solution interpreted their requests and needs.

Figure DS13.5 illustrates a small portion of the reflected ceiling plan in the construction document phase (see Chapter 6). Note the use of the curved reception desk in the Entry and curved seating area in the Town Square. The slightly angled walls help to lead the visitor through the Gallery Walk and past the focal point artwork.

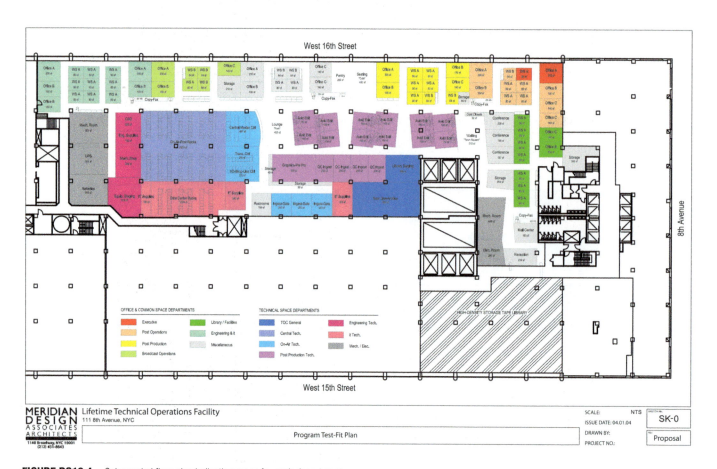

FIGURE DS13.4 Color-coded floor plan indicating areas for each department.
(Architect: Meridian Design Associates)

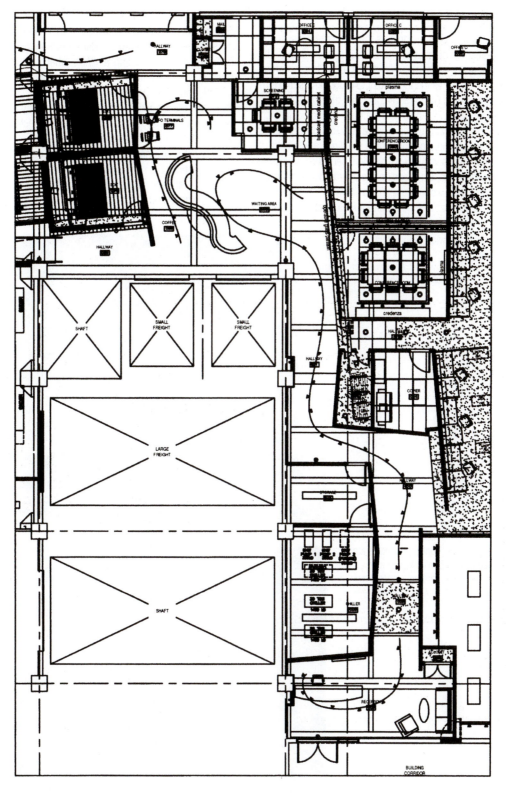

FIGURE DS13.5 Partial reflected ceiling plan at Entry, Gallery Walk, and Town Square.
(Architect: Meridian Design Associates)

THE OUTCOME

The three leaves, seen in Figure DS13.6, serve as the conceptual inspiration for the interior design. Design elements were to be pulled from nature. The leaves, over 5 feet tall, illustrate the company's desire to work in a natural environment. The leaves also serve as the focal point to draw visitors and employees into the space, through the Gallery Walk, and into the Town Square.

The Town Square (Figure DS13.7) serves as a central meeting point, waiting area, and prefunction area for conferences. A large curved sectional serves many functions. It is a central location for impromptu meetings and breaks, it conceals a coffee bar, and it also (and this was planned) serves as a place to stretch out and catch a night's sleep. On occasion, weather and shift changes require employees to extend their work hours. ("The show must go on!") A comfortable place to catch a few zzzz's is an important feature to employees.

The Café (Figure DS13.8) is another location that promotes collaboration and teamwork among employees. Positioned on a window wall, the Café is centrally located between the Hard and Soft divisions. The Alpha Workshops transformed the Café into a diner, where employees gather for meetings, celebrations, and lunch.

The Park, also called the Garden (Figure DS13.9), required special consideration for the technical staff. Because they are locked up in a studio for several hours a day, the Hard area staff requested an area for reflection. Water was the missing feature here; however, due to obvious technical requirements, water was not compatible with the equipment. The Alpha Workshops, knowing about the staff's desire for water and the complications it imposed, created a series of plates painted to reflect the element of water. Comfortable seating was added to the Garden, and it is flooded with daylight. The Garden

FIGURE DS13.6 Focal point art drawing visitors from the Entry through the Gallery Walk.
(Lifetime Networks Technical Operations Center. Architect: Meridian Design Associates. Art: The Alpha Workshops. Photograph © 2007 Andy Washnik— CORPRICOM.)

FIGURE DS13.7 The Town Square. Conference rooms are to the right; the coffee area is behind the curved lounge sofa.
(Lifetime Networks Technical Operations Center. Architect: Meridian Design Associates. Art: The Alpha Workshops. Photograph © 2007 Andy Washnik— CORPRICOM.)

idea includes a ramped area (part of the studio is on raised flooring) to allow for cabling and other equipment (see Chapter 9).

The new facility meets the needs of the firm, and the employees have responded favorably. The stone floor, custom wood reception desk, and earth tones support the conceptual inspiration of nature. Spaces were designed to meet the physical and psychological needs of the client, as evidenced by the participatory use of the Garden, Town Square, and Café. Sunlight floods the office spaces. Flexible conference rooms meet the need for gatherings of smaller groups, or they can be opened up for larger functions, spilling into the Town Square.

This carefully developed design, based on the human factor needs of Lifetime employees, has received two unusual marks of approval. First, *Reader's Digest* listed Lifetime as one of the "Best Places to Work" as a result of its facility design and consideration of employee needs. Second, the industry also has noted this quality environment by requesting tours. Lifetime administers tours several times per week to other companies desiring to update their technical facilities.

More info online @

http://alphaworkshops.org The Alpha Workshops
www.lifetimetv.com/index.php Lifetime Entertainment Services
www.meridiandesign.com/index.html Meridian Design Associates, Architects, P.C.

FIGURE DS13.8 Looking through a glassed corridor into the Café.
(Lifetime Networks Technical Operations Center. Architect: Meridian Design Associates. Art: The Alpha Workshops. Photograph © 2007 Andy Washnik—CORPRICOM.)

FIGURE DS13.9 The Garden Park includes an accessible ramp. Plates painted to resemble water are the focal point.
(Lifetime Networks Technical Operations Center. Architect: Meridian Design Associates. Art: The Alpha Workshops. Photograph © 2007 Andy Washnik—CORPRICOM.)

Part VI

The Profession of Interior Design

The future belongs to those who understand that doing more with less is compassionate, prosperous, and enduring, and thus more intelligent, even competitive.

—Paul Hawken

CHAPTER 14

Interior Design as a Career

FIGURE VI.1A The original grand hall was brought into human scale through the addition of a second-floor catwalk. The fabric-draped ceiling and colored gels are particularly poignant on this second level. Floor-to-ceiling mirrors on the opposite wall reflect the festive setting.

(Architect/Designer: Haverson Architecture and Design. Photograph © Peter Paige.)

As discussed in Chapter 1, the interior design profession is a complex blend of technical design skills and creative artistic skills. Additionally, designers possess strong business skills in order to be accurate and competitive in the design market. Interior designers address the needs of their clients while balancing budget, environmental, aesthetic, and regulatory issues. Although many opportunities are open to the aspiring interior designer, a career should be based on a sound educational foundation that continues throughout the designer's career. Part VI addresses the path toward a career in interior design, professional involvement in design organizations, and specific issues relating to business practices, such as professional ethics.

FIGURE VI.1B At Nyla's, guests are treated to a warm ambiance of colors and light pulled from a "blooming flowers" concept and a Georgia O'Keeffe painting. The bar is backlit with painted fluorescent lamps and yellow gels. Multicolored gels produce an ethereal ambiance through the layers of chiffon. *(Architect/Designer: Haverson Architecture and Design. Photograph © Peter Paige.)*

Chapter 14 features outstanding interiors to inspire the beginning designer. These photographs were selected to represent a variety of specialty fields in residential and commercial design. Careful analysis of these interiors reveals professionals' accomplished use of visual literacy and the principles and elements of design. Figures VI.1 and VI.2 begin this process by reviewing two commercial design solutions.

Figures VI.1 and VI.2 represent two exceptional restaurant renovations, both located within a hotel. Figures VI.1A and VI.2A focus on creative solutions to bar design. Bars require an immense amount of preliminary planning to ensure the efficient use of space for the many pieces of equipment required in the "back bar." Figures VI.1B and VI.2B illustrate a broader view of the respective restaurants. Both designs accentuate the existing interior architecture; however, they also accentuate the distinct differences between decorative and structural design.

Figure VI.1A emphasizes a decorative feminine design creating a vivacious and warm interior. Existing masculine characteristics of plaster walls, walnut patterned wood flooring, and 8-foot wainscoting were softened by the use of chiffon ceiling fabrics and colored gel uplights. A brass stairway, catwalk, and banquettes were added to create a more intimate space and to allow the restaurant to flow into the mezzanine level.

Figure VI.2B emphasizes a more structural design allowing the expression of the architecture. Rigid diagonal and vertical columns are enhanced by the organic movement created by curved ceilings, undulating walls, and geometric patterns. The honesty of the interior architecture has been exposed.

A

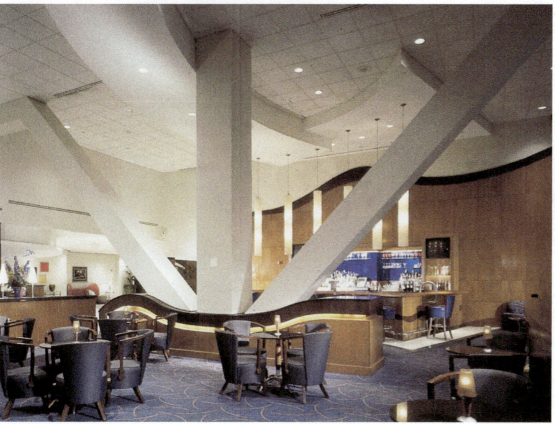

B

FIGURE VI.2 Creating a welcoming interior in a building with unyielding architecture and a seven-story atrium requires vision. The strength of the architecture at Novatel was allowed to express itself throughout the restaurant. To add movement to the space and help direct the flow of traffic, curved forms were added to floor patterns, walls, and ceiling details. The custom bar accentuates the welcoming effect, while the deep, rich blue embraces the patrons. The organic forms and accent lighting enhance the inflexible architectural vocabulary of the building by creating a playful environment.
(Designer: Elias Design Group. Photographs © Peter Paige.)

14 Interior Design as a Career

■ CAREER PROGRESSION

Deciding on a career is a search process that requires careful examination and evaluation of one's interests and capabilities, as well as one's shortcomings. Creativity, sensitivity to the environment, and an interest in cultural heritage as well as contemporary design are all necessary traits for anyone who is seriously considering a career in interior design. Additionally, a designer is always concerned with improving the quality of the human environment.

The images selected throughout this chapter illustrate a variety of career options in the field of interior design. Although most are not directly related to their callout locations in the text (as was the case in the previous thirteen chapters), these images provide a broad view of job opportunities and outstanding design solutions (Figures 14.1 and 14.2, Aircraft Interior Design). No matter what the field of design, interior designers are qualified by education, experience, and examination (as discussed in Part I, Introduction to Interior Environments). These three steps ensure the quality of the design professional and should be pursued *before* starting a business.

Education

One of the initial steps toward becoming a professional interior designer is to successfully complete an interior design program at a college, university, or design school. Programs are offered leading to an associate degree (usually two to three years) or a bachelor degree (four to five years). Advanced education is also possible. Master of science (MS) or master of arts (MA) degrees typically require a minimum of one year of additional study. A master of fine arts (MFA) degree typically requires a minimum of two years of additional study and a display of the resulting work.

FIGURE 14.1 Aircraft Interior Design.
Designing a custom interior for a private jet involves the implementation of national and international regulations. For instance, all furnishings are required to be bolted to the floors or walls and, according to federal regulations, must be periodically removed from the plane to allow inspection of the aircraft's structure. Keeping these and many other requirements in mind, the designers decided to complete a full-scale mockup, 70-plus feet long. From a design perspective, the client requested a custom coach, "not a decorous house." After researching the architecture of transportation, the designers selected a modern Art Deco design theme. The lavatory is illustrated at left. See also Figure 14.2A and B.
(Designer: Leavitt-Weaver. Photography by John Vaughan.)

FIGURE 14.2 Aircraft Interior Design.
(A) The Boeing 727 jet, the framework for the project. (B) The dining/lounge area includes multipurpose furnishings—the tables can be converted into ottomans; a folding leaf creates more work surface. Blinds create one uniform line across the smaller porthole-like windows to give the illusion of a larger window surface.
(Designer: Leavitt-Weaver. Photography by John Vaughan.)

A

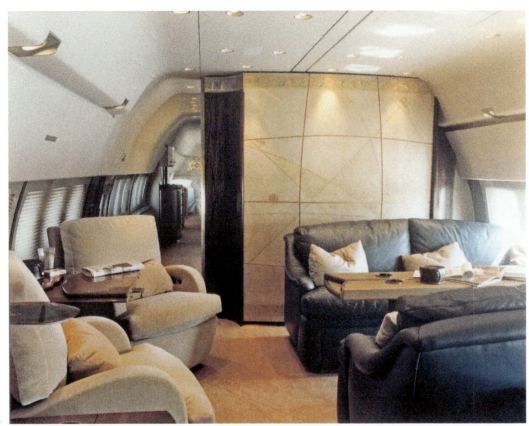

B

Most master degrees in interior design are considered terminal degrees; some programs also offer a master of interior design (MID). Depending on the university, this may be a terminal degree or a professional degree as certified by the Council for Interior Design Accreditation (CIDA). Once an MFA in interior design is attained, advanced study towards a doctoral degree is not necessary; however, some universities offer a PhD in interior design for those wishing to pursue advanced research.

Curriculum

Programs certified by CIDA offer broad-based curricula that prepare students for entry-level careers in the field of interior design. CIDA, founded in 1970 and previously called the Foundation for Interior Design Education Research, is a self-governing organization whose accreditation commission and teams of site visitors are composed of educators and practitioners who review educational programs in interior design. The standards developed by CIDA, with input from the practitioners

and educators, form a common body of knowledge required by all interior designers, regardless of their specific career direction.

There are several requirements for an institution to be eligible for CIDA accreditation. From a curriculum standpoint, the program must culminate in a minimum of a bachelor's degree and have a significant, diverse liberal arts and sciences component. CIDA Professional Standards are "organized in four sections that broadly reflect the evolving components of graduate preparation for interior design practice. Each standard is defined by a set of more specific student learning expectations and/or program expectations."

An overview of the Professional Standards follows.

I. Mission, Goals, and Curriculum

Standard 1. Mission, Goals, and Curriculum: The interior design program has a mission statement that describes the scope and purpose of the program. Program goals are derived from the mission statement and the curriculum.

II. Critical Thinking, Professional Values, and Processes. These standards describe the framework of interior design practice:

Standard 2. Global Context for Design: Entry-level interior designers have a global view and weigh design decisions within the parameters of ecological, socioeconomic, and cultural contexts.

Standard 3. Human Behavior: The work of interior designers is informed by knowledge of behavioral science and human factors.

Standard 4. Design Process: Entry-level interior designers need to apply all aspects of the design process to creative problem solving. Design process enables designers to identify and explore complex problems and generate creative solutions that support human behavior within the interior environment.

Standard 5. Collaboration: Entry-level interior designers engage in multi-disciplinary collaborations and consensus building.

Standard 6. Communication: Entry-level interior designers are effective communicators.

Standard 7. Professionalism and Business Practice: Entry-level interior designers use ethical and accepted standards of practice, are committed to professional development and the industry, and understand the value of their contribution to the built environment.

III. Core Design and Technical Knowledge. These standards describe historical, theoretical, and technical contents of interior design practice.

Standard 8. History: Entry-level interior designers apply knowledge of interiors, architecture, art, and the decorative arts within a historical and cultural context.

Standard 9. Space and Form: Entry-level interior designers apply the theories of two- and three-dimensional design and spatial definition and organization.

Standard 10. Color and Light: Entry-level interior designers apply the principles and theories of color and light.

Standard 11. Furniture, Fixtures, Equipment, and Finish Materials: Entry-level interior designers select and specify furniture, fixtures, equipment, and finish materials in interior spaces.

Standard 12. Environmental Systems and Controls: Entry-level interior designers use the principles of lighting, acoustics, thermal comfort, and indoor air quality to enhance the health, safety, welfare, and performance of building occupants.

Standard 13. Interior Construction: Entry-level interior designers have knowledge of interior construction and building systems.

Standard 14. Regulations: Entry-level interior designers use laws, codes, standards, and guidelines that impact the design of interior spaces.

IV. Program Administration. These standards describe the institutional and program administrative structures and resources that are fundamental to an effective higher education learning environment for interior design.

Standard 15. Assessment and Accountability: The interior design program must engage in systematic program assessment contributing to ongoing program improvement. Additionally, the program must provide clear, consistent, and reliable information about its mission and requirements to the public.

Standard 16. Support and Resources: The interior design program must have a sufficient number of qualified faculty members, as well as adequate administrative support and resources, to achieve program goals.

Council for Interior Design Accreditation Professional Standards Approved June 2008, Effective July 1, 2009

All standards have indicators that further describe the required outcomes. Students are also required to be involved in team approaches to design solutions and designs for multicultural and diverse populations, as well as adaptive use, historic preservation, and sustainable design.

CIDA standards are periodically updated. CIDA's Future Vision teams, composed of practicing interior designers, educators, and business affiliates, meet to provide direction for the new standards. Their most recent findings include the priorities for interior design graduates listed in Table 14.1. Of the approximately 215 bachelor-level interior design or interior architecture programs throughout the United States, approximately 70 percent are accredited by CIDA.

Some institutions may meet or exceed CIDA's list of standards and guidelines, but for financial or pedagogical reasons elect not to apply. On the other hand, some states require students to attend a CIDA-accredited school (or its equivalent) in order to become registered as interior designers.

More info online @

www.accredit-id.org Council for Interior Design Accreditation
www.careersininteriordesign.com Industry-sponsored career site

Internships

Most interior design programs require students to participate in an internship or work-study program as a prerequisite for graduation. Internship programs vary, but all have the same objective: to enable the student to experience the professional business world firsthand before graduation by combining classroom education with practice. Internship experience is invaluable to the student. By becoming actively involved in the professional world of interior design, students:

- Experience operational procedures, policies, and various phases of design, such as client–designer relationships
- Learn about interactions of designers within a firm
- Observe and participate in design from concept to implementation
- Learn to be open to new and different attitudes and perspectives in all aspects of design (Figure 14.3, Hospitality Design—Hotel)
- Learn more about themselves in terms of their goals as professional interior designers
- Acquire valuable experience that can be entered on a job résumé for use after graduation

Experience

There is no better teacher than experience. All designers, whether just out of college or pursuing a career change, need to work with a

TABLE 14.1 Priorities for interior design education authored by CIDA's Future Vision Teams

The interior design graduate will need to be able to

1. Think critically.	Increased world complexities will require greater attention to the examination of problems and their solutions. Knowledge of liberal arts fields will provide a basis for this reasoning. Critical thinking is the synthesis of this knowledge.
2. (tie) Apply the design process and engage in a creative approach to problems.	Interior design ties together humans and the built environment with creative solutions. A more rigorous methodology supported by research and holistic thinking is required, including analytical thinking and problem-solving skills.
2. (tie) Address sustainability.	The Future Vision priorities include the bottom line of sustainability, encompassing knowledge of economic, social, and environmental impacts.
3. Design from a functional knowledge of human behavior.	Designers will need to be able to respond to diverse populations. This is prompted by shifts in values, cultural diversity, aging populations, technology, physical security, and the increased emphasis on spirituality.
4. Have a broad worldview and a global perspective.	Greater global and intercultural awareness will be required; education is enhanced by opportunities to travel, visit galleries, and read widely. Visual communication skills will assume greater importance in a multilingual world connected by technology.
5. Be a thought leader.	Graduates will be required to be effective communicators demonstrating competence and a sense of purpose.
6. (tie) Apply research methods and integrate findings into the design process.	This is tied closely with priority 2 and the demand for evidence-based design with measurable outcomes.
6. (tie) Innovate and generate intellectual capital.	Interior design's value "is in the idea and owning the knowledge." Graduates will need a thorough understanding of the methodology of innovation.
7. Reflectively integrate knowledge and experience.	Real-world practice develops design thinking. Students pursuing terminal degrees need to be "reflective" through the integration of knowledge and experience in practice.
8. Collaborate.	Graduates will be required to work in teams and collaborate both inside and outside the design disciplines.
9. Understand and embrace a professional identity.	"A professional interior designer employs design thinking as a way of knowing, understands the ethical premise embodied in practice, and is an engaged, curious person with self-confidence and the ability to work well with others."

Source: Summarized from *CIDA's Future Vision Establishes Priorities for Interior Design Education,* found at www.accredit-id.org/updatesfvpriorities.html. Published January 2007.

licensed professional for a minimum of two years before establishing their own firm. Experience offers many advantages that simply cannot be achieved in an educational environment. Perhaps the most rewarding is the actual installation of one's design ideas.

In 1999, a structured work experience program called the Interior Design Experience Program (IDEP) started a pilot program. This program, developed and researched by Buie Harwood and outlined in the *Journal of Interior Design,* links a graduate's internship experience to CIDA and the National Council for Interior Design Qualification (NCIDQ) standards (discussed later). NCIDQ coordinates this program. The program provides a structured interior design experience in preparation for the NCIDQ exam.

More info online @

www.ncidq.org/IDEP.aspx Information on IDEP

Examination

NCIDQ was formed in 1972 to establish a professional level of competence for interior designers. Level of competence is determined through an examination that is accepted as the standard throughout North America. NCIDQ is also investigating the advantages and disadvantages of pursuing legal registration or certification of the profession.

To be eligible to sit for the exam, potential professional designers must meet a stringent combination of education and work experience. Only college credit may be applied toward the educational requirements; continuing education, audit, and noncredit courses are not accepted. All work experience (with a CIDA-accredited degree, a minimum of 3,520 hours or approximately two years) must be completed under the direction of an NCIDQ certificate holder, a licensed/registered interior designer, or an architect offering interior design services and must be documented in a log. Additionally, participants must submit three letters of recommendation, employment verification, and college transcripts. The NCIDQ website, listed below, details the various routes to eligibility without a CIDA-accredited degree.

The three-part exam can be taken individually or all within the same testing period. The first section, called the Interior Design Fundamentals Exam, or IDFX, consists of 100 multiple-choice questions assessing knowledge of building systems, construction standards, and design application. Candidates are given three hours to complete IDFX. Once all education requirements are met, candidates may sit for this portion of the exam.

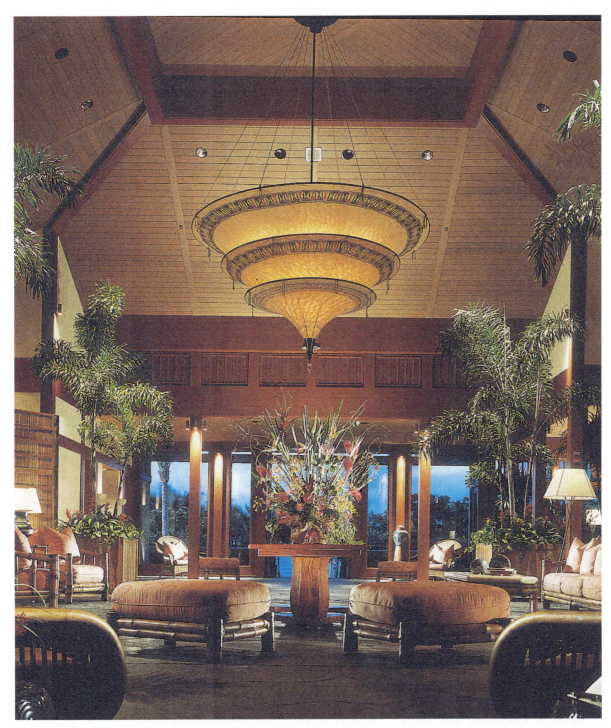

FIGURE 14.3 Hospitality Design—Hotel.
In this Hawaiian resort hotel, a custom silk and steel chandelier serves as the focal point. Furniture arrangements, floral designs, and architectural lighting add support to this locally inspired design. *(Designer: James Northcutt/Wilson and Associates. Photograph by Robert Miller.)*

The second and third sections of the exam can be taken only upon completion of all education and work experience requirements. The second section is called the Interior Design Professional Exam, or IDPX. It consists of 150 multiple-choice questions. This section is designed to assess knowledge of building systems, codes, professional practice, and project coordination. Candidates are given four hours to complete IDPX.

The third session, lasting an entire day, is called the Interior Design Practicum or PRAC. It consists of seven unique exercises requiring candidates to produce several design solutions. Exercises cover space planning, lighting design, egress, life safety, restroom design, systems integration, and millwork design. All candidates on a given test date receive the same exercises. The exercises require candidates to interpret a program into schematics, produce plan drawings, and develop appropriate specifications and schedules. Work products must address codes and the principles of universal design.

The test is administered twice per year, and participants may elect to take from one to three sections at any given time. All three sections must be successfully completed within a 5-year period. Sections 1 and 2 are scanned and scored by computer. Scores are reported on a scale ranging from 200 to 800, with the passing point anchored at 500.

1 Entry 4 Living
2 Kitchen 5 Office
3 Dining 6 Bedroom

FIGURE 14.4 Residential Design—Urban Apartment. This residence required many structural changes, including an expanded kitchen and visual division between the living and dining areas. Color and light are strong elements in this apartment, alternating the forms and adding an explosion of character. The floor plan illustrates the appropriate balance and clever use of relatively small space.
(Designer: Hassan Abouseda. Photograph by John M. Hall.)

Section 3 is scored by professional designers extensively trained by NCIDQ to grade the practicum portion. Professionals assemble in one location to grade all tests together using specific criteria.

Passage of the NCIDQ exam provides designers the opportunity for professional membership in other design organizations. (NCIDQ does not offer membership to individuals.) In fact, most of the professional design organizations *require* passage of the exam for professional membership. Additionally, passage of the NCIDQ exam is mandatory in those states and provinces that have licensing or registration statutes.

More info online @

www.ncidq.org National Council for Interior Design Qualification

Licensing and Registration

As of the writing of this text, 29 states or jurisdictions have passed some form of interior design legislation, usually in the form of a title act or practice act. A *title act* protects those who are competent to use particular titles such as "certified" or "registered" interior designer. Because of the title act, clients can be assured that persons using these titles are qualified professional interior designers (Figure 14.5A–E, Historic Preservation/Adaptive Use).

A *practice act* requires those who qualify as professional interior designers and plan to practice this occupation to be licensed by a state board. The practice act is designed to legally recognize interior design as a profession; to ensure that designers work to protect the health,

safety, and welfare of their clients; and to ensure that interior designers are qualified by education and experience to practice. In addition to passage of the NCIDQ exam, most of the acts require a combination of education and experience in order to qualify. More information can be found at the links below.

More info online @

www.asid.org/legislation/state_info ASID's site that specifically addresses legislation in each state
www.careersininteriordesign.com/licensing.html Careers in Interior Design Legislative. Includes information and links to other professional organizations' legislative sites

Continuing Education

To maintain their registration, professionals are required in most states and provinces to acquire continuing education units, or CEUs. CEUs are awarded for coursework completed at the professional development level and must be recorded by the state or province. NCIDQ serves as the repository for official transcripts of individuals completing approved CEU courses. Individuals register with NCIDQ and update their own transcripts; however, CEUs must be approved by the Interior Design Continuing Educational Council to be applicable. Designers also voluntarily attend sessions on new products, designs, and procedures in order to remain current in the field.

Research into the interior design profession and the effect of interior design on human behavior is an important topic in continuing

FIGURE 14.5A Historic Preservation/Adaptive Use.
This Queen Anne Classic residence, listed on the National Register of Historic places, was built in 1914. The interior was being converted into a university office and alumni gathering facility. The desire was to create a functional interior that reflected the cultural heritage of the residence. Polychromatic paints were selected to accent the custom moldings. The color scheme was inspired by the wisteria vines on the property. This photograph shows the exterior in the 1920s.
(Designer: Jones Interiors. Color photographs by Michael Wood.)

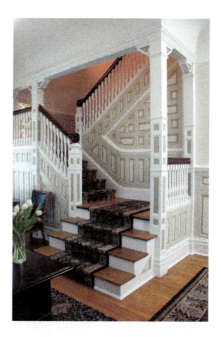

FIGURE 14.5C Central staircase with a strong pink stained glass window at the landing. A five-color paint scheme was applied in order to accentuate the wood dado and soften the pink stained glass. The custom wool/nylon carpet should service the institution for a decade or more.

1 Reception
2 Parlor/Waiting
3 Conference Room
4 Director's Office
5 Office
6 Web Control
7 Bath
8 Accessible Ramp

FIGURE 14.5B First-floor furniture location plan. Working with existing furnishings can be a challenge, but necessary, particularly for nonprofit organizations. Cross hatching indicates furniture that was reused.

FIGURE 14.5D The reception area included the reuse of existing light fixtures, meticulously converted from gas to electric. Layers of paint were removed from the wood mantel.

FIGURE 14.5E Parlor looking into dining/conference room. Sliding doors were reworked and are now serviceable. Wool mohair was applied to Belter-style chairs. The designer worked with the campus' curator to select art from the campus collection.

education. Through the sponsorship of ASID and the efforts of the design community at the University of Minnesota, InformeDesign was created as a "research and communication tool for designers." InformeDesign is a database of design research summaries that is updated weekly.

More info online @
www.informedesign.umn.edu InformeDesign website

PROFESSIONAL INTERIOR DESIGN ORGANIZATIONS

There are many professional interior design organizations that assist professionals in sharing information, continuing their education, promoting the profession, and serving the public. Most of these organizations require a combination of education and experience in order to join, with professional membership also requiring passage of the NCIDQ exam. Names and addresses of many of these organizations are found in Table 14.2.

ASID

The American Society of Interior Designers (**ASID**) is an international professional organization established to enact and maintain standards of excellence to enhance the growing recognition of interior design as a profession. ASID was formed in 1975 through the consolidation of the American Institute of Interior Designers and the National Society of Interior Designers, but its roots date back to the founding of the American Institute of Decorators in 1931. ASID is the largest organization of interior designers in the world, representing over 36,000 members in the United States and abroad. It represents interior design as a profession dedicated to serving people, and it provides a forum for its members to bring their differing points of view into harmony to promote unified action. ASID's mission statement is as follows: "ASID inspires and enriches its members by promoting the value of interior design, while providing indispensable knowledge and experiences that build relationships." According to ASID's website, their value statements/strategic guideposts are as follows:

- ASID represents the best practices of interior design and its impact on our psychological, physical, and economic quality of life.
- ASID provides the resources needed to excel in today's marketplace.
- ASID is a thought leader on issues impacting the practice of interior design.
- ASID supports and is committed to sustainable design and business practices (Figure 14.6, Commercial Office Design—International Clients).

IIDA

The International Interior Design Association (**IIDA**) is an internationally established design organization founded in 1994 as a merger of the Institute of Business Designers, the Council of Federal Interior

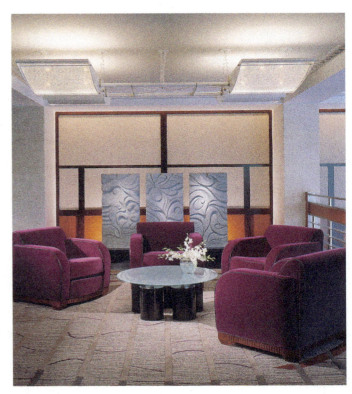

FIGURE 14.6 Commercial Office Design—International Clients.
At the Embassy of the Republic of Singapore in Washington, D.C., the designers were sensitive to the multicultural heritage of Singapore. The reception area is enhanced with naturalistic art, and the adaptive grid pattern is accented by fine organic curved forms in the furniture and custom area rug. The floor plan, in the shape of a cross, reflects the typical residential floor plan in the "Garden City."
(Architect/Designer: RTKL Associates. Photograph by Scott McDonald/Hedrich Blessing.)

Designers, and the International Society of Interior Designers. With over 13,000 members, the organization serves a broad base of professionals, industry members, and students. IIDA "strives to create a strong niche for the most talented and visionary Interior Design professionals, to elevate the profession to the level it warrants, and to lead the way for the next generation of Interior Design innovators" (Figure 14.7, Environmental Design—Strawbale House).

IDC

Interior Designers of Canada (**IDC**) is the Canadian national professional association. It works with the provincial associations to advance the interior design profession and to promote quality in education and practice. IDC has served the Canadian interior design industry since 1973. With over 3,500 members, IDC advances the profession through high standards of education, professional development, professional responsibility, and communication. Full professional membership requires passage of the NCIDQ exam.

IDEC

The Interior Design Educators Council (**IDEC**), incorporated in 1967, is dedicated to the development of interior design education.

TABLE 14.2 Professional Organizations

The American Institute of Architects, **AIA** 1735 New York Avenue NW Washington, DC 20006-5292 1-800 AIA-3837 www.aia.org	Illuminating Engineering Society of North America, **IES** 120 Wall Street, 17th Floor New York, NY 10005 (212) 248-5000 www.iesna.org	International Federation of Interior Architects/ Designers **IFI** 317 Outram Road, #02-57, Concorde Shopping Centre Singapore 169075 65-6338 6974 www.ifiworld.org
American Society of Interior Designers, **ASID** 608 Massachusetts Avenue NE Washington, DC 20002-6006 (202) 546-3480 www.asid.org	Institute of Store Planners, **ISP** 25 North Broadway Tarrytown, NY 10590 1-800 379-9912 www.ispo.org	International Furnishings and Design Association, **IFDA** 150 S. Warner Road, Suite 156 King of Prussia, PA 19406 (610) 535-6422 www.ifda.com
Business & Institutional Furniture Manufacturer's Assoc., **BIFMA** 678 Front Avenue NW, Suite 150 Grand Rapids, MI 49504-5368 (616) 285-3963 www.bifma.com	Interior Design Educators Council, **IDEC** 9100 Purdue Road, Suite 200 Indianapolis, IN 46268 (317) 328-4437 www.idec.org	International Interior Design Association, **IIDA** 222 Merchandise Mart, Suite 567 Chicago, IL 60654 1-888 799-4432 www.iida.com
Color Association of the United States 33 Whitehall Street, Suite M3 New York, NY 10004 (212) 947-7774 www.colorassociation.com	The Interior Design Society, **IDS** 164 S. Main St. 8th Floor High Point, NC 27260 1-888-884-4469 www.interiordesignsociety.org	National Association of Home Builders, **NAHB** 1201 15th Street NW Washington, DC 20005 (202) 266-8200, ext.0 1-800 368-5242 www.nahb.org
Color Marketing Group, **CMG** 1908 Mount Vernon Avenue Alexandria, VA 22301 (703) 329-8500 www.colormarketing.org	Interior Designers of Canada, **IDC** C536-43 Hanna Avenue, Toronto, Ontario, Canada M6K 1X1 (416) 649-4425 1-8777-443-4425 www.interiordesigncanada.org	National Council for Interior Design Qualification, **NCIDQ** 1602 L Street, NW, Suite 200 Washington, DC 20036-5681 (202) 721-0220 www.ncidq.org
Council for Interior Design Accreditation, **CIDA** 200 Grandville Avenue, Suite 350 Grand Rapids, MI 49503 (616) 458-0400 www.accredit-id.org	International Association of Lighting Designers, **IALD** Merchandise Mart, Suite 9-104 Chicago, IL 60654 (312) 527-3677 www.iald.org	National Kitchen and Bath Association, **NKBA** 687 Willow Grove Street Hackettstown, NJ 07840 1-800-THE-NKBA www.nkba.org
Environmental Design Research Association, Inc., **EDRA** 1760 Old Meadow Road, Suite 500 McLean, VA 22101 (703) 506-2895 www.edra.org	International Colour Authority, **ICA** PO Box 6356 London W1A2WA, England (020) 7637 2211 www.internationalcolourauthority.org	National Lighting Bureau, **NLB** 8811 Colesville Rd, Suite G106 Silver Spring, MD 20910 (301) 587-9572 www.nlb.org
Hospitality Industry Network NEWH, Inc., **NEWH** P.O. Box 322 Shawano, WI 54166 1-800-593-NEWH www.newh.org	International Facility Management Association, **IFMA** One East Greenway Plaza, Suite 1100 Houston, TX 77046-0194 (713) 623-4362 www.ifma.org	

Its mission "is the advancement of interior design education, scholarship, and service." In its core values, IDEC believes

- "in the value of an accredited, formalized interior design education.
- the preparation of an interior designer includes learning through formalized education, scholarship, and service.
- the foundation of interior design education is grounded in ethics and encompasses environmental, cultural, social, global issues.

- in an open dialogue and collaboration among colleagues.
- a successful interior design education depends upon the participation of diverse groups of people."

IFI

The International Federation of Interior Architects/Designers (IFI) is a nonprofit organization formed in 1963 that serves as the singular

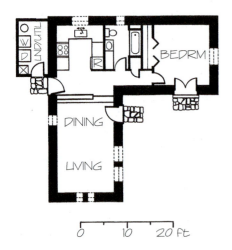

FIGURE 14.7 Environmental Design—Straw Bale House.
Designed as a guest house, this 850-sq.-ft. straw bale home boasts 24"-thick walls with R values from R-40 to R-55. Custom niches, handmade tiles, and softly tinted plaster walls add to the cozy character.
(Architect: Paul Weiner. Designer: Pam Tillman. Photographs by Bill Steen.)

international voice that "acts as a global forum for the exchange and development of knowledge and experience, in worldwide education, research, and *practice.*" The organization "exists to expand, internationally and across all levels of society, the contribution of the Interior Architecture/Design profession through the exchange and development of knowledge and experience, in education, practice, and fellowship."

Its five core values include:

1. "Lead the Interior Design discipline into the future

2. Further public awareness of the influence and impact of Interior Design

3. Connect the global Interior Architecture/Design profession and community to identify and provide design solutions to global problems

4. Establish and implement world standards and guidelines for the profession, education, and research by establishing and adopting best practices

5. Educate the profession through actionable programs, events, and publications."

■ THE BUSINESS OF INTERIOR DESIGN

Successful interior designers are not only creative artists but also perceptive businesspeople. Designers must be aware of business practices, procedures, management, and marketing techniques in order to succeed in the profession (Figure 14.8A and B, Multipurpose Design—Showroom and Display). *Before starting a business, a designer should consult with an attorney, an accountant, an insurance agent, and a tax advisor.* The following section highlights the business issues involved in the practice of interior design.

The Business Plan

Most lending institutions require the submission of a business plan in order to qualify for a business loan. The plan describes the business, its market, competition, location, management, personnel, and projected revenue and expenses. The Small Business Administration can assist designers in developing this plan.

Business Structures

There are four basic ways to structure an interior design business. The *sole proprietorship* is the simplest. The individual and the company are basically one. The owner personally receives all the benefits of the business, but also bears all the risks. Personal belongings, such as an owner's home, car, and other valuables, may be garnished by a business loss. The *partnership* is similar to the sole proprietorship, except the benefits and risks are shared by two or more individuals.

In an *association* an individual "associates" with an existing or established firm. The associate may bring clients to the firm, and the firm may offer the associate a working environment and limited liability. Other forms of associations also exist.

The safest of all business types is the *corporation*. A corporation is a separate entity from its owners, who are the shareholders. Although more difficult to start, corporations offer limited liability to their owners.

Insurance

Before starting a business, the designer must research and decide upon necessary types of insurance. The two broad types of insurance are *property and liability insurance*, which protects the business, and *life and health insurance*, which protect the individuals. Another important type of business insurance, called *errors and omissions*, protects designers when errors are made in contract documents. Consulting with a trustworthy insurance agent and attorney is important.

Business Documents

Designers will find it necessary to acquire several business documents. Most municipalities require a *business license*, available from local city or county officials. A *resale certificate* or *tax number*, required in some states, allows designers to purchase products for clients and collect the sales tax from the clients for submission to the state; other states require alternative tax documentation.

Designers also will establish a separate business *checking account* to accurately track revenue and expenses. Other business documents may

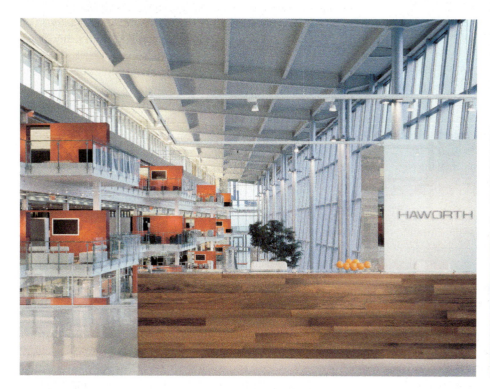

FIGURE 14.8 Multipurpose Design—Showroom and Display.
(left) Bright red-orange dividers highlight this vast open space designed for large gatherings and to showcase Haworth's product line. The display area (right) tells the story of the company's history.
(Left: Craig Dugan © Hedrich Blessing; Right: Steve Hall © Hedrich Blessing)

include items such as purchase orders, invoices, timesheets, and telephone logs. An accountant can be very helpful in identifying and tracking income and expenses.

Setting up a Design Studio

There are generally three types of office arrangements when setting up a design studio: the home office, an office associated with retail sales, and the business office. The decision should be based on the goals and financial viability of the firm. For any office arrangement, budgets need to be considered for furnishings and equipment. One significant consideration is the cost of computers for business and computer-aided design work.

Technology in the Studio

Computers and related technologies have become essential pieces of equipment in all design firms. Aside from their obvious assistance with word processing and general office tasks, advanced computer systems can help in performing the following functions:

- **Estimating costs:** With cost information stored in the computer's memory, the task of projecting plan proposals into cost estimates is simplified.
- **Preparing specifications:** The computer can store suppliers' catalog data, including prices and other valuable information, facilitating efficient preparation for project specifications. Manufacturers can supply electronic images of their products that can be introduced in plans and perspective drawings.
- **Ordering:** Orders for required furnishings can be placed directly through the computer to the manufacturer.
- **Drafting:** Computer-aided design (CAD) programs allow drafting on the computer. Although some firms develop initial programming and conceptual designs by hand, construction documents are commonly completed on the computer.
- **Drawing perspectives:** CAD systems are also extremely beneficial in creating three-dimensional design drawings. Some programs can render perspectives. Advanced computer systems perform immediate color changes, as well as changes in lighting design and location. Other advanced systems permit a client to visually walk through an interior by viewing the moving images on the computer screen.
- **Researching and communicating:** Because of the power of the Internet, manufacturers' data, new product information, current research data, and the ability to transfer mail and design files are all immediately available to the designer.

CAD software called building information modeling (BIM) is an excellent way to meet many of the above electronic needs. BIM tracks building data, creates 3D building sections and models, and interfaces with other building systems. BIM allows designers to detect design issues in the design phases before construction. BIM also allows for time-lapse design, or 4D design, thereby allowing projects to be electronically viewed over a phase-in process. The U.S. General Services Association discusses the importance of BIM.

> Critical to successful integration of computer models into project coordination, simulation, and optimization is the inclusion of information—the

"I" in BIM—to generate feedback. As a shared knowledge resource, BIM can serve as a reliable basis for decision making and reduce the need for re-gathering or re-formatting information. GSA is currently exploring the use of BIM technology throughout a project's lifecycle in the following areas: spatial program validation, 4D phasing, laser scanning, energy and sustainability, circulation and security validation, and building elements. www.gsa.gov/portal/content/105075

Design teams may consist of multiple firms located in different parts of the country or world. Designers and allied professionals frequently communicate via the computer. For instance, CAD files can be transferred via the Internet. Teleconferencing and digital cameras allow information to be quickly communicated on a global scale.

Obviously, technology is an essential tool in design firms. Before purchasing a particular software package, designers should thoroughly review the software marketplace. With prices ranging from $150 for basic software to more than $15,000 for a complete system, a personalized hands-on class and demonstration are essential for understanding the possibilities and limitations of various programs.

The Source Library and Trade Relationships

A unique aspect of the design studio is the source room or resource library. The library contains catalogues of furnishings and furniture, along with actual samples of a variety of finishes and fabrics. Websites, however, provide the most up-to-date source options and are the best sustainable option for the cataloging of furniture and furnishings. Apps for specific manufacturers, and accounts with these companies, also provide valuable resource information. Design firm libraries must include high-speed Internet connections, high-resolution computer screens, and color printers.

Textile samples are also available online, and memo and/or cut samples also may be ordered and received overnight from many of the textile suppliers. However, it is often the "hand" of a textile that confirms the design decision, so most firms maintain ample samples of the textiles, be they carpet, fabric, or wallcoverings.

The acquisition and organization of these materials require careful planning. A firm specializing in health care design will need to contact different sources than would a firm specializing in residential design. A listing of manufacturers for specific sources is available through reputable design periodicals and their annual source guides.

Industry representatives also supply designers with these source materials. For a wider array of samples or to view actual furniture pieces, designers work with design centers or merchandise marts. Many of these centers are open only to members of the design trade. Clients are brought to these establishments as guests of the designer to view specific furnishings. Establishing a working rapport with these trade sources provides for efficient business transactions. It is said that "designers are only as good as their sources." Interiors of design firms are seen in Figures 14.9 and 14.10.

Marketing

Before starting any business, the owners must decide who their prospective clients are, how to reach them, and who the competition is. Useful marketing tools include the following, among others:

- A creative yet professional name
- A company branding

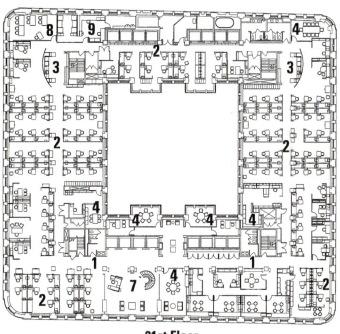

FIGURE 14.9 Interior Design Studio.
Designers frequently work in open office environments, as shown here and in Figure 14.10. Strong geometric forms and a keen sensitivity to natural light define the interiors of OWP & P in Chicago.
(Architect/Designer: OWP & P. Photographs by Chris Barrett/Hedrich Blessing.)

21st Floor

Legend

1. Main Street
2. Neighborhood
3. Town Square
4. Conference Room/Team Room
5. Central Resource Library

6. Office Services
7. Reception
8. Training Room
9. Information Technology

A 24th FLOOR

FIGURE 14.10 Interior Design Studio.
Drama and contrasting curvilinear and angled forms define the interiors of Cooper Carry offices in Atlanta. The award-winning space is all LEED-CI (commercial interiors) Platinum. (A and B) The floor plan (A) and axonometric (B) indicate the main reception and conference area as well as studio spaces. Note the use of huddle rooms and corner offices. (C) The reception area includes steel flooring and OSB walls. (D) View from a principal office into the studio space. The entire facility maximizes the use of daylight through glazed offices and low-height partitions. VOC-free and FSC-certified Sierra Pine millwork was used in the studio spaces. (E) The marketing area lit by Lumetta drum pendants.
(A, D, and E: Architect/Designer: Cooper Carry. Photography by Gabriel Benzur.)

B 24th FLOOR AXONOMETRIC

1 Reception
2 Conference
3 Town Center
4 Resource Library
5 Studio
6 Huddle Room
7 Principal's Office
8 In-house Printing
9 Accounting/ HR
10 Information Technology

- A proper business location based on the firm's needs
- Letterhead, business cards, résumé, and related marketing materials
- A website and social networking sites
- A professional portfolio of previous projects
- Signage
- Advertisements in the telephone book and other strategically placed locations

Other places to advertise a firm include local chamber of commerce gatherings, community clubs and organizations, and professional interior design society referral networks.

Business Contracts

Once the business has been established, designers must develop contracts with clients. Contracts consist of two basic types: the letter of agreement and the professional contract.

The *letter of agreement*, a simple contract written in the form of a letter, is legally binding. It is typically used for smaller residential projects. *Professional contracts* more thoroughly define the agreement between the owner and the client. Professional contracts are available to members through professional organizations or can be developed in conjunction with an attorney.

C

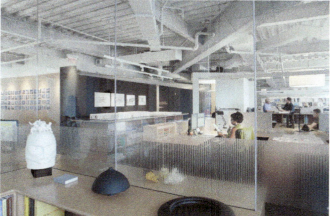

D

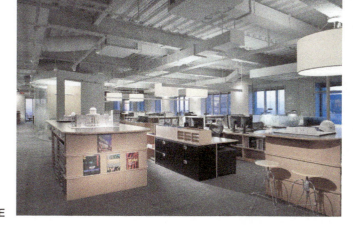

E

FIGURE 14.10 Interior Design Studio *(continued)*.

Both forms of contracts should contain, at a minimum, the following information:

- Date
- Identification of parties involved
- Location of work, including an address and description
- Scope of services
- Cost of services and payment schedule
- Additional or reimbursed charges

- Arrangements for working with allied professionals
- Purchasing arrangements
- Expressed consent to photograph and publish project
- Time frame for completion
- Appropriate signatures with date
- Retainer due upon acceptance of contract

All contracts, regardless of their source, need to be reviewed by an attorney.

FIGURE 14.11 Bathroom Design.
For this gentleman's bathroom, the original narrow room was gutted, and sleek, contemporary, moisture-resistant materials were used.
(Designer: Jackie Naylor Interiors. Photograph © Robert Thien.)

Fee Structures

One of the most complicated tasks in writing the contract is determining the cost of the services. Interior designers are compensated for their services in a number of ways. It is important that the designer and client agree on the terms of payment. Following are the most common fee systems:

- A designer who receives a *flat or fixed fee* determines the time and expense involved for the particular project and charges the client this specified amount.

- An *hourly fee* is a set rate for each hour of time spent on the project. This fee varies depending on many factors, including customary fees in a particular area, the competence and status of the designer, and the demand for his or her services. Sometimes this fee has a cap on the total cost of the design services.

- A designer who charges a *cost plus fee* buys merchandise at wholesale prices and sells the goods to clients for an additional percentage charge. The reverse of this is the *retail cost less a percentage fee:* The designer purchases merchandise at wholesale cost, but sells it to the client at a percentage off retail.

- A *fee based on the total square footage of the project* is generally used by experienced designers who are fairly knowledgeable in estimating costs involved in completing a space. The fee is charged for each square foot based on the square footage required for the entire project.

- A designer may receive a *percentage of the total project expenditure.* This system provides a guaranteed fee regardless of what the project may cost. If the completed project has additional costs, the designer is financially protected (Figure 14.11, Bathroom Design).

More info online @

http://www.asid.org/designservices/hire_designer/Selecting+a+Designer/How+Interior+Designers+Charge+for+Their+Services.htm ASID article on how designers charge for their services

■ PROFESSIONAL ETHICS

Professional interior designers must maintain the highest level of integrity. Designers need a clear definition of right and wrong. Facts should not be muddied or glossed over to hide the truth. Designers have a responsibility to maintain the highest of standards with the public, the client, other interior design professionals, allied colleagues, and employers. ASID's Code of Ethics preamble states, "Members of the American Society of Interior Designers are required to conduct their professional practice in a manner that will inspire the respect of clients, suppliers of goods and services to the profession and fellow professional designers, as well as the general public. It is the individual responsibility of every member of ASID to uphold this code and bylaws of the Society."

FIGURE 14.12 Yacht Design.
Interior design for water vessels requires attention to moisture and balance issues. This design includes custom cabinetry and seating. As in the design of aircraft interiors, all features must be secured. The curved ceiling and seating reflect the gentle lines of the yacht, and the ceiling also conceals lighting, wiring, and cabling.
(Designer: Charles Greenwood, IDA, of Greenwood Design Group. Photography by Robert Thien.)

Designers have a responsibility to the public. Designers must recognize that they are required to follow all building codes and regulations. Ignorance of codes is not an acceptable reason to skirt requirements. Designers are responsible for researching codes for a project and then following those requirements. Designers must always consider the health, safety, and welfare of the public.

Designers have a responsibility to the client. When dealing with clients, the designer must clearly define the scope of work and compensation received for the project. Designers should not discuss one client's project with another client, and they should never accept a financial "kickback" from a vendor for specifying their product. Sources of revenue should be clearly defined to the client. Furthermore, designers should always let the client know the status of a job. If a specified product has been discontinued, designers must verify the appropriate substitution with the client (Figure 14.12, Yacht Design).

Designers also have a responsibility to their design and allied professional colleagues. Designers should never criticize other designers' work. Designers should not solicit other designers' business. If freelancing for another designer, the freelancer must honor the employer's design decisions. Designers should work as a collaborative team with allied professionals. When problems arise, shifting blame does not solve the problem; teamwork does.

Additionally, *designers have a responsibility to the profession of interior design.* They should encourage the exchange of information and remain current in design practices. Designers should become involved in community projects and always present the interior design profession in the best possible light. Problems should be addressed in professional society meetings where true grassroots change can take place.

Designers have a responsibility to their employers. Information completed at one firm should not be copied or taken to another firm or used in another freelance project without the consent of the employer. As designers leave a firm, every effort should be made to facilitate the exchange of information to the new employee.

While not part of ASID's Code of Ethics, *designers have a responsibility to maintain a sustainable environment.* Forty percent of all resources are consumed by the building industry, and 40 percent of all landfill waste comes from buildings (Lichtenwalter, R., *Green Eggs and Spam*). The protection of the "welfare of the public," as advocated in the definition of interior design, requires the respectful use of the Earth's resources. Designers must accurately research products and apply design solutions that do not harm occupants or result in wasteful or destructive harvesting or farming practices.

More info online @
www.asid.org/about/ethic ASID's Code of Ethics

■ INTERIOR DESIGN FORECAST

The profession of interior design is relatively young, since the field of interior design has emerged only in the last 100 years. Many organizations project the growth of the design environment. The Design Future Council is one such interdisciplinary network. Their annual forecast is published in *DesignIntelligence*. ASID, IIDA, IFDA, and CIDA also are involved in future forecasts. The predictions include growth and specialization in numerous areas including professional advancement.

Outlook for the Profession

Because of the recognition of the health benefits of a comfortable environment, the aging population, technological advancements, the need for energy conservation, economic globalization, and a move toward a simpler and more meaningful lifestyle, significant changes in the design industry are occurring. For example:

- Due in part to the studies on EBD, the medical profession recognizes that patients heal faster and fewer mistakes are made by staff in well-designed medical facilities. EBD is now filtering into all interior design specialties.

- Technology is changing in many fields, and in particular the health care industry.

- The private office is shrinking and becoming portable. Open office environments are interspersed with conferencing areas and personal spaces.

- Individuals are working later in life.

- Because of the Internet, networking capabilities, and government emphasis on sustainability and globalization, more people are working from home and internationally.

- Designers are continuing to expand their business in global marketplaces such as China and India.

- Residences are becoming more intergenerational; according to the U.S. Census, approximately 4 million households consist of three or more generations.

- The aging population is aware of the need for accessible housing and buildings.

- The retail market has found the value in "less is more."

- Advancements in LEDs are changing the interior lighting industry.

- The public has embraced the need for a sustainable environment. The public is more aware and more apt to act on the old adage "Reduce, Reuse, Recycle."

These changes have created new and innovative design opportunities in the health care/elderly care industry, in multigenerational and home office residential design, in the commercial office environment, and in sustainable green design. The similarity among these specializations is seamless integration of technology and the trend toward convenience in the work and home environment to improve the quality of life and the quality of the environment.

Health Care Design

Led by the EBD research, awareness has evolved in the medical profession of the need for quality aesthetics in the healing environment (Figure 14.13, Health Care Design—Dental Suite). Where possible, health care interiors are incorporating hospitality characteristics. Fabrics and furnishings have taken on a warmer and richer appearance. Engineered fabrics such as Crypton have expanded antimicrobial and durability options. Hospital furnishings are designed to conceal medical equipment and are losing their institutional appearance.

Hospital rooms are designed with areas for family members; many include places for family to stay overnight. Rooms have window access to gardens and outside views, while artwork incorporates nature. Indirect lighting and acoustical controls soften the previous institutional setting. Patients heal faster by design.

TABLE 14.3 Tips from a Registered Nurse on Hospital Design

1. **Timing is everything** Designers should attend clinical and facility IT planning sessions. Listen to the needs.

2. **Casework planning for technology device storage** Ventilation, counter space, and cabinet size are critical points to consider.

3. **Charting areas for computer storage and paper charts** Even though healthcare is going to a paperless environment, there is still need for paper consent forms and other legal documents. Additionally, the computer station on wheels needs a home, near the nursing station, but also adjacent to a power source.

4. **Electronic white boards for OR schedules, patient status, etc.** The most important points to consider when placing an electronic white board are workflow and visibility for the staff that need the displayed information.

5. **Wired and wireless keyboards** Wireless keyboards and a wireless mouse pose a problem for space and use.

6. **Technology for public waiting areas** It is almost a given now that each visiting family member or guest will have some type of smartphone or laptop with them. Prepare for these needs.

7. **Headwall review** With the ongoing increase in technology, a lot of equipment is transitioning to "smart technology." Smart equipment (beds, pumps, etc.) require power and data outlets. When considering headwall design and specialty casework, it is important to understand the functionality and power/data requirements necessary to create intentional placement and coordination with the architect, construction manager, and technology project manager.

8. **Coordination of access control devices** Access control devices can be a "thorn in the wall" of the overall interior design of many spaces. Trying to position signage, artwork, donor plaques, etc., can be difficult as they compete with access control devices.

9. **Nurse call device placement** Many nurse call systems today have terminals that are mounted on the walls either near the headwall, door, or bathroom. Like access control devices, these, too, provide challenges for the interior designer to incorporate them in the overall design of the room. With so many items that are placed on the patient room walls (clocks, artwork, casework, sharps containers, hand sanitizers, etc.), early coordination is necessary to implement an organized and thoughtful wallscape.

10. **Ceiling-mounted technology** Attempting a lighting plan with the growing technology necessary for communication is challenging. In the ceiling, you will find wireless access points, paging speakers, nurse call dome lights, nurse call zone lights, RFID tracking sensors, air intake, exit signage, and lighting. Sconces outside of patient rooms can often overshadow the dome lights.

Source: www.healthcaredesignmagazine.com/article/ten-tips-technology-planning-implications-interiors

Technology is also affecting changes in the health care professssion. In a recent article in *Healthcare Design Magazine*, Debbie Gregory, a registered nurse and associate member of IIDA, noted that "electronic medical records, wireless communications, medication bar coding, RFID technology, and kiosks" are affecting interior design. She listed 10 tips to help architects and designers with technology trends. The information in Table 14.3 is adapted from the article.

Evidence-based design knowledge has also reached into the areas of elderly care centers, dental and medical offices, child care centers, public schools, and the office place. Students learn better and employees work more efficiently in quality interior environments.

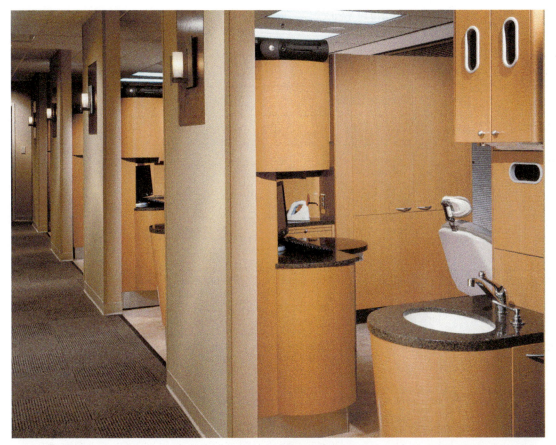

FIGURE 14.13 Health Care Design—Dental Suite.

This award-winning dentist office is promoted as a Dental Spa. The upscale furnishings and finishes are designed to place the patient in a comfortable environment and thereby alleviate the anxiety sometimes associated with a visit to the dentist. Open walkways, in lieu of doors between patient rooms, and ample storage assist staff. Lighting designed to avoid glare in the patient's eyes adds to the quality of this interior.

(Architect/Designer: LeVino Jones Medical Interiors. Photography by Thomas Watkins.)

Generations at Work

Traditionals	1928 to 1945
Boomers	1946 to 1964
Gen Xers	1965 to 1980
Millennials	1981 to 1999

	Traditionalists	Boomers	Gen X	Millennials
Size of generation	59 million	80 million	46 million	108 million
Fun generation fact	Get along famously with Millennials	Like "triggers" in the environment to aid narrative and memory	Emphasize results over process	Three times more likely to work off-site than other gens
What they might say	"I do what I'm told." "No news is good news."	"I paid my dues." "Let's work until it's complete."	"Let's have some fun while we are here." "Why do you care how I do it as long as I give you results?"	"What is it you want me to do now?" "Hey, how am I doing?"
Work environment	Status and rank	Connection to people	Connection to resources	Anywhere & everywhere
Technology	Adopt it	Accept it	Expect it	Born with it

> "Young workers desperately want mentors.
> We hear that time and time again."
>
> "Millenials love technology. Theirs is the first generation raised with the
> internet, instant messaging, and email."
>
> Steelcase

FIGURE 14.14 Anticipated changes in the workforce demographics.

Commercial Office Design

Changes in work style and populations are affecting design in the commercial office. Socialization in the workplace is a business asset fueling top-performing companies. Designers must create environments that include teamwork space, small group areas, cafes, and other gathering areas for interactive learning; however, designers also must be aware of the need for privacy and quiet contemplative work. Small conferencing areas or informal work areas are also needed.

The workforce also is changing. Traditional workers are remaining at the office after age 65. According to *Metropolis*, "What's Next," Suzanne LaBarre indicates that workplaces will include rest spaces for relaxation and perhaps an afternoon nap. Shelly Hughes, principal at Hughes|Litton|Godwin, shares the information above regarding employee demographics with her commercial clients (Figure 14.14).

There is also an increase in the number of mobile employees and employees working part-time from home. This reduces travel costs for employees, and business owners do not require as much real estate—leased or owned. This *hoteling* trend requires workstations to be adaptable to multi-users (Figure 14.15, Furniture Design), and also leads to a need for changes in residential design.

A study conducted by ASID called *FutureWork 2020: Presenting the Future of the Workplace* brought together leading experts "to think about the future of the workplace and its implications for the design profession." The *FutureWork* experts began by identifying seven factors

FIGURE 14.15 Furniture Design.
Flexibility in office design is a critical feature in the corporate marketplace. Telecommuters need areas in which to work, but not permanent offices. This semiprivate workstation by Asymptote, called A3, provides work surfaces, storage, and a sense of enclosure.
(Courtesy of Knoll, Inc.)

outside the workplace that will drive future workplace design. These factors and their implications are defined as follows:

- **Multigenerational workplaces:** An aging workforce and postponed retirement will lead to four generations in the same workplace, each with unique needs and values.

- **Growing diversity:** Ethnic and racial diversity and the increase of women in the workplace.

- **Technological innovations:** The Internet, cell phones, and the miniaturization of the computer are allowing for a mobile workplace from just about anywhere.

- **Knowledge revolution:** Comparable to the Industrial Revolution in innovation, this will include decentralized decision making, entrepreneurship, and collaboration.

- **Globalization:** A global economy exists. Traditional nine-to-five jobs are spread throughout the twenty-four-hour day. Short trips overseas may be more frequent.

- **Quality of life concerns:** Because the global economy, technology, and knowledge invade the worker 24/7, the "quest for meaning, satisfaction, and balance between work and family life will become increasingly important."

- **Environmental concerns:** This includes the desire for sustainable design, as well as design that survives extreme weather, the shift to nontraditional workplaces, and video conferencing to reduce the need for travel.

The implications of these factors on interior design are noteworthy. The changing workforce will require a workplace that does the following:

- Supports nomadic workers through flexible spaces to accommodate a growing and shrinking workforce. The Japanese created the concept of just-in-time inventory; this theory may soon be applied to just-in-time human resources.

- Seamlessly integrates digital technology that is incorporated during the design planning phases and is not added after the structure is built.

- Emphasizes productivity.

- Provides for increased collaboration areas while not eliminating private concentration zones.

- Provides space set aside to "celebrate" the community. As social animals, humans naturally congregate. The dispersed workforce will require spaces such as childcare areas, recreation areas, kitchens, generous circulation zones, and war rooms to allow for collaboration.

- Enhances the quality of life to ensure the retention of the workforce, due particularly to global competition.

The underlying needs for workplace interiors include flexibility and the seemingly opposite requirements of standardization and customization (Figure 14.16, Commercial Office Design—Collaborative Spaces). The complete findings from this study, along with a written analysis of the sessions, can be found at the ASID and IDEC websites.

The Virtual Office

With the electronic developments of online networking, teleconferencing, and Internet access, going to work may no longer mean going to an office. The office furniture market has expanded to include ergonomically designed furniture available for home use. Designers specify appropriate power and communication lines to all potential computer locations including bedrooms and kitchens.

Residences may actually include two offices—one for each spouse. Work or study areas are also needed for other family members; however, Internet connections are moving "to the lap." Wireless computers, tablets, and cell phones provide Internet access virtually anywhere in the home. Designers must provide space for placement and charging of these devices.

The *virtual office* is a portable office. Furniture designed to be transported as luggage allows employees to take their office on the road. Consequently, the hospitality market is adapting to the electric and space needs of the virtual office in hotel rooms and restaurants. Conference centers are now equipped with teleconferencing and interactive video capabilities.

The airline industry has also recognized the needs of the commuting office and responded accordingly. Wi-Fi is common on airplanes, and airlines have begun to provide greater comfort via more first-class and business seats and more gracious spacing in coach.

FIGURE 14.16 Commercial Office Design—Collaborative Spaces.
This office space includes two gathering areas: an open one on the left, and an enclosed conference room on the right. Note the fabric light diffusers in the open collaborative space.
(Designer: Perkins + Will. Photography by Chris Little)

Multigenerational Residences

In response to many factors including a tight economy, longer life expectancy, a more agile aging population, an understanding of the personal benefits of living at home, and the high costs of institutional care, many households include three or more generations.

Planning for an additional family member requires careful consideration. Many factors are addressed through universal design principles. For instance, entries without a step work well for wheelchairs as well as strollers. Changes in heights of kitchen counters assist children as well as those seated. Three-foot-wide doors and lever handles work well for all.

Diana Patterson, ASID, also points out in ASID's ICON that seniors may also need their own entry, plenty of storage, and if possible a small kitchenette. Independence is just as important as family time. However, a location in a basement or on the second floor, while "away," may be too difficult to negotiate or too remote, and therefore encourage lack of participation with the family.

The aging population has also recognized the importance of accessibility in housing as well as in the commercial environment. Retirement communities provide various levels of assistance to their occupants.

Individual and community residences for the elderly are designed to accommodate wheelchairs; furnishings and cabinetry are readily available to meet universal needs.

Retail Design

The retail industry is experiencing significant changes in their facilities design (Figure 14.17, Retail Design). Major chains are shrinking their footprint in order to conserve costs and to address sustainability. High-rise mixed-use facilities include commercial office space, condominiums, retail establishments, and restaurants all in the same building. It is also interesting to note that some businesses in large cities are using the space below the streetscape for their display areas. The Apple Store in New York City, for instance, has a three-story glass cube on the street level and its merchandising all underground.

Lighting Design

One of the biggest changes in the interior design profession is in the lighting industry and the use of LEDs (see Chapter 6). LEDs will revolutionize the way designers use light by allowing lighting to become more of an art form. LEDs make walls glow and change colors, and

make furnishings appear translucent (as seen on page 81). Lighting can be placed in grids or in strips and be moved to various locations, all the while using less energy and providing a higher quality of light (Figure 14.18, Restaurant Design—LEDs and the Human Element).

Environmental Design

The need for environmental conservation has surfaced not only in interior design practice, but also as a relevant national and global issue involving industry, manufacturing, and education. This trend, which began with the environmental movement of the 1960s, is still evolving. Mindy S. Lubber, in her *Green Money Journal* article "Sustainability Gets a Warmer Embrace from US Companies," states, ". . . hundreds of companies have spent billions of dollars to understand and reduce their impacts on biodiversity, water quality, energy use, and climate risks" (Source: www.greenmoneyjournal.com/article.mpl?newsletterid=42& articleid=559).

Fortune Magazine notes in their article "Green Buildings, Green Profits," ". . . green buildings cost about the same to make as those built with conventional methods, but they can be significantly less expensive to operate. . . . A 2008 report by the New Buildings Institute concludes that buildings that meet the USGBC's LEED requirements report 25%–30% lower operating costs than conventional buildings." The article also recognizes that much of the savings comes from better lighting control and design because lighting, according to the U.S. Department of Energy, "accounts for 39% of the electricity used in office buildings."

As noted throughout this text, many manufacturers in the design industry also recognized this trend and are now producing sustainable design products. Websites and periodicals are dedicated to green products and green design. A truly sustainable product mimics nature. All designs in nature are based on recycling; nothing is wasted. True green products are not only environmentally friendly, they also provide for the sustainability of the natural environment. Manufacturers and inventors are wise to follow in this direction; designers, as representatives of end users, are wise to specify these green products.

In residential design, owners want homes with high energy efficiency, low maintenance, labor-saving devices, and water-saving appliances, especially dishwashers, toilets, and showerheads. In commercial design, clients are requesting sustainable products and building materials and attention to IAQ. Businesses recognize the significance of green design (see Sustainable Design: LEED-CI in Chapter 11).

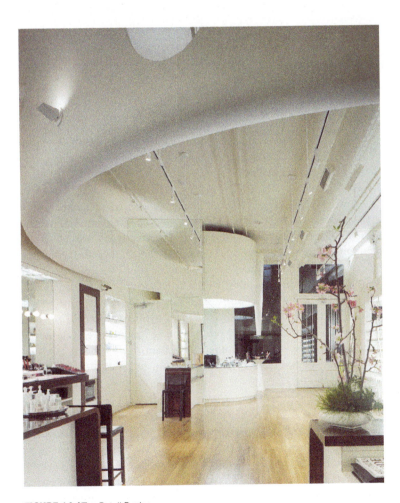

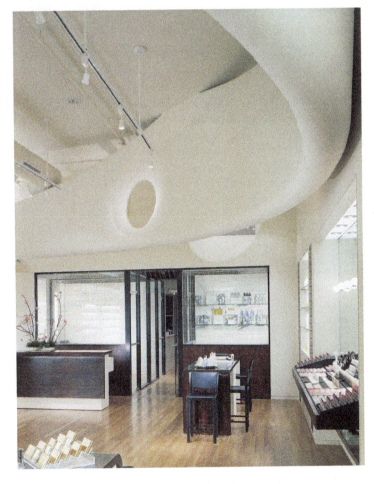

FIGURE 14.17 Retail Design.
Form defines the character of this sweeping cosmetics showroom. The designer was charged with creating an interior environment that did not feel like a tunnel in this 24' W × 100' L × 14' H space. Undulating gypsumboard soffits draw clients into the retail establishment, adding interest and the appearance of width.
(Designer: Yoshinari Matsuyama. Photographs by Paul Warchol.)

FIGURE 14.18 Restaurant Design—LEDs and the Human Element.
The onyx bar is lit with LED strip lighting. Custom light fixtures provide sparkle through glowing stones. The floor-to-ceiling front windows were designed to present a "town square" feel, striving for a sense of community.
(Architect/Designer: Wid Chapman Architects. Photograph by Bjorn Magnea.)

Dennis Weaver, actor, humanitarian, and environmentalist, developed an interesting approach in response to this trend by forming the Institute of Ecolonomics. "Ecolonomics" is a blend of the words *ecology* and *economics* in recognition of human dependence on both a healthy environment and a healthy economy. The institute advocates the use of responsible business practices—including design—to clean up the environment. In Weaver's words, "When we realize we can make a buck cleaning up the environment, it will be done." As demonstration of his commitment to the environment, Weaver built an Earthship—a building made from used tires, aluminum cans, and sustainable materials. (See Sustainable Design: Solar Architecture and the Earthship.)

More info online @

www.di.net/article.php?article_id=101 Design Futures Council information
http://www.di.net/videos/3524/www.di.net/videos/3524 Video on future trends
http://designwire.interiordesign.net/projects/residential/5563/ifda-announces-residential-trend-forecast-for-2020 Residential trend forecast by IFDA

Challenges for the Profession

All young professions work through a process in establishing their foundation, body of knowledge, and economic potential. Interior design is such a profession and is working toward the goals of accountability and professional recognition. The interior design professional organizations will continue to work together to demonstrate the tangible benefits of interior design.

Accountability

FutureWork 2020 notes that globalization will emphasize productivity. The profession will continue to research and document that interior design affects worker productivity.

Kerwin Kettler, in *ASID Professional Designer*, surveyed 200 business owners to learn their opinions about productivity. Ninety percent believe that productivity could be increased by improvements in office design. The top four factors influencing productivity included access, comfort, privacy, and flexibility. As designers work with commercial clients, a preliminary productivity analysis could be performed. The results of this analysis could be used as a baseline to measure productivity levels at the end of the design process. Designers must be able to document the benefit of their services to clients, particularly commercial clients. Research and programming analysis need to establish productivity baselines to document the quantifiable benefits of a quality interior environment.

Profession Gains Respect

As the interior design profession engages in environmentally sustainable practices and develops quantifiable standards of accountability through processes such as EBD, respect for the profession will grow. According to White and Dickson in the *Journal of Interior Design*, sociologists have found that professions mature based on the development of their educational requirements and legal recognition. In the past thirty years, the interior design profession has sought to define educational programs through CIDA and establish a basic competency level through NCIDQ. The continuing registration and licensing

efforts, coupled with the ongoing development of an advanced research database, will enhance the profession's image and credibility.

Another key factor in establishing credibility (and thereby developing respect for the profession) is to ensure that the various voices of the professional design organizations blend as one to work with the public and represent the profession's goals, ideals, and visions. In the late 1980s and early 1990s, a move called the Unified Voice sought to establish a single organization. The move met with some success as three professional organizations merged to form IIDA. In the fall of 2001, ASID and IIDA jointly announced that they were pursuing a merger into one professional organization. Although the merger did not happen, ongoing efforts to share information and establish joint events continue, particularly at the local level. Perhaps future leadership and grassroots efforts will allow a truly unified voice to emerge.

An additional move to strengthen the profession revolves around the need to establish the profession's body of knowledge, or research base. At the IIDA Design Research Summit, delegates considered the following six key issues:

1. Although an abundance of interior design research exists, it is difficult to access quickly.

2. Design professionals need to collaborate more with each other and with experts from related fields.

3. Academics and practitioners reside in different cultures, and this communication issue must be addressed.

4. Unlike other professions such as engineering and medicine, interior design practitioners, the industry, and school administrators do not yet appreciate the need for graduate education and research to broaden the intellectual foundation of the profession.

5. Increased sponsorship and funding are imperative to building and maintaining a strong and relevant body of knowledge for the design profession.

6. The design profession must consider and define ethical boundaries with regard to interior design research.

According to Neal Frankel, IIDA, the connection between practitioners and researchers will continue to grow, creating an expanded body of knowledge.

As previously mentioned, ASID partnered with the University of Minnesota's interior design department to develop a website of summaries of interior design research projects. InformeDesign is a database that includes summaries of research articles on interior design. The site serves as an excellent resource on the interior design profession for students, faculty, and practitioners (Figure 14.19, International Design—Vacation Home and the Human Element).

More info online @
www.informedesign.umn.edu InformeDesign website

FIGURE 14.19 International Design—Vacation Home and the Human Element. This residence, perched on a steep hillside overlooking St. Martin and St. Barts islands in the British West Indies, is designed for indoor/outdoor living. The open-air living room pavilion serves as the main entertaining area. The residence includes concealed hurricane shutters for quick close-ups. A cistern to collect rainwater and a water treatment plant provide irrigation for the landscape. The Oceanic and African art displayed are from the owner's private collection. See Figure 12.2 for a bedroom shot.
(Interior Architectural Design by Wilson Associates. Photography by Michael Wilson.)

SUSTAINABLEdesign

SOLAR ARCHITECTURE AND THE EARTHSHIP

As discussed in Chapter 5, passive and active solar designs and earth-sheltered designs create living environments that require less energy to run and produce less waste. A cutting-edge design utilizing these principles, while incorporating waste materials as building blocks, is the Earthship.

The ecological consequences of the construction industry are well explored and documented. Old-growth forests are vanishing forever. Generating electricity leaves nuclear waste and gasses that lead to acid rain. Sewage and chemicals contaminate the groundwater necessary for all life to survive. The environment cannot indefinitely support the current methods of construction and their many hidden costs.

Michael Reynolds, the architect behind the Earthship philosophy and design, noted the direction of these wasteful construction methods over thirty years ago. He also noted the inordinate amount of time and effort that is required to obtain the "American dream" of home ownership. The average wage earner works thirty years to pay off the debt of the home, in addition to paying monthly bills to utility companies. Reynolds searched for a better solution to this seemingly endless cycle of bills and waste. His goals were far reaching:

- Develop construction methods that would reuse existing waste products as building blocks for construction.
- Design a building that would create its own energy and treat its own waste.
- Develop construction methods that can be executed with little training.
- Make the design affordable.

The major structural building component of the Earthship is recycled automobile tires filled with compacted earth to form a 3-foot-thick rammed-earth brick enclosed in steel-belted rubber. The massive "brick" walls, and the method of incorporating them into the earth, create living spaces that retain a constant temperature. Thus, with natural ventilation systems built in, an Earthship will heat itself in the winter and cool itself in the summer without the use of fossil or nuclear fuels.

Earthships produce their own electricity through a photovoltaic power system; they also collect their own water from a unique roof, silt catch, and cistern system, and deal with their own sewage through food-producing greenhouse technology that allows contained-flush toilets.

Earthships have been designed and developed with an emphasis on global availability of all aspects of their construction. They exist now in Bolivia, Australia, Mexico, Japan, Canada, and all over the United States. Earthships are comparable in cost to typical frame construction; however, they are much more durable, are better insulated, and have no utility bills.

The buildings look like Spanish adobe structures and can be designed in single- or multifloor units (Figures SD14.1 and SD14.2).

Interior walls, which can be painted or left in their natural color, are formed out of stacked aluminum cans and covered with adobe. Walls can be pierced with clear or colored glass and formed in a variety of shapes. Figure I.3 illustrates a completed Earthship called the Suncatcher.

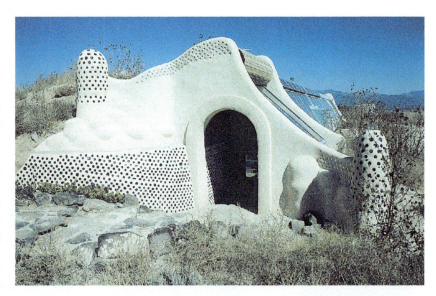

FIGURE SD14.1 The exterior of an Earthship with glass sloping to the south. Facades can be customized utilizing various-size tires, shaped retaining walls, and whimsical accoutrements. *(Architect: Michael E. Reynolds)*

More info online @

www.earthship.net Earthship website

SOLAR ARCHITECTURE AND THE EARTHSHIP—cont'd

FIGURE SD14.2 Rooms in an Earthship are based on U-shape modules grouped side by side or on two levels that can be added or deleted as needed. The sections through the designs illustrate construction and airflow.
(Architect: Michael E. Reynolds)

SUMMARY

The progression of steps to become a professional interior designer includes education, experience, and examination. Once established as a professional, the designer continues his or her education through advanced coursework and participation in professional organizations. The successful professional designer knows that the diverse nature of design, both as a science and as an art, also requires an advanced knowledge of business skills and ethical behavior.

The future of interior design will see the maturation of a young profession eager to provide for a multicultural, technologically savvy community. Designers will work in specialized fields with allied design professionals in teams that encourage the sustainable use of products, materials, and space. Designers will actively search for universal design solutions that enhance the quality of life in all interior environments while inspiring the human spirit. The final Design Scenario, Stonehurst Place, reviews the renovation of a residence in a metropolitan area into an upscale bed and breakfast incorporating sustainability, historic preservation, and design elements created to inspire and relax.

Chief Oren R. Lyons, traditional Faithkeeper of the Turtle Clan, speaking at the 20th Congress of the International Council of Societies of Industrial Design, said,

"Each generation raises its intellectuals, heroes, and leaders. . . . We must raise leaders of vision who think and make decisions in the long term. . . . Think positive, be courageous, be generous, share your wealth. Divest for the future" (Figure 14.20, Lighting Design).

FIGURE 14.20 Lighting Design.
In this contemporary interior, emphasis has been placed on interior lighting. The focal point chandelier is suspended from a custom-designed frame. Recessed downlighting highlights the artwork, and lights hidden from view create a silhouette of the art on the ceiling.
(Designer: Charles Greenwood, IIDA, of Greenwood Design Group, Inc. Photograph © Robert Thien.)

designSCENARIO

Stonehurst Place

Stonehurst Place pays homage to the merger of sustainable design and historic preservation, while addressing technology in the face of history and the need for the business traveler to find respite in a fast-paced urban environment.

Inspired by the gardens and stone structures near her current residence in London, designer Barbara Shadomy found similar traits in a historic home in downtown Atlanta she came to call Stonehurst Place. Shadomy's vision, as designer and owner, was to create a retreat in the city for the technology-savvy business traveler. The bed and breakfast should be refined, sexy, and respectful of the historical character of the home as well as respectful of the environment.

Built in 1896, the Queen Anne shake and stone residence had been used as a bed and breakfast but was in need of a major renovation and much TLC. For example, the exterior shake siding's multiple layers of paint were carefully removed using nonchemical treatments and repainted. New custom shakes were applied where needed (Figure DS14.1).

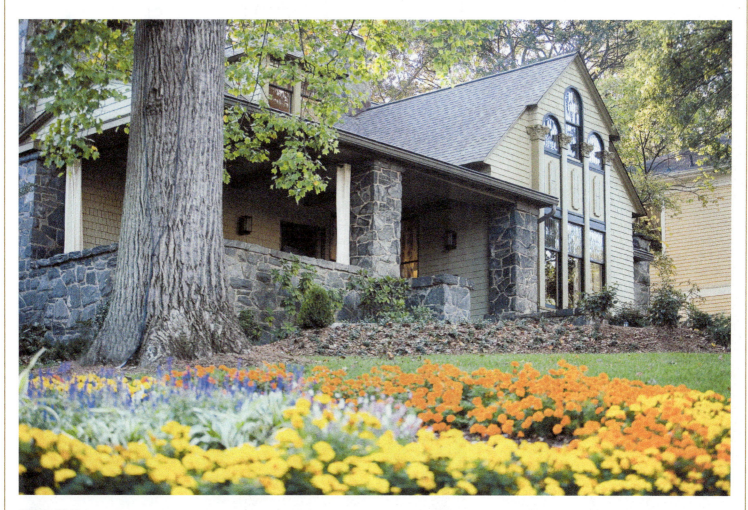

FIGURE DS14.1 The exterior renovation included meticulous restoration of the original shake siding. The construction and landscaping crews were cautious of the roots of the old oak trees throughout the property. The preservation of the stonework, Corinthian columns, and leaded glass windows reflects the attention to detail to accentuate the historical character of the structure.
(Designer: Barbara Shadomy. Photograph by Allison Shirreffs.)

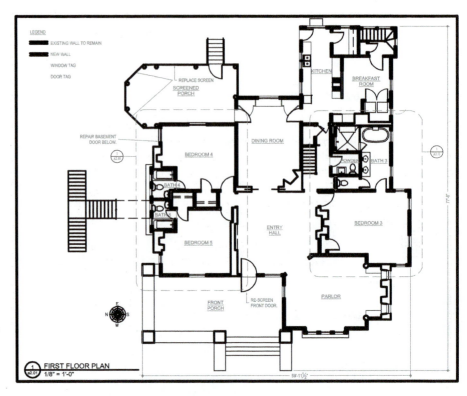

FIGURES DS14.2 and DS14.3 The first and second floor plans illustrate the design changes to the existing plan. While the changes were relatively minor on first review, the contract documents also called for a complete renovation of mechanical, electrical, and plumbing systems, essentially requiring the removal and reconstruction of the majority of the interior walls and ceilings.
(Designer: Barbara Shadomy.)

The existing floor plan lent itself to minor wall renovations for improved circulation, creating three single-room suites on the first floor (Figure DS14.2) and two double-room suites on the second floor (Figure DS14.3). Attention to detail was paramount in the renovation. On the second floor, attic spaces were opened and structural changes cleverly camouflaged to increase the size and height of the sewing room, creating a more generous second floor suite. Mechanical,

electrical, and plumbing systems were completely upgraded, requiring the total removal and subsequent return of the majority of the interior walls and ceilings.

Shadomy sought to use energy-efficient materials and appliances. Solar power preheats the water using glycol; panels are discreetly mounted on the backside of the residence (Figure DS14.4). A rainwater harvesting system collects water from the roof and channels it to underground storage tanks for use in irrigation

FIGURE DS14.4 Solar panels were installed on the back side of the house away from the street and garden views.
(Designer: Barbara Shadomy. Photograph by Allison Shirreffs.)

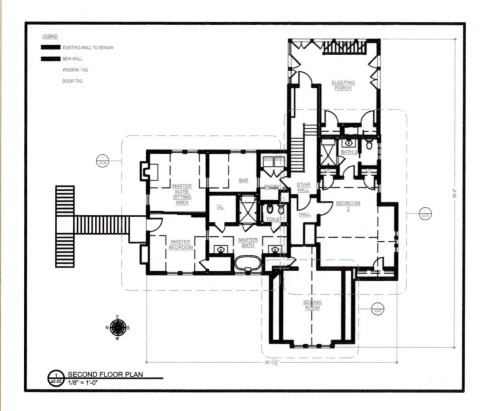

FIGURE DS14.3 Second floor plan.

(Figure DS14.5). A Brac greywater recycling system collects water from sinks, bathtubs, and showers; the water is then filtered, treated, and used for flushing toilets. Where possible, fabrics and furnishings were salvaged from overruns. The historic inn was the recipient of the EarthCraft Home and Southface Renovation Project Award.

This attention to detail continues beyond the sustainable design features, allowing the historic characteristics to become the focal point of the inn, supported by the sophisticated neutral color palette. All carpets and rugs were removed and the original floor refinished. Pets are welcome in this dog-friendly establishment. Figures DS14.6 through DS14.9 illustrate before and after shots of the rooms. More information (including shots of the sustainable systems and the other rooms) can be found at http://StonehurstPlace.com or at www.stonehurstplace.com/green.php

FIGURE DS14.5 Underground tanks were installed to hold rainwater for irrigation.
(Designer: Barbara Shadomy. Photograph by Allison Shirreffs.)

FIGURE DS14.6 The original music room is now used as the Parlor. The expansive tiled hearth (called an inglenook), Corinthian columns, entablature, and wood floor are brought forward in the lighter wall palette. The original chandelier was rewired and remains.
(Photograph by terrygreene.com)

FIGURE DS14.7 The Farnsworth room overlooks the back patio. The fireplace surround and wood trim were restored. Note the electrical outlets now in the base molding.
(Photograph by terrygreene.com)

FIGURE DS14.8 The Hinman room is dominated by the four-poster canopy bed. The floor plan illustrates a luxurious bathroom addition. Note the iPod charger/alarm clock on the nightstand. Full-length draperies add drama and sound attenuation.

(Photograph by terrygreene.com)

FIGURE DS14.9 The upstairs Gable Suite includes the bedroom and sewing room which overlooks the front lawn. A work area, lounge seating, and original art allow the suite to be functional as well as comfortable.

(Photograph by terrygreene.com)

Appendix A

Residential Programming Questionnaire

RESIDENTIAL PROGRAMMING QUESTIONNAIRE

I **General Information** **Date**

Client Name

Address

Home Phone Work Phone

Occupation(s)

II **Family Members**

Name	Age	Universal Concerns

III **Family Members' Hobbies and Activities**

Activity	Family Member(s)	Where does activity take place?
Office work		
Television		
Sewing		
Crafts		
Instruments		
Model Building		
Reading		
Other		

IV **Room Requirements**

Living Room

Entertainment Yes _____ No _____ How Many? _____ How Often? _____

Dining Room

Formal/Casual/Both (circle one)

Number of people maximum _____

Comments _____

Breakfast Room

Number of people maximum _____

Comments _____

Family Room

Activities

Bedrooms

#	Who	Requirements
1		
2		
3		
4		
5		

Baths

1		
2		
3		
4		

Other Rooms

Rooms	Requirements
Laundry	
Kitchen	
Office	
Workshop	
Garage	
Playroom	
Study	
Music Room	

V Design Preferences

Colors	
Mood	
Budget	
Time Frame	
Reuse Items	(if yes, see furniture inventory sheet)
Other	

VI Other Information & Comments

VII Business Information
Travel Directions

Fee Basis

Appendix B

Furniture Inventory Sheet

FURNITURE INVENTORY SHEET

Item #	Description	Size W × D × H	Style	Comments

Appendix C

Typical Set of Residential Construction Drawings

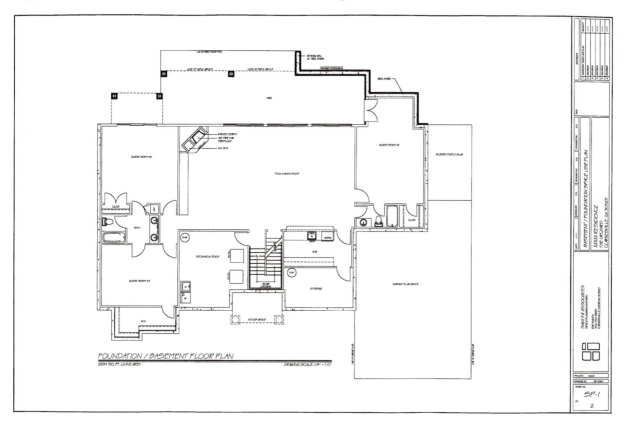

FIGURE C.1 Basement/foundation space use plan.
(Courtesy of Santa & Associates)

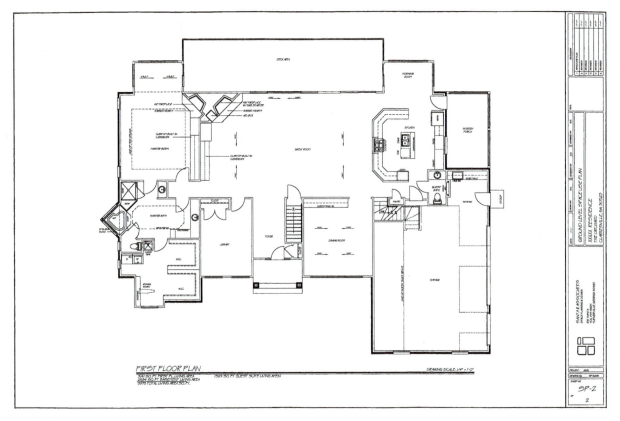

FIGURE C.2 First floor space use plan.
((Courtesy of Santa & Associates)

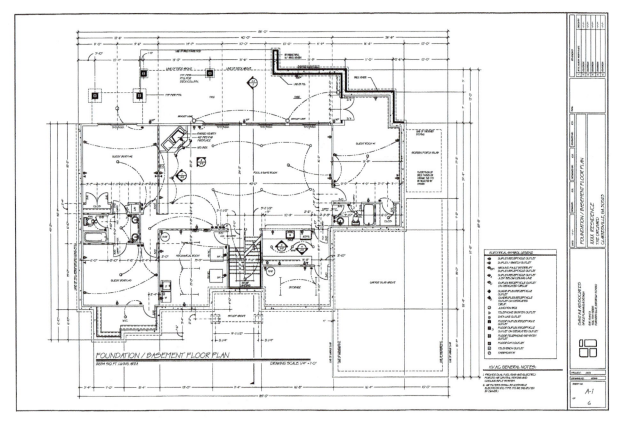

FIGURE C.3 Foundation/basement floor plan.
((Courtesy of Santa & Associates)

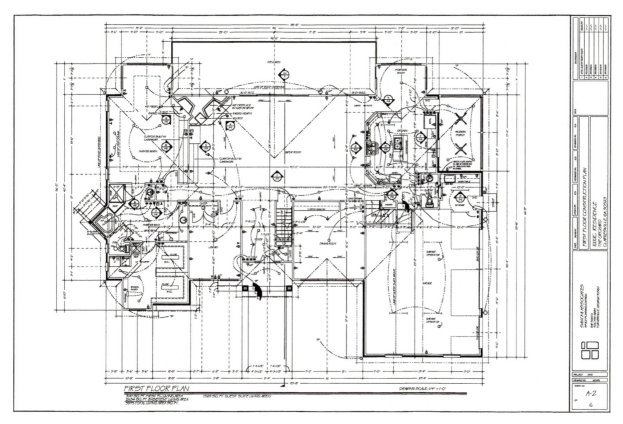

FIGURE C.4 First-floor construction plan.
((Courtesy of Santa & Associates)

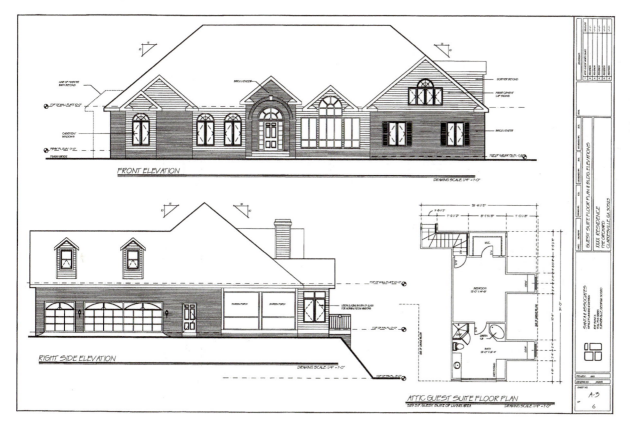

FIGURE C.5 Guest suite floor plan and exterior elevations.
((Courtesy of Santa & Associates)

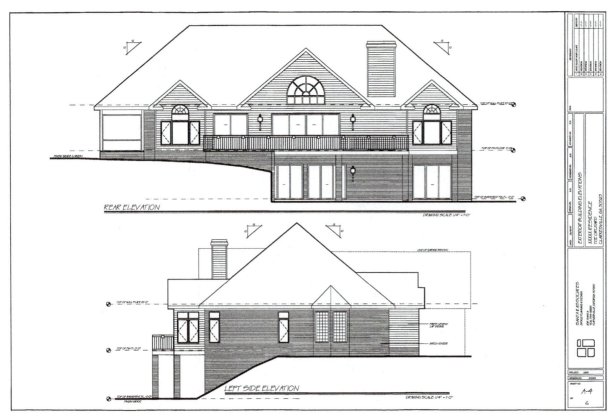

FIGURE C.6 Exterior elevations.
((Courtesy of Santa & Associates)

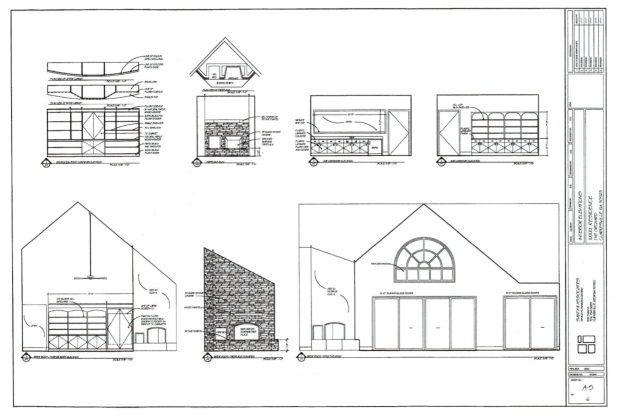

FIGURE C.7 Interior elevations.
((Courtesy of Santa & Associates)

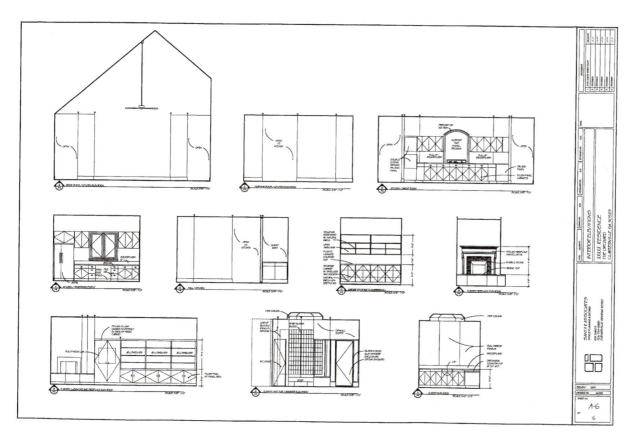

FIGURE C.8 Interior elevations.
((Courtesy of Santa & Associates)

FIGURE C.9 Building section.
(Courtesy of Santa & Associates)

Glossary

Also see pages 388 through 391 for textile terms.

Abacus A small slab found on top of the capital of a column.

Abstract A type of decorative design, modified so that the subject may not be recognizable.

Acanthus leaves A stylized design motif inspired by the acanthus plant and especially favored by the ancient Greeks and Romans.

Accent lighting Lighting used to focus and/or emphasize particular objects or features.

Accessible Unobstructive passage into and throughout a structure making it negotiable for wheelchair users and others with physical limitations.

Achromatic Hues "without color"; specifically, gray, black, and white.

Acoustics In design, the study of sound, including its properties and successful adaptation in a human environment.

Active solar energy system A mechanical system particularly designed to collect and distribute solar heat.

Adaptation The modification of an item to make it fit more perfectly under conditions of its current environment. In furniture design, the term indicates that only some elements of the original have been adapted to the present design.

Adaptive reuse Historical structures redesigned for a current use.

Additive color Mixing or adding primary hues through the use of either dyes and pigments or lighting.

Adobe brick A brick of sun-dried earth and straw; most often used in Southwest adobe-style dwellings.

A.F.F. Above finished floor.

Afterimage When the human eye focuses on a strong hue, the eye becomes saturated with that hue and an afterimage of that hue's complement can be seen when the eye focuses on a neutral surface.

Air-exchange unit A unit that allows fresh outside air to be drawn into a structure and discharges stale air; contributes to a "healthy environment."

Aisle A hallway that runs parallel to the nave of a church and is separated from it by an arcade.

Alignment A perceptual theory based on how a design or structure is organized.

Ambient lighting A term interchangeable with *general lighting*; lighting that provides overall illumination.

Amp (or ampere) The measurement of electrical current in a particular circuit.

Analogous colors Hues that are adjacent on the color wheel.

Anodize The application of a protective oxide covering on metal.

Anthemion A radiating stylized honeysuckle flower motif used by the ancient Greeks and in Neoclassic design.

Anthropometrics The science of measuring the dimensions and proportions of the human body in various activities.

Antique A work of art, piece of furniture, or decorative object made during a much earlier period than the present; often at least 100 years old.

Apron The horizontal section beneath a tabletop, chair seat, chest of drawers, or windowsill.

Apse A semicircular or polygonal recess at the end of a church plan.

Arabesque A leaf-and-scroll pattern with stems rising from a root or other motif branching in spiral form; usually in a vertical panel.

Arcade A series of adjoining arches with their supporting columns on piers.

Architectural lighting Permanently wired and architecturally fixed luminaires.

Architrave A horizontal member located above the column and capital in classical architecture.

Armoire The French term for a tall cupboard or wardrobe with doors.

Artesonado Ornately carved wood; usually used in Hispanic styles.

Ashlar Square or rectangular blocks of stone masonry used in the construction of a building.

ASID American Society of Interior Designers.

Asymmetrical balance Balance created by grouping objects or furnishings to give a sense of equilibrium.

Baffle A mechanism for deflecting light or directing it to reduce glare.

Balance Placing objects or furnishings in a symmetrical, asymmetrical, or radial approach to create a sense of equilibrium.

Balcony A platform projecting from the exterior or interior wall of a structure, enclosed by a railing.

Ballast An electrical transformer that converts current necessary for fluorescent lighting.

Balloon-frame construction A type of construction employing a simple, economical skeletal frame. Used most often for small wood houses with closely placed supportive elements, with spaces in between for wiring, plumbing, and insulation.

Baluster A turned, upright support of a rail, as in the railing of a staircase.

Balustrade A row of balusters topped by a rail.

Banister A handrail.

Banquette Architecturally built-in seating units used in restaurants and sometimes in residential design.

Barrel vault An arched roof known since 4000 B.C. and perfected by the ancient Romans.

Barrier-free design Designs in which no physical obstacles prevent access for wheelchair users to various facilities throughout a space.

Base molding Molding near or at the bottom of the wall along the floor's edge.

Bas-relief A type of decoration in which the design is slightly raised from the surface or background.

Batik A process of decorating fabric by wax coating the parts not to be dyed. After the fabric is dyed, the wax is removed.

Batten A long strip of wood covering the joint between two larger wood strips.

Bay window An angled window that projects outward from the wall surface.

Bead-and-reel A convex classical Greek molding, with disks singly or in pairs alternating with oblong beads.

Beam A horizontal timber or metal bar supported on vertical posts, used to support a roof or ceiling.

Bell gambrel A type of gambrel roof in which the lower section splays outward to give the roof a "bell-shaped" appearance.

Beltcourse See *stringcourse*.

Belveder See *cupola*.

Bentwood A process of bending narrow strips of wood into various artistic forms; developed primarily by Austrian designer Michael Thonet during the latter half of the nineteenth century.

Bergère A French armchair featuring a wood frame with upholstered arm panels, seat, and back.

Berm A mound of soil. In solar design, it is placed against a building to add insulating qualities.

Bevel The edge of any flat surface that has been cut at a slant to the main surface.

Bidet A water fixture used for cleaning.

Biodegradable The ability of a material to decompose naturally.

Biotechnology The use of advancements in engineering and technology relating to environmental products.

Blocking In construction, rough lumber is placed in a hidden location to support a joint or future object.

Blocking diagram A visual drawing that groups individuals, departments, or spaces into blocks. Used in conceptual design.

Blueprint A photographic print, formerly white lines on a bright blue background, used for copying architectural plans. The standard today is blue lines on a white background.

Board-and-batten construction Construction employing wide upright boards placed side by side with joints covered by battens.

Boiserie A French word generally used to designate elaborate carved wood paneling.

Bolection molding A projecting molding with a rounded edge.

Bonnet roof A type of French hipped roof with a bottom that covers a surrounding porch. The shape resembles a bonnet.

Bow window A semicurved window that projects outward from the wall surface.

Breakfront A large cabinet or bookcase with a center section projecting beyond the flanking end sections.

Brewster color theory Another term for the standard color wheel theory based on the three primary colors of blue, red, and yellow. Also called the Prang or Palette system.

Broadloom Carpet woven in 27-inch to 18-foot widths. Most commonly used in 12-foot widths.

Bubble diagram A visual drawing indicating individuals, departments, or spaces with bubbles. Used in conceptual design.

Buffet A cabinet for holding dining room accessories and from which food may be served.

Bullnose A 180-degree rounded wooden edge on a table, step, or cabinet top.

Burl A strong irregularity in the wood grain providing an interesting design and color; often used for veneering furniture.

Burnish To make shiny or lustrous by rubbing.

Butt joint An expensive joint where two flush edges are joined by glue, screws, or other means.

Buttress A supportive structure, first used on the Gothic cathedral, that splays from a wall to make it stable.

Cabriole leg A furniture leg support designed in the form of a conventionalized animal leg with knee, ankle, and foot creating a double curve or S shape.

CAD (CADD) Computer-aided design (and drafting).

Calendering A finishing process for fabrics; the textile is pressed between rollers.

Candela In lighting, the unit of measure for the intensity of light in a given direction directly from the lamp.

Caning Flexible rattan or cane woven in open mesh for chair backs, seats, and other furniture members.

Canister A small box or case for holding tea, coffee, flour, salt, or sugar.

Cantilever A projecting beam or furniture member supported at one end only.

Capital The top treatment of a column. In classical Greek architecture, the capitals were Doric, Ionic, or Corinthian in style.

Captain's walk A balustraded observation platform built atop the roof of a coastal dwelling, providing an unobstructed view of the sea; also called a widow's walk.

Caryatid The female human form used as a structural support.

Casement window A window hinged on one side only, allowing it to swing inward or outward.

Casepiece A general term applied to furniture storage pieces that have no upholstered components.

Cathedral In ceiling design, the vertical area formed by a pitched roof.

Cella The interior space (or cell) of an ancient Greek or Roman temple, copied especially during the Greek Revival period.

Chair rail The decorative trim horizontally positioned at about 3 feet above the floor.

Chaise longue A French term for a lounge chair (with or without arms) with an extended seat providing leg support for the occupant.

Chandelier A lighting fixture suspended from the ceiling with branches to support candles or electric lamps.

Chase A concealed channel in a wall that carries HVAC, electrical, or plumbing lines from floor to floor.

Chateau A castle or large country house in France.

Chevron A repeating V-shape or zigzag motif consisting of diagonal bars meeting at a point.

Chimneypiece The architectural design that sheathes the firebox and flue.

Chinoiserie (shinwá zor ee) (French) Chinese lacquered designs, which were popularly employed during the eighteenth century on European furniture.

Chroma The purity or saturation of a color; also called *intensity*.

Chromaticity The color of light measured in Kelvin temperature (K).

CIDA Council for Interior Design Accreditation. Not-for-profit agency that accredits first professional interior design programs.

Circulation The traffic patterns of occupants within an interior space; particularly important when planning rooms, stairways, hallways, etc.

Clapboard A horizontal overlapping of thin wood boards used for the exterior sheathing of structures; popularly employed in seventeenth- and eighteenth-century colonial-style homes.

Classic A term generally applied to design of timeless quality that transcends changes in taste and fashion.

Classical A term relating to the arts of ancient Greece or Rome.

Clearance The planning of space required by building codes to clear combustible heating units such as fireplaces, stoves, or furnaces. Also, adequate clearance space between furnishings for the convenience of users.

Clerestory Windows placed at the top of a structure's wall allowing extra light.

Closure A Gestalt concept where the eye completes or recognizes an image based on a partial representation of that image.

Club foot A club-shaped or rounded foot on a cabriole leg, especially associated with Queen Anne furniture.

Cluster planning A method of arranging concentrated dwelling units, usually low-rise and either separate or attached, to take advantage of communal open spaces.

Code Federal, state, or local laws applied to the design of buildings in relation to safety and health standards.

Coffered ceiling Ornamental sunken panels between beams employed for a flat, vaulted, or domed ceiling providing a three-dimensional effect.

Colonnade Columns arranged in a straight or curved row, often supporting an entablature.

Colonnette A miniature colonnade used for decoration.

Color quality scale A measurement of a lamp's color spectrum quality based on 15 highly saturated colors.

Color rendering index A measurement of a lamp's color spectrum quality based on eight medium saturated colors.

Columned chimney (clustered chimney) A cluster or arrangement of a number of chimneys.

C.O.M. Customer's own material. The customer purchases fabric for a job from another source.

Commode A French term referring to a low chest supported on legs with drawers.

Complementary colors Contrasting colors based on the opposite colors of the color wheel. Various combinations of cool and warm colors.

Compression A force that squeezes together. When a load (or force) is placed directly on a vertical member, it is in compression.

Computer network Computers within an office that are connected, permitting access to the same data.

Concept The basic beliefs that define the solution to a project. May include physical elements or design directions such as historical styles, but also extends to abstract thoughts and feelings.

Conceptual design The phase of the design process in which designers formulate preliminary broad-based concepts. May be called *schematic design*.

Condominium A multi-unit structure, such as an apartment house, in which each unit is individually owned. Maintenance and services are paid for by the residents as a group.

Console table A table designed to be fixed on a wall; sometimes supported by two front legs.

Construction drawings Drawings that indicate how to build something. May be called working drawings.

Contemporary style Living or occurring at the same period of time. In furniture, the term commonly refers to a modified type of modern or updated traditional design. Some styles are considered classic.

Continuance A Gestalt concept in which the eye is drawn in the direction of an arrangement.

Contract administration A phase of design in which the designer administers the contracts completed in construction documentation.

Contract documentation A design phase in which the designer documents the design decisions approved by the client in previous design phases.

Corbel A bracket or projection from a wall used to support a molding or beam.

Corinthian The most ornate of the three Greek orders, characterized by its capital of small volutes (spiral, scroll-shaped ornaments) and acanthus leaves.

Cornice A horizontal and projecting member that crowns an architectural composition; a molding on a wall near the ceiling or under the eaves of the roof. Cornice board is a molding used with drapery instead of a valance.

Coromandel screen A large, freestanding, paneled, and lacquered screen with incised designs, made in China but originally imported from the Coromandel Coast of India.

Corridor A term used for a hallway, generally in a public building.

Coved ceiling A ceiling that meets the wall by means of a concave curve rather than a right angle.

Credenza A long, table-height cupboard with drawers and doors. Popular during the Italian Renaissance. Today, a low storage unit with doors and often drawers, usually placed behind a desk.

Critical path A timetable or schedule used to determine the processes needed to complete a construction project.

Crown lintel An architectural detail used above windows, particularly in the late eighteenth and early nineteenth centuries. The lintel, often called a jack-arch lintel, features a crown-shaped keystone.

Crown molding The uppermost molding, usually joining the wall and ceiling.

Cruciform A cross-shaped form.

Crystal The finest quality of lead glass.

Cupola A small structure built on top of a roof for a lookout or to provide interior lighting; commonly used in Georgian, Federal, and Victorian structures.

Cyma curve A double curve formed by the union of a concave and a convex line.

Dado The lower part of an interior wall when treated in a different manner from the wall above; usually defined by a molding called a dado cap or chair railing.

Daub A sticky or heavy mud or plaster infill between half-timber construction work with wattle.

Daybed An extended type of couch or chair that can be used as a bed.

Decibel The unit by which sound is measured.

Design The planned arrangement of basic elements and principles that work together to create an image, object, or environment.

Design concept statement A statement outlining the goals and needs of the end users for a specific design project.

Design development A phase of design that involves specific selections of FF&E and illustrated 3-D designs.

Design process A progression of steps involving the analysis and synthesis of the design solution.

Direct lighting See *downlighting*.

Distressed Refers to a surface treatment for antique reproductions in which the furniture is intentionally damaged to provide an aged appearance.

Doric The simplest of the three orders of ancient Greek architecture.

Dormer A window in a small gablelike projection built out from a sloping roof.

Double glazing A process of hermetically sealing two sheets of glass together with air trapped between them. Provides efficient insulation against heat and cold.

Double-hung window A window divided into two sections, one lowering from the top and the other rising from the bottom. Each section is called a sash.

Dovetail joint A type of wood joint used in furniture construction consisting of two slotted fan-shaped pieces that interlock.

Dowel A round wood peg. Often used for furniture joinery, the peg is inserted into a cavity of the same size.

Dower chest A chest to hold items for a prospective bride. In early Pennsylvania it took on distinctive characteristics.

Downlighting Recessed or ceiling-mounted architectural lighting with lamps that direct the light downward. Sometimes called *direct lighting*. Downlights produce general lighting.

Dresden Fine porcelain made in Meissen, near Dresden, Germany. Established 1710–1720, the factory produced some of the most famous china in Europe.

Drop-leaf table A table with one or two hinged members that can drop to the sides or be supported to provide a larger tabletop surface.

Drywall A type of wallboard applied to studs. May also be called Sheetrock, plasterboard, or gypsumboard.

Dutch door A single-hinged door divided horizontally so that each section can be opened independently.

Ears Small squares or rectangles outlined with moldings; found on the edges of some chimneypieces, doors, or other architectural details.

Eave A protecting lower edge of a roof that overhangs the walls of a building.

Eclecticism Mixing furnishings or borrowing styles from various sources and periods with an eye to compatibility.

Efficacy In lighting, measures the efficiency of a lamp.

Egg-and-dart A classical Greek molding consisting of ovoid (egg-shaped) forms alternating with dartlike designs.

Egress The direct route to exit a building. Commonly used in life safety/fire codes.

Elements of design The "tools" used by the designer to create an environment and achieve the goals or principles of design. The elements are space, line, shape and mass, texture, color, light, and pattern.

Elevation Two-dimensional drawings of walls.

Ell A wing or extension placed at a right angle to the structure.

Elliptical fanlight A fan-shaped window that tops doorways or other windows.

End user The client or the client's client; the person who ultimately uses the interior space.

Entablature The upper part of a wall, usually supported by columns or pilasters and in classical orders consisting of the architrave, friezé, and cornice.

Ergonomics The study of human beings and their responses to various working conditions and environments.

Escutcheon In hardware, a shaped plate for a keyhole or a metal fitting to which a handle or knob is attached.

Etagere A series of shelves supported by vertical supports; used chiefly for display.

Evidence-based design A research layer of the design process that incorporates the scientific method. According to the Center for Health Design, it is "the process of basing decisions about the built environment on credible research to achieve the best possible outcomes."

Eyeball In lighting, a ceiling-mounted or recessed fixture with a pivoting spherical lamp that can be maneuvered to direct the light where desired.

Fabrics Fibers and yarns made into cloth.

Facade The exterior front of a building, either decorative or structural.

Fanlight See *elliptical fanlight*.

Fascia The vertical portion of the eave.

Fauteuil (fau toy) The French term for an open armchair.

Faux finish A "false" impression of a natural material such as wood, marble, or granite.

Fenestration The placement, type, and design of windows and other openings found on a building or wall.

Festoon A carved, molded, or painted classical ornament representing a decorative chain, swag, or strip.

FF&E Furniture, fixtures, and equipment.

Fiber A natural or synthetic substance processed into a thread or yarn of continuous length.

Fiberglass Glass fibers used for fabric or molded for furniture, furniture parts, or skylights.

FIDER Foundation for Interior Design Education Research, now called the Council for Interior Design Accreditation, CIDA.

Filament A threadlike conductor (as of carbon or metal) that is rendered incandescent (brilliant) by the passage of an electric current.

Finial An upright ornament that forms the upper extremity of an architectural detail, a piece of furniture, or an accessory.

Fish-scale shingles Small pointed or rounded shingles that provide decorative interest on the exterior of the Queen Anne Victorian house.

Fixture In lighting, the physical structure that supports the lamp and other necessary and decorative accoutrements.

Flemish gable A gable composed of graceful curves or steps. An architectural detail especially used by the Dutch settlers.

Fluorescent lighting Artificial light produced when a gaseous mixture of mercury and argon, sealed within a glass tube that is lined with a fluorescent coating, is activated by an electrical current.

Fluting Parallel concave grooves commonly used on the shafts of columns.

Foil Anything that serves, by contrast of color, pattern, texture, or other elements, to adorn or set off another thing to advantage; a wallpaper with the appearance of a thin sheet of metal; a background.

Footcandle An international unit of light measurement. It is the illumination at a 1-foot distance from the light of one candle falling onto a 1-square-foot surface. The intensity of light is calculated in footcandles.

Footings The structural foundation of a building.

Footlambert In lighting, the unit of measure for reflected light.

French doors Single-hinged doors of paned glass, sometimes paired; a walk-through window that swings either inward or outward.

Fresco The art of painting on moist lime plaster with water-based pigments.

Fretwork Interlaced ornamental work either perforated or cut in low relief, usually in geometric patterns; also, tracery of glazed doors and windows.

Friezé The horizontal decorative section found between the architrave and the cornice in classical architecture.

Fusuma screen A sliding, movable screen used in Japanese houses as a partition to define space.

Gable The triangular-shaped end portion of a building formed by a pitched roof.

Galerie A term for a covered porch found on a French home.

Gallery A miniature railing placed along the edge of a tabletop or shelf.

Gambrel roof A roof made from two lengths of lumber, the upper one being flatter and the lower one steeper.

Generic In textile use, a term pertaining to the characteristics of a particular type or class of fibers.

Geodesic dome A dome of interlocking polygons held together by a self-supporting network of rods and covered with a variety of materials; usually a plastic membrane or glass.

Gilding A finish added to any surface that includes the addition of a precious metal such as gold, silver, or an alloy.

Gingerbread Lacy architectural detail.

Glass block Hollow glass forms made in a variety of sizes and textures and used in building construction to emit light.

Glazing (paint treatment) A type of painted surface treatment achieved by applying layers of colored transparent paint to produce a striated effect.

Glazing (windows) The placement of window glass in an architectural opening.

Golden mean The division of a line somewhere between one-half and one-third its length.

Golden rectangle A rectangle with a width-to-length proportion of 2:3.

Golden section The division of a line or form in such a way that the ratio of the smaller portion to the larger is the same as that of the larger portion to the whole. Sometimes called the golden ratio.

Gradation A type of rhythm produced by the succession of the size of an object from large to small, or of a color from dark to light, or vice-versa.

Grain The vertical configurations or textural (coarse or fine) features of wood.

Gray goods or greige Woven fabrics that have not been dyed, treated, or changed from their natural state.

Green design Interiors and products designed to be environmentally friendly and sustainable.

Grotesques Decorative architectural treatment incorporating fanciful human/animal forms.

Grout A mortar (generally composed of cement) used to set tiles or fill cavities.

Half-timber construction Construction of timber frame, with the spaces filled with masonry or lath and plaster.

Hand or handle The feel of an object or drape of a fabric.

Hardware Metal fittings used for furniture such as keyholes and drawer and cupboard pulls.

Header In construction, the structural member over a door, window, or other opening that transfers the weight to the side supports.

HID lighting High-intensity discharge lighting.

Hieroglyphics Inscriptions on walls, some telling pictorial stories.

Highboy A tall chest of drawers supported on tall legs and divided horizontally into two sections; particularly popular during the Georgian period.

Hip roof A roof with sloping ends and sloping sides.

Hue The distinct name of a color such as blue, orange, or yellow. One of the three dimensions of color in the Munsell color system.

Hutch An informal chest or cabinet, common to many countries, that came to America from England. The type most commonly used has bottom doors and open upper shelves.

HVAC Heating, ventilating, and air-conditioning systems.

IAQ Indoor air quality.

IDC Interior Designers of Canada.

IDEC Interior Design Educators Council.

IIDA International Interior Design Association.

Ikebana The Japanese term for the art of arranging flowers according to precise rules.

Illuminance Also called *illumination*, the quantity of light from the source that strikes a surface. Expressed in footcandles, or lux in metric terms.

Incandescent lamps Light produced by heating a filament sealed in a lamp.

Indigenous Inherent; native to or living naturally in an environment.

Indirect lighting See *uplighting*.

Inglenook A large alcove in front of a fireplace. May include seating.

Ingress The entrance into a building.

Inlay Pieces of stone, wood, shell, metal, or ivory arranged in a design composition and set into another piece of wood or other material for a decorative effect.

Intensity A dimension of color that denotes the dullness or brightness of a hue. Also referred to as *chroma*.

Ionic The Greek order designated by the spiral volutes of its capital.

Jack-arch lintel See *crown lintel*.

Jacquard A special loom designed by Joseph-Marie Jacquard to produce intricate weaves. Weaves produced on the loom, such as damasks and tapestries, are called Jacquard weaves.

Jalousie window A window made of narrow horizontal and adjustable glass louvers that control ventilation and light.

Jamb The vertical side sections of a window or door.

Jetty The overhang produced when a second floor of a building extends over the first.

Kelvin A measurement of a light's temperature.

Ladderback A term describing a chair with a back composed of horizontal slats resembling a ladder.

Lambrequin An ornamental window treatment, usually in the form of a wooden frame across the top and down the sides of the window, either painted or covered with fabric.

Laminate The binding of layers of materials together. In paneling, several layers are laid alternately across the grain for strength and durability. For decorative purposes, a thin layer of fine wood (veneer) is glued to the surface of the base wood; a process also used for plastics.

Lamp The light source (bulb or tube) of artificial lighting.

Lath Thin strips of wood or a metal mesh attached to the structural frame of a building to support plaster, tile, reinforced concrete, or other material.

Lathe A machine used to turn wood or metal into various shapes.

Latillas Crude sticks laid between the vigas (pole beams) in the Southwest adobe-style home.

Law of chromatic distribution The large areas should be covered in the most neutralized colors of the scheme. As areas reduce in size, the chromatic intensity may be proportionally increased.

Life cycle costing Analysis of a product's total costs from conception through disposal.

Light-emitting diode lamp or LED Light produced without a heated filament. Strands of light typically are grouped together in interior applications. Used for accent lighting.

Linenfold A Gothic decorative detail depicting a stylized folded linen fabric.

Lintel The horizontal beam or component that spans the area between openings such as columns, windows, and doors.

Louver A slatted panel (usually wood) for controlling the flow of air and the radiation of light; most often used as a window treatment.

Lowboy A low chest of drawers supported on legs; particularly associated with the Georgian style.

Lumen A measure of the flow of light produced by one lamp.

Luminaire A complete light fixture including the lamp and all supportive elements.

Luminance General term for the amount of light the user perceives entering the eye; referred to by the user as the brightness of an environment. Historically measured in footlamberts.

Luminance flux Measurement of the total light output that leaves the light source in all directions.

Luminosity The ability of a surface to reflect light.

Mansard roof A roof having two slopes on all sides, the lower one steeper than the upper one. The roof usually conceals a second or third floor.

Mantel The shelf that projects from a chimneypiece.

Marbleizing A painted surface treatment that imitates the texture of polished marble.

Marlborough leg A square, straight leg with a square foot, most often associated with Chippendale furniture.

Marquetry A decorative inlay design glued into furniture and floors employing a variety of woods or other materials.

Masonry Construction materials of stone, bricks, tiles, blocks, or other material joined with mortar.

Matrix A diagram indicating adjacencies between individuals, departments, or spaces.

Matte A dull finish.

Metamerism The effect of various types of light in changing the appearance of a color.

Metope In classic architecture, the square panels between the triglyphs found on the entablature of the Doric order.

Miter Joining two members of material at a 45-degree angle to form a corner.

Modern style A new art form that breaks all ties with previous design forms and styles.

Modillion An ornamental bracket (usually console-shaped) that often supports a cornice or soffit.

Modular Constructed with standardized units or modules.

Module One in a series of standardized units to be integrated together, such as building construction units or a set of furniture.

Molding An architectural wood strip, usually decorative, that projects from the ceiling or wall surface; may also be made of metal, plaster, or plastic.

Monochromatic A color scheme that uses one color with varying value and chroma.

Monotone A color scheme that uses one color of very low chroma, neutralized.

Mordant Any substance that serves to produce a fixed color in a textile fiber, leather, or other similar material.

Mortise-and-tenon joint A type of joint used in furniture construction with a projecting tenon that fits into the mortise or cavity.

Mosaic A floor or wall decoration made up of small pieces of stone or glass arranged in a design.

Mottle A dripped or irregular color.

Mullion A vertical member dividing glazed doors, windows, or bookcases.

Munsell color theory A color theory based on three dimensions of color: hue, value, and chroma. Each color has a number notation.

Muntin A horizontal bar dividing the panes of a window, door, or bookcase. The term is often used interchangeably with *mullion*.

Nap A fuzzy surface found on fabrics composed of short fibers or hairs.

Nave The principal section of a church, usually flanked by the aisles and extending from the entrance to the altar or chancel.

NCIDQ National Council for Interior Design Qualification.

Newel post The main post at the foot of a stairway.

Niche A shallow recess in an exterior or interior wall; usually with a rounded head.

Nogging The brickwork (or infill) found between timbers in half-timber construction.

Nonarchitectural lighting Any type of luminaire that is portable.

Nosing The projecting edge at the top of a stair's riser.

Open office planning A large office space where divisions are made by modular furnishings to create workstations.

Orders of architecture In classical Grecian architecture, the Doric, Ionic, and Corinthian styles of columns.

Organic design or architecture A modern architectural approach put forth by Frank Lloyd Wright. The house should "grow out of the land."

Orientation The placement or arrangement of various elements such as buildings, windows, rooms, or furnishings in relation to points on the compass or other elements.

Ormolu mount A decorative treatment usually applied to furniture; made from copper and zinc alloy to look like gold. Common in French design.

Ostwald color theory A color theory based on yellow, red, blue, and green and the amount of black and white added to a hue.

Ottoman A general term for a large upholstered footstool.

Palladian window A window consisting of three vertical parts with the central section higher than the flanking ones and surmounted by a fanlight.

Panic hardware In commercial design, hardware on a door that opens when pushed against.

Parapet A low wall or protective railing at the edge of a roof or platform.

PAR lamp A reflective parabolic aluminized reflector lamp.

Parquetry A mosaic of wood laid in geometric patterns.

Parti Usually an abstract or geometric sketch that helps to form the basis of a design concept. The shape or forms of the parti are reflected in characteristics of the interior environment.

Passive solar energy system A system of collecting, storing, and distributing solar heat by employing elements of the structure.

Paterae Oval or round decorative details, particularly used during the Neoclassic era.

Patina A mellow surface often developed with age.

Patio A courtyard.

Pavilion A part of a building projecting from the main structure.

Pedestal A support at the base of a column; any base or foundation on which to display an art object.

Pediment A triangular architectural structure above a portico, window, or door.

Pembroke table A small table with one drawer and drop leaves.

Pendant An object suspended from above.

Pendant chandelier A light suspended from the ceiling with a single fixture.

Pent roof A small projected eave found above the first story.

Period style A term used to designate a single item or a complete interior including the architectural background, furniture, and decorative arts prevalent in a specific country or at a particular time in history.

Peristyle A series of columns surrounding a structure. Also, a garden surrounded by columns at the back of an ancient Roman house.

Piece dyeing Adding color to a fabric after it is woven.

Pier A rectangular pillar devoid of detail.

Pilaster An upright rectangular or circular projection or partial column fixed to a wall and architecturally treated as a column.

Pitched roof A sloping roof, either a low or a high pitch.

Plan A drawn arrangement of elements in a structure indicating walls, rooms, spaces, and so forth, shown looking down at the floor.

Plenum An area between the ceiling of one level and the floor of the next; usually conceals mechanical, electrical, and plumbing systems.

Plywood A process of laminating layers of wood with alternating grain direction. Usually the top layer or veneer is of a finer quality; used for furniture and paneling.

POE Postoccupancy evaluation.

Poeche A drawing technique that darkens the area inside an object. In plan view drawings, such as a furniture presentation plan, this technique is applied to the walls between rooms.

Portfolio A flexible case used by designers containing renderings, pictures, and other design-related projects.

Portico A projection from the main structure of a building over the front entrance, supported by columns and often capped by a pediment.

Prang color wheel Another term for the standard color wheel.

Prefabricated (prefab) Mass-produced in standardized modules or parts for later assembly at the factory or building site.

Principles of design The goals of a design composition consisting of scale, proportion, balance, rhythm, emphasis, and harmony.

Programming The information-gathering phase of the design process.

Proxemics A study of spatial needs of humans relating to personal and cultural aspects.

Proximity A Gestalt concept where the eye groups items together based on their vicinity.

Pueblo One of the Native American tribes of New Mexico. A Native American village built in the form of apartment houses.

Punch list A final list indicating all items still to be completed on a construction or design project.

Quoin A solid material at the corner of a building distinguished from the adjoining surface by material, color, size, or projection.

Rabbeted A type of joint in which one edge has a groove cut the entire width to accommodate a straight-edge piece.

Radial balance Balance created from a central point.

Ragging and rag rolling A wall surface treatment in which paint is partially wiped or rolled off with a rag.

Rail The horizontal member of a door frame or panel.

Ranch style Also known as a California ranch or rambler home; a ground-hugging, single-level plan with a low-pitched overhanging roof supported by posts.

Random plank Wood planks laid in a manner disregarding the width of individual boards.

Reeding A small convex molding, the reverse of fluting; used on columns, pilasters, and furniture.

Reflected ceiling plan A commercial design lighting plan in a set of construction drawings; may include HVAC and sprinkler information.

Replica An accurate reproduction.

Repoussé Relief work done on metal, created by hammering the material on the reverse side.

Reproduction A precise duplication of a historic style; a replica.

Resilience The ability of a particular material to give or spring back when pressed.

Rhythm Elements in a room that assist the eye in moving easily from one area to another.

Riser The upright member between two stair treads.

Sash The framework (in a window or door) in which the glass is set. It may constitute a movable part.

Schematic design See *conceptual design*.

Sconce A lighting fixture secured to the wall.

Scope of services The tasks that designers will perform to complete a specific client's job; used when describing the responsibilities of the designer in a business contract.

Section A cut-through view of a building, interior wall, cabinet, or other interior component.

Shade The darkening of a color by adding black; a low value.

Shed In ceiling design, the area formed by one wall extended higher than the opposite wall; also called a lean-to.

Shibui (shih BOO ee) A Japanese approach to beauty; an appreciation of serenity, not ostentation.

Shoji A basic element of a Japanese house, made of panes of rice paper and wooden mullions and used as an exterior window. Shoji panels are also employed as wall partitions and freestanding screens.

Sick building syndrome Health problems caused by an unhealthy environment with stale or polluted air.

Sidelight A vertical window placed beside a door.

Sillplate The construction member that secures the floor to the foundation.

Similarity A Gestalt concept where the eye groups items together based on their likeness.

Simultaneous contrast When a hue, value, or chroma is perceived as different as a result of being viewed beside or on a different colored background.

Soffit A lower section of a ceiling; the area underneath this section.

Solution dyeing Adding color to the liquid-state fiber.

Space planning The process of determining square footage requirements and then manipulating the spaces into an appropriate arrangement to meet the client's needs. May involve the use of a matrix; bubble, blocking, and stacking diagrams; and furniture plans.

Specifications or spec book Written directions indicating appropriate means to produce or purchase furniture, furnishings, and equipment.

Spinneret A device (similar to a showerhead in appearance) through which liquid viscose is forced to form manufactured fibers.

Stacking diagram A chart or graph indicating on which floors individuals, departments, or spaces will be placed. Used in conceptual design.

Standard milled items Items of various kinds (e.g., doors, door frames, windows, window frames, and mantels) made in standard sizes in large quantities in the factory, thus making the cost much less than for custom-made items.

Stepped gable A gable in which the sides ascend to the peak in steps.

Stile The vertical or upright supportive frame for a door.

Stock dyeing Adding color to fibers before they are processed into yarns.

Stretcher The horizontal supportive crosspiece spanning the area between the legs of a chair or table.

Stringcourse A narrow, horizontal band placed on the exterior of the Georgian house between the first and the second floors.

Stucco A type of plaster surface treatment used on exterior or interior walls.

Subtractive color Color that is visible to the eye via the reflection of wavelengths not absorbed by an object.

Sustainable design Designs incorporating energy-conscious and environmentally friendly elements and products.

Swag A festoon of flowers or fruit. Also refers to a gathering of fabric at the top of a window, gently draped over each end.

Symmetrical balance Balance created by arranging objects equally on either side of an imaginary line.

Synthetic Something artificial simulating the genuine piece.

Systems furniture A flexible type of component furniture that can be arranged and rearranged to accommodate various needs for workstations.

Tambour The front of a piece of furniture made with strips of wood attached to fabric and adjusted on a track, allowing it to open and close.

Task lighting Lighting designed for specific types of work or tasks.

Tatami mat A soft straw mat, approximately 3' × 6' × 1", which is the basic element of the Japanese house and serves as a unit of measurement, determining the size and proportion of all spaces. The dark lines of its binding form an overall grid pattern, according to which rooms are sized.

Templates Small patterns of furniture (either to cut or trace) used as guides in planning rooms.

Tension A force that causes elongation. When a structural member is loaded in such a way that the force is trying to pull it apart, it is under tension.

Terrace Usually refers to a relatively level paved area adjoining a building.

Textile A general term used to describe a fiber, yarn, or fabric.

Thermoplastics Plastics that soften when heated and harden when cooled. They may be reheated and manipulated.

Thermoset plastics Plastics that become permanently hard (or solid) after a manufacturing heat-set process.

Tint The lightening of a color by adding white; a high value.

Tokonoma A sacred recessed niche or alcove in the Japanese house.

Tone A neutralized hue produced by adding gray or the color's complement.

Tongue-and-groove joint A joint in which the rib on one edge of a board is made to fit into a corresponding groove in the edge of another board to make a flush joint.

Torchère A tall floor lamp that casts light in an upward direction; particularly popular for Art Deco and postmodern styles.

Trabeated construction A post and lintel design for structural support; developed by the Egyptians.

Tracery Decorative carved stone or wood openwork; associated with Gothic design.

Traffic lanes In design, refers to the walkways or passages.

Transept The lateral arms (across the nave) of cruciform churches.

Transom A small window above a door or window.

Tray In ceiling design, the area that extends vertically above the lower ceiling. Usually a 6-inch to 18-inch rise.

Tread The horizontal section of a stair.

Trompe l'oeil A French expression meaning "to fool the eye"; a term applied to two-dimensional decoration showing a three-dimensional drawing or effect.

Truss system A triangular construction system for structural support; developed by the Greeks.

Tryglyph Greek for "thrice grooved." On a Doric friezé, the blocks that alternate with the metopes.

Tudor arch A low or flattened elliptical arch.

Turning See *lathe*.

Universal design Spaces and furnishings created to meet the needs of individuals regardless of age and ability.

Uplighting Suspended or wall-mounted lighting with lamps that direct the light upward. Sometimes called *indirect lighting*.

Valance A short decorative fabric treatment at the top of a window that conceals drapery, curtains, and often lighting.

Value The lightness or darkness of a color, on a scale from white to black.

Vaulted In ceiling design, the area formed beneath the arch.

Veneer Thin sheets of wood or other material (usually of fine quality) used as a top surface over other more ordinary materials such as particleboard.

Veranda An open galley or portico (usually roofed) attached to the exterior of a building.

Vernacular A reference to the distinguishing attributes or qualities of a certain culture.

Vigas The large exposed pole beams that support the roof in the Southwest adobe structure.

Villa (Italian) A large residential structure.

Viscose The liquid used in the manufacture of synthetic fibers.

Visual communications The drawings, plans, and presentation materials that designers create to visually explain the design to the client before implementation.

Visual literacy The effective application of design elements and principles coupled with an understanding of pattern, ordering, and visual perception.

Volume The area that occupies any space including the width, depth, and height.

Volute The spiral-shaped decoration that tops the capital of the Ionic column.

Wainscoting Wood paneling that extends partway to the ceiling.

Wall-washer In lighting, a ceiling-mounted or recessed fixture with a lens that focuses the light on the wall or object.

Warp Vertical or lengthwise threads in a woven fabric.

Wattle Interlacing twigs that function as infilling for timber frame structures. Wattle and daub often work together.

Weft Horizontal threads in a woven fabric; also called filling threads.

Working drawings See *construction drawings*.

Wrought iron Ornamental iron that has been worked into a decorative shape or design.

Yarn Twisted or assembled fibers that produce cloth.

Yarn dyeing Adding color to yarns before they are woven into fabrics.

Zapata A carved decorative supportive bracket found on the Southwest adobe house.

References

Texts by Subject

Accessibility, Building Codes, and Universal Design
Business Profession
Color
Fundamentals and Theory
Furniture and Accessories
General
Historic Preservation
History
Lighting
Materials (Floors, Walls, Window Treatments, Etc.)
Research
Space Planning/Human Scale
Specialty Design
Sustainable Design
Technical Data (Systems and Construction)
Textiles
Visual Communications

Accessibility, Building Codes, and Universal Design (Also see website references in Chapter 5)

2009 International Building Code. Country Club Hills, IL: International Code Council, 2009.

American National Standard for Buildings and Facilities—Providing Accessibility and Usability for Physically Handicapped People. A11.1–1986. Washington, DC: U.S. Department of Housing and Urban Development, 1986.

American National Standard Specifications for Making Buildings and Facilities Accessible to and Usable by Physically Handicapped People. ANSI A117.1–1980. New York: American National Standards Institute, 1980.

Ching, Francis D. K., and Steven R. Winkel. *Building Codes Illustrated: A Guide to Understanding the 2006 International Building Code®*. 2d ed. Hoboken, NJ: Wiley, 2007.

Evan Terry Associates, P.C. (ed.). *Pocket Guide to the ADA: Americans with Disabilities Act Accessibility Guidelines for Buildings and Facilities*. 3d ed. Hoboken, NJ: Wiley, 2007.

Harmon, Sharon Koomen, and Katherine E. Kennon. *The Codes Guidebook for Interiors*. 5th ed. Hoboken, NJ: Wiley, 2011.

Jordan, Wendy A. *Universal Design for the Home*. Beverly, MA: Quayside Publishing Group, 2008.

Leibrock, Cynthia A., and James Evan Terry. *Beautiful Universal Design: A Visual Guide*. New York: Wiley, 1999.

Minimum Guidelines and Requirements for Accessible Design. Washington, DC: U.S. Architectural & Transportation Barriers Compliance Board, 1982.

NFPA 101® Life Safety Code® 1991. Quincy, MA: National Fire Protection Association, 1991.

Perry, Lawrence G., Michael A. Jawer, John T. Murdoch, and James C. Dinegar. *ADA Compliance Guidebook: A Checklist for Your Building*. Washington, DC: BOMA, 1992.

Wilkoff, W. M. L., James S. Brady, and Laura W. Abed. *Practicing Universal Design: An Interpretation of the ADA*. New York: Wiley, 1997.

Business Profession

Coleman, Cindy (ed.). *Interior Design Handbook of Professional Practice*. New York: McGraw-Hill, 2001.

Downey, Joel, and Patricia K. Gilbert. *Successful Interior Projects Through Effective Contract Documents*. Kingston, MA: R.S. Means, 1995.

Farren, Carol E. *Planning and Managing Interior Projects*. 2d ed. Kingston, MA: R. S. Means, 1999.

Kettler, Kerwin. *ASID Professional Practice Manual: Philosophical Framework*. New York: Whitney Library of Design, 1992.

Knackstedt, Mary V. *The Interior Design Business Handbook: A Complete Guide to Profitability*. 4th ed. New York: Wiley, 2005.

Loebelson, Andrew. *How to Profit in Contract Design*. New York: Van Nostrand Reinhold, 1983.

Morgan, Jim. *Marketing for the Small Design Firm*. New York: Whitney Library of Design/Watson-Guptill Publications, 1984.

Murphy, Dennis Grant. *The Business Management of Interior Design*. North Hollywood, CA: Stratford House Publishing Company, 1988.

Piotrowski, Christine. *Interior Design Management: A Handbook for Owners and Managers*. New York: Van Nostrand Reinhold, 1992.

———. *Professional Practice for Interior Designers*. 4th ed. New York: Wiley, 2007.

Rose, Stuart W. *Achieving Excellence in Your Design Practice*. New York: Whitney Library of Design/Watson-Guptill Publications, 1987.

Siegel, Harry, and Alan Siegel. *A Guide to Business Principles and Practices for Interior Designers*. Rev. ed. New York: Whitney Library of Design, 1982.

Stasiowski, Frank, and David Burstein. *Project Management for the Design Professional*. New York: Whitney Library of Design/Watson-Guptill Publications, 1982.

Thompson, Jo Ann Asher (ed.). *ASID Professional Practice Manual*. New York: Whitney Library of Design, 1992.

Veitch, Ronald, et al. *Professional Practice*. Winnipeg, Canada: Peguis, 1990.

Wasserman, Barry, Patrick Sullivan, and Gregory Palermo. *Ethics and the Practice of Architecture*. New York: Wiley, 2000.

White, A. C., and A. W. Dickson. The Polsky Forum: The Creation of a Vision for the Interior Design Profession in the Year 2010. *Journal of Interior Design*, 1994, 20(20), pp. 3–11.

Color

Birren, Faber. *Color and Human Response*. New York: Van Nostrand Reinhold, 1984.

Holtzschue, Linda. *Understanding Color: An Introduction for Designers*. 2d ed. New York: Wiley, 2001.

Hope, Augustine, and Margaret Walch. *The Color Compendium*. New York: Van Nostrand Reinhold, 1990.

Hornung, David. *Color: A Workshop Approach*. Boston: McGraw-Hill, 2005.

Kaufman, Donald. *Color: Natural Palettes for Painted Rooms*. New York: Clarkson Potter, 1992.

Ladau, Robert F., Brent K. Smith, and Jennifer Place. *Color in Interior Design and Architecture*. New York: Van Nostrand Reinhold, 1989.

Leibrock, Cynthia A. *Design Details for Health: Making the Most of Interior Design's Healing Potential*. New York: Wiley, 1999.

Mahnke, Frank H. *Color, Environment, and Human Response: The Beneficial Use of Color in the Architectural Environment*. New York: Wiley, 1996.

Miller, Mary C. *Color for Interior Architecture*. New York: Wiley, 1997.

Ostwald, Wilhelm. *The Color Primer*. New York: Van Nostrand Reinhold, 1969.

Sharpe, Deborah T. *The Psychology of Color and Design*. Chicago: Nelson-Hall, 1975.

Verity, Enid. *Color Observed*. New York: Van Nostrand Reinhold, 1982.

Fundamentals and Theory

Abercrombie, Stanley. *A Philosophy of Interior Design*. New York: Harper & Row, 1990.

Anderson, Katherine S., and Jill Pable. *Interior Design: Practical Strategies for Teaching and Learning*. New York: Fairchild, 2008.

Barnard, Malcolm. *Approaches to Understanding Visual Culture*. New York: Palgrave, 2001.

Bevlin, Marjorie Elliott. *Design Through Discovery: An Introduction to Art and Design*. 6th ed. Belmont, CA: Wadsworth, 1994.

Carpenter, James M. *Visual Art: A Critical Introduction*. New York: Harcourt Brace Jovanovich, 1982.

Cheatham, Frank R., Jane Hart Cheatham, and Sheryl A. Haler. *Design Concepts and Applications*. Upper Saddle River, NJ: Prentice Hall, 1983.

Ching, Francis D. K. *Architecture: Space, Form, and Order*. New York: Van Nostrand Reinhold, 1980.

De Sausmarez, Maurice. *Basic Design: The Dynamics of Visual Form*. New York: Van Nostrand Reinhold, 1983.

Dondis, Donis A. *A Primer of Visual Literacy*. Boston: MIT Press, 1973.

Faimon, Peg, and John Weigand. *The Nature of Design*. Cincinnati, OH: HOW Design Books, 2004.

Hale, Jonathan. *The Old Ways of Seeing*. Boston: Houghton Mifflin Cmpany, 1994.

Johnson, Paul-Alan. *The Theory of Architecture*. New York: Wiley, 1994.

Kleeman, Walter B. *The Challenge of Interior Design*. New York: Van Nostrand Reinhold, 1981.

Kopec, DAK. *Environmental Psychology for Design*. New York: Fairchild, 2006.

Kopec, DAK, E.L.A. Sinclair, and Bruce Matthes. *Evidence Based Design*. Upper Saddle River, NJ: Pearson Education/Prentice Hall, 2012.

Lauer, David A., and Stephen Pentak. *Design Basics*. 4th ed. Fort Worth, TX: Harcourt Brace College Publishers, 1995.

Malnar, Joy Monice, and Frank Vodvarka. *The Interior Dimension: A Theoretical Approach to Enclosed Space*. New York: Van Nostrand Reinhold, 1992.

McClure, Wendy R., and Tom J. Bartuska (eds.). *The Built Environment: A Collaborative Inquiry into Design and Planning*. 2d ed. Hoboken, NJ: Wiley, 2007.

Ocvirk, Otto G., Robert E. Stinson, Philip R. Wigg, Robert O. Bone, and David L. Cayton. *Art Fundamentals: Theory & Practice*. 8th ed. New York: McGraw-Hill, 1998.

Pena, William. *Problem Seeking*. Washington, DC: AIA Press, 1989.

Poldma, Tiiu. *Taking Up Space: Exploring the Process*. New York: Fairchild, 2009.

Postrel, Virginia. *The Substance of Style*. New York: HarperCollins, 2003.

Rengel, Roberto J. *Shaping Interior Space*. 2d ed. New York: Fairchild, 2007.

Rodemann, Patricia A. *Patterns in Interior Environments*. New York: Wiley, 1999.

Rybczynski, Witold. *Home: A Short History of an Idea*. New York: Penguin Books, 1987.

Sommer, Barbara, and Robert Sommer. *A Practical Guide to Behavioral Research*. 4th ed. New York: Oxford, 1997.

Taylor, Mark, and Julieanna Preston (eds.). *Intimus: Interior Design Theory Reader*. West Sussex, England: Wiley, 2006.

Winchip, Susan M. *Visual Culture in the Built Environment: A Global Perspective*. New York: Fairchild, 2010.

Wong, Wucius. *Principles of Two-Dimensional Design*. New York: Wiley, 1972.

Zelanski, Paul, and Mary Pat Fisher. *Shaping Space*. Fort Worth, TX: Harcourt Brace College Publishers, 1995.

Furniture and Accessories

Aronson, Joseph. *The Encyclopedia of Furniture*. 3d ed. New York: Crown, 1965.

Battersby, Martin, et al. *History of Furniture*. New York: Morrow, 1976.

Boger, Louise Ade. *The Complete Guide to Furniture Styles*. Prospect Heights, IL: Waveland Press, 1997.

Boyce, Charles. *Dictionary of Furniture*. New York: Roundtable Press, 1985.

Butler, Joseph T. *Field Guide to American Antique Furniture*. New York: Henry Holt and Company, 1985.

Crochet, Treena M., and David Vleck. *Designer's Guide to Furniture Styles*. Upper Saddle River, NJ: Pearson Education/Prentice Hall, 1999.

Deasy, C. M., and Thomas E. Lasswell. *Designing Places for People*. New York: Whitney Library of Design, 1985.

Elsasser, Virginia Hencken. *Know Your Home Furnishings*. New York: Fairchild, 2004.

Emery, Marc. *Furniture by Architects*. New York: Harry N. Abrams, 1983.

Fitzgerald, Oscar P. *Three Centuries of American Furniture*. Upper Saddle River, NJ: Prentice Hall, 1982.

Furuta, Tok. *Interior Landscaping*. Reston, VA: Reston Publishing Company, 1983.

Gandy, Charles D., and Susan Zimmermann-Stidham. *Contemporary Classics: Furniture of the Masters*. New York: McGraw-Hill, 1981.

Garner, Philippe. *Twentieth-Century Furniture*. New York: Van Nostrand Reinhold, 1980.

Habegger, Jerryll, and Joseph H. Osman. *Sourcebook of Modern Furniture*. 2d ed. New York: Norton, 1996.

Hanks, David A. *Innovative Furniture in America from 1800 to the Present*. New York: Horizon, 1981.

Lewin, Leonard Bruce. *Shopping for Furniture: A Consumer's Guide*. Fresno, CA: Linden, 1999.

Lucie-Smith, Edward. *Furniture: A Concise History*. London: Thames & Hudson, 1985.

Mackay, James. *Turn-of-the-Century Antiques: An Encyclopedia*. New York: Dutton, 1974.

Mang, Karl. *History of Modern Furniture*. New York: Harry N. Abrams, 1979.

Meadmore, Clement. *The Modern Chair*. New York: Van Nostrand Reinhold, 1975.

Russell, Frank, Philippe Garner, and John Read. *A Century of Chair Design*. New York: Rizzoli International, 1980.

Stimpson, Miriam. *Modern Furniture Classics*. New York: Whitney Library of Design, 1987.

Watson, Sir Francis. *The History of Furniture*. London: Orbio, 1982.

General

Allen, Edward, and Joseph Iano. *The Architect's Studio Companion*. New York: Wiley, 1989.

Ball, Victoria Kloss. *The Art of Interior Design*. 2d ed. New York: Wiley, 1982.

Ballast, David Kent. *Architecture, Design, and Construction Word Finder*. Upper Saddle River, NJ: Prentice Hall, 1991.

———. *Interior Design Reference Manual*. 5th ed. Belmont, CA: Professional Publications, 2010.

Binggeli, Corky. *Interior Design: A Survey*. Hoboken, NJ: Wiley, 2007.

Ching, Francis D. K. *Interior Design Illustrated*. New York: Van Nostrand Reinhold, 1987.

DeChiara, Joseph, Julius Panero, and Martin Zelnik. *Time-Saver Standards for Interior Design and Space Planning*. 2d ed. New York: McGraw-Hill, 2001.

Dizik, A. Allen. *Concise Encyclopedia of Interior Design*. 2d ed. New York: Van Nostrand Reinhold, 1988.

Faulkner, Ray, Sarah Faulkner, and LuAnn Nissen. *Inside Today's Home*. 5th ed. New York: Holt, Rinehart & Winston, 1986.

Friedmann, Arnold, John F. Pile, and Forrest Wilson. *Interior Design: An Introduction to Architectural Interiors*. 3d ed. New York: Elsevier, 1982.

Gandy, Charles D., and Chris Little. *Beautiful Interiors: An Expert's Guide to Creating a More Livable Home*. New York: Sterling, 2005.

Guthrie, Pat. *The Interior Designer's Portable Handbook*. New York: McGraw-Hill, 2000.

Kilmer, Rosemary, and W. Otie Kilmer. *Designing Interiors*. Fort Worth, TX: Harcourt Brace Jovanovich College Publishers, 1992.

McGowan, Maryrose, and Kelsey Kruse. *Interior Graphic Standards*. New York: Wiley, 2003.

National Council for Interior Design Qualification. *NCIDQ Examination Guide*. New York: National Council for Interior Design Qualification, 1989.

Nielson, Karla J., and David A. Taylor. *Interiors: An Introduction*. 5th ed. New York: McGraw-Hill, 2011.

Nissen, LuAnn, Ray Faulkner, and Sarah Faulkner. *Inside Today's Home*. 6th ed. Fort Worth, TX: Harcourt Brace College Publishers, 1994.

Pile, John. *Dictionary of 20th-Century Design*. New York: Facts on File, 1990.

——. *Interior Design*. 4th ed. Upper Saddle River, NJ: Pearson, 2007.

Ramsey, Charles George, and Harold Reeve Sleeper. *Architectural Graphic Standards*. 8th ed. New York: Wiley, 1988.

Reznikoff, S. C. *Interior Graphic and Design Standards*. New York: Whitney Library of Design, 1986.

Russell, Beverly. *Architecture and Design*. New York: Harry N. Abrams, 1989.

Slotkis, Susan J. *Foundations of Interior Design*. New York: Fairchild, 2006.

Tate, Allen. *The Making of Interiors: An Introduction*. New York: Harper & Row, 1987.

Historic Preservation

Debaigts, Jacques. *Interiors for Old Houses*. New York: Van Nostrand Reinhold, 1973.

Duerksen, Christopher J. (ed.). *A Handbook on Historic Preservation Law*. Washington, DC: The Conservation Foundation and The National Center for Preservation Law, 1983.

Gottfried, Herbert, and Jan Jennings. *American Vernacular Design: 1870–1940*. Ames, IA: Iowa State University Press, 1988.

Guidelines for Local Surveys: A Basis for Preservation Planning. Washington, DC: National Register of Historic Places, 1985.

Hiss, Tony. *The Experience of Place*. New York: Vintage Books, 1990.

Maddex, Diane (ed.). *All About Old Buildings*. Washington, DC: The Preservation Press, 1985.

Murtagh, William J. *Keeping Time: The History & Theory of Preservation in America*. Rev. ed. New York: Wiley, 1997.

Respectful Rehabilitation: Answers to Your Questions About Old Buildings. Washington, DC: The Preservation Press, 1982.

Shopsin, William C. *Restoring Old Buildings for Contemporary Uses*. New York: Whitney Library of Design, 1986.

Stipe, Robert E., and Antoinette J. Lee (eds.). *The American Mosaic: Preserving a Nation's Heritage*. Washington, DC: United States Committee of the International Council on Monuments and Sites, 1987.

Tyler, Norman, Ted J. Ligibel, and Ilene R. Tyler. *Historic Preservation: An Introduction to Its History, Principles, and Practice*. 2d ed. New York: Norton, 2009.

Vale, Thomas R., and Geraldine R. Vale. *U.S. 40 Today: Thirty Years of Landscape Change in America*. Madison, WI: University of Wisconsin Press, 1983.

History

Abercrombie, Stanley, and Sherrill Whiton. *Interior Design & Decoration*. 6th ed. Upper Saddle River, NJ: Pearson, 2008.

Anscombe, Isabelle. *Arts and Crafts Style*. New York: Rizzoli, 1991.

Ball, Victoria Kloss. *Architecture and Interior Design: A Basic History Through the Seventeenth Century*. New York: Wiley, 1980.

——. *Architecture and Interior Design: Europe and America from the Colonial Era to Today*. New York: Wiley, 1980.

Blakemore, Robbie G. *History of Interior Design and Furniture from Ancient Egypt to Nineteenth Century Europe*. New York: Van Nostrand Reinhold, 1997.

Blumenson, John J.-G. *Identifying American Architecture*. New York: W. W. Norton, 1981.

Brown, Erica. *Sixty Years of Interior Design*. New York: Viking Press, 1982.

Bush, Donald J. *The Streamlined Decade*. New York: George Braziller, 1975.

Clark, Robert Judson (ed.). *Arts and Crafts Movement in America, 1876–1916*. Princeton, NJ: Princeton University Press, 1972.

Curtis, William J. R. *Modern Architecture Since 1900*. 3d ed. Upper Saddle River, NJ: Prentice Hall, 1996.

de la Croix, Horst, Richard G. Tansey, and Diane Kirkpatrick. *Art Through the Ages*. 9th ed. Fort Worth, TX: Harcourt Brace Jovanovich College Publishers, 1991.

Fehrman, Cherie, and Kenneth Fehrman. *Post-War Interior Design, 1945–1960*. New York: Van Nostrand Reinhold, 1986.

Ferebee, Ann. *A History of Design from the Victorian Era to the Present*. New York: Van Nostrand Reinhold, 1970.

Foley, Mary Mix. *The American House*. New York: Harper & Row, 1980.

Garner, Philippe. *Contemporary Decorative Arts*. New York: Facts on File, 1980.

Gaynor, Elizabeth. *Scandinavia, Living Design*. New York: Stewart, Tabori & Chang, 1987.

Gowans, Alan. *Styles and Types of North American Architecture*. New York: Harper Collins, 1992.

Hicks, David. *Style and Design*. Boston: Little, Brown, 1987.

Hitchcock, Henry-Russell, and Philip Johnson. *The International Style* (1932, reprint). New York: Norton, 1966.

Horn, Richard. *Memphis: Objects, Furniture, and Patterns*. Philadelphia: Rushing Press, 1985.

Itten, Johannes. *Design and Form: The Basic Course at the Bauhaus*. New York: Van Nostrand Reinhold, 1964.

Jaffe, Hans L. C. *De Stijl*. New York: Harry N. Abrams, 1967.

Janson, H. W., and Janson, A. F. *History of Art*. 2 vols. 6th ed. New York: Harry N. Abrams, Inc. 2001.

Jones, Frederic H. *Concise Dictionary of Architectural and Design History*. Los Altos, CA: Crisp Publications, 1992.

Jordan, R. Furneaux. *A Concise History of Western Architecture*. London: Thames & Hudson, 1969.

Klein, Dan. *Art Deco*. New York: Crown, 1974.

Kostof, Spiro. *History of Architecture*. New York: Oxford University Press, 1985.

Kron, Joan, and Suzanne Slesin. *High Tech: The Industrial Style and Source Book for the Home*. New York: Clarkson N. Potter, 1978.

Maass, John. *The Victorian Home in America*. New York: Hawthorn, 1972.

Massey, Anne. *Interior Design of the 20th Century*. New York: Thames and Hudson, 1990.

Mather, Christine, and Sharon Woods. *Santa Fe Style*. New York: Rizzoli International, 1986.

McAlester, Virginia, and Lee McAlester. *A Field Guide to American Houses*. New York: Alfred A. Knopf, 1984.

McFadden, David. *Scandinavian Modern Design*. New York: Harry N. Abrams, 1982.

Naylor, Gillian. *The Bauhaus*. New York: Dutton, 1968.

Pevsner, Nikolaus. *Pioneers of Modern Design from William Morris to Walter Gropius*. 2d ed. New York: Museum of Modern Art, 1975.

Pierson, William H., Jr. *American Buildings and Their Architects: The Colonial and Neoclassical Styles*. New York: Doubleday, 1970.

Pile, John. *A History of Interior Design*. 2d ed. Hoboken, NJ: Wiley, 2005.

Radice, Barbara. *Memphis*. New York: Rizzoli International, 1984.

Sharp, Denis. *Showcase of Interior Design—Pacific Edition*. Grand Rapids, MI: Vitae, 1992.

——. *Twentieth Century Architecture*. New York: Facts on File, 1991.

Smith, C. Ray. *A History of Interior Design in 20th Century America*. New York: Harper & Row, 1987.

Smith, S. Jane. *Elsie de Wolfe: A Life in the High Style*. New York: Atheneum, 1982.

Tate, Allen, and C. Ray Smith. *Interior Design in the 20th Century*. New York: Harper & Row, 1986.

Trachtenberg, Marvin, and Isabelle Hyman. *Architecture from Prehistory to Post-Modernism*. New York: Harry N. Abrams, 1986.

Warren, Geoffrey. *Art Nouveau Style*. London: Octopus, 1972.

Whiffen, Marcus, and Frederick Koeper. *American Architecture, 1607–1976*. 2 vols. Cambridge, MA: The MIT Press, 1983.

Whiton, Sherrill, and Stanley Abercrombie. *Interior Design & Decoration*. 5th ed. Upper Saddle River, NJ: Prentice Hall, 2002.

Wright, Frank Lloyd. *The Natural House*. New York: Bramhall House, 1954.

Lighting

Burton, Jack L. *Fundamentals of Interior Lighting, Volume One*. Upper Saddle River, NJ: Pearson Education/Prentice Hall, 1999.

Design Criteria for Lighting Interior Living Spaces. New York: Illuminating Engineering Society of North America, 1980.

Gardner, Carl, and Barry Hannaford. *Lighting Design: An Introductory Guide for Professionals*. New York: Wiley, 1993.

General Electric. *The Light Book*. Cleveland, OH: Nela Park, 1981.

Gordon, Gary. *Interior Lighting for Designers*. 4th ed. New York: Wiley, 2002.

Grosslight, Jane. *Light: Effective Use of Daylight and Electric Lighting in Residential and Commercial Projects*. Upper Saddle River, NJ: Prentice Hall, 1984.

Jankowski, Wanda. *Designing with Light*. Glen Cove, NY: P. B. C. International, 1992.

Jones, Frederic H. *Architectural Lighting Design*. Los Altos, CA: Crisp Publications, 1989.

Karlen, Mark, and James R. Benya. *Lighting Design Basics: Design Methods for Architects*. New York: Wiley, 2002.

Kaufmann, John E. *IES Lighting Handbook Reference Volume*. New York: Illuminating Engineering Society of North America (IESNA), 1981.

Lightolier. *The Light Book*. Jersey City, NJ: Lightolier, 1981.

Michel, Lou. *Light: The Shape of Space*. New York: Van Nostrand Reinhold, 1996.

Moore, Fuller. *Concepts and Practice of Architectural Daylighting*. New York: Van Nostrand Reinhold, 1985.

Nuckolls, James L. *Interior Lighting for Environmental Designers*. 2d ed. New York: Wiley, 1983.

Robbins, C. C. *Daylighting Design and Analysis*. New York: Van Nostrand Reinhold, 1986.

Rooney, William F. *Practical Guide to Home Lighting*. New York: Van Nostrand Reinhold, 1980.

Smith, Fran Kellogg, and Fred J. Bertolone. *Bringing Interiors to Light*. New York: Whitney Library of Design, 1986.

Sorcar, Prafulla C. *Architectural Lighting for Commercial Interiors*. New York: Wiley-Interscience, 1987.

Steffy, Gary R. *Architectural Lighting Design*. 2d ed. New York: Wiley, 2001.

Winchip, Susan M. *Designing a Quality Lighting Environment*. New York: Fairchild, 2005.

——. *Fundamentals of Lighting*. New York: Fairchild, 2011.

Materials (Floors, Walls, Window Treatments, Etc.)

Beylerian, George M., and Andrew Dent. *Material ConneXion: The Global Resource of New and Innovative Materials for Architects, Artists, and Designers*. Hoboken, NJ: Wiley, 2005.

Commercial & Residential Wallcoverings Reference Manual, Created for Design Schools. Chicago: Wallcoverings Association, 1997.

Conran, Terence. *The House Book*. New York: Crown, 1976.

——. *The Bed and Bath Book*. New York: Crown, 1978.

——. *New House Book*. New York: Random House, Villard Books, 1985.

Eiland, Murray L. *Oriental Rugs: A Comprehensive Study*. Greenwich, CT: New York Graphic Society, 1973.

Fernandez, John. *Material Architecture: Emergent Materials for Innovative Buildings and Ecological Construction*. Amsterdam: Architectural Press, 2006.

Hall, William R. *Contract Interior Finishes: A Handbook of Materials, Products, and Applications*. New York: Whitney Library of Design, 1993.

Jacobson, Charles W. *Check Points on How to Buy Oriental Rugs*. Rutland, VT: Charles E. Tuttle, 1969.

Kahlenberg, Mary Hunt, and Anthony Berlant. *Navajo Blanket*. New York: Praeger, 1972.

Kopp, Joel, and Kate Kopp. *American Hooked and Sewn Rugs*. New York: Dutton, 1975.

McGowan, Maryrose. *Specifying Interiors: A Guide to Construction and FF&E for Commercial Interiors Projects*. 2d ed. Hoboken, NJ: Wiley, 2006.

Neal, Mary. *Custom Draperies in Interior Design*. New York: Elsevier, 1982.

Nielson, Karla J. *Window Treatments*. New York: Van Nostrand Reinhold, 1990.

Radford, Penny. *Designer's Guide to Surfaces and Finishes*. New York: Watson-Guptill, 1984.

Reznikoff, S. C. *Specifications for Commercial Interiors*. Rev. ed. New York: Whitney Library of Design, 1989.

Riggs, J. Rosemary. *Materials and Components of Interior Architecture*. 6th ed. Upper Saddle River, NJ: Prentice Hall, 2003.

Rupp, William, and Arnold Friedmann. *Construction Materials for Interior Design*. New York: Whitney Library of Design/Watson-Guptill Publications, 1989.

Wrey, Lady Caroline. *Complete Book of Curtains and Draperies*. London: Ebury/Random Century, 1991.

Research

Dickinson, Joan, and John P. Marsden (eds.). *Informing Design*. New York: Fairchild, 2009.

Koper, DAK. *Environmental Psychology for Design*. New York: Fairchild, 2006.

Nussbaumer, Linda L. *Evidence-Based Designs for Interior Designers*. New York: Fairchild, 2009.

Robinson, Lily B., and Alexandra T. Parman. *Research-Inspired Design: A Step-by-Step Guide for Interior Designers*. New York: Fairchild, 2010.

Zimmerman, David, Peggy Zimmerman, and Charles Lund. *Healthcare Customer Service Revolution: The Growing Impact of Managed Care on Patient Satisfaction*. New York: McGraw Hill, 1996.

Space Planning/Human Scale

Hall, Edward T. *The Hidden Dimension*. Garden City, NY: Doubleday, 1982.

Harrigan, J. E. *Human Factors Research: Methods & Applications for Architects & Interior Designers*. New York: Elsevier Dutton, 1987.

Henry Dreyfuss Associates. *The Measure of Man and Woman: Human Factors in Design*. Rev. ed. New York: Wiley, 2002.

Karlen, Mark. *Space Planning Basics*. 3d ed. Hoboken, NJ: Wiley, 2009.

Krier, Rob. *Elements of Architecture*. Hoboken, NJ: Wiley, 1993.

Laseau, Paul. *Graphic Problem Solving for Architects & Designers*. 2d ed. New York: Van Nostrand Reinhold, 1986.

Mitton, Maureen, and Courtney Nystuen. *Residential Interior Design: A Guide to Planning Spaces*. Hoboken, NJ: Wiley, 2007.

Niels, Diffrient. *Humanscale Four-Five-Six*. Cambridge, MA: MIT Press, 1981.

——. *Humanscale One-Two-Three*. Cambridge, MA: MIT Press, 1974.

——. *Humanscale Seven-Eight-Nine*. Cambridge, MA: MIT Press, 1981.

Panero, Julius, and Martin Zelnick. *Human Dimensions and Interior Space*. New York: Whitney Library of Design, 1979.

Papanek, Victor. *Design for Human Scale*. New York: Van Nostrand Reinhold, 1983.

Preiser, Wolfgang. *Post-Occupancy Evaluation*. New York: Van Nostrand Reinhold, 1988.

——. *Programming the Built Environment*. New York: Van Nostrand Reinhold, 1985.

Scott-Webber, Lennie. *Programming: A Problem-Solving Approach for Users of Interior Spaces*. Houston: Dame Publications, 1998.

Sommer, Robert. *Social Design: Creating Buildings with People in Mind*. Upper Saddle River, NJ: Prentice Hall, 1983.

Temple, Nancy. *Interior Design Workbook*. New York: Van Nostrand Reinhold, 1993.

Specialty Design

Baraban, Regina S., and Joseph F. Durocher. *Successful Restaurant Design*. 2d ed, New York: Wiley, 2001.

Barr, Wilma, and Charles Broudy. *Designing to Sell: A Complete Guide to Retail Store Planning and Design*. New York: McGraw-Hill, 1985.

Boykin, Paula Jo. *Hotel Guestroom Design*. Dubuque, IA: Kendall/Hunt Publishing, 1991.

Bush-Brown, Albert. *Hospitable Design for Healthcare and Senior Communities*. New York: Van Nostrand Reinhold, 1992.

Gosling, David, and Barry Maitland. *Design and Planning of Retail Systems*. New York: Whitney Library of Design, 1976.

Howell, Sandra C. *Designing for Aging: Patterns of Use*. Cambridge, MA: MIT Press, 1987.

Jones, Lynn M. *The Design of National Park Visitor Centers: The Relationships Between Buildings and Their Sites*. Athens, GA: University of Georgia, 1990.

Logrippo, Ro. *In My World: Designing Living & Learning Environments for the Young*. New York: Wiley, 1995.

Malkin, Jain. *Hospital Interior Architecture: Creating Healing Environments*. New York: Van Nostrand Reinhold, 1992.

——. *Medical and Dental Space Planning: A Comprehensive Guide to Design, Equipment, and Clinical Procedures*. New York: Wiley, 2002.

Mazzurco, Philip. *Bath Design*. New York: Whitney Library of Design, 1986.

Mount, Charles Morris. *Residential Interiors*. Glen Cove, NY: P. B. C. International, 1992.

Novak, Adolph. *Store Planning and Design*. New York: Lebhar Friedman, 1977.

Olds, Anita Rui. *Child Care Design Guide*. New York: McGraw Hill, 2000.

Pile, John. *Open Office Planning: A Handbook for Interior Designers and Architects*. New York: Whitney Library of Design/Watson-Guptill Publications, 1986.

Piotrowski, Christine. *Open Office Planning: A Handbook for Interior Designers and Architects*. New York: Whitney Library of Design, 1986.

Piotrowski, Christine M., and Elizabeth A. Rogers. *Designing Commercial Interiors*. 2d ed. Hoboken, NJ: Wiley, 2007.

Raschko, Bettyann. *Housing Interiors for the Disabled and Elderly*. New York: Van Nostrand Reinhold, 1982.

Russell, Beverly. *The Interiors Book of Shops and Restaurants*. New York: Watson-Guptill, 1981.

Weinhold, Virginia. *Interior Finish Materials for Health Care Facilities*. Springfield, IL: Charles C. Thomas, 1988.

Weishar, Joseph. *Design for Effective Selling Space*. New York: McGraw-Hill, 1992.

Sustainable Design

Bonda, Penny, and Katie Sosnowchik. *Sustainable Commercial Interiors*. Hoboken, NJ: Wiley, 2007.

Coles, Elizabeth A. *Designing Green Interiors: Green Concepts Teaching Manual*. Indianapolis, IN: Purdue School of Engineering and Technology, 1999.

Elizabeth, Lynne, and Cassandra Adams (eds.). *Alternative Construction: Contemporary Natural Building Methods*. New York: Wiley, 2005.

The Green Guide to NeoCon: A Roadmap for Sustainable Product Evaluation and Selection. Cedar Rapids, IA: Stamats Business Media, 2007.

Hawkseed Group. *The Passive Solar House Book*. New York: Rand McNally, 1980.

Jones, Louise (ed.). *Environmentally Responsible Design: Green and Sustainable Design for Interior Designers*. Hoboken, NJ: Wiley, 2008.

Kibert, Charles J. *Sustainable Construction: Green Building Design and Delivery*. Hoboken, NJ: Wiley, 2005.

Kopec, DAK. *Health, Sustainability, and the Built Environment*. New York: Fairchild, 2009.

Lichtenwalter, Rachel. *Green Eggs and Spam: Could You, Would You, Should You, Use These Materials?* [Brochure]. Atlanta, GA: Author, 2002.

McDonough, William, and Michael Braungart. *Cradle to Cradle: Remaking the Way We Make Things*. New York: North Point Press, 2002.

Pilatowicz, Grazyna. *Eco-Interiors*. New York: Wiley, 1995.

Reynolds, Michael. *EARTHSHIP Vol. I—How to Build Your Own*. Taos, NM: Solar Survival Press, 1990.

——. *EARTHSHIP Vol. II—Systems and Components*. Taos, NM: Solar Survival Press, 1990.

——. *EARTHSHIP Vol. III—Evolution Beyond Economics*. Taos, NM: Solar Survival Press, 1993.

Tucker, Lisa M. *Sustainable Building Systems and Construction for Designers*. New York: Fairchild, 2010.

Winchip, Susan M. *Sustainable Design for Interior Environments*. 2d ed. New York, Fairchild, 2011.

Wright, David. *Natural Solar Architecture: The Passive Solar Primer*. 3d ed. New York: Van Nostrand Reinhold, 1984.

Zeiher, Laura C. *The Ecology of Architecture*. New York: Whitney Library of Design, 1996.

Technical Data (Systems and Construction)

Allen, Edward, and Joseph Iano. *The Architect's Studio Companion: Rules of Thumb for Preliminary Design*. 3d ed. New York: Wiley, 2002.

Allen, Edward, and Rob Thallon. *Fundamentals of Residential Construction*. New York: Wiley, 2002.

Anderson, L. O. *How to Build a Wood-Frame House*. New York: Dover Publications, 1973.

Ballast, David Kent. *Interior Construction & Detailing for Designers and Architects*. 5th ed. Belmont, CA: Professional Publications, 2011.

——. *Practical Guide to Computer Applications for Architecture and Design*. Upper Saddle River, NJ: Prentice Hall, 1986.

Binggeli, Corky. *Building Systems for Interior Designers*. 2d ed. Hoboken, NJ: Wiley, 2009.

Browning, Hugh C. *The Principles of Architectural Drafting*. New York: Whitney Library of Design, 1996.

Ching, Francis D. K. *Building Construction Illustrated*. 4th ed. New York: Wiley, 2008.

The Encyclopedia of Wood. New York: Sterling, 1989.

Flynn, John E., A. Segil, and G. Steffy. *Architectural Interior Systems*. 2d ed. New York: Van Nostrand Reinhold, 1988.

Giesecke, Frederick E., Alva Mitchell, Henry Cecil Spencer, et al. *Technical Drawing*. 12th ed. Upper Saddle River, NJ: Prentice Hall, 2003.

Graf, Don. *Basic Building Data*. 3d ed. New York: Van Nostrand Reinhold, 1985.

Huth, Mark W. *Understanding Construction Drawings*. Albany, NY: Delmar Publishers, 1983.

Indoor Air Quality Programs: A Two-Part Program Package for the Design Professions. Washington, DC: American Society of Interior Designers, 1994.

Jones, Frederic H. *Interior Architecture Drafting and Perspective*. Menlo Park, CA: Crisp Publications, 1986.

Kicklighter, Clois E., Ronald J. Baird, and Joan C. Kicklighter. *Architecture: Residential Drawing and Design*. South Holland, IL: The Goodheart-Wilcox Company, 1990.

Kicklighter, Clois E., and Joan C. Kicklighter. *Residential Interiors*. South Holland, IL: Goodheart-Wilcox, 1986.

Lamit, Louis Gary. *Technical Drawing and Design*. Minneapolis/St. Paul: West Publishing Company, 1994.

Liebing, Ralph W. *Architectural Working Drawings*. 4th ed. New York: Wiley, 1999.

Muller, Edward J., and James G. Fausett. *Architectural Drawing and Light Construction*. Englewood Cliffs, NJ: Prentice Hall, 1993.

O'Shea, Linda S., and Rula Awwad-Rafferty. *Design and Security in the Built Environment*. New York: Wiley, 2009.

Salvadori, Mario. *The Art of Construction: Projects and Principles for Beginning Engineers & Architects*. Chicago: Chicago Review Press, 1990.

Smith, R. C. *Materials of Construction*. 3d ed. New York: McGraw-Hill, 1979.

Staebler, Wendy. *Architectural Detailing in Contract Interiors*. New York: Whitney Library of Design/Watson-Guptill Publications, 1988.

Stein, Ben M., Frederick H. Reynolds, and William McGuiness. *Mechanical and Electrical Equipment for Building*. New York: Wiley, 1986.

Veitch, Ronald M. *Detailing Fundamentals for Interior Design*. Winnipeg, Canada: Peguis, 1994.

Wakita, Osamu A., and Richard M. Linde. *The Professional Practice of Architectural Detailing*. 3d ed. New York: Wiley, 1999.

———. *The Professional Practice of Architectural Working Drawings*. 3d ed. New York: Wiley, 2003.

Wallach, Paul I., and Donald E. Helper. *Reading Construction Drawings*. New York: McGraw-Hill, 1979.

Textiles

Corbman, Bernard P. *Fiber to Fabric*. New York: McGraw-Hill, 1983.

Jackman, Dianne R., and Mary K. Dixon. *The Guide to Textiles for Interior Designers*. 2d ed. Winnipeg, Canada: Peguis, 1988.

Joseph, Marjory L. *Essentials of Textiles*. 3d ed. New York: Holt, Rinehart & Winston, 1984.

Kadolph, Sara J., and Anna L. Langford. *Textiles*. 8th ed. Upper Saddle River, NJ: Merrill/Prentice Hall, 1998.

Larsen, Jack Lenor, and Jeanne Weeks. *Fabrics for Interiors*. New York: Van Nostrand Reinhold, 1975.

Lyle, Dorothy Siegert. *Modern Textiles*. New York: Wiley, 1983.

Tortora, Phyllis G., and Billie J. Collier. *Understanding Textiles*. 5th ed. Upper Saddle River, NJ: Merrill/Prentice Hall, 1997.

Willbanks, Amy, Nancy Oxford, Dana Miller, and Sharon Coleman. *Textiles for Residential and Commercial Interiors*. 3d ed. New York: Fairchild, 2010.

Yates, Marypaul. *Fabrics: A Guide for Interior Designers and Architects*. New York: Norton, 2001.

Yeager, Jan I. *Textiles for Residential and Commercial Interiors*. 2d ed. New York: Fairchild, 2000.

Visual Communications

Bertauski, Tony. *Plan Graphics for the Landscape Designer*. 2d ed. Upper Saddle River, NJ: Pearson, 2007.

Burde, Ernest. *Design Presentation Techniques*. New York: McGraw-Hill, 1992.

Ching, Francis D. K. *Architectural Graphics*. 4th ed. New York: Wiley, 2003.

Cooper, Douglas. *Drawing and Perceiving: Life Drawing for Students of Architecture and Design*. 3d ed. New York: Wiley, 2000.

Dong, Wei. *Color Rendering: A Guide for Interior Designers and Architects*. New York: McGraw-Hill, 1997.

Doyle, Michael E. *Color Drawing*. New York: Wiley Reinhold, 1999.

Evans, Larry. *Illustration Guide, Vol. Two*. New York: Van Nostrand Reinhold, 1988.

Gerds, Donald A. *Markers: Interiors, Exteriors, Product Design*. Santa Monica, CA: DAG Design, 1983.

Kilmer, W. Otie, and Rosemary Kilmer. *Construction Drawings and Details for Interiors*. 2d ed. New York: Wiley, 2009.

Koenig, Peter A. *Design Graphics: Drawing Techniques for Design Professionals*. Upper Saddle River, NJ: Pearson Education/Prentice Hall, 2000.

Laseau, Paul. *Graphic Thinking for Architects & Designers*. 3d ed. New York: Wiley, 2001.

McGarry, Richard, and Greg Madsen. *Marker Magic: The Rendering Problem Solver for Designers*. New York: Van Nostrand Reinhold, 1993.

McNeill, Steven H., and Daniel John Stine. *Interior Design Using Hand Sketching, SketchUp and Photoshop*. Mission, KS: SDC Publications, 2011.

Mitton, Maureen. *Interior Design Visual Presentation: A Guide to Graphics, Models, and Presentation Techniques*. 3d ed. New York: Wiley, 2008.

Natale, Christopher. *Perspective Drawing for Interior Space*. New York: Fairchild, 2011.

Porter, Tom, and Sue Goodman. *Manual of Graphic Techniques 2*. New York: Charles Scribner's Sons, 1982.

Walker, Theodore D. *Perspective Sketches II*. West Lafayette, IN: P. D. A. Publishers, 1975.

———. *Plan Graphics*. West Lafayette, IN: P. D. A. Publishers, 1975.

Wang, Thomas C. *Plan and Section Drawing*. New York: Van Nostrand Reinhold, 1979.

Selected Periodicals, Trade Journals, Product Publications, and Professional Journals

Abitare
American Craft
American Homestyle & Gardening
American School & University
Architectural Digest
Architectural Lighting
Architectural Record
Art and Antiques
Atlanta Homes & Lifestyles
Audio/Video Interiors
Colorado Homes & Lifestyles
Conference Proceedings—Interior Design Educators Council
Contract Design
Design Solutions
The Designer Magazine
Domus
Elle Decor
EnvironDesign Journal
Facilities Design and Management
Fine Furnishings International
Florida Design
Healthcare Design
Home
Home Building
Hospitality Design
Interior Design
Interiors
Interiors & Sources
Journal of Interior Design
Kitchen and Bath Business
Lighting Dimensions
Luxe Interiors Design
Luxury Kitchen and Bath
Metropolis
Metropolitan Home
National Trust for Historic Preservation
Old House Journal
On Design
Professional Builder
Southern Accents
Traditional Home
Veranda

Current catalogs and brochures are published by and available from major manufacturers of fabrics, wallpaper, wall paneling, hard floor coverings, carpets, and furniture.

Index